20522

265

New

Cu 5%

 SO-AZF-141

THE FOUR MODES OF SEEING
APPROACHES TO MEDIEVAL IMAGERY
IN HONOR OF MADELINE HARRISON CAVINESS

Madeline Harrison Caviness

The Four Modes of Seeing

Approaches to Medieval Imagery in Honor of Madeline Harrison Caviness

Edited by
Evelyn Staudinger Lane, Elizabeth Carson Pastan,
and Ellen M. Shortell

ASHGATE

© Evelyn Staudinger Lane, Elizabeth Carson Pastan, Ellen M. Shortell 2009

All rights reserved. No part of this publication may be reproduced, stored in a retrieval system or transmitted in any form or by any means, electronic, mechanical, photocopying, recording or otherwise without the prior permission of the publisher.

Evelyn Staudinger Lane, Elizabeth Carson Pastan, Ellen M. Shortell have asserted their moral right under the Copyright, Designs and Patents Act, 1988, to be identified as the editors of this work.

Published by
Ashgate Publishing Limited
Wey Court East
Union Road
Farnham
Surrey, GU9 7PT
England

Ashgate Publishing Company
Suite 420
101 Cherry Street
Burlington
VT 05401-4405
USA

www.ashgate.com

British Library Cataloguing in Publication Data
The Four Modes of Seeing: Approaches to Medieval Imagery in Honor of Madeline
 Harrison Caviness
 1. Art and society – Europe – History – To 1500 2. Glass painting and staining,
 Medieval 3. Art, Medieval – Themes, motives 4. Art, Medieval
 I. Caviness, Madeline Harrison, 1938– II. Lane, Evelyn Staudinger, 1955–
 III. Pastan, Elizabeth Carson, 1955–. IV. Shortell, Ellen M., 1954–
 709'.02

Library of Congress Cataloging-in-Publication Data
The Four Modes of Seeing: Approaches to Medieval Imagery in Honor of Madeline
 Harrison Caviness / edited by Evelyn Staudinger Lane, Elizabeth Carson Pastan,
 Ellen M. Shortell.
 p. cm.
 Includes bibliographical references and index.
 1. Caviness, Madeline Harrison, 1938– 2. Art, Medieval. 3. Visual perception.
 I. Lane, Evelyn Staudinger, 1955–. II. Pastan, Elizabeth Carson, 1955– .
 III. Shortell, Ellen M., 1954–. IV. Caviness, Madeline Harrison, 1938–

 N7483.C38F68 2007
 709.02--dc22 2007022641

ISBN 978-0-7546-6010-1

Typeset by Manton Typesetters, Louth, Lincolnshire, UK.

Mixed Sources
Product group from well-managed
forests and other controlled sources
www.fsc.org Cert no. SA-COC-1565
© 1996 Forest Stewardship Council
FSC

Printed and bound in Great Britain by
MPG Books Ltd, Bodmin, Cornwall.

Contents

Illustrations

1 The Glazing of Siena Cathedral's *fenestra rotunda magna*: Preliminary Observations from a Production Standpoint

1.1 Siena, Cathedral of S Maria, stained-glass window executed by an anonymous glazier on designs attributed to Duccio di Buoninsegna, ca. 1287–88. (Originally published in G. Marchini, *Le vetrate italiane*, CVMA-Italia and Electa, Milan, 1955; photo courtesy of the BIVI Archives.)

1.2 Siena, Cathedral of S Maria, *Assumption of the Virgin*, detail of fig. 1.1. (Originally published in G. Marchini, *Le vetrate italiane*, CVMA-Italia and Electa, Milan, 1955; photo courtesy of the BIVI Archives.)

1.3 Siena, Cathedral of S Maria, *Coronation of the Virgin*, detail of fig. 1.1. (Originally published in G. Marchini, *Le vetrate italiane*, CVMA-Italia and Electa, Milan, 1955; photo courtesy of the BIVI Archives.)

1.4 Assisi, Upper Church of St Francis, south transept, detail. (Originally published in G. Marchini, *Le vetrate italiane*, CVMA-Italia and Electa, Milan, 1955; photo courtesy of the BIVI Archives.)

1.5 Assisi, Upper Church of St Francis, south transept, detail. (Originally published in G. Marchini, *Le vetrate italiane*, CVMA-Italia and Electa, Milan, 1955; photo courtesy of the BIVI Archives.)

2 Holding Hands in the Virgin Chapel at Beauvais Cathedral

2.1 Beauvais, Cathedral of Saint-Pierre, *A*, axial window in the Virgin Chapel, ca. 1245; *B*, chart showing the distribution of work. (Photo: Michael Cothren; chart: M. Cothren with the assistance of Meghan Barry.)

2.2 Beauvais, Cathedral of Saint-Pierre, lower portion of the Maternity of the Virgin lancet (Photomontage: Michael Cothren.)

2.3 Beauvais, Cathedral of Saint-Pierre, Maternity of the Virgin lancet: *A*, *8b*, *detail*, Virgin and Child receiving the Magi; *B*, *6b*, *detail*, Three Magi standing before Herod. (Photos: Emile Rousset.)

2.4 Beauvais, Cathedral of Saint-Pierre, four prophets from the Jesse Tree lancet. (Photos: Emile Rousset.)

2.5 Beauvais, Cathedral of Saint-Pierre, axial window: *A*, details of the Maternity of the Virgin lancet: *12b*, Massacre of the Innocents, and, *13b–14b*, the Flight into Egypt. (Photomontage: M. Cothren.) *B*, *24a*, Prophet from the Jesse Tree. (Photo: Emile Rousset.)

Pierpont Morgan Library, New York. MS M 673, fol. 206v.)

19.2 Wilgefortis, *Book of Hours*, Princeton University Library, MS Garrett 59, Netherlands, ca. 1500, fol. 161r. (By permission, Princeton University Library, Manuscripts Division, Department of Rare Books and Special Collections.)

19.3 Theodora, *Légende dorée*, Paris, BnF MS fr. 244, fol. 195v, France, fourteenth century.

19.4 Eugenia, Master of Soriguerola, Altar frontal of Saint Eugenia, Spain, thirteenth century, Paris, Musée des Arts Décoratifs. (Photo: Laurent Sully Jaulmes, Musée des Arts Décoratifs, all rights reserved.)

20 Women in English Royal Genealogies of the Late Thirteenth and Early Fourteenth Centuries

20.1 London, British Library, Cotton Roll XV.7: Genealogical Roll. Detail with St Margaret, King Cnut and his sons. (Photo: British Library.)

20.2 London, British Library, Cotton Roll XV.7, Genealogical Roll. Detail with Kings William Rufus, Henry I, Stephen, and Henry II, and the two Mauds, the wife and daughter of Henry I. (Photo: British Library.)

20.3 Cambridge, Corpus Christi College, MS 16, fol. iiiv: Matthew Paris, *Chronica majora*, vol. 2. Prefatory material with genealogy of the kings of England from William the Conqueror to Henry III. (Photo by permission of the Master and Fellows of Corpus Christi College, Cambridge, Parker Library.)

20.4 London, British Library, MS Add. 24026: Genealogical Roll. Detail with Kings Henry III, and Edward I, with secondary genealogy of the kings of Scotland in the left margin. (Photo: British Library.)

20.5 London, British Library, MS Add. 29504: Genealogical Roll. Detail with Kings John (cropped at the top), Henry III, Edward I and Edward II (cropped at the bottom), with small marginal hands pointing out the texts describing homage of the Scottish kings. (Photo: British Library.)

20.6 London, British Library, Cotton Galba Charter XIV.4: Genealogical Tree of the kings of England and Scotland, once attached to Oxford, Bodley Rolls 3. (Photo: British Library.)

21 Mirror, Mirror on the Wall: Reflections on the Performance of Authority in Eike von Repgow's *Sachsenspiegel*

21.1 Eike converses with Constantine and Charlemagne. Sachsenspiegel W, Herzog August Bibliothek Wolfenbüttel: Cod. Guelf 3.1 Aug 2° fol. 9v u.f. 85, Reg. 1.

21.2 Eike, seated as author under the arms of the Counts of Oldenburg. Sachsenspiegel O, Landesbibliothek Oldenburg: CIM I 410, fol. 6r, Reg. 1.

21.3 Eike under his book, two low-born men kick and spit on the book. Sachsenspiegel W, Herzog August Bibliothek Wolfenbüttel: Cod. Guelf 3.1 Aug 2° fol. 9v u.f. 85, Reg. 1.

21.4 Eike under his book. Sachsenspiegel D, Sächsischen Landesbibliothek MS Dresden M32, 91a, Reg. 1, reprinted from Karl von Amira, *Die Dresdner Bilderhandschrift Des Sachsenspiegels*, vol. 1 (Stuttgart 1968). Reprinted by permission of Anton Hiersmann KG Verlag.

22 St Hedwig's Personal Ivory Madonna: Women's Agency and the Powers of Possessing Portable Figures

22.1 Dedication Miniature, Hedwig Codex. J. Paul Getty Museum, Los Angeles, fol. 12v. (From Wolfgang Braunfels, ed., *Der Hedwigs-Codex von*

Acknowledgments

We owe the authors who chose to honor Madeline Harrison Caviness with their work a debt of thanks for their time, patience, and creativity. Many others have contributed to the production of this book. The editors thank, first and foremost, Marilyn M. Beaven for her editorial assistance. In addition, we are deeply grateful for the hard work of our anonymous editorial committee.

We are indebted to several institutions as well. At Tufts University, Dean Kevin Dunn, Cristelle Baskins, and Rosalie Bruno deserve our thanks. Susanne Woods, Eric Snoek, Jeanne Finlayson, and Marie Oliver at Wheaton College lent tremendous administrative support and financial guidance. The assistance of Wheaton students Antonia Dimitrova, Hailey O'Donnell, Elizabeth Raynor, and Blake Worrall is greatly appreciated as well. We would also like to thank Emory University and Massachusetts College of Art for their administrative support.

Early on our plans for this project were formulated with the wise advice and support of William W. Clark, Paul Crossley, Richard K. Emmerson, Patrick Geary, Eva Hoffman, Danielle Johnson, Claudine Lautier, Charles T. Little, Richard Marks, Phyllis Anina Thompson Moriarty, Nancy Netzer, David Ogawa, Elizabeth Parker, Virginia C. Raguin, Elizabeth Sears, Mary B. Shepard, John Smedley, Kathryn A. Smith, Bonnie Turner, and Yvette Vanden Bemden. Further editorial guidance offered by Julien Chapuis, David Lane, Mary Mahoney-Robson, and Phyllis Reid Thompson has been invaluable. We are also indebted to Anne F. Harris, Nancy Thompson, Timothy Husband, and Julien Chapuis for their translations. We wish to express our appreciation as well to Verne S. Caviness Jr., Jonathan J. G. Alexander, and Lucy Freeman Sandler.

Many other colleagues have lent their scholarly expertise to this project. For their time, counsel, and encouragement, we thank Barbara Abou-El-Haj, Lilian Armstrong, Pamela Berger, Sheila Bonde, Robert Bork, Carlee Bradbury, Sarah Brown, Kathryn Brush, James Bugslag, Stefano Carboni, Rachel Dressler, Theodore Evergates, Paula Gerson, Stephanie Moore Glaser, Gerry Guest, Glenn Gunhouse, Anne F. Harris, M. F. Hearn, Debra Higgs Strickland, Laura H. Hollengreen, Melissa Jolliffe, Naomi Kline, Genevra Kornbluth, Jennifer Lee,

Elizabeth Lipsmeyer, Clark Maines, Janice Mann, Andrew McClellan, Abby Lee McGehee, Elizabeth McLachlan, Scott Montgomery, Stephen Murray, Barbara Newman, Carol Newman de Vegvar, Patricia Pongracz, Felicity Ratté, Donna Sadler, Alexander Schwarz, Elizabeth Bradford Smith, Robert Sullivan, Richard Sundt, Nancy Thompson, Harry Titus, Stephen D. White, Nancy Wu, and Helen Zakin.

Finally, in an era when the 'bottom line' steers most projects, a volume of this scope requires a substantial subvention. Instead of a private foundation, however, we have many individuals to thank; the colleagues and friends who contributed financially attest to the esteem in which Madeline Harrison Caviness is held. We offer our profound thanks to the following:

Benefactor

Office of the Dean of the School of Arts and Sciences, Tufts University.

Patrons

Renée and Warren Burnam, Mr and Mrs David Giles Carter, Verne S. Caviness Jr., Timothy Husband, Christine Kondoleon, Phyllis Anina Thompson Moriarty, Nancy Netzer, Elizabeth Parker, and Lewis Rosenberg and Jo Ann Rothschild.

Sponsors

Marilyn M. Beaven, Michael W. Cothren, Richard K. Emmerson, Peter J. Fergusson, Dorothy F. Glass, Alyce A. Jordan, Evelyn Staudinger Lane, Suzanne Lewis, Elizabeth Carson Pastan, Virginia C. Raguin, Allyson Sheckler, Pamela Sheingorn, Mary B. Shepard and Charles K. Steiner, Ellen M. Shortell, The J & R Lamb Studios, Inc., Yvette Vanden Bemden, Susan Leibacher Ward, and Helen Zakin.

Contributors

Anonymous donors, Helen Dickinson Baldwin, Carl F. Barnes Jr., Barbara A. Beall, Pamela Z. Blum, Charlotte Brown, Jacqueline Brown, Elizabeth A. R. Brown, Linda L. Brownrigg, Robert G. Calkins, Annemarie Weyl Carr, Mary Carruthers, Mary Casey, Raymond Cormier, Marie Costello, Cummings Stained Glass Studios, Michael Curschmann, Constancio and Elizabeth V. del Alamo, Michael T. Davis, Lucy Der Manuelian, Martha W. Driver, Ilene H. Forsyth, Gerald Guest, Christine Havice, Mary Clerkin Higgins, Joan A. Holladay, Laura H. Hollengreen, Nancy Rogers Huntsinger, Danielle Johnson, C. Michael

Kauffmann, Herbert L. Kessler, Naomi Reed Kline, Meredith Parsons Lillich, Carol Neuman de Vegvar, Barbara Newman, Kathleen Nolan, Anne Prache, Lillian M. C. Randall, Felicity Ratte, Donna Sadler, Corine Schleif, Elizabeth Sears, Serpentino Stained Glass, Inc., George Spera, Leslie Bussis Tait, Nancy Thompson, Harry B. Titus Jr., and William D. Wixom.

Friends

Kathleen Biddick, Sarah Carrig Bond, Jennifer Borland, Sarah Bromberg, Kathryn Brush, Caroline Walker Bynum, Walter Cahn, Willene B. Clark, Giles Constable, Giovanna De Appolonia, Annette Dixon, Heidi Gearhart, Jean A. Givens, Sigrid Goldiner, Melanie Hanan, Kris Haney, Eva R. Hoffman, Virginia Jansen, Deborah Kahn, Jennifer Lee, Rebecca Leuchak, Charles T. Little, Amanda R. Luyster, Lyn Hovey Studio, Inc., Janice Mann, Richard Marks, Steven P. Marrone, Robert A. Maxwell, Anne McClanan, Abby Lee McGehee, Elizabeth Parker McLachlan, Laura Good Morelli, Karl F. Morrison, Kristin Mortimer, Lawrence Nees, Margot Nishimura, Judith H. Oliver, Vibeke Olson, Pamela A. Patton, Elizabeth A. Peterson, Eric M. Ramírez-Weaver, Anna Russakoff, Roland Sanfaçon, Rui Sasaki, Elizabeth B. Smith, Kathryn A. Smith, Susan Smith, Janet Snyder, Sarah Stanbury, Marilyn Stokstad, Rachel Strutt, Richard A. Sundt, Elizabeth C. Teviotdale, Tom Venturella, Christine B. Verzar, and William Voelke.

We thank all of you for contributing in another very substantial way: keeping this project secret from someone as inquisitive and ubiquitous as Madeline Caviness.

Introduction

I do not expect a Festschrift on retirement in a few years; a study I began a few years ago and never completed indicated how few women are honored in that way … . Women do not need genealogies; we know who our mothers and children are.[1]

A Festschrift is more than a genealogy; it paints a portrait of its honoree. A sense of the intellectual breadth of the scholar who inspired them emerges through the colleagues whose essays are assembled here, the kinds of subjects they address, and the approaches they take. Embedded in their texts are memories of the travels and conversations that have enhanced their professional and personal friendships with the art historian we honor in this volume, Dr Madeline Harrison Caviness. Numerous works by Caviness are cited throughout the thirty articles that follow, and many of these citations serve as key references on Canterbury, Saint-Remi of Reims, on the medium of stained glass, and in the field of gender studies.[2] Often her scholarship is the inspiration for the very nature of the inquiry pursued or for the theoretical issues explored. These explicit and implicit citations underscore many of the ways that Caviness has shaped the study and practice of medieval art history.

The title of this volume is borrowed from one of Madeline Caviness's most influential works, 'Images of Divine Order and the Third Mode of Seeing.'[3] In this article, she questioned the validity of 'period style' through the examination of images made between the tenth and fourteenth centuries with attention to their underlying compositional similarities, rather than the stylistic differences traditionally used to classify these works as Early Medieval, Romanesque, or Gothic. In order to explore the perspective of a medieval beholder, she drew upon the writings of the twelfth-century cleric Richard of Saint-Victor (†1173), who saw vision as a four-fold process, analogous to the four increasingly complex levels of scriptural exegesis: literal, allegorical, tropological, and

[1] Madeline Caviness, 'Tacking and Veering through Three Careers,' *Medieval Feminist Forum* 30 (2000): 26.

[2] For a list of selected published writings by Madeline Caviness, see pp. 565–70.

[3] Madeline Caviness, 'Images of Divine Order and the Third Mode of Seeing,' *Gesta* 22 (1983): 99–120.

eschatological. Caviness used Richard's conceptual armature to discuss how a medieval artist's and patron's understanding of a given subject may determine the way it should be depicted. She posited a first mode of artistic perception that corresponds to the actual appearances of things,[4] as would be appropriate for images in an herbal. The second mode of seeing would combine the outward appearance of an object or person with its symbolic content, such as was frequently employed in typological representations. The third mode pertains to spiritual revelation; it often occurred in apocalyptic scenes and was expressed through diagrammatic compositions. The fourth mode is entirely spiritual; although this mode cannot be experienced by the physical eye, it may be described in words or approximated by purely abstract and non-representational forms.[5] Scholars have turned again and again to this study, not only because it challenges us to rethink the canon but also because it invites us to engage anew with medieval objects and their reception. Since this study has continued to be an inspiration for many, we have chosen *The Four Modes of Seeing* as a fitting title for this volume.

As Madeline Caviness noted at the end of her discussion of Richard of Saint-Victor, 'the modes of seeing … are in fact seldom isolated in art; the richest works … might allow exegesis on all four levels.'[6] Similarly, her own scholarship is rich in interpretive strategies and draws its inspiration across disciplinary lines. The essays that follow do the same, pulling together several threads of subject matter and approach that are woven into Caviness's scholarship, including stained glass and monumental painting, gender, the historiography of art history, and relations between text and image. They engage with Caviness's work, and thus with issues that are at the forefront of scholarly investigation.

The Material Object

The first essays in this volume focus primarily on the material object. Because the study of the physical properties of the art object was the starting point for Caviness's earliest scholarly activities with French glass experts Louis Grodecki

4 See Madeline Caviness, '"The Simple Perception of Matter" and the Representation of Narrative, ca. 1180–1280,' *Gesta* 30 (1991): 48–64. In this article, published as a pendant to 'Images of Divine Order,' she considers themes favoring a realistic mode of presentation.

5 For this reason, few authors employing the notion of modes of seeing, including the Parker, Kurmann-Schwarz, and Davis contributions to this volume, refer to a fourth mode. However, it is interesting to note that in her discussion of the aniconic colored ornamental windows, which surrounded the axial window of the Crucifixion in the tribune of Saint-Remi of Reims, Caviness is essentially discussing images that could pertain to the fourth mode. See Madeline H. Caviness, 'The Twelfth-Century Ornamental Windows of Saint-Remi in Reims,' in *The Cloisters, Studies in Honor of the Fiftieth Anniversary*, ed. Elizabeth C. Parker (New York, 1992), 186–91. She later proposed that the third and fourth modes were experienced by visionary women, especially Hildegard of Bingen. See Madeline H. Caviness, 'Artist: To See, Hear, and Know, All at Once,' in *Voice of the Living Light: Hildegard of Bingen and her World*, ed. Barbara Newman (Berkeley, 1998), 110–24.

6 Caviness, 'Images of Divine Order,' 21.

and Jean Lafond, these essays honor the foundations of her work.[7] The approach to art through modes of vision was never intended to supplant traditional art historical tools, but rather to deepen the understanding of the complexities of artistic style. Indeed, her abiding curiosity about how things are made and how materials inform meaning are among her legacies in art history. Those of us who have known her as a teacher appreciate her commitment to instructing her students in the fundamentals of visual analysis. In a characteristic moment of self-critique, Caviness once noted that students who, prompted by her article on modes of seeing, approached style solely from the perspective of the mode of the subject matter, were unable to provide the date, provenance, or artistic comparanda for medieval objects. Caviness has demonstrated that a close study of objects often lays the groundwork for methodological approaches that seek new art historical ends. The results of such careful observation are exemplified here by the contributions of Renée K. Burnam, Michael W. Cothren, and Timothy Husband. Virginia Chieffo Raguin makes the case that materials are as important in the interpretation of medieval art as they are for contemporary art.

Documentary Reconstruction

The responsible reconstruction of lost or fragmented works has been one of the primary goals of Madeline Caviness's scholarship in the field of stained glass,[8] and is the topic for the next grouping of papers. As she noted in her introduction to *Paintings on Glass: Studies in Romanesque and Gothic Monumental Art*, 'The "lost" parts have become indispensable to accounts of the originary whole.'[9] In this group of essays, Peter J. Fergusson, Richard Marks, Rüdiger Becksmann, and Evelyn Staudinger Lane propose reconstructions of objects or programs through documentary evidence. Wary, like Caviness, of accepting the primacy of text over image,[10] they interpret their documents and pursue their visual implications in rigorous and layered analyses.

Post-Disciplinary Approaches

One of the most frequently cited works in these papers, aside from Caviness's 'Images of Divine Order,' is the anthology *Artistic Integration in Gothic Buildings*.[11] In her own contribution to that volume, entitled, 'Artistic

7 Madeline Caviness, *Art in the Medieval West and its Audience* (Aldershot, 2001), xii.

8 Madeline H. Caviness, *Paintings on Glass: Studies in Romanesque and Gothic Monumental Art*, (Aldershot,1997), vii–viii.

9 Caviness, *Paintings on Glass*, xi.

10 Caviness, *Paintings on Glass*, xi.

11 Virginia Chieffo Raguin, Kathryn Brush, and Peter Draper, eds, *Artistic Integration in Gothic Buildings* (Toronto, 1995), particularly the contribution by Madeline H. Caviness, 'Artistic Integration in Gothic Buildings: A Post-Modern Construct?' 249–61.

Integration in Gothic Buildings: A Post-Modern Construct?' Caviness decried the separation of modern scholarship into media-based specialties. The approach she took in her book, *Sumptuous Arts at the Royal Abbeys in Reims and Braine*, broke down the hierarchy that once placed stained glass in the category of minor arts by producing a study that drew on architecture, stained glass, floor mosaics, light fixtures, sculptures, patronage, workshop practice, liturgy, iconography, style, and politics. Throughout her career, she has called for engagement with painting on glass as an integral part of the fabric of the church, along with sculpture and sumptuous arts.[12] It is fitting, therefore, in a work that honors her to find essays on stained glass throughout this volume. This engagement across media is particularly true of the essays in this section by Anne Prache, Paul Crossley, Claudine Lautier, Michael T. Davis, and Ellen M. Shortell.

Multiple Readings

Other papers consider the levels of exegesis and the visual cues to 'reading' presented to the viewer through figural imagery, a topic taken up by Madeline Caviness in a number of her studies. The pages she devoted to Joseph cycles in another influential article, 'Biblical Stories in Windows: Were They Bibles for the Poor?'[13] pointed to multiple readings of the subject, made possible according to the individual viewer's educational and experiential level. The articles of Dorothy Gillerman, Brigitte Kurmann-Schwarz, Elizabeth C. Parker, and Meredith Parsons Lillich are closely argued contextual analyses about the circumstances of creation, the communicative language of the work, the interpretive level of the viewer, and, in one instance, a later beholder who imposed his own vision on the original context.

Gender and Reception

Caviness's interest in new approaches to art historical problems led her to study literary and critical theory at a time when these ideas were not widely used in the field. Her subsequent work has been grounded in her reading of deconstructionism, psychoanalysis, and gender theory in particular. One case in which Caviness proposed a different reading for a particular group of viewers pertains to the message conveyed through the Virgin and Child portal on the west façade of Chartres to mothers who visited the cathedral.[14] For this audience she identified a message of hope for safe childbirth that complements

[12] Madeline H. Caviness, *Sumptuous Arts at the Royal Abbeys in Reims and Braine, Ornatus Elegantiae, Varietate Stupendes* (Princeton: 1990), xix.

[13] Madeline H. Caviness, 'Biblical Stories in Windows: Were They Bibles for the Poor?' in *The Bible in the Middle Ages: its influence on literature and art*, ed. Bernard S. Levy (Binghamton, New York, 1992), 128–47.

[14] Caviness, *Art in the Medieval West*, viii.

the theological interpretation of the central sculpture of the Virgin and Child as 'Sedes Sapientiae.'[15] Inspired by feminist criticism, Caviness has investigated the difficulties of becoming 'fully visible' in the sense of being truly taken into account, artistically and otherwise.[16] A gender conscious approach appeared in her article for the Speculum issue of 1993 devoted to 'Studying Medieval Women'[17] and was the subject of her seventh book, Visualizing Women in the Middle Ages. While her work on gender may be seen as a new departure in her scholarship, a number of her examples, such as the representation of Lot's Wife,[18] draw from Canterbury stained glass, suggesting that a gendered gaze allowed her to revisit and explore the ramification of themes to which she had previously devoted more traditional iconographic analyses.

In fact, her scholarly studies dealing with gender have in some ways returned to the fundamental issue of one's perspective as a beholder. She has described her strategy as utilizing both traditional history and feminist criticism to 'pressure' the medieval object, like two levers of different lengths working from different angles.[19] As she has remarked, 'herstory' and the traditional male-centered view of western society are not mutually exclusive visions, as 'either [view] presented alone involves a silencing of the other.'[20] In pursuing a gendered approach to the Hours of Jeanne d'Evreux in her 'Patron or Matron? A Capetian Bride and a Vade Mecum for Her Marriage Bed' article, Caviness also focused on issues of reception. Rather than subscribe to an essentializing notion of 'the female reader,' she imagined the effect on the particular young queen for whom the book was commissioned. Caviness demonstrated the ways that the so-called marginal imagery might have instructed the impressionable fourteen-year-old third wife on her marital obligations.[21] Any study that treats the issue of reception, or what might be termed 'active beholding,' is acknowledging the communicative power of art not just to reflect important ideas, but indeed to shape them. For this reason, many inquiries that deal with gender are simultaneously also about reception, as is demonstrated in the contributions by Pamela Sheingorn, Martha Easton, and Joan A. Holladay.

[15] Madeline Caviness, 'Obscenity and Alterity: Images that Shock and Offend Us/Them, Now/Then?' in Obscenity: Social Control and Artistic Creation in the European Middle Ages, ed. Jan M. Ziolkowski, Cultures, Beliefs and Traditions 4 (Leiden, 1998), 155–75.

[16] Madeline H. Caviness, Visualizing Women in the Middle Ages: Sight, Spectacle and Scopic Economy (Philadelphia, 2001), 15.

[17] Madeline H. Caviness, 'Patron or Matron? A Capetian Bride and a Vade Mecum for Her Marriage Bed,' Speculum 68 (1993): 333–62.

[18] Madeline Harrison Caviness, The Early Stained Glass of Canterbury Cathedral, ca. 1175–1220 (Princeton, 1977), 54, 125, and 132; Caviness, Visualizing Women, 22, 28–36, and 55–64.

[19] Madeline Caviness, 'The Feminist Project: Pressuring the Medieval Object,' Frauen Kunst Wissenschaft 24 (Marburg, December 1997): 14–15.

[20] Madeline Caviness, 'The Rationalization of Sight and the Authority of Visions? A Feminist (Re)Vision,' Miscellània en Homenatge à Joan Ainaud de Lasarte 1 (Barcelona, 1998): 181–87.

[21] Caviness, 'Patron or Matron?'

Performativity

Related to the notion of reception is a consideration of the ways that works of art perform, a perspective that has long occupied Caviness. She chaired a groundbreaking session at the meeting of the College Art Association in Boston in 1987 entitled, 'Affective Aspects of Medieval Art,' where one of the studies in this volume had its debut.[22] In recent publications she has interrogated one of the ways that stained glass had always been assumed to perform, as illustration for the liturgy. Observing that the Matins service in which the office was first recited took place soon after midnight when the windows were dark, she effectively dislodged appealing notions about their presumed function.[23] This insight in turn pointed to the more complex medieval performance of the glass where spoken word, image, and ceremony might cohere through contemplation and recollection. Corine Schleif and Agostino Paravicini Bagliani demonstrate that the medieval dynamic, as suggested by Caviness's work, is often considerably more complex than has been assumed. Caviness has also worked collaboratively with Charles G. Nelson, a scholar of medieval German literature, on the interrelationships of text and image in illustrated German law books. Nelson presents here an analysis of the *Sachsenspiegel* manuscripts through the lens of speech act theory, which complements Caviness's work on gesture.[24]

Text and Image

Text and image play reciprocal roles in the creation and reception of the work as a whole in illuminated manuscripts like the *Sachsenspiegel*. In another instance, close examination of textual and visual material together led Caviness to argue that Hildegard of Bingen herself created the illuminations in the

[22] Corine Schleif, 'Saint Hedwig's Personal Ivory Madonna: Women's Agency and the Powers of Possessing Portable Figures,' unpublished paper, College Art Association, 1986.

[23] Madeline Caviness, 'Stasis and Movement: Hagiographical Windows and the Liturgy,' in *Corpus Vitrearum Medii Aevi, XIXth. International Colloquium, Kraków, 1998, 14–16 May*, ed. Lech Kalinowski, Helena Malkiewicz, and Pawel Karaskiewicz, (Cracow, 1999), 67–79; and its pendant, Madeline Caviness, 'Stained Glass Windows in Gothic Chapels, and the Feasts of the Saints,' in *Römisches Jahrbuch der Bibliotheca Hertziana: Kunst und Liturgie im Mittelalter*, ed. Nicolas Bock, Sible de Blaauw, Christoph Luitpold Frommel, and Herbert Kessler, *Akten des internationalen Kongresses der Bibliotheca Hertziana und des Nederlands Instituut te Rome, Rom, 28–30 September 1997*, (Munich, 2000), 135–48, esp. 140–43.

[24] In Caviness's collaboration with Charles G. Nelson on the texts and images of the manuscripts of the Sachsenspiegel, many of her analyses hinge on the gestures of figures in the illustrations of the law texts. See, for example, 'Women's Bodies, Women's Property: Limited Ownership under the Law,' an electronic exhibition in the Slater Concourse of the Aidekman Arts Center, Tufts University, November 18–December 15, 1998, University Archives, Tisch Library, Tufts University, http://dca.tufts.edu/features/law; and also, Madeline Caviness with Charles G. Nelson, 'Silent Witnesses, Absent Women, and the Law Courts in Medieval Germany,' in *Fama: The Politics of Talk and Reputation in Medieval Europe*, ed. Thelma Fenster and Daniel L. Smail (Ithaca, New York, 2003), 47–72.

original twelfth-century manuscript of her *Scivias*. Her verbal descriptions and images complement one another to communicate the multiple sensory aspects of her visions.[25] In a longer contribution, Elizabeth A. R. Brown also examines the dynamics of text and image in the *Vie de Saint Denis* manuscript.

Collecting and Consumption

Working with the great range of displaced glass in American collections for the Corpus Vitrearum,[26] Caviness became acutely aware of the vicissitudes of taste and the role of collectors in forming public taste, in encouraging the study of works of art from particular periods, and in reinforcing political positions. Also crucial to the collecting history of stained glass are the conservation policies of modern institutions, which have often served national political agendas. In France, both Alexandre Lenoir and Viollet-le-Duc were intimately involved in creating an awareness of French medieval monuments.[27] Their choices of works to collect, display, or restore contributed to establishing the so-called canon of medieval art. The dynamics of collecting have intrigued Caviness in two quite different ways: as a key to provenance and therefore important in reconstructing and preserving lost monuments;[28] and, in her 'Learning from Forest Lawn' article, as an aspect of the consumption of works of art, when the original resonance of the work is replaced by something which might be more personal, dramatic, or even commercial.[29] The 'lessons' of Forest Lawn that she articulated were as unsparing as they were perceptive: how to turn the static object into performance art (a process she characterizes as a medieval one), how the better-than-real copies of works of art change our perception of the

[25] Madeline Caviness, 'Anchoress, Abbess and Queen: Donors and Patrons or Intercessors and Matrons?' in *The Cultural Patronage of Medieval Women*, ed. June Hall McCash (Athens, Georgia, 1996), 115–17; Madeline Caviness, 'Gender Symbolism and Text-Image Relationships: Hildegard of Bingen's *Scivias*,' in *Translation Theory and Practice in the Middle Ages*, ed. Jeanette Beer, (Kalamazoo, 1997), 71–111; and Madeline Caviness, 'Hildegard as Designer of the Illustrations to her Works,' in *Hildegard of Bingen: The Context of her Thought and Art*, ed. Charles Burnett and Peter Dronke, (London, 1998), 29–63.

[26] Madeline H. Caviness et al., *Stained Glass before 1700 in American Collections*, Corpus Vitrearum (Checklists I–IV) National Gallery of Art, *Studies in the History of Art*, volumes 15, 23, 28, and 39 (Washington, D.C., 1985–91). In overseeing the efforts to catalogue stained glass in American collections, Caviness obtained and administered the following grants: National Endowment for the Humanities, Project Grant, 1977–78; National Endowment for the Humanities, Basic Research Grant, 1985–87, 1987–90, and 1990–92; Kress Foundation Grants for the Corpus Vitrearum, 1986–90; and the Getty Trust Grant, 1987–90.

[27] Madeline Harrison Caviness, with the assistance of Evelyn Ruth Staudinger, *Stained Glass before 1540: An Annotated Bibliography*, Reference Publications in Art History (Boston, 1983), 1, 3, and 129. A fundamental reference tool, this volume gathered together glass bibliography for the first time in an English language publication.

[28] Jane Hayward and Madeline H. Caviness, 'Introduction,' to *Stained Glass before 1700 in American Collections: New England and New York*, Corpus Vitrearum Checklist I, *Studies in the History of Art*, 15 (Washington, D.C., 1985):, 13–17.

[29] Madeline H. Caviness, 'Learning from Forest Lawn,' *Speculum* 69 (October 1994): 970–72.

originals, and how this fetishization ultimately devalues the art. In this section, the consumption of medieval art by later beholders is very much at stake as Carl F. Barnes Jr. probes the little-known engagement of Viollet-le-Duc (1814–79) in the reception and interpretation of Villard d'Honnecourt's manuscript. Marilyn M. Beaven analyzes the activities of Grosvenor Thomas (1837–1923), who would become the premier dealer of stained glass in America, while Mary B. Shepard investigates the role stained glass played in the installations of Alexander Lenoir (1761–1839), founder and director of the Musée des monuments français.

Politics and Ideology

Caviness characteristically marshaled the 'lessons' of Forest Lawn into a call for political action when she enunciated them in her presidential address to the Medieval Academy in 1994 and advocated a program devoted to the physical rehabilitation of works of art.[30] Reflecting on the uncertain future of the humanities and social sciences in the year 2000, Caviness, then president of the Union Académique Internationale, suggested that we stand at a moment of 'extraordinary opportunity to use the past as a laboratory for the exploration of human behaviors and conditions.'[31] She had come to appreciate the connections between her interest in the history of human culture and her passionate engagement with contemporary politics, especially with regard to women's rights and to censorship. The silencing of a woman such as Hildegard of Bingen in the annals of history, for example, took place not so much in the twelfth century as in more modern times and in places of strong masculinism, such as Nazi Germany. Hildegard's recent resurgence in popularity no doubt has its roots in late twentieth-century feminism.[32]

Caviness's perspective on the art world thus has a political aspect, not only in her scholarship, but also in her activism as president of the Medieval Academy (1993–94), the Union Académique Internationale (UAI) (1998–2001), the International Center of Medieval Art (1984–87), the International Corpus Vitrearum (1987–95), and the Conseil International de la Philosophie et les Sciences Humaines (an organization closely allied with UNESCO) (2001–4).[33]

She served on the UAI with her distinguished colleague and friend, the late Ernst Bacher, former delegate from the Austrian Academy and founding member and former director of the International Committee for the Conservation of Stained Glass, as well as a former vice president of the International Board of the Corpus Vitrearum. Professor Bacher worked tirelessly after his retirement for the Austrian Commission for the Restitution of Works of Art. Caviness

30 Caviness, 'Learning from Forest Lawn,' 991–92.
31 Caviness, *Art in the Medieval West*, xxiv–xxv.
32 Caviness, *Art in the Medieval West*, xvii–xxii.
33 For other committees and boards on which Madeline Caviness has served, see Appendix.

remembered him with special fondness: 'When I spent time with him in Vienna after the last [Corpus Vitrearum] colloquium, he spoke with great enthusiasm and delight about contacting descendents of Jewish owners to tell them of the works of art his team had traced.' We will always treasure his contributions, not just to art history but also to the way he applied his art historical training to provenance research.

In fact, Professor Bacher had begun a contribution for this volume on his work in the Austrian Commission on Provenance Research for the Restitution of Works of Art.[34] He stressed the importance of the art historian's role as one that "can serve highly topical socio-political issues." As his synopsis explains:

The Provenance Research project was founded in 1986 to address ambiguities in existing restitution laws. Systematic research into the background of artworks in museums and collections is necessary to winnow out remaining stolen art. In the 1998 law governing the return of stolen works, the Republic of Austria committed to undertake the examination of its museums and collections regarding the possibility of any questionable circumstances connected with all acquisitions made after 1938.

Since 1998, 2,659 artworks from state museums and collections in Austria have been returned to their previous owners or their legal heirs as a result of intensive research on individual artworks of 'dubious acquisition,' and on the archival and historical documentation connected with this topic. The Provenance Research project has made clear that the ownership histories are not only an issue to be questioned by museums and collections in Austria, but all over the world. No one is immune from acquiring stolen art, even unwittingly. Moreover, critical confrontation with the theme of art stolen during the Nazi regime and the restitution activities in the post-War era did not begin until the 1990's with the generation that was not itself directly involved in the events and was thus not personally affected by the War's shock wave. From this perspective, the traditional preoccupation with the background and pedigree of artworks has recently attained particular topicality as provenance research in carrying out a mission for contemporary history.

In this section, Sarah Stanbury compares the ideologies inherent in 15th-century devotional practice and in Mel Gibson's contemporary film, both focused on the Passion of Christ. Elizabeth Pastan explores the politics of the counts of Champagne through the lens of their artistic patronage, while Alyce

34 For the history of art stolen by the Nazi regime in Germany and Austria, and of efforts at its restitution, see Evelyn Adunka, *Der Raub der Bücher: Plünderung in der NS-Zeit und Restitution nach 1945* (Vienna, 2002); Theodore Brückler, ed., *Kunstraub, Kunstbergung und Restitution in Österreich 1938 bis heute. Studien zu Denkmalschutz und Denkmalpflege*, 19 (Vienna, 1999); Cay Friemuth, ed., *Die geraubte Kunst: der dramatische Wettlauf um die Rettung der Kulturschätze nach dem Zweiten Weltkrieg: Entführung, Bergung und Restitution europäischen Kulturgutes 1939–1948* (Braunschweig, 1989); Eva Frodl-Kraft, *Gefährdetes Erbe. Österreichs Denkmalschutz und Denkmalpflege 1918–1945 im Prisma der Zeitgeschichte. Studien zu Denkmalschutz und Denkmalpflege*, 16 (Vienna, 1997); Sophie Lillie, *Was Einmal War. Handbuch der entzogenen Kunstsammlungen Wiens. Bibliothek des Raubes*, 18 (Vienna, 2003); and Birgit Schwarz, *Hitlers Museum. Die Fotoalben Gemäldgalerie Linz: Dokumente zum Führermuseum*, (Vienna, 2004); Discussion of a number of related issues was published in volumes 10, 17, 21, and 22 of *Veröffentlichungen der Österreichishen Historikerkommission. Vermögensentzug während der NS-Zeit sowie Rückstellung und Entschädigungen seit 1945 in Österreich* (Vienna, 2004).

Jordan offers a political reading of images of the cult of Thomas Becket in the stained glass of Sens Cathedral.

The topics around which this volume of essays is organized—the Material Object, Documentary Reconstruction, Post-Disciplinary Approaches, Multiple Readings, Gender and Reception, Performativity, Text and Image, Collecting and Consumption, and Politics and Ideology—are themes that Madeline Caviness has pursued vigorously and creatively throughout her career. It is our hope that this gathering of original scholarly contributions will paint a large picture of someone who once described herself as having 'a numerically small direct legacy.'[35] In fact, many scholars who graciously contributed to other aspects of this volume could also have produced wonderful studies, if space permitted. As this brief overview suggests, Madeline Caviness's legacy is tremendous, and continuing.

35 Caviness, 'Tacking and Veering,' 26.

PART ONE

The Material Object

The Glazing of Siena Cathedral's *fenestra rotunda magna*: Preliminary Observations from a Production Standpoint

Renée K. Burnam

The magnificent *occhio*, or round window, installed high in the apse of Siena Cathedral, has been approached by scholars primarily focused on attributing the window's design to the Sienese painter Duccio di Buoninsegna. In fact, the window, dated around 1287–88, is popularly known as simply the *occhio di Duccio* (fig. 1.1),[1] and the identification of Duccio as the author of the occhio's design will not be brought into question here. Rather, this essay will consider the window as the product of a multi-phase process that engaged the skills of not one but two principal individuals: a designer and a master glazier. Some initial suggestions will be offered about the glazier's possible origins and sphere of activity within the context of Italian thirteenth-century stained glass. Then preliminary observations will be made about how the production of Siena's window challenged designer and master glazier alike. My vantage point speaks to one of the most critical aspects of Italian stained-glass research, namely that the production of stained glass was often a collaborative venture.[2]

N.B. This essay, submitted in 2003 for the Festschrift in honor of Madeline H. Caviness, was revisited as a paper, presented in her presence, at the twenty-third Corpus Vitrearum International Colloquium in Tours, France, in July of 2006 (see forthcoming volume *Le vitrail et les traités du Moyen Âge à nos jours*, Peter Lang Publishers, Bern, Switzerland).

[1] The attribution made by Enzo Carli, *Vetrata duccesca* (Florence, 1946), has been reconfirmed by Luciano Bellosi. For a summary of the issues surrounding attribution see Alessandro Bagnoli, Roberto Bartalini, Luciano Bellosi, Michel Laclotte, eds, *Duccio. Alle origini della pittura senese* (Milan, 2003), esp. 128–30 and 166–70. Heartfelt thanks to my readers and Caterina Pirina, President, Corpus Vitrearum Medii Aevi, Italia (CVMA-Italia).

[2] Specialized studies that address stained glass in Tuscany include: Giuseppe Marchini, *Le vetrate italiane* (Milan, 1955); Renée George Burnam, *The Stained Glass Windows of the Oratory of Orsanmichele in Florence, Italy*, unpublished diss. (Syracuse University, 1988); Renée K. Burnam, 'Medieval Stained Glass Practice in Florence, Italy: The Case of Orsanmichele,' *Journal of Glass Studies* 30 (1988): 77–93; Enrico Castelnuovo, *Vetrate medievali. Officine tecniche maestri* (Turin, 1994), esp. 89–91; Frank Martin, 'Domenico del Ghirlandaio *delineavit*? Osservazioni sulle vetrate della Cappella Tournabuoni', in *Domenico Ghirlandaio 1449–1494*, (Atti del Convegno Internazionale, Firenze: 16–18 October, 1994), ed. Wolfram Prinz and Max Seidel (Florence, 1996), 31–34 and 118–40; Nancy M. Thompson, *The Fourteenth-Century Stained Glass of Santa Croce in Florence*, unpublished diss. (Indiana University, 1999); Renée K. Burnam, *Le vetrate del Duomo di Pisa*, Corpus Vitrearum Medii Aevi, Italia 2, Annali della Scuola Normale

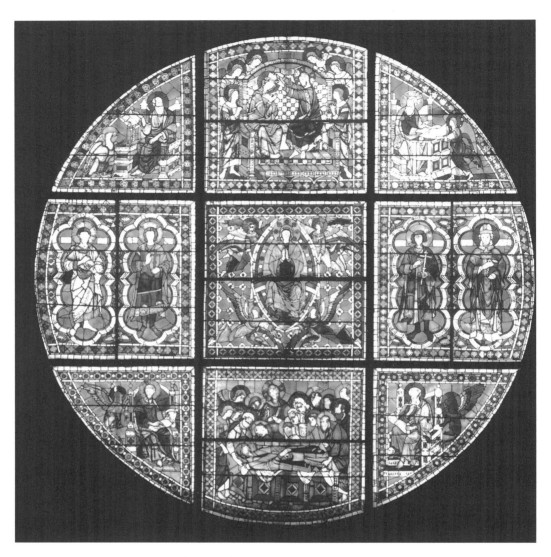

1.1 Siena, Cathedral of S Maria, stained-glass window executed by an anonymous glazier on designs attributed to Duccio di Buoninsegna, ca. 1287–88.

Very little stained glass dating to the thirteenth century survives in Italy. This fact has led to the erroneous conclusion that the craft did not flourish there until the fourteenth century. But Francesca Dell'Acqua has shown that stained-glass windows were being produced in Italy during the eighth and ninth centuries, and maintains that stained glass was already an established craft by

Superiore di Pisa, 4 (Pisa, 2002); and Nancy M. Thompson, 'The Franciscans and the True Cross: the Decoration of the Cappella Maggiore of Santa Croce in Florence,' *Gesta* 43 (2004): 61–79.

the thirteenth century when Cistercian houses were being constructed on Italian soil and glazed with stained-glass windows.[3] Although the statutes of the Cistercian order prohibited windows of colored glass, it has been well established that in France and elsewhere this regulation was ignored, and there is no reason to believe that the situation was any different in Italy.[4]

Dell'Acqua's research is relevant here, since the Cistercian complex of San Galgano, founded not far from Siena, likely had stained-glass windows by the time of Siena Cathedral's occhio commission.[5] In fact, it was a friar from San Galgano, a certain fra' Magio, who directed the production of the cathedral's occhio. It is tempting to presume that, besides having administrative abilities, the friar had more than a passing acquaintance with stained-glass production.[6] Unfortunately, the abbey is in ruins and there have not yet been any attempts to recover fragments of glass from the site. But San Galgano's occhio and windows (finestre) are held forth as exemplars of high quality in a 1440 document that records the commissioning of a stained-glass window for Siena Cathedral's facade.[7] That the document was referring to the house's early, venerable windows, can perhaps be adduced from the only other exemplar cited, the thirteenth-century occhio in the apse of Siena Cathedral, the subject of this study.

Unquestionably, there were other thirteenth-century windows in the region that have disappeared and left no traces in recorded history. Nonetheless, besides the cathedral's occhio, there exists a modestly-scaled, stained-glass window preserved in the Santuario della Madonna della Grotta, near Siena, that has been dated to around 1280.[8] The panel's design, an image of the *Madonna and Child*, has been considered the work of an anonymous Sienese artist. While the cathedral's occhio and the Santuario window could have been executed by the same workshop, the poorly preserved state of the Santuario window, and the *retardataire* figural style of its underlying design prevent an informative comparison. Moreover, the two projects differ greatly in scale,

3 Francesca Dell'Acqua, '*Illuminando colorat,*' *La vetrata tra l'età tardo imperiale e l'alto medioevo: le fonti, l'archeologia* (Spoleto, 2003): esp. 68.

4 Helen Zakin, *French Cistercian Grisaille Glass* (New York, 1979), 4–7.

5 By 1224, San Galgano was already being referred to as 'abbatiam novam Sancti Galgani' and was consecrated in 1288.

6 The friars of San Galgano likely carried out the building of the abbey themselves, since this was Cistercian practice. In exchange for military protection and economic benefits, Cistercians assumed administrative duties in Siena, such as directing the ongoing construction of Siena's cathedral and running the city's charitable institutions and hospitals. On San Galgano, Vito Albergo, *Eremo e abbazia di San Galgano* (Pistoia, 1981); Giuseppe Amante and Andrea Martini, *L'abbazia di San Galgano, un insediamento cistercense nel territorio senese* (Florence, 1969); and Carlo Perogalli, 'Cistercense architettura,' in *Le Muse – Enciclopedia di tutte le arti* 3 (Novara, 1965), 315–17.

7 Carli, *Vetrata*, 21.

8 Silvia D'Argenio, in *Il Gotico a Siena: miniature pitture oreficeria oggetti d'arte* (Florence, 1982), 43, the dimensions are 64.8 × 45 cm (25.5 × 18 in.). As the Santuario was not under construction until 1457, the origin of the stained-glass panel is an open question, but its Sienese figural style indicates that it must have originated in the region. See also Marchini, *Le vetrate*, 27 and 223 n 27, and Enzo Carli, *Dipinti senesi del contado e della Maremma* (Milan, 1955), 35.

scope, and format. But the Santuario window is relevant, since it constitutes concrete evidence for glazing activity in the environs of Siena just prior to the time when the cathedral embarked on its ambitious project to glaze the occhio.

Pertinent, too, is the glazing that was being carried out in Assisi, located just to the southeast of Siena. In the Upper Church of the basilica of Saint Francis there is a large corpus of thirteenth-century stained-glass windows, attesting to an intense and prolific production that was underway by 1275 and continued to the 1290s.[9] Many glaziers were employed at Assisi, but though several hands can be distinguished, there is no record of the names or origins of the various glaziers who were engaged in the project.

Thus, the situation is classic: for the few existing thirteenth-century windows, the names of the stained-glass masters who carried out the commissions are undocumented, and for glaziers who are named in archival material, no windows have survived.[10] The identity of the master glazier who executed Siena Cathedral's occhio has received scant attention from scholars who—it bears repeating—have focused on the author of the window's design, presumably Duccio. Nevertheless, there is ample evidence that, at the time of Siena's occhio project, there was a ready source of glaziers working locally, if not in Siena or at San Galgano, then nearby in Assisi.[11] But the glazier's identity is beyond the scope of this essay, which is devoted to reconstructing the master glazier's role in the production of Siena's stained-glass window.

Before delving into the details of Siena's commission, it is opportune to outline briefly the master glazier's general procedures, and discuss the ways in which painters such as Duccio could be involved in the glazing process. Italy's thirteenth-century stained-glass practices can be deduced from some later Italian treatises, which make it clear that, for some commissions, local painters could be called upon to participate in glazing projects.[12] Indeed, the myth that Italian glaziers were unskilled as painters stems from Cennini's fourteenth-century treatise on painting, in which the author touted the

[9] On Assisi, Giuseppe Marchini, *Le vetrate dell'Umbria*, Corpus Vitrearum Medii Aevi, Italia 1 (Rome, 1973); Castelnuovo, *Vetrate medievali*, 353–57; Frank Martin, 'The St. Francis Master in the Upper Church of S. Francesco, Assisi: Some Consideration Regarding His Origins,' *Gesta* 35 (1996): 177–91; Frank Martin, *Die Glasmalereien von San Francesco in Assisi* (Regensburg, 2003); and Frank Martin and Gerhard Ruf, *Le vetrate di San Francesco in Assisi* (Assisi, 1998).

[10] For example, Tura di Ciaffone (called frate Giusto), whose windows for Siena's Palazzo Pubblico, glazed in 1309, have been lost (Carli, *Vetrata*, 15); Carli quotes from Milanesi's manuscript *Sulla storia civile e artistica senese*: 'Non restano tra i più antichi maestri di vetro che Dono and Giunta, de' quali forse si servì fra' Magio, quando nel 1287 cominciò una finestra grande a capo l'altar maggiore.' (13).

[11] Camillo Tarozzi, in Bagnoli et al., *Duccio*, 35, speculates that the window was 'obviously executed by a skilful artisan … maybe a glass master from the area north of the Alps.'

[12] Giordana Benazzi et al., *Vetrate: arte e restauro. Dal trattato di Antonio da Pisa alle nuove tecnologie di restauro* (Milan, 1991); Alessandro Lusini, *De la practica de comporre finestre a vetri colorati, trattello del secolo XV* (Siena, 1885); Cennino Cennini, *The Craftsman's Handbook 'Il Libro dell'Arte,'* trans. Daniel V. Thompson Jr. (New York, 1960) or Franco Brunello, ed., *Il libro dell'arte*, (Vicenza, 1971). For a fuller discussion of stained-glass practice see Castelnuovo, *Vetrate medievali*, 37–70.

superiority of his own craft: '[Glaziers] possess more skill than draftsmanship, and they are almost forced to turn, for help on the drawing, to someone who possesses finished craftsmanship, that is, to one of all-round, good ability.'[13]

Painters had the greatest opportunity to exert their artistic influence during two stages of stained-glass production: when the designs were prepared and when the glass was painted. Speaking to the first, the master glazier required designs that were to scale.[14] Although there are cases in which painters furnished small-scale designs which had to be converted to full size, that practice seems to have emerged only later. The discovery of a fourteenth-century glazier's table reveals that designs could also be sketched directly on the glazier's working surface.[15] But it is more likely that Duccio furnished to-scale drawings, called 'cartoni,' which the master glazier laid on top of the workshop table as a guide for cutting the glass pieces, as may be confirmed by comparing the occhio's figures with those in paintings attributed to Duccio.[16] The contours are typical of the painter's work, and since it is improbable that Duccio cut the glass himself, this must have been done by the master glazier with the aid of one-to-one scale cartoni. The glass pieces were replaced on the cartoni in order to accomplish the next phase, the glass painting, which could involve the designing artist. In fact, Luciano Bellosi maintains that Duccio applied the vitreous paint to the faces of the occhio's figures, for he sees a similarity with the way the painter applied pigments to panel paintings that have been attributed to him.[17] While this may have been the case, recent work by Hartmut Scholz on southern German glazing has demonstrated that when explicit designs were provided, it can be extremely difficult to ascertain whether the painting was carried out by the creator of the drawings or the executing glass painter.[18] Indeed, the variation that exists in both the application and preservation of the occhio's vitreous paint suggests a more complex arrangement.

The remainder of the glazing process is far less controversial: it fell entirely to the master glazier to fire the glass pieces in a furnace in order to fuse the vitreous paint to the glass material itself. The cartoni, placed on the tabletop once again, guided the leading-up of the glass, pane by pane. Before installation, the leaded panels were reinforced with crossbars at intervals to provide stability.

Thus, stained-glass treatises provide a basic framework for approaching Siena's commission, but the issues that are at the heart of this inquiry are not conveniently defined in any existing document. For example, did Duccio plan

[13] Cennini, *Craftsman's Handbook*, 111.

[14] On working methods, collaboration, stained-glass cartoni and drawings, see Hartmut Scholz, 'Monumental Stained Glass in Southern Germany in the Age of Dürer,' in *Painting on Light*, ed. Barbara Butts and Lee Hendrix (Los Angeles, 2000), 17–42, esp. 28–29.

[15] Joan Vila-Grau, 'La table du peintre-verrier de Gérone,' *Revue de l'Art* 72 (1986): 32–34.

[16] For comparisons, Bellosi, in Bagnoli et al., *Duccio*, 130, figs. 26–27; 136, figs. 42–43; and 181–82.

[17] Bellosi, in Bagnoli et al., *Duccio*, 168 and 181–82.

[18] Scholz, 'Monumental,' esp. 28–29.

the overall format of the window, or was this considered a production issue best delegated to the master glazier? And how explicit were Duccio's cartoni? While recent scholarship has demonstrated that Duccio developed the window's figural compositions, little attention has been devoted to ascertaining whether he also designed the decorative borders that frame the window's nine scenes. Lastly, who influenced the window's final appearance, the painter Duccio or the window's master glazier? Surely, if Duccio's cartoni were still in existence, reconstructing the dynamics of this joint venture would be more straightforward. But stained-glass cartoni rarely survive, partly because they were consumed in the production process. Nevertheless, the challenges posed by the production of Siena's window can be rediscovered through close analysis of the window itself. But first, let us reconstruct the circumstances surrounding the stained-glass commission.

Glazing the cathedral's window opening, or *fenestra rotunda magna*, was an enormous undertaking considering its diameter of six meters (19.6 ft.) and, thus, its high cost of production.[19] Financing the stained-glass window was undoubtedly the most fundamental problem that confronted fra' Magio, referred to in documents as the *Operaio*, or director of the cathedral works. A document dated 1287 reveals that the city of Siena had agreed to meet the cost of the glass material itself, while all of the other glazing expenses were to be covered by the cathedral.[20] But the city officials did not initially uphold their end of the agreement. In May of 1288 the commune's *Camerlingo* and four *Provveditori* were threatened with ten lire fines each if they did not carry out their obligation to provide the cathedral with the promised funds.[21] The severity of the consequences had the desired effect. The next month one hundred lire was paid out to fra' Magio, and a few months later a payment of twenty-five lire was made.[22] This is the full extent of the known documentation pertaining to the glazing of the window.[23]

[19] Carli, *Vetrata*, 9, the radius is 2.80 m (9 ft).

[20] The document, dated September 1287, reads, 'Item statutum et ordinatum est quod fenestra rotunda magna que est post altare beate Marie virginis maioris ecclesie debeat vitriari ad requisitionem Operarij Operis eiusdem beate Mariae virginis hoc modo silicet quod vitrum dicte fenestre debeat haberi et emj expensis comunis senarum et totum aliud laborerium expensis operarii predicti.' (MS Archivio di Stato di Siena, Statuti di Siena, 16, c. 11r, transcribed in Carli, *Vetrata*, 12). The declaration was first published by Péleo Bacci, *Documenti e commenti per la storia dell'arte* (Florence, 1944), 21–22.

[21] MS Archivio di Stato di Siena, Statuti di Siena, 16, c. 11r, May 1288, 'Et camerarius et iiii[or] provisores comunis senarum teneantur et debeant ad petitionem operarii operis sancte Marie de Senis eidem operario dare et solvere omnes expensas que fieri opporterent pro emendo vitro dicte fenestre et si non solverent condempnentur et puniantur ipsi iiii[or] Provisores comunis senarum comuni senensi, videlicet quilibet eorum, in x. libris denariorum comuni senesi, quos potestas teneatur eisdem et cuilibet eorum auferre et in utilitatem comunis convertere.' (Carli, *Vetrata*, 13).

[22] MS Archivio di Stato di Siena, Biccherna, 96, cc. 94r, 95r, 'Item c. lib. fratri Magio operario operas sancte Marie pro fenestra de vitreo que fieri debet supra altare sancte Marie,' and 97, cc. 142r, 143 r, 'Item XXV lib. operario sancte Marie pro vitro fenestre fiende supra altare sancte Marie ex forma statute.' (Carli, *Vetrata*, 14).

[23] For documents pertaining to restoration, Carli, *Vetrata*, 19–21, and Bagnoli et al., *Duccio*, 166, 170, and 180.

It can be assumed that the cathedral's Operaio both acquired the glass and managed the project, which could have been well on its way by 1288.[24] No contract has survived to reveal the specific arrangements that fra' Magio made, but it is virtually certain that he commissioned Duccio di Buoninsegna to work up the cartoni.[25] Perhaps fra' Magio turned to a painter for designs because the figural program that was envisioned was ambitious: the Virgin's Death, Assumption, and Coronation, and depictions of the gospel writers Sts Matthew, Mark, Luke, and John the Evangelist, as well as four locally venerated saints; Bartholomew, Ansanus, Crescentius, and Savinus (fig. 1.1). As the execution of the cathedral's window required a practical knowledge that was outside a painter's training, it can be presumed that fra' Magio contracted with a master glazier as well. Considering the scale and expense of the undertaking, it stands to reason that the friar took care to select a seasoned glazier who had demonstrable expertise and experience.

Clearly then, Siena Cathedral's great round window was not accomplished single-handedly by Duccio, even though it is commonly referred to as 'Duccio's window.' Two artistic personalities, with distinctly different perspectives, were involved in the project from the outset. Defining the differing perspectives of these individuals is crucial to unraveling the threads of their collaboration. Duccio di Buoninsegna had much to recommend him even at this early moment in his artistic development, according to the most recent studies.[26] However, there is no evidence that by this stage in his youthful career Duccio had ever been hired to furnish stained-glass designs or that he had previously acquired any practical knowledge of, or actual experience in, stained-glass production. He would have approached the commission purely as a painter, though he may have looked to nearby stained-glass windows for some pictorial guidance.

The master glazier's preparation and perspective would have been different. He would have acquired a hands-on sense for the glass material through years of experience in a glazing workshop, first as an apprentice and then as a master. The master glazier thus came to the glazing project with a certain repertoire in his back pocket, a familiarity with the standard formats for stained-glass windows, and a practical knowledge of established procedures for window construction. The master glazier was accustomed to carrying out commissions within the context of a workshop, where he would divide the labor among several glaziers, including apprentices or assistants, and along the lines that were most efficient and cost effective.

In approaching this collaborative venture, we would do well to resist the impulse to visualize the cartoni that the master glazier had to work with by turning immediately to Duccio's extant paintings. Instead, our analysis will begin with the window opening itself. Unlike the beautifully ornate rose

[24] Carli, *Vetrata*, 14: fra' Magio may have acquired the glass immediately after the 1287 deliberation, presuming that he would be promptly reimbursed by the commune, and this would explain the severity of the threats made in 1288.

[25] Stained-glass commissions involved various arrangements; see Burnam, *Le vetrate*, esp. 73–87; and Castelnuovo, *Vetrate medievali*, 89–91.

[26] Bellosi, in Bagnoli et al., *Duccio*, 118–30.

windows of French Gothic acclaim, and the great wheel-like *rosoni* that were so popular in Lombardy, the occhio of Tuscan building tradition is an immense expanse of uninterrupted space—a gaping hole in the cathedral wall. There are no architectural members, such as spokes of a wheel, that would dictate the size and shape of the individual stained-glass panels and, perhaps even more significant from the master glazier's point of view, no interior stonework to which stained-glass panels could be attached. Therefore, it can be assumed that, from the very start, serious attention must have been given to devising an internal grid to support the glass panels, and anticipating a method for installing the huge window in its circular opening. The method originally employed to fix the glass window in its opening is not known, because the choir was rebuilt during the *trecento*. Upon its completion in 1365, the stained-glass window was reinstalled in a window-opening especially created for it in the newly enlarged apse. This installation employed a circular wooden frame that was bolted to the stonework of the round opening.[27]

More important to the present inquiry is an understanding of the stained-glass window's internal grid or armature. The major structural elements are robust, wooden members, arranged horizontally and vertically to divide the window into its nine large pictorial fields (fig. 1.1). Iron bars bolted to the wooden members further support the stained-glass panels. Tarozzi, who directed the window's most recent conservation, observed that the window's three central scenes, which narrate events from the Life of the Virgin, are 'subdivided horizontally into various panels whose long sides constitute the weakest part of the structure's system of vertical holding forces.'[28] As a result, the lower panels, which bore the brunt of the weight, were suffering from a severe 'bellying out' before conservation. Nevertheless, the occhio's glass has been judged to be largely original.[29]

The scheme that was adopted for the cathedral's window—a division by means of horizontal and vertical supports into immense pictorial fields—was inspired by contemporary innovations in the field of painting, of which Duccio was a leading proponent. From Duccio's perspective, this would have been an optimum layout for the ambitious, multi-figural compositions that he was to provide (fig. 1.1). From the master glazier's viewpoint, the scenes depicting the Virgin's Death, Assumption, and Coronation, exceeded the dimensions normally considered feasible for individual glazed panels, not only in terms of production, but with regard to stability. Moreover, the master glazier had to

[27] Carli, *Vetrata*, 14 and 18–21; Camillo Tarozzi, 'Considerations Relating to the Large Wooden Supporting Frame of the Duccio di Buoninsegna Stained Glass Window in Siena Cathedral,' *Corpus Vitrearum Newsletter* 47 (June 2000): 18–20; and Camillo Tarozzi, 'Tecnica e conservazione della vetrata di Duccio,' in *Duccio. La vetrata del duomo di Siena e il suo restauro* ed. Alessandro Bagnoli and Camillo Tarozzi, (Milan, 2003), esp. 35–38.

[28] Tarozzi, 'Considerations,' 18.

[29] Carli (*Vetrata*, 24–25), who carefully examined the occhio when it was taken down in 1943, estimates a minimal number of replacement pieces, between four and six percent, and identifies a wine-colored glass, mostly present in the Burial of the Virgin, as constituting the most significant replacement. Carli's viewpoint is upheld by Luciano Bellosi in 2003, in Bagnoli et al., *Duccio*, 166.

construct each scene with several, overly long panels which, as Tarozzi has noted, tended to be structurally less stable than vertical panels and prone to 'belly-out.' There is also another technical consideration: the horizontal panels are not bolted directly to the masonry of the window opening, which would efficiently absorb the outward thrust, but are attached, instead, to adjacent panels—a far less stable arrangement. The master glazier resolved the problem of stabilizing the composition, in part, by inserting iron supports between the paired saints, thereby increasing the rigidity of the saint panels. Horizontal panels impinge far less on the figural compositions; vertical panels would have bisected the figure of the Virgin in the scene of the Assumption (fig. 1.2). Clearly, the structure of the window was driven by the demands of the design.

The employment of long, horizontal panels was not ideal from a glazing standpoint and this practice was not implemented for the paired saints, situated on either side of the Assumption (fig. 1.1). From a pictorial point of view, the saints did not require horizontal panels, and it is tempting to suppose that this greatly relieved the master glazier. The length of the long sides of the saint panels is comparable to that of the *Assumption* panels, but for the standing saints the panels are oriented vertically, an arrangement that was far more stable and customary for the glazier. It is even possible that the saints' polylobe, geometric frames were suggested by the glazier, since standing saints, enclosed in similar framing devices, were routinely stacked one above the other in lancet windows. Frank Martin, noting that these frames do not appear in Duccio's panel paintings, attributes this design element directly to the glazier of the occhio.[30]

The use of ornamental borders to subdivide windows and embellish their figural content with decoration was also conventional in stained-glass practice. Master glaziers had a ready repertory of border designs on hand in their workshops that had been left over from other commissions. But the collaborative nature of Siena's project begs the question: was it the glazier who supplied the border designs for the occhio, or was it the painter Duccio?

As we shall see, Duccio's commission surely entailed furnishing detailed designs for the borders as well the window's figural compositions. But not all of Duccio's border designs were carried out in accordance with his drawings, only those that frame the middle-tier panels, with the exception of the Assumption, and the three scenes at the top of the window (figs. 1.1 and 1.3). The rest of the borders are unpainted. Duccio's borders consist of exquisitely painted quatrefoils, octagons, and foliage, made of blue, yellow, red, and green colored glasses. The painted border elements reiterate decorative motifs used by the artist in his panel paintings, particularly to depict fabrics and emboss halos and garment trim; these would have been the basis for the occhio's unpainted borders as well, for the Assumption's border of lozenges (fig. 1.2) is

30 Martin and Ruf, *Le vetrate*, 141–43; on geometric frames, Eva Frodl-Kraft, 'Die "Figur im Langpaß" in der österreichischen Glasmalerei und die Naumberger Westchor-Verglasung,' in *Kunst des Mittelalters in Sachsen, Festschrift Wolf Schubert, Dargebracht zum Sechzigsten Geburtstag am 28 Januar 1963* (Weimar, 1967), 309–14.

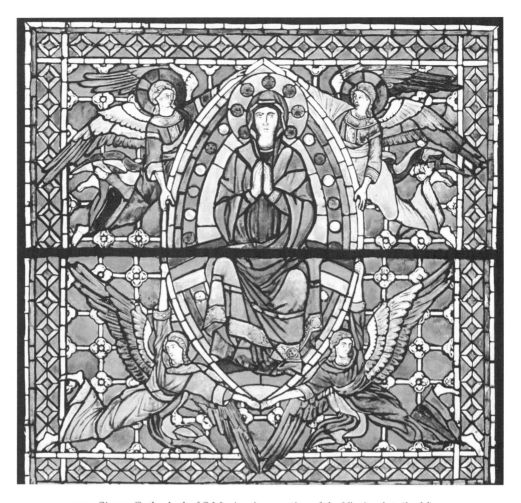

1.2 Siena, Cathedral of S Maria, *Assumption of the Virgin*, detail of fig. 1.1.

reiterated in the neckline trim that embellishes the garments of the scene's angels and St Luke's throne back (fig. 1.1, upper left), while in the occhio's left and right lower borders, rosettes similar to those that adorn the Virgin's mandorla, halo, and mantle trim were likely meant to alternate with the small circles of quatrefoils that the artist used in the occhio's foliate border.[31] But it

[31] For elaborate quatrefoils similar to those used in the glazed borders, see cloths of honor in Duccio's *Crucifixon* in the Salini Collection, Siena, and the *Madonna Rucellai*, Uffizi, Florence, as well as the Madonna's embossed halo in his triptych in the National Gallery, London. The occhio's foliate motif was a common design for embossed halos (cf. Guido da Siena's panel painting of the *Madonna and Child with Saints* in the Pinacoteca Nazionale, Siena). A stained-glass border of alternating rosettes was being produced around the same time as the occhio commission for the south transept windows of the basilica of Saint Francis, though at Assisi the rosettes are strung together by a cord of pearls that lends movement. Duccio may have

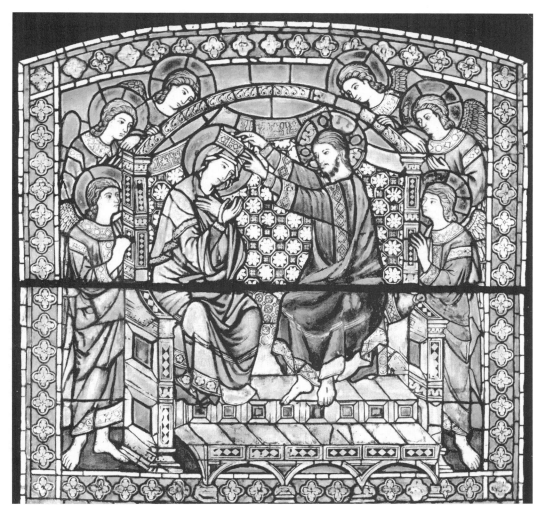

1.3 Siena, Cathedral of S Maria, *Coronation of the Virgin*, detail of fig. 1.1.

is not just the existence of these motifs in Duccio's oeuvre that betrays his artistic vision; it is the careful, measured disposition of the decorative elements within the space of the border. The motifs appear suspended and motionless, as if they were 'floating' on the red field of the borders' ground. Completely lacking is the appearance of continuous movement that typifies most stained-glass borders, which are often composed of repeated motifs that are either entwined or otherwise linked, such as floral motifs connected with vines or strings of pearls, as seen in many of the Assisi windows (figs. 1.4 and 1.5). The

been aware of the Assisi border, but he also made use of rosettes in his paintings, such as the halo for the Madonna in Turin's Galleria Sabauda. Giuseppe Marchini (*Le vetrate italiane*, 27) attributed the occhio's borders to Duccio on the basis of their simplicity.

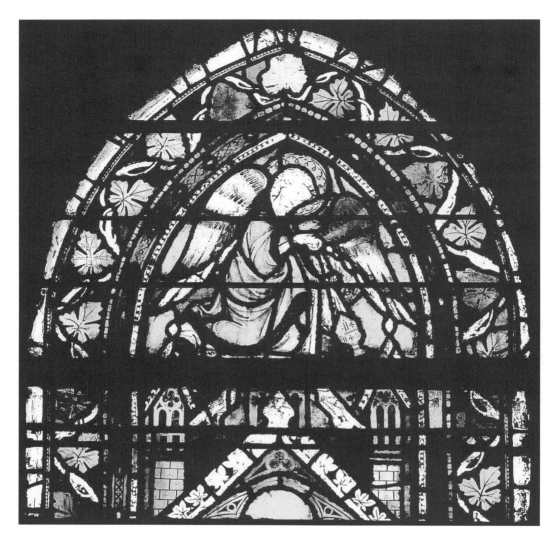

1.4 Assisi, Upper Church of St Francis, south transept, detail.

borders that frame the vignettes with Sts John the Evangelist and Matthew in the upper 'corners' of the occhio—composed of oval, foliate motifs alternated with small circles inscribed with quatrefoils—are static in contrast with an oak-leaf border employed at Assisi, which runs like a trellis up the sides of the lancet (cf. figs. 1.1 and 1.5).

Moreover, Duccio's border designs betray his orientation as a painter. Fundamentally pictorial in concept, they depend primarily upon the use of glass paint for their effectiveness. Glaziers, on the other hand, used various leading techniques and did not rely solely on the glass paint; indeed, a few strokes of paint were sufficient, since the pattern of the colored glasses plays a major role in the decorative effect (see Assisi border, fig. 1.4). In contrast to the

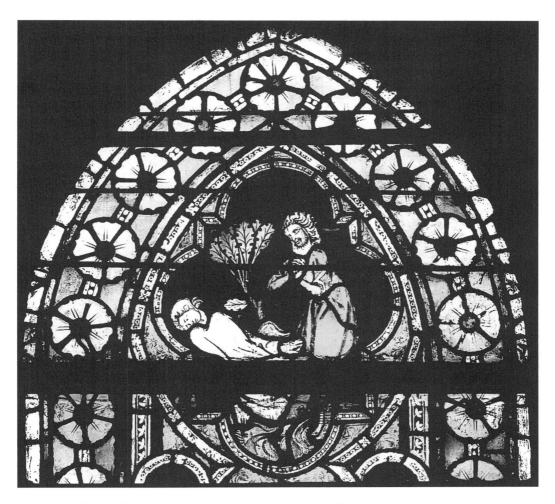

1.5 Assisi, Upper Church of St Francis, south transept, detail.

amount of painting required by Assisi's window borders, Duccio's decorative elements, far more delicate and refined, demanded a substantially higher level of painting expertise. This kind of detail and expertise must have lengthened the glazing process. While the assistants in the workshop were used to cutting glass and leading the pieces, it is unlikely that there were many assistants who could paint to the level required by Duccio's border designs. The painter Duccio may not have anticipated what his borders would involve in the executive phase, but this was undoubtedly a major concern for the master glazier.

This last point is brought into focus by Enrico Castelnuovo's acute observations on Siena's great round window.[32] He notes that the Virgin's throne in the Coronation is projected into the viewer's space, extending into and interrupting the window's decorative border (fig. 1.3). In this and other scenes,

[32] Castelnuovo, *Vetrate medievali*, 366.

angels' halos 'overlap' the border, creating a spatial effect. In the Assumption, angels' feet and wings impinge on the border at several points; in fact, this scene is a striking example of how the expansive quality of the pictorial representation results in an intrusion on the area that was normally reserved in stained-glass windows for decorative embellishment (fig. 1.2). This overflowing of the figural compositions into the decorative borders must really have given the glazier pause, since it had considerable ramifications for the window's production. When the panels were leaded-up, the decorative borders were usually delegated to assistants because they were repetitive and required less expertise. Working the projection of feet and halos in between a border's decorative motifs must have required an inordinate attentiveness on the part of the master glazier. Where parts of the figural compositions interrupt the border, some of the decorative elements are partial and had to be cut specially. These observations confirm that Duccio must have provided comprehensive designs that included figural scenes as well as detailed, decorative borders. The master glazier would never have conceived of inserting feet, halos, wings, and throne finials into the spaces blocked out for the borders—and not just because it would have seemed to him an anomaly. It was going to cost him extra time and labor, and went contrary to production practice.

Relevant here is the recent discovery of assembly marks on glass pieces in the borders around the upper scenes of the window—the Coronation and the vignettes with Sts John the Evangelist and Matthew[33]—that is, borders mentioned earlier as having been produced with close adherence to Duccio's designs (figs. 1.1 and 1.3). The unpainted borders that frame the Assumption and the three scenes at the base of the window are unmarked (figs. 1.1 and 1.2). Assembly marks served a specific purpose in production.[34] They consist of numbers, letters, or other symbols that glaziers inscribed on individual glass pieces with vitreous paint before those pieces were placed in the furnace for fusing the painted details on to the glass. When the glass pieces came out of the furnace, these assembly marks made it easier to identify individual pieces during the sorting process. But time would not have been wasted needlessly by marking pieces that would have been readily recognizable. For instance, any border of repeated elements, like the quatrefoils around the Coronation, would not have required assembly marks unless its pieces could be confused with identical or very similar elements belonging to another border being fired at the same time. But the same quatrefoils occur in two other borders, and in two different colors. Thus, the potential for a great deal of confusion resulted in the necessity for many marked pieces.

Alessandro Bagnoli points to the occhio's unmarked and unpainted borders as evidence of a hurried last phase of production.[35] Indeed, for those borders

[33] Bagnoli et al., *Duccio*, 180. The marks are roman numerals painted with grisaille in lowercase, Gothic characters.

[34] On assembly marks, see Michael W. Cothren, 'Production Practices in Medieval Stained Glass Workshops: Some Evidence in the Glencairn Museum,' *Journal of Glass Studies* 41 (1999): 117–34.

[35] Bagnoli et al., *Duccio*, 180.

the painting process could be dispensed with entirely, saving the time and labor that would have been expended to apply the paint, fire the pieces, and sort the decorative elements when they came out of the furnace. In fact, the mechanics of the process brings to the fore a practical problem that the glazier had to confront: not only did all of the painted pieces have to be fired in a furnace, they had to be cooled slowly within it. If the pieces were taken out too soon, the glass would fracture due to thermal shock, that is, a rate of cooling that is too rapid for the glass material to maintain its integrity. The occhio's unpainted borders suggest that the master glazier may have been encountering a backup at the furnace. If the glazier had only one furnace, the impact on production would have been great because, in reality, not very many pieces could be fired at one time. The pieces were placed in large pans, but could not be near the rim, which was too hot, and hot spots in the furnace itself had to be avoided.[36] Indeed, unpainted borders could be produced much more quickly. Finally, it is interesting to note that three of the scenes with unpainted borders—those at the window's base—display another notable difference: the figural scenes do not interfere with the border, but are contained within it, thus further simplifying production (fig. 1.1).

The glazier's efforts to streamline production proposed here should be seen from a financial perspective. Was it that the window was behind schedule? More likely, the occhio was well 'over-budget' in terms of the labor and expertise required. It is not inconceivable that the master glazier wanted to renegotiate his contract with fra' Magio, based on the inordinate labor that the designs for the upper scenes and the Assumption had required. Perhaps Fra' Magio reached a compromise with the glazier concerning Duccio's design, which empowered the glazier to exert greater control over the project. These observations suggest that although Duccio would have provided explicit cartoni, the master glazier likely modified the lower scenes to facilitate production.

The master glazier also interposed himself into Duccio's design in other ways, particularly in many of the occhio's decorative passages, such as in the Virgin's ornate throne, and the richly decorated fabrics and intricately embroidered garment trim (fig. 1.3). Throughout the window, there is a zealous celebration of color and pattern that contrasts sharply with Duccio's interest in constructing lucid, pictorial space. Glaziers exploited the glass medium for its inherent decorative possibilities in order to produce a splendorous effect. To achieve this end, a wide array of techniques were employed, such as cross-hatching and sticklighting, the latter to create a design in negative, by lifting paint from a matte surface. The window's emphasis on decoration is inconsistent with Duccio's artistic sensibilities, and the glazing techniques employed to produce these embellishments were well outside of the artist's

36 On thermal shock, Burnam, *Le vetrate*, 35; I thank Valeria Bertuzzi and Amerigo Corallini of Studio Fenice, Bologna for their generous assistance in informing me about how these considerations are taken into account even today. Unusable pieces of glass are placed around the perimeter of the pan to absorb some of the heat and shield the painted pieces.

technical training and experience. The decorative passages, which had to have been the work of the glazier, demonstrate that the occhio's glazier was a highly accomplished painter of glass. This refutes Cennini's assertion that glaziers in Italy were unskilled as painters, and the myth—counterintuitive though it may be—that for the most important parts of figural windows the vitreous paint must have been applied by an individual trained primarily in panel and fresco painting, and not a glazier, whose training was specifically in the painting of glass.[37]

Martin attributes to the occhio's glazier the decorative grid in the background of the Assumption of the Virgin, since it is an element that does not appear in Duccio's painting but was part of northern European glazing tradition (fig. 1.2).[38] Indeed, the technique used for the grid's quatrefoils, which are composed of two colored glasses, one leaded into the other, indicates that the occhio's master glazier conceived of the motif. But the decorative grid lacks the solidity of northern European examples, since its blue ground, typically painted with a checkerboard of embellished squares, is completely unpainted. Thus, the occhio's grid has an airy quality, as if it were a net, suspended behind the image of the Virgin, herself still and motionless against the blue of the skies. Castelnuovo credits Duccio with the transformation of a northern decorative motif into a naturalistic spatial setting.[39] But was this the effect intended by the painter, Duccio? Or might it have resulted from practical necessity? Could it be that the master glazier dispensed with painting the grid's ground to facilitate production? It is intriguing to ponder the dynamics that may have brought about this unique effect.

The aim of this foray into the practical aspects of stained-glass production has been to demonstrate the collaborative nature of the project. Undoubtedly, Duccio's designs were explicit and detailed. For the uppermost scenes and the Assumption, I suggest, the master glazier must have followed Duccio's designs to the letter, and possibly under the watchful eye of the painter himself. Indeed, Duccio's expansive pictorial vision for the window exerted a decisive influence from the outset, and this orientation was both a rose and thorn. In fact, I infer that the window's master glazier was challenged by many aspects of the project and, not least, the window's unconventional and labor-intensive designs. The master glazier seems to have exerted increased control over the work, to ease and speed production.

The collaborative nature of any enterprise is not easy to document, and the accomplishment of Siena's stained-glass window was doubtless driven by powerful and intangible motivating forces, such as civic pride and spiritual devotion, which are difficult to quantify. Yet, I have sought to demonstrate how the realization of Siena's window might have been achieved through working arrangements that were fluid and dynamic. The project of glazing

[37] Vitreous paint would fire imperfectly if applied thickly, as in the layers of paint that panel painters build up.

[38] Martin and Ruf, *Le vetrate*, 141.

[39] Castelnuovo, *Vetrate medievali*, 366.

the *fenestra rotunda magna* was a bold undertaking that required an incredible measure of confidence and a level of collaboration that, by all indications, was unprecedented in Italian stained-glass production.

Holding Hands in the Virgin Chapel at Beauvais Cathedral

Michael W. Cothren

Detailed stylistic analysis was at the heart of the mid-twentieth-century revitalization of art historical interest in stained-glass windows.[1] As a result of the restorations following World War II, this major medium of medieval painting had recently become more readily accessible, and the enhanced availability allowed scholars to identify and assess the character of individual workshops and artists within and among glazings. The method deployed in this inquiry was far from innovative. Rooted in ancient Greek and Italian Renaissance attempts to determine and express those particular visual features that individualize the work of great artists, the modern 'science' of connoisseurship was outlined by Giovanni Morelli late in the nineteenth century and codified, even popularized, as an interpretive practice in the work of Bernard Berenson and his followers into the first half of the twentieth.[2] It was a venerable art historical tradition when Louis Grodecki—student of eminent formalist Henri Focillon—wrote the foundational publications for modern stained-glass studies, concentrating on establishing the relationship between style and workshop as an organizing factor in both the creation and the study of medieval glazings.[3]

[1] This article benefited greatly from the very helpful comments of my colleague and friend Mary B. Shepard and from the feedback of the anonymous readers who evaluated my essay in the early stages of editing this volume. I am singularly indebted to Susan Lowry for her sharp editorial skills, her wise counsel, and her enduring love and support in so many ways for so many years.

[2] For a brief, thoughtful introduction to 'Connoisseurship,' with a list of principal sources—including the primary works of Morelli and Berenson as well as secondary methodological assessments—see the article under that name by Enrico Castelnuovo and Jane Anderson, *The Dictionary of Art*, Jane Turner, ed., 34 vols (New York, 1996) 7:713–5.

[3] Grodecki's pathbreaking article outlined a method for the study of stained glass that identified style with workshop: 'A Stained Glass *Atelier* of the Thirteenth Century: A Study of the Windows in the Cathedrals of Bourges, Chartres and Poitiers,' *Journal of the Warburg and Courtauld Institutes* 11 (1948): 87–111. See also the following representative studies where he puts this method into practice: 'Le maître de saint Eustache de la cathédrale de Chartres,' in *Gedenkschrift Ernst Gall*, ed. Margarete Kuhn and Louis Grodecki (Munich, 1965), 171–94; in Marcel Aubert et al., *Les vitraux de Notre-Dame et de la Sainte-Chapelle de Paris*, Corpus Vitrearum Medii Aevi, France, vol. 1 (Paris, 1959), esp. 91–93. It is also the backdrop for his

Though in some circles connoisseurship seems even more old-fashioned now than it was at the middle of the twentieth century, postmodern practitioners still seek meaning in close readings of stylistic distinctions. Recently, attention has been paid to the sorting of individual 'hands' within the execution of a single window as well as to the definition of the window's overall stylistic character in relation to Grodecki's workshop model.[4] Not only is it possible to identify individual painters working collaboratively to produce stained-glass windows; it is clear that the observations gathered in this exercise, far from being ends in themselves, actually serve to open up possibilities for broader questions and richer understandings concerning the way stained-glass windows were made, perhaps even about the way production and reception could have been, and may still be, related. The relationships are tricky and definitive conclusions may be elusive, but without deploying the traditional exercise of close visual analysis to sort glazings and windows among identifiable makers, underlying questions will remain unasked.

In the course of a broader study of the stained glass of the Cathedral of Beauvais, I had the rare privilege of examining the three windows of the Virgin Chapel from close range on a scaffold erected directly in front of them.[5] This axial choir chapel was glazed during the 1240s with a stained-glass triptych that still looms as a radiant altarpiece within a privileged liturgical space.[6] The opportunity provided by the scaffolding allowed me to divert my art historical attention from seemingly weightier issues of reception, meaning, and heritage so that I could explore, verify, and expand stylistic observations and hypotheses about production that I had developed while examining these windows through binoculars or by pouring over photographs. Perhaps the most stunning confirmation was the clarity this proximate investigation brought to my sense that the central window (fig. 2.1)—dedicated to the Maternity of the Virgin,[7] a

two magisterial surveys: *Le vitrail roman* (Fribourg, 1977); and with Catherine Brisac, *Le vitrail gothique au XIIIe siècle* (Fribourg, 1984).

4 For example, see Claudine Lautier, 'Les peintres-verriers des bas-côtés de la nef de Chartres au début du XIIIe siècle,' *Bulletin monumental* 148 (1990): 7–45; Michael W. Cothren, 'The Infancy of Christ Window from the Abbey of Saint-Denis: A Reconsideration of its Design and Iconography,' *Art Bulletin* 68 (1986): 398–420; Elizabeth A. R. Brown and Michael W. Cothren, 'The Twelfth-Century Crusading Window of the Abbey of Saint-Denis: "Praeteritorum enim Recordatio Futurorum est Exhibitio,"' *Journal of the Warburg and Courtauld Institutes* 49 (1986): esp. 33–35.

5 For the spectacular opportunity to study the windows of the Virgin Chapel for eleven days from an interior scaffolding installed during Spring of 1999 by the Direction Régionale des Affaires Culturelles de Picardie, Ministère de la Culture et de la Communication de France, I am deeply indebted to Claudine Lautier of the French Corpus Vitrearum and the late Michel Caille, then Conservateur en chef des Monuments Historiques, who worked on my behalf to make this extraordinary opportunity possible.

6 The dating of this ensemble, the subjects of the individual windows, the sort of program they might create as a triptych, and explorations of the sources and meanings of their stylistic diversity are discussed in some detail in Michael W. Cothren, *Picturing the Celestial City: The Medieval Stained Glass of Beauvais Cathedral* (Princeton, 2006), 4–99.

7 In referring to this visualized account of the early life of Jesus within a Virgin chapel as a 'Maternity of the Virgin lancet,' I pay tribute in following the example of Madeline Caviness in 'Stained Glass Windows in Gothic Chapels, and the Feasts of the Saints,' in *Römisches*

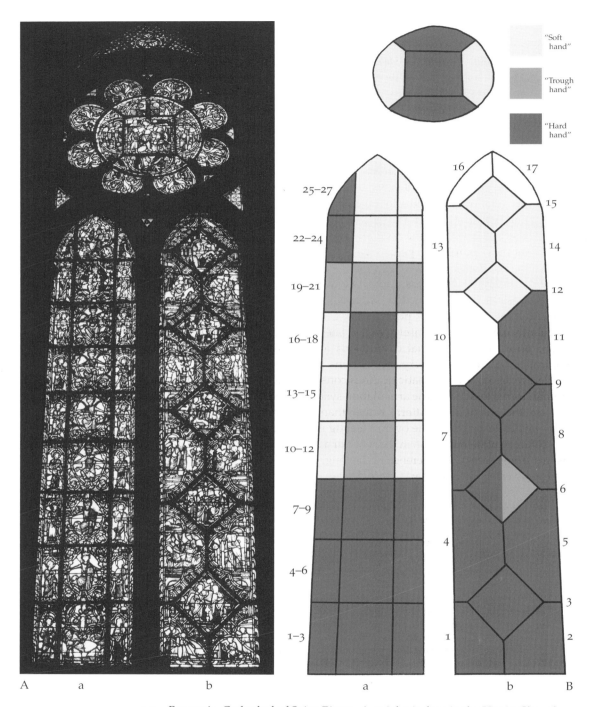

2.1 Beauvais, Cathedral of Saint-Pierre, *A*, axial window in the Virgin Chapel, ca. 1245: *Left lancet*, Jesse Tree; *Right lancet*, Maternity of the Virgin, and *Rose*, a Sacramental Crucifixion; with *B*, a chart showing the distribution of work among three artists. (Panel *10b* and the lobes of the rosette are modern.)

Jesse Tree, and a Sacramental Crucifixion—was executed by a group of distinguishable painters who had worked within a shared regional glass-painting tradition.[8] The overall style of the window is strikingly conservative for the period (fig. 2.2). Compact, stiffly posed, and intricately articulated figures conform to rectilinear compositional principles, eschewing narrative expressiveness for the stodgy and schematic stability of an old-fashioned local tradition. Yet even if this cohesive stylistic vision characterizes the window as a unified formal whole, under close examination, evidence of regular variations in the realization of standard articulation formulae stood out with real clarity to support sorting its execution among a set of definable painters. Subtle differences in conception and execution from panel to panel, figure to figure, reveal the collaboration, and allow the identification, of three distinguishable artistic hands who shared in the production of the window.[9]

The first and most prolific painter—whom I will name the 'hard hand'—embodies most purely the generalized stylistic profile for the window as a whole.[10] The work of this artist (figs. 2.2 and 2.3) is characterized by firm, precise painting and hardness of line. Even when loops are employed to relieve the stiffness of the drapery, the painted lines which define them still taper carefully to sharp, brittle points. Broad, unarticulated areas of clothing frequently contrast with densely painted ones. Outlines of figures are especially crisp; poses are stiff. Facial expressions are consistently alert and tightly controlled. Although drapery conventions point to plasticity, tight painting, linear precision, and emphatic outlines conspire to lend a sense of flatness to human forms and faces. The articulation systems used by the 'hard hand' lean toward the creation of pattern, rather than conforming to the demands of naturalistic description. The overall feeling is wiry, tense, tight, precise, hard.

I detect a subtle relaxation in the work of a second painter, whom I designate as the 'trough hand,' in reference to the long, illusionistic recessions filled with half-tone wash that appear within broad expanses of drapery. This artist

Jahrbuch der Bibliotheca Herziana: Kunst und Liturgie im Mittelalter ed. N. Bock, S. de Blaauw, C. L. Frommel, and H. Kessler, *Akten des internationalen Kongresses der Bibliotheca Hertziana und des Nederlands Instituut te Rome, Rom, 28–30 September 1997* (Munich, 2000), 139.

[8] For the regional extension of this style, see Michael W. Cothren, 'The Choir Windows of Agnières (Somme) and a Regional Style of Gothic Glass Painting,' *Journal of Glass Studies* 28 (1986): 40–65.

[9] For another instance where close formal analysis has allowed the identification of several artists working within a shared stylistic tradition, see Elizabeth Carson Pastan, '"And he shall gather together the dispersed": The Tree of Jesse at Troyes Cathedral,' *Gesta* 37 (1998): 233–36. At Troyes, however, where Pastan distinguished four hands, one of the artists deviates so significantly from the work of the other three that she proposes a gap between two campaigns of execution. At Beauvais, we are clearly dealing with three artists working at the same time and within the same artistic formation.

[10] The work of this painter is found in the lower nine panels of the Jesse Tree (1a–9a), as well as in one additional king (17a) and two other prophets (22a and 25a); most of the lower part of the Maternity lancet (panels 1b–9b and 11b); and the three-panel central scene of the Crucifixion in the rose (4a/b, 7a/b, and 10a/b). In all, this artist seems to have been solely responsible for twenty-three panels and to have shared the execution of one (6b) with the 'trough hand.'

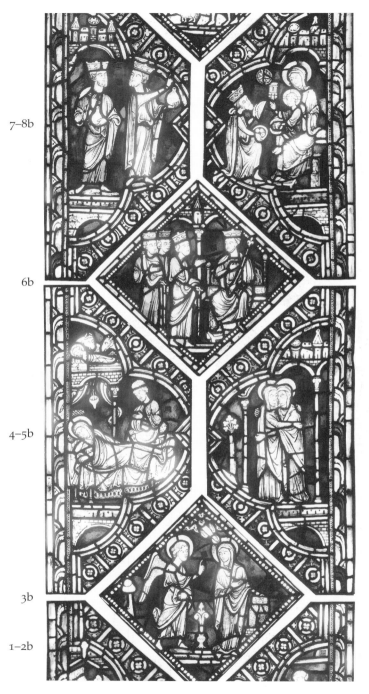

7–8b

6b

4–5b

3b

1–2b

2.2 Beauvais, Cathedral of Saint-Pierre, lower portion of the Maternity of the Virgin lancet painted by the "hard hand" (with the exception of the figure of King Herod who greets the Magi in panel *6b*, assigned here to the "trough hand").

2.3 Beauvais, Cathedral of Saint-Pierre, examples of painting by the "hard hand" in the Maternity of the Virgin lancet: *A*, *8b*, *detail*, Virgin and Child receiving the Magi; *B*, *6b*, *detail*, Three Magi standing before Herod.

contributed but a single figure to the Maternity lancet (King Herod at the right in 6b on fig. 2.2), working predominantly in the Jesse Tree on a series of five figures of prophets and kings (e.g., fig. 2.4b and 2.4d).[11] Evoking a sense of three-dimensional form was clearly more important to this artist than tight patterns, sharp outlines, or precise painting. Expressions on the broadened faces are more relaxed and less focused, at times even vacuous, but never tense like those attributed to the 'hard hand.' Figural outlines are somewhat softer. Postures are more relaxed, conveying a sense of grandeur rather than alert involvement. The painting, though just as careful, seeks a different overall effect with more fluid lines realizing a more relaxed rendering of the shared systems of articulation.

[11] The figure of King Herod who greets the Magi in panel 6b of the Maternity lancet (fig. 2), and panels 11a, 14a, 19a, 20a, and 21a in the Jesse Tree.

2.4 Beauvais, Cathedral of Saint-Pierre, four prophets from the Jesse Tree lancet:
A, 7a, painted by the "hard hand"; *B, 19a*, painted by the "trough hand"; *C, 9a*,
painted by the "hard hand"; *D, 21a*, painted by the "trough hand."

The comparison between these two artists may be clearest when juxtaposing two sets of prophets from the Jesse Tree that were painted by each using the same two models or cartoons (fig. 2.4).[12] The poses, outlines, basic configuration of drapery, and facial types of these standing figures were clearly imposed on both painters from a full-scale drawing or workshop pattern, but distinct artistic temperaments are embodied in the way the formulae were realized. Through the interior articulation of drapery, the 'trough hand' gives the figures a greater sense of plasticity—both in terms of underlying body mass and within the depth of the enveloping fabric itself (fig. 2.4b and 2.4d). This is especially noticeable in the pull of the mantle over the right leg of one of the prophet types (fig. 2.4d). The heads painted by the 'trough hand' are noticeably broader and more rounded. Eyes are opened wider, and the more relaxed lines that define them take more arched curves, emphasizing roundness rather than flatness. This allows the creation of the iris as a separate rounded form rather than an adjunct mark pulled from, and contiguous with, the outline of the eyes. Hair is enlivened with fewer but more relaxed waves, and they curve around contours to convey three-dimensionality, in contrast with the tight surface configurations that craft the crisp coiffures of the 'hard hand' figures. The latter painter's penchant for bold—at times double—'chin' contours to underline beards works to counteract a sense of recession (fig. 2.4a and 2.4c), whereas the tapering, serpentine strokes defining the bases of beards on the prophets painted by the 'trough hand' (fig. 2.4b and 2.4d) imply foreshortening.[13]

The more extensive work of a third painter—the 'soft hand'—is concentrated in the upper parts of both lancets and the marginal panels of the rose (fig. 2.1b).[14] This artist's figures are characterized by even more relaxed, at times even flabby, outlines (fig. 2.5). Detailed but disorganized, the painting seems haltingly executed, antithetical to the confident precision characterizing the work of the 'hard hand.' Broad areas of drapery are generally filled with a

[12] For another instance of two artists, distinguishable by temperament but working with the same cartoon, see Meredith Parsons Lillich, *The Armor of Light: Stained Glass in Western France, 1250–1325* (Berkeley, 1994), 213–17.

[13] It is quite interesting to trace this difference between the work of these painters from figures to ornament, where it is more subtle, but still apparent. For instance, in the delineation of the foliate flourishes beneath the feet of the kings in the Jesse Tree, the flattened buds with berries reserved as stark outlines within a dark field prevalent in the kings of the 'hard hand,' are replaced by the 'trough hand' with fleshy leaves filled with contour lines that evoke, even outline, a sense of three-dimensionality. Even more subtle is the distinction between the crowns of the 'hard hand' Magi in 6b and the 'trough hand's' figure of Herod in the same panel.

[14] To this artist can be assigned panels 10a, 12a, 13a, 15a, 16a, 18a, 23a, 24a, 26a, and 27a in the Jesse Tree; panels 12b-15b and possibly the leftmost figure in panel 9b of the Maternity lancet; and the figures of John and the Virgin in panels 6a/b and 8a/b flanking the Crucifixion in the rose. It is possible that this group of panels, though unified by stylistic variant, might represent the work of two artists rather than one. Panels 10a, 12a, 16a, and 18a seem lower in quality than the other panels of this group. Figures are flabbier and more vacuous; painting is more disorganized. This distinction could, however, be the by-product of uneven conservation. These panels have more cracked pieces, more and clumsier re-leaded repairs, and more significant passages of modern replacement than others in the group. Indeed they are among the least well-preserved panels in the entire lancet.

2.5 Beauvais, Cathedral of Saint-Pierre, portions of the axial window painted by the "soft hand": *A*, details of the upper portion of the Maternity of the Virgin lancet showing, *12b*, the Massacre of the Innocents, and, *13b–14b*, the Flight into Egypt; *B*, *24a*, Prophet from the Jesse Tree.

repetitive series of bunched lines or small loops (e.g., upper body of the female figure in the Massacre of the Innocents in fig. 2.5a), lacking either the tension created by the 'hard hand' through the opposition of densely and sparsely articulated passages (e.g., fig. 2.3) or the three-dimensionality implied by the depressed folds favored by the 'trough hand' (e.g., fig. 2.4d). Likewise, faces have neither the crisp precision of the flat patterning favored by the 'hard hand' nor the relaxed plasticity of the 'trough hand's' work. Possibly due in part to this relaxed conception and articulation, both individual figures and narrative enactment are bland and detached, hesitant rather than bold in demeanor and presentation (e.g., fig. 2.5a).

Teasing out the formal distinctions that enabled me to attribute the execution of the Maternity and Jesse Tree window to three distinct artistic hands is relatively straightforward. All that is required is looking within and beneath the larger stylistic system that unifies the window as an artistic whole to

discover individual idiosyncrasies and Morellian motifs manifesting artists' habits of working or thinking. But for meaningful interpretation, for developing a richer understanding of the working practices and organizational structures of the human beings who created medieval stained-glass windows, sorting and holding these hands is a beginning rather than an end. The primary challenge rests in seeking significance in this distribution of labor, either to construct or to evoke a larger interpretive context for artistic creation.

For instance, is it significant that most of the work of the 'soft hand' appears in the upper registers of both lancets or the marginal panels of the rose, while the painting of the 'trough hand' is most prominent in the upper half of the Jesse tree (fig. 2.1b)?[15] Were these two painters considered less gifted by patron or workshop, and their panels relegated to remote reaches where it would be less available for close scrutiny? After all, the more painstaking painting of the 'hard hand,' embodying most consistently the stylistic profile of the window as a whole, is concentrated in the lower registers of each lancet, closest to viewers and therefore more immediately visible than the upper reaches of the window. The 'hard hand' was also responsible for the crucial scene of the Crucifixion, an iconographic keystone with enhanced visibility at the center of the rose.[16] Because of the privileged location of this artist's work within the window—both visually and iconographically—I am tempted to designate the 'hard hand' as the 'master' or 'principal painter' of the workshop or team that was responsible for its creation. Unfortunately, we have no way of knowing if artists who made medieval windows organized themselves along such hierarchical lines, nor if our own assessments of quality and representativeness coincide with the unknowable judgments of those who organized the collaborative production of medieval stained-glass windows,[17] not to mention

[15] Of course in the case of the modular design of the Jesse Tree, where there is little clear narrative or chronological progression of unlabeled kings and prophets to help establish their stacking order, it is impossible to be sure if the arrangement today reproduces the original installation. But the placement of the three panels of the top register is secured by the pointing of the lancet opening, and these panels were executed by the 'soft hand.' Could the clustering of the work of the 'hard hand' near the bottom here be the result of modern aesthetic preferences?

[16] The stylistic relationship between the Crucifixion and the lower panels attributable to the 'hard hand' is not immediately apparent since the upper scene is more monumentally painted, presumably an acknowledgement of the need to take into account the greater distance that separates the top of the window from viewers. In *Picturing the Celestial City*, 15–24, 110, I argue for a programmatic assessment of this particular scene within the glazing of the church as a whole—viewed not only within the confines of this one chapel but from within the main choir, where it coordinates with the celebration of the Mass on the main altar and the later Eucharistic crucifixion in the axial clerestory window looming above both. This would make a bolder articulation in the rose even more understandable.

[17] There is no extra-visual evidence for making such hierarchical distinctions among the artists who worked on a medieval window: Michael W. Cothren, 'Suger's Stained Glass Masters and Their Workshop at Saint-Denis,' in *Paris: Center of Artistic Enlightenment*, ed. George Mauner, et al., Papers in Art History from The Pennsylvania State University 4 (University Park, Penn. 1988), 51–53. For what we do know concerning the organization of medieval stained-glass workshops, see also Meredith Parsons Lillich, 'Gothic Glaziers: Monks, Jews, Taxpayers, Bretons, Women,' *Journal of Glass Studies* 27 (1985): 72–92; Sarah Brown and

the expectations of those who 'consumed' them within their original devotional and liturgical contexts. What's an interpreter to do?

No single monument holds the key to unlock the door out of this art historical cul-de-sac. There is no reason to assume a standard or standardized way of working, or of organizing the work involved in making medieval windows. Even within the microcosm of the Virgin Chapel at Beauvais this is not the case. The artists who painted the side wings of the glazing triptych worked within two other divergent stylistic traditions. The left window embodies a precisely painted mannerist transformation of the classicizing Muldenfaltenstil that had flourished in northeastern France in a variety of media around the year 1200. Oddly proportioned figures are posed in movement along languid curves within crowded compositions, often stepping in unison with awkward elegance and dance-like postures.[18] The style of the third window looks forward rather than back, conforming to a cosmopolitan Parisian avant-garde trend characterized by airy compositions, emphatic silhouettes, heightened legibility, streamlined painting, narrative austerity, and simplified compartments and ornament. The emphasis shifts from interior delineation to the clearly defined and elegantly cut contours of whole forms, often indicated with the broad strokes of lead lines.[19] As with the axial window, my close examination of the flanking windows revealed subtle stylistic differences that seem to betray the 'handwriting' of individual painters within the teams of artists who executed them. But whereas the variations in execution within the axial window can be convincingly keyed to a panel-by-panel distribution of work among distinguishable makers,[20] this is not the case in the other two windows in this same chapel. Isolated heads, drapery flourishes or ornamental motifs stand out here and there, but there are fewer deviations from a pervasive stylistic uniformity, and I could discern no pattern in their distribution. At times I wondered if these seemingly deviant details represented the incursion of later restorers rather than the individual hands of original makers. Does this greater degree of uniformity indicate a more cohesive workshop practice, the strong hand of a domineering master painter, or my lower sensitivity to the sorts of variation that marked the work of individual makers in these two stylistic traditions? It is difficult to know, but one thing seems clear to me: interpreters should be cautious not to generalize

David O'Connor, *Medieval Craftsmen: Glass Painters* (Toronto, 1991); and Madeline H. Caviness, *Stained Glass Windows*, Typologie des sources du Moyen Age Occidental 76 (Turnhout, 1996), esp. 30–38 and 67–69; all with references to earlier literature and more detailed studies of individual sites. One of the most thorough, intelligent, and revealing explorations of a particular instance is Madeline Harrison Caviness, *Sumptuous Arts at the Royal Abbeys in Reims and Braine: Ornatus Elegantiae, Varietate Stupendes* (Princeton, 1990), 98–128.

[18] Cothren, *Picturing the Celestial City*, 58–71.

[19] Cothren, *Picturing the Celestial City*, 88–96.

[20] There seem to be two deviations in the Maternity lancet from the panel-by-panel distribution of work by these painters. The panel portraying the Magi before Herod (fig. 1, 6a) was clearly a collaboration; the Magi were painted by the 'hard hand' and King Herod by the 'trough hand.' Although I am less certain in the second case, the 'soft hand' may have painted the figure at the left in the scene of the Annunciation to the Shepherds (9a).

too broadly from any one particular example since at Beauvais artists, gathered into three possibly independent groups to work at the same time and in the same place, seem not to have followed the same working procedures in the projects assigned to them.[21]

But the situation is even more complicated, involving a number of interpretive possibilities as well as variations in the evidence itself. For example, not all formal variations within standardized systems or patterns need indicate evidence of corporate execution; distinctions may mean different things in different contexts. Madeline Caviness's pioneering study of the relationship among a series of stylistically linked glazings at Canterbury, Braine, Saint-Remi at Reims, and Sens, traced the way artists moved with patterns from church to church, introducing variations to tailor their designs to the demands of individual sites.[22] She has also explored how during the glazing of the choir clerestory at Saint-Remi, variations from figure to figure within an individual program can represent the evolution of workshop attitudes to the execution of reused cartoons formed during sequential critique and revision over the process of an extended glazing campaign, here with an eye to enhancing legibility and accommodating design to the conditions of viewing dictated by lofty location when windows were installed within the building.[23]

But even if we should be cautious in generalizing broadly from any one example and even if we acknowledge interpretive flexibility in assessing the significance of individual situations themselves, internal stylistic variations in the painting of the axial window in the Virgin Chapel at Beauvais still reveal to me the hands of three distinguishable artists who shared execution of a single window rather than the evolution and correction of a team style in the process of executing a shared design over time and space. Other art historical interpreters, faced with a similar situation, have come to a similar conclusion. Some have mapped such variations in painting on a hierarchical model of labor organization, confident of their ability to relate their assessment of quality to individual members situated within a stratified workforce, even if the style of argument verges on circularity. Jane Hayward, for instance, discovered within a single 'composite panel' of fourteenth-century Norman grisaille, now in the Metropolitan Museum of Art, six distinct 'glaziers' marks' distributed over sixteen whole or partial quarries, each of which she coordinated with the stylistic 'handwriting' of six individual painters. Her assessment of the relative

[21] At Saint-Denis during the middle of the twelfth century, even within an individual 'workshop' the distribution of work between two definable painters changes in character from window to window. In one case (Maternity of the Virgin window) they divided their labor panel by panel, but in another (*Crusading* window) they seem to have shared in the execution of individual panels: Cothren, 'Suger's Stained Glass Masters,' 48–50.

[22] This work, presented initially within the extensive investigations of Caviness, *Sumptuous Arts*, has been revisited and refined in Madeline Harrison Caviness, 'Tucks and Darts: Adjusting Patterns to Fit Figures in Stained Glass Windows around 1200,' in *Medieval Fabrications*, ed. Jane Burns (London, 2004), 105–19, and the web supplement at http://www.tufts.edu/~mcavines/glassdesign.html.

[23] Caviness, *Sumptuous Arts*, 107–17.

'control' and 'crudeness' of these painters' quarries inspired her to identify each with a specific position within a hierarchically structured work force, embodying within her summary statement a set of undocumented and unexamined—if logical or even traditional—assumptions:

Surely what can be suggested by these quarries is that they are the work of three different journeymen (glaziers 1–3) and that there were three apprentices (glaziers 4–6), all of whom were learning the art of glass painting by assisting with the routine work of painting quarries. The wild-rose pattern, one of the most common of all motifs for glazing in the years following the invention of silver stain, would have been an ideal teaching exercise. The use of individual marks by apprentices was probably an attempt to isolate their work from the output of the paid journeymen.[24]

Whereas the scrutiny that allowed Hayward to coordinate style with makers' marks in this panel is impressive and instructive, I would prefer at Beauvais to adopt a somewhat more cautious and flattened model for the organization of labor among the three painters I have identified in the axial Virgin Chapel window. Perhaps they were of equal standing within a collective workshop, agreeing as a group how their individual painting styles might best be mapped over the expanse of a large narrative window on which they would collaborate. But it is quite tempting for me to speculate that the 'hard hand'—whose painting I find the most assured and controlled and whose scenes occupy privileged positions within the window—was the master or principal painter of a collaborative team, all of whom may have been 'master painters' on their own. Firm conclusions and broader generalizations must await the assessment of other evidence from other sites; much work remains to be done before we can catalogue with any authority the way variations in standardized formulae document the human dimension of the production of stained-glass windows. Although the method that has been and will be used to assemble the evidence necessary to chart this larger history is old-fashioned formal analysis, its use has the potential to bring new life to our understanding of the creative process that produced the stained-glass windows that inspire the art historical scholarship of a continually enlarging art historical workshop organized by the international Corpus Vitrearum project. My goal in highlighting here the discovery of three hands at work in one window at Beauvais, as well as in holding back on generalizing too boldly from this one example of connoisseurly differentiation, is to challenge my colleagues, present and future, to make this sort of close visual analysis a priority in researching stained glass so that one

[24] Jane Hayward, *English and French Medieval Stained Glass in the Collection of the Metropolitan Museum of Art*, edited and expanded by Mary B. Shepard and Cynthia Clark, Corpus Vitrearum, United States of America, Part I, 2 vols (New York, 2003), 2:25–27. On the question of when marks on individual pieces of glass within a panel might be artists' marks and when they might be installation or assembly marks, see Madeline H. Caviness and Suzanne M. Newman in *Medieval and Renaissance Glass from New England Collections*, ed. Madeline H. Caviness, exhb. cat., Busch-Reisinger Museum of Harvard University (Medford, Mass., 1978), 43; and Michael W. Cothren, 'Production Practices in Medieval Stained Glass Workshops: Some Evidence in the Glencairn Museum,' *Journal of Glass Studies* 41 (1999): esp. 127–34.

day we will have sufficient evidence to generalize with more confidence. That could have a powerful impact on the sorts of conclusions we will be able to form from the medieval material that remains.

The Asseburg-Hedwig Glass Re-emerges

Timothy Husband

According to the *Legenda Aura*, Saint Hedwig (ca. 1178–1243, canonized 1267) was born in the Bavarian town of Andechs and at a young age was placed in the convent of Kitzingen in Franconia.[1] At the age of twelve, however, she was withdrawn and married to the eighteen-year-old Heinrich, duke of Silesia. After the birth of their last child in 1209, Hedwig and Heinrich took a vow of continence and devoted themselves to religious pursuits, establishing numerous hospitals and monastic foundations. For her part, Hedwig retreated to an ascetic existence at the monastery of Trebnitz near Breslau, and ministered to the needs of others, frequently assisted by divine intervention. Her husband, according to one account, aware of her fasting and fearing for her health, implored her to take more nourishment supplemented with a little wine. On one occasion he examined her glass and much to his surprise discovered that it contained wine even though he knew she had filled it with water; this felicitous transmutation became a regular occurrence. The vessel in which these small miracles transpired is thought, by tradition, to be the very glass that was formerly in the Museum of Silesian Antiquities in Breslau, now Wrocław, Poland, and either lost or destroyed in 1944.[2] Since the late Middle Ages, this glass and a small number of closely related vessels have been called Hedwig glasses after the saint.

Hedwig glasses number amongst the most intriguing, indeed mysterious, of medieval objects to have survived. Only thirteen are known.[3] All are made from a gather of free-blown glass ranging in tones from pale smoky gray to a

[1] I am grateful to the following, all of whom in varying ways helped me in the preparation of this paper: Peter Barnet, Stefano Carboni, Julien Chapuis, Bernd Hochemeyer, Melanie Holcomb, Lisa Pilosi, David Whitehouse, Mark Wypyski, and Rainer Zietz.

[2] Eugen von Czihak, 'Die Hedwigsgläser,' *Zeitschrift für christliche Kunst* III (1890): 339, figs. 2 and 14; Eugen von Czihak, *Führer durch die Sammlung des Museum schlesischer Altertümer zu Breslau*, 3rd ed. (Breslau, 1891), 70, fig. 22.

[3] Additionally, seven fragments have been recovered from as many archaeological excavations: Weinsberg, Göttingen, Hilpoltstein, and Oberursel in Germany; Novogrudok, Belarus; Budapest; and Pistoia. See Erwin Baumgartner and Ingeborg Krueger, *Phönix aus Sand und Asche*, exhb. cat., Rheinisches Landesmuseum Bonn and Historisches Museum Basel (Munich, 1988), 99–101, nos. 43–5; David Whitehouse, 'A Note on Hedwig Glasses,' in *Cairo to Kabul: Afghan and Islamic Studies presented to Ralph Pinder-Wilson* (London, 2002), 258.

light honey color. All are distinctly thick-walled vessels supported by an applied foot, and all are distinguished by surface decoration in cut, ground, and polished high relief, projecting two or more millimeters. And all appear to date from the later twelfth through the first third of the thirteenth century. By date and technique Hedwig glasses are an anomaly for they are the only examples of cut and polished blown glasses made between Late Antiquity and the sixteenth century.[4] No two examples are identical in design but all possess commonalities of decorative vocabulary and organization. All are slightly conical but cut with vertical facets, most distinct near the lip, often slightly fluted and ranging in number from eight to sixteen.

The ornament consists of varying combinations of abstracted palmettes and other vegetal forms, either alone or in some combination with a limited repertoire of creatures often associated with heraldic imagery, specifically, lions, eagles, and griffins. Five beakers are engraved solely with palmettes or abstracted vegetal forms and crescents or geometric motifs, often enhanced with cross-hatching. Eight of the beakers are decorated with one or two lions, usually in combination with an eagle or a griffin or both, and three of these also include a highly stylized vegetal form of bilateral symmetry, sometimes interpreted as a Tree of Life. All employ passages of engraved parallel lines that accentuate or ornament surfaces. The volumes of the creatures, for example, are reduced to triangular fields articulated with compressed parallel-engraved lines. The effect is similar to that of the 'cross-hatched' paintings of Jasper Johns executed in the 1970s that likewise manipulate the image and the transitions of mass and plane.[5] The optical illusion has the viewer seeing an individual component—say, a lion—in a single plane seemingly floating over the curved and faceted surface of the vessel. The deep carving in all the beakers and the resulting mass of the relief endows them with a pronounced sculptural presence. The voids and solids created by the high relief, the refractive cuts of the engraved lines, and the translucency of the glass combine to create a radiant play of light and dark across the surfaces.

The material—which resembles a quartz hardstone such as topaz or rock crystal—the exotic designs, as well as the tactile and visual appeal account, in part, for the fact that Hedwig glasses were highly valued already at the time of their creation. All of these vessels almost immediately entered monastic or cathedral treasuries or became the coveted possessions of princely families (see Appendix). Their saintly associations, no doubt, significantly heightened their esteem. The lost Breslau example (Appendix 8) was linked to Saint Hedwig, a holy connection shared by another glass in Nysa, Poland (Appendix 13). And the beaker in Veste Coburg (Appendix 12) is thought to have belonged to Saint Elizabeth, Landgräfin of Thüringia (1211–34, canonized 1235), the niece of Saint Hedwig and a member of the Franciscans at Eisenach. This association elevated

4 No examples of Roman cut and polished glass seem to date later than the fourth century CE. See, for example, Donald B. Harden, *Glass of the Caesars*, exhb. cat., Corning, London, Cologne (Milan, 1987), 189–237, Group G: Cut and/or Engraved.

5 Jasper Johns not infrequently drew upon medieval imagery; in *Racing Thoughts* (New York, 1983), for example, there are visual references to Matthias Grünewald's *Isenheim Altarpiece*.

the glass itself to the status of a relic; the women of the House of Wettin, who believed that the apotropaic powers of the beaker protected them in childbirth, especially revered it. This same glass is said to have been later in the possession of Martin Luther and to have been rendered in a drawing of 1507 by the Cranach workshop.[6] Six of the thirteen vessels were transformed into chalices, ostensories, or reliquaries in medieval times, thus assuming sacred functions, and three others were likewise notched in the ring foot, indicating that they, too, were adapted for similar purposes. Those that remained in private hands until modern times were similarly held in high esteem. The etched inscription on the bottom of the vessel now in the Rijksmuseum (Appendix 4) states that in 1643, when one thousand years old, the glass was presented to Ludwig Philippe, Count Palatine.[7] While its age is significantly exaggerated, the inscription indicates that the conveyance of the vessel into the hands of the count was an occasion worthy of commemoration. Thus, early in the existence of Hedwig glasses, the spiritual and mystic value vested in them transcended their material value.

The mystique of Hedwig glasses has only been intensified by their elusive origins, the subject of continuing scholarly debate. Eugen von Czihak was the first to study Hedwig glasses systematically. Recognizing that they comprised a small but coherent group, he believed that they were executed in a technique unknown in European medieval glass production. He perceived the ornament to be of an 'oriental' character similar to that found on Islamic rock crystal; he therefore argued that the Hedwig glasses originated in the Near East and suggested that pilgrims returning from the Holy Land brought them to Europe.[8] Robert Schmidt enlarged von Czihak's group from eight to twelve and in a detailed study noted the connection between Fatimid rock crystal carvings of the tenth century and the Hedwig glasses, but, likewise, discerned considerable differences; he reconciled the disparities by assigning the Hedwig glasses a later date, in the eleventh or twelfth century.[9] Carl Johan Lamm, in his monumental study of Middle Eastern glass and rock crystal, saw the Hedwig glasses as a coherent subgroup, which he attributed to Egypt in the twelfth century.[10] While other scholars have looked to Syria,[11] Iran,[12] or elsewhere in the Middle East, arguments placing the origins of the Hedwig glasses in the

[6] Weimar, Staatsarchiv, Reg. 0.213 folio 51. Reproduced in Robert Koch, *Sankt Elizabeth Fürstin Dienerin Heilige; Aufsätze, Dokumentation, Katalog* (Sigmaringen, 1981), 278, fig. 2.

[7] *Alsz dies glas war alt tausent jahr Es Pfalzgraf Ludwig Philipsen verehret war: 1643.*

[8] Eugen von Czihak, *Schlesische Gläser. Eine Studie über die schlesische Glasindustrie früherer Zeit* (Brelsau, 1891), 184–206.

[9] Robert Schmidt, 'Die Hedwigsgläser und die verwandten fatimidischen Glas—und Kristallschnittarbeiten,' *Jahrbuch des schlesischen Museums für Kunstgewerbe und Altertümer* VI (Breslau, 1912): 53–78.

[10] Carl Johan Lamm, *Mittelalterliche Gläser und Steinschnittarbeiten aus dem Nahen Osten*, Forschungen zur islamischen Kunst V, ed. Friedrich Sarre (Berlin: 1930), 1:171–5; 2:pl. 14, nos. 27–8; pl. 15, nos. 1–10.

[11] Basil Gray, 'Thoughts on the Origin of "Hedwig" Glasses,' *Colloque international sur l'histoire du Caire—27 Mars-5 Avril 1969* (Gräfenhaichichen, n.d.), 191–94.

[12] R. H. Pinder-Wilson, 'A Hedwig Glass for the Museum,' *The British Museum Quarterly* 22, no. 1/2 (1960): 45; Samuel Kurinsky, *The Glassmakers—An Odyssey of the Jews, The First three Thousand Years* (New York, 1991), 339–41.

Islamic world remain the most enduring, largely because of the perceived similarities in the design and technique between Islamic cut rock crystal and the Hedwig beakers. Egypt and, to a lesser degree, Iran have been particularly favored because they are known to have had a tradition of both glass and rock crystal cutting.

Noting that not even a fragment of a Hedwig beaker has ever surfaced in the Near East, Joseph Philippe proposed a Byzantine or Byzantine-influenced origin with particular reference to Byzantine textiles.[13] Hans Wentzel agreed with this theory and in an exhaustive discussion linked the Hedwig vessels to the dowry of Theophanu (ca. 960–91), attendant to her marriage to Otto II in 972, assigning the vessels a corresponding date around 1000.[14] Philippe responded by reaffirming the Byzantine attribution but questioning the date, observing that Byzantine treasures were also brought to the West in the wake of the fifth crusade. He also noted the apparent connection of the two Hedwig glasses in Namur (Appendix 3 and 10) with Jacques de Vitry, bishop of Acre (1216–26).[15]

Based on a fragment found at Novogrudok, a known glass-making site, B. A. Shelkonikov postulated that the Hedwig glasses were made in Russia,[16] a theory that has met with little acceptance. Julia Ščapova further argued that the Novogrudok fragment was hand-engraved while the complete glasses were engraved by a water-powered wheel, a technique she asserts was only introduced by Martin Winter in 1686; she therefore concluded that the Hedwig glasses are all post-medieval and were made in Silesia, probably in the workshop of Friedrich Winter around 1700.[17] The technique of cutting and polishing hardstone, however, is known to have existed in Paris, Venice, and in the Meuse-Rhine region already in the twelfth and thirteenth centuries,[18] and there is no physical evidence that the Hedwig glasses were cut and polished by water-driven wheels. Furthermore, the fact that most of the glasses have or had medieval mounts, that other fragments have been found in medieval contexts, and that the Amsterdam glass (Appendix 4) has an etched date of 1643 all render this argument untenable.

Erwin Baumgartner and Ingeborg Krueger, in their landmark study of the medieval glass industry in northern Europe, provided a more measured and cautious introduction to the Hedwig glasses.[19] They supported a date in the twelfth century largely on the basis of the datable contexts in which some of

[13] Joseph Philippe, *Le monde byzantin dans l'histoire de la verrerie* (Bologna, 1970), 127–31.

[14] Hans Wentzel, 'Das byzantinische Erbe der ottonischen Kaiser—Hypothesen über den Brautschatz der Theophano,' *Aachener Kunstblätter* 43 (1972): 11–96, esp. 56–61.

[15] Joseph Philippe, 'Reliquaires médiévaux de l'Orient chrétien en verre et en crystal de roche conservés en Belgique,' *Bulletin de l'institut archéologique liégeois* 86 (1974): 247–50.

[16] B. A. Shelkonikov, 'Russian Glass from the 11th to the 17th Century,' *Journal of Glass Studies* 8 (1966): 95–115, esp. 109–112.

[17] Julia Ščapova, 'A propos des coupes dites de Sainte Hedwig,' *Annales du 7e Congrès de l'Association Internationale pour l'histoire du verre—15–21 août 1977* (Liège, 1978): 255–69.

[18] Hans R. Hahnloser and Susanne Brugger-Koch, *Corpus der Hartsteinschliffe des 12.-15. Jahrhunderts* (Berlin, 1985), 13–19 and 25–28.

[19] Baumgartner and Krueger, *Phönix aus Sand und Asche*, 86–88.

the fragments were found and on the acceptance of the evidence that the Namur vessels were in Oignies by the early thirteenth century. The source of the Hedwig glasses, however, posed a more vexing problem. Arguing against an origin in Fatimid Egypt, they noted that not a single fragment of a Hedwig glass has ever emerged from the extensive excavations at the Fatimid capital at Fustat or from other Egyptian sites, and, while inscriptions are commonplace on Islamic glass and rock crystal vessels, not one appears on a Hedwig glass. Most compellingly, they argued that the ineluctable differences in decorative vocabulary between the Islamic and Hedwig vessels could not be reconciled by merely assigning a later date to the Hedwig glasses. Concluding that the thick-walled vessels and the rigid stylization of the ornament were inconsistent with Islamic sensibilities, they posited that the origins of the Hedwig glasses must lie either in the greater reaches of the Byzantine empire, in regions under Byzantine influence such as Italy, in Syria, or elsewhere in the Middle East.

While not necessarily accepting Baumgartner and Krueger's attribution, scholarship of the last several decades does reflect their view that the origins of Hedwig glasses can be explained only by a more complex scenario in which the coincidence of technical ability, stylistic influences, and discerning clientele occurred as a result of the convergence of cultural influences. Axel von Saldern, for example, saw the Hedwig glasses as a late style of glass cutting related to Fatimid techniques and design but suggested they, in fact, were produced in the Near East by a workshop that, after the fall of the Fatimid Empire in 1171, moved to Tyre, Acre, Antioch, or another city with glass-making traditions in the Holy Land.[20] These exotic luxury items, he argued, appealed to the Latin audience and were brought to Europe by returning pilgrims, crusaders, and the like. This theory accords well with the apparent connection of Jacques de Vitry, Bishop of Acre, with the Namur glasses. David Whitehouse concluded that there was insufficient evidence to determine whether Hedwig glasses were made in the Islamic world, Byzantium, or southern Italy.[21] Later refining his opinion, Whitehouse observed that the massiveness of Hedwig glasses is antithetical to the aesthetic of Islamic rock crystal vessels, which strove for delicate thinness of the wall.[22]

[20] Axel von Saldern, 'Early Islamic glass in the Near East—Problems of Chronology and Provenances,' *Annales du 13e congrès de l'association internationale pour l'histoire du verre 28 août-1 septembre 1995* (Lochem, 1996): 239–42.

[21] David Whitehouse, 'Molded and Engraved Glass,' *Glass of the Sultans*, Stefano Carboni and David Whitehouse, with contributions by Robert H. Brill and William Gudenrath, exhb. cat., The Metropolitan Museum of Art, New York (New Haven, 2001), 161. He also found both Sčapova's conclusions ('A propos des coupes …') and Rosemarie Lierke's argument—based largely on erroneous technical assumptions—that Hedwig glasses were made in central Europe (Rosemarie Lierke, *Antike Glastöpferei—ein vergessenes Kapital der Glasgeschichte* [Mainz, 1999], 140–45) unconvincing.

[22] Whitehouse, 'A Note on Hedwig Glasses,' 255–59. He also observed that the dominant motifs—lion, griffin, eagle, and Tree of Life—are significantly more resonant in Christian than Muslim symbolism, and therefore concluded that the glasses were most likely made for a Christian audience, without specifying where.

The recent re-emergence of the Hedwig glass that belonged to the Asseburg family (fig. 3.1),[23] thought to have been lost more than a half a century ago (Appendix 11), marks a felicitous turn of events by reintroducing an exceptional work of art while prompting a reconsideration of its origins. This glass, by tradition, has always belonged to the counts of Asseburg, whose nobility was established between 1218 and 1223. Proprietors of substantial estates in Meisdorf and Falkenstein, southeast of Halberstadt (Sachsen-Anhalt), members of the family served as canons of the cathedral of Halberstadt and privy counselors to the Landgraves of Thuringia. The glass remained, however, undocumented until 1831 when it was conveyed to Ludwig-August von der Asseburg.[24] Apparently it remained in the castle at Falkenstein[25] until it was moved to another family castle at Hinnenburg, east of Paderborn in Westphalia, probably by Karl-Christoph von der Asseburg-Falkenstein-Rothkirch, in anticipation of the advancing Soviet army in early 1945. There the glass remained until it was placed on the London art market in 2002 and subsequently was acquired by a European collector. The glass is currently on long-term loan to the Metropolitan Museum of Art.[26]

Made of pale, honey-colored glass, the seemingly simple raised decoration of the Asseburg-Hedwig glass reveals subtle complexities upon closer examination. Essentially cut in eight facets, most noticeable at the lip, the design is centered on the edges of these facets and symmetrically distributed around the body of the vessel. Four abstract cordate leaves point down from the upper register and alternate with the four abstract deltoid leaves that point up from the lower register. A series of cordate frames encloses the leaf forms, correspondingly alternated in direction, bound together at the points with bands defined by engraved parallel lines and cross-hatched fields. The frames are engraved in a reeded pattern and accented with bands of intersecting parallel lines. Likewise the leaves are textured with cross-hatching and radiating ribs. The overall pattern is continuous, and reads in both directions as well as in either orientation. Adding a further visual dimension, the pattern, which in fact projects, gives the illusion of receding when angled against the light.

The dense, complex composition of the decoration on the Hedwig glasses has no specific parallel in Byzantine decorative vocabulary, but similarities can

[23] See Schmidt, 'Die Hedwigsgläser,' 60 and 63, fig. 10. See also Francis N. Allen, *The Hedwig Glasses; A Survey* (unpublished typescript, 1987), 8–9, fig. 8.

[24] For legends associated with its early history, see Max Trippenbach, *Asseburger Familiengeschichte: Nachrichten über das Geschlecht Wolfenbüttel-Asseburg und seine Besitzungen* (Hannover, 1915), 519–29. For a monographic study in unpublished typescript, see Karl-Christoph, Malve Graf, and Gräfin Rothkirch, *Die Asseburger Becher und ihre Herkunft* (Hinnenburg, 1972).

[25] Trippenbach, *Asseburger Familiengeschichte*, 524.

[26] A thick-walled, undecorated beaker of free-blown amethyst glass, long in the possession of the Asseburg family, traditionally has been associated with the Hedwig beaker. Thought by some to be a blank for a Hedwig glass, this vessel was provided a leather case in the fourteenth century, suggesting that it was highly valued at an early date. See Schmidt, 'Die Hedwigsgläser,' 61. This vessel and its case, sold with the Asseburg-Hedwig glass, are also currently on loan to the Metropolitan Museum of Art.

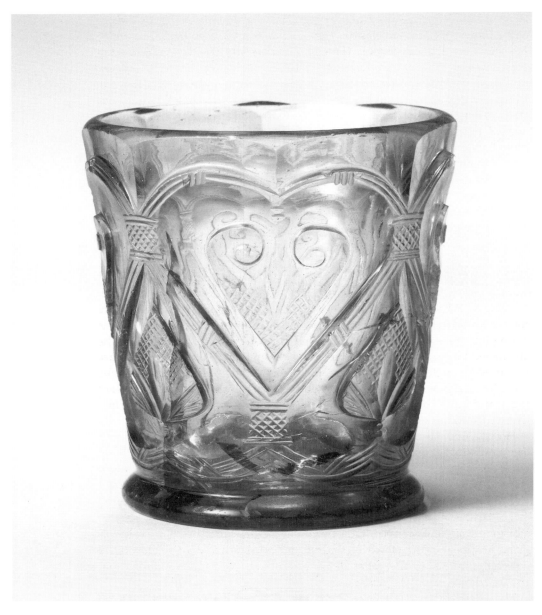

3.1 Asseburg-Hedwig Beaker, Central Europe (Silesia or Saxony?), ca. 1175–
1225, free-blown glass with cut, polished, and engraved decoration, 10.2 × 9.5 cm.
Lent by Bernd and Eva Hockemeyer, Germany (L.2004.32.1) to The Metropolitan
Museum of Art, New York.

be found in Islamic art. This explains, in part, their distinctly exotic appearance in the context of European glass production and their 'oriental' character, which has long been remarked upon. If Hedwig glasses are, indeed, the product of cross-cultural fertilization, where did this occur? The distribution of the glasses and fragments is densely, indeed almost exclusively, concentrated in central Europe; only one fragment has surfaced south of the Alps, for example, and that was in the bishop's palace at Pistoia.[27] If these vessels were made at a cultural crossroads, such as Sicily, or southern Italy under the Barbarosa, or the Holy Land—and all have been proposed—it would seem unlikely that not a trace has survived. The crossroads, I therefore propose, were closer at hand.

The Asseburg beaker is singular among the Hedwig glasses in the symmetry and balance of its design. Each element of the alternating deltoid and cordate leaf patterns hinges on the angle where two vertical facets conjoin so that each half of the leaf conforms to the corresponding surface, eight leaf forms across eight facets as though each was creased at the central axis. Only the decoration of the glass at Veste Coburg is similarly composed, but the vegetal forms there are reduced to almost geometric abstractions; the counterpart of the deltoid leaf on the lower register of the Asseburg glass, for example, is reduced in the Coburg vessel to a simple volute form. But more importantly, the cordate frames bound by a cross-hatched band where the ribbons at the tip of one frame spring into the arcs of the next are entirely missing in the Coburg glass. The abstracted forms of the sculpted vessel wall seem then to rise above a surface fractured by angled planes. The framing device on the Asseburg glass, on the other hand, defines a series of eight fields, each of which is centered by one of the leaf forms, creating a linear, frieze-like band around the vessel that distinguishes this design from those of all other Hedwig glasses.

However evanescent, Islamic influence on the Hedwig glasses is manifest. The similarity between the lion carved on a glass bowl in the Treasury of Saint Mark's in Venice,[28] for example, and those on the Hedwig glasses (fig. 3.2) is certainly striking. The rounded forms in the Venice example, however, are in sharp contrast to the angled planes and stylized patterns of parallel lines found on Hedwig glasses. The lion on a glass brought up from a shipwreck at Serçe Limani, firmly datable 1000–50, and now in the Bodrum Museum, Turkey, is closer in appearance.[29] However, the linearity of its form and the shallow bevel cut that diminishes the relief deprive it of the sculptural qualities that characterize the Hedwig glasses.

More striking comparisons can be found in the case of the cordate leaf form in the Asseburg glass. A corresponding motif with the cusps of the leaves similarly rendered in a volute form can be found, for example, on a single-handled rock-crystal cup, now in the treasury of the Aachen Cathedral.[30] A

[27] Baumgartner and Krueger, *Phönix aus Sand und Asche*, 99, no. 43.

[28] Hans R. Hahnloser et al., *It Tesoro di San Marco 2, Il Tesoro e il Museo* (Florence, 1971), pl. XCIV.

[29] See Richard Ettinghausen, Oleg Grabar, and Marilyn Jenkins-Medina, *Islamic Art and Architecture 650–1250* (New Haven, 2001), 207, fig. 332.

[30] Wentzel, 'Das byzantinische Erbe,' 70, fig. 72a.

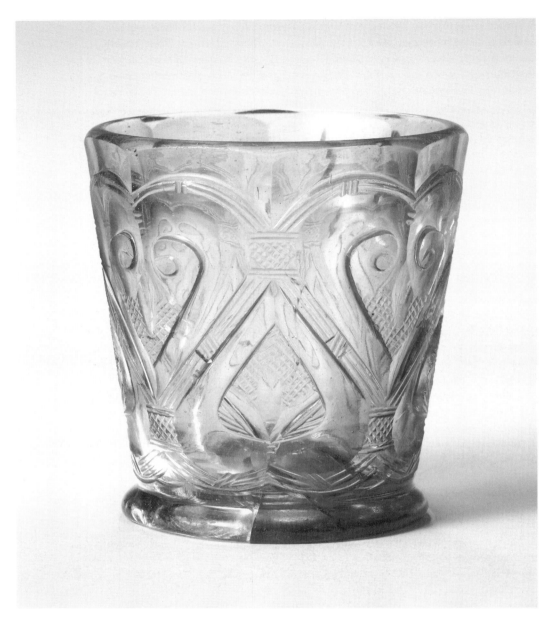

3.2 Asseburg-Hedwig Beaker, alternate view of fig. 3.1.

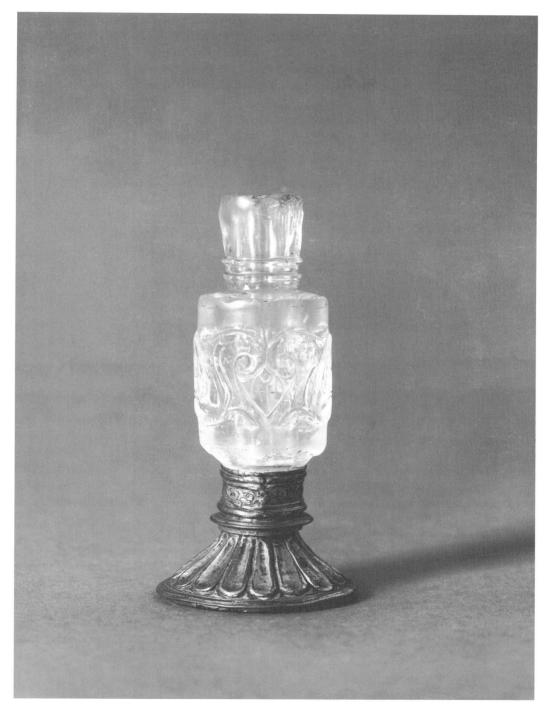

3.3 Perfume phial, rock crystal, Fatimid, Egypt, eleventh century, Schnütgen
Museum, Cologne.

similar motif also appears on an eleventh-century perfume phial, once incorporated in a reliquary cross that was probably a donation of the emperor Heinrich II, and is now in the parish church of Borghorst in Westphalia.[31] Two pieces of eleventh-century Fatimid rock crystal, incorporated as a knop and baluster in a candlestick assembled in the sixteenth century, are now in the Treasury of Saint Mark's, Venice.[32] The carving on these elements consists of cordate leaves with volute cusps similar to the above examples, but here the leaves, although not alternatively reversed as in the Asseburg beaker, are framed with a vine meander of corresponding form. And another perfume phial, now in the Schnütgen Museum, Cologne (fig. 3.3),[33] is carved with the same cordate leaf form, but here they alternate directions and, as in the Asseburg glass, they are interlinked by vine-like ribbons, forming a band around the center of the vessel wall.

The closest comparison, however, can be found on a rock crystal bottle carved in Egypt in the eleventh century, which Wentzel believes came to central Europe as part of the dowry of Theophanu.[34] The mounts, in any case, indicate that the vessel was in central Europe by the thirteenth century, at which date it was already in the treasury of the Halberstadt Cathedral (figs. 3.4, 3.5). The familiar cordate leaf pattern pointing upward and framed by a vine meander appears cartouche-like four times evenly spaced over the body of the vessel. On the narrow straight-walled neck of the bottle, however, the same cordate leaves alternately reverse direction, and the vine here becomes more rope-like and symmetrically both connects and frames the leaves, thus forming a continuous frieze-like band and providing a striking prototype for the relief pattern on the Asseburg glass.

While the design of the Asseburg glass may have formal analogues in the Cologne phial and even more so in the Halberstadt rock crystal bottle, the visual effects they achieve are, again, very different. Islamic rock crystal carvers strove for the thinnest vessel wall possible so that the relief, of denser tonality and refractive qualities, would seemingly float above the dematerialized transparency of the wall. This effect is heightened by the large areas of openness between the cartouche-like motifs on the Halberstadt bottle. In the finest examples, such as the famed ewer of the caliph al-Azîz bi'llâh (975–96) in the Treasury of Saint Mark,[35] every element of the composition seems to float in a world of sparkling, limpid clarity. The Hedwig glasses, on the other hand, exploit the deliberate mass of the vessel to create sculptural effects through the contrasts of voids and solids and through the play of light off both the reflective surfaces and the refractive cuts into the varying densities of glass. Hedwig glasses spring from a very different aesthetic and, it may therefore be presumed, from a different origin.

[31] Wentzel, 'Das byzantinische Erbe,' 46–48, fig. 51.

[32] Hahnloser, *Il Tesoro e il Museo*, pl. XCV.

[33] Lamm, *Mittelalterliche Gläser und Steinschnittarbeiten*, pl. 68, no. 12.

[34] Wentzel, 'Das byzantinische Erbe,' 21, fig. 9.

[35] See David Alcouffe, *The Treasury of San Marco Venice*, exhb. cat., The Metropolitan Museum of Art, New York (Milan, 1984), 216—21, no. 31.

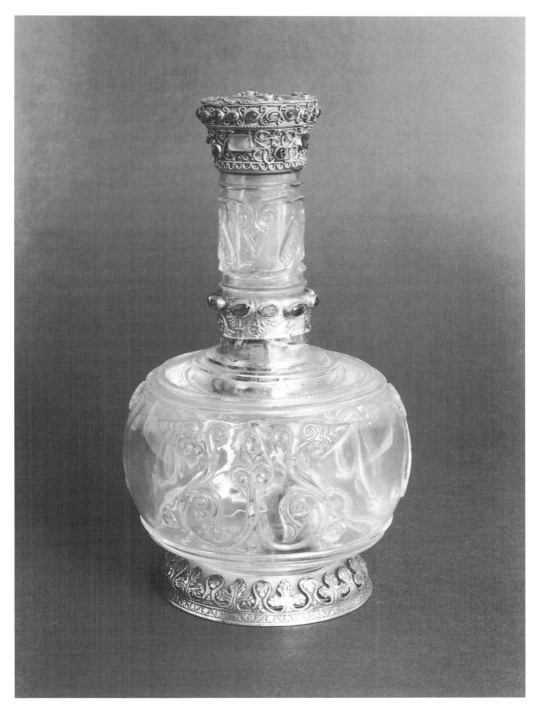

3.4 Bottle, Egyptian, late tenth or early eleventh century, rock crystal. Mounts:
Lower Saxony, early thirteenth century, silver-gilt, Halberstadt, Cathedral
Treasury (Inv. no. 69), H. 8.9 cm.

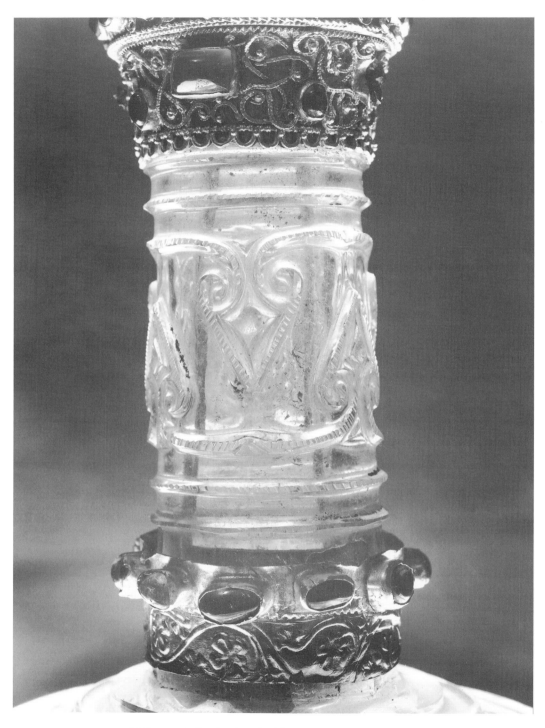

3.5 Halberstadt Bottle, detail of fig. 3.4.

It cannot be mere coincidence that the all the Hedwig glasses but the two now in Namur have a medieval connection with central Europe, especially with Thuringia, Saxony, or Silesia. All of the excavated fragments save two, likewise, were recovered within the same area of distribution; the context of the other two—the bishop's palace at Pistoia and the trading center of Novogrudok—suggest imports. Conversely, no physical evidence has surfaced anywhere to link the glasses with Byzantium, with the greater Islamic world, or with southern Italy or Sicily. While the lion, griffin, eagle, and Tree of Life motifs are not without resonance in Byzantium and the Islamic world, they are, in a Western context, bound by specific Christological symbolism, underscored by the fact that most of the Hedwig glasses have been adapted for a sacred function.[36] Furthermore, the very duchies of central Europe with which the Hedwig glasses have both historical and legendary connection are known to have had thriving glass industries throughout the Middle Ages and, indeed, remained vital centers of the glass industry up to modern times—those in the Hirschberger Tal, for example. And finally, the impulse to confine a motif that floated freely in its Islamic manifestation in a symmetrical and continuing band was entirely consistent with precepts of ornament in Western art and is commonplace in the borders of twelfth- and thirteenth-century illuminated manuscripts and stained-glass windows. A comparable leaf pattern with the leaves alternating direction and the whole bound within a band by angular strapwork is found, for example, in the borders of a thirteenth-century ornamental stained-glass panel from the former Cistercian abbey at Schulpforta (fig. 3.6).[37]

By no means was the medieval glass industry of central Europe limited to the production of clear, green utilitarian vessels (*Waldglas*) as has been suggested.[38] As Baumgartner and Krueger so clearly demonstrated in the exhibition *Phönix aus Sand und Asche*, medieval glassmakers had a wide array of materials and techniques at their command. In the twelfth and thirteenth centuries, they were not limited to potash glass, but produced both soda-lime[39] and leaded glasses,[40] all of which they could transmute with opacifiers, clarifiers, and colorants achieving an astonishing range of tonalities. The composition of the Asseburg-Hedwig glass is therefore not inconsistent with a European origin.[41] Likewise, free-blown, mold-blown, and cast glasses were

[36] Whitehouse, 'A Note on Hedwig Glasses,' 257.

[37] See Hiltrud Westermann-Angerhausen, ed., with the collaboration of Carola Hagnau, Claudia Schumacher und Gudrun Sporbeck, *Himmelslicht—Europäische Glasmalerei im Jahrhundert des Kölner Dombaus* (1248–1349), exhb. cat., Schnütgen-Museum, Cologne (Cologne, 1998), 158–59, no. 18.1.

[38] Franz Rademacher, *Die deutschen Gläser des Mittelalters* (Berlin, 1930), for example, presents such a one-dimensional account.

[39] Baumgartner and Krueger, *Phönix aus Sand und Asche*, 19.

[40] Baumgartner and Krueger, *Phönix aus Sand und Asche*, 161–84.

[41] Chemical analysis of the Asseburg-Hedwig beaker, conducted by Mark Wypyski in the Department of Scientific Research at The Metropolitan Museum of Art, has revealed it to be a soda-lime glass and similar compositions have been reported for the Corning and British Museum beakers, as well as for the fragments from Göttingen and Hilpoltstein. Investigations

3.6 Grisaille panel, Germany, 1251–68, colorless glass, pot-metal glass, and vitreous paint, from a choir window of the Cistercian abbey at Schulpforta, 77 × 50 cm.

all in the European repertoire, and there is no reason that the techniques of hardstone cutting, polishing, and engraving could not have been applied as well.[42] Indeed, a European connection is suggested by the vertical faceting apparent on all the Hedwig glasses, which is also characteristic of and specific to continental rock crystal vessels carved from the thirteenth century on.

A flourishing and technically accomplished glass industry, Islamic and Near Eastern influences, and a discerning market, in fact, all converged in central Europe. In the case of the Asseburg glass, specific Islamic models had already been imported to the region. It cannot be by coincidence alone that decorative formula of the Asseburg glass finds its closest analogue in a Fatimid rock crystal vessel that since the early Middle Ages had been in the treasury of Halberstadt cathedral, less than twenty-five kilometers from Falkenstein.[43]

Years before von Czihak's 1891 study, August Ottmar Essenwein puzzled over the origins of the Breslau, Krakow, and Nuremberg glasses; while wondering if the glasses were not somewhat Arabic ('etwa arabisch'), he concluded that because there was nothing specifically 'oriental' about the decoration, they should be attributed to the West.[44] Returning to the same issue several years later, he opined that while an oriental origin is not excluded, he believed the Hedwig glasses to be of western, indeed, German origin ('… abendländisches Fabrikat, also natürlich deutsches …'), dating to the thirteenth century.[45] With little evidence to support it, the attribution failed to convince, and so it largely remains today. With the re-emergence of the Asseburg-Hedwig glass, however, the supposition merits reconsideration. The arguments marshaled here suggest that Essenwein may have been correct after all and are proposed in hopes that incontrovertible evidence may one day resolve this persistent conundrum.

undertaken by Lisa Pilosi and Mark Wypyski indicate that the compositions of these three glasses are extremely close and that they are similar to but distinct from typical Islamic glasses of the period. In the absence of a larger body of data, particularly of European glasses, such analyses remain open to differing interpretations. Hans Karl Wedepohl ('Die Gruppe der Hewigsbecher,' *Nachrichten der Akademie der Wissenschaften zu Göttingen, II. Mathematisch-physikalishe Klasse*, 1 [2005]), for example, using very much the same data, concludes that these three Hedwig glasses are of Islamic origin.

[42] The subtle variations in color, which were almost certainly a matter of choice, suggest that, of the quartz hardstones worked in the twelfth and thirteenth centuries, Hedwig glasses were intended to imitate topaz rather than rock crystal.

[43] Recent studies by Rudolf Distelberger broaden our understanding of rock crystal cutting in southern Italy and particularly in Norman Sicily. See Wilfried Seipel, ed., *Die Kunst des Steinschnitts: Prunkgefässe, Kameen und Commessi aus der Kunstkammer*, exhb. cat. (Milan, 2002), 25–51 and Wilfried Seipel, ed., *Nobiles Officinae: Die königlichen Hofwerkstätten zu Palermo zur Zeit der Normannen und Staufer im 12. und 13. Jahrhundert*, exhb. cat. (Milan, 2004), 'Die Gefässe auf Bergkristall,' 109–13. Twelfth- and thirteenth-century vessels may well have been introduced to the north by the Hohenstaufer.

[44] August Ottmar Essenwein, 'Ein "Hedwigsbecher" im germanischen Museum,' *Anzeiger für Kunde der deutschen Vorzeit. Organ des Germanischen Museums*, 1877, no. 8, col. 233.

[45] August Ottmar Essenwein, 'Deutsche Gläser im germanischen Museum,' *Anzeiger für Kunde der deutschen Vorzeit. Organ des Germanischen Museums*, 1879, no. 2, col. 34.

Appendix: The Thirteen Hedwig Glasses

1 Kraków, Cathedral Treasury, purportedly since the Middle Ages. H. 11.2 cm (4.4 in.) beaker. Eagle flanked by facing lions and geometric ornament. Converted to a chalice. Silver-gilt mounts, Central European, first half of the fifteenth century.

2 Minden, Cathedral Treasury. H. 9.8 cm (3.9 in.) beaker. Tree of Life flanked by an eagle and a lion with geometric ornament. Converted to a reliquary or ostensory. Silver-gilt mounts, German, 1325–50. The ring foot has been notched out to receive the mounts.

3 Namur, Convent of the Sisters of Our Lady. Treasury of the Monastery at Oignies, probably since the first third of the thirteenth century, transferred to Namur after the secularizations. H. 8 cm (3.1 in.) beaker. Lion, griffin, and geometric ornament. Converted to a reliquary or ostensory. Copper-gilt mounts, Lowlands, first third of the thirteenth century. Attributed to Hugo d'Oignies and lay brothers. Said to have been given to Oignies by Jacques de Vitry (1170–1240), benefactor of the monastery, crusader, and bishop of Acre (1216–26). Documents in the archives at Oignies indicate that Jacques de Vitry presented objects to the monastery during this period but these references cannot be linked to the Hedwig glasses with certainty (for the second example from Oignies, see 10, below).

4 Amsterdam, Rijksmuseum (Inv. N.M. 712). Early history unknown. According to an etched inscription on the bottom, this glass was given to Ludwig van Simmern, Count Palatine, in 1643. Inherited by his wife, Maria of Nassau-Orange and thence by descent in the House of Nassau-Orange. With the rise of the Batavian Republic, the Nassau properties were sequestered and in 1801 the glass was placed in the National Art Gallery, The Hague, and then successively transferred to the Royal Cabinet of Curiosities and in 1875 to the Museum voor Geschiedenis en Kunst, the forerunner of the Rijksmuseum in Amsterdam. H. 14.7 cm (5.8 in.). Two lions, an eagle, and geometric ornament.

5 Corning, Corning Museum of Glass (67.1.11). Purportedly since the Middle Ages in Halberstadt Cathedral. Found in the sacristy and removed from the cathedral in 1820. Passed through several hands, thence to Major General Röse, Berlin; Duke of Gotha, Erfurt; Alexandrine de Rothschild, Paris; auctioned May 18, 1967, Sotheby's London. H. 8.7 cm (3.4 in.). Two lions facing left and geometric ornament. Ring foot has been notched to receive mounts, now removed.

6 London, British Museum (1959.4-14.1). Early history unknown. Private collection in Thüringia before World War I; private collection Germany, after World War II. H. 14 cm (5.5 in.). Lion and griffin confronting an eagle; opposite the eagle, a Tree of Life.

7 Nuremberg, Germanisches Nationalmuseum (Inv. Nr. KG 564). Early history unknown. Swiss private collection; Lorenz Gedon, Munich; acquired by the Germanisches Nationalmuseum in 1877. H. 9.5 cm (3.7

in.). Lion, griffin, lion, all facing left and geometric ornament. Converted to a chalice; ring foot notched in three places.

8 Wrocław, Silesian Museum of Antiquities (Inv.Nr. 5613). Early history is unknown. Apparently kept in the Town Hall in the sixteenth century. Disappeared in 1944. H. 12.3 cm (4.8 in.). Geometric ornament surmounted by a crescent moon and star flanked by facing lions separated by adorsed palmette patterns. Converted to a footed beaker supported by three kneeling angels; silver-gilt mounts, late fifteenth century.

9 Halberstadt, Cathedral Treasury (Inv. Nr. 69). Presumably entered the Treasury prior to the thirteenth century. H. 8.9 cm (3.5 in.). A cross-hatched band with an abstract symmetrical pattern consisting of an ellipse over a crescent shape within a reversed arch, repeated four times. Converted to a reliquary, the ring foot notched in four places to receive the mounts. Silver-gilt mounts consisting of a hexagonal foot, knopped stem and a hexagonal cover rising to a point, each facet faced with a crocketed triangular pediment with openwork tracery. Central European, fourteenth century.

10 Namur, Convent of the Sisters of Our Lady. Treasury of the Monastery at Oignies, probably since the first third of the thirteenth century, transferred to Namur after the secularizations. H. 9 cm (3.5 in.) beaker. Cross-hatched band with pattern consisting of an ellipse over an abstract crescent or palmette pattern repeated symmetrically four times. Converted to a reliquary or ostensory. Copper-gilt mounts, Lowlands, first third of the thirteenth century. Attributed to Hugo d'Oignies and lay brothers. Like 3 above, said to have been given to Oignies by Jacques de Vitry (1170–1240).

11 Asseburg-Falkenstein. By tradition, since at least the thirteenth century, in the family of the counts of Asseburg, Meisdorf, and Falkenstein. First documented in 1831. Thought to have been lost in 1944–45. H. 10.3 cm (4 in.). Abstract vegetal pattern of alternating cordate forms within a continual series of arcaded bands engraved with parallel lines and cross-hatching.

12 Coburg, Kunstsammulungen der Veste Coburg. (Inv. Nr. S. 652). Said to have belonged to Saint Elizabeth, Landgräfin von Thüringia († 1231); apparently in the treasury of the Franciscan friary at Eisenach in 1331; recorded in the possession of the House of Wettin in Thüringia, 1469–82 where it was considered a relic of St Elizabeth; illustrated in a sketch by the Cranach workshop without mounts in 1507; recorded in the treasury of the Kurfürst Friedrich the Wise of Saxony in the sixteenth century; Johann Mathesius (1504–65), evangelical priest at Joachimstal in the Ezrgebirge records the glass in the possession of Martin Luther in 1541; rediscovered at Veste Coburg and recognized as a Hedwig glass by Alexander Schnütgen in 1912. H. 10.3 cm (4 in.). Segmented band with cross-hatching separated by eight protruding hobs below which are four symmetrical placed palmettes interspersed with chevrons of parallel engraved lines. Below and alternating with the palmettes are four volute

patterns over a row of cross-hatched triangles. Ring foot notched in eight places to receive mounts.

13 Nysa, Museum. Early history unknown. Remnants of mounts dated 1578 at base of glass; glass broken in the eighteenth century and remounted as a chalice. H. 10.6 cm (4.2 in.). A cross-hatched band interrupted by four ellipses below which are four symmetrical placed volute palmettes. Ring foot notched in four places to receive mounts.

Material Meaning: Stained Glass and the Questions of Authenticity, Reception, Workshop Practice, and Aesthetics

Virginia Chieffo Raguin

Step into the modern museum in Worcester, Massachusetts, its carefully appointed galleries categorizing art according to geography and chronology—Asia, Ancient Rome, American Paintings—and before the staircase leading to the Renaissance, turn left to enter the medieval gallery. There, glowing (literally) on the wall and writhing in exquisite slow motion are two nude half-length figures. *Union* (fig. 4.1) by Bill Viola is a diptych of two vertical 42-inch flat panel monitors showing a nude man and woman struggling to reach upward. The agonizing process plays in slow motion over eight minutes. Placed by innovative curatorial strategy in the medieval galleries of the Worcester Art Museum, *Union* evokes late medieval panel painting of the era of Dirick Bouts with its meticulous detail, satin finish, and crisp contour, and at the same time, the abstracted and frequently truncated suffering bodies that are already displayed in these rooms.[1]

Technology is the basis for Viola's 'Passions' series, to which *Union* belongs. For the series, first exhibited at the Getty Museum of Art in 2003, Viola turned to plasma screen imagery, a move that brought him into creative contact with the late medieval art he had long admired:

I'll never forget when, in 1998, an engineer friend brought one of the first of these new generation LCD flat panels into my studio for us to evaluate. When we turned it on, I couldn't contain myself. … This is a new technology adrenaline rush that I hadn't felt for years. The image has a soft, satin-like quality because there was no glass in front of the picture. It was photographic, but it also had a texture, a really unique physical appearance more like the page of a book than an electronic screen. … But the scale was the most startling. I found myself falling into the image, getting lost in its aura, and it was only sixteen inches wide! … I thought about how a small icon of the Madonna is a powerful focal point that can command the entire space of an enormous cathedral.[2]

[1] Viola describes a poignant visit to the Bouts *Annunciation* (Getty Museum 85.PA.24) 1450–55, 'with muted colors verging on monochrome except for a piercing red drapery burning like a soft visual mist.' Bill Viola, *The Passions*, ed. John Walsh (Los Angeles, 2003), 225–56, Illustration of *Passions* notebook for Tuesday, Feb. 24, 2000.

[2] Viola, *The Passions*, 203. Many of Viola's works have been set in religious spaces, for example, *The Messenger*, 1996, commissioned for Durham Cathedral by the Chaplaincy to the Arts and Recreation in North East England.

4.1 Bill Viola, *Union*, Installation at the Worcester Art Museum, Worcester, Massachusetts, 2000.

Viola's statement makes explicit the comparison to medieval works that inspired *Union*'s placement in this gallery. The luminous work makes the visitor suddenly aware of the many fragmented images, representations of corporeal pain, and also of the materials, stained glass, fresco, painted wood, and stone, chosen for the adjacent works, which were clearly juxtaposed with intention by an astute curator. Most telling is the stained glass panel from 1510–30 located on the opposite wall that commemorates Prior Peter Blommeveen (fig. 4.2), from the Monastery of Saint Barbara in Cologne.[3] The glass shows the figure in a believable three-dimensional setting and evokes the portrait likeness of Viola's piece. The body in torment appears again in a French capital where facing lions each munch a leg of a pathetically naked man who is also being seized from above by a dragon.[4] The vulnerability of these naked bodies is reiterated in the aged wood of a life-size Crucifixion group on the next wall.[5]

The nature of materials is as crucial for the genesis and the reception of medieval art as it is to the work of Viola. It is ironic that it often takes the contrast of contemporary art to make this obvious. In the debate about the future of the discipline of art history, and certainly the repudiation of a single metanarrative focusing on the progress of style, scholars have sometimes distanced themselves from the object. The meticulous attention to a work's morphology is often peripheral to the art historical text. In this essay, I will argue that many issues in contemporary art history are impossible to study

3 Worcester Art Museum, Accession #1920.105; Virginia Raguin, *Northern Renaissance Stained Glass: Continuity and Transformations*, exhb. cat., Iris and B. Gerald Cantor Gallery (Worcester; 1987), 73.

4 From a column in the nave arcade of Notre-Dame de Montermoyen, France early twelfth century, Worcester Art Museum, Accession #1941.42.

5 Spanish (Oviedo, Asturias), *The Crucifixion with the Virgin and Saint John*, late thirteenth century, Worcester Art Museum, Accession #1934.26a, b, c.

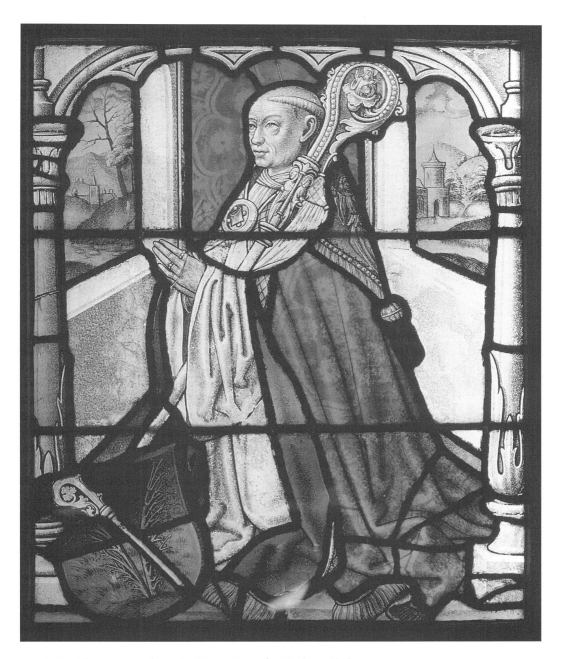

4.2 Prior Blommeveen from the Monastery of St Barbara, Cologne, ca.1510–30, stained and painted glass.

without attention to the material structure of the work of art. Physical examination reveals complex and multileveled observations vital to the analysis of many aspects of art history and material culture.

Medieval Materials

In the Middle Ages materials, as much as form, were fundamental to the meaning of a work. Medieval aesthetic ascribed value according to three criteria that are inherent in Abbot Suger's frequently quoted writings on Saint-Denis. An object was worthy if it were constructed of important materials, displayed skilled workmanship, and was destined for an important function. In assessing art in this way, Suger validated his transformation of a splendid late-Antique porphyry vase into an eagle-shaped pitcher. Since it now serves the liturgy, 'This stone deserves to be enclosed in gems and gold. It was marble, but in these (settings) it is more precious than marble.'[6]

Relics, too, were enshrined in the most lavishly built objects, justified by reference to Scripture. Durandus, bishop of Mende from 1285 to 1296, was one of many medieval commentators who cited passages such as Exodus (35.4–9):

Let everyone that is willing and hath a ready heart, offer them to the Lord: gold, and silver, and brass, violet, and purple, and scarlet twice died, and fine linen, goat's hair … and oil to maintain lights and to make ointment and most sweet incense. Onyx stones, and precious stones, for the adorning of the ephod and the rational.

Accordingly, Durandus stated that God wishes the virtues of the priest to shine, along with his vestments and the ornaments of the altar.[7] Thus the medieval worshipper was committed to enshrining objects in the gleam of precious stones and vivid color, exactly the same qualities provided by stained glass.

Medieval literature also abounds with allusions to sensual delight similar to Suger's extolling of 'the loveliness of the many colored gems' that eased his cares.[8] The Pearl poet, writing in the 1380s in western England easily displays the craft of language and precision of form similar to Saint-Denis's windows and Suger's text. *Sir Gawain and the Green Knight* is visually tactile and replete with exuberant descriptions of textiles, forms, and colors, where the challenging apparition 'glemered and glent al of grene stones.'[9] The text of the *Pearl* bristles with vivid detail such as the gleam of gems or glitter of light on water. In the heavenly city Christ's presence transfigures light and 'Thurgh Hym blysned

6 Erwin Panofsky, ed. *Abbot Suger on the Abbey Church of St.-Denis and its Art Treasures,* 1946, 2nd ed., Gerda Panofsky-Soergel, (Princeton, 1979), 79.

7 Guillaume Durand (ca. 1230–96), *Manuel pour comprendre la signification symbolique des cathédrales et des églises,* bk. 3, ch. 45 (Château-Gontier, 1966), 92; See also Panofsky, *Abbot Suger,* 65.

8 Panofsky, *Abbot Suger,* 63.

9 J. R. R. Tolkien and E. V. Gordon, eds, *Sir Gawain and the Green Knight,* fol. 93, (Electronic Text Center, University of Virginia Library, 1993), 6.

the borgh al bryght.'[10] The *Pearl's* structure, however, is the true gem. In alliterative verse, the poem comprises 1212 lines grouped in 101 stanzas to suggest beginning and return, using skillful repetition of first and last words within each division. For the true meaning of the story, already compelling in its superficial narration, word structure and richness of the description must be seen as reciprocal. The form and subject are inseparable.

Authenticity: Problems in the Study of Stained Glass

A specialist is often asked: Is the work of art from the twelfth or the nineteenth century? This question is just as essential to the study of monumental sculpture, liturgical objects, and architecture as it is to stained glass. Clearly the establishment of the authoritative text is fundamental, whatever one's field. The Corpus Vitrearum, established in 1953 and now under the authority of the Union Académique International, has grouped scholars dedicated to the study of the material of glass to include its aesthetic impact, its composition, history of manufacture, and conservation.[11] Founded with the purpose of establishing an 'authentic text,' akin to the editing of a manuscript, these scholars furnish future viewers with a firm basis for interpretation. Since a window comprises segments of glass linked by a lead matrix, each section can be any one of the following, and gradations in between: historically authentic; of historic materials but compromised by repainting or by the deliberate erasure of original paint with the superposition of modern; or modern restoration using new materials. In the analysis of authenticity and the production of a diagram of levels of intervention (fig. 4.3), all aspects of the object, including paint, glass, and lead, are examined visually and tactilely from both sides to reveal paint and lead as well as glass in raking and transverse light, frequently using laboratory tools such as microscope and spectrometer.

These techniques are needed because stained glass is resistant to expertise. A single panel may exhibit a wide variety of problems of authenticity. A segment may have been entirely replaced by a credible modern copy since the transparency of the material allowed restorers to place cracked or effaced pieces on a light board and to model new portions by tracing the lines of the original piece. This creates a situation where the copy may be so close to the original that only a meticulous analysis of the glass's texture, the nature of the way the segment was cut, and its paint application and color may help identify the replacement. Other interpolations may be well designed infills for missing sections replaced during a series of historic restorations. In addition, works may recombine segments of two or more similar windows to achieve a very credible appearance of a whole.

[10] *Pearl*, line 1048, ed. Sarah Stanbury (Kalamazoo, Mich., 2001), 63.

[11] See Madeline H. Caviness, *Stained Glass Windows*; Typologie des Sources du Moyen Age Occidental (Turnhout, 1996), esp. 30–38 and 67–69, in which the Corpus Vitrearum's work and the broad subject of the study of stained glass is summarized.

4.3 Deacon Saint, Toledo Museum of Art (TMA 6), restoration chart following the Corpus Vitrearum guidelines.

Analysis of a piece of glass with various levels of later intervention reveals dimensions of art historical relevance. The reasons why different segments were combined may have varied from one era to another. Frequently, such a piece was created because of the importance of possessing an ancient object in apparently unscathed condition. The result reveals much about a culture's priorities, as seen in the reception of a panel of stained glass since its creation, whether in situ or in collection.

Reception: Taste, Revivals, and Fakes

If the panel is a product of another time, what motivated the makers to follow a specific historic style *so* closely that the work could be confused with its inspiration? All 'imitations' are not fakes. Like period objects, such as A. W. N. Pugin's Gothic-inspired buildings and metalwork, they emulate, while still achieving a sense of independence.[12] Stained-glass researchers of museum collections have discovered historicizing panels that were mistaken for medieval objects. These works were not intended to deceive, and have their own authenticity as Revival styles; they need to be evaluated as part of the appropriate historical era.

Medieval Revival styles from the early nineteenth century through the 1930s have been studied within their political and social contexts; the Celtic Revival, for example, supported in the United States as well as Ireland, was deeply connected to Ireland's effort at independence.[13] Revival movements, however, have been less understood, for their ability to influence styles of collecting.[14] As Madeline Caviness has demonstrated, admiration for a prevailing modern style, such as Post Impressionism, could condition the reception of art of the past and vice versa.[15] William Valentiner, director of the Detroit Institute of Arts from 1924 to 1945, for example, acquired stained glass that exemplified the bold, expressive painting style of southern German and upper Rhenish schools of the fifteenth century. This bias paralleled his deep commitment to German Expressionism of the early twentieth century.[16] Valentiner's championing of the commonalties of style across time formed a vigorous response to the denigration of modern art and the purging of modernist artists from German schools and museums by the National Socialist regime in Germany.

[12] Paul Atterbury and Clive Wainwright, eds, *Pugin: A Gothic Passion* (New Haven, 1994).

[13] T. R. Edelstein, ed., *Imagining and Irish Past: The Celtic Revival 1840–1940*, exhb. cat., David and Alfred Smart Museum of Art (Chicago, 1992).

[14] A notable exception is Bradford Smith, et al., *Medieval Art in America: Patterns of Collecting 1800–1940*, exhb. cat., Palmer Museum of Art, The Pennsylvania State University (University Park, Penn., 1996).

[15] Madeline Caviness, 'Broadening the Definitions of "Art": The Reception of Medieval Works in the Context of Post Impressionist Movements,' in *Hermeneutics and Medieval Culture,'* eds Patrick J. Galcher and Helen Damico (Albany, N.Y., 1989), 259–82.

[16] Virginia C. Raguin, 'Three German Saints and a Taste for German Expressionism at the Detroit Institute of Arts,' *Gesta* 37 (1998): 244–50.

Like Valentiner's choices, the Gothic revivals of the mid-nineteenth and early twentieth centuries in the United States were deeply connected to both idealism and spiritual expression.[17] The Gothic Revival of the early 1900s, in particular, exerted a profound influence on collectors' tastes; French High Gothic stained glass became the most prized element in museum collections and comprised the canon of university instruction in medieval art.[18] Henry Adams published his own search for spiritual values in the influential *Mont-Saint-Michel and Chartres*, with phrases such as 'no architecture that ever grew upon earth, except the Gothic, gave this effect of flinging its passion against the sky.'[19] In 1906 he advised Isabella Stewart Gardner to purchase a Gothic stained-glass window he believed to be from Saint-Denis. The panel has been subsequently identified as originating from Soissons Cathedral, dated before 1202 or shortly after 1205.[20] This acquisition represented a change of taste since Gardner had earlier favored more representational works such as the fifteenth-century panels from the cathedral of Milan that she acquired in 1875.[21] The Milan panels demonstrate typical late medieval conventions of three-dimensional modeling and incipient perspective. Gardner's appreciation for later medieval glass painting was undoubtedly linked to her experience of similar conventions in windows installed in the 1880s by the London firm of Clayton & Bell in the Church of the Advent, Boston, where she was a prominent patron.[22]

An interest in Gothic also supported the commerce of detached works, and invariably the production of modern works presented as old—the deliberate fake. Instructive in this context is a so-called 'medieval' panel bequeathed by William Randolph Hearst to the Los Angeles County Museum of Art. In 1945 the Museum published an assessment of Hearst's bequests, according pride of

[17] Phoebe Stanton, *The Gothic Revival & American Church Architecture. An Episode of Taste 1940–1856* (Baltimore, 1968; reprint 1997); Ethan Anthony, *The Architecture of Ralph Adams Cram and His Office* (New York, 2007); Atterbury and Wainwright, *Pugin*.

[18] See Madeline H. Caviness and Jane Hayward, 'Introduction,' in *Stained Glass before 1700 in American Collections: Midwestern and Western States* (Corpus Vitrearum Checklist III), *Studies in the History of Art*, 28 (Washington D.C., 1989), 13–14; Virginia Raguin, 'Antiquarianism, Publication, and Revival: Stained Glass in the Nineteenth Century,' in *Sacred Spaces: Building and Remembering Sites of Worship in the Nineteenth Century*, ed. Virginia Raguin and Mary Ann Powers, (Worcester, 2002), 27–46. Indeed, even twenty years ago, the selection of Louis Grodecki and Catherine Brisac's *Le Vitrail gothique* (Fribourg, 1984) for English translation as Louis Grodecki and Catherine Brisac, *Gothic Stained Glass, 1200–1300*, trans. Barbara Boehme (Ithaca, N.Y., 1985) and the absence of any general overview of fourteenth- through sixteenth-century glazing practices attests to the still powerful identification of the art of stained glass with this narrow historical period. Virginia Raguin, *Stained Glass from its Origins to the Present* (New York, 2003), makes an effort to redress this imbalance.

[19] Henry Adams, *Mont-Saint-Michel and Chartres* (1905: reprinted Princeton, 1981), 34.

[20] Installed in the chapel of the museum: Madeline H. Caviness, Elizabeth Pastan, and Marilyn M. Beaven, 'The Gothic Window from Soissons: A Reconsideration,' *Fenway Court* (1983): 6–25.

[21] Caterina Pirina, 'Stained Glass from Milan Cathedral in the Isabella Stewart Gardner Museum,' *Fenway Court* (1983): 26–37.

[22] Mark A. Wuonola, *Church of the Advent, Boston: A Guidebook* (Boston, 1975), 17–20, 38, and 45. Clayton & Bell, London, appear to have been favored by the architect John H. Sturgis, who designed the Church of the Advent in a High Victorian Gothic mode.

place, and cover illustration, to the modern panel showing *Christ before a Seated Monarch* (fig. 4.4). The description is replete with period bias about 'true' stained glass linked to the early period of the twelfth or thirteenth centuries, a narrative built on an erroneous assessment of its technical limitations, especially the size of glass sheets:

This medallion is of French workmanship and dates from the thirteenth century, the greatest period of stained glass manufacture. In it can be seen the stiff, formal, and hieratic composition, the jeweled patterns, and exuberance of color characteristic of thirteenth-century glass. ... The metallic ores used by the medieval craftsman to color the glass were crude and impure but nonetheless produced amazing varieties of color. The glass, although capable of being made only in small pieces, none larger than the palm of a man's hand [sic] gives by this very fact a jewel-like quality to the windows. ... By the sixteenth century, when glass could be made in large sheets, ... the mosaic technique of the medieval windows was entirely supplanted and the true art of stained glass became extinct.[23]

In retrospect, the fake is an obvious one. It is useful, however, to ask how the now illogical folds, awkward composition, and disjunctive color harmonies could have been accepted as authentic. The counterfeit is a glass scholar's ever-present challenge, and yet it may also be one of the most valuable learning tools. Max J. Friedländer characterized the appeal of the fake in a graceful admission in *Genuine and Counterfeit*:

No matter how successfully the art scholar may have labored to enter into the manner of the past, no matter how sincere and deep his love for the old masters, the gulf of time can never be entirely bridged ... The forgery, a contemptible thing when once seen through, possesses before its disclosure a double charm; it is supposedly the work of a great and famous old master, and it is also the product of a contemporary, whose taste is akin to our own.[24]

Hearst's panel has many of the qualities that we expect to see in an old work of art which have been articulated in precisely the language that we have used to characterize the coveted past. In short, the panel looks a great deal like many Gothic Revival windows that dominated stained glass production in the United States before the 1950s. An example of this acknowledged revival style (fig. 4.5) was designed by Charles J. Connick, whose Boston studio was one of the most prolific of this era. Connick was also an author and his publications were well known in curatorial circles.[25] Connick's window in 'the style and colors of the vitraux of The Sainte-Chapelle' was ordered in 1930 at the bequest of Gertrude Hill Gavin for a fifteenth-century French chapel that Gavin had acquired in 1926.[26]

[23] *Los Angeles County Museum Quarterly*, 4/3 & 4 (Fall and Winter, 1945): 3. The panel is noted in the inventory of Hearst donations, No. 241: acquired from the dealership A. Seligmann, Rey & Co., Nov. 28, 1933. I am grateful to Marilyn Beaven for this information.

[24] Max J. Friedländer, *Genuine and Counterfeit* (New York, 1930) (Originally *Echt und Unecht* [Berlin, 1929], 51.

[25] See Charles J. Connick, *Adventures in Light and Color* (New York, 1937).

[26] The chapel was originally at Chasse, near Lyon. It was installed at Gavin's estate in Wheatley Hills, Long Island, N.Y. Mr and Mrs Marc Rotjman bought the property in 1962 and donated the chapel to Marquette in 1964. I thank Annemarie Sawkins for this information.

QUARTERLY

LOS ANGELES COUNTY MUSEUM

Published by the MUSEUM ASSOCIATION of the LOS ANGELES COUNTY MUSEUM

FALL AND WINTER, 1945 VOL. 4, NOS. 3, 4

Christ and a monarch in conversation. Stained glass panel, 25x21 inches. French, 13th century.
William Randolph Hearst Collection

4.4 Cover of the *Los Angeles County Museum Quarterly* 4: nos 3, 4 (1945), illustrating stained glass panel of Christ and a Monarch in Conversation, early twentieth century? Lost; formerly Los Angeles County Museum of Art, William Randolph Hearst Collection.

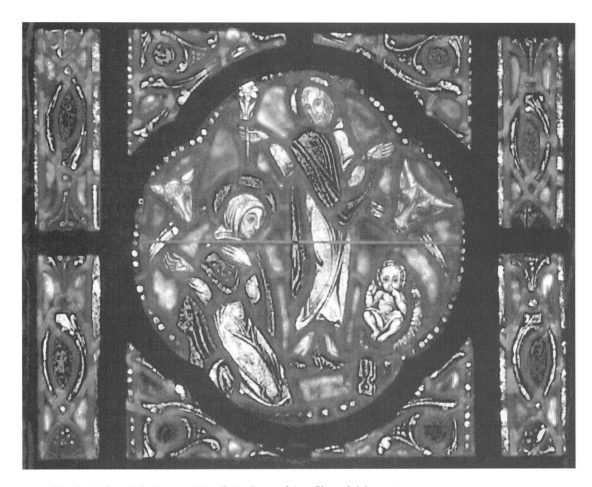

4.5 Charles J. Connick, *Resurrection*, Saint Joan of Arc Chapel, Marquette
University, Milwaukee, Wisconsin, 1930.

Workshop Practice: Techniques, materials, and division of labor

Can we read evidence in the structure and materials of a work of art that allows
us to understand its production? How might the marks of the brush, choice of
glass, or reuse of designs reveal artistic communication and shared under-
standing among both the producer and the patron? Just as the authenticity of
the object necessitates physical analysis, the assessment of workshop practices
and patronage associations demands an examination of the object. The student
must also acquire an understanding of the highly complex process that
produced the window, including the nature of its materials.

Stained glass is almost always the product of several hands within a single
workshop, each of which can leave their own defining mark. During the late
Middle Ages, the designer was often located at a distance from the actual team

creating the window: in modern terms, an 'out-of-house designer.' Nuremberg's Albrecht Dürer, Hans Baldung Grien, Hans Süss von Kulmbach, H. L. Schäufelein, and Hans Sebald Beham, or Bernard van Orley and Dirick Vellert in the Low Countries, well known for their prints and paintings, also designed stained-glass windows.[27] These images or 'drawings' evolved into windows in ways that testify to the continued aesthetic attraction of the materials, even as prints became common workshop resources. The interconnectedness of works on paper, panel, and glass was demonstrated during the exhibition *Painting on Light: Drawings and Stained Glass in the Age of Dürer and Holbein*, 2000, at the J. Paul Getty Museum; the recognition of these connections yielded greater insight in the interpretation of art.[28] In addition to preliminary sketches, drawings were made after the construction of windows to serve for future commissions. Models passed from workshop to workshop as they did from painter to painter. Michel Hérold has looked to the use of reconfigured cartoons, or same size models, in Renaissance France, and Helen Zakin studied fifteenth-century Cologne workshops, as Caviness did for Saint-Remi.[29]

Attention to materials enhances understanding of artistic choice whether by patron or artist. Hans Baldung Grien worked in the Minster and in other locations in Freiburg as a panel painter and designer of stained glass. His windows of *Christ as Man of Sorrows* and the *Mater Dolorosa*, made for the Carthusian Monastery of Freiburg, are deeply moving representations of human suffering, intensified by the reciprocity of red against blue and blue against red backgrounds that speaks to the spiritual bond between the figures.[30] When such works in glass and panel are experienced in their original settings as the viewer moves through the architecture, the stained glass, with its monumental scale and penetration of color, considerably overpowers painting on panel or canvas. In Cologne's cathedral, the windows of the era actually overshadow Stephan Lochner's exquisite panel painting of the *Adoration of the Magi* unless artificial light is provided.[31]

[27] See esp. Hartmut Scholz, *Entwurf und Ausführung: Werkstattpraxis in der Nürnberger Glasmalerei der Dürerzeit*, Corpus Vitrearum Medii Aevi Deutschland Studien Series, 1 (Berlin, 1991).

[28] Barbara Butts and Lee Hendrix, *Painting on Light: Drawings and Stained Glass in the Age of Dürer and Holbein* (Los Angeles, 2000) with contributions by Hartmut Scholz, Barbara Giesicke, Mylène Ruoss, and Peter van Treek.

[29] Michel Hérold, 'Cartons et pratiques d'atelier en Champagne méridionale dans le prémier quart du XVIe siècle,' in *Mémoire de verre: Vitraux champenois de la Renaissance* (Châlons-sur-Marne, 1990), 67–73; Virginia Raguin and Helen Zakin, with contributions by Elizabeth Pastan, *Stained Glass Before 1700 In Midwest Collections, Illinois, Indiana, Michigan, Ohio*, Corpus Vitrearum United States of America, 8 (London, 2002), 1:25–26 and 2:200–7; Madeline H. Caviness, 'Tucks and Darts: Adjusting Patterns to Fit Figures in Stained Glass Windows around 1200,' in *Medieval Fabrications*, ed. Jane Burns (London, 2004), 105–19; web supplement: http://www.tufts.edu/~mcavines/glassdesign.html.

[30] Karlsruhe, Badisches Landesmuseum, C8524 and C8524; Butts and Hendrix, *Painting on Light*, 22–27 and 240–43.

[31] Often called the *Dombild*, made for the chapel of the City Council about 1445 and transferred to Cologne's Cathedral in 1809. See for the windows, Herbert Rode, *Die mittelalterlichen Glasmalereien des Kölner Domes*, Corpus Vitrearum Medii Aevi Deutschland, 4/1 (Berlin, 1974).

Workshops often avoided a top-down hierarchy of a controlling figure, allowing individual personalities to coexist. A series of five panels from the manor house of Stoke Poges (Buckinghamshire), now in the Detroit Institute of Arts date to 1510–25 and display an intriguing amalgam of styles.[32] The configuration of three-dimensional figures within a shallow niche evoke Lowlands' spatial concepts as seen in windows from the Chapel of the Holy Blood in Bruges of about 1496.[33] The long, elegant proportions of the forms seem particularly close to the art of Arnoult de Nimègue, who also worked extensively in Normandy. Close examination of the painting technique, however, also shows a Rhenish connection. Arnoult's style and that of his circle emphasize a summary description of the spatial plane, with brushed-in highlight and shadow building the form.[34] In contrast, the Stoke Poges panels show a meticulous application of modeling conceptions using stippling and hatch work, much more characteristic of Rhenish ateliers.

One of the glass painters exemplified by the *Virgin with Christ Child holding a Ball* (fig. 4.6) used granular washes in a manner similar to windows in the north nave of Cologne cathedral designed by the panel painter known as the Master of Saint-Severin.[35] The extraordinary detail reminiscent of contemporaneous engravings suggests that the Detroit panels were designed for close viewing such as that afforded by a private chapel. In contrast, the cathedral's windows show a more summary indication of feature, consistent with their considerable distance. Other panels from the Stoke Poges group, exemplified by *Virgin with Christ Child holding a Top and Spinning String* (fig. 4.7) show an alternate technique of a smooth base of mat over which the artist applies linear strokes both scratched out and painted on.

The panels are not only superbly designed and painted, but demonstrate a high level of firing skill. The vitreous paint is completely integrated with the glass surface arguably due to its even application and the controlled temperatures and length of firing time in the kiln. The glass itself is of unusually high quality, showing an attractive smooth surface, quite silken to the touch, and a high resistance to corrosion. Despite the general uniformity of surface that provides such a fine foundation for painted detail, subtle imperfections in the mouth-blown glass create additional variations for the transmission of light.

[32] Six panels auctioned by Sotheby's, London, May 16, 1929; William Randolph Hearst of Los Angeles; for sale by Gimbel Brothers, New York, through Hammer Galleries, 1941; *St. Adrian in Armor*, purchased by the Higgins Armory Museum, Worcester, Mass., 1941; Detroit Institute of Arts acquires remaining five panels, *Three Standing Figures of Saints and Two Representations of the Virgin and Child* (DIA 23–27), from the Hearst Foundation, 1958. Raguin and Zakin, *Stained Glass in Midwest Collections*, 201–10.

[33] Paul Williamson, *Medieval and Renaissance Stained Glass in the Victoria and Albert Museum* (London, 2003), 145, figs. 57–60; Yvette vanden Bemden, *Les vitraux de la première moitier du XVIe siècle conservés en Belgique: Provence du Hainaut I, La collégiale Sainte-Waudru, Mons*, CVMA Belgium vol. 5/1 (Naumur, 2000), 104–5 and 146, figs. 31, 36, and 56.

[34] Jean Lafond in Marcel Aubert et. al., *Le Vitrail français* (Paris, 1958), 215–17; Martine Callas Bey, Véronique Chaussé, Françoise Gatouillat, and Michel Hérold, *Les Vitraux de Haute-Normandie* Corpus Vitrearum France, Recensement 6 (Paris, 2001), 43–44.

[35] Windows nXXI and nXXII, 1508–9: Herbert Rode, *Die mittelalterlichen Glasmalereien des Kölner Domes*, CVMA Germany, vol. 4/1 (Berlin, 1974), 186–97.

4.6 Virgin with Christ Child holding a Ball, 1510–25, detail. Detroit Institute of Arts, Detroit, Michigan.

This examination allows us to posit the existence of highly proficient artists and designers, working reciprocally. In some ways, one might argue that delight in craftsmanship has a certain independent reward for the viewer. Painting on glass, certainly in Renaissance aesthetic, combines the ability to use color and exploit graphic techniques that had become so much a part of the growing appreciation for the art of drawing and print. The substrata has color but it is modulated through paint overlay, applied as wash and also as hatch, allowing the viewer to delight in the play of linear pattern that is far different from the blending brushwork of oil painting.

The Medium is the Message[36]

Historical texts and the inscriptions placed on works of art often refer to the nature of the material of glass, in vessel, window, or mosaic, and its abilities to transfigure light. The twelfth-century apse mosaic of Santa Maria in Trastevere, for example, boasts the inscription, 'In your honor, shining Mother, this palace

36 Marshall McLuhan, *Understanding Media: The Extensions of Man* (New York, 1964).

4.7 Virgin with Christ Child Holding a Top and Spinning String, 1510–25, detail. Detroit Institute of Arts, Detroit, Michigan.

glows with the brightness of beauty.'[37] Windows in the apse of the Franciscan church in Erfurt, Germany demonstrate an awareness of the subject matter and materials working together as a testimonial to the prodigious event of Francis's reception of the stigmata. Set in the most prestigious section of the church, above the central altar, the three apse windows typify medieval symbiosis of image, patron, and meaning. A central lancet with a Tree of Jesse showing the genealogy of Christ stemming from the Old Testament prophet Jesse was flanked by a Life of Christ on the left, and to the right a Life of Saint Francis.[38] The windows appear to have been installed as early as 1230–35, following the erection of the building. The importance of the windows has been ascribed to their artistic qualities of design and boldness, vigor, and surety of draftsmanship.

37 Dale Kinney, 'The Apse Mosaic of Santa Maria in Trastevere,' in *Reading Medieval Images*, ed. Elizabeth Sears and Thelma K. Thomas (Ann Arbor, 2002), 25.

38 Hans Wentzel, *Meisterwerke der Glasmalerei* (Berlin, 1954), 27–28, text. ill. 13a, figs. 62–66; Erhard Drachenberg, Karl-Joachim Maercker, and Christa Schmidt, *Die Mittelalterlich Glasmalerei in den Ordenkirchen und in Angermuseum zu Erfurt*, CVMA Deutschland, 15/ 1 (Berlin, 1976), 3–86; Louis Grodecki, *Le Vitrail roman* (Fribourg, 1977), 242–46, 271, figs. 205 and 206, dated the glass somewhat later, 1235–45; Virginia Raguin, 'Medieval Tropes for Spiritual Experience: Verification of St. Francis' Seraphic Vision through Erfurt's Stained Glass,' *Glas. Malerei. Forschung. International Studien zu Ehren von Rüdiger Becksmann*, ed. Hartmut Scholz, Ivo Rauch and Daniel Hess (Berlin, 2004): 77–84.

The iconography, moreover, proved to be of seminal importance, as one of the earliest images of St Francis in any medium, one which integrated the hagiographic subject into a typological program.

The text and image in the Erfurt window function as precursors of a symbolic interpretation that St Bonaventure would later bring to his account of the life of Francis.[39] The stigmatization, in particular, was an event that became highly known, indeed; the key element in Franciscan imagery. The rhymed couplets surrounding the Erfurt panels are sophisticated poetry, and, like the iconography, were probably composed for the panels themselves. The texts of the Life and other preserved Franciscan narrative do not parallel this particular Latin text.[40] In the panel of the seraphic vision, the book is inscribed 'Lord make a sign with me in good' (D(OMI)NE FAC MECU(M) SIGNV(M) IN BONO). The text could mean the 'good' book of the scriptures, or also relate to the generic 'good' of making a sign of God's good faith, or good advice. Then follows, 'He sees on the cross a distinct seraphim anointed with wounds' (PLAGIS DISTINCTUM SERAPHIN UIDET IN CRVCE UINCTVM) and 'From this (event), those signs of Christ are soon to be known' (EX HINC SVNT ISTI MOX INOITA STIGMATA XRISTI). I suggest that the inscription works on three important levels. First, it relates to Francis's reverence of the written word, in the book, in which God's will is made manifest in writing. Secondly the seraphic vision is not only depicted in an image, but in words, and, thirdly that in the future these marks—that is, the stigmata in his hands, the marks of these words, and also the mark of the image carried in the glass—will allow this singular event to become known.

In other panels in the Erfurt program, the viewer is called upon to be a witness, as around the Adoration of the Magi: 'See how powerful is the one (king) to whom they give gifts of kings' (ASPICE QVAM FORTIS QVEM REGVM DONA DECORA(N)T). Similar sophistication is found in the verses on the panel of the confirmation of the Rule by Honorius III. Around the lobe framing the hand of God appears the word LUX, beginning the text, 'A new light is formed, approved by the judgment of the Fathers. Therefore is confirmed a new law and rule of the brothers.' These verses do not identify the subject. Being too far away, they are also rendered illegible because they follow the shape of the medallion, and create an honorific pattern, a word play on the dual nature of the image in history and in glass. In the windows the viewer is commanded to see (ASPICE) the light (LUX) and admire the embellishment (DECORANT). The nature of the material underscores the meaning of the

39 St Bonaventure, *The Life of St. Francis*, trans. Ewert H. Cousins (New York, 1978); Thomas de Celano, *First and Second Lives*, ed. Marion A. Habig, O.F.M., *St. Francis of Assisi: Writings and Early Biographies. English Omnibus of the Sources of the Life of St. Francis* (Chicago, 1973), 629–787.

40 The Latin texts published in *Legendae S. Francisci Assisiensis: saeculis XIII et XIV conscriptae ad codicum fidem recensitae*, Analecta Franciscana 10 (Florence: 1926), reveal no parallels. These include Thomas of Celano, Chapter II, 69–73; Legenda Ad Usum Chori section 11, 123; Legenda Monacensis S. Francesci, cap. XXVI–XXVII, 714—15; and Bonaventura, *Legenda Major*, cap. XIII, 616–17. For help with translation of the Latin verses at Erfurt, I am grateful to Stephen M. Beall and Edward Vodoklys, S. J.

passion of Francis; the glass re-presents him and the miracle of his identification with Christ. Subsuming text into form and color, the windows show the founder present and effective, hovering in multi-hued radiance above the altar of the church.

Reflection

In this brief essay, I have tried to present an overview of the nature of visual art—it is constructed of 'something.' In contemporary works, we are more and more confronted with materials. An appreciation of Mies van de Rohe's German Pavilion at the Barcelona International Exposition of 1929 is unthinkable without the evaluation of polished onyx, brass, and reflecting water. In Walter Gropius's family home in Lincoln, Massachusetts, built in 1937, now administered by Historic New England, the use of contemporary industrial products of cast glass blocks and large plates of glass, which might easily be overlooked today for their commonality, in their time were aggressive modern statements. Ati Gropius Johansen reflected that 'plate glass brought about a sudden breakdown of the rules that had always forced a firm division between the interior and the exterior.'[41] The nature of stained glass, as well, compels our attention. It is an extraordinary material, enabling large-scale colorful images to enrich architectural space. The excitement of the graphic gesture—the bold line of a woodcut, for example, or the delicacy of engraving, is melded with the substrata of color in ways that allow the enhanced appreciation of line and hue as aesthetic issues.

As Viola was galvanized to creative exploration by the presence of new technology, so too, does the researcher communicate with maker and viewer by an empathetic understanding of the presence of the object in its corporal intensity. Material choices by the makers both facilitate and focus the communication of meaning not only in the originating period but also over time. The survival of these works also depends on the longevity of materials, and each generation's commitment to conservation by understanding the material presence of a tangible past.

41 http://www.spnea.org/NEHM/2003FallPage02.htm.

PART TWO

Documentary Reconstruction

Prior Wibert's Fountain Houses: Service and Symbolism at Christ Church, Canterbury

Peter J. Fergusson

The most celebrated architectural drawing to survive from the twelfth century is the bird's eye view of Canterbury Cathedral and its conventual buildings (fig. 5.1). Made between 1160 and 1165 and known as the Waterworks drawing, it covers a parchment bifolium and is placed at the end of the Eadwine Psalter (Trinity College Cambridge, MS R.17.1 fol. 284 v and 285 r).[1] As seen in the manuscript today, the cathedral is shown along the left side of the bifolium, meaning that west is at the top of the manuscript, and the north-facing conventual buildings are spread to the right across both pages.[2] While the

Madeline Caviness's interest in the interrelations between monumental painting on glass and architecture and the intellectual culture in which these arts flourished opened my eyes to new and richer meanings of medieval art in the mid-1960s. The questions posed by such interests were placed before me with characteristic quietness and in a characteristic setting—high on wooden scaffolding erected for her outside the south transept of Canterbury Cathedral which swayed unpredictably, much to my alarm but not hers. Adding this small note to her much larger contributions to Christ Church, acknowledges warmly her gifts as mentor and friend.

Many people helped me in the preparation of this paper. I owe particular thanks to: Glyn Coppack, Christopher Wilson, Lindy Grant, Margaret Sparks, Stuart Harrison, Lilian Armstrong, Neil Stratford, Deborah Kahn, Paul Meyvaert, Tim Tatton-Brown, Jeff West, Clark Maines, and the paper's three anonymous referees.

[1] The fullest treatment is Francis Woodman, 'The Waterworks Drawings of the Eadwine Psalter,' in *The Eadwine Psalter: Text, Image, and Monastic Culture in Twelfth Century Canterbury*, ed. Margaret T. Gibson, T. A. Heslop, and Richard William Pfaff (London, 1992), 168–85. To this may be added: Klaus Grewe, 'Der Wasserversorgunsplan des Klosters Christchurch in Canterbury (12. Jahrhundert),' in *Die Wasserversorgung im Mittelalter*, Geschichte der Wasserversorgung 4, ed. Klaus Grewe (Mainz am Rhein, 1991), 229–36; Klaus Grewe, 'Le monastère de Christchurch á Cantorbéry (Kent, Grande-Bretagne): interprétation et signification du plan du réseau hydraulique (XIIe siècle),' in *L'hydraulique monastique: milieu, réseaux, usages*, ed. Armelle Bonis and Monique Wabont (Grâne, 1996), 123–34; H-E. Paulus, H. Reidel, et al., *Wasser-Lebensquelle und Bedeutungsträger*, Regensburger Herbstsymposium sur Kunstgeschichte und Denkmalpflege 4 (Regensburg, 1999); Roberta J. Magnusson, *Water Technology in the Middle Ages: Cities, Monasteries, and Waterworks after the Roman Empire* (Baltimore, 2001); Sheila Bonde and Clark Maines, eds, *Saint-Jean-des-Vignes in Soissons: Approaches to its Architecture, Archaeology and History*, Bibliotheca Victorina, XV (Turnhout, 2004), ch. 9 'Monastic Infrastructure and Water Management.'

[2] For the drawing's early positioning in the Psalter, see Woodman, 'Waterworks Drawings,' 171, n. 17. A second, more diagrammatic representation of the waterworks appears on the

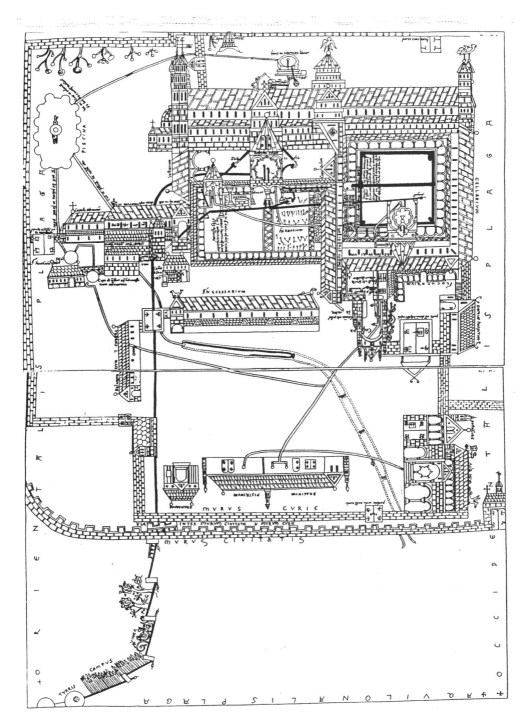

5.1 Christ Church, Canterbury, and Conventual Buildings. Tracing of the
Eadwine Psalter Waterworks drawing published by Robert Willis.

cathedral is the single largest building represented, the drawing's main focus was not this massive and venerable structure, but the conventual buildings and the water system devised to service them. The drawing includes some thirty buildings, many identified by *tituli*.[3]

There is widespread agreement that the drawing was made to illustrate the newly constructed water system devised by Christ Church's Prior Wibert (1153–67). The new system resulted from a gift of land with an abundant spring made by Archbishop Theobald (1139–61) between 1155 and 1157. Replacing the wells previously relied upon by the community, the Prior's pressure-fed, piped water system was vastly more sophisticated. It included settling tanks or cisterns, conduit houses, junction boxes, standpipes, waste pipes, and fountain houses equipped with lavers and spigots. These distributed fresh spring water to various parts of the monastery.[4] There is less agreement about why the drawing was made. Some authors argue it was commemorative; others favor a technical purpose; and others again suggest utility, such as repair. Much of the literature is concerned with hydraulic matters and stresses the engineering aspects of the Canterbury system.[5] Interesting as these are, this paper has a different focus. It is centered on the architecture of the major terminals of the waterworks. These are depicted at exaggerated scale by the artist and represented as aediculated fountain houses. Apart from their inherent interest, the fountain houses raise more general questions: What led Prior Wibert to select this type of structure? Were there models and even prototypes? What do they tell us about the patron and his intentions for them? Were the fountain houses primarily service structures, or were they conceived, as well, to be carriers of meaning?

following page, fol. 286 r. and was drawn by another hand. Woodman argues that the larger bifolium was intended to supersede this smaller drawing. See 169 and 170–71.

To illustrate this paper I have used Robert Willis' 1868 tracing of the bifolium. As a line drawing it offers much clearer images than the original where the discolored parchment, brown ink, and various colored washes reduce the range of tones. See Robert Willis, 'The Architectural History of the Conventual Buildings of the Monastery of Christ Church, Canterbury,' *Archaeologia Cantiana* 7 (1868): 1–206, facing 196. To clarify the paper's argument which centers on the architecture of the fountain houses, I have removed the indication of the inflow and outflow pipes from Figs. 5.2 a, b, c, and d.

3 Willis, *Archaeologia Cantiana*, 197–78. See also William Urry, *Canterbury under the Angevin Kings*, 2 vols, (London, 1967), 204–7, and map 2.

4 The earliest piped system in England seems to be the one constructed by Bishop Henry of Blois for his Palace in Winchester in the 1130s using technology brought from Rome; see Frank Barlow et al., *Winchester in the Early Middle Ages* (Oxford, 1976), 284. The Canterbury system is by far the best documented of a number of such systems installed in twelfth-century England and France; see Deborah Kahn, *Canterbury Cathedral and its Romanesque Sculpture* (London, 1991), 98 and nn. 12, 13, and 14. In France, Abbot Roger at Bec in Normandy installed a system contemporary with Canterbury's with interesting parallels, see Richard Howlett, ed., *Chronicles of the Reigns of Stephen, Henry II, and Richard I*, Rolls Series (London, 1884), 286; I owe this reference to Dr Lindy Grant.

5 There has been no archaeological investigation of the waterworks. A conduit house surveyed in 1982–83 turned out to be Post-Suppression and to be fed from adjacent Saint Augustine's Abbey, see Tim Tatton-Brown, 'The Precincts Water Supply,' *The Canterbury Chronicle* 77 (1983): 45–51.

All monastic establishments needed water to survive. It was essential for drinking, cooking, cleaning, the growth of flowers and crops, industrial production, and waste disposal. In piped systems, water was introduced into the monastery and its service areas by pipes set into or against the walls of buildings. Such wall-mounted arrangements are most often seen outside refectories, where the brethren washed before meals. Beginning in the 1150s a separate structure or fountain house was often provided for this function.[6] If not exactly a standard feature of a large monastic institution, a single fountain house is at least not an uncommon one, and just such a fountain house was installed at Christ Church by Prior Wibert. What is unique about Canterbury is the provision of four such fountain houses. In addition to the refectory fountain house, there were two others in the Infirmary Cloister—the Water Tower and the fountain at the entry to the Infirmary Hall—and a fourth set within the monumental staircase leading to the *Aula Nova*, adjacent to the monastery's main entrance gate (the Greencourt Gate) in the northwest corner of the precinct. Today, at a distance of eight hundred years, only the architectural shells of the Water Tower and Aula Nova fountain survive, and they are bereft of their lavers and enlivening waters.

Since two of the four fountain houses are known solely from the Eadwine Psalter drawing, it is well to ask if their depiction is reliable enough to give an impression of the lost structures. Comparison of the standing with the drawn structures helps to answer this question (figs. 5.2 b, d and 5.3). In his placement of the fountain houses in relation to other buildings, the artist emerges as a reliable recorder; the Water Tower is accurately positioned in the middle of the south alley of the Infirmary Cloister. His handling of scale produces more mixed results; the slender Water Tower is shown as the same size as the massive north transept in front of which it stands. Depth is depicted with similar results with buildings sometimes compressed or simply juxtaposed. Yet, much useful detail is included. The Water Tower is correctly shown as two-storied with the bottom story carried on arches framing a stout central column, a shorthand way of representing the existing encircling columns, arcades, and the central, clustered-columned support. For the upper story, the artist unexpectedly opens the wall to display the interior with the scallop-sided laver, although a hint of the enclosing wall comes from the three arches behind the laver. A similar liberty, accomplished by changing from an elevation to a bird's-eye view, allows us to see the central laver bowl from above (rather than in elevation) and, with greater license still, we are shown the enclosing roof with an open door under which is written *hostium cripte* (the door to the crypt). This jarring transposition suggests the artist's need to render important known features which were optically disguised behind the Water Tower.

[6] Glyn Coppack, 'Free-Standing Cloister Lavabos of the Twelfth and Thirteenth Centuries in England, their Form, Occurence, and Water Supply,' in H-E Paulus et al, *Wasser* (1999); also W. H. Godfrey, 'English Cloister Lavatories as Independent Structures,' *Archaeological Journal* 66 (1949): 919–97; Meredith Lillich, 'Cleanliness and Godliness: A Discussion of Medieval Monastic Plumbing,' 123–49 in *Mélanges à la mémoire du père Anselme Dimier*, ed. Benoît Chauvin (Arbois, 1982), 3.

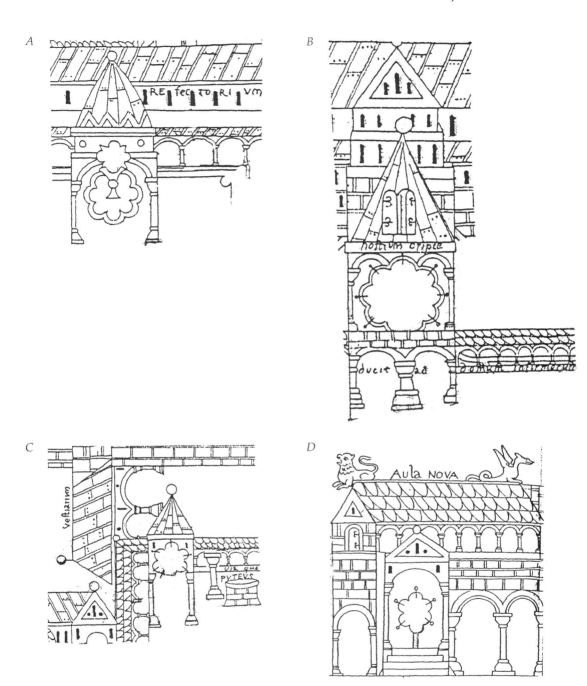

5.2 Details of fig. 5.1, without pipe runs: *A*, Refectory Entry Fountain House;
B, Water Tower; *C*, Infirmary Hall Entry Fountain House; *D*, *Aula Nova* Fountain
House.

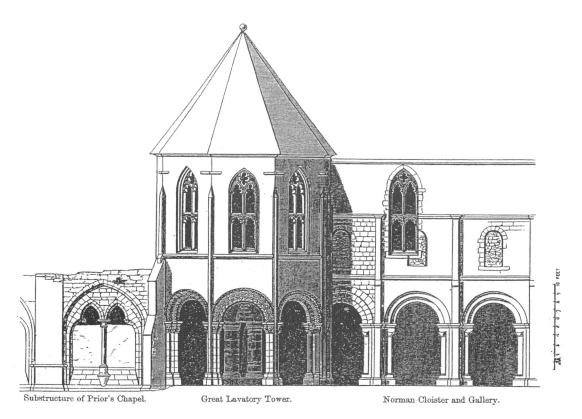

Substructure of Prior's Chapel. Great Lavatory Tower. Norman Cloister and Gallery.

5.3 Christ Church, Canterbury, Water Tower.

The drawing mixes different kinds of information. Much is trustworthy. Sometimes, we are given more information than would be possible with single-point perspective as when the artist favors interiors over exteriors. Such representational freedom is extended by a clear penchant for exaggeration. Throughout, particular prominence is given to the buildings constructed by the Prior. The artist impresses us with their novelty and importance, and, doubtless, reflects his patron's pride in the new work.

The Four Fountain Houses

(A) THE GREAT CLOISTER FOUNTAIN HOUSE

The large and elaborate fountain house in the Great Cloister was placed in the west bays of the north alley of the cloister, opposite the entry to the refectory. It was designed to provide for the washing of hands prior to the monks' entry to the building. Nothing is known of its plan. It is drawn (fig. 5.2a) as a two-dimensional aedicule. More likely, it was octagonal, a feature suggested by the

small gables at the base of the tall conical roof which indicates a complex timber frame. The lavers are shown in mixed projection, like those in the Water Tower. The larger octofoil laver supports a smaller quatrefoil laver with angular projections separating the semicircles. Neither is shown with spigots. Such two-tiered fountains in which water flowed continuously from the upper into the lower basin, survive in small number from the twelfth century, with several Cistercian examples.[7]

Further information about the laver emerged from the discovery in 1968 of sculpture immured as fill in the west wall of the cloister, only a few feet from the fountain house.[8] Attributed at first to the cathedral's choir screen mentioned by Gervase in his 1190 *Chronicle*, it is now convincingly assigned to the laver.[9] The sculptures include nine heads in roundels and seven bust-length figures in quatrefoils. Among the latter are two with crowns, plausibly Old Testament kings such as David and Solomon, with the other figures likely prophets.[10]

(B) INFIRMARY CLOISTER—WATER TOWER

The standing Water Tower (fig. 5.2b) is among the most widely illustrated examples of twelfth-century conventual architecture.[11] It was inserted into the passageway from the Great Cloister to the Infirmary which, although traditionally placed by Lanfranc, took an unusual double-storied form as the monks' day and night entry following Anselm's extension of the cathedral's east end. To dramatize the Water Tower's novelty, a strikingly different architecture was employed. Whereas Anselm's earlier passageway had used bulky supports and groin vaults, Prior Wibert's new Water Tower presented an architecture composed of delicate, richly ornamented forms with slender supports and small-scale rib vaults.

Constructed on an octagonal plan, the Water Tower rests on an outer ring of eight columns, each with an attached shaft that rises into the upper story (later

7 See Terryl Nancy Kinder, *Cistercian Europe* (Grand Rapids, 2002), 85–87 and Plate 6.

8 See Kahn, *Canterbury Cathedral*, 145–71; for additional illustrations, see George Zarnecki, Janet Holt, and Tristram Holland, eds, *English Romanesque Art 1066–1200* (London, 1984), 195–98.

9 The observation was first made by Professor Christopher Wilson based on the 135-degree angle joints of some remaining fragments (indicating an octagonal design). See Jill Franklin's review of Deborah Kahn, *Canterbury Cathedral and its Romanesque Sculpture* (London, 1991), in *Burlington Magazine* 133 (1991): 547. The stones have recently been studied by Dr Jeffrey West, who is preparing a publication on them.

10 Sculpture programs for twelfth-century fountains await elucidation. The program suggested for the Canterbury sculptures when they were thought to come from a choir screen, see Zarnecki, *English Romanesque Art*, 195, would equally apply to a fountain setting. For other twelfth-century examples, see George Zarnecki, 'A Late Romanesque Fountain from Campania,' *Minneapolis Institute of Art Bulletin*, 1973, 1–10; for the Folardusbrünnen in Trier, see Grewe, *Die Wasserversorgung*, 132; for a Cistercian example, see Roger Stalley, 'Decorating the Lavabo: Late Romanesque Sculptures from Mellifont Abbey,' *Proceedings of the Royal Irish Academy* 96 (1996): 237–64.

11 See D. Caroe, 'The Water Tower,' *Friends of Canterbury Cathedral* (January 1929): 25–37; J. Hayes, 'Prior Wibert's Waterworks,' *The Canterbury Chronicle* 71 (1977): 17–26.

concealed when applied buttresses were added to stabilize the building). The arches have a central roll-molding flanked by bands of chevron filled with simple triangles. Between the central support and the arcade, the encircling space is rib-vaulted over alternating square and triangular compartments (one for each two arch openings). The ribs have profiles worked with center rolls and flanking rectangular moldings accented with rows of billet, and their intersections boast carved keystones. To support the room above (with the laver) and to carry the piping and drain, four piers with paired attached shafts towards the aisle were close-clustered in the center of the space. Two retain their capitals with trumpet scallop leaves and an impost of palmettes bordered by beaded frames.[12]

The upper room is a spacious octagon, lit originally by six round-headed windows, three of which escaped Prior Chillenden's (1391–1411) remodeling when larger, two-light transomed windows were substituted (fig. 5.3). The original windows have chevron ornament both downward-facing and outward-facing, the latter with an unusual superimposed fret motif. A bench with inset Purbeck marble benching in each bay circled the room. Now void, the room needs to be imagined with the large scallop-edged laver with eight spigots.[13] The laver's waters are shown with strigillated patterns on their surface in the Eadwine Psalter (but omitted in Willis's line drawing), a device to accentuate the constant surface motion from the play of eight jets.

The lavish decoration applied at small scale gives the Water Tower a highly-worked, even precious quality, and needs to be considered along with its purpose. Placed where the monks turned from their dormitory passageway to enter their choir for the night office, the upper room served as a space for ritual cleansing.[14] This rite originated at Canterbury. It can be traced to Archbishop Lanfranc's Constitutions (around 1077), which specified such a cleansing prior to the monks' entry into choir.[15] The provision of expensive benching lacks explanation.[16]

[12] See Kahn, *Canterbury Cathedral*, 102.

[13] Lavers more or less contemporary with Canterbury survive at a number of sites such as the Palace of Westminster, Much Wenlock, and Durham Cathedral. See Kahn, *Canterbury Cathedral*, 103–5, 193 n. 12, and 194 n. 23.

[14] The room's ritual function was acknowledged more than two hundred years ago. Although Gostling referred to it in 1777 as a 'baptistery,' William Gostling, *A Walk in and Around the City of Canterbury* (Canterbury, 1825 reprint), 203–6, his misreading was soon corrected by Samuel Denne, 'Evidence of a Lavatory Appertaining to the Benedictine Priory of Canterbury Cathedral and Observations on Fonts,' *Archaeologia* 11 (1794): 108.

[15] See David Knowles and Christopher N. L. Brooke, eds, *The Monastic Constitutions of Lanfranc*, rev. ed. (Oxford, 2002): 20, 22, 40, and 60. Where Lanfranc's rite was carried out in the eighty years prior to the construction of the Water Tower is unknown. The practice attracted followers after ca.1150. Four further examples can be traced, all related to the upper entry of choirs: at the cathedrals of Ripon and York, and at two Cistercian houses, Rievaulx and Byland. For Rievaulx see Peter Fergusson and Stuart Harrison, *Rievaulx Abbey: Community, Architecture, Memory* (London, 1999), Fig. 133. I owe these examples to Stuart Harrison.

[16] It cannot have served for the weekly *mandatum* ceremony; this was specified for the Chapter House, see Knowles and Brooke, *The Monastic Constitutions*, 4.

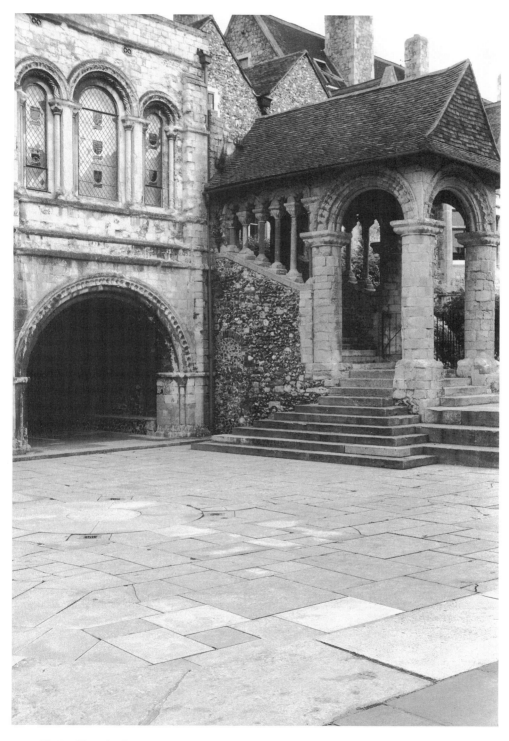

5.4 Christ Church, Canterbury, Norman Entry Staircase.

Neither the octagonal form, nor the number eight for the laver's foils for the Water Tower can have been arbitrary. The long association of this number with baptism and the regenerative associations connected with water can be assumed to have played a central role in the building's intentions.[17]

The later medieval history of the Water Tower is sketchy. The laver was replaced by Prior Goldstone in 1465, more likely to reflect fashion than because of wear or damage. It was presumed destroyed at the Suppression in 1540.[18]

(C) INFIRMARY CLOISTER—INFIRMARY FOUNTAIN HOUSE

The Infirmary Cloister contained a second fountain house. Although located only about thirty feet from the Water Tower, it differed in form and purpose. A single-story structure, it was constructed outside the entry door to the Infirmary Hall (fig. 5.2c) and probably projected westwards into the cloister. No trace survives. Information comes, therefore, solely from the Waterworks drawing. This shows a single-story, aedicular structure whose framing columns support a conical roof with a surmounting ball finial. An octagonal laver with six spigots for the water lay within.

The fountain house's placement is clearly related to the entry to the Infirmary Hall. Parallels are scarce. Traditionally, the Infirmary Hall's need for water was met by a separate structure which provided baths allowed to the sick in the Rule of St. Benedict.[19] At Canterbury this was located on the north side of the Infirmary Hall. Elsewhere, conduit houses in the vicinity of the Infirmary Hall are known at Waverley and Fountains Abbey in the early thirteenth century.[20] Neither resembles a fountain house, however, and their placement suggests a service function related as much to adjacent buildings as to the Infirmary. By contrast, the Canterbury fountain house is unambiguously connected to the entry of the massive infirmary hall.

Later generations regarded this fountain house with less respect than Prior Wibert might have hoped for. As much emerges from the time of Archbishop Winchelsey (1294–1313). Affronted by the condition of the fountain house in front of the Infirmary Hall, the archbishop enjoined the monks to keep the laver clean and not to spit or blow their noses into it.[21]

[17] See Richard Krautheimer, 'Introduction to an "Iconography of Medieval Architecture,"' in *Studies in Early Christian, Medieval and Renaissance Art*, ed. Richard Krauthaimer (New York, 1969): 115–50; Paul Underwood, 'The Fountains of Life in Manuscripts of the Gospels,' *Dumbarton Oaks Papers* 5 (1950): 41–138.

[18] See William George Searle, ed., *The Chronicle of John Stone Cambridge Antiquarian Society* 34 (1902): 95. The reference was kindly given to me by Margaret Sparks.

[19] See Justin McCann, *The Rule of St. Benedict* (London, 1952), 90–91.

[20] For Waverley, see Harold Brakspear, *Waverley Abbey. Surrey Archaeological Society* (London, 1905), 64; for Fountains, Glyn Coppack, *Fountains Abbey: The Cistercians in Northern England* (Stroud, 2003), 96.

[21] See Rose Graham, ed., *Registrum Roberti Winchelsey*, 2 vols, Canterbury and York Society (Oxford, 1952), 1:819. This reference was kindly drawn to my attention by Margaret Sparks.

Just to the west of the fountain house, the Waterworks drawing also shows a column and a well.[22] The former is identified in a *titulus*: 'Columna in quam ductu acque deficiente, potest haurire aqua de puteo et administrabitur ominibus officinis' (Standpipe into which, when the waters of the source fail, water raised from the well may be poured and it will be distributed to all the offices). The column dates, therefore, from the same time as the fountain house and is discussed further below.

(D) AULA NOVA FOUNTAIN HOUSE

The Aula Nova fountain has vanished leaving only its architectural housing. In the present this is called the Norman Entry Staircase. It projected at right angles to the Aula Nova and provided access from a separate courtyard adjacent to the monastery's Great Gatehouse. It is drawn as the smallest and simplest of the four fountain houses (fig. 5.2d) and takes the form of an aedicule raised at the top of four steps whose spandrels and pediments are pierced by windows. The last are missing and today the roof rests directly on the arches. A sexfoil laver with spigots is shown within.

The entry juxtaposes two distinct forms: the ciborium or canopy for the laver, and the stairway proper leading to the upper hall. The ciborium served, then, as a covered entry (fig. 5.4) reached by ten steps from the courtyard, and sheltering a landing for a further fourteen to the building's upper story. The landing under the ciborium is approximately six feet square, a restricted space that would have allowed sparse room for the sexfoil laver with spigots. This suggests either a laver of small-scale within the ciborium (following the drawing), or, somewhat less likely, a location in front of it.

The surviving ciborium's four supporting columns with their stout capitals and imposts are noticeably large for the slender arcades they support, even with the original superstructure (if the drawing is to be believed). A similar disconnectedness of parts marks the juncture of ciborium and staircase (particularly evident on the south side). Such qualities point to a lack of familiarity with the program on the part of the masons who were called upon to realize it. Compared to the sturdy simplicity of the ciborium, the stairway rising to the hall above is framed by a delicate, open colonnade made of semi-precious stones.

The fountain house's purpose needs to be considered in the context of the Aula's function as the prior's judicial hall and is discussed below.

[22] The well was dismantled and reassembled as the font in Saint Martin's Canterbury, Tim Tatton-Brown, 'The Font in St. Martin's Church,' in Margaret Sparks, ed., *Historical Essays in Memory of James Hobbs* (Canterbury, 1980), 19–20.

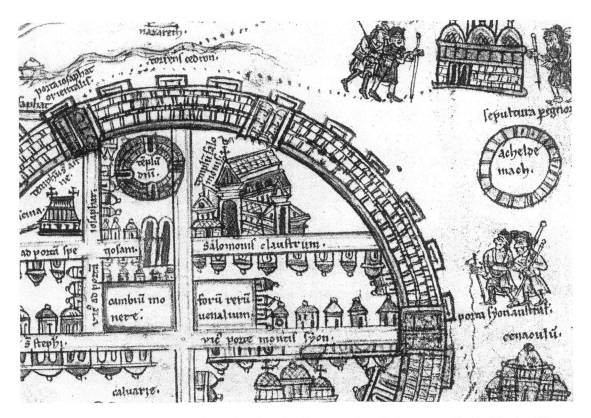

5.5 Jerusalem, city plan, detail top portion of plan, second half of the twelfth century, Royal Library of Belgium, Brussels, MS 9823–24.

Context

Prior Wibert's extensive modernization of the conventual buildings at Christ Church took place in the 1150s and 1160s. It involved the extensive reconstruction of old work as well as the introduction of new architectural types without precedent in the slow-changing traditions of monastic planning. For the latter, the Aula Nova may serve as an example. It comprised a huge nine-bay raised courtroom space and related structures and was built on land newly acquired for the purpose. The courtroom served as the Prior's Court of the Liberty of Canterbury, called the *Alta Curia*, or High Court, in contemporary documents.[23] Formerly, such functions took place in the prior's old house (and earlier still in the Chapter House). Their relocation to the newly developed Outer Court of the monastery distanced these secular contacts from the lives of the community.

[23] See Margaret Sparks, 'The *Aula Nova* Documentary Evidence,' *Canterbury Archaeological Trust Report* (forthcoming); also, Reginald Anthony Lendon Smith, *Canterbury Cathedral Priory: A Study of Monastic Administration* (Cambridge, 1943), 87–99.

Equally innovative were other buildings like the Treasury, or, as seen, the new state-of-the-art water system.[24]

In the case of the Aula Nova and the Treasury, the model for the new buildings may be traced to Biblical accounts of the Temple of Solomon in Jerusalem.[25] For patrons over many centuries, the Temple stood as the archetype ecclesiastical building raised by the archetype patron. They are described principally in 1 Kings 7, Ezekiel 40–4, and 2 Chronicles 3–7. Interest at Canterbury in Solomon's Temple predates Wibert. Anselm had used torsade or Solomonic columns for the bays reserved for the main altar in the crypt (around 1100), and similar references surface elsewhere in claustral contexts. By the mid-twelfth century, the Jerusalem archetypes had become the subject of explicit scholarly and exegetical analysis of the biblical texts, notably Richard of Saint-Victor's *In Visionem Ezechielem*.[26] Prompting such interests was the First Crusade's conquest of Jerusalem in 1099 and the subsequent building operations to restore the *loca sancta*. Among other things, rebuilding allowed the texts to be newly checked against the standing buildings.

Can the Canterbury fountain houses be seen as part of these same interests? Biblical accounts describe Solomon's Temple as flanked by different courts (like Canterbury), which were adorned by his favored sculptor, Hiram of Tyre. Among his sculptures, Hiram devised '… ten basins of bronze … each [holding] forty baths' (1 Kings, 7.13), five of which were set on the north side of the Temple and five on the south (v. 38–9). Some of these details surface in early pilgrim texts, such as the early fourth-century Bordeaux Pilgrim. He reported that 'there are in Jerusalem two large *piscinae* at the side of the Temple, that is, one upon the right hand and one upon the left, which were made by Solomon; and further in the city are *piscinae gemellares* with five porticoes which are called Bethsaida.'[27]

More specific references relevant to the four Canterbury fountain houses may be suggested. At the Aula Nova, the monumental entry ciborium and stairway recall the famous *porticum columnarum* that provided access to Solomon's judgment hall. Described in I Kings, 7.6, the *porticum* was composed of '… pillars and a canopy in front of them', and three verses later it is noted that they were made of '… costly stones.'[28] Although Ezekiel mentions no

[24] For the Treasury, see Peter Fergusson, 'Modernization and Mnemonics at Christ Church, Canterbury: the Treasury Building,' *Journal of the Society of Architectural Historians* 65:1, (2006): 2–19.

[25] For the *Aula Nova*, see Peter Fergusson, 'The Greencourt Gate at the Cathedral Monastery of Christ Church, Canterbury,' in *Das Bauwerk und die Stadt: aufsatze für Eduard Sekler*, ed. Wolfgang Böhm (Vienna, 1994): 87–97. For the Treasury, see preceding note.

[26] For Anselm's columns, see Eric C. Fernie, 'Archaeology and Iconography: Recent Developments in the Study of English Medieval Architecture,' *Architectural History* 32 (1989): 18–29. For the claustral associations, see Walter Cahn, 'Solomonic Elements in Romanesque Art,' in Walter Cahn, *Studies in Medieval Art and Interpretation* (London, 2000), 157–82; Wayne Dynes, 'The Medieval Cloister as Temple of Solomon,' *Gesta* 12 (1973): 61–67. For exegetical commentary, Walter Cahn, 'Architecture and Exegesis: Richard of St.-Victor's Ezekiel Commentary and its Illustrations,' *Art Bulletin* 76 (1994): 53–68.

[27] *Bordeaux Pilgrim, Palestine Pilgrims Text Society*, vol. 1 (London, 1894), 20.

[28] See Fergusson in Böhm, *Das Bauwerk*, 87–97.

fountain house, pilgrims' descriptions indicate some water feature. Saint Willibald reported in the eighth century that 'in front of Solomon's porch … there is the *piscina*, and there lay the infirm people waiting for the moving of the water….'[29]

Similarly, the Infirmary Hall's fountain brings to mind biblical references to healing waters. One such, in the book of Revelation, has the Evangelist describe the vision of the Lord surrounded by a multitude of witnesses who were identified as '… those who have come out of the great ordeal …' and who 'will no longer experience hunger, thirst, or heat … for the Lord … will be their shepherd, and he will guide them to the springs of the water of life, and God will wipe away every tear from their eyes' (Rev. 7.14–17). For the Middle Ages, the *fons vitae* cleansed and healed in a manner allegorized with the wounds of Christ.[30] Similarly, the famous pools of Bethsaida, close to the Temple Mount, were renowned for their healing properties.

Such references do not of course preclude other interpretations. The Infirmary Fountain House doubtless served the Infirmary Master, the cultivators of the Infirmary garden with its *herbarium*, and visitors to the sick. In addition, it dignified and graced the threshold leading to the sick and aged-infirm in the Infirmary Hall and as such emphasized the community's obligation to serve them. These purposes were secondary, however.

As seen, the architecture devised to enclose the fountain houses is dominated by aedicular forms. In the Eadwine Psalter, the artist emphasizes this particular architectural form, and, in the case of the Aula Nova, the remains attest to his accuracy (as well as to the biblical source). As a general form, the aedicule has a long history of signifying a sacred space, most notably as a canopy erected over altars.[31] The Prior's choice of this form for at least two of his fountain houses underlines their symbolic intentions. A more specific model may derive from plans of Jerusalem made in the second half of the twelfth century such as the Fulco plan (Brussels, Bibl. Royale, MS. 9823–24) (fig. 5.5). This shows the Temple of Solomon (the present al-Aqsa mosque on the Haram al Sharif or Temple Mount) fronted by a rectangular atrium labeled 'Salomonus claustrum', which is shown surrounded by small aedicular forms. It is tempting to imagine Prior Wibert with some such illustration to hand, or being prompted by other literary references.

Solomonic connotations may be paralleled by another element of the Canterbury waterworks; the standpipe in the Infirmary cloister. This backup engineering device, located between the Infirmary Fountain House and the Water Tower, took the unconventional and embellished architectural form of a column with a capital (fig. 5.2c). Again, Ezekiel mentions that Hiram's work included the construction of 'pillars of bronze' (v. 15). Such a reading of the standpipe's form may be found in exegetical texts like Bede's *De Templo*. This heavily allegorized text devotes fifteen chapters to the Temple's lavers (20.1–

29 *The Hodceporicon of Saint Willibald, Palestine Pilgrims Text Society* (London, 1891), 20.

30 See Underwood, 'The Fountains of Life,' 41–138.

31 John Newenham Summerson, *Heavenly Mansions* (London, 1949), 1–28.

20.15). In chapter 20.9 Bede explains that '… the laver was at the top of the capital to teach that the way to the heavenly kingdom had been open to us through baptism.'[32]

Many of the new buildings raised for the convent were the direct consequence of the Prior's patronage.[33] Wibert's *obits* directly credit him with the construction of the waterworks, and, therefore, of the fountain houses of which they were a part. They carry a distinctly idiosyncratic stamp. The substitution of fountain houses with their animated waters for the static wells previously used by the convent was more than a technological innovation. Fountains per se bring to mind a Mediterranean source, one adjusted to long hot seasons, rather than to the cooler climate of Canterbury. Indeed, in such conditions, playing fountains in confined spaces can be as much a source of annoyance as of adornment.

The fountains' introduction throws a light on the Prior as patron. Documents illustrate Wibert's different qualities. He emerges as resolute in business and astute in repossessing monastic property to produce income. They specify his role in the commissioning of the casting of a great bell (reputedly requiring thirty-two men to ring it) and an interest in bronze-working, recalling Hiram of Tyre. Returning to the Eadwine Psalter, it can be no coincidence that the artist depicts only the conventual buildings over which Wibert had jurisdiction and omits the adjacent buildings of the archbishop. The omission affirms and celebrates the Prior's realm, and parades his work as builder and patron.

How might Prior Wibert have come by information about models for his new buildings and fountain houses? More than a thousand years separated him from the Temple of Solomon. Aside from the plan mentioned above, archetypes like the Temple, even when ruined or destroyed, could be brought to mind through mnemonic procedures which, in the period, were standard modes of education and thought.[34] Biblical descriptions supplemented by secondary material such as commentary or the accounts of pilgrims like Willibald, furnished locational references allowing a patron like Wibert to bring to mind an archetype. St. Bernard singled out precisely this procedure for praise in the 1140s in connection with Bishop Malachy's envisioning of architectural archetypes and his copying of them.[35] Such thinking depended on the assemblage of known or imagined parts. It was explicitly selective and non-literal.

To provide a context for Prior Wibert's architectural designs, one need look no further than next door to the household or *curia* of Archbishop Theobald. During the years of his rule, concord reigned between the convent and curia, as may be inferred from one of Theobald's mid-century charters which states

[32] See Seán Connolly, trans., *Bede: On the Temple* (Liverpool, 1995), 99.

[33] The literature offers no agreement on whether the Prior or the Archbishop should receive credit for the new work. For the view, counter to this paper, that Theobald was the major influence, see Kahn, *Canterbury Cathedral*, ch. III; also Smith, *Canterbury Cathedral Priory*, 5.

[34] See Mary Carruthers, 'The Poet as Master Builder: Composition and Locational Memory in the Middle Ages,' *New Literary History* 24 (1993): 881–904; Mary Carruthers, *The Arts of Memory: A Study of Memory in Medieval Culture* (Cambridge, 1992).

[35] Conrad Rudolph, 'Building Miracles as Artistic Justification in the Early and Mid-Twelfth Century,' 399–409 in Wolfgang Kerten, ed., *Radical Art History: Internationale Anthologie: Subject, O. K. Werckmeister* (Zurich, 1997), 401.

'... it is not the community that should build for the archbishops but the archbishops for the community.'[36] Theobald's curia comprised a brilliant intellectual circle. It included philosophers, poets, theologians, lawyers; among them two future archbishops and six bishops. Two of his then clerks—Thomas Becket and John of Salisbury—stand out for their remarkably informed classical interests and antiquarian tastes.[37] The latter's ten journeys to Rome (with its many fountains), included one in 1159 to the Papal court at Saint John Lateran during the papacy of the English Pope, Hadrian IV (1154–59). Hadrian's biography, written by his contemporary, Cardinal Boso, records that he carried out extensive building works within Rome including the construction of a 'large cistern' at the Lateran palace. Such a feature may be plausibly linked to a piped and pressure-fed system, and, which may, in turn, have influenced Christ Church's.[38]

Today at Canterbury we are denied the unbroken murmur and plash of the Prior's fountains, the light-catching arcing and sparkling descent of their many jets, the beauty of their novel housings and furnishings adorned with expensive materials and rich carving. To their contemporaries, whether monks, distinguished visitors, or court petitioners, the fountain houses were much more than service mechanisms or practical amenities. Even to the uninformed they were manifest assertions of the modernization and prestige of Christ Church. Their visible display of technology and engineering, prominent positioning within the monastery, and self-referencing sounds drew attention and prompted telling comparisons for those accustomed to the community's old water arrangements dependent on static wells. At the same time, the fountain houses summoned up deeper meanings. To the discerning observer, they stood as enriching symbols, carriers of vivid association, memory-triggers of archetypes located in time and beyond time.

36 For Gervase, see Avrom Saltman, *Theobald, Archbishop of Canterbury*, (London, 1956), 258–59, ch. 30.

37 For Becket see Ursula Nilgen, 'Intellectuality and Splendor: Thomas Becket as Patron of the Arts,' in Sarah Macready and F. H. Thompson, *Art and Patronage in English Romanesque* (London, 1986), 145–58; for John of Salisbury, see Christopher N. L. Brooke, 'Adrian IV and John of Salisbury,' in *Adrian IV the English Pope 1154–1159*, ed. Brenda Bolton and Anne Duggan (Aldershot, 2003), 3–13.

38 See Bolton and Duggan, *Adrian IV*, 230–31.

Sir William Horne and His 'Scowred' Window at Snailwell, Cambridgeshire

Richard Marks

The small Cambridgeshire village of Snailwell is a beacon of calm and preservation amid the tumult of the main Newmarket-Norwich road and the spread of Newmarket itself; ironically, it is the principal business and identity of this town which has protected the rural community—quite literally by its enclosure within the white posts and rails of horse-racing establishments. The modest flint and pebble parish church of St Peter (fig. 6.1) consists of a Norman round west tower and thirteenth-century nave south aisle; the nave arcades and north aisle were reconstructed together with the chancel in the fourteenth century. Further alterations and additions took place during the fifteenth or early sixteenth centuries, when the nave clerestory was added, together with a new and handsome timber roof. Parclose screens were also erected around the east ends of both aisles, of which the north one still exists and its southern counterpart is shown on a lithograph published in 1848 of the interior of the church.[1] A bequest of barley in 1462 'to the reparation of the nave' is likely to have been connected with these alterations, although whether it pre-dated their commencement is unknown.[2]

As is so often the case in English village churches, all that remains of its medieval glazing are a few fragments, collected in the two south porch windows. These mainly comprise architectural fragments from canopies dating variously from the second half of the fourteenth and the fifteenth centuries as well as a piece of a black-letter inscription. These tiny survivals at least suggest that by the end of the Middle Ages, Snailwell church possessed some figurative windows. Evidently nothing of sufficient genealogical or heraldic interest

Author's note: As so often, I am indebted to Peter Northeast for bringing this will to my attention and providing a transcription. Thanks are also due to Katie George, the archivist of the Salters' Company, for drawing publications to my attention and for putting me in touch with Geoffrey Horne, who generously provided many details on Sir William Horne and his family.

[1] The lithograph hangs in the church.

[2] Nikolaus Pevsner, *The Buildings of England: Cambridgeshire*, 2nd ed. (Harmondsworth, 1970), 456–57; for the history of the church, see A. F. Wareham and A. P. M. Wright, eds, *A History of the County of Cambridge and the Isle of Ely*, vol. 10., *The Victoria History of the Counties of England*, (Oxford, 2002), 485–88.

6.1 Snailwell church (Cambridgeshire) from the south-east.

survived into the seventeenth and eighteenth centuries to attract the attention of local antiquaries like John Layer and William Cole.[3] However, there is compensation for this dearth in the survival of a late medieval will which is remarkably informative both about the commissioning of one window here and the concerns of its patron.

On 27 November 1494, Sir William Horne made his last will and testament in the vernacular. The section relevant to Snailwell (transcribed into modern English spelling and punctuation) reads as follows:

My executors, with £20 of my goods & more if more need & require, to do make in & for the parish church of Sneylwell in Cambridge[shire] the works following: that is to say that they do new paint well & conveniently the image of Our Lady in the S. chapel of Snelwell aforesaid & do make for her a convenient tabernacle there to be set & painted. Also that they do make & set on the south side of the same chapel a like tabernacle with an image of Saint Clement therein, both to be conveniently painted. Also that they make & cause all the glass now in the east window of the said south window [sic–chapel] to be taken down & to be scoured ['scowred'] & of

new to be set up there & whereas glass lacketh, it to be fulfilled with new glass. And in the one side of the same window to be made the images of my father & mother & his 24 children, & in the other side of the same window the image of me, my wife and our 12 children, with scripture remembering the same and with rolls of prayers running ['rennyng'] up unto an image of the Coronation of Our Lady in the same window. And the arms of me & my wife to be set in the same window in places there most convenient. Also to ordain for the altar there in the same chapel convenient altarcloths stained.[4]

For the historian of stained glass, Sir William Horne's will is of considerable interest. The reference to 'scowring,' meaning to polish or scour, is unique as far as this writer is aware.[5] In preserving the existing glazing of the east window of the nave south aisle, Sir William was not motivated by conservation concerns; instead, he showed the instincts of a prudent and cost-conscious individual by reusing an expensive commodity through erasing the old painting by means of rubbing with a substance like sand.[6] Whether the original glass was colored and figurative is uncertain, although perhaps it is more likely to have consisted of white glass. Almost as rare in English wills is the specification of the desired subject matter to be placed in the new window, reusing both the old glass and new where necessary.[7] The glazing was principally to be devoted to commemorative familial imagery, with the designated religious element confined to a representation of the Coronation of the Virgin. The window itself was rebuilt along with the entire south aisle during the 1878–79 restoration of the church, but its late medieval Perpendicular design can be discerned partly in the 1848 lithograph. It comprised three main lights with cinquefoil cusped heads, separated from the tracery lights by small cusped oculi over the outer lights and quatrefoils above the central light; the only visible details of the tracery are the two openings over the latter. At the time the lithograph was made, the window was filled with clear diamond-shaped quarries. Some idea of its design can be obtained from a church window, albeit lacking the small oculi, less than thirty miles away at Sudbury (Suffolk); like Snailwell, this is the work of East Anglian masons (fig. 6.2). The Perpendicular form suggests that the window was reconstructed as part of the renovation of the nave, which, as we have seen, may have been in progress in the 1460s. Horne indeed may have been familiar with the design, for the Coronation of the Virgin is a subject which would fit neatly into the two central tracery lights, and he envisaged their location in the upper part of the window.

4 London, Public Record Office, Prerogative Court of Canterbury Probate Records, PCC1 Horne.

5 Robert E. Lewis, ed., *Middle English Dictionary*, vol. S–SL (Ann Arbor, Mich.), 233.

6 The word 'scowred,' has been transcribed as 'stored;' whilst this is plausible, it is an unusual Middle English rendering of the word and the letter 'c' is unmistakeable (Colin Richmond, *The Paston Family in the Fifteenth Century, Endings* [Manchester, 2000], 80, n. 94.)

7 For other examples of the specification of glazing imagery by testators, see Richard Marks, 'Wills and Windows: Documentary Evidence for the Commissioning of Stained Glass Windows in Late Medieval England,' in *Glas. Malerei. Forschung. Internationale Studien zu Ehren von Rüdiger Becksmann*, ed. Harmut Scholz, Ivo Rauch, and Daniel Hess, (Berlin, 2004), 245–52.

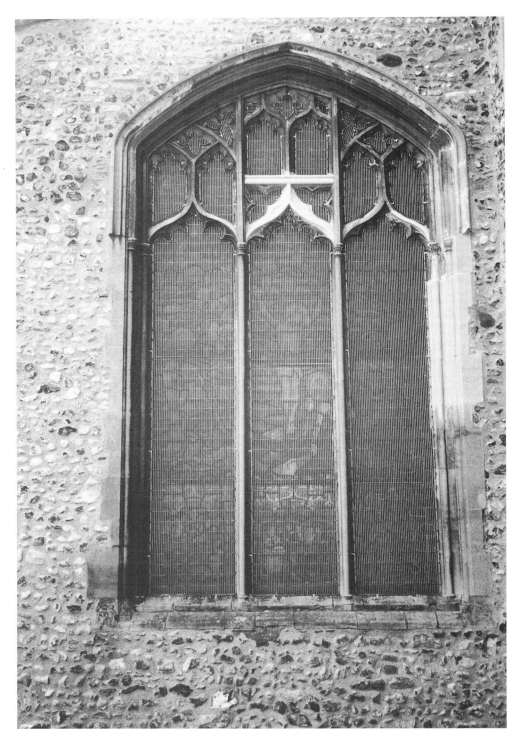

6.2 Sudbury, Suffolk, church window.

The representations respectively of his parents and his brothers and sisters, and of himself and his wife and their dozen children (elsewhere in his will they are described as five sons and seven daughters) were to occupy respectively the left and right main lights. Where the shields of arms of Horne and his wife were to be placed was left to the glass-painter to work out. Indeed, the entire design as well as the 'scowring' differs from existing examples of late medieval glazing schemes, in which religious imagery forms the principal element in the main lights and the donors are placed at the base. At Snailwell, the required familial imagery, heraldry, scrolls, and inscriptions were intended to occupy the main lights, an unusual arrangement in late medieval England, but not intrinsically problematic for the Church authorities.

The generous sum of £20 or more which Horne left to Snailwell included several bequests which memorialized him and his family in the church. As the extract from the will shows, this money was to be applied to the devotional images in the south chapel. Judging by the fourteenth-century niches flanking the chancel east window (which would have been occupied by the patronal image of St Peter and that of the Virgin) and the pair of corbels in the nave north aisle east wall and another in the north wall, Snailwell was already quite well-equipped with images by 1494.[8] Now the existing image of Our Lady which presumably stood on the north side of Horne's window at the east end of the south aisle was to be painted and a new tabernacle made and painted for it. A new companion image of St Clement within a tabernacle was to be commissioned for the south side of the window. Nor was this all. Over and above the designated expenditure of £20, the sum of five marks was assigned to the purchase of a copper-gilt cross-staff and a green altar cloth embellished with beaten gold, on which St Clement featured again together with St Andrew. In addition to the stained altar cloths for the altar below the window in this south chapel, Horne bequeathed to Snailwell his cope and another unspecified vestment of white damask embroidered with golden flowers, presumably from the private chapel in one of his residences. The purpose of these material endowments is spelt out:

… praying that the souls of my father which lieth buried in Sneylwell church & of my mother & of their children, the souls also of me, my wife & our children, for my bequests aforesaid thereto made, the more specially by the parishioners there be recommended in their prayers to almighty God.[9]

Who was Sir William Horne and what was his connection with Snailwell? He was prominent in the commercial and corporate life of the City of London. Resident in London by 1467 (and probably earlier), he was a member of the Staple of Calais from at least 1472 and of the Salters' Company from 1476–77. In 1478–79 Horne was one of the largest exporters of wool and, like other Staplers, traded in various commodities. Between 1480 and his death Sir

[8] For patronal and Marian images in chancels, see Richard Marks, *Image and Devotion in Late Medieval England* (Stroud, 2003), ch. 4.

[9] London, Public Record Office, Prerogative Court of Canterbury Probate Records, PCC1 Horne.

William served as an alderman and was Lord Mayor of London in 1486. A year later he received his knighthood from Henry VII. He died on 16 April 1496.[10] That Sir William came from a Snailwell family is confirmed by the reference to his father's grave in the parish church and explains his bequest to the maintenance of the highway between Cambridge and London. His father was named Thomas and his grandfather (also named William) possessed lands in several Cambridgeshire parishes. The Thomas Horn of Snailwell who made his will in 1440 must have predated Sir William's father, but his occurrence shows that the family was resident in the parish by the early fifteenth century. This Thomas had male and female issue, but it has not been possible to establish their precise kinship to Sir William and his father.[11]

Sir William Horne was a wealthy man and at the time he made his will he possessed very extensive assets. The will is not explicit about these, merely stipulating that an inventory of all his goods, chattels, jewels, and debts (presumably owed to him) be made by his executors after his decease, but they are evident in the scale of his bequests.[12] Sir William's legacies to Snailwell were far from being his only pious endowments; to understand the functions of the imagery in his window and his other gifts here it is necessary to locate them within his commemorative strategies as a whole. His pious legacies were extensive and accounted for half of his estate. His widow Joan (*née* Somes) was to receive the other moiety and after her death this too was to be disposed of by his executors on works of charity and the provision of masses for his and his family's souls, so he must have been predeceased by all of his dozen children (none is named in the will).[13]

Sir William's non-Snailwell bequests reflected his City of London connections and mercantile interests. As is evident in his directions for his window, the precision of his specifications and allowance for all eventualities reflect the habits of a successful man of commerce with an eye for detail. Typically, he states that the use of income from some of his property was to be safeguarded by his executors 'with such & as many clauses therein to be had as they shall

[10] Details of Horne's career are taken variously from Alfred B. Beaven, *The Aldermen of the City of London*, vol. 1 (London, 1908), 154, 175, and 233; ibid., vol. 2 (London, 1913), 16 and 166; Sylvia L. Thrupp, *The Merchant Class of Medieval London* (Chicago, 1948), 350; Alison Hanham, *The Celys and their World: An English Merchant Family of the Fifteenth Century* (Cambridge, 1985), 242, 245, and 246. The day and month of his decease are mentioned in the will of his fellow-Salter Sir Richard Chawry; see Hugh Barty-King, *The Salters' Company 1394–1994* (London, 1994), 19–20.

[11] Peter Northeast, ed., *Wills of the Archdeaconry of Sudbury 1439–1474: Wills from the Register 'Baldwyne' Part 1: 1439–1461*, Suffolk Record Society, 44 (Woodbridge, 2001), 69, no. 183. These family links give the lie to John Stow's assertion that Sir William's real name was Littlesbery which was changed to Horne by Edward IV because of his prowess as a horn-blower; Charles Lethbridge Kingsford, *A Survey of London by John Stow Reprinted from the Text of 1603* (Oxford, 1908), 246.

[12] In addition to the named properties, he may have owned a house at Cuxton on the river Medway near Rochester, known today as Whorne's Place (Richmond, *Paston Family*, 80, n. 94), although other late medieval Hornes had Kent connections.

[13] His eldest son John is mentioned in 1467 and Thomas, another son, is recorded in the same year and in 1472 and possibly in 1485–86.

seem most best & necessary for the surety & performing of my intent aforesaid.'[14]

His and his wife's bodies were to be buried in the City of London church of St Thomas the Apostle in Knightrider Street in a 'comely' marble tomb-chest with his arms, those of his wife and of the Staple of Calais and of the Salters' Company carved on the sides; these four shields were to be repeated in brass on the tomb slab, together with the images of Sir William, Joan, and their children, as well as 'scripture,' that is, inscriptions. Horne was a parishioner of St Thomas's church and the tomb was to be placed in front of the image of the Holy Trinity 'where my sitting-place is.'[15] He left the sum of £20 or more to St Thomas's church for a replacement set of four new bells. Such bequests of material objects, like those to Snailwell, ranked as 'Good Works' and helped alleviate the time spent in Purgatory. Horne, as a man of commerce, was aware that charity could be applied to the benefit of trade; in addition to his aforementioned bequest to the highway between Cambridge and London, he also left sums for other (unspecified) London roads and to the repair of London Bridge. Good Works (a term which Horne uses in his will) might also include charitable endowments, of which Horne made several relating to his position as a leading citizen of London and a prominent figure in the Salters' Company. Bequests were made to the poor in twenty-five wards; the twenty-eight most needy householders in five named parishes who were to carry the torches and wax tapers at his funeral and 'month's mind' (commemorative mass) and pray for his soul were each to receive a black gown. One of these parishes was Horne's own of St Thomas the Apostle, the seven poorest men of which were also to receive 3 shillings 4 pence at the discretion of the warden of the Salters' Company. Further bequests to the poor and dowries for poor maidens of good reputation were to be made after his widow Joan's death—also to the redemption of poor prisoners. Relief for prisoners is quite common in wills of late medieval urban elites and Horne stipulated that at Easter and on the feast of St Erasmus, those incarcerated in the prisons of Newgate, Ludgate, the Marshalsea, and the King's Bench (the last in Southwark) were to receive food to the value of £4 in total. With characteristic precision, he directed that the moneys were to be disbursed evenly, that is, 10 shillings per prison on each of the feasts. Charitable bequests to the poor and to prisoners were included in the Works of Mercy (or 'deeds of charity,' to use Horne's own words), which were represented monumentally in late medieval parish church glazing and wall-painting as exemplars of moral conduct and duty (fig. 6.3).[16]

[14] London, Public Record Office, Prerogative Court of Canterbury Probate Records, PCC1 Horne.

[15] Burial before images and/or on the site of their seats was a privilege accorded to elite parishioners (Marks, *Image and Devotion*, 173–74). Only one brass to a Salter still exists, that of Andrew Evyngar († 1533) and his wife Ellen in All Hallows-by-the-Tower church, London. For the church of Saint Thomas the Apostle (destroyed in the Great Fire), see Ben Weinreb and Christopher Hibbert, eds, *The London Encyclopaedia* (London, 1983), 76–77.

[16] Richard Marks, *Stained Glass in England during the Middle Ages* (London, 1993), 79–80.

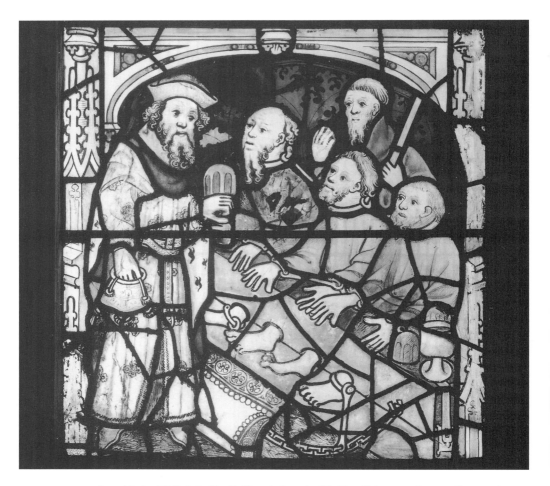

6.3 York, All Saints North Street church, Visiting Prisoners from a Corporal Works of Mercy window.

The Salters' Company features prominently in Horne's will. The four liverymen acting as pallbearers at his funeral were each to receive 1 shilling 8 pence and the wardens and seven Company almsmen were to share 4 shillings 8 pence between them for attending his annual obit on 16 April in St Thomas's church and praying for his soul. In order to maintain this obit, the cost of which also included wax for lights, bread, ale, and payments to the clergy and to the parish clerk, the inn called the 'George on the Hoop' on Bread Street was to be given to the Salters' Company. Horne also stipulated that ownership of the tenement known as the 'Red Lion' which stood in the same street along with associated properties was to pass to the Company after the death of Elizabeth, widow of George Nevill, Lord Abergavenny and of a fellow Salter, Sir Robert Bassett. The George on the Hoop, which stood to the south of Salters' Hall, was a substantial property with thirty-two pairs of bed-boards, stables, and a cellar. Horne had purchased it in 1477 in partnership with Sir Richard Chawry,

another Salter; subsequently the pair acquired a block of storehouses and drapery shops, including the Red Lion, which stood behind the George.[17]

Following the death of Horne's wife Joan, the rental income from some of these properties was to be divided between the aforementioned poor prisoners and the preacher at the popular location of Saint Paul's Cross, the latter for including prayers for Horne's soul during his sermon every Sunday; also to the priest who preached for three days during Easter week in the Church of Saint Mary Spitall for doing the same.

Sir William Horne's voice as heard through his will is that of a conventionally pious individual. The scale of his benefactions is generous, although the absence of surviving issue is likely to have increased them. The stipulation that to qualify for financial assistance, maidens had to be of unsullied reputation reveals Horne's adherence to the concept of the morally worthy. That at least some of his devotional interests were related to his livelihood is suggested by the disbursement of food to prisoners on St Erasmus's day, 2 June. Although one of the attractions of this saint's cult, which underwent a revival in late medieval England, was that those who performed an act of charity in his name were promised a comprehensive range of corporeal and spiritual boons, his attribute of a windlass (with which he was disemboweled) gave him special significance for mariners and those who depended on the sea. He was also particularly favored by those engaged in spinning and weaving and thus on both counts may well have appealed as a special helper to Horne as a member of the Staple. Likewise St Clement, to be represented at Snailwell by new images in carving and fabric, was considered to offer protective powers over sailors and voyagers and hence was of relevance to Horne's trading interests (fig. 6.4).[18]

Horne's overriding concern was to make provision for the well-being of his soul, and, secondarily, those of his kith and kin. Repeatedly, the purpose of his material commissions, endowments and payments is stated to be the saying of commemorative prayers and masses. The 'scripture' in his Snailwell window and on the tomb in Saint Thomas the Apostle's church were intended to invite prayers: 'for these bequests … I trust and heartily pray that my soul may be more tenderly remembered among the parishioners there in their prayers unto almighty God.'[19] In the inclusion of personal prayers with the sermons of the two preachers, Horne linked a collective, public act with private commemoration. The overlapping of the public and private spheres is equally apparent in his enrichment of Snailwell church. By providing new images in glass, sculpture, and fabric, Horne was both contributing to the common good and expressing veneration for favored saints in the hope of securing their

[17] Barty-King, *Salters' Company*, 19–20. For the Salters' Hall and the George on the Hoop (also the location of Saint Thomas the Apostle's church), see John Schofield, *Medieval London Houses* (New Haven, 1994), 166, Map 1.

[18] For St Erasmus's popularity in late medieval England, see Marks, *Image and Devotion*, 113–17.

[19] London, Public Record Office, Prerogative Court of Canterbury Probate Records, PCC1 Horne.

6.4 Barnwell All Saints church (Northamptonshire), St Clement.

intercession. This would have been most evident in his window, in which representations of Horne and his family were to be linked visually with the image of the Coronation of the Virgin by prayer scrolls. Horne's window and its flanking images and altar cloth would not have been a privatization of space in Snailwell church; apart from his widow, his family were all dead, so the east end of the south aisle was not their own chapel, but could function in collective worship and provide foci for individual devotion by the parishioners. Horne's bequests to Snailwell instead would have represented what Eamon Duffy has characterized as a personalization of parish church space in late medieval England.[20] In this process, the social status of the donor was made manifest. The observation that in fifteenth-century Florence it was not possible to 'worship God without worshipping man' is equally applicable to fifteenth-century England.[21] In his Snailwell window, the figures of Sir William and his wife were to be accompanied by their shields of arms and no doubt they would have been portrayed in clothing appropriate to their 'degre.' The presence of their images meant that, when the viewer prayed to the Virgin (as represented in the window or within the adjacent tabernacle), he or she was also invited to include Sir William and Lady Horne in their supplications. In making such careful provision for the well-being of his soul, Sir William revealed not only his preoccupation with selfhood and status, but also with familial identity and *locus.*

Although his parents were included in the chantry prayers to be said in St Thomas the Apostle's church, in general the Snailwell bequests are more concerned with family, ancestry and place than the London bequests. In the latter, Horne's commercial interests are to the fore, exemplified by the stipulation that his tomb should include the arms of the Staple of Calais and of the Salters' Company. In contrast, his endowment of the window and associated imagery at Snailwell is the most personalized and inclusive, reflecting his family's role in the parish community. Alone of all his bequests, the individual saintly images and representations of his deceased parents, brothers and sisters as well as himself, his wife and their dead children were specified. Wealth and the attainment of the highest civic office may have taken Sir William Horne far from his presumed birthplace, but to the last, Snailwell and his family origins mattered to him.

Sadly for Horne, there was a wide gap between aspiration and realization. Often enough, in medieval times as in any other age, the road to hell may not only be paved with good intentions, but also with the negligence and even venality of executors.[22] From the outset, trouble arose in fulfilling the terms of the will, despite Horne's stipulation that the inventory of his goods was to be drawn up quickly (by the first Michaelmas after his death) and all his efforts

[20] Eamon Duffy, 'Late Medieval Religion,' in *Gothic: Art for England 1400–1547*, ed. Richard Marks and Paul Williamson, exhb. cat., Victoria and Albert Museum (London, 2003), 60.

[21] The phrase was used by Richard C. Trexler, *Public Life in Renaissance Florence* (Ithaca, N.Y., 1980), 94; for a discussion of the social context of imagery in the English parish church, see Marks, *Image and Devotion*, 171–81.

[22] Marks, 'Wills and Windows,' 250.

to ensure that his testamentary intentions were carried out. His trust was betrayed by the overseers of his will. These were two clerics, Master Thomas Horne, BD, and John Horne of London, chaplain, presumably Sir William's kinsmen, although their precise relationship to him has not been established. Not long after Sir William's death, his old business partner Sir Richard Chawry had the two Hornes imprisoned on a charge of stealing £200 in gold and pearls and £700 in cash from the estate; also for refusing to carry out some of the bequests (unspecified). However, even incarceration of the perpetrators did not result in the swift enactment of Sir William's will. Chawry's own will of 1505 reveals that the properties behind the aforementioned George inn, which had been bought by him and Sir William, must have been amongst the denied bequests, for ownership had still not passed to the Salters' Company in accordance with his and Horne's wishes in return for charitable services for the latter's soul. Stow was therefore probably correct in stating that the proceeds from the sale of the George were never applied to their specified purposes, nor were the new bells ever cast for St Thomas the Apostle's church.[23] Were his executors equally negligent with his Snailwell bequests? Stow may have been better-informed about the London provisions of the will, but there remains the possibility that Sir William's window too was never 'scowred' and glazed with imagery commemorating his family and that of his parents. Unfortunately, there is no way of knowing if any of the fragments of Perpendicular glass reset in the Snailwell church porch came from this window. If they did, they were perhaps amongst the remnants of the 'superstitious pict[ures]' which were ordered to be destroyed by the notorious Puritan iconoclast William Dowsing when he descended on Snailwell in 1644.[24]

Indeed, despite all his extensive and costly efforts to ensure that he and his family were not forgotten, not a trace remains of any of Sir William Horne's memorials. His tomb in St Thomas the Apostle's church has vanished and his chantry provisions were swept away during Edward VI's reign, under the legislation which abolished all such institutions. Even if his window was glazed as he desired, after the Reformation no one in Snailwell would have been prompted by its inscriptions to offer prayers of intercession for the souls of Sir William and his family. All that survives is his will, which at least informs us about a highly individual glazing bequest.

23 Barty-King, *Salters' Company*, 19–20; Kingsford, *A Survey of London*, 1, 246.

24 Trevor Cooper, ed., *The Journal of William Dowsing: Iconoclasm in East Anglia during the English Civil War* (Woodbridge, 2001), 282.

Learning from Muskau: The *Throne of Solomon* Window from the Carmelite Church at Boppard and its Donation by Jakob von Sierck, Archbishop of Trier (1439–56)

Rüdiger Becksmann

Nearly two hundred years ago, the glazing of the Carmelite church at Boppard lost its architectural framework through revolution, occupation, and sale. Homeless, its various components dispersed in all directions, this important glass was, and remains, endangered. With the goal of making its historical circumstances part of our cultural memory, this essay first will assess the relocated stained glass from Boppard in order to understand the nature of the program through the extant evidence and then move back in time to the circumstances of its original commissioning.

Muskau Park

In his *Remarks on Landscape Gardening* of 1832–33, Prince Hermann von Pückler-Muskau gives insight into much more than the theoretical underpinnings of the designs he had conceived for the park at Muskau beginning in 1815. The prince, who with this publication became the father of modern landscaping, conjures up through text and illustrations such a convincing impression of his park that the reader is seduced into accepting projected plans as having already been executed, and thereby embracing the design concept as a reality.[1]

An excellent example of this phenomenon is Pückler's plan for a funerary chapel, which he intended to build, based on a design by Karl Friedrich Schinkel, on a terrace east of the Neisse River 'at pleasant and soothing distance' from the castle. The chapel was to include a series of stained-glass panels he had acquired in 1818 from the Carmelite church at Boppard.[2] But Wilhelm

Translated by Julien Chapuis and Timothy Husband.

[1] Hermann Fürst von Pückler-Muskau, *Andeutungen über Landschaftsgärtnerei verbunden mit der Beschreibung ihrer praktischen Anwendung in Muskau* (Stuttgart, 1834), cited from Günter J. Vaupel's edition with commentary (Frankfurt am Main, 1988). The prince became a celebrity almost overnight with his *Briefe eines Verstorbenen* (Letters of a Deceased), which was published anonymously in 1830.

[2] Von Pückler-Muskau, *Andeutungen über Landschaftsgärtnerei*, 225, 236–38, and pl. XXVIII. On Schinkel's project, see Gottfried Riemann and Christa Heese, *Karl Friedrich Schinkel, Architekturzeichnungen* (Berlin, 1996), 72.

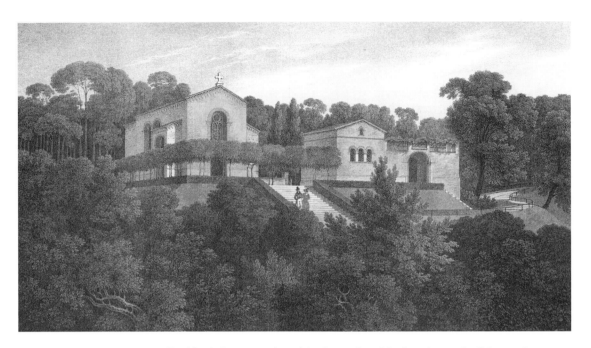

7.1 Pückler's funerary chapel in the park at Muskau (never built), ca. 1833. Lithograph after a watercolor by Wilhelm Schirmer based on a sketch by Karl Friedrich Schinkel.

Schirmer's watercolor after Schinkel's drawing, which accompanies the text as a lithograph (fig. 7.1), shows an aperture with Gothic tracery large enough to accommodate only a single window from Boppard over the entrance.[3] Further, the construction of Pückler's funerary chapel in fact never took place, since the prince sold the property of Muskau in 1845. Taking with him all the Boppard windows, he moved to his father's estate, Branitz near Cottbus, where he died in 1871.[4] The division of the Muskau property by the Oder-Neisse border in

[3] Pückler may have had the Throne of Solomon window in mind from the start, since this is the only one not consisting of two superimposed parts and of a lesser height. Behind the high altar, on which a panel with the Crucifixion by Marten van Heemskerck was intended to stand, there was apparently no room for a window, but for a 'draped portal,' which would have led to a temple with the statue of the Apollo Belvedere brightly lit from either side.

[4] Jane Hayward, 'Stained Glass Windows from the Carmelite Church at Boppard-am-Rhein. A Reconstruction of the Glazing Program of the North Nave,' *Metropolitan Museum Journal* 2 (1969): 75–114, esp. 79 and 85. Hayward's was the first thorough study of the now-dispersed Boppard windows, which brought together the surviving physical and documentary evidence. Hayward wrote mistakenly, however, that before Pückler's death one half of a Boppard window, i.e. the Throne of Solomon window, was installed in the chapel and destroyed by bombs in 1945. This information is also cited in Rüdiger Becksmann, *Deutsche Glasmalerei des Mittelalters I: Voraussetzungen, Zusammenhänge, Entwicklungen* (Berlin 1995), 174–75. Equally erroneous is the information on this subject in Alkmar Freiherr von Ledebur, *Die Kunstdenkmäler des Rhein-Hunsrück-Kreises,* vol. 2.1: *Ehemaliger Kreis St. Goar, Stadt Boppard, Die Kunstdenkmäler von Rheinland-Pfalz 8* (Munich, 1988), 140f, 339–43, and esp. 341–42. A more careful formulation is found in Hans Wentzel, 'Unbekannte mittelalterliche Glasmalereien

1945 hindered scholarship for many years, as the funerary chapel that was eventually built on the grounds suddenly stood on Polish soil.[5]

A recent study by Katrin Schulze reviews all the sources on Muskau and attempts to clarify the confusing evidence.[6] Count Traugott Hermann von Arnim acquired the park in 1883. In 1888 he commissioned from Julius Raschdorff, later architect of Berlin Cathedral, a mausoleum in the English Gothic style for his wife, who had drowned two years earlier. In the three-light east window of the mausoleum, Arnim eventually installed those parts of the *Throne of Solomon* window from Boppard that, for unknown reasons, had remained at Schloss Branitz. Pückler's heirs sold to Arnim 'for a significant sum'[7] the window that Pückler himself would have installed prominently in his intended funerary chapel, thus separating it from the other windows.[8] Katrin Schulze also proved that Arnim's Mausoleum at Muskau was only slightly damaged in World War II but afterwards was plundered and used as a quarry. Whatever was left was blown up in 1972.[9] Parts of the Throne of Solomon window may even have been removed and, thus, may have survived at an unknown location.

The Throne of Solomon Window

In the absence of other evidence, our observations on the fragments of the Throne of Solomon window once installed in Muskau are based first on a large color lithograph (fig. 7.3), which Kolb selected as the penultimate plate of his collection of stained glass assembled between 1884 and 1889, as well as on two photographs, one made in the workshop before the installation of the panels

der Burrell Collection zu Glasgow' (3 vols.), *Pantheon* 19 (1961): 240–48, esp. 244. On the history of the stained glass, see also Alexander Stollenwerk, 'Wie eine Stadt Kostbarkeiten verlor. Die Fenster der Bopparder Karmeliterkirche, ihr Verkauf und ihr Verbleib,' *Rheinische Heimatpflege* 9 (1972): 249–63.

 [5] Jane Hayward had visited Muskau in the late 1960s with the help of Edgar Lehmann, but was not allowed into the Polish section of the park. See Jane Hayward, 'Neue Funde zur Glasmalerei aus der Karmeliterkirche zu Boppard am Rhein,' *Bau- und Bildkunst im Spiegel internationaler Forschung, Festschrift zum 80. Geburtstag von Edgar Lehmann* (Berlin, 1989), 182–93, esp. 191, n. 1.

 [6] Katrin Schulze, *Das Mausoleum im Muskauer Park, Zusammenstellung und Auswertung historischer Quellen*, (commissioned by the Stiftung Fürst Pückler-Park, Bad Muskau, 2000).

 [7] On this subject, see Theodor Prüfer, 'Die Gräfliche Begräbnis-Kirche im Muskauer Park,' *Archiv für kirchliche Baukunst und Kirchenschmuck* 12 (1888): 82–87, esp. 85–86.

 [8] In any case, according to the inventories the glass had not been sent for restoration to the Royal Stained Glass Institute in Charlottenburg in 1871, and they had not been purchased in 1875 with all the other windows for the Spitzer collection in Paris. See *Catalogue des objets d'art de haute curiosité antiques, du moyen-âge et de la renaissance composant l'importante et précieuse Collection Spitzer* (Paris, 1893), vitraux Nr. 1953–61, supplément Nr. 3349–69. A comprehensive study of the activities of the Royal Institute for Stained Glass remains to be written. See Angela Nickel, 'Das Königliche Glasmalerei-Institut (1843–1905),' *Berlinische Monatsschrift* 2 (1993–99): 8–16.

 [9] Katrin Schulze, *Das Mausoleum*, 5 and 25.

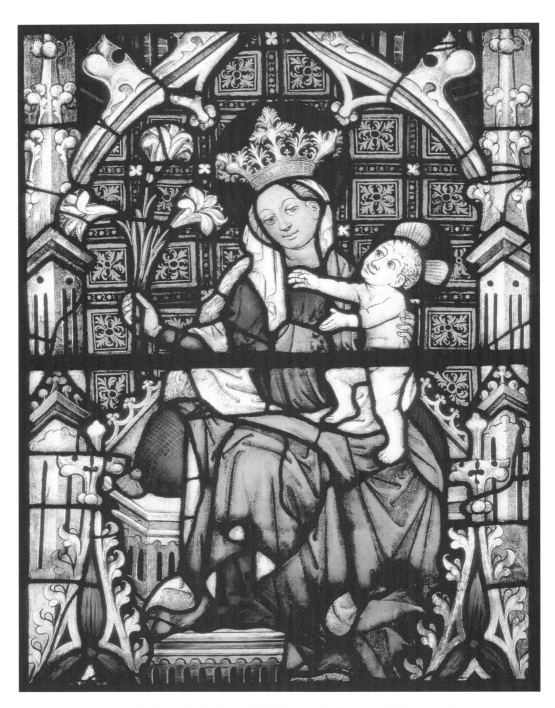

7.2 Enthroned Virgin and Child from the Throne of Solomon window (originally in the Carmelite church at Boppard, n IV, 6/7 b), Hessisches Landesmuseum Darmstadt (Inv. Kg 31:23b), Middle Rhine, ca. 1440–44.

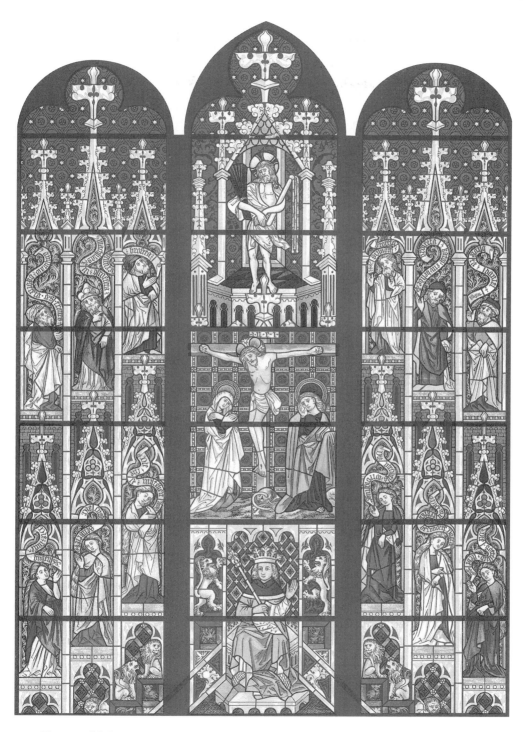

7.3 Throne of Solomon window from the Boppard Carmelite church after its installation in Arnim's funerary chapel in the park at Muskau, 1888–89.

and the other taken around 1900 in situ.[10] Fortunately, two panels representing the enthroned Virgin and Child (fig. 7.2), preserved at the Hessisches Landesmuseum in Darmstadt and first identified as belonging to this window by Hermann Schmitz,[11] convey a sense of the technical and artistic quality of the ensemble and make its loss all the more regrettable. The panels came to Darmstadt from the collection of the Grand Duke von Hessen und bei Rhein who had acquired them at an unknown date.[12] The photographs of the glass installed in 1888 in the east window of Arnim's funerary chapel indicate that it had suffered severe corrosion and paint loss, which suggests that the enthroned Virgin, in nearly pristine condition, either was not installed in Muskau or, if it was, only for a brief period.[13]

As already pointed out by Kolb and Oidtmann, the stained-glass window of the Throne of Solomon, which comprised eighteen rectangular panels and three headers—all probably lost or destroyed since 1945—was not installed according to its original Boppard composition in the Arnim chapel.[14] Their assumption that the *Crucifixion* and the *Man of Sorrows* (two registers each) in the middle light above the enthroned Solomon came from another ensemble and were added later has sent historians in the wrong direction.[15] Suzanne Beeh-Lustenberger, however, has persuasively argued that the Crucifixion belonged

[10] H. Kolb, *Glasmalereien des Mittelalters und der Renaissance. Original-Aufnahmen* (Stuttgart, n.d.), pl. 58–59. The contemporary photograph taken in the workshop, probably by Dr Franz Stoedtner, Berlin, was first reproduced in 1912: Heinrich Oidtmann, *Die rheinischen Glasmalereien vom 12. bis zum 16. Jahrhundert* (Düsseldorf, 1912), 1: pl. XIX, Fig. 400. Freiherr von Ledebur, *Kunstdenkmäler Stadt Boppard*, Fig. 69, contains a sharper photograph taken around 1900, which illustrates the situation on site: The window was apparently mounted in tracery in front of an existing narrower and taller window; see also Prüfer, 'Die Gräfliche,' 86.

[11] Hermann Schmitz, 'Einführung in die Geschichte der deutschen Glasmalerei,' in *Die Glasgemälde des königlichen Kunstgewerbemuseums in Berlin* (Berlin, 1913), I, 42, Fig. 66.

[12] Suzanne Beeh-Lustenberger, *Glasmalerei um 800–1900 im Hessischen Landesmuseum in Darmstadt*, plate volume (Frankfurt am Main, 1967), Fig. 102; text volume (Hanau, 1973), 155–57 (Nr. 216). According to a note from Heinz Merten of 1949 (on file at the Hessisches Landesmuseum Darmstadt) the enthroned Virgin never was in Muskau, but directly entered the possession of the Grand Dukes von Hessen und bei Rhein. Pückler may have exchanged the glass panels for Heemskerck's Crucifixion (see n. 2) with Grand Duke Ludwig, a passionate collector of stained glass.

[13] For decades the panels were kept in crates in Muskau and then Branitz, and stored in a barn. Hayward, 'Neue Funde,' 192, n. 40, has rightly pointed out that this must have damaged the panels.

[14] Kolb, 'Glasmalereien des Mittelalters,' caption for Fig. 58–59; Oidtmann, *Die rheinischen Glasmalereien*, 233.

[15] In her reconstruction of the Throne of Solomon window, Jane Hayward exchanged the Darmstadt Virgin for the Crucifixion and ascribed the latter scene along with the Man of Sorrows to another narrative window corresponding in format to that of the Tree of Jesse. Her arguments fail to convince as she overlooks the fact that the lower panel of the Man of Sorrows contains the crockets and finials that belonged to the framework around the Virgin and that the background of the Crucifixion corresponds to that of the Virgin in dimensions and type, if not in drawing and palette. Hayward, 'Stained Glass Windows,' 103–105, Figs. 20 and 28. For these reasons she left the Man of Sorrows in her photo reconstruction, apparently because she considered at least parts of the tabernacle architecture, in which he stands, to be original.

7.4 Throne of Solomon window from the Boppard Carmelite church.
Reconstruction.

7.5 Boppard, former Carmelite Church, north side aisle (1439–44; vaulted 1454–55), ground plan showing placement of windows and keystones.
n X, Standing figures (*G*). Gift of the Carmelite convent, Boppard or Mainz, ca. 1446.
Keystone *N 9*, Lamb with standard (emblem of the Boppard Carmelite convent?)
n IX, Jesse Tree Window (*F*). Gift of an unknown knight for himself and his wife, Boppard or Mainz, ca. 1444.
Keystone *N 8*, Arms of the Imperial City of Boppard (*Sable an Eagle displayed Or*, repainted after 1979).
n VIII: Standing figures (*E*). Gift of a municipal representative (Schultheiß? Schöffen?), Cologne, ca. 1440–44.
Keystone *N 7*, Arms Archbishop Jakob von Sierck (repainted after 1979; originally *Quarterly I & IV Argent a Cross Gules and II & III Gules on a Chevron Or three Escallops Argent*; see n.35).
n VII, Standing figures (*D*). Joint gift of Jakob von Sierck for his parents (?) and of Kuno von Pirmont for himself and his family, Boppard or Mainz, ca. 1440–44.
Keystone *N 6*, Arms of the Holy Roman Empire (originally *Or an Eagle displayed Sable*; see n.36).
n VI: Ten Commandments window (*C*). Gift of Elizabeth of Hungary for herself and her husband King Albrecht II (d. 1439), Boppard or Mainz, ca. 1440/44.
Keystone *N 5*, Enthroned Virgin and Child (emblem of the Brotherhood of Bakers?).
n V: Standing figures (*B*). Gift of the Boppard confraternities (coopers, smiths, weavers, bakers), Cologne, ca. 1440–44.
Keystone *N 4*, St. George (emblem of the Brotherhood of St. George?)
n IV, Throne of Solomon Window (*A*). Gift of Archbishop Jakob von Sierck as Patron of the Archbishopric of Trier, Boppard or Mainz, ca. 1442–44.

in this window from the beginning and was installed directly under the enthroned Solomon at the center of the two-register-high throne base.[16] Indeed, in view of the stepped, triaxial architectural structure of the lateral lights, the

[16] Beeh-Lustenberger, *Glasmalerei um 800–1900*, text volume, 157. The author did not answer the question whether the tabernacle above the Virgin comprised a Man of Sorrows from the start, because of the clear 'traces of a considerable restoration.'

7.6 Boppard, Carmelite Church, north aisle (1439–44), diagrams of the windows indicating the placement of the surviving, documented, or lost panels.

extant

dispersed

lost

Originally 282 panels excepting tracery lights; 211 panels extant, 150 in place and 61 dispersed to collections; and 71 lost with no documentation.

Abbreviations for current location

DHL Darmstadt, Hessisches
 Landesmuseum
DIA Detroit, Institute of Art
GBC Glasgow, Burrell Collection
KMS Cologne, Schnütgen Museum
NOC Newport, Ochre Court
NYC New York, The Cloisters
NYM New York, Metropolitan Museum
SFM San Francisco, The Fine Arts
 Museum

Abbreviations for former location

FL Glendale, Forest Lawn
HS Collection of A. Huber, Sihlbrugg
 bei Zürich (last documented in
 1912)
MA Muskau, Arnim burial chapel (lost
 or destroyed, 1945)
PB Parke-Bernet Galleries, New York
 (last offered for sale 1948)

**n X: Window with Standing
Figures (G)
(Donation of the Boppard
Convent)**

19 panels extant; 23 panels lost or
destroyed

1–7a	Saint in architectural canopy (lost)
1–6b	Saint Cunibert under an architectural canopy
7b	Lost
1–4c	Bishop Saint under an architectural canopy
5–7c	Architectural surmount (lost)
8a	Lost
9–14a	Archangel Michael under an architectural canopy
8b	Lost
9–11b	Lost (Assumption of the Virgin?)
12–14b	Architectural surmount with prophet
8c	Lost
9c–14c	Lost (Archangel Gabriel?)

continued overleaf

n IX: Tree of Jesse Window (F)
(Donation of an unidentified
knight/nobleman)

29 panels extant; 13 panels lost or
destroyed
(7 known from photographs)

1a+c	Lost
1b	Unidentified donor couple with armorial shield
2a–c	Sleeping Jesse
3/4a+c	Mount of Olives/Christ Appearing to Peter
3/4b	Birth of the Virgin
5–7a+c	Christ before Pilate/ Resurrection
5/7b	Annunciation
8/9a+c	Crowning with Thorns/ Entombment
8/9b	Visitation
10/11a	Carrying of the Cross
10/11b	Nativity
10/11c	Descent from the Cross
12–14a	Three Mourning Women
12–14b	Christ on the Cross (lost)
12/13c	John the Evangelist and Nicodemus
14c	Lost

n VIII: Window w. Standing
Figures (E)
(Donation of municipal officials?)

14 panels extant; 28 panels lost or
destroyed
(18 known from photographs)

1a	Two angels with armorial shield (lost)
2–7a	Saint Servatius under an architectural canopy
1b	Saint James with a pilgrim saint and armorial shield
2–7b	Saint Norbert under an architectural canopy
1c	Two angels with armorial shield
2–5c	Bishop saint in architectural canopy
6/7c	Baldacchin (lost)
8a	Figure of a saint (lost)
9–14a	Saint James the Greater under an architectural canopy
8b	Saint Agatha with donors
9–14b	Lost (Virgin in the Rose Bower?)
8c	Saints John the Baptist and James the Greater
9–14c	Saint Gerard under an architectural canopy

n VII: Window with Standing
Figures (D)
(Joint donation Sierck/Pirmont)

14 panels extant; 28 panels lost or
destroyed
(7 known through photographs; 6
documented)

1/2a–c	Panels with Donors: a bishop (Jakob von Sierck?), a knight and his wife (bishop's parents?)
3–7a–c	Lost (Death of the Virgin under an architectural canopy?)
8a	Kuno von Pirmont and his Sons
9–14a	Saint George under an architectural canopy
8b	Combined arms Pirmont/Schönberg
9–14b	Virgin as the Woman of the Apocalypse under an architectural canopy with a prophet
8c	Margarete von Schönberg and her Daughters
9–14c	Saint Quirinus under an architectural canopy

n VI: Ten Commandments Window (C)
(Donation of King Albrechts II and Elizabeth of Hungary)

all 42 panels extant

1–3a–c	Saint Elizabeth flanked by angels holding the imperial arms
4/5a	Moses receiving the Tablets of the Law
4/5b	First Commandment
4/5c	Second Commandment
6/7a	Third Commendment
6/7b	Fourth Commandment
6/7c	Fifth Commandment
8/9a	Sixth Commandment
8/9b	Seventh Commandment
8/9c	Eighth Commandment
10/11a	Ninth Commandment
12–14a	Left part of architectural surmount
10/11b	Virgin in Glory
12–14b	Middle part of architectural surmount
10/11c	Tenth Commandment
12–14a	Right part of architectural surmount

n V: Window with Standing Figures (B)
(Donation of the Boppard Guilds)

30 panels extant; 13 panels lost or destroyed
(1 known from photographs)

1a	Two angels with the arms of the coopers
2–7a	Saint Catherine under an architectural canopy
1b	Trinity
2–7b	Saint Dorothy under an architectural canopy
1c	Two angels with the arms of a guild (lost)
2–7c	Saint Barbara under an architectural canopy
8a	Saint Michael weighing souls
9–14a	Female saint under an architectural canopy (lost)
8b	Angels with the arms of three guilds
9–14b	Virgin in the Corn Robe under an architectural canopy
8c	Lost
9–12c	Female saint under an architectural canopy (lost)
13–14c	Architectural surmount

n IV: Throne of Solomon Window (A)
(Donation of Archbishop Jakob von Sierck)

3 panels extant; 27 panels lost or destroyed
(22 known from photographs)

1a	Arms of Sierck (lost; deduced from 1c)
1b	Arms of Montclair
1c	Arms of the Electorate of Trier
2/3a	Base of throne with lions (lost, reconstructed)
2/3b	Christ on the Cross
2/3c	Base of Throne with Lions (lost, reconstructed)
4–10a	Three virtues and three prophets each under gabled arcades
4/5b	Enthroned Solomon flanked by two lions
6/7b	Enthroned Virgin and Child
8–10b	Man of Sorrows under an architectural canopy
4c–10c	Three virtues and three prophets each under gabled arcades

lost base of Solomon's throne must have comprised two additional registers, to arrive at the six steps necessary to accommodate the twelve lions mentioned in 1 Kings 10:18–20, six on one side and six on the other (fig. 7.4).

As it did centuries later in Pückler's and Arnim's structures, the Throne of Solomon window would have assumed an important role in the new lateral addition to the Carmelite church at Boppard (fig. 7.5). The northern aisle was constructed between 1439 and 1444, glazed between 1440 and 1446, but not vaulted until 1454–55.[17] It comprises seven triple-lancet windows, of which all five in the north wall, as well as that above the west portal, are divided into two equal halves of six registers each (fig. 7.6). Only minor variations occur in the headers, while the upper traceries are configured with quatrefoil rosettes and ogive traceries alternating in an a-b-a rhythm. The nine-register-high east window above the altar, the only one with no tracery subdivisions, is clearly the most important. The Virgin as the Throne of Solomon, the most complex Mariological subject, received the prominent place in the east window above the altar (n IV, fig. 7.5). The correspondence of window shape and iconography allows no doubt here.[18]

In order to elucidate the Boppard program, I will first attempt to establish that the Man of Sorrows was originally part of this Throne of Solomon window. The photographs reveal that the figure of Christ and the instruments of the Passion, which comprise two panels, appear to be uniform, while the background behind the throne architecture, consisting of blue diamonds with rosettes in the centers and yellow stars at the intersections, is replaced in the upper panel by a damascened ground of disproportionately large flowers (see fig. 7.3, center lancet; n IV, 9b in fig. 7.6). In addition, deviations in the drawing of the pinnacles and the finials imply an extensive restoration. This happened neither in 1888 nor at an earlier point in the nineteenth century, since the background pattern would then have been made consistent with that of the panels above and below. Therefore, the insertion of the Man of Sorrows as well as the elimination of the enthroned Virgin cannot have resulted from the adaptation of surviving subject matter to a new function in the central window of Arnim's funerary chapel. On the contrary, the unusual form of the flower background, for which there are parallels only in the short period around 1450–60,[19] suggests that this must be a repair from this time. This probably

[17] The structure and history of the construction have been properly analyzed and described in Freiherr von Ledebur, *Kunstdenkmäler Stadt Boppard*, 331–37, plans IV, 1–3 (there is unfortunately no cross-section facing east). According to Otto Volk, 'Boppard im Mittelalter,' *Boppard. Geschichte einer Stadt am Mittelrhein I*, ed. Heinz E. Mißling (Boppard, 1997): 348–60, esp. 352, the convent signed a contract in 1454 with the Bacherach master Heinz Schmirling for the vaulting of the aisle, according to which he would receive for each completed cross-ribbed vault, in addition to his payment, a *Malter* (old dry measure, approximately 2⅓ Imperial quarters) of wheat, and for the first and the last ones a barrel of wine.

[18] Hayward, 'Stained Glass Windows,' 81 and 89.

[19] Comparanda are found in stained glass by the Walburg Master, especially in the St. Guillaume window of the Église Saint-Guillaume at Strasbourg. On the still-insufficiently researched glazing, see for the time being Françoise Gatouillat, *Les vitraux de Lorraine et d'Alsace*, Corpus Vitrearum France Recensement IV (Paris, 1994): 152, 218–20, and plate XXII. Similar

reflects damage incurred during the vaulting of the northern aisle in the years 1454–55, damage that had to be redressed immediately. We may therefore assume that the Man of Sorrows was part of this window from the start, however unlikely this might seem.

In its overall program, the Throne of Solomon window at Boppard corresponds first of all to the figural type developed around 1280–90 in the Upper Rhine region, mainly under the influence of such French models as the miniature with the Virgin as Throne of Solomon in the *Verger de Soulas* (Bibliothèque nationale de France, Paris, MS fr. 9220, fol. 2r) or the gable of the then-completed central portal of the west facade of Strasbourg Cathedral.[20] Manuscripts such as the Bonmont Psalter (around 1260) or the Gradual of St. Katharinenthal (around 1312) also offer precedents for the representation of the Crucifixion as the climax of Salvation history in the socle of the throne.[21] A similar architectural framework, spanning all the lights, as in Boppard, must once have been found in a Throne of Solomon window in the nave of Freiburg Cathedral. Donated by the owners of two silver mines and executed in 1330 or shortly thereafter, it has been associated with the painters' guild since 1540.[22] As in Boppard, the Crucifixion and the enthroned Virgin occupy two registers each. Surrounded by the seven gifts of the Holy Spirit in the shape of doves, the Virgin in Freiburg sits on the Throne of Wisdom, while Solomon and David, like the two archangels with banderoles who flank her throne, stand below the uppermost step of the throne socle, on which a lioness breathes life into her still-born young, a typological allusion to the resurrection. Compared with this radical deviation from the canonical formulation, the Boppard composition appears formally and iconographically retardataire. The architectonic framework is no more three-dimensional—with the exception of isolated, tentatively corporeal details such as the thrones of Solomon and Mary, the baldachin over the Man of Sorrows, as well as a few elements perpendicular to the picture plane—than that of examples prior to the middle of the fourteenth century.

The conservatism of the Boppard window is apparent when compared with another daring creation, the Throne of Solomon window of around 1335 in the south transept of Augsburg Cathedral, which, especially in the ordering and arrangement of the virtues and prophets, breaks new ground.[23] Formally the

patterns occur at the same time in paintings by the Master of the Darmstadt Passion; see Michael Wolfson, 'Der Meister der Darmstädter Passion,' *Kunst in Hessen und am Mittelrhein* 29 (1989): 10–30, and Figs. 1–2, which does not address this detail. Significantly, there is not a single comparable pattern in the collection of over one thousand patterns in the Württembergisches Landesmuseum in Stuttgart; see Hans Westhoff et al. *Graviert, Gemalt, Gepreßt. Spätgotische Retabelverzierungen in Schwaben*, (Stuttgart, 1996).

[20] See most recently: Rüdiger Becksmann, 'Die Bettelorden an Rhein, Main und Neckar und der höfische Stil der Pariser Kunst um 1300,' *Deutsche Glasmalerei des Mittelalters II: Bildprogramme, Auftraggeber, Werkstätten* (Berlin, 1992): 53–75, esp. 62–68, and 70–74.

[21] Hanns Swarzenski, *Die lateinischen illuminierten Handschriften des XIII. Jahrhunderts in den Ländern an Rhein, Main und Donau* (Berlin, 1936), 126–28, Fig. 540; Ellen J. Beer, *Kommentar zur Faksimile-Ausgabe des Graduale von St. Katharinenthal* (Lucerne, 1983), 163–66.

[22] Becksmann, *Deutsche Glasmalerei*, 105–7 and 131.

[23] Hans Jakob Meier, 'Das Thron-Salomis-Fenster im Augsburger Dom,' *Jahrbuch des Vereins für Augsburger Bistumsgeschichte* 23 (1989): 134–61. See, most recently, Rüdiger Becksmann,

Boppard composition follows the figural scheme of the late thirteenth century, exemplified by the miniature in the *Verger de Soulas*, so brilliantly analyzed and commented on by Francis Wormald,[24] but it takes liberties with the popular identification of the Virtues, as well as with the choice of the prophets, who are not recognizable at first sight. Indeed, the virtues are not given their traditional Latin names—Solitudo (love of solitude), Verecundia (modesty), Prudentia (prudence), Virginitas (virginity), Humilitas (humility), and Oboedientia (obedience)—but are identified in German as *Die süese miltekeit* (sweet gentleness), *Die virsihtig wurdig tug(ent)* (noble prudent virtue), *Die suese Selikeit* (sweet bliss), *Die minnekliche besunder Dugent* (exceptional virtue of love), *Die suese dugent* (sweet virtue), and *Die gottelich liebe* (divine love). Among the prophets not only Jeremiah, Moses, Malachias, Amos, and Daniel appear, but also *brofeta Cato ein heide* (the prophet Cato, a pagan), presumably Cato the Elder, the father of Roman prose.[25]

It is quite surprising that one would find in the glazing of a Carmelite church around 1440–44 a decorative program that is so particularly High Gothic in its theological content as well as in its formal appearance. It was after all a program that had completely disappeared from glazing cycles by the late fourteenth century. The last Throne of Solomon to precede the one at Boppard was probably that of around 1360–70 in a transept window of the abbey church of Arnstein an der Lahn, a rather modest composition comprising nine panels.[26]

Why a Man of Sorrows with rod and flail was included here in lieu of the more standard scene of the Seven Gifts of the Holy Spirit (in the form of doves above the Virgin's throne) is hard to explain. The figure of Christ hovering like a vision above the finials of the baldachin housing the enthroned Virgin can hardly be understood as an anticipation of the inclusion of the Man of Sorrows in the superstructure of carved retables so popular in the late fifteenth century.[27]

'Das Thron-Solomonis-Fenster im Augsburger Dom und Kaiser Ludwig der Bayer. Ein Fall von deletio memoriae?,' *Für irdischen Ruhm und himmlischen Lohn. Stifter und Auftraggeber in der mittelalterlichen Kunst*, ed. Hans-Rudolf Meier, Carola Jäggi, and Philippe Büttner (Berlin, 1995): 247–63, Figs. 94–103.

[24] Francis Wormald, 'The Throne of Solomon and St. Edward's Chair,' *De Artibus Opuscula XL. Essays in Honor of Erwin Panofsky*, ed. Millard Meiss (New York, 1961): 532–39, Figs. 175–77.

[25] In the overly ambitious theological program of Mary as Throne of Solomon on an altar retable painted in the late fourteenth century (presumably in Soest) for the convent of the Cistercian nuns in Wormeln near Warburg (Staatliche Museen zu Berlin, Gemäldegalerie), the prophets have even been replaced by pagan philosophers and sybils; Wolfgang Eckhardt, *Westfälische Malerei des 14. Jahrhunderts*, exhb. cat. Landesmuseum Münster (Münster, 1964), 77–81.

[26] Rüdiger Becksmann, *Meisterwerke mittelalterlicher Kunst aus der Sammlung des Reichsfreiherrn vom Stein*, exhb. cat. Museum für Kunst und Gewerbe Hamburg, (Hamburg, 1966), 56–60.

[27] Tilman Riemenschneider's Holy Blood Altarpiece (1499–1505) in the Jakobskirche in Rothenburg comes to mind as well as the high altar (1466) in the same church. One is hard pressed to name earlier, documented examples, and in the Middle Rhine region this type of retable does not seem to have existed; see Walter Paatz, *Süddeutsche Schnitzaltäre der Spätgotik*, Heidelberger Kunstgeschichtliche Abhandlungen n.s., 8 (Heidelberg, 1963).

Instead, the peculiar pose of the arms with crossed hands may reflect a potential original context, as it calls to mind the famous micro-mosaic icon of a half-length *Imago Pietatis* in Santa Croce in Gerusalemme in Rome.[28] The donor may have specified that a retable or a wall painting above the altar represent the Mass of St. Gregory,[29] to which the Man of Sorrows in a tabernacle above the Virgin in the window refers. Might the Carmelites at Boppard have transformed the traditional iconography of Mary as the Throne of Solomon in such an unconventional way as a means of strengthening of the true belief, thereby emulating the Carthusians in a time made increasingly insecure by pre-Reformation thinking? This would explain why, until now, neither models nor echoes have been found for this particular thematic constellation. It remains to be seen what role the donor of this window played in spelling out the program to the glass painter. Likewise, the sequence of these other windows can only be addressed once their donors have been identified.

The Northern Aisle Glazing of the Carmelite Convent at Boppard

Jane Hayward has demonstrated that it was of particular concern to the Boppard Carmelites that the Virgin be featured at the center of each of the seven windows of the newly built north aisle.[30] Most of the scenes of the central light (fig. 7.6, n IX, 3–11b) in the Tree of Jesse window are dedicated to events in the life of the Virgin: a Virgin in Glory crowned by angels occupies the upper registers of the central light (n VI, 10–14b) of the Ten Commandments window; Mary in the corn robe or *Ährenkleid* is similarly placed in one of the two windows commissioned by guilds (n V, 9–14b); and Hayward has suggested a Virgin in the Rose Bower in the second window of standing figures executed by the Cologne workshop. If, from here on, one deviates from her suggested reconstructions and moves the lost part of the Pirmont window along with the donors' register to the upper half of a window, Mary as the Apocalyptic Woman would appear at the same spot in the third window with standing figures on the north side. Should one finally move all these six-register-high (without headers) baldachins with figures (which in Hayward's reconstruction occupy the upper part of the Pirmont window) to the west window, then the inscription in the base with the directives for the execution of the entire glazing cycle would occupy the only adequate place in the new building of the north aisle.[31] The convent may well have commissioned the window over the portal (n X), since it contains no donor's image. Given the dedication of the Carmelite

[28] Of seminal importance on this question: Hans Belting, *Das Bild und sein Publikum im Mittelalter. Form und Funktion früher Bildtafeln der Passion* (Berlin, 1981), 66–68, 276, and Fig. 14.

[29] Uwe Westfehling, *Die Messe Gregors des Großen. Vision, Kunst, Realität*, exhb. cat. Schnütgen-Museum der Stadt Köln (Cologne, 1982).

[30] Hayward, 'Stained Glass Windows,' 91–93.

[31] On the reading and interpretation of the fragmentary inscription in the base, see Wentzel, 'Unbekannte mittelalterliche,' 244.

church, it is not far-fetched to expect the Assumption of the Virgin surrounded by archangels and crowned by prophets in the missing central portion of the upper half of this window.[32] The absence of the Death and Coronation of the Virgin is noticeable. Correspondences in window shape and iconography thus confirm that the most complex Mariological subject, the representation of Mary as the Throne of Salomon, occupied the preeminent position in the east window (n IV), above the altar.

One must next consider the function of the north aisle glazing. Although a number of scholars have made this assumption, it is not quite correct that the Boppard Carmelite convent assumed the functions of a parish church and that this was the cause for the construction of the new aisle.[33] Although the Carmelites were the first mendicant order to settle in Boppard, in 1262, they did not experience the same expansion as the Dominicans and Franciscans in larger cities. The construction of their single-nave monastic church proceeded slowly. Although in 1330 the choir was completed, it was not until Archbishop Otto von Ziegenhain's rule (1418–30) that the nave was vaulted. Nonetheless, the Carmelite church enjoyed the favor of noble families in Boppard and its environs, and it was highly desirable as a burial ground. Additionally, the church was the meeting place of several brotherhoods made up of Boppard citizens and artisans, among them the Brotherhood of St. George and the Brotherhood of the Virgin Mary, which had been founded by the bakers.[34]

The construction of the north aisle, which had been envisioned from the start, proceeded much faster, but this space too remained without a vault for a decade after the completion of its exceptionally rich glazing. Armorial shields adorn the keystones of the three central bays of the north aisle (fig. 7.5). Those who bore these arms may not only have contributed in generous fashion to the construction and furnishing of the building, but the sequence of the shields may also reflect their rank and thus help to clarify the still unresolved questions concerning the donation of the windows. The central keystone bears a shield with arms heretofore unidentified but they are clearly those of Jakob von Sierck, archbishop of Trier from 1439 to 1456.[35] The keystone to the east is emblazoned with a gold eagle on a black ground within a cinquefoil; in spite of the absence

32 Hayward, 'Stained Glass Windows,' esp. 91–103. She addresses the personal questions so important for the formulation of the iconography on pp. 80–81 and 93. See also Volk, 'Boppard im Mittelalter,' 354–58. In her search for iconographic parallels for the program at Boppard, Jane Hayward gave great importance to the Albrechtsaltar in Klosterneuburg, which she believed King Albrecht II had donated to the Carmelite monastery in Vienna (1438–39). See Floridus Röhrig, ed., *Der Albrechtsaltar und sein Meister* (Vienna, 1981). In cases where I differ from Hayward's reconstructions, I have often adopted, modified, or rejected suggestions made in an unpublished MA thesis of 1995 by Annegret Kotzurek of Stuttgart University, titled 'Die Farbverglasung der Bopparder Karmeliterkirche und ihr Bildprogramm. Versuch einer Rekonstruktion.'

33 Hayward 'Stained Glass Windows,' 80–83, but also Becksmann, *Deutsche Glasmalerei*, 174–75, had taken this for granted.

34 See also n. 17.

35 Quarterly I & IV Argent a Cross Gules (Archbishopric of Trier) and II & III Or on a Chevron Gules three Escallops Argent (von Sierck); the colors and drawing were restored incorrectly after 1979 to II & III Gules on a Chevron Or three Escallops Argent. A corresponding

of a shield and the incorrect tinctures, these must be, on a formal basis alone, the imperial arms. The shield emblazoned with an eagle appearing on the west keystone must be identified as the arms—here correctly tinctured—of the former imperial city of Boppard, which had been ceded to the Electorate of Trier in 1312.[36]

The Role of Jakob von Sierck in the Boppard Glazing Program

That Jakob von Sierck played a prominent role in the construction and furnishing of the north aisle, as Jane Hayward suspected,[37] is evident because the three images of donors listed in the 1893 auction catalogue of the Spitzer collection and since lost include a praying bishop as well as the arms of the Electorate of Trier.[38] Contrary to all the other donors' panels, the ones missing since 1948 occupy not one but two registers, and were thus remarkable for their size alone. It is fair to assume that they represented Archbishop Jakob von Sierck and his parents.[39] Since the framework of the panels documented by photographs corresponds mostly with that of the enthroned Solomon, and since the arms of the archbishopric of Trier, turned toward the left, presuppose a pendant with the shield, turned toward the right, of the arms of the Sierck family, the east window above the altar (n IV) would have been sufficiently

shield occurs in the choir of the parish church at Irsch an der Saar; see Pater Markus Laser, Pfarrchronik (1999, available at: http://www.irsch-saar.de/pfarr2.htm).

36 As a rule, the imperial eagle appeared in the same form and tinctures as that of the German king, even after Emperor Sigismund (r. 1410–37) introduced the double-headed eagle as the imperial symbol. See Johannes Enno Korn, 'Adler und Doppeladler. Ein Zeichen im Wandel der Geschichte,' *Der Herold*, NF 6, 1966, 343–34.

37 Although Jane Hayward assumed that Jakob von Sierck had played a prominent role in the construction and furnishing of the north aisle, because his mother belonged to the influential Beyer von Boppard family, she could not identify any of the seven windows as his donation. Hayward, 'Stained Glass Windows,' 91 and 93. On the Beyer von Boppard family, see Volk, 'Boppard im Mittelalter,' 216–20.

38 *Catalogue Collection Spitzer*, supplément Nr. 3361–63: three groups of panels of three panels each. They are described as a kneeling bishop with hands raised in prayer, with an armorial shield held by two lions below, a donatrix and a donor in the same pose, with angels holding a shield under the former, and two donors with their shields under the latter. This last panel entered the Burrel Collection, Glasgow in 1948: *Stained and Painted Heraldic Glass, Burrell Collection* (Glasgow, 1962), Nr. 161, where the couple was identified as Siegfried von Gelnhausen and his wife. There is at least one photograph of the first panel that corresponds to the description in the sale's catalogue of 1893: John Dinkel, 'Stained Glass from Boppard: New Findings,' *Scottish Art Review* 13 (1971): 22–27, esp. 27, Fig. 5c. There is no trace of the armorial panel under the donatrix, since its description does not correspond with the panel reproduced by Dinkel of an angel with the armorial shields of three guilds (Dinkel, 'Stained Glass from Boppard,', Fig. 5a). The three donors' panels were last recorded in an auction catalogue of the Parke-Bernet Galleries, New York, March 19, 1948, Nr.165f. Their description contains useful indications of their colors.

39 Jane Hayward, 'Stained Glass Windows,' 91, had tentatively, without considering such an identification, linked the donors' portrayals with the Throne of Solomon window, but then rejected this hypothesis, since the reconstructed throne architecture already fills eight of the available nine registers of the east window.

documented as Jakob's, even without a portrayal of the patron. In addition, the armorial panel with a red key on a silver ground (Montclair) added to the window now at The Cloisters originally belonged at the center of the heraldic constellation of the Sierck donation.[40]

The lost donors' images, as documented in the Spitzer catalogue, were already remarkable for their size. They may have been intended for the lower part of the middle window of the north wall (n VII) and have been associated there either with a representation of the Death or of Coronation of the Virgin. The imperial window with the Ten Commandments was installed in the adjacent window to the east (n VI), dictated by the location of the armorial shields, as described above. Consequently the two donations of the city did not flank the imperial Ten Commandments window. Instead, the window of the presumed representatives of the city-village mayor and *Schöffen* or lay assessors must have been located in n VIII (fig. 7.5) as indicated by the placement of the Boppard arms in the vaulting. This means that the original site of the window of the Boppard guilds was n V (fig. 7.5). If one interprets the enthroned Virgin and Child in the keystone of this bay as a sign of the guild of the bakers, this would be another example of concordance between window and keystone.

Why Archbishop Jacob Sierck shared the central window of the north wall (n VII) with Kuno von Pirmont deserves an explanation. The latter witnessed von Sierck formally take office in 1439, but this is not a sufficient reason, nor is the observation that only in the lower registers of these two gifts do two generations appear as donors.[41] The Tree of Jesse theme would therefore, as the donation of a noble family, occupy the west window of the north wall (n IX), as Hayward suggested.[42] The connection of the panel with donors in Glasgow is convincing both for formal and stylistic reasons; there are doubts only on the identification of the donor as Siegfried von Gelnhausen, primarily because his family belongs neither in the orbit of the Boppard nobility nor in that of Jakob von Sierck.[43]

The construction and decoration of the impressive northern addition to the Boppard Carmelite church (1439–55) correspond almost precisely with the rule

[40] The territory of Montclair fell in 1427 to the lords von Sierck. In 1440 Jakob von Sierck allowed the reconstruction of the citadel destroyed by Archbishop Balduin von Luxemburg. In 1442 Jakob received from Friedrichs III, on his way to Aachen to be crowned, confirmation that the territory of Montclair was made a county. See Ignaz Miller, *Jakob von Sierck 1398/99–1456*, Quellen und Abhandlungen zur mittelrheinischen Kirchengeschichte 45 (1983): 6, 18, and 135–36. The confirmation conferred by Friedrichs III may even have caused the armorial shield of Montclair to be placed in the center of the base of the Throne of Solomon window.

[41] The tomb of Kuno von Pirmont († 1447), who was married to Margarete von Schönberg zu Ehrenburg († 1439), stands in the parish church at Karden. On his role as a witness, see Miller, *Jakob von Sierck*, 58 and 67. More importantly, Emperor Karl IV gave the Schönburg near Oberwesel in fiefdom to the Trier Archbishop in 1374; see Georg Dehio, *Handbuch der Deutschen Kunstdenkmäler, Rheinland-Pfalz, Saarland* (Munich, 1984), 778–80.

[42] Hayward, 'Stained Glass Windows,' 93–98.

[43] See n. 38. The identification of the donor as Siegfried von Gelnhausen is based, according to a letter from Hans Wentzel to Hansmartin Decker-Hauff on November 2, 1961, on a communication of Karl Demandt, Wiesbaden. A bearer of this name was bishop of Chur from 1298 until 1321. His descendants may have been canons of Mainz Cathedral.

of the Trier archbishop, prince elector, and later imperial chancellor, Jakob von Sierck (1439–56). In addition, it is the only large-scale ecclesiastical construction project in the Electorate of Trier at the middle of the fifteenth century in which von Sierck personally participated and emerged as the donor of stained glass.[44] This has, no doubt, to do with his familial and financial connections to the town of Boppard, which was once a property of the empire. The court in which his mother grew up was in the vicinity, to the east of the Carmelite convent, and taxes levied on goods transiting on the Rhine had fallen to the Trier archbishops in 1312 when the city was ceded to them. These taxes were a major source of income for the Electorate of Trier, of which the most eloquent testimony, still visible today, is the fortress built by Archbishop Balduin von Luxemburg in Boppard to ensure these revenues.[45]

As the proud scion of an ambitious, untitled ministerial family, but primarily because of his comprehensive education, mostly in law, and his diplomatic talent, Jakob von Sierck was an exceptional figure among the ecclesiastic Electors of the empire.[46] As early as 1430 the majority of the Trier cathedral chapter had elected him archbishop, but the pope named Raban von Helmstadt, then bishop of Speyer, instead; von Sierck only succeeded him in 1439. Until then he was active in or on behalf of Rome: He accompanied Giuliano Cesarini at the Basel Council, he acted as the negotiator between the pope and King Sigismund, and he spent long periods at the court of René d'Anjou, whose release from Burgundian captivity he attempted to secure. As archbishop of Trier, he devoted tremendous energy and acumen toward restoring the finances of the Electorate and breaking the deadlock of imperial politics. In these endeavors von Sierck always remained loyal to the house of Luxembourg, to which he owed his ascension, but he never forgot his own interests when working for others. He achieved his greatest political successes as an interlocutor between the empire and the French court. All of this notwithstanding, his otherwise thorough biographer Ignaz Miller, noticed no 'particular intellectual interests' in von Sierck, and judged him 'molded from rapacity' and governed by 'pathological greed.'[47]

44 Much more modest, yet revealing was his participation in the remodeling of the former parish church of St. Paulinus in Welling: His shield appears next to that of counts of Virneburg on a keystone in the choir, which contains remnants of a wall painting representing the Mass of St. Gregory. Finally, the Sierck arms attached to interlaced trefoils and a figure of the sainted Trier bishop Paulinus, which are the only figurative elements in the blank glazing of the choir, which consists of apertures with traceries and quarries with flowers, and suggest that Jacob von Sierck was the patron of the choir glazing. Mentioned and reproduced in Oidtmann, *Die rheinischen Glasmalereien*, 1:131–32 and 237. See also Dehio, *Handbuch der Deutschen Kunstdenkmäler*, 1122.

45 Concerning the taxes levied on goods transiting on the Rhine, the citadel of the prince electors, and the former court of the Beyer von Boppard family, which at the middle of the fifteenth century still received 2/21 of the tax revenue, see Volk, 'Boppard im Mittelalter,' 203–6, 293–98, 306, esp. 403–14; esp. Freiherr von Ledebur, *Kunstdenkmäler Stadt Boppard*, 403–14 and 425–26.

46 Of seminal importance, but difficult to summarize because of the mass of material: Miller, *Jakob von Sierck*, esp. 278–87.

47 See Miller, *Jakob von Sierck*, 285.

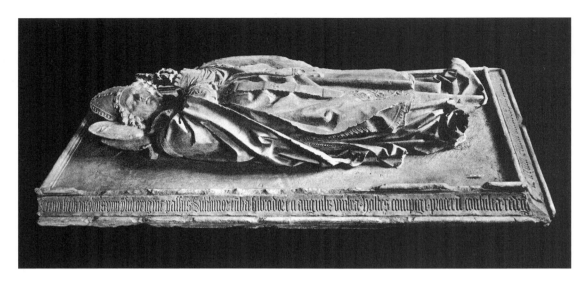

7.7 Nikolaus Gerhaert von Leyden, Tomb of Archbishop Jakob von Sierck (†1456), formerly Trier, Liebfrauenkirche. Trier, Bischöfliches Dom- und Diözesanmuseum, Trier, 1462.

In his testament von Sierck stipulated that his body be interred in the Church of Our Lady in Trier, between the high altar and the altar of the Holy Cross, his heart in Metz Cathedral, and his entrails in Mettlach. He achieved historical immortality, however, less by his public deeds than by his spectacular tomb, carved by Nikolaus Gerhaert von Leyden (fig. 7.7). Although the inscription around the archbishop's effigy, which he composed himself in 'barbarian Latin,' does not disclose what brought him fame, it leaves little doubt as to what he expected after death.[48] The verses also reveal that he intended his tomb to be of the two-level variety ('*Doppeldecker*'), then popular in France, in which the *gisant* lies on the upper slab and the *transi* underneath.[49] The commission to Gerhaert may have been conferred by one of von Sierck's testamentary executors, probably his brother Philip, on the recommendation of von Sierck's successor, Archbishop Johann von Baden (r. 1456–1503).[50]

As far as the glazing at Boppard is concerned, the monastery may not only have devised the overall program, but also have selected the so-called 'Middle-

[48] See again Miller, *Jakob von Sierck*, 254–57, as well as Ignaz Miller, 'Nachlaßregelung und Testament des Trierer Erzbischofs Jakob von Sierck († 1456),' *Landeskundliche Vierteljahresblätter* 2, (1985): 51–67. Finally, see Anette Schommers, 'Das Grabmahl des Trierer Erzbischofs Jakob von Sierck († 1456). Deutungs- und Rekonstruktionsversuch von Inschrift und Grabaufbau,' *Trierer Zeitschrift* 53 (1990): 311–33.

[49] For a definition of this concept, see Erwin Panofsky, *Grabplastik* (Cologne, 1964), 62 and 70. Since Jakob von Sierck sojourned in Burgundy, it is likely that he had seen tombs of this type himself; see Schommers, 'Das Grabmahl,' 326–28.

[50] This was the opinon of Eva Zimmermann, 'Forschungsergebnisse und Nachträge zur Ausstellung: Spätgotik am Oberrhein,' *Jahrbuch der Staatlichen Kunstsammlungen in Baden-Württemberg* 9 (1972): 95.

Rhenish workshop' for its execution. The glaziers are thought to have worked in Mainz or Koblenz, but they may just as well have been established in Boppard itself, which would have made it easier for the Carmelites to coordinate planning and production.[51] Significantly, only the guilds in Boppard and the representatives of the city were able to escape this 'interference' and to commission their two windows from a Cologne workshop.[52] Jakob von Sierck may have played his part, however, in the choice of donors and the distributions of the windows. Indeed after Albrecht II's sudden death of in the fall of 1439, von Sierck maintained diplomatic ties with Albrecht's widow, Elizabeth of Hungary, for years with regard to mortgages with Burgundy and Luxembourg.[53] Above all, it may have been for political reasons that he insisted on an imperial donation for a window, as he was already Friedrich III's chancellor at that time.[54] Members of the convent probably devised the iconographic program of the remarkable glazing of the north aisle of the Boppard Carmelite church. They would not only have suggested to the donor that the east window above the altar (n V) should represent the Throne of Solomon, but also have provided the glass workshop with models that

[51] See most recently Becksmann, *Deutsche Glasmalerei*, 175–76. The technical and stylistic similarities of the five Boppard windows to the Partenheim glazing executed at the same time in Mainz are not close enough to prove that the Boppard windows were made in Mainz. Archival documents mention a few painters in Koblenz at the middle of the century, but no glass painter who could have executed large commissions; Fritz Michel, 'Coblenzer Maler und Glasbrenner im späten Mittelalter,' *Rheinische Heimatblätter* 1 (1924): 119–25 (I wish to thank Uwe Gast for this reference). On the other hand, a glazer named Hans von Boppard, who may have come from a workshop in Boppard, was working in Frankfurt in 1490. See Walther Karl Zülch, *Frankfurter Künstler 1223–1700* (Frankfurt am Main, 1935), 207 (I would like to thank Ivo Rauch for this reference).

[52] See Hayward, 'Stained Glass Windows,' 107–13. Contrary to the 'middle Rhenish' windows, the two 'Cologne' windows are so close to the Trinity window of ca. 1430 in the north transept of Cologne Cathedral, that one must conclude that there were two workshops, one possibly in Boppard, the other in Cologne.

[53] See Miller, *Jakob von Sierck*, 51, 84, 87, 90–93, 95–99, 108, 127, and 130–31.

[54] Eberhard J. Nikitsch, *Die Inschriften des Rhein-Hunsrück-Kreises I (Boppard, Oberwesel, St. Goar)*, Die Deutschen Inschriften 60 (Wiesbaden, 2004): 76–88, Figs. 63–68. Nikitsch, referring to a dissertation in preparation for Mainz University by Gepa Spitzner on Late Gothic stained glass in the Middle Rhine region, follows in general Hayward's reconstructions and interpretations with a significant exception: He doubts that the two eagle arms in the Ten Commandments window prove that the window is a donation of King Albrecht II and his wife, Elizabeth of Hungary. In suggesting that the window was instead donated by the town of Boppard, he overlooks that the imperial and municipal arms have different tinctures, as illustrated by the shields on the keystones. As far as the Throne of Solomon window is concerned, Nikitsch provides a precise transcription of all the inscriptions, as well as a convincing explanation for the inscription of Cato: It probably comes from a collection of aphorisms from the third century, which was popular in the Middle Ages, the *Dicta Catonis*. Regrettably he does not address the regional linguistic variations. Following Dinkel, 'Stained Glass from Boppard,' he wrongly considers that the base panel, lost since 1948, with an angel holding the arms of the blacksmiths, the weavers, and the bakers, belonged to the Throne of Solomon window. Concerning the shield of the Electorate of Trier held by two lions, he assumes a reversed tincture and describes the arms as 'unknown.' He mentions the many connections of the couple Kuno von Pirmont/Margarete Schönberg zu Ehrenburg to Boppard; he also calls into question the identification of a Siegfried von Gelnhausen as the donor of the Tree of Jesse window and describes both arms as 'unknown.'

determined the window's archaic composition. On the other hand, the unusual inclusion of a Man of Sorrows in the Throne of Solomon may reflect the wish of the donor, Jakob von Sierck.

Images Lost/Texts Found: The Original Glazing Program at Notre-Dame of Noyon

Evelyn Staudinger Lane

Few interiors of French Gothic churches would be recognizable today to the medieval worshipper. In place of the kaleidoscopic effect of the sun's rays breaking through panes of multicolored glass, a stark, harsh, and even light permeates many Gothic spaces. Notre-Dame of Noyon is no exception (fig. 8.1). Here light entering through colorless glass results in an unnaturally bright interior that draws far too much attention to the weighty mass of its architecture. Rather than a luminous space that changes with every passing hour of the day, the interior is static.

It is Noyon's architecture that has engaged scholars over time.[1] Rarely do art historians speak of the cathedral's stained glass, and the reasons are obvious. Of the major cathedrals situated in and around Paris, Noyon has one of the worst survival rates for its glass.[2] Only two lancets containing nine historiated panels (fig. 8.2), a few border fragments, and two circular grisaille panels remain. The lancets are located in the ambulatory Chapel of the Virgin (fig. 8.1), the fragments in the chapels to its side, and the grisaille in the north chapel of

[1] For a recent contribution to the study of Noyon's sculpture, in particular the originality of the transept portal sculpture, see Charles Little, '*Resurrexit*: A Rediscovered Monumental Sculptural Program from Noyon Cathedral,' in *The Cloisters, Studies in Honor of the Fiftieth Anniversary*, ed. Elizabeth Parker (New York, 1992), 234–59. Accounts of the history of the church and its architecture must begin with the seminal study by Charles Seymour, *Notre-Dame of Noyon in the Twelfth Century, a Study in the Early Development of Gothic Architecture* (New Haven, 1939). More recent discussions, some of which also include issues related to the development of the town, are: *La Ville de Noyon, Cahiers de l'Inventaire* 10 (Amiens, 1987) (in particular, see Anne Prache, 'La cathédrale de Noyon, état de la question,' 70–80 and Michel Hérold, 'La sculpture à la cathédrale de Noyon,' 130–35); M. Bideault and Claudine Lautier, *Île-de-France Gothique*, vol. 1: *Les églises de la vallée de l'Oise et du Beauvaisis* (Paris, 1987), 246–71; *Courtauld Institute Illustration Archives, Archive 3, Medieval Architecture and Sculpture in Europe, France: Noyon Cathedral*, ed. Lindy Grant (London, 1983).

[2] Extensive damage to the fabric of the church was incurred during the twentieth century as a result of the bombardments of World War I. However, during the French Revolution, Noyon, having being transformed into a granary and stable, suffered primarily from neglect. Numerous restorations took place beginning in the year 1801 and continued throughout the nineteenth and twentieth centuries. For a discussion of the damage to this church and subsequent restorations, see Seymour, *Notre-Dame of Noyon*, 84, 91–95.

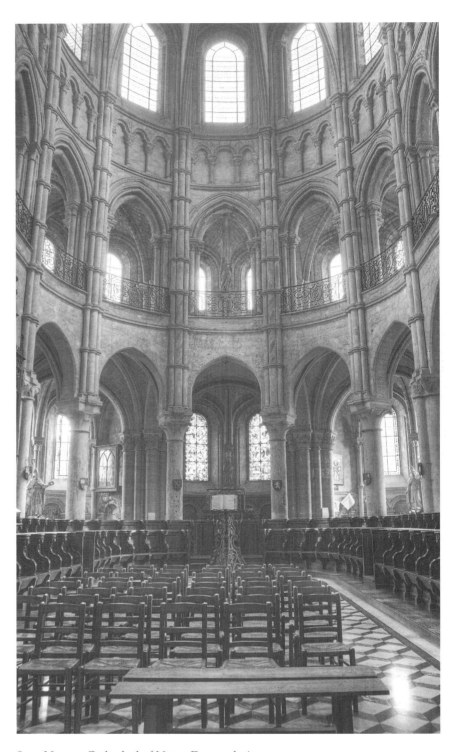

8.1 Noyon, Cathedral of Notre-Dame, choir.

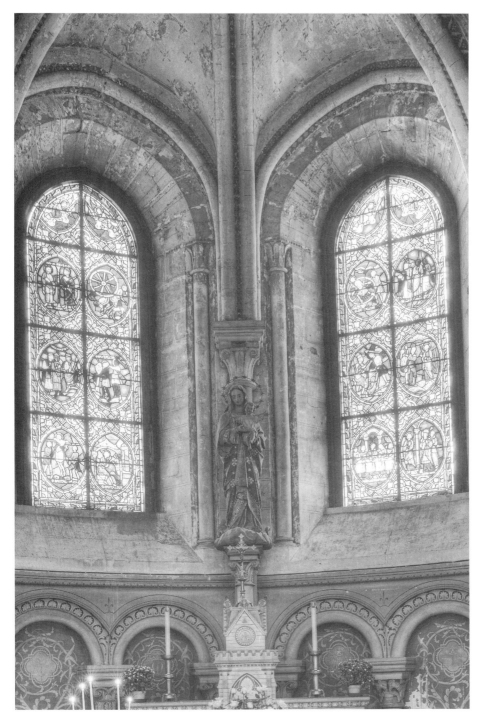

8.2 Noyon, Cathedral of Notre-Dame, St Pantaleon windows, Chapel of the Virgin.

the nave. The two lancets depicting scenes from the life of St Pantaleon no longer occupy their original position, having been moved at least once from the *revestiaire* in 1825.[3] No other panels of Noyon glass exist outside the church whether in a museum, private collection, or another ecclesiastical setting.

Moreover, very little reference in literature has been made to these meager remains. In the last two decades they have appeared as brief accounts in the Recensement I of the Corpus Vitrearum series, published in 1978[4] and by Michel Hérold in *La Ville de Noyon, Cahiers de l'Inventaire 10*, published in 1987.[5] Unpublished material includes my study of Noyon's stained glass, a master's thesis completed in 1980 under the direction of Madeline Caviness.[6]

This article will focus on the glass that has been destroyed by addressing the question, how do the early texts associated with the cathedral contribute to our understanding of the original glazing program at Notre-Dame of Noyon? Two documents that mention the stained glass will be analyzed: one dated 1185 and the other 1425–29 (Appendix A). The earlier of the two will help to establish the chronology of some of Noyon's glass and the later text will shed light on its iconographic program as well as the possible size, location, and configuration of some of its original windows. It is my intention to show that most of the glass that survived in Notre-Dame of Noyon in the fifteenth century was situated in the southeastern portion of the cathedral, the part least damaged by a devastating fire that occurred in the thirteenth century. In addition, I will demonstrate that legendary windows occupied the glazed passageways of Noyon's south transept, at least in the fifteenth century, a somewhat unusual location for this type of glass.

The 1185 document was cited by Charles Seymour in his influential study on the architecture of Noyon as one 'of capital importance' because it provided evidence for a *terminus ante quem* (1185) for the third phase of construction at Noyon that was begun in 1170.[7] Written by Bishop Renaud, the document refers to the chapter's hiring of two bell ringers and briefly defines their duties.[8] From the job description outlined and the location for that work, Seymour concluded that the choir, transept, and adjacent bay of the nave were completed by 1185.[9] For the purpose of this paper, however, it is not the hiring of the bell ringers that is significant, it is the description of their duties, which included helping to clean the glass. Thus, by 1185 the choir, transept, and last bay of the nave— the first three phases of construction according to Seymour—must have been

[3] For a discussion of their change of location see Evelyn Staudinger, *Thirteenth-Century Stained Glass in Notre-Dame de Noyon*, master's thesis (Tufts University, 1980), 133–42.

[4] Louis Grodecki, Françoise Perrot, Jean Taralon, *Recensements des vitraux anciens de la France, Les vitraux de Paris, de la région parisienne, de la Picardie, et du Nord-Pas-de-Calais*, Corpus Vitrearum Medii Aevi, Recensement Vol. I (Paris, 1978), 202–3.

[5] Michel Hérold, 'Les vitraux de la cathédrale,' in *La Ville de Noyon, Cahiers de l'Inventaire 10* (Amiens, 1987), 106–9.

[6] See note three above.

[7] Seymour, *Notre-Dame of Noyon*, 58, 61–62.

[8] Act of Renaud dated by the Incarnation 1185. See Seymour, *Notre-Dame of Noyon*, 61–62.

[9] Seymour, *Notre-Dame of Noyon*, 62.

glazed. No doubt Philip Augustus's visit to the city in 1186 was an added incentive for glaziers to complete much of their work.[10] Similarly, St Louis's visit to the city in 1242 might have signaled a date for the completion of the rest of Noyon's glass as I have argued elsewhere.[11]

The fifteenth century brings to light additional information on Noyon's glazing program. A document cited in a footnote by Seymour[12] and preserved in the Archives départementales de l'Oise (G 1357) contains an inventory of 640 panels of stained glass that were repaired by a restorer named Pierre Le Verrier between the years 1425 and 1429 under the direction of the canon, Robert Guyart.[13] The inventory is presented in the form of twenty-two entries identifying the repaired glass followed by the total sum owed to the glass restorer[14] (see Appendix A). The importance of this document cannot be overstated since it is the only piece of evidence from the medieval period that offers insight into the iconographic program of the stained glass at Noyon, including matters related to window configuration and distribution. I will organize the data from this document below, under the headings subject matter, type of glass, size, and location. I will then analyze the data to show how G 1357 enhances our knowledge of the original glazing program at Notre-Dame of Noyon.

Subject Matter

From the twenty-two entries listed (Appendix A), only nine (6, 7, 8, 12, 13, 14, 15, 16, 19) identify the subject of their windows. Seven entries refer to the story or life of the following saints: Catherine (7),[15] Thomas (8), Margaret (12), Nicolas (13), Aufren (14), Giles (14), John (15), Agnes (15), and Blaise (16). The medallion windows of Sts Nicholas (13) and Blaise (16) were represented in two lights each, while the remaining eight were depicted in one. In addition, two windows contained large prophet figures (19) and another a single representation of St

[10] Staudinger, *Thirteenth-Century Stained Glass*, 34. Seymour, *Notre-Dame of Noyon*, 17, cites the reference to this visit as Bibl. Nat., Coll. de Picardie, CLXV, 20.

[11] Staudinger, *Thirteenth-Century Stained Glass*, 34–35. According to Seymour, *Notre-Dame de Noyon*, 67, 1240 marks the date in which 'the cathedral had been completed, if not ideally, at least practically and realistically.'

[12] Seymour, *Notre-Dame of Noyon*, 74.

[13] Archives départmentales de l'Oise, G 1357. A summary of this material was published by M. Rendu in *Inventaire sommaire des archives départementales de l'Oise antèrieures à 1790*, I (Beauvais, Moirand, 1879), 317–88, although this synopsis is incomplete and contains numerous errors. See Staudinger, *Thirteenth-Century Stained Glass*, 51 for a discussion of the latter. A more reliable transcription can be found in A. de La Fons Melicocq, *Les Artistes du nord de la France et du midi de la Belgique, aux XIVe, XVe, et XVIe siècles* (Béthune, 1848), 50–54 and appears in Appendix A. Also for a brief discussion of this text, see Hérold, 'Les vitraux de la cathédrale,' 107.

[14] G 1357. Also paid was *Huet le Platrier* who made *les hours* for *le grant fourme*, presumably the panels in the west end.

[15] Numbers in parentheses refer to the item number that I have included in G 1357. See Appendix A.

Nicolas (6). This document fails to designate a subject for the remaining eleven entries.

Type of Glass

Only three entries refer to a particular type of glass. A single image of St Nicholas is set within *blanc voirre* (6). Since the entry that follows refers to *une aultre fourme de couleur*, this term presumably indicates potmetal surrounded by grisaille. Clear glass in quarries or diamond-shaped panels (*blanc voirre losengment*) are specified in one window (21) and round pieces of glass (*rons*) surmounting lancets, listed in the previous entry, can be found in another (10). In the remaining entries, no differentiation between potmetal, grisaille, or a combination of the two is made.

Size and Configuration

The author of this document refers to the glass using the terms *peniaux* and *fourmes*. The word *peniaux* designates panels, and its inclusion in the text relates to issues of economy. Since the fee for the glass restorer was determined by the number of panels he repaired, every entry ends by stipulating the exact number contained within each window.[16] The term *fourme*, however, has several connotations. In most cases it seems to refer to a lancet or double-lancet window; however, in one entry (3) reference is made to *le grant fourme de le nef du moustier*. Said to have contained 154 panels, this window was likely a rose or a large multi-lancet configuration.

In total 640 panels were repaired. A breakdown of the size of each of the windows (1W) based on the number of panels (P) follows in Table 8.1. While the largest and second largest windows were composed of 154 and 40 panels, respectively, the majority contained between fourteen and twenty-three. Not included in this list are eighteen *rons* (10) that do not form a single window but appear to have been placed over the four lancets located in the chapel of St Catherine in the cloister (9).

Location

Most entries are followed by a brief descriptive phrase pertaining to the panels' general location within the church and its annexed structures. However, none stipulates the exact bay in which each window was situated. Occasionally, entries begin with the abbreviation *ens.* meaning *ensuite*, thus probably indicating that the glass is in the same location as the panels cited above.

[16] In this case Pierre le Verrier earned 74 livres, 13 sous, and 4 deniers for his work in Noyon.

Table 8.1

# of P.	# of W.	It. #	Possible location	Subject
154	1	(3)	Nave	
40	1	(11)	Choir	
23	1	(12)	Choir	St Margaret
22	1	(6)	South Transept	St Nicholas
21	1	(8)	?	St Thomas
20	1	(14)	South Transept	St Aufren
18	1	(2)	Near the Annunciation?	
18	2	(19)	South Transept clerestory	Prophets
18	1	(21)	Choir clerestory?	(quarries)
16	1	(15)	South Transept?	St Agnes
15	1	(11)	Choir	
14	1	(15)	South Transept?	St John
14	1	(7)	South Transept	St Catherine
14	1	(14)	South Transept	St Giles
14	2	(13)	South Transept	St Nicholas
14	2	(16)	Chapel St. Lucy	St Blaise
14	4	(9)	Cloister Chapel St. Catherine	
14	1	(18)	South Transept	
11	1	(2)	Near the Annunciation?	
6	6	(1)	Tribune chapels	
6	1	(17)	Vestry	
6	1	(22)	Nave	
6	1	(20)	South Transept	
6	1	(4)	Chapel fons	
4		(5)	South Transept clerestory, four panels in four places	
4		(3)	Nave, four new panels	

All portions of the cathedral are named or inferred including the transept, choir, and the nave. Although the word transept is never used, these windows (5, 6, 7, 13, 14, 18, and 19) are clearly designated as transept lights by reference to altars or portals known to have existed in this part of the church, such as St Eutrope's altar, the *portail des merchiers* and the portal through which one gains access to the bishop's chapel.[17] Reference to panels near the altar St Eloy (11 and 12) can be identified as windows in the choir, since a document refers to the presence of a chapel dedicated to the saint in this location.[18] In addition,

[17] The *portail des merchiers* refers to the portal that was later called the *Portail Saint-Eutrope* located in the transept. See Seymour, *Notre-Dame de Noyon*, 19.

[18] Seymour, 1968, 15, cites this source as *Acta Capitularia Ecclesiae Noviomensis*, copied by Dom Grenier, Bibl. Nat., Coll. de Picardie, CLXV, 16.

windows said to have been located above the choir (1) were in the galleries over the ambulatory while the chapel St Lucy was annexed to the nave (16). Glass could also be found in areas adjacent to the cathedral, such as the cloister chapel (9) and the vestry (17). In three cases, however, no locations can be proposed due to the lack of specific information. One entry (2) states that a window was situated above *l'Annonciacion*, which is likely a reference to sculpture that has not survived. Another places the glass in the *chapel des fons* (4) which can no longer be located, but may refer to a chapel in the west end. The third (15) introduces the life of St John and St Agnes medallion windows as simply *une aultre fourme*. Without including the word *ensuite* one cannot be certain of the window's location; however, since the entry above situates two other medallion windows in the south transept, it is likely that the Sts John and Agnes lancets were found there as well. Table 8.2 below lists these possible locations.

Table 8.2

It. #	Possible location
(9, 10)	In the Chapel St Catherine in the cloister (4W. and rounds)
(17)	In the vestry (1W.)
(1)	Near the tribune Chapel of St Michael above the choir (6W.)
(18)	In the South Transept, near the *Portail des Merciers* and in the old tower (1W.)
(20)	In the South Transept, near the *Portail des Merciers* above the door (1W.)
(5)	In the South Transept, above the *Portail des Merciers*, clerestory (4 p. in 4 places)
(19)	In the South Transept, above the *Portail des Merciers* in the clerestory (2W.)
(6, 7)	In the South Transept, before the altar of St Eutrope(2W.)
(13, 14, 15)	In the South Transept, above the portal where one enters the bishop's residence (6W.)
(21)	Opposite the bishop's residence in the clerestory (choir?) (1W.)
(8)	East of the *Portail des Merciers* near the holy water font (?) (1W.)
(11, 12)	Choir, near the altar of St Eloi towards the bishop's residence (3W.)
(22)	In the nave where the crucifix is on the side toward the bishop's residence (1W.)
(16)	In the chapel dedicated to St Lucy (2W.)
(3)	West end, in a large window in the nave (1W.)
(4)	In the chapel of the baptismal font (1W.)
(2)	Above the Annunciation (possibly sculpture or painting) (2W.)

Analysis

Based on this information, it is possible to realize a partial view of the glazing program at Noyon as it existed in the fifteenth century. In 1425–29 at least 640 panels of stained glass were still preserved in the cathedral. According to the document these panels formed at least thirty-six windows that ranged in size from 154 panels to several containing only six. Since only three entries refer to panels *par hault* (5, 19, and 21), it may be assumed that few of these lancets were found in the clerestory.[19] Most must have been set below this level. The subject matter confirms this assumption for at least nine windows. These represent the lives of the saints; hence, they are legendary windows, a type traditionally situated in the lower levels of the church for easier viewing. Single monumental figures normally found in clerestory windows are indicated only twice; these include two great prophet windows (19) and a single representation of St Nicholas (6). The largest window containing 154 panels (3), likely a rose or a window composed of a series of lancets, would have been located in the upper elevation of the church.

Although this analysis indicates that these windows were situated in all major sections of the cathedral (fig. 8.3), i.e. the transept, choir, tribune, and nave, their distribution favored the eastern half: approximately thirteen were to be found in the transept, ten in the choir and its tribunes, while only four or five were placed in the nave. Similarly, although exact window placement is not defined, several conclusions can be made with regard to the relative placement of the glass within each of these spaces. For example, the majority of the glass was located not just in the eastern portion of the church, but also on the south side. This is true of the transept and choir glazing. The *portail des merchiers* (5, 6, 7, 18, 19, and 20), St Eutrope's altar and the door to the bishop's palace (13 and 14) were located in the south arm of the transept (fig. 8.3).[20] The south portion of the choir is also implied; a distinguishing logistical marker for glass in this area was its proximity to the bishop's palace, which was located next to the south arm of the transept and south side of the chevet (11, 12, and 21). As for the nave glass, the window containing 154 panels could only have been situated in the west end, while the Chapel of St Lucy occupied a position in the second and third bay of the nave aisle on the south side. The glass named in the cloister chapel (9) and the vestry (17), however, would have been located north of the church proper.

The question remains as to whether a correspondence exists between the location for the stained glass as interpreted through this document and the actual size of Noyon's windows. Confirmation of the placement of the smallest lancets, those with six panels each, in the cathedral's choir tribune chapels can be found in the present position of the two St Pantaleon lights (fig. 8.1). Today located in an ambulatory chapel, the St Pantaleon windows containing eight

[19] One (18) designating a window in the transept's 'petite viese tour' also indicates a clerestory level.

[20] Seymour, *Notre-Dame de Noyon*, 19.

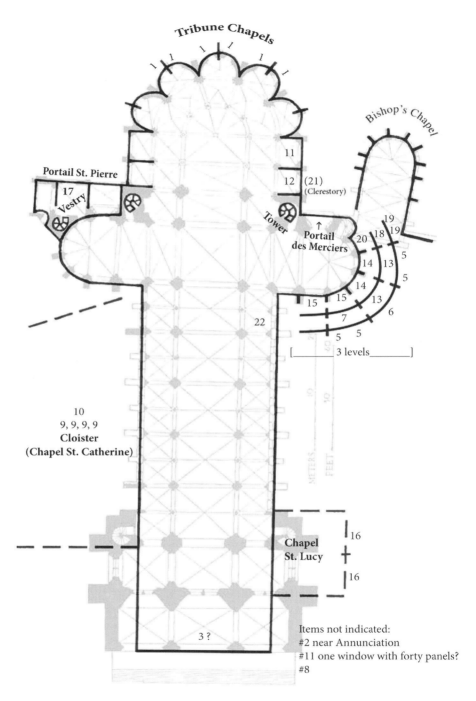

8.3 Noyon, Cathedral of Notre-Dame, plan and annexes, and approximate location of glass in G 1357.

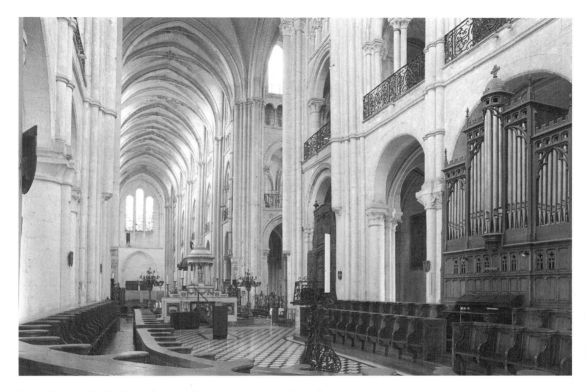

8.4 Noyon, Cathedral of Notre-Dame, view from choir facing west.

panels each are slightly larger than their counterparts in the tribune above (fig. 8.1). Thus, six-paneled lights in the upper chapels would have been a comfortable fit. As to the largest light mentioned in the document, composed of 154 panels and placed by me in the west end, the situation is somewhat more complicated. At present triple lancets are located in the west facade of the cathedral (fig. 8.4). According to Seymour, the central light, which was heavily restored after being damaged in a fire of 1293, was originally a rose whose dimensions would have been approximately nine meters in diameter.[21] A similar size rose at Mantes Cathedral, measuring eight meters in diameter, contains approximately 112 panels of stained glass. Given that Noyon's rose was completed before Mantes', one could argue that it would have been composed of a higher proportion of glass to stone. Thus, 154 panels, though a large number for a window of this size, is not impossible. Lastly, my placement of Noyon's windows on various levels in the south transept conforms to the number of apertures that could have held stained glass in the fifteenth century.

[21] Seymour, *Notre-Dame de Noyon*, 140–41, notes that the colonnettes in the central triplet are set in a significantly lower position as compared to their counterpart on either side, indicating that a window with a different shape occupied that space, most likely a rose.

Most of the remaining lights vary in size from fourteen to twenty-three panels and are generally of the medallion type located in the south transept (fig. 8.5).[22] This variation in number of panels would be in direct relation to the diversity of the scenes and the actual size of the windows. Comparatively speaking, none approximates the size of those at Chartres, which often contained thirty medallions, but at Notre-Dame of Noyon the window openings are a much smaller size. The configuration of windows in Noyon's south transept includes single lancets, which could have contained the windows with fourteen panels (fig. 8.5). The double-lancets in the glazed passageway in the third story could have held the eighteen to twenty-two-paneled windows, and the clerestory no doubt was glazed with the two single prophet figures composed of eighteen panels each. The placement of the forty-paneled window in the choir is problematic (fig. 8.1). The large single openings which today occupy the clerestory were originally double lancets.[23] Whether forty panels could have fit into such a location is at this time questionable; thus, the setting for this window remains uncertain.

Because this document deals with only a portion of the windows that once graced Noyon's interior, it is difficult, if not impossible, to assess the thematic content of Noyon's glazing program. However, three observations can be made about the iconography of this program and the placement of its glass within the cathedral. First, legendary windows occupied a prominent position at least with respect to the glass that was named in the fifteenth century. Secondly, of the nine saints depicted, at least six were associated with the cathedral in other ways. Noyon contained chapels or altars dedicated to Sts Thomas, Nicholas, John, and Catherine and it possessed relics of Sts Aufren, Thomas, and Giles.[24] Thirdly, questions of reception arise from the placement of a number of these windows within the transept space, a four-storied elevation that was uniquely aisleless (fig. 8.5).[25] According to my reading of this text, medallion windows were situated not only in the lowest level of the transept, but also two levels above in its glazed passageways. This location raises the issue of how these windows would have been viewed. Given that only a narrow passageway preceded them, the viewer had no opportunity to step back and look up at individual medallions. Moreover, this begs the question as to who had access to these transept passageways in the first place. Had they served as connectors between the nave galleries and the choir galleries, the presence of medallion windows along a well-trafficked area would have been more suitable; however,

[22] The source for the photograph in fig. 8.5 is Dieter Kimpel and Robert Suckale, *L'architecture gothique en France 1130–1270* (Paris, 1990), Fig. 124.

[23] Seymour, *Notre-Dame de Noyon*, 82.

[24] Among them are: 1246 dedication of chapel to St Catherine; 1286 dedication of chapel to Sts Lucy and Margaret; 1389 mention of a chapel dedicated to St Thomas along with Sts Eloi, Lawrence, Martin; 1592 chapel dedicated to St Giles; 1643 chapel dedicated to St Nicholas. For a discussion of these chapels and relics see Staudinger, *Thirteenth-Century Stained Glass*, 134–42.

[25] Other churches with similar rounded transepts such as at Tournai, Chaalis or Soissons were aisled, and, thus, their transept glass would have been viewed differently.

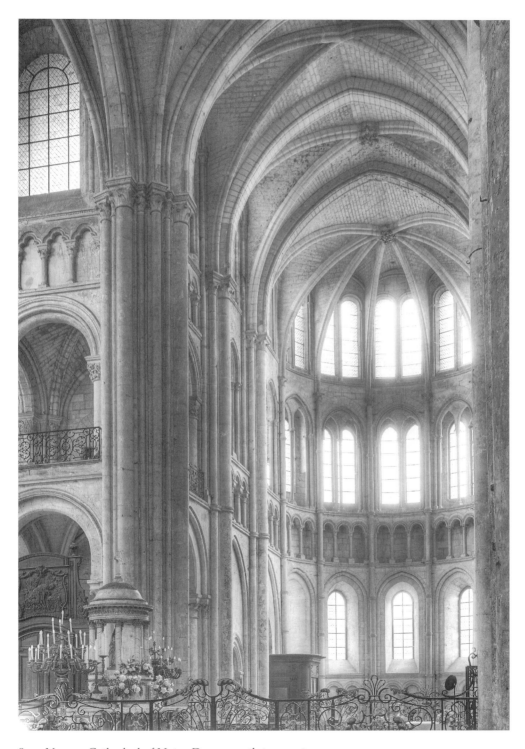

8.5 Noyon, Cathedral of Notre-Dame, south transept.

that function was carried out by the blind arcades located in the level below.[26] Thus, at least in the fifteenth century, legendary windows occupied the upper stories of the south transept in Noyon.[27]

Two additional questions also arise from this analysis: how much of the glass named is twelfth and thirteenth century and thus indicative of Noyon's original glazing program and to what extent does this document name all of the glass preserved in the fifteenth century? As to the first, the answer is likely that most was original to the church. Legendary windows, a distinctly twelfth- and thirteenth-century type, make up twelve of the thirty-six, while only four panels listed were newly made. Of the remaining twenty-four windows only six were situated in areas of the cathedral built after the initial campaigns but nevertheless still in the thirteenth century. Yet, perhaps the more important question is the second: Were there other examples of stained glass from Noyon's early history that survived into the fifteenth century but simply were not named in G 1357? The fact that the St Pantaleon lancets do not appear in the document would suggest that this may be the case.[28] In addition, Moët de la Forte-Maison, writing in 1845, describes stained glass still situated in the chapels of the nave built beginning in the fourteenth century but not identified in the fifteenth century document.[29] The latter, however, might have occurred for the simple reason that the fourteenth-century glass was not in need of repair in 1425, at least not to the extent of the earlier panels.

On the other hand, there is reason to believe that a significant portion of Noyon's original glass had already been destroyed by the fifteenth century when G 1357 had been written. This loss resulted from a fire that swept through the town in 1293, raging continuously for thirty-six hours. Documents tell us that the cathedral was damaged, although not in its entirety. According to a papal bull written by Pope Boniface VIII, damage occurred to 'only a certain part,'[30] identification of which can be deduced from texts and archaeological evidence. Chroniclers tell us that only two establishments in Noyon were spared: the church of St Pierre and the buildings belonging to the Templars and Hospitallers.[31] Since both were situated immediately outside the east end of the cathedral, one could assume that the eastern half of the church was spared, where the majority of the windows named in G 1357 were located. According to Seymour, examination of the fabric of the church showed much the same. Based on physical evidence, Seymour concluded that Noyon's western part was the most heavily damaged, specifically the north side.[32] Given that much

[26] One gained access to the tribunes through the stairways situated in the choir towers.

[27] There is also the possibility that stained glass, which originally occupied the nave aisle windows, was removed and reset when the later fourteenth century chapels had been built.

[28] St Pantaleon's ties to Noyon are nevertheless reinforced by the fact that the cathedral contained relics of the saint. See my discussion in Staudinger, *Thirteenth-Century Stained Glass*, 92–94.

[29] C. A. Moët de la Forte-Maison, *Antiquités de Noyon* (Rennes, 1845), IV, 296 and 303. See also Hérold, 'Les vitraux de la cathédrale,' 107.

[30] Seymour, *Notre-Dame de Noyon*, 69.

[31] Seymour, *Notre-Dame de Noyon*, 69.

[32] Seymour, *Notre-Dame de Noyon*, 69.

of the glass repaired in the fifteenth century was situated on the south side, this seems plausible. In addition, the omission of monumental windows from G 1357 can be explained by the fact that the nave vaults were completely demolished as a result of the 1293 fire.[33] It follows that many of the original clerestory windows must have been destroyed concurrently. Furthermore, Seymour postulates that restoration work initiated by the fire moved slowly, taking several hundred years to complete.[34] Thus, the 640 panels that were taken down for repair in 1425 may account for the majority of the windows that survived the late thirteenth-century fire.

In conclusion, an analysis of this fifteenth-century document adds to the limited knowledge of Noyon's original glazing program. Although the presence of stained glass in this cathedral would hardly have been doubted, G 1357 confirms its existence and provides the scholar with a glimpse into Noyon's original iconographic program, distribution, and placement for at least a portion of its glass. Thus, returning to Noyon's stark interior (fig. 8.5), we can now attempt to replace this modern image with one that is more resplendent, more jewel-like and, ultimately, more medieval.

Appendix A

OISE G 1357

1425		C'est le décleracion des réparacions des verrières de l'église de Nostre-Dame de Noyon faictes par Pierre le Verrier, en l'an IIIIc xxv et xxvi, depuis que mons. maistre Robert Guyart, official de Noyon et chanoine de ledite église, fu maistre de l'oeuvre d'icelle esglise.
(1)	P.	Es vautes de ledite esglise, au deseure du cuer, à l'endroit de le chapelle saint Michiel, vi fourmes de verrières, contenant chascune fourme vi peniaux, qui montent en somme xxxvi peniaux.
(2)	It.	Deseure l'Annonciacion, ii fourmes, l'une de xviii peniaux, et l'autre de xi peniaux, montent à xxix peniaux.
(3)	It.	En le grant fourme de le nef du moustier, cent et Liiii peniaux, dont il en y a iiii peniaux neus, qui montent à xxii pies.
(4)	It.	En le chapelle des fons vi peniaux.
(5)	It.	Es verrières haultes deseure le portail des merchiers en iiii lieux, iiii peniaux.
(6)	It.	Aud. portail devant l'autel saint Eitrope, une fourme de blanc voirre, en laquelle il y a l'ymage de saint Nicholay, qui contient xxii peniaux.
(7)	It.	Aud. portail une aultre fourme de couleur, où est l'istoire de sainte Cateline, et contient xiiii peniaux.

33 Bideault and Lautier, *Île-de-France Gothique*, 248.
34 Seymour, *Notre-Dame de Noyon*, 70.

(8) It. Au deseure du lieu où le grant benoitier soulait estre aud. portail, une fourme en lequelle la vie saint Thomas est, contenant xxi peniaux.

(9) It. En le chapelle saint Kateline en cloistre, iiii fourmes, chascune fourme de xiiii peniaux, montent Lvi peniaux.

(10) It. Au deseure desdites fourmes xviii rons.

(11) It. A l'endroit de l'autel saint Eloy, au lez de l'ostel mons. de Noyon, ii fourmes, l'une de xv peniaux et l'autre de xL peniaux, montent Lv peniaux.

(12) It. Ens. une fourme où est l'istoire sainte Marguerite, et contient xxiii peniaux.

(13) It. Ens. au deseure du portail par où on entre de l'esglise à l'ostel mons. de Noyon, pour monter au palais, ii fourmes où est la vie de saint Nicolay, contenant chascune fourme xiiii peniaux, valent xxviii peniaux.

(14) It. Ens. ii aultres fourmes, l'une de le vie saint Aufren, contenant xx peniaux, et l'autre de le vie saint Gille, contenant xiiii peniaux, montent icelles ii fourmes xxxiiii peniaux.

(15) It. Une aultre fourme de le vie saint Jehan, contenant xiiii peniaux, et une de le vie sainte Agnez contenant xvi peniaux, montent lesd. Fourmes xxx peniaux.

(16) It. Emprès le chappelle sainte Luce deux aultres fourmes de le vie saint Blesne contenant chascune xiiii peniaux, valent xxviii peniaux.

(17) It. Ou revestiaire de led. eglise vi peniaux.

(18) It. Au portail des merchiers à le petite viese tour, une fourme de xiiii peniaux.

(19) It. Aud. portail par hault ii fourmes, où est I grant prophète, en chascune fourme xviii peniaux, valent xxxvi peniaux.

(20) It. Une fourme deseure l'uis du portail dessusd. contenant vi peniaux.

(21) It. De l'autre lez, à l'encontre de l'ostel mons. de Noyon par hault, une fourme de blanc voirre losengment, contenant xviii peniaux.

(22) It. En le nef du moustier, à l'endroit du cruchefix, o lez devers l'ostel de mons. de Noyon, une fourme contenant vi peniaux.
 Somme de tout l'ouvrage dessusd. jusques au jour de juing, l'an mil iiiic xxix.
 vic xL peniaux, sans comprendre les iiii peniaux neux, qui valent à iis iiiid par chascun penel, forte monnoye, l'escu pour xviijs P., la somme de LxxiiiiL. .xiiiis iiiid P., qui valent, l'escu pour xviiis, en somme iiii**iiii escus, xviis iiiid P.

 It. Et pour les iiii peniaux neux contenant xxii pies, v escus d'or.
 Somme tout iiii**ix escus d'or et xviis iiiid P.

 It. Es deu aud. Pierre, pour les despens de Huet le Platrier, pour faire les hours de le grant fourme xis P.

 It. Pour une neufve esquielle de xxv pies, pour che paiet par led. Pierre iiiis P.

PART THREE

Post-Disciplinary Approaches

Stained Glass and Architecture at Saint-Remi of Reims and at Braine: Distinct or Complementary Disciplines?

Anne Prache

I had just finished my doctoral dissertation on the architecture of the church of Saint-Remi, and was teaching at the Institut d'art at the University of Paris IV, when I first met Madeline Caviness. She had undertaken a study of the stained glass of Saint-Remi, and had come to discuss her work with Louis Grodecki in his office there. This was the beginning of a friendship, and of a dialogue that provides the point of departure for this essay.

In 1990, Madeline Caviness published her major work on the late twelfth-century stained glass of two closely related former abbey churches, Saint-Remi of Reims and Saint-Yved of Braine.[1] Both buildings have been of great interest to historians of medieval architecture. This essay will consider the extent to which Caviness's work on their stained glass has contributed to a more complete understanding of the two monuments from the point of view of architectural history.

At Reims, the church of the former Benedictine Abbey of Saint-Remi, founded at the site of the tomb of the bishop of the same name, was built during the first half of the eleventh century.[2] Its eastern terminus and westernmost bays were modified and rebuilt during the second half of the twelfth century. By that time, the Romanesque western block had already been razed, with the exception of its lateral stair towers, to make room for a double-bay extension of the nave. A new, extensively glazed facade was constructed; unfortunately, none of the medieval glass survives from this part of the church. A greatly expanded eastern sanctuary was built in place of the earlier apse, the height of the transept and nave was increased, and these spaces were vaulted. Some of the glass from

Translated by Ellen Shortell and Elizabeth Pastan.

[1] Madeline H. Caviness, *Sumptuous Arts at the Royal Abbeys in Reims and Braine: Ornatus Elegantiae, Varietate Stupendes* (Princeton, 1990).

[2] Anne Prache, *Saint-Remi de Reims, l'oeuvre de Pierre de Celle et sa place dans l'architecture gothique* (Geneva, 1978), with extensive bibliography. For a more recent and more general introduction, see Jean Bony, *French Gothic Architecture of the 12th and 13th centuries* (Berkeley, 1983), 147–48, 168–69, and 337–38; Dieter Kimpel and Robert Suckale, *Die gotische Architektur in Frankreich 1140–1270* (Munich, 1985), 180–97; Willibald Sauerländer, *Le siècle des cathédrales* (Paris, 1989), 7–9.

the end of the twelfth century was preserved in the sanctuary and in the clerestory windows of the nave, but there is scarcely any documentation of the restorations to the stained glass carried out during the nineteenth century, and the damage inflicted during World War I was considerable. Due to these factors, Louis Grodecki, the great expert on medieval French stained glass in the second half of the twentieth century, asserted that the medieval glazing of Saint-Remi presented an unsolvable problem. Madeline Caviness recalled this briefly in the preface to her book:

Following a series of heated debates with Louis Grodecki (d. 1982), which were occasionally suspended while I took the train to Reims and climbed round the choir with a Polaroid camera to present 'proofs' on my return to Paris, he generously ceded the study of this magnificent glass to me, but not without the warning that no conclusions could be drawn from it: the subject was impossible.[3]

The chronology of the twelfth-century construction of the abbey church is unclear. Pierre de Celle, abbot from 1162 to 1181 wrote three letters about it, but it seems that the work had not been completed yet when he left to become Bishop of Chartres, and there is no document to tell us when the nave was vaulted. The iconographic program of the choir clerestory windows seemed to me to offer a clue. The windows there depict the successive bishops and archbishops of Reims, the last of which on the north side is Henri de France, who died in 1175. It was unheard of at that time to depict a living person, and thus one might deduce that the upper windows were installed under his successor, William of Champagne (1175–1202). During my dissertation defense, Louis Grodecki reproached me for using this argument: 'Stained glass specialists,' he told me, 'depend on architectural chronology to date the windows. You can't do the opposite.'

I continue to believe that the iconography of a window can, in some cases, help to pinpoint a particular stage in the successive steps of construction of a building. Caution is obviously advised, since, as all experts know, panels and entire windows have often been moved, recomposed, or replaced. Stained glass is essentially a moveable element, much more fragile than stone construction, and at Saint-Remi itself, there is a variety of reused glass in the tribune of the chevet. Nonetheless, when an iconographic program is homogeneous and is part of a unified concept, as in the clerestory windows at Saint-Remi, stained glass may well contribute to the understanding of the chronology of a building.

Two additional points merit consideration. First, the glass could have been completed and installed with a roof in place but before the construction of vaults, since removing and replacing stained-glass windows presents little difficulty; they could have been accessed from an exterior passageway as at Saint-Remi, or by using the scaffolding built for the vault construction. However, at Saint-Remi, the construction of the retrochoir seems to have been carried out rapidly and without interruption, before the construction campaigns of the transept and nave. Second, Caviness's dating of the stained glass

3 Caviness, *Sumptuous Arts*, xix.

demonstrates that such a study can indeed bring to bear a forceful argument to establish the building's chronology, an argument I was unable to benefit from while writing my thesis. Through her technical analyses and stylistic comparisons, Caviness was able to arrive independently at a date for the upper windows of the choir which confirmed the date suggested by architectural study. One can thus affirm that, in the case of the choir of Saint-Remi, research on architecture and on stained glass, two distinct disciplines within the history of art, are complementary.

The stained glass windows of the upper nave illustrate a different example. In 1975, Louis Grodecki maintained that they had been part of the ensemble in the monks' choir, in the eastern bays of the nave, which was built under Abbot Odo (1118–51).[4] It must be noted that these windows were removed and heavily restored during the nineteenth century and, in addition, that the nave itself underwent several changes. To cite just one example, its state in the 1830s was such that it was at first slated for demolition, although ultimately only the vaults were destroyed. Then, when the nave roof burned at the end of World War I, the entire south wall collapsed. What we see there today is in large part a reconstruction. Certain elements of the architecture allow us nonetheless to see that the twelfth-century work proceeded hastily from east to west, with much less care than that given to the work done on the façade and retrochoir. From an architectural point of view, the nave constitutes the final building campaign, completed after the departure of Pierre de Celle.

Caviness sought to identify distinct groups of related windows within the ensemble of glass at Saint-Remi, and to establish an internal chronology among them. From their composition as well as their color, she concluded that five border patterns should be dated prior to 1175. In addition, she argued that two figures in the tribune of the retrochoir could have been executed before the abbacy of Pierre de Celle. The most coherent group is that of the choir clerestory, which Caviness compared to certain windows at Canterbury and which she dated to the same period as the construction, that is, around 1175–81.

The windows of the nave clerestory appear to be more recent. The same cartoon was reused seven times for the few figures of kings that have survived, demonstrating the same hasty work seen in the architecture.[5] Further, the drapery in the clothing of these figures resembles that of work dated to the beginning of the thirteenth century, most notably its large trough folds (*grands plis coudés*) also found at Saint-Yved of Braine. Similarly, the figures' hair flows freely rather than tightly hugging their heads. Comparisons with stained glass from Braine and Canterbury indicate a date later than the other windows of the abbey church. Several of the figures at Canterbury seem to have served as models, and the same artist may have worked both in England and at Reims. In sum, the technical and stylistic analyses of the stained glass of the nave lead

4 Louis Grodecki, 'Les plus anciens vitraux de Saint-Remi de Reims,' in *Beiträge zur Kunst des Mittelalters. Festschrift für Hans Wentzel zum 60. Geburtstag* (Berlin, 1975), 65–77.

5 Caviness, *Sumptuous Arts*, 125.

to the same conclusion as the architectural study: the height of the nave was raised and the vaulting added last.[6]

The nave of Saint-Remi, then, through its reconstructions at the end of the twelfth century, was built later than the choir. This relative chronology is of interest in a broader context. For the history of art, the chronology of the construction of a building is always important, since it allows through comparison a better understanding of the artistic milieu of the era, of the contacts among patrons, the circulation of models, and the movements of artists. Further, when they lack documentary sources, historians often refer to works of art as a point of reference; such documents have little value if they are not clearly dated.

Thanks to the complementary studies of architecture and stained glass, it appears that the stained-glass windows of the nave of Saint-Remi depicting the kings of France are the oldest surviving windows to sacralize royal power in the interior of a church. The appearance of Germanic emperors at almost the same moment in the windows of Strasbourg Cathedral is surely no coincidence. After the Investiture Controversy and the murder of Archbishop Thomas Becket, a new ideology was elaborated to reconcile lay and ecclesiastic powers. At Saint-Remi, however, the kings occupy a lesser place in the hierarchy—that is, in the nave, whereas the Church is glorified in the choir.

The art historical situation at Saint-Yved of Braine provides a different case for the complementary methodologies of architecture and stained glass. The church is partly contemporaneous with the Remois abbey and Caviness treated the windows of the two buildings in a single book because of their temporal and geographic proximity—they are about thirty-five kilometers apart—and because of their common stylistic links with the stained glass of Canterbury Cathedral, the subject of her first major study.[7] Saint-Yved, which today is without its western section, was the church of an abbey of Premonstratensian canons, founded around 1130 by André de Baudement, seneschal of the Count of Champagne, and his wife Agnes of Braine. Their granddaughter, Agnes II of Braine, was married in 1152 to a brother of King Louis VII of France, Robert I of Dreux. It was this couple, at one time represented as donors at the feet of the Virgin in the axial window of the church, who built the current church. The date of the beginning of work is not certain; only the date of Robert of Dreux's death, 1188, has been securely established.

Caviness believed that construction on Saint-Yved might have begun in 1176 or 1179, because at the latter date the couple founded a Mass in memory of Henry of France, Robert's brother and Archbishop of Reims, deceased in 1175.[8] However, this Mass could also have been celebrated for a time in the first abbey

[6] Prache, *Saint-Remi de Reims*, 42–43 and 75.

[7] Madeline H. Caviness, *The Early Stained Glass of Canterbury Cathedral, circa 1175–1220* (Princeton, 1977); and Madeline H. Caviness, *The Windows of Christ Church Cathedral, Canterbury*, Corpus Vitrearum Medii Aevi Great Britain 2 (London, 1981).

[8] Caviness, *Sumptuous Arts*, 69. For the architecture, see also Bony, *French Gothic Architecture*, 172–78; Kimpel and Suckale, *Die gotische Architektur*, 266–69 and 511–12; and Sauerländer, *Siècle des cathédrales*, 146–65.

church, certainly a more modest structure than the present monument. In addition, eight years after the publication of Caviness's book, Dany Sandron published an important study of the cathedral of Soissons, located about fifteen kilometers or six-and-a-half miles from Braine, arguing convincingly for the influence of the cathedral workshop on that of the abbey.[9] Following Bruno Klein, Sandron recognized two campaigns of construction in the church of Saint-Yved, the first comprising the choir and transept, and the second the nave.[10] The builders of the first campaign at Braine came from the workshop responsible for the lower parts of the chevet of Soissons Cathedral: they used the same methods of construction and even the same templates for the moldings, and the identical masons' marks are found at both churches. Thus, it seems more likely that, if Robert of Dreux and Agnes of Braine had planned a new church at Braine, it was Agnes who initiated it following the sudden death of her husband in the Dauphiné, as he was apparently leaving to join the third Crusade. This decade's change of date, however, has only a minor effect on the study of the stained glass of Saint-Yved.

The great question that these windows pose above all is that of their identification, since not a single panel remains *in situ* in Braine. Caviness had to carry out extensive research to trace the modern history of the windows, which were still visible in the church in the eighteenth century, but which were taken in the nineteenth century to the cathedral of Soissons to fill gaps in its glazing. Most were subsequently removed, dispersed, and partially destroyed.[11]

In order to reconstruct the iconographic program of the stained glass of Saint-Yved, Caviness made use of descriptive documents and, for the upper windows, called again on comparisons with the windows of Canterbury. She was able to locate the roses in relationship to more or less similar work at Laon, Paris, and Lausanne. In contrast to Saint-Remi, there was no biographical evidence on which to fix a chronological point since, as Caviness notes, the effigy of Robert of Dreux 'was certainly commemorative, whereas Agnes's might have been placed there in her lifetime.'[12] The exact date of Agnes of Braine's death is not known for certain, but can be placed securely between 1204 and 1208.[13] The countess who had been the benefactor of the abbey was buried in the center of the canons' choir, without a date inscribed on her tomb.[14] The first campaign of construction, the choir and transept, must have been completed by that time, while the nave might still have been under construction.

[9] Dany Sandron, *La cathédrale de Soissons, architecture de pouvoir* (Paris, 1998), 196–99. This study shows that Soissons Cathedral was begun prior to that of Chartres, contrary to previous opinion. See also Kimpel and Suckale, *Die gotische Architektur*, 261–62 and 543.

[10] Bruno Klein, *Saint-Yved in Braine und die Anfänge des hochgotischen Architektur in Frankreich*, Veröffentlichung der Abteilung Architektur des Kunsthistorischen Instituts der Universität zu Köln (Cologne, 1984).

[11] Caviness, *Sumptuous Arts*, 78–97 and 150–51.

[12] Caviness, *Sumptuous Arts*, 85.

[13] Caviness, *Sumptuous Arts*, 73–74.

[14] Anne Prache, 'Saint-Yved de Braine,' *Congrès archéologique de France* 148 (1990): 105–18, esp. 106–7.

Does this mean that the study of the stained glass of Braine has no bearing on our knowledge of the church's architecture? It would be an error to believe so. First, the comparisons suggested by Caviness show clearly that the building was decorated at the very end of the twelfth century or at the beginning of the thirteenth. And these comparisons indicate contacts independent of Paris, discerned by Jean Bony some time ago, along the route between Canterbury and Lausanne which passed through northeastern France and, notably, through Braine.[15] In addition, and perhaps more importantly, the reconstruction of the glazing program allows one to imagine the effect of its strong color on the interior, and the spiritual vision which emanated from it. Caviness evoked these qualities in her conclusion: 'Impressive ranks of enthroned ancestors now float in the upper zone, motionless and dignified yet subtly indicating the east where the Virgin [first seen in the sculpture above the western portal] appears again, this time with the Child though already enthroned in heaven ... From the vantage point of the crossing comes the breathtaking view of the three great wheel windows that protect the north, south and west ... Other windows crowd close to the viewer so that one could almost touch the precious gems that fill them.'[16] Thanks to this study, the architecture of Saint-Yved, rather brittle and cold as it appears now, comes to life.

Caviness is sensitive to the monumental structure of the church and to the remains of its remarkable sculpted decor. Like architectural historians, she has gathered together all the historical clues and has researched the placement of altars, and of the canons' choir and its enclosure, in order to define the liturgical spaces. At Saint-Remi of Reims and at Saint-Yved of Braine alike, the church forms a whole. Although various experts dissect the construction, the sculpted decor, the stained glass—each one according to their discipline—they all contribute to a greater understanding of the whole. Caviness's book magnificently completes what has been written about the history and architecture of the two churches. It seems clear that no historian can broach the subject of a building like Saint-Savin without evoking its wall paintings; for stained glass, the question is more delicate, since the glazing has often been destroyed or moved. Saint-Yved is an exemplary witness and confirms that the studies of stained glass and architecture are at the same time distinct and complementary.

[15] Jean Bony, 'The Resistance to Chartres in Early Thirteenth-Century Architecture,' *Journal of the British Archeological Association* 20–21 (1957–58); 35–52; Robert Branner, in *Burgundian Gothic Architecture* (London, 1960), esp. 50–62 where he elaborated on Bony's ideas.

[16] Caviness, *Sumptuous Arts*, 96–97.

The Integrated Cathedral: Thoughts on 'Holism' and Gothic Architecture

Paul Crossley

In her classic study of the stained glass of Saint-Remi at Reims and Saint-Yved at Braine, Madeline Caviness issued a warning to all those bent on dismantling the barriers between media in the study of the liturgical art of the medieval Great Church. Stained glass, she rightly argued, was an integral part of all the other 'sumptuous arts' which decorated and gave meaning to the whole church; but equally, these 'arts,' gathered together in the *Gesamtkunstwerk* of the cathedral, were not the coherent product of a single intelligence. 'The inference,' she warned, 'that they were the result of a sustained programmatic intention made me uneasy, and it is one I have wished to avoid.'[1]

The caution is timely, for the recent resurgence of interest in the Gothic cathedral as a 'holistic' experience—a resurgence directly inspired by Caviness's pioneering contextual histories of medieval stained glass—carries with it possibilities both self-evident and elusive. The broad term 'holism' runs a gamut of logical categories from the multi-media (the integrated analysis of all medieval art forms within the ordering and sheltering framework of the cathedral) to the multi-discursive (the 'webs of significance'[2]—human, artistic and ideological— within which the cathedral was produced and understood). There are points of general agreement in this modern holistic agenda: to treat the great cathedrals, especially those in northern France constructed from the mid-twelfth to the mid-thirteenth century, as totalities of glass, sculpture, architecture, and *ars sacra*, and to beware of the dangers of unitary explanation, for the cathedral was not the product of an all-encompassing blueprint. The belief in some unitary and unifying 'program,' informing all aspects of the cathedral's imagery and

Author's note: I am pleased to thank Paul Binski, Sandy Heslop, Alexandra Gajewski, Claudine Lautier, Kate McCarthy, and Jochen Schröder for help in the preparation of this paper, and the Chancellor and Vice-Chancellor of the University of East Anglia for inviting me to give a version of it as the Andrew Martindale Memorial Lecture for 2004.

[1] Madeline Caviness, *Sumptuous Arts at the Royal Abbeys in Reims and Braine: Ornatus Elegantiae, Varietate Stupendes* (Princeton, 1990), xix.

[2] I borrow the term, coined by the American anthropologist Clifford Geertz, from Paul Binski, *Becket's Crown: Art and Imagination in Gothic England 1170–1300* (New Haven, 2004), xii.

performance, and expressive of a wider cultural order, both political and ideological, is a mirage—what Caviness, in a seminal paper on artistic integration, called 'a structuralist and formalist construct.'[3] The Gothic Great Church was not the reflection of a romantic world order, in which all aspects of a culture merged into a harmonious *Gesamtkunstwerk*. But these points of agreement hardly conceal the complexities of the cathedral's prolix imagery and its relations to other medieval discourses—pilgrimage, power, propaganda, and liturgy. Such interconnections continue to elude complete diagnosis. Cathedrals may have been *summae*, but in reconstructing their original installations, and their cultural connotations, they continue to defy summation.

At least two impediments to this project of holistic understanding were outlined in an important collection of essays published in 1995 under the title *Artistic Integration in Gothic Buildings*.[4] The first is hermeneutic. A full holistic reconstruction of these buildings is doomed in most cases because the evidence for such total pictures simply does not exist. The great churches of medieval Europe have suffered so drastically from the interventions of decay and changing fashion, that the 'text' of the cathedral—its screens, glass, images, shrines, altars, liturgies, as well as its context; the mentalities of its patrons, adversaries, users—are lost to us. As Willibald Sauerländer warned us in his introductory essay to the book, there is no way back to the *real* Gothic cathedral, to the *real* twelfth-century audience, or to any kind of medieval wholeness, if ever such a thing existed.[5] The second obstacle to holistic interpretation is the relentless specialization of modern art history—indeed of the humanities as a whole. Architectural historians, stained-glass experts, sculpture specialists each have their own regimes and supporting institutions. We all suffer from what Aby Warburg called 'the restrictions of the border police.' But there has been a third impediment in the path of holistic understanding, which studies in 'Gothic integration' have been less willing to acknowledge, and which this article will review in some detail: 'holistic' scholarship itself. From the closing years of the nineteenth to the middle of the twentieth century, two related intellectual disciplines—iconography and cultural history—established models for a synthetic view and integrated understanding of the cathedral. The iconographic impetus came first from the later nineteenth-century *renouveau catholique* of Huysmans, Peguy, and Emile Mâle in France, while the model of cultural history can be traced back to post-Hegelian notions of 'style' propounded by Riegl, Wölfflin, and Frankl, in which style, or its psychological equivalent, *Kunstwollen* or *Weltanschauung*, was identified as the index and motor of all manifestations of a unitary culture.[6] Despite the intellectual energy

3 Madeline Caviness, 'Artistic Integration in Gothic Buildings: A Post-Modern Construct?,' in *Artistic Integration in Gothic Buildings*, ed. V. C. Raguin, K. Brush, and P. Draper (Toronto, 1995), 249–61, esp. 256.

4 See n. 3 above.

5 Willibald Sauerländer, 'Integration: A Closed or Open Proposal?' in *Artistic Integration*, 3–18, esp. 9.

6 The 'renouveau catholique,' and particularly the work of Emile Mâle, is discussed by Sauerländer, 'Integration,' 7–8. See also Elizabeth Emery, *Romancing the Cathedral: Gothic*

both traditions brought to the problem of holism, neither ignited a long-term interest in the cathedral as an entity. They remained isolated forays—some of such distinction that they blocked the path of advance. Many of these works now belong to the dustbin of art historical method; some still linger in the twilight world of university art history courses on 'methodology.' But they are worth pursuing in some detail at this stage, partly because they form the intellectual ancestry of modern holism, and partly because they acted as the target orthodoxies, the flawed edifices, against which recent scholarship has reacted with critical vehemence. They are fruitful coefficients of friction.

It is hardly surprising that the first and most successful investigations into the ordered meaning of the cathedrals took place in the discipline of iconography, the study of the meaning of images. The Gothic cathedral witnessed an explosion of imagery on a scale never seen before in Western art, and unmatched until the nineteenth century ushered in Walter Benjamin's 'age of mechanical reproduction.' This teeming multiplication of images was accompanied by a rigorous sense of order.

'The Middle Ages had a passion for order': with this lapidary sentence Emile Mâle opened his magisterial account of the figural art of France in the thirteenth century, first published in 1898, the first volume of a monumental trilogy on the history of French art in the Middle Ages.[7] The work itself resembles both a vast cathedral and a medieval *summa*, for Mâle organized his chapters according to Vincent of Beauvais's thirteenth-century encyclopedia, the *Speculum Majus*, and he treated all art forms—glass, sculpture, wall, and manuscript painting— as a sacred visual book which could be deciphered with the help of patristic texts, biblical quotations, miracle plays, and liturgical hymns. These myriad images stood as encyclopedic visual texts for the literate and illiterate, but they found their proper place in a codified and harmonious whole: the public and unifying ambience of the cathedral. Mâle's compendia placed the cathedral at the centre of medieval life and spirituality.

It was, and is, a poetically beautiful vision, and its particular insights have been followed gratefully by all iconographers of medieval art, right up to the present day. But it is ironic that Mâle's wider legacy left his cathedral—and with it the whole notion of the integrated Great Church—in fragments. His method was so successful, his erudition so persuasive, that he helped inaugurate the new discipline of iconography, and with it another discourse of specialization. His followers classified and identified images, discussed their pious meanings, decoded their subject matter in terms of typology and

Architecture in Fin-de-Siècle Culture (New York, 2001), esp. 34–35, 41–42, and 146–49. Paul Frankl's intellectual ancestry is set out in my introduction to Paul Frankl, revised by Paul Crossley, *Gothic Architecture* (New Haven, 2000), 7–31.

7 Emile Mâle, *L'Art religieux du XIIIe siècle en France. Etude sur l'iconographie du moyen âge et sur ses sources d'inspiration* (Paris, 1898); or Emile Mâle, *Religious Art in France, The Thirteenth Century: A Study of Medieval Iconography and Its Sources*, ed. Harry Bober, trans. Marthiel Matthews, (Princeton, 1984). The other two volumes were: *L'art religieux du XIIe siècle en France. Etude sur l'origine de l'iconographie du Moyen Age* (Paris, 1922); and *L'art religieux de la fin du moyen âge en France. Etude sur l'iconographie du moyen âge et sur ses sources d'inspiration* (Paris, 1908).

hagiography, but they had little of Mâle's genius for synthesis. Their horizons were limited to a learned, often esoteric, cryptography. Iconography, which in the hands of its pioneers—Mâle in France, Aby Warburg and Erwin Panofsky in Germany—had held out the dream of locating art in a vast repertory of cultural expression, soon retreated into a technique for deciphering subject matter in terms of a notional primary 'text' or program. To read Adolf Katzenellenbogen's monumentally learned exegesis on the sculpture of Chartres, written in the 1940s, is to feel transported, not to the thirteenth-century cathedral in all its multiplicity and color, but to the abstractions of the theological seminary.[8]

But the critics of Mâle and his followers questioned not just the limitations of iconography, but the theoretical premises of the whole discipline. For the Parisian deconstructionists of the 1960s and 1970s, Mâle's overt Catholicism and French nationalism represented everything they most cordially loathed about medievalist scholarship: his cathedral did not need broadening; it needed wholesale demolition. Their first target was his great volume on thirteenth-century French art, translated into English under the title *The Gothic Image*.[9] In 1989 the *enfant terrible* of medievalist art history of his day, the late and much-missed Michael Camille, published a comprehensive study of Gothic imagery entitled *The Gothic Idol*. Camille's stated purpose was to 'chip away at the neatly organized foundations of Mâle's cathedral' to 'reveal the ambiguous gaps, inconsistencies and contradictory cracks in what he saw as a supremely codified whole.'[10] Camille's armory of neo-Marxist and French post-structuralist critiques had no difficulty in finding those cracks and prizing them open. We cannot blame Mâle for failing to anticipate post-Saussurean semiotics, but his tendency to see images as secondary reflections of primary texts collided with the semantically fluid world of intertextuality, where art was seen as a text itself, inextricably implicated in other texts, acting as an equal partner with (say) scholastic treatises and liturgical prescriptions in making and expressing meaning. To privilege, as Mâle did, texts over images, was also to privilege literate over illiterate response. And were the cathedrals really the reflections of a harmonious medieval society in all its diversity? The strong whiff of incense and plainchant in Mâle's poetic writing was anathema to the new radicals of the 1970s. Otto Werckmeister and his pupils Jane Welch Williams and Barbara Abou-el-Haj dismissed Mâle's cathedral as the spiritual embodiment of a social and political consensus, and branded it, instead, as a center of power and persecution. The cathedrals, they argued, presided over fractured societies and were themselves causes of social unrest. Behind their harmonious facades, replete with idealized images, bishops and chapters waged war on heretics, Jews, and the recalcitrant inhabitants of their own towns, who, ironically, were

[8] Adolf Katzenellbogen, *The Sculptural Programs of Chartres Cathedral: Christ, Mary, Ecclesia* (New York, 1959).

[9] Emile Mâle, *The Gothic Image: Religious Art in France of the Thirteenth Century* (New York, 1958).

[10] Michael Camille, *The Gothic Idol: Ideology and Image-Making in Medieval Art* (Cambridge, 1989), xxvii.

forced to subsidize these gigantic symbols of oppression. Here, the neo-Marxists argued, was a classic instance of ideology in the Marxist sense, or what Louis Althusser called the 'Ideological State Apparatus': under the guise of universal truth and God-given authority, the cathedral's imagery promoted the values and interests of a clerical and aristocratic ruling class.[11] By failing to note the gap between the myth of the harmonious cathedral and the reality of its social oppression, Mâle, so the history-as-power historians argued, was himself the dupe of ideology. 'All art,' said Walter Benjamin, 'is the art of victors.'

Mâle's cathedral—and with it the whole discipline of iconography—also collided with the attacks on authorial intention launched by Michel Foucault and Roland Barthes in the early 1970s,[12] and their corollary, the growth of reception theory and the interest in audience and response.[13] Traditional iconographers had classified and identified images, but they had shown little or no interest in the functions of these figures, in their placement in the church, or in the kinds of audience they attracted. How were these images used and seen, carried and displayed? 'It is not *what* [images] mean,' said James Marrow in his classic account of Passion iconography, 'it is *how* they mean.'[14] This new world of 'subjectivity,' the space where all texts are potentially inscribed in the mind of the ideal viewer or reader, sees the work of art from, so to speak, 'in front' and not from 'behind.' By ranging across the text to its intertextual allusions rather than penetrating through it to its authorial voice, the idea of subjectivity posed real problems to the traditional idea of creative intention and iconographical meaning. By denying that art keeps its secret about what is 'right,' subjectivity raised the vertiginous vision of post-modern relativism, where all interpretations are more or less valid, since the intentions of the author, as ultimate umpire, are no longer recoverable.[15]

A similar attack on the Romantic notion of the cathedral as the spotless mirror of medieval society came from Michael Camille's invigorating examinations of the marginal in medieval art. For Camille, the cathedral's meaning can be located in the tension—what he might have called 'the contradictory crack'—between its public and official imagery (its saints and biblical narratives) and its marginal figures (its grotesque corbel heads and gargoyles, usually placed on the upper or lower fringes of the building). The relations between the two

[11] Louis Althusser, 'Ideology and Ideological State Apparatuses (Notes towards an Investigation),' in *Lenin and Philosophy and Other Essays* (London, 1971), 121–73.

[12] A convenient introduction to the 'Death of the Author' debates is provided by Catherine Belsey, *Poststructuralism: A Very Short Introduction* (Oxford, 2002), 18–21, 26, 43, and 69; and by Terence Hawkes, *Structuralism and Semiotics* (London, 1977), 106–22.

[13] Hans Robert Jauss, 'History of Art and Pragmatic Theory,' in *Towards an Aesthetic of Reception*, trans. Timothy Bahti (Brighton, 1982), 46–75.

[14] James Marrow, *Passion Iconography in Northern European Art of the Late Middle Ages and Early Renaissance* (Kortrijk, 1979); and James Marrow, 'Symbol and Meaning in Northern European Art of the Late Middle Ages and the Early Renaissance,' *Simiolus* 16 (1986): 150–69, esp. 168.

[15] For a critique of subjectivity and relativism see Paul Boghossian, 'What the Sokal Hoax Ought to Teach Us: The Pernicious Consequences and Internal Contradictions of "Postmodernist" Relativism,' *Times Literary Supplement* (December 13, 1996): 14–15.

polarities, Camille argued, were ultimately one-sided. The official imagery always acted as the policeman, ensuring orthodoxy and social unity, while the marginal figures functioned as the parodic projections of the central; not as subversions of the status quo but as bolsters of its control. The monsters on the fringes were a carnival manipulated by the powerful and serving as a social safety valve.[16] This provocative thesis rescued such marginalia from their prevailing interpretation as the free-spirited doodles of self-expressive craftsmen, and integrated them back to the controlling center. But were those meanings, in Camille's ideology, irreducibly social and political? His Bakhtinian concentration on the profane, the subversive, and the everyday, over and against 'high' ritual, theological texts, and sacred imagery deconstructed Mâle's 'spiritual' cathedral; but it also created a new fragmentation: it split the margins off from the religious and theological life at the centre of the cathedral's existence, and underplayed the theological agencies vital to the integrated workings of the cathedral's imagery.[17] It also suggested that the marginal had its ultimate source in the popular and the subversive, yet at least one creative strand of its life was nurtured by monastic Benedictine communities, and can be traced back to the literary and classical origins of the grotesque genre, in Horace, Virgil, and Boethius.[18] And in the broadest sense, the post-structuralist critique, by promoting the image as resistant to texts, demoted the value of theological doctrine as the source and handmaiden of iconography.[19]

If traditional iconography failed to build a Gothic cathedral consistent with modern critiques, the German dream of a cultural history of art (*Kulturwissenschaft*), in the shape of a total history of the cathedral, attracted little or no modern attention. Paradoxically, its synoptic methods were particularly influential when they avoided grand explanatory systems and confined themselves to isolated manageable problems. In the years following the Second World War, when the brutalities of recent history had made the notion of the spiritual cathedral especially attractive, three German scholars, all of them conditioned by the idea of iconography as iconology—the manifestations of culture in artistic form—set out to integrate Mâle's spiritual cathedral into its wider contexts. In 1951 Erwin Panofsky, in his *Gothic Architecture and Scholasticism*, attempted to link the design of the Gothic cathedrals of France to the 'habits of mind' of contemporary theologians. The reconciling, clear and divisional composition of the Gothic elevation (especially its tracery) expressed

16 Michael Camille, *Image on the Edge: The Margins of Medieval Art* (London, 1992). The theme of interaction between profane and sacred architectures is developed in Camille's 'At the sign of the "Spinning Sow": the "other" Chartres and Images of Everyday Life of the Medieval Street,' *History and Images: Towards a New Iconology*, ed. Axel Bolvig and Phillip Lindley (Turnhout, 2003), 249–76.

17 See Jeffrey Hamburger's review of *Image on the Edge*, in *Art Bulletin* 75 (1993): 319–27.

18 For example, the ceiling painting of the *Ass and Harp* in Peterborough: see Paul Binski, 'The Painted Nave Ceiling of Peterborough Abbey,' in *The Medieval English Cathedral: Papers in Honour of Pamela Tudor-Craig*, ed. Janet Backhouse, *Harlaxton Medieval Studies* 10 (Stamford 2003): 41–62.

19 Jeffrey Hamburger, *St. John the Divine: The Deified Evangelist in Medieval Art and Theology* (Berkeley, 2002), 1.

(for Panofsky) the categorical clarity, logical ordering, and dialectical reasoning of the scholastic habit of mind.[20] A little earlier, in 1946, in an essay on Abbot Suger of Saint-Denis, Panofsky had changed the direction of Gothic architectural studies by launching the highly influential theory that the catalyst in the creation of Gothic lay not in structural experiment, nor stylistic innovation, but in the extensive deployment of stained glass windows saturating a skeletal interior structure with colored light. The first of such glazing ensembles, the choir and ambulatory of the abbey church of Saint-Denis, was, he argued, shaped by Abbot Suger's fascination with the neo-Platonic light theology of the Pseudo-Dionysius the Areopagite.[21] At a stroke, Gothic was transformed from an architecture of structure to an architecture of light, from the creature of the mason to the child of the theologian. Panofsky's thesis became a cornerstone of the most ambitious of these German attempts at synthesis, Hans Sedlmayr's sensational book on the Gothic cathedral—*Die Entstehung der Kathedrale* of 1950, whose 614 pages drew almost every aspect of medieval culture, from furnishings to liturgy, from literature to stained glass, from music to miracle plays, into the transcendent embrace of the cathedral. Sedlmayr's stated purpose was to restore the spiritual significance of the cathedral as a mystical entity—to see it as a 'transcendent vision of our physiological seeing,' where 'presentiment and imagination work together with visual perception to achieve a vision of the whole.'[22] To understand the cathedral as 'the representation of supernatural reality' was the aim of another attempt at integration, itself indebted to Sedlmayr: Otto von Simson's 1956 book on the Gothic Cathedral. Here the broad-brush phenomenology of Sedlmayr's symbolic cathedral was given an historical focus through a concentrated analysis of two Great Churches, Saint-Denis and Chartres, both treated as integrated totalities of all media, and therefore as a 'total experience' (*Totalerlebnis*), whose aesthetic of order and light was deemed to originate in contemporary neo-Platonic theology: the light 'metaphysics' of the Pseudo Dionysius and Augustinian cosmological number harmonies.[23]

None of these German attempts to link the arts of the cathedral to wider cultural processes has stood the test of time. Panofsky (and Otto von Simson) overestimated the influence of the Pseudo-Dionysius on Abbot Suger and his conception of the new Gothic choir.[24] His *Gothic Architecture and Scholasticism* was founded on an ideal, not a historical, conception of the union of Mind and

[20] Erwin Panofsky, *Gothic Architecture and Scholasticism* (Latrobe, 1951).

[21] Erwin Panofsky, ed., *Abbot Suger on the Abbey Church of St.-Denis and Its Art Treasures* (Princeton, 1946).

[22] Hans Sedlmayr, *Die Entstehung der Kathedrale* (Zürich, 1950), 83.

[23] Otto von Simson, *The Gothic Cathedral: Origins of Gothic Architecture and the Medieval Concept of Order* (New York, 1956).

[24] A vividly dismissive case against the influence of the Pseudo-Dionysius was presented by Peter Kidson in 'Panofsky, Suger and St.-Denis,' *Journal of the Warburg and Courtauld Institutes* 50 (1987): 1–17. The most thorough-going demolition of the supposed Dionysian connection is by Christoph Markschies, *Gibt es eine 'Theologie der gotischen Kathedrale'?: nochmals, Suger von Saint-Denis und Sankt Dionys vom Areopag*, Abhandlungen der Heidelberger Akademie der Wissenschaften, Philosophisch-historische Klasse, (Heidelberg 1995): 1.

Art, and, as such, it stands as the swan song of a distinct tradition of nineteenth-century cultural (or critical) history.[25] For Panofsky it was enough to show the architect and the theologian as the exponents of an identical Zeitgeist; no historical evidence was brought to bear to indicate how the abstractions of the schoolroom percolated into the rough world of the masons' lodge. Otto von Simson's concentration on the 'metaphysics of light' underestimated the formal and structural agencies at work in the shaping of Saint-Denis, while his sanguine vision of the building of Chartres as an expression of social consensus was convincingly dismissed by local French historians and neo-Marxist commentators.[26] Sedlmayr's ambitious phenomenology of Gothic, might, at first sight, have seemed the most likely platform for a future history of the holistic cathedral. But it was not a work of iconography in Mâle's sense (it never examined any particular figures or scenes in the cathedral) and it rarely discussed any particular cathedrals—referring instead to *the* cathedral, as a sort of disembodied Platonic absolute—explicitly a vision—behind which its historical contexts—Mariolatry, Scholasticism, neo-Platonism, etc.—floated like an impressionistic backdrop. In fact, Sedlmayr's cathedral, with its faceted surfaces of glass and stone (*Splitterflächen*), its windows seen as 'luminous walls,' its vault shafts growing downwards into the interior, its whole structure not tethered to the ground but floating in space (*schwebend*), belongs as much to the crystalline and non-organic architectural visions of inter-war German Expressionism as to the thirteenth century: to Paul Scheerbart's *Glasarchitektur* of 1914, to Bruno Taut's 1919 *Monument of the New Law*, or to Feininger's beacon-like cathedral on the 1919 cover of the first Bauhaus manifesto—the cathedral of socialism, in which all craftsmen, on the model of the medieval mason's lodge, labored collectively in anonymous cooperation.[27] Sedlmayr's pro-Nazi sympathies may have attracted him to this collectivist, semi-mystical utopia, but they hardly recommended his book to a post-war art historical community traumatized by the Holocaust. His *Gesamtkunstwerk* sank virtually without trace.[28]

[25] E. H. Gombrich, 'In Search of Cultural History' in *Ideals and Idols: Essays on Values in History and in Art* (Oxford, 1979), 24–59, esp. 44–45; Michael Podro, *The Critical Historians of Art* (London, 1982), 199–208; Paul Crossley, 'Medieval Architecture and Meaning: the Limits of Iconography,' *Burlington Magazine* 130 (1988): 116–21, esp. 119–20.

[26] André Chédeville, *Chartres et ses campagnes (XIe-XIIIe s.)* (Paris, 1973); Jane Welch Williams, *Bread, Wine and Money: The Windows of the Trades at Chartres Cathedral* (Chicago, 1993); and Barbara Abou-el-Haj, 'Artistic Integration Inside the Cathedral Precinct: Social Consensus Outside?,' in *Artistic Integration*, 214–35.

[27] The expressionist debt was noted in Willibald Sauerländer, 'Abwegige Gedanken über frühgotische Architektur und "The Renaissance of the Twelfth Century,"' in *Études d'art Médiéval offertes à Louis Grodecki*, ed. Sumner McK. Crosby et al., (Paris, 1981), 176; and Crossley, 'Medieval Architecture,' 118–19. The relations between the idea of the crystalline and expressionist interpretations of Gothic are discussed in Neil H. Donahue, ed., *Invisible Cathedrals: The Expressionist Art History of Wilhelm Worringer* (Pennsylvania, 1995). See also Hans-Joachim Kunst, 'Die Vollendung der romantischen Gotik im Expressionismus, die Vollendung der Klassizismus im Funktionalismus,' *Kritische Berichte*, 7 (1979): 35.

[28] For the ultra-conservative background to Sedlmayr's Strukturforschung, see Wilhelm Schlink, 'The Gothic Cathedral as Heavenly Jerusalem: A Fiction in German Art History,' in

It is a commonplace that each age builds its own Gothic cathedral. The cathedrals constructed in this historiography—those of the first half of the twentieth century, and their later post-modern critiques—have acted both as warnings and starting points for contemporary forays into 'holism': T. A. Heslop on the Angel Choir at Lincoln (1990), Madeline Caviness on Saint-Remi and Saint-Yved at Braine (1989), Paul Binski on Westminster Abbey (1995), Andreas Köstler on Saint Elizabeth's at Marburg (1995).[29] Despite their diversity of approach, all these investigations share a common agenda. They ignore the specialist boundaries of media and concentrate on the totality of the church's art forms and activities; they recognize that the cathedral is not a secondary reflection of a primary text, but an object which constitutes, as well as embodies, discursive practices; they are particular in focus, rejecting Sedlmayr's dream of a Wagnerian *Gesamtkunstwerk* as at once too inclusive and too imprecise: the 'total cathedral' is a mirage unless we understand the particular structures of connection and agency which bind together its component parts. For that reason any attempt at integration must start with the irreducible work of art itself—not *the* cathedral but *a* cathedral (hence the monographic format of many of these studies). And the meaning of the marginal figure—an issue of particular importance for a definition of what kind of order the cathedral's imagery proposed—is now being seen, not in opposition to theological discourse, but as an extension of it, at a lower level of decorum: the zodiac signs on the Saint-Remi pavement belong to the basic strata of a world order;[30] the grinning masks in the upper parts of Reims cathedral participate in the same rediscovery of the human and the sentient as the smiling angels beneath them.[31] My particular interest in the holistic cathedral concerns what might be called its sacred topography—the images and installations which form meaningful relations in the cathedral's space. How and why was a complex set of relationships between altars, relics, images, and the pathways between them set up in the cathedral? How were these nodal points joined by what might be called 'axes of meaning'? How do we recognize what Pamela Graves called the 'cognitive maps' of the church?[32]

The Real and Ideal Jerusalem in Jewish, Christian and Islamic Art: Studies in Honor of Bezalel Narkiss on the Occasion of his Seventieth Birthday, Journal of the Center for Jewish Art, Jerusalem, 23/24, ed. Bianca Kühnel (Jerusalem, 1997–98), 275–85. A more balanced assessment of his career is given by Eva Frodl-Kraft, 'Hans Sedlmayr (1896–1984),' *Wiener Jahrbuch für Kunstgeschichte* 44 (1991): 7–64, esp. 27–28.

[29] T. A. Heslop, 'The Iconography of the Angel Choir at Lincoln Cathedral,' in *Medieval Architecture and Its Intellectual Context: Studies in Honour of Peter Kidson,* eds. Eric Fernie and Paul Crossley (London, 1990), 151–58; Caviness, *Sumptuous Arts*; Paul Binski, *Westminster Abbey and the Plantagenets: Kingship and the Representation of Power 1200–1400* (New Haven, 1995); Andreas Köstler, *Die Ausstattung der Marburger Elisabethkirche. Zur Ästhetisierung des Kultraums im Mittelalter* (Berlin, 1995).

[30] Caviness, *Sumptuous Arts*, 38–39.

[31] Paul Binski, 'The Angel Choir at Lincoln and the Poetics of the Gothic Smile,' *Art History* 20 (1997): 350–74; Paul Binski, *Becket's Crown*, 233–59.

[32] C. P. Graves, 'Social Space in the English Medieval Parish Church,' *Economy and Society* (1989): 297–322, esp. 309.

A test case for plotting such 'holistic' pathways in the cathedral is provided by Chartres Cathedral, whose near-complete ensemble of architecture, sculpture, and painting invites investigation as an integrated undertaking. An article of this kind is not the place to dilate on the web of interconnections between imagery, liturgy, and space at Chartres, uncovered recently by—among others—Peter Kurmann and Brigitte Kurmann-Schwarz, Claudine Lautier, Johannes Tripps, and Madeline Caviness herself.[33] But certain general conclusions about the nature of present-day holism can be drawn conveniently from this rich body of published research, and my own attempts at cognitive mapping can be briefly directed towards what once stood at the literal and metaphorical crux of the cathedral: the now-vanished choir screen.

The semantic topography of Chartres Cathedral seems to have been created out of subtle and self-conscious coordinations between simple ingredients— altars, relics, images, and liturgies. For example, the imagery of the stained-glass window is used, almost like a retable, to mark the dedication of the altar beneath it and to advertise the presence of the relics of the saint in the cathedral's possession. As Lautier has shown, the windows depicting the lives of certain saints correspond remarkably closely to Chartres's possession of their relics, so that iconographical choice depended on the need to advertise the prestigious contents of the cathedral's treasury.[34] Secondly, the periodic emphases of the liturgy of a saint's feast underlines their imagery, their altars and their relics. The new Chartres Ordinal, written between about 1225 and 1235, a few years after the installation of the liturgical choir in 1221, promotes certain saints from their humbler, or nonexistent, status in the twelfth-century Ordinal, and allows them to play a significant role in the imagery of the new church and its enlarged relic collection.[35] Finally, images of certain saints which appear in the portals—the *lapides vivi* of St Peter's first Epistle (2.46)—act, for

33 Peter Kurmann and Brigitte Kurmann-Schwarz, 'Chartres Cathedral as a Work of Artistic Integration: Methodical Reflections,' in *Artistic Integration*, 131–52; Brigitte Kurmann-Schwarz and Peter Kurmann, *Chartres. La cathédrale*, trans. Thomas de Kayser, (Saint-Léger-Vauban, 2001); Claudine Lautier, 'Les vitraux de la cathédrale de Chartres. Reliques et images,' *Bulletin monumental* 161 (2003): 3–96; Johannes Tripps, *Der handelnde Bildwerk in den Gotik. Forschungen zu den Bedeutungsschichten und der Funktion des Kirchengebäudes und seiner Ausstattung in der Hoch- und Spätgotik* (Berlin, 1998); Madeline Caviness, 'Stasis and Movement: Hagiographical Windows and the Liturgy,' in *Stained Glass as Monumental Painting, Proceedings of the 19th International Colloquium of the Corpus Vitrearum Medii Aevi*, ed. Lech Kalinowski, Helena Malkiewicz, and Pawel Karaszkiewicz (Kraków, 1998), 67–79. Madeline Caviness, 'Episcopal Cults and Relics: The Lives of Good Churchmen and Two Fragments of Stained Glass in Wilton,' in *Pierre, lumière, couleur. Études d'historie de l'art du Moyen Âge en l'honneur d'Anne Prache*, ed. Fabienne Joubert and Dany Sandron (Paris, 1999), 77–87. Madeline Caviness, 'Stained Glass Windows in Gothic Chapels, and the Feasts of the Saints,' in *Römisches Jahrbuch der Bibliotheca Hertziana: Kunst und Liturgie im Mittelalter*, ed. Nicolas Bock, Sible de Blaauw, Christoph Luitpold Frommel, and Herbert Kessler, *Akten des internationalen Kongresses de Bibliotheca Hertziana und des Nederlands Instituut te Rome, Rom, 28–30 September 1997* (Munich, 2001), 135–48.

34 Lautier, 'Les vitraux.'

35 For example, SS. Lubin, Piat, Matthew, Lawrence, Thomas, Denis, Bartholomew, and the 'new' saints: Thomas Becket, Anne, Catherine, Blaise. See Lautier, 'Les vitraux,' 17–19; and Yves Delaporte, 'L'ordinaire chartrain du XIIIe siècle,' *Mémoires de la Société archéologique d'Eure-et-Loire* XIX (1952–53): 1–297.

the visitor, as animate preparations for the altars, images, and relics of those same saints in the interior. Kurmann and Kurmann-Schwarz point to an eloquent series of such links between the south transept portals and porches (a main entrance to the cathedral, facing the largest open space around the church, the site of cathedral fairs)[36] and the immediately adjoining south aisle of the choir. They also draw our attention to the themes of the three south transept portals (Martyrs-Apostles-Confessors), and their conscious repetition in the dedication of the three large radiating chapels of the choir.[37]

These hagiographical pathways found their center at Chartres in the choir screen, demolished in 1763 but reconstructable from pre-eighteenth-century views and from sculpted fragments. Standing at the east of the crossing, at the iconographic crossroads of the interior, the screen was, to borrow Eamon Duffy's formulation, 'a barrier and no barrier.'[38] Its three-tiered imagery, with an Incarnation cycle at the top (rare in screens) and a Passion (?) cycle below it, both supporting the central Rood, emphasized the eucharistic significance of the high altar it concealed.[39] And it linked some of the most powerful images at the dominant extremities of the cathedral. Its upper panels, showing the Birth of Christ, the Annunciation to the Shepherds and the Presentation in the Temple, consciously echoed those same scenes—with their overtones of eucharistic sacrifice and divine entrance into the church and the world—on the right hand tympanum of the twelfth-century west facade (below 51; for this and subsequent references to windows, see fig. 11.3). And, in turn, the screen's infancy cycle linked the enthroned Mother and Child, the *sedes sapientiae* which dominates that tympanum, with the intentionally similar image of the Virgin and Child enthroned above the eucharistic bread in the axial window of the sanctuary's clerestory, above the high altar (bay 100).[40] All three sets of images—west portal, screen, axial clerestory—marked out the three critical stages in the procession which passed along the full length of the cathedral when the bishop made his solemn entrance into the church on the major feasts of the liturgical year. As Margot Fassler has shown, the Introit tropes used for the bishop's entrance processions—particularly for the feasts of the Nativity, Epiphany, and

36 Williams, *Bread, Wine and Money*, 38–89.

37 Kurmann and Kurmann-Schwarz, 'Chartres Cathedral,' and *Chartres*, 143–50.

38 Eamon Duffy, 'The Parish, Piety and Patronage in Late Medieval East Anglia—The Evidence of Rood Screens,' in *The Parish in English Life 1400–1600*, ed. Katherine L. French, Gary G. Gibbs, and Beat A. Kümin (Manchester, 1997), 133–62. For the screen as both exclusive and inclusive see Jacqueline E. Jung, 'Beyond the Barrier: the Unifying Role of the Choir Screen in Gothic Churches,' *Art Bulletin* 82 (2000): 622–57. The handiest guide to the Chartres screen is Jean Mallion, *Le jubé de la Cathédrale* (Chartres, 1964).

39 Mallion, *Le jubé*, 56–59, identified the two registers below the Infancy as the Last Judgment. In her unpublished MA dissertation, Kate McCarthy identified fragments of the screen in the crypt lapidarium as a Harrowing of Hell and an Entry into Jerusalem, see 'Both a Barrier and No Barrier,' *The Jubé of Chartres Cathedral* (MA dissertation, Courtauld Institute of Art, 1998), 21–22. Equally eucharistic was the Agnus Dei rosette decorating the back wall of the screen, and placed below the Rood, on the central location above the screen door leading from transept to choir.

40 For the eucharistic character of the bread in this window and elsewhere in the cathedral, see Williams, *Bread, Wine and Money*, 37–72.

Presentation—underline precisely the themes of the western portals he traversed: prophecy, God's descent to earth, the 'throne of his kingdom,' Simeon and Anna who saw what they had prophesied.[41] The Introit hymns, like the portals, celebrate procession, prophecy, entering. But the connections of imagery and processional liturgy need not stop at the west portal. By the same token, these tropes must have set up resonances with the almost identical imagery of the screen (a second façade portal), through which the bishop and procession passed on their way to the sanctuary. Just as the Chartres jubé was exceptional in the early and mid-thirteenth century in giving pride of place to Incarnation iconography when most other choir screens favored the Passion,[42] so Chartres preserved its proper Introit trope repertory well into the thirteenth century, considerably after most other churches in France had abandoned the genre.[43] West portal, screen, and high altar are integrated not only through repetitive images, but by a liturgical action which physically links them, and amplifies their iconography of entrance and Incarnation.

A similar 'map,' but this time marking out a possible pilgrimage route and not a liturgical path, may be found around the north transept, where, not fortuitously, most of the cathedral's Infancy of Christ imagery is concentrated, and where, once again, the screen seems to act as a kind of transitional lever, though here in a north-south, not a west-east, direction. Critical in this sequence is the presence of the popular wooden cult statue of the Virgin, Notre-Dame-sous-Terre, a kind of *sedes sapientiae* enthroned figure of the type just seen on the right hand west portal and in the axial clerestory window. It was placed in a chapel at the eastern end of the long north aisle of the Romanesque crypt, a chapel built on one of the most venerable sites in the history of Chartres, the setting of the mythic Druids' well, where Chartres's first martyrs met their death.[44] Pilgrims visiting this holiest historical site would have walked along the north crypt corridor, venerated the image in the chapel, and—if they then wished to move into the cathedral above—could have exited from a door in the western flank of the north transept porch, where they would have been greeted by the standing paired figures of St Potentien and St Modeste, both early Christian local saints, the former supposedly imprisoned on the site of the crypt, the latter thrown into its well.[45] Once again, the saints remembered within the church come alive in their images outside it. From this point, the entrance to the cathedral would have been either through the central portal of the north transept, with its trumeau figure of St Anne and the Virgin, and its

[41] Margot Fassler, 'Liturgy and Sacred History in the Twelfth-Century Tympana at Chartres,' *Art Bulletin* 75 (1993): 499–520.

[42] Bourges, Strasbourg, Gelnhausen, Mainz, Naumburg, and Amiens.

[43] Fassler, 'Liturgy and Sacred History,' 504.

[44] A good summary of the rich literature on this figure can be found in Lautier, 'Les vitraux,' 19 and 36–37. On the relationship of sculpture and pilgrimage at Chartres, see also L. Spitzer, 'The Cult of the Virgin and Gothic Sculpture: Evaluating Opposition in the Chartres West Facade Sculptural Frieze,' *Gesta* 35 (1994): 135–50.

[45] For St Potentien see Lautier, 'Les vitraux,' 24, 37, and 52; for St Modeste see Lautier, 'Les vitraux,' 37 and 52. See also Charles Challine, *Recherches sur Chartres, transcrites et annotées par un arrière-neveue de l'auteur* (Chartres, 1918), 114–17.

Coronation of the Virgin in the tympanum above or, more probably, via the left hand infancy portal. Once inside the north transept the theme of the Virgin, the Infancy, and St Anne would have been repeated insistently. The standing figure of St Anne and the Virgin is reiterated in the central lancet of the north transept terminal window with the apotheosis of the Virgin in the rose above it (bay 121); windows with infancy themes dominate the north transept and crossing space (bays 115, 125, 127, and 114). The Annunciation to Joachim and the Meeting at the Golden Gate (bay 125) look down on the same theme carved in sculpture on the north, return, side of the jubé.[46] At this point it seems as if the narrative of the Infancy on the jubé, read from left to right, would have carried the viewer across the crossing space, terminating on its southern face with the Flight into Egypt—a theme repeated in glass in the choir clerestory directly above (bay 114). The Virgin cycle in the glass returns in the south aisle of the choir, with scenes from the life of the Virgin at bay 28, directly to the left of one of the most popular cult images of the Virgin, another *sedes sapientiae*— the famous Notre-Dame de la Belle Verrière (bay 30), in front of which stood the altar of Our Lady of the Snows, placed against the westernmost pillar of the southern choir aisle.[47] From here it is a short step to the southern gates of the choir, and the Virgin's feretory behind the high altar.

This is a putative reconstruction of a pathway, deduced solely from the imagery itself,[48] but as a way of traversing a space guided by imagery it finds some circumstantial confirmation in a similar interior sequence in the cathedral of Strasbourg. In his treatise on memory, *Ars memorativa*, published in 1523, Laurent Fries, an early sixteenth-century Strasbourg humanist and preacher, used the jubé of Strasbourg Cathedral, a jubé stylistically very close to Chartres's, as a locus for memory sequences. By mentally 'walking though' twenty-four familiar stations in the cathedral, from the north transept to the nave via the screen, and connecting letters words, phrases, or images to each, Fries's memory system could recall complex sequences of thought and association.[49] The very similar Chartres sequence may be seen as another kind of mnemonic, throwing up sets of sequential associations and conjunctions, but this time enacted in real, as well as mental, space.

The Chartres jubé acted not only as a link in a long axis or a lever in a transverse progression; it also formed an appropriate background for liturgical theatre. The annual Nativity play, which took place in the nave, and probably in front of the screen, reenacted all the major episodes of the Infancy in the Gospels, episodes permanently displayed in the 'stage scenery' of the jubé.[50]

46 McCarthy, *Both a Barrier*, 21, identified figures in the lapidarium which show this theme, and which would therefore have been positioned at the beginning of the narrative of the infancy, on the short northern face of the screen.

47 Lautier, 'Les vitraux,' 21.

48 I owe much of this reconstruction to the insights of Kate McCarthy, *Both a Barrier*, 37–47.

49 Jean Michel Massing, 'Laurent Fries et son "Ars memorativa"': la cathédrale de Strasbourg comme espace mnémonique,' *Bulletin de la cathédrale de Strasbourg* 16 (1984): 69–78.

50 Karl Young, *The Drama of the Medieval Church* (Oxford, 1933), 1:2–10, 90, and 176–78.

The Chartres ordinals are silent on the use of imagery for the feast of the Assumption,[51] but if the liturgy for the feast celebrated from at least 1198 in the collegiate church of Our Lady at Mantes was substantially the same as that for Chartres (and as the principal shrine of the Virgin in France something similar is likely to have occurred at Chartres) then the screen formed the mis-en-scène for elaborate theatricals. On the vigil of the Assumption, according to the Mantes liturgy, a gilded and painted statue of the Virgin was lowered by ropes from the vaults. On the same day, her Dormition and Assumption *corporis et anima* was enacted by similar sculpted and assembled statues floating down from, and rising into, the vaults: the Virgin passing away in the company of the Apostles; her soul conducted upwards by Christ himself; her soul brought out of heaven by the Archangel Gabriel and joined to her body, thence both to be reassumed, finally, into heaven.[52] A fifteenth-century reference notes a procession at Chartres, after Terce on the feast of the Assumption, holding its last station in front of the screen. This suggests that these literal ascensions and descensions took place at Chartres in front of the screen and under the crossing, an inference confirmed by the presence of a large 'heaven hole' (or *Himmelsloch*) at the center of the crossing vault.[53] Once more, the screen acted as the crux of a synaesthetic experience.

Such holistic interpretations of imagery as markers in sacred maps by no means exhaust the 'webs of significance' which envelope the cathedral. On the contrary, there is a danger that they can be imposed, like some ideal schema, on the real historical and social space of the Great Church. Integration of imagery has to go hand in hand with integration of historical and social context. Questions of order presuppose questions of control. Who founded these altars and windows? Who determined where they were to go? And how was the cathedral cordoned off into exclusive and inclusive spaces? In the last twenty years Chartres has been the stimulating battleground for conflicting approaches to such questions. Are its windows the monuments to a compromise between two antagonistic classes, a cash-strapped clergy committed to ruinously expensive building and a generous bourgeoisie, whose increasing financial power allowed it to impose the themes (though not the theological details) of its choice on the windows it donated? And could these confraternities use their windows as advertisements for their trades? If so, then the Chartres glass could have no overall program.[54] Or were the windows of the trades at Chartres a gigantic hoax, paid for and devised by the clergy to create the illusion of cooperation and harmony between town and gown, behind which the real power struggles of church and fledgling municipality could be fought out,

51 Yves Delaporte, 'L'Assumpton dans la liturgie chartraine,' *Ephemerides Liturgicae* 65 (1951): 5–23.

52 A. Durand and E. Grave, *La Chronique de Mantes où Histoire de Mantes depuis le IXe Siècle jusqu'à le Révolution* (Mantes, 1883), 83–84 and 540. Quoted in Tripps, *Der handelnde Bildwerk*, 188–190, who gives the fullest account of these ceremonies with moveable figures.

53 See Tripps, *Der handelnde Bildwerk*, 190.

54 Wolfgang Kemp, *The Narratives of Gothic Stained Glass*, trans. Caroline Dobson Saltzwedel (Cambridge, 1997).

often to the point of open revolt?[55] Or, alternatively, should we discount this ideological (in the Marxist sense) explanation in favor of a predominantly theological exegesis—namely, that all the narrative windows of Chartres, behind their apparent thematic diversity, are united into a vast single program, held together by a cat's cradle of interconnecting textual commentaries, a program which moves from typology, theology, and mysticism in the nave to history, hagiography, and sacramental redemption in the choir?[56] There is still no agreement on these issues.[57]

Part of the complexity of Chartres lies in the fact that even this cathedral, planned self-consciously as the ideal vision of what a Gothic Great Church should look like, was not the product of a single blueprint, devised at a single moment, in one creative act. Its unities are as much diachronic as synchronic— accumulations over time, put together in response to new cults and customs. That is why integrated schemes of imagery tend to be confined to select parts of the medieval Great Church (e.g. choir screens, choirs, and their surrounding images), not to the whole ensemble.[58] One of Chartres's most potent relics, the head of St Anne, was given to the cathedral only in 1204, ten years after its beginning, and it set in motion a new program of imagery and cult management which lasted well into the fourteenth century. The altar of the head of St Anne, under the choir screen, usually associated with the St Anne and Virgin imagery in the north transept, is in fact a late foundation of Charles V in 1367; the original St Anne's altar was placed in the south aisle of the nave, some way from this nexus of images.[59] The liturgy, as Alexander Sturgis has shown, was not always integral to the planning process of a large cathedral; new ordinals, like those of Chartres and Reims, both commissioned as a response to their new cathedrals, had to accommodate themselves to the demands of the new building, not vice versa.[60] This process of meaning by accumulation, this medley of alterations and enrichments over time, is itself an entity requiring holistic analysis, but (as Paul Binski put it) as an 'ontological whole' not necessarily an integrated one—as an historical existence, partly coherent, but also diverse and even chaotic.[61] The integrative and organizing qualities of Chartres, and a small and related circle of High Gothic and Rayonnant Great Churches in northern France, may be exceptional in the history of cathedral

55 Williams, *Bread, Wine and Money*.

56 Colette Manhes-Deremble, *Les Vitraux Narratifs de la Cathédrale de Chartres. Étude iconographique, Corpus Vitrearum France, Etudes* 2 (Paris, 1993).

57 Though the best adjudication of the competing views is by Brigitte Kurmann-Schwarz, 'Récits, programme, commenditaires, concepteurs, donateurs: publication récentes sur l'iconographie des vitraux de la cathédral de Chartres,' *Bulletin monumental* 154 (1996): 55–71.

58 Willibald Sauerländer, 'Integrated Fragments and the Unintegrated Whole: Scattered Examples from Reims, Strasbourg, Chartres and Naumburg,' in *Artistic Integration*, 153–66.

59 Lautier, 'Les vitraux,' 21.

60 Alexander Sturgis, *The Liturgy and its Relations to Gothic Cathedral Design and Ornamentation in Late Twelfth and Early Thirteenth-Century France* (unpublished diss., Courtauld Institute of Art, University of London, 1991).

61 Paul Binski, 'The English Parish Church and its Art in the Later Middle Ages: A Review of the Problem,' *Studies in Iconography* 20 (1999): 1–25, esp. 15–17.

architecture, and should not blind us to the disruptive and organic changes of their history. For all its insights into the theological subtleties of the Chartres windows, Manhes-Deremble's exegesis, like Mâle's, is utopian: it tends to identify integration with integrity, to confuse *integratio* with its original connotations of restoring and making whole. The copious chaos which so many medieval buildings present us always proves resistant to our attempts at unifying reorganization because fragmentation and semiotic overlay are part and parcel of their historical reality. Indeed their lack of system may even be endemic, a kind of structure in itself.[62] No single prelapsarian key can unlock their secrets.

Yet order (*cohaerentia*), or unity in diversity (*multiplicatio et variatio unversorum*) —the universal principles of high scholastic aesthetics[63]—were never far from the minds of the clerics who presided over the construction of the northern French cathedrals. Peter of Roissy, Chancellor of the cathedral school of Chartres, talks in his *Manual of the Mysteries of the Church* (around 1204) of the square and the unity of the Ecclesia, mystically prefigured in Noah's Ark and Solomon's Temple.[64] Richard of Saint-Victor's *Commentary on the Vision of Ezekiel* is founded on a consciousness of the relationship of part to whole, of the 'relations of unity between length and breadth;'[65] and it touches, albeit unsystematically, on the liturgy, liturgical installations, ornaments and architecture, and their connections.[66] But by far the most influential endorsement of the idea of the new Gothic style as one of mediation and integration comes from Abbot Suger of Saint-Denis's long-familiar appeal, in his *De Consecratione*, to 'concordance and coherence' (*convenientia et cohaerentia*) in the merging of the new Gothic choir of his abbey church with its old Carolingian nave and his new westwork beyond it. 'My first thought,' he claimed, 'was for the concordance and coherence of the ancient and the new work.'[67] It was a proportional coherence in aligning the dimensions of the old with the new, a material coherence in bringing Merovingian spolia from the old church into the new crypt and choir[68] and an aesthetic coherence between the 'retrospective'

[62] A point made by Binski, 'The English Parish Church,' 17, though in relation to the parish church, not the cathedral, and in comparison to fourteenth-century manuals and compendia of instruction for lay people, which contain their own unconventional order.

[63] Terms used consistently by Hugh of Saint-Victor, Aquinas, Bonaventure, and Albertus Magnus, see R. Assunto, *Die Theorie des Schönen im Mittelalter* (Cologne, 1987), 97–100.

[64] Victor Mortet and Paul Deschamps, *Recueil de textes relatifs à l'histoire de l'architecture et à la condition des architectes en France au moyen-âge* (Paris, 1929), 2: 187: '… per quod figuratur unitas ecclesiae, sicut in archa Noe, que consummata est in uno cubito. Et Sicut in Templo erant tria tabulata …'

[65] Jochen Schröder, *Gervasius von Canterbury, Richard von Saint-Victor und die Methodik der Bauerfassung im 12. Jahrhundert*, (Cologne, 2000), 2:486 (text) and 1:231 (commentary).

[66] Schröder, *Gervasius von Canterbury*, 1:237–41, emphasizes the lack of interest in liturgical function and ornament in Richard's text.

[67] Panofsky, *Abbot Suger*, 90, line 15.

[68] William W. Clark, '"The Recollection of the Past Is the Promise of the Future." Continuity and Contextuality: Saint-Denis, Merovingians, Capetians and Paris,' in *Artistic Integration*, 92–113. And Beat Brenk, 'Sugers Spolien,' *Arte medievale*, 1 (l983): 101–7.

forms of his monolithic choir columns and those of the old basilica.[69] But it also amounted—as Andreas Speer has shown—to the collation of all these constituents into a sacred topography by a particular liturgy: the consecration of the choir on 11 June 1144. Here, at least for Suger, space and light were brought into concordance with meaning and cult. The procession of the celebrants round his light-filled ambulatory; their aspersions of the church, including the new west front, where they were protected from the crowd by the king and his entourage; the procession to the tombs of the patron saints; the king himself carrying the relics into the monastic cloister; the consecration first of the high altar and then the altars in the radiating chapels; the likening of the celebrants and the ceremony to a chorus celestial rather than terrestrial; the consecration Mass in the upper choir and in the crypt—all the constituents of the new church are drawn into a spectacle that unites the new with old, space with space, altar with relic, the stones with their quasi-celestial inhabitants.[70] Little wonder that Suger's concluding prayer in *De Consecratione* calls on all in heaven and on earth to unite into a single state (*Respublica una*), in which, through priestly unction and the Eucharist, the material and the immaterial, the corporeal and the spiritual, are joined together. 'The single republic' is a Ciceronian gloss on the familiar Pauline image of the church—celestial and terrestrial—as the foundations of the prophets with Christ as the chief cornerstone (Cor 1.15.24), but it comes alive in the performative rhetoric of the liturgy.[71] Here, in what Suger called 'the marriage of the Eternal Bridegroom,'[72] we come close to what the twelfth century may have described as the 'holistic cathedral.'

[69] Bruno Klein, 'Convenientia et cohaerentia antiqui et novi operis: ancien et nouveau aux débuts de l'architecture gothique,' in *Pierre, lumière, couleur*, ed. Joubert and Sandron, 19–32.

[70] For the consecration the most convenient reference is still Panofsky, ed., *Abbot Suger*, 105–121. The idea of *De Consecratione* (liturgical enactment) as the key to Suger's intentions as patron and builder I borrow from Andreas Speer: Gunter Binding and Andreas Speer, *Abt Suger von Saint-Denis, 'De Consecratione'. Kommentierte Studienausgabe* (Veröffentlichung der Abteilung architekturgeschichte des Kunsthistorischen Instituts der Universität Köln, 56), (Cologne, 1996), esp. 65–69 and 71–79, an edition which surpasses Panofsky's in depth and detail; Andreas Speer, 'Kunst als Liturgie: zur Entstehung und Bedeutung der Kathedrale,' in *Kein Bildnis Machen: Kunst und Theologie im Gespräch*, ed. C. Dohmen and T. Sternberg (Würzburg, 1987), 97–117; Andreas Speer, 'Art as Liturgy: Abbot Suger of Saint-Denis and the Question of Medieval Aesthetics,' in *Roma, magistri mundi. Itineraria culturae medievalis. Mélanges offerts au Père L.E. Boyle à l'occasion de son 75e anniversaire* (Louvain-la-Neuve, 1998).

[71] For a close analysis of the *Respublica una* meanings of the closing section of *De Consecratione*, see Hanns Peter Neuheuser, 'Die Kirchweihschreibungen von Saint-Denis und ihre Aussagefähigkeit für das Schönheitsempfinden des Abtes Suger,' in *Mittelalterliches Kunsterleben nach den Quellen des 11. bis 13. Jahrhunderts*, ed. Günther Binding and Andreas Speer (Stuttgart, 1993),116–83, esp. 161ff.

[72] Panofsky, *Abbot Suger*, 114, line 20.

The Sacred Topography of Chartres Cathedral: The Reliquary Chasse of the Virgin in the Liturgical Choir and Stained-Glass Decoration

Claudine Lautier

Madeline Caviness has analyzed in a number of instances the relationships between the iconography of stained-glass windows and the placement of altars, the liturgy, and the presence of relics.[1] This innovative approach in the historiography of stained glass has stimulated research into the links that may be established between the relics belonging to particular churches and the iconographic themes found in their stained-glass ensembles. Like Canterbury Cathedral, the subject of two important volumes by Professor Caviness,[2] Chartres Cathedral is one of the best subjects for this type of study because it retains the great majority of its original windows and because the contents of its treasury at the moment of the cathedral's rebuilding following the fire of 1194 are known. The cataloguing of the relics it contained reveals that two-thirds of the stained-glass windows can be seen in relation to the relics owned by the cathedral.[3] Among these, the relic of the Virgin's 'tunic' or *Sancta Camisa*,

Translated by Ellen Shortell and Elizabeth Pastan

[1] Madeline H. Caviness, 'Biblical Stories in Windows: Were They Bibles for the Poor?' in *The Bible in the Middle Ages, Its Influence on Literature and Art*, ed. Bernard S. Levy, Medieval and Renaissance Texts and Studies, 89, CMERS Conference, October 1985 (Binghamton, N.Y., 1992), 103–47; Madeline H. Caviness, 'Stasis and Movement: Hagiographical Windows and the Liturgy,' *Corpus Vitrearum Medii Aevi, 29th International Colloquium, Kraków, 1998, 14–16 May*, ed. Lech Kalinowski, Helena Malkiewicz, Pawel Karaskiewicz (Cracow, 1999), 67–79; Madeline H. Caviness, 'Episcopal Cults and Relics: The Lives of Good Churchmen and Two Fragments of Stained Glass in Wilton,' in *Pierre, lumière, couleur: Etudes d'histoire de l'art du Moyen Age en l'honneur d'Anne Prache*, ed. Fabienne Joubert and Dany Sandron (Paris, 1999), 77–87; Madeline H. Caviness, 'Stained Glass Windows in Gothic Chapels, and the Feasts of the Saints,' in *Römisches Jahrbuch der Bibliotheca Hertziana: Kunst und Liturgie im Mittelalter*, ed. Nicolas Bock, Sible de Blaauw, Christoph Luitpold Frommel, and Herbert Kessler, *Akten des internationalen Kongresses der Bibliotheca Hertziana und des Nederlands Instituut te Rome, Rom, 28–30 September 1997* (Munich, 2000), 135–48.

[2] Madeline H. Caviness, *The Early Stained Glass of Canterbury Cathedral, circa 1175–1220*, (Princeton, 1977); Madeline H. Caviness, *The Windows of Christ Church Cathedral Canterbury*, Corpus Vitrearum Medii Aevi, Great Britain 2 (London, 1981).

[3] Claudine Lautier, 'Les vitraux de la cathédrale de Chartres: reliques et images,' *Bulletin monumental* 161/1 (2003): 3–97. For the history and description of the windows, one must consult the irreplaceable work of Yves Delaporte, *Les vitraux de la cathédrale de Chartres. Histoire et description* (Chartres, 1926), 1 vol. text, 3 vol. plates, (photographs by Etienne Houvet).

given by Charles the Bald in 876, held the primary place of honor and was the inspiration for one of the first great pilgrimages in honor of the Virgin in Western Europe. This donation was made during the time of Gislebert, who had been close to the emperor for thirty years before attaining the episcopal seat of Chartres; the gift may have coincided with the consecration of the Carolingian cathedral rebuilt after the ravages of the Norman invasions.[4]

At the end of the tenth century, a sumptuous reliquary chasse[5] was made by a certain Teudo to protect the sacred garment.[6] It consisted of a cedar box covered with gold plaques and encrusted with a considerable number of precious and semi-precious stones, cameos, antique intaglios, and small secondary reliquaries. The chasse was further enriched over the course of subsequent centuries with gems, precious metalwork, and ex-votos. The only image of it that is known is found in the upper part of the *Triomphe de la sainte Vierge dans l'église de Chartres*, a work by Nicolas de Larmessin dated to 1697. This large engraving is essentially devoted to the chapel of Notre-Dame-sous-Terre in the cathedral crypt, renovated and redecorated in the middle of seventeenth century. Above the chapel in the center of the print, two angels hold the *Sainte Châsse* (fig. 11.1), albeit in a simplified representation, to judge by contemporary descriptions.[7] At the bottom of the image are the town and the cathedral, and at the sides several miniature vignettes are dedicated to the miracles worked by the Sancta Camisa, to the statue of Notre-Dame-sous-Terre, and lastly to the miraculous healing of Fulbert by the Virgin's milk.[8]

4 André Chédeville, *Chartres et ses campagnes (XIe-XIIIe s.),* (Paris, 1973), 264.

5 Originally a 'chasse' ('*capsa*') was merely a stone or wooden or metal coffin containing remains of a corpse. In the Middle Ages the word was often used for coffin- or chest-shaped reliquaries in the liturgy. The chasse was not shaped as a chapel or a church before the twelfth century. See Dom Fernand Cadrol and Dom Henri Leclercq, *Dictionnaire d'archéologie chrétienne et de liturgie* III (Paris, 1913), col. 1100–44. In the cartulary of Chartres Cathedral, the *Sainte Châsse* is called '*scrinium*' or '*capsa*'. The name '*capsa*' is also given to the chasses of several saints' bodies on the *tribune des corps saints*. In French sources the reliquary of the '*sancta camisa*' is called '*chasse*' and not '*reliquary*'.

6 His obit is recorded in the necrology of the cathedral. See Eugène de Lépinois and Lucien Merlet, *Cartulaire de Notre-Dame de Chartres* (Chartres, 1862–65), III: 221: '*Obiit Teudo, qui aureum scrinium composuit in quo est tunica beate Marie …*' The sacred chasse was destroyed during the Revolution, with the exception of a few cameos and ornaments, now preserved in the Cabinet de médailles of the Bibliothèque Nationale de France.

7 Among the seventeenth-century descriptions, see above all Sébastien Roulliard, *Parthénie, ou Histoire de la très-auguste et très-dévote Eglise de Chartres* (Paris, 1609), part 1, fol. 197 r-200 v; Charles Challine († 1678), *Recherches sur Chartres, transcrites et annotées par un arrière-neveu de l'auteur* (Chartres, 1918), 172–76; Lucien Merlet, *Catalogue des reliques et joyaux de Notre-Dame de Chartres* (Chartres, 1885) (publication of the catalogue of canon Claude Estienne, 1682), 30–86.

8 Some of the pilgrims suffered from the same illness as Fulbert, the 'mal des ardents,' and were cared for in the north aisle of the crypt, in which they remained for nine days, nursed by the 'dames des saints lieux forts': Lépinois and Merlet, *Cartulaire* I, 58; René Merlet and Abbé Clerval, *Un manuscrit chartrain du XIe siècle* (Chartres, 1893), 112. This part of the crypt was known as 'Saints-Lieux-Forts,' in reference to the 'Puits des Saints-Forts,' located near the chapel of Notre-Dame-sous-Terre, the well into which were thrown the bodies of the martyrs of the diocese, including St Modeste. The water of the well was reputed to have miraculous healing powers.

11.1 The *Sainte Châsse* carried by angels, detail of an engraving by Nicolas de Larmessin, *Le triomphe de la sainte Vierge dans l'église de Chartres, dédié à Messieurs du chapitre de la cathédrale*, 1697. Chartres, Archives diocésaines.

The Sainte Châsse was never opened between the time that the relic was placed there in the tenth century and 1712, the date at which the bishop, surrounded by canons, made an inventory of its contents. Two pieces of cloth were found inside: the one known as the Sancta Camisa of the Virgin, which turned out to be a long piece of white silk, and the other a piece of damask of more recent manufacture, wrapped around the first.[9] Other relics were also found inside, most notably those of Saint Lubin. The placement of the Sainte Châsse in Fulbert's cathedral after 1020 remains the object of speculation, but it is likely that it was placed in the Romanesque choir on a platform covered in silver, given by Jean le Sourd, physician to king Henri I during the second third of the eleventh century.[10]

Fulbert's devotion to the Virgin, and his wish to maintain, even increase, the pilgrimage to Chartres, inspired him to commission an image of the Virgin and Child enthroned, a *sedes sapientiae*, known since the Middle Ages as Notre-Dame-sous-Terre (fig. 11.2). The sculpture was inspired by the statue of Sainte Foy of Conques described by Bernard d'Angers and probably contained a

9 The long veil of the Virgin was cut upon the destruction of the chasse during the Revolution. A fragment, about two meters, was returned to the cathedral and placed in a reliquary monstrance in 1876. Yves Delaporte, *Le voile de Notre-Dame* (Chartres, 1927).

10 This is suggested by the obit of this figure recorded in the necrology of the cathedral: '*Obiit Johannes medicus qui capsarum sedem deargentatam construxit*': Lépinois and Merlet, *Cartulaire* III: 2.

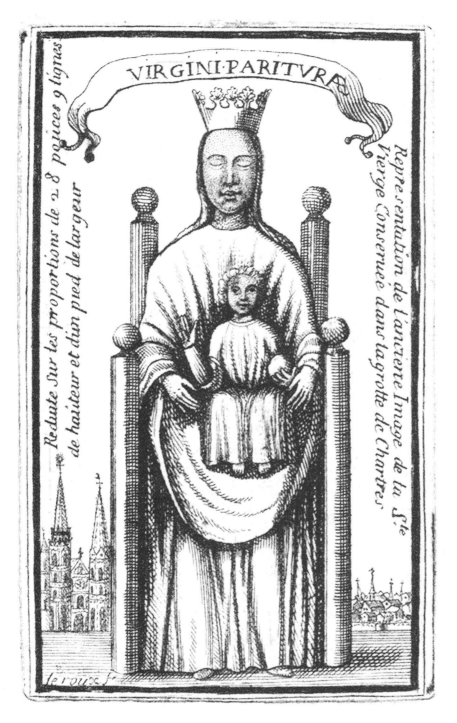

11.2 Notre-Dame-sous-Terre, engraving by Leroux, ca. 1690. Chartres,
Bibliothèque municipale, MS NA 29.

cavity to hold relics.[11] Fulbert had this image placed in a rectangular lateral chapel on the north side of the new crypt of the cathedral.[12] It was accessed directly from the exterior by a staircase, which he had built with its entrance facing north, at the juncture of the north arm of the transept and the present Gothic chevet. The pilgrim emerging from the darkness of this staircase must thus have been overwhelmed at the sight of the reliquary statue. The engraving by Larmessin thus highlights the cathedral's two primary objects of devotion, the chasse containing the Sancta Camisa and the statue of Notre-Dame-sous-Terre, which together comprised the goal of pilgrimage to Notre-Dame. The several surviving pilgrims' badges dating to the thirteenth century bear witness to this association, as both the statue and the chasse were represented, one on the obverse and the other on the reverse.[13]

Following the fire in the Romanesque cathedral in 1194, rebuilding began in the nave, which was erected on the foundations of Fulbert's crypt and placed against the twelfth-century western façade and towers.[14] Once completed, the nave served as the cult space while the Romanesque chevet was destroyed and its crypt modified to accommodate additional chapels before raising the new chevet. In the new Gothic nave it was evidently necessary for the canons to delimit a liturgical choir whose installation, even though provisional, was all the more necessary since it might be several decades before the new chevet would be ready (fig. 11.3).

The chapter was quite large, as it housed seventy-two canons, including seventeen dignitaries, to which must be added chaplains, wardens, and choir boys.[15] The daily offices could not have been held in the crypt, as its architecture was not suited to this purpose.[16] A part of the nave, then, was necessarily

[11] Ilene H. Forsyth, *The Throne of Wisdom* (Princeton, 1972), 31–37, in her study of the Virgin and Child in *sedes sapientiae* does not venture on the existence of a cavity holding relics in the statue of Notre-Dame-sous-Terre, as was the case in Le Puy or Clermont-Ferrand statues, among others. Nevertheless the eleventh-century pilgrimage was so important that the statue probably held relics in a forgotten cavity. On the statue itself, see Forsyth, *The Throne of Wisdom*, 105–11. The statue of Notre-Dame-sous-Terre was destroyed during the Revolution.

[12] When the chapel was remodeled in the middle of the seventeenth century, the altar underneath the statue of Notre-Dame-sous-Terre, previously facing south, was moved ninety degrees to the east so that it was set against an enclosing wall perpendicular to the corridor of the crypt. The reorientation of the chapel was completed by means of an awkward angled passage. Challine, *Recherches sur Chartres* 127n6, plan of the Notre-Dame-sous-Terre Chapel.

[13] Adolphe Lecocq, 'Recherches sur les enseignes de pèlerinages et les chemisettes de Notre-Dame de Chartres,' *Mémoires de la société archéologique d'Eure-et-Loir* 6 (1876), 194–242.

[14] The overall chronology of construction of the Gothic cathedral is now established, thanks to a dendrochronological analysis of fragments of wood scaffolding still reserved above the impost blocks of the nave and choir piers. This analysis yielded a date of 1195–1200 for the nave aisles and of about 1210 for the choir aisles. See Georges Lambert and Catherine Lavier, *Etude dendrochronologique de la cathédrale de Chartres*, unpublished report, Besançon, Laboratoire de chrono-écologie, (1991); Anne Prache, 'Observations sur la construction de la cathédrale de Chartres au XIII^e siècle,' *Bulletin de la Société nationale des Antiquaires de France* (1990), 327–34.

[15] Lépinois and Merlet, *Cartulaire* I, lxx–xcvj. Louis Amiet, *Essai sur l'organisation du chapitre cathédral de Chartres (du XIe au XVIIIe siècle)* (Chartres, 1922).

[16] The crypt takes the form of a semicircular passageway with long corridors, onto which the radiating chapels are grafted; in the center is the 'cellar of St. Lubin.' There is no space in the crypt that could accommodate the entire chapter for the offices.

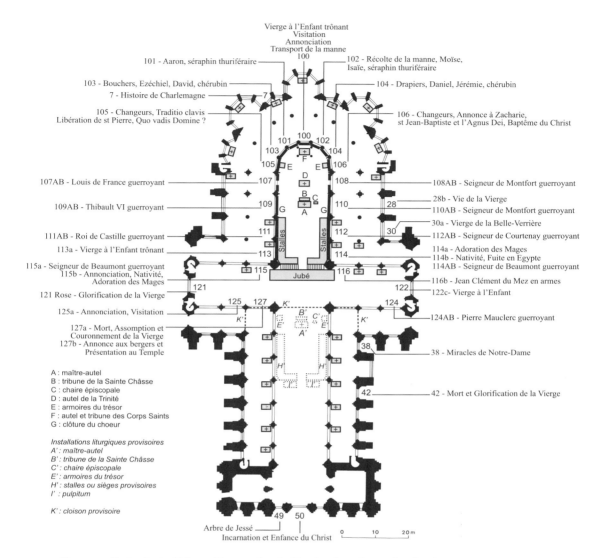

Vierge à l'Enfant trônant
Visitation
Annonciation
Transport de la manne
100

101 - Aaron, séraphin thuriféraire

102 - Récolte de la manne, Moïse, Isaïe, séraphin thuriféraire

103 - Bouchers, Ezéchiel, David, chérubin

104 - Drapiers, Daniel, Jérémie, chérubin

7 - Histoire de Charlemagne

105 - Changeurs, Traditio clavis
Libération de st Pierre, Quo vadis Domine ?

106 - Changeurs, Annonce à Zacharie,
st Jean-Baptiste et l'Agnus Dei, Baptême du Christ

107AB - Louis de France guerroyant

108AB - Seigneur de Montfort guerroyant

109AB - Thibault VI guerroyant

28b - Vie de la Vierge
110AB - Seigneur de Montfort guerroyant

30a - Vierge de la Belle-Verrière

111AB - Roi de Castille guerroyant

112AB - Seigneur de Courtenay guerroyant

113a - Vierge à l'Enfant trônant

114a - Adoration des Mages
114b - Nativité, Fuite en Egypte
114AB - Seigneur de Beaumont guerroyant

115a - Seigneur de Beaumont guerroyant
115b - Annonciation, Nativité,
Adoration des Mages

116b - Jean Clément du Mez en armes

121 Rose - Glorification de la Vierge

122c - Vierge à l'Enfant

125a - Annonciation, Visitation

124AB - Pierre Mauclerc guerroyant

127a - Mort, Assomption et
Couronnement de la Vierge
127b - Annonce aux bergers et
Présentation au Temple

38 - Miracles de Notre-Dame

A : maître-autel
B : tribune de la Sainte Châsse
C : chaire épiscopale
D : autel de la Trinité
E : armoires du trésor
F : autel et tribune des Corps Saints
G : clôture du choeur

42 - Mort et Glorification de la Vierge

Installations liturgiques provisoires
A' : maître-autel
B' : tribune de la Sainte Châsse
C' : chaire épiscopale
E' : armoires du trésor
H' : stalles ou sièges provisoires
I' : pulpitum

K' : cloison provisoire

Arbre de Jessé
Incarnation et Enfance du Christ

Jubé
Stalles Stalles

0 10 20 m

11.3 Chartres, Cathedral of Notre-Dame, plan indicating locations of stained-glass windows related to the *Sainte Châsse* with provisional locations (dotted lines) and permanent locations (shaded areas) of liturgical furnishings.

consecrated for this function between about 1205–10 and 1221, the date at which the canons were installed in their permanent choir stalls. During this period, a temporary wall closed off the nave at the western crossing piers.

One can imagine the following arrangements, with all the caution necessary in the absence of documentation: near the partition, in the easternmost bay, the high altar probably preceded a small platform supporting the chasse of the Sancta Camisa; in the second and third bays from the east stood the canons'

and dignitaries' seats (provisional stalls?);[17] the bishop's chair must have been located near the high altar[18]; and finally to the west was a *pulpitum*, to which the record of the revolt of 1210 attests.[19] The pulpitum was probably a raised platform, an indispensable liturgical furnishing for the reading of the Gospel and the Epistle. It may have been of the type represented in several stained-glass windows at Sens, Laon, and Chartres (fig. 11.4).[20] The clergy would have mounted the pulpitum at Chartres to pronounce anathema against the rioters who invaded the dean's house and forced open the cathedral doors in 1210. On that day, the reliquaries and the Sainte Châsse, as well as the great crucifix above the entrance to the liturgical choir, were taken down and placed on the ground as the excommunication was pronounced. The report of the incident thus shows that the Sainte Châsse and the other reliquaries were usually present in the provisional liturgical choir, the former near the high altar and the others probably in one or two armoires at the side.

In addition, the great number of clerics at Notre-Dame de Chartres required the presence of a number of altars in the nave: certain of the canons were priests, who were obliged to offer Mass daily, and chaplains were likewise charged with services at the altars. Their presence in the nave was even greater during the expansion of the crypt to accommodate new chapels that complemented those built by Fulbert, preventing the normal conduct of the liturgy in the crypt. Seventeenth-century descriptions, written before the destruction of the nave altars in 1661,[21] make it clear that the dedications of a number of these accorded with the themes of the stained-glass windows. They must therefore have been put in place at the beginning of the thirteenth century, at the same time that the windows dedicated to the same saints were completed. This is the case with the altar of St Eustace, placed near the window dedicated to this martyr (window 43), with the altar of Mary Magdalene, in front of the two windows consecrated to her (windows 46 and 138) and with

[17] One is therefore confronted with a configuration of liturgical furnishings comparable to that of Reims Cathedral, where the canons' stalls were placed in the three easternmost bays of the nave and the high altar in the crossing. At Reims, these dispositions were permanent rather than provisional as at Chartres. See Peter Kurmann, *La façade de la cathédrale de Reims* (Paris, 1987), 18 and 44–45.

[18] Bulteau tells us that the cathedral had three Episcopal chairs: one made of stone, near the high altar; one of wood without a back, or *faldistorium*, and a 'very old' small portable chair, which was used for the installation of a new bishop. See Abbé Bulteau, *Monographie de la cathédrale de Chartres*, III (Chartres, 1892), 96.

[19] Lépinois and Merlet, *Cartulaire* II, 56–62, esp. 57. The word '*pulpitum*' denotes a tall structure, platform or gallery, which is not necessarily a choir screen. On this subject, see Fabienne Joubert, 'Epistola et evangelium leguntur in pulpito …': quelques remarques sur le mobilier de la parole dans les cathédrales gothiques, en particulier à Bourges,' in '*Tout le temps du veneour est sanz oyseuseté*' : *mélanges offerts à Yves Christe pour son 65ème anniversaire par ses amis, ses collègues, ses élèves*, ed. Christine Hediger (Turnhout, Brepols, 2005), 365–76. I owe sincere thanks to Fabienne Joubert for having shared the manuscript of her article with me.

[20] At Sens, the Legend of St Thomas Becket, window 23; at Laon, the Legend of Theophilus, window 1; at Chartres, the Legend of St Martin, window 20; and the Miracles of St Nicolas, window 29b.

[21] Regarding the dedications of the nave altars, see especially Roulliard, *Parthénie* (see n. 6), 1st part, fol. 135 v-137 v, and Challine, *Recherches sur Chartres*, 145–47.

11.4 Chartres, Cathedral of Notre-Dame, window 20: St Martin preaching from a *pulpitum*.

the altar of the Crucifix, situated below the typological Passion window (window 37).[22]

Two stained-glass windows on the south nave aisle are consecrated to the Virgin. The first, at the angle of the transept, tells of the Miracles of Notre-Dame (window 38), and the second, two bays further to the west, is dedicated to the Glorification of the Virgin (window 42). To these must be added two of the three windows of the western facade, that is, the Infancy window dating to 1145–50 (window 50), which is dominated by a large figure of the Virgin and

[22] For the links between the positions of altars and the placement of stained-glass windows, see Lautier, 'Les vitraux de la cathédrale,' Fig. 16 and pp. 19–21.

Child, and the Tree of Jesse (window 49), dedicated to the Incarnation. The four windows can be tied to the relic of the Sancta Camisa which was preserved in the provisional liturgical choir at the beginning of the thirteenth century. The legends of Chartres, especially the book of the *Miracles of Notre-Dame*, the earliest version of which dates to the second decade of the thirteenth century, relate that Mary wore this garment at the Annunciation, or even at the Nativity, scenes represented in the central window in the western facade. Other legends report that she still had this garment at the moment of her death, a scene which figures in the Glorification window.[23] As for the window of the Miracles of the Virgin, even though it is incomplete,[24] its presence near the Sainte Châsse around 1200 is a veritable appeal to the generosity of the faithful to contribute to the reconstruction of the cathedral and to undertake the pilgrimage to the Sancta Camisa and Notre-Dame-sous-Terre. The lower quatrefoil shows, in effect, the devotions of the faithful in procession toward a triptych with the Virgin and Child in the center, their fervor rewarded by the miracle of the healing of a child.[25]

The nave held three other windows consecrated to the Virgin. In the right lancet of window 138, again on the south, is found a beautiful lactating Virgin, which is best understood in relation to another Marian relic, the milk that healed Fulbert.[26] Two rosettes on the north side also present a figure of the Virgin and Child. The first, given by the residents of Tours, is found in window 129; the second, showing the Virgin accompanied by the seven gifts of the Holy Spirit is in window 135. Neither of these directly evokes the relic preserved in the Sainte Châsse.

It seems unlikely that those who conceived the iconographic program of the windows elaborated a sacred topography focused on the location of the chasse in this provisional arrangement in the nave, even if the iconography of the entire south nave aisle is predominantly Marian.[27] The situation is markedly different with the second phase of the fabrication and installation of the stained glass, however, which accompanied the construction of the chevet. The liturgical choir which was placed there, with its furnishings and decor, was of course meant to be permanent (fig. 11.3). The principle disposition of the choir

[23] Lautier, 'Les vitraux de la cathédrale,' 29–34. For an analysis of the *Livre des Miracles de Notre-Dame*, see Dawn Marie Hayes, *Body and Sacred Place in Medieval Europe, 1100–1389: Interpreting the Case of Chartres Cathedral*, unpublished diss, (New York University, 1998),. 72–128.

[24] Of the quatrefoils that form the center of the composition, only the lowest has survived, along with the small semicircular lateral panels. If this quadrilobe is a veritable explanation of devotion to the Virgin, the other scenes (several of them at least) seem to relate either to the legend of Theophilus, which was read at Chartres on September 8—the feast of the Nativity of the Virgin, one of the major feasts of the cathedral. Colette Manhes-Deremble, *Les vitraux narratifs de la cathédrale de Chartres. Etude iconographique*, Corpus Vitrearum—France, Etudes II (Paris, 1993), 50–52.

[25] Gabriela Signori underlined the fact that the relic of the sacred tunic played a major role in the healing of children at Chartres: *Maria zwischen Kathedrale, Kloster und Welt* (Sigmaringen, 1995), 174–201.

[26] Lautier, 'Les vitraux de la cathédrale,' 23 and 38.

[27] Manhes-Deremble, *Les vitraux narratifs*, 42–52.

furnishings in the 1220s is known both from texts, especially the cartulary and an ordinary of the thirteenth century compiled shortly after the canons were installed in the chevet,[28] and by a plan of 1768.[29]

A charter dated January 1221[30] indicates that the canons took their places in permanent stalls of an unusual new type, with misericords.[31] The places of the dignitaries and the ordinary canons were fixed, including those of the canons *in minoribus* who had the right only to a simple bench of the same height as that of the choir boys.[32] The stalls were arranged along the north, south, and western boundaries of the choir in the two western bays. It was at the west that the chapter dignitaries took their places. The high altar was installed in the third bay from the crossing; at the same time the episcopal chair was placed next to the altar on the south side, the side of the Epistle.[33] The altar was made from a great slab of Egyptian granite, ten feet long and five feet wide, supported by twenty-four colonettes gathered into six pier bundles. Placed on the altar table, in addition to the crucifix, was a large Virgin and Child of gilded silver, three feet high, given in May of 1220 by Pierre de Bordeaux, archdeacon of Vendôme.[34] It is probably this Virgin that is shown, venerated by two pilgrims, at the base of the window of the Miracles of Saint Nicholas (window 29b). The Sainte Châsse was placed in immediate proximity to the high altar, set on a small platform slightly higher than the altar table, so that one could pass beneath it during certain acts of devotion.[35] A similar disposition is represented

[28] Yves Delaporte, 'L'ordinaire chartrain du XIII⁰ siècle,' *Mémoires de la société archéologique d'Eure-et-Loir* XIX (1952–53), 1–297. This ordinary was probably compiled around 1225–30, at a time when the ceremonies could take on their full extent in a nearly completed church (Delaporte, 'L'ordinaire chartrain,' 23).

[29] This plan known as 'plan de Félibien' was made in 1678, probably by Antoine Benoist, at the request of canon Claude Estienne, for Bernard de Montfaucon. Rüdiger Hoyer, 'Documents primordiaux de l'archéologie chartraine: les plus anciens plans connus de la cathédrale Notre-Dame,' *Bulletin de la société archéologique d'Eure-et-Loir* XXXI/1, supplément n°19 (1988): 1–57. The plan of the cathedral and that of the crypt are published in Challine, *Recherches sur Chartres*, 118 (plan of the crypt) and 134–35 (plan of the upper church).

[30] Lépinois and Merlet, *Cartulaire* II, 95–96.

[31] Lépinois and Merlet, *Cartulaire* II, 95: '… in choro nostre ecclesie nova stalla forme insolite nova dispositionne ponentes …' The stalls now in the choir were remade at the end of the eighteenth century. At one time one could read on the first of these the name of the woodworker and a date: 'Lemarchand, 1788.' See Bulteau, *Monographie* III:98–99.

[32] Amiet, *Essai sur l'organisation du chapitre*, 2–130. The canons '*in minoribus*' were neither priests, deacons, nor subdeacons.

[33] Delaporte, 'L'ordinaire chartrain,' 24.

[34] Merlet, *Catalogue des reliques*, 162–64. Pierre de Bordeaux died in 1261; his obit clearly mentions this Virgin, who was accompanied by two angels: 'Petrus de Burdegalis … qui fecit fieri ymaginem beate Marie cum duobus angelis argenteis qui sunt super majus altare,' Lépinois and Merlet, *Cartulaire* III:162.

[35] In 1210, after the revolt of the residents of Chartres against the chapter, when Philip Augustus passed below the *Sainte Châsse*, the latter was still located in the provisional liturgical choir in the nave. Lépinois and Merlet, *Cartulaire* II:59. According to Abbé Bulteau, the high altar was surrounded by six columns surmounted by angels carrying the instruments of the Passion and linked by curtains in the liturgical color of the day. Bulteau described a state of the sanctuary which belonged to the end of the seventeenth century; Bulteau, *Monographie* III, 85. These curtains had the role of marking the 'separation between the Holy and the Holy of

in a window of the Trinity Chapel at Canterbury (sVII) dedicated to the miracles of St Thomas Becket, where a woman is shown approaching the saint's chasse behind the altar.[36]

If we may believe Alexandre Pintard (ca. 1700),[37] two altars followed behind the high altar before the choir was transformed during the Renaissance. The first was reserved for obituary masses, and the second was placed against the piers of the central bay of the hemicycle. A platform, five or six *toises*, or about twelve meters, in height, was set above the second altar and known as the 'tribune des Corps-Saints.' According to the description of canon Claude Estienne,[38] it consisted of a platform on which compartments containing chasses and reliquaries were arranged in a pyramid. A simplified representation of it is found in the Charlemagne window (window 7) (fig. 11.5), which shows clearly that it was erected at the same time that the choir was constructed.[39]

On the north and south sides of the apse, two armoires were used as treasuries to hold reliquaries and the most precious liturgical items. They were replaced by two sculpted wooden dome-shaped treasuries given by the French queens Marie de Medici, in 1614, and Anne of Austria, in 1661.[40]

The choir was closed at the west by a choir screen at the end of the 1230s or at the beginning of the 1240s.[41] However, the Ordinary of the cathedral, compiled around 1225–1230, mentions a 'pulpitum' a number of times in relation to certain feasts, and it accommodated several clerics.[42] This provisional structure of a certain height was thus used for ten or fifteen years

holies' (Ex. 26.33). This type of disposition, appearing it seems in the second half of the thirteenth century, probably did not exist at the beginning of the century.

36 Caviness, *The Windows of Christ Church*, 208–9, 214, and pl. 160.

37 Chartres, Bibliothèque municipale, MS NA 29, 383: 'Il y avait par le passé dans le choeur de l'église Notre-Dame de Chartres trois autels dont le principal auquel se disaient les messes canoniales était placé au milieu du choeur vis à vis la chaire épiscopale. Le second qui servait aux messes d'obits ou d'anniversaires était presque au même endroit où est à présent le grand autel et le troisième était le même qui reste encore entre les deux piliers du milieu au-dessous du rond-point.' See Delaporte, 'L'ordinaire chartrain,' 24.

38 Merlet, *Catalogue des reliques*, 141–42: 'Dans l'arcade du milieu du rond-point du choeur, et à cinq ou six toises au-dessus de l'autel qu'on appelle de Tous les Saints, on a disposé encore un troisième lieu pour y mettre des reliques. L'on y monte par un escalier de pierre pratiqué entre deux piliers, au devant duquel il y a un balustre qui conduit devant et derrière ce dernier trésor … Il est disposé en trois étages qui diminuent en grandeur à proportion qu'ils s'élèvent les uns au-dessus des autres. L'on y entre point, mais ils sont à jour, et l'on peut voir aisément au-dedans par les deux bouts …'

39 The 'tribune des Corps-Saints' was probably destroyed in 1773 to make a place for the Assumption of the Virgin group sculpted by Charles-Antoine Bridan.

40 Merlet, *Catalogue des reliques*, 3 and 109.

41 Jean Mallion, *Chartres, le jubé de la cathédrale* (Chartres, 1964); Léon Pressouyre, 'Pour une reconstitution du jubé de Chartres,' *Bulletin monumental* 125 (1967): 419–29; Brigitte Kurmann-Schwarz and Peter Kurmann, *Chartres. La cathédrale*, trans. Thomas de Kayser, (Saint-Léger-Vauban, 2001), 302–26. The choir screen was destroyed in 1763.

42 Joubert, 'Epistola et evangelium leguntur in pulpito.' See note 19. The author indicates that the *pulpitum* accommodated not only several clerics, but also banners, books, and crosses, and was itself used in certain rites. Thus it was wide enough and deep enough for these purposes.

11.5 Chartres, Cathedral of Notre-Dame, window 7: Charlemagne giving relics to the church of Aachen.

(fig. 11.4). The Ordinary also frequently refers to the '*porte du crucifix*,' that is, the central door to the liturgical choir, which was surmounted by a great silver crucifix.

Along the sides, two doorways gave access to the choir in the fourth bay, between the high altar and the altar of the Trinity. Curtains covered these doorways, and other hangings were found behind the clerics and all around the choir. Curtains and hangings are frequently cited in the Ordinary, and their usage was varied.[43] Their numbers multiplied to decorate the building during

43 Bulteau, *Monographie* III, 94–95.

certain feast days such as the Birth of the Virgin, Easter, or Pentecost.[44] It is clear that some tapestries were placed more or less permanently around the choir, since they were removed 'from behind the clerics' during Advent, Septuagesima, and Lent, periods of penitence, just as at the same time the Sainte Châsse and the high altar were covered.[45] Thus, when the chasse was uncovered, it was not ordinarily visible from the ambulatory since the entire sanctuary was closed off by curtains and tapestries. When the tapestries were removed, the chasse and the high altar were covered, rendering them invisible.

This arrangement was, in any case, what was described in the thirteenth-century Ordinary, a short time before the construction of the choir screen in the 1230s and 1240s. The iconography of the sculpted decoration of the choir screen is rather unusual in comparison to other thirteenth-century examples, which are most often dedicated to the Passion and Last Judgment. At Chartres, scenes of the Incarnation constituted the main theme, beginning with the Annunciation and ending with the Presentation in the Temple.[46] This unusual theme suggests that the choir screen should also be seen in relation to the reliquary of the Sancta Camisa, since the legend says that it was worn on the day of the Annunciation or of the Nativity. The central doorway of the choir screen, through which almost all the processions passed, thus constituted the passage from the nave and transept into the sacred space of the liturgical choir where the Sainte Châsse was exposed.

The installation of the choir screen was probably accompanied by the construction of a first choir clôture built of stone, transformed over the course of centuries until a new clôture was built beginning in 1514. At the end of the fourteenth century the *Vieille Chronique* alludes to '*chambres*' situated close to the altar, that is, between the piers, intended for the wardens responsible for guarding the Sainte Châsse.[47] At the beginning of the fifteenth century, also to accommodate another '*chambre*,' a mason was engaged to 'tear down or take apart and rebuild the wall enclosing the choir of the church.'[48] At the end of the same century, in 1482, the Parisian painter Pierre Pantin was charged with 'painting three spaces which are in the choir, on the right side, with the

44 Delaporte, 'L'ordinaire chartrain,' 26, 112, 130, and 174. Delaporte supposed that the curtains were suspended from the piers, 'comme cela se fait encore à Rouen.'

45 Delaporte, 'L'ordinaire chartrain,' 41–42, 75, Advent: 'In sabbato adventus domini ante nonam de dorso cleri auferantur dorsalia;' and later, 77: 'Feria ij. Summo mane cooperiuntur altare et capsa uno pallio;' 94, Septuagesima: 'Sabbato septuagesime ante nonam auferuntur cortine de tentura ecclesie et scannalia de dorso clericorum;' 99, Lent: 'Post primam cooperiantur altare et capsa et alia sacramenta.'

46 Mallion, *Chartres, le jubé*, 119–50.

47 Lépinois and Merlet, *Cartulaire* I:61. See also Françoise Jouanneaux, *Le tour du choeur de la cathédrale de Chartres*, Eure-et-Loir (Orléans, 2000), 5.

48 Lucien Merlet, 'Comptes de l'oeuvre de la cathédrale de Chartres en 1415–1416,' *Bulletin archéologique du comité des travaux historiques et scientifiques* VII (1889): 63: 'A Guillaume Brifer, maçon, pour 3 jours qu'il a besongnié à abatre ou despecier et à refaire le mur faisant la closture du cuer de l'eglise à l'endroit et là où doit estre faicte et assise une chambrète pareille et semblable aux autres chambrètes nagaires faictes, pour jour 4 s. 2 d.'

clerestory and the piers surmounting the clerestory.'[49] If this 'clerestory' was within the first three straight bays, it crowned the wall discussed above. On the other hand, if it was found in the three turning bays, one might imagine a pierced clôture wall of the same type that was formerly found around the apse of Notre-Dame of Paris.[50] Probably as tall as the choir screen (which measured about 5.5 meters or eighteen feet in height), it blocked the view of the interior of the liturgical choir more than simple *dorsalia*.[51]

Four altars were also situated behind the stalls and choir clôture. They were located in the first two bays of the choir, set against the piers. When the clôture was rebuilt, these were enclosed in three small chapels established within the thickness of the new enclosing wall itself. But the fact that the altar of Saint Martin, against the second pier on the south side, was aligned with the stained-glass window dedicated to the same saint (window 20) (fig. 11.4), suggests that it had been in the same place since the beginning of the thirteenth century, and it was probably the same for the other three.

The ensemble of these liturgical arrangements shows that the Sainte Châsse was not visible ordinarily to the faithful who circulated in the nave or in the ambulatory. The simple pilgrim could not easily enter into the sanctuary, since on the one hand the chasse and the relics of the treasury were guarded day and night by the wardens, and on the other hand the offices followed one another throughout the day and part of the night,[52] not to mention the Masses said on

49 Maurice Jusselin, 'Introduction à l'étude du tour du choeur de la cathédrale de Chartres,' *Mémoires de la société archéologique d'Eure-et-Loir* XXI (1958): 83–84. Pierre Pantin was hired to: 'peindre trois espaces étant au choeur, du côté dextre, avec la clairevoie et les piliers surmontant les clairevoies, lesdits piliers et clairevoies avec quatre piliers de pierre, deux au milieu et deux aux deux bouts; le dedans desdits trois espaces et chacun d'iceux faire aucun ymaige tel qu'il plaira à messieurs.'

50 Dorothy Gillerman, 'The Cloture of the Cathedral of Notre-Dame: Problems of Reconstruction,' *Gesta* 14 (1975): 41–61. Françoise Baron, 'La partie orientale détruite du tour du choeur de Notre-Dame de Paris,' *Revue de l'art* 128 (2000): 11–29.

51 Cologne Cathedral preserves today, behind the choir stalls, the original clôture wall, painted on the interior and ornamented on the side facing the aisles with decorative arches. In the turning bays, the original clôture wall has been replaced by eighteenth-century grills. Reiner Haussherr, 'Die Chorschrankenmalereien des Kölner Doms,' in *Vor Stefan Lochner. Die Kölner Maler von 1300–1430. Ergebnisband des Colloquiums* (Cologne, 1977), 28–59.

52 Lépinois and Merlet, *Le Cartulaire* I, 61. One could compare this hypothesis to the scene of the Miracle of the *Presepe di Greccio* painted by Giotto in the upper church of Assisi: there one sees the interior of the choir of the church, separated from the nave by a clôture and a '*pulpitum*', with a central portal surmounted by a crucifix. In the choir itself are the monks and seigneurs, while the women and laity press at the entrance. Given that the sacred chasse was not protected until the sixteenth century by a container or case, there was clearly no question of allowing an ordinary pilgrim easy access to it. Fear of theft and of accidents was too great, as the construction of *chambrettes* between the piers for the wardens who were responsible for guarding the chasse indicates. At Saint Gertrude in Nivelles, which was not a pilgrimage church, the chasse was kept in a sculpted and decorated wooden box designed to protect it. It was only brought out on rare occasions, and during processions that left the church, it remained in its case. See Robert Didier, 'La présentation de la châsse gothique,' in *Un trésor gothique: la châsse de Nivelles*, exhb. cat., Cologne, Schnütgen Museum/Paris, Musée national du Moyen Age—Thermes de Cluny (1996), 101–3; Robert Didier and Christina Ceulemans, 'Les processions et le char de la châsse de sainte Gertrude,' *Un trésor gothique,: la châsse de Nivelles*, 104–6.

the three altars of the choir. Certain pilgrims, such as princes and nobility, and the upper classes of society, who frequently went on pilgrimage to Chartres, were sometimes authorized to enter the sanctuary.[53] Sometimes, however, although we don't know the circumstances, pilgrims seeking a miracle were allowed to pass under the Sainte Châsse, as the *Livre des Miracles de Notre-Dame* attests.[54] But the ensemble of the liturgical choir was conceived in fact principally for the chapter; this includes its decoration with glass.

The '*tribune des Corps-Saints*' was visible to pilgrims looking from the nave toward the choir screen. On this platform were presented a certain number of reliquaries and above all the large chasses of the treasury (with the exception of the Sainte Châsse), in particular those of the Merovingian bishops of Chartres, a display which exalted the local Church (fig. 11.5).[55] In effect, if one could superimpose the 5.5 meter high choir screen and this 'tribune,' almost as high as the main arcades, on a longitudinal section of the building, one would see that the faithful entering the church through the west facade perceived at the far end of the choir the pyramid formed of chasses and reliquaries stacked upon one another. Above this, one saw the luminous crown of stained-glass windows in the apse, which all referenced the Sainte Châsse and the relic of the Virgin.

The plan of 1678, although very precious, like that of the crypt traced in the same period, presents the choir in a state that was no longer exactly that of the medieval era.[56] In 1508, it was decided that the Sainte Châsse should be enclosed in a sort of box with a lock and double key to deter theft and disturbances of the cult; then in 1513 it was elevated on four copper piers and attached to the high altar with two chains. In 1520, the high altar was moved back toward the apse—as was the Sainte Châsse—the altar of the Trinity was combined with that of the Corps-Saints, and the number of canons' stalls was increased by one bay of seats.[57] This was also the era of the reconstruction of the clôture, a project that would continue until 1727.

At the beginning of the thirteenth century, for the pilgrim who had little chance of seeing the Sainte Châsse and who could not circulate through the ambulatory around the sanctuary, only three windows clearly evoked the relic of Mary's tunic: the Life of the Virgin (window 28b), the Belle-Verrière (window

[53] Chédeville, *Chartres* (see n. 4), 509–12. From this perspective, Chartres is not unlike the Sainte-Chapelle, where only aristocrats and important persons could have access to the upper chapel, at the invitation of the king, to visit the relics. See Karel Otavsky, *Die Sankt Wenzelskrone im Prager Domschatz und die Frage der Kunstauffassung am Hofe Kaiser Karls IV* (Berne, 1992), 103–7.

[54] Pierre Kunstmann, *Jean Le Marchant. Miracles de Notre-Dame de Chartres* (Chartres/Ottawa, 1973), 158, 162, and 209. For Delaporte, 'L'ordinaire chartrain,' 32–33, the demonstrative devotional acts of pilgrims before the Sainte Châsse did not endure: 'A l'époque où fut rédigé l'ordinaire … ces manifestations devaient être déjà moins fréquentes.'

[55] Lautier, 'Les vitraux de la cathédrale,' 39–43.

[56] See n. 28.

[57] Maurice Jusselin, 'Les brodeurs à Chartres et les vêtements liturgiques de la cathédrale au XVIᵉ siècle,' *Bulletin de la société archéologique d'Eure-et-Loir, Mémoires* XVIII/1 (1947–51): 219.

30a), and the History of Charlemagne (window 7) (fig. 11.5). In the first window, the allusion is rather general, since it concerns above all the life of the patron saint of the cathedral, except for the fact that it faces topographically the third bay of the choir, where the Sainte Châsse was located.

Nearby, at the entrance to the ambulatory, is the Virgin of the Belle-Verrière, a window from the former Romanesque cathedral reused in the new Gothic chevet. This Virgin clothed in the Sancta Camisia is crowned in a *couronne fermée*, a clear allusion to the gift of the relic by Charles the Bald in 876. The crown that Mary wears, of the imperial rather than royal type, recalls that of the emperor, which was conserved until 1340 in the treasury of the Abbey Church of Saint-Denis.[58] When this Romanesque *sedes sapientiae* was reinserted in the new Gothic chevet, its iconographic content was amplified. It was placed under an architectural canopy, and the dove of the Holy Spirit symbolizing the Incarnation was added above her head. All around her, angels holding candles and censing accompany her, and angels holding columns support her throne. The ensemble of this complex image refers to the Tabernacle of Moses, and to the Arc of the Covenant, as was shown several years ago.[59] This analogy between the Virgin and the Arc is repeated in the windows of the apse, as we shall see shortly.

Further to the east, in one of the radiating chapels on the north side, the lower part of the Charlemagne window (window 7) depicts the story of the acquisition of the Virgin's tunic by the sainted Emperor and constitutes in itself an authentication (*authentique*), in lieu of the fabric band that usually attests to the veracity of a relic. Depicted in the stained glass are Charlemagne's mythical voyage to Constantinople and Jerusalem, the meeting between the Byzantine emperor Constantine and Charlemagne, Emperor of the West; Constantine's gift of relics to Charlemagne; and the donation of relics by the latter to the church of Aachen.[60] The panel is particularly interesting as one can recognize in the architectural setting of the scene not an image of the Emperor's palatine chapel, but indeed a representation of the cathedral of Chartres, with the *tribune des Corps-Saints*, the main arcades and the colonettes of the triforium behind the high altar and the *tribune*.

In the sanctuary, on the other hand, the stained-glass windows related to the Sainte Châsse and to the relic that it contains are numerous. In the axial window (window 100), above the two figures carrying a large basket of bread, are the

[58] Hervé Pinoteau, 'Une couronne de Charles le Chauve visible par tous,' *Emblemata* 6 (2000): 39–60. Lautier, 'Les vitraux de la cathédrale,' 31–32.

[59] Chantal Bouchon, Catherine Brisac, Claudine Lautier, Yolanta Zaluska, 'La "Belle-Verrière" de Chartres,' *Revue de l'art* 46 (1979): 16–24, esp. 20–21.

[60] Lautier, 'Les vitraux de la cathédrale,' 34–35; Claudine Lautier, 'Le vitrail de Charlemagne à Chartres et les reliques du trésor de la cathédrale,' *Actes du colloque: Autour de Hugo d'Oignies, Namur, 20–21 octobre 2003* (Namur, 2004): 229–40. Elizabeth Carson Pastan, 'Charlemagne as Saint: Relics and the choice of window subjects at Chartres Cathedral,' in *The Legend of Charlemagne in the Early Middle Ages: Power, Faith, and Crusade*, ed. Matthew Gabriele and Jace Stuckey, (New York, forthcoming). I am very grateful to Elizabeth Pastan for having shared the manuscript of her article with me. The upper part of the window relates Charlemagne's crusade in Spain and the story of Roland.

Annunciation, the Visitation, and a large figure of the Virgin and Child enthroned (fig. 11.6). This Virgin is not a representation of Notre-Dame-sous-Terre as has often been thought, but evokes instead quite clearly the relic of the *camisa* preserved in the chasse in the center of the liturgical choir. Mary is in fact crowned with the same imperial crown as the Virgin of the Belle-Verrière, that is, the crown of Charles the Bald, donor of the relic.[61] The scenes of the Infancy of Christ placed below attest to this, since one of the legends regarding the sacred garment relates that Mary was wearing it at the moment of the Annunciation.

Distributed around the other windows of the hemicycle are scenes and figures that all make reference to the Arc of the Covenant, as Ivo Rauch has demonstrated brilliantly,[62] a theme based on the writings of Peter of Celle, Bishop of Chartres from 1181 to 1183, whose writings strongly influenced the designers of the iconography of the stained-glass windows of the cathedral.[63] Since the Council of Ephesus in 431, the Arc containing the manna, Aaron's rod, and the tablets of the Law, was for the fathers of the Church a prefiguration of the Virgin. The Old Testament figures represented in the hemicycle on either side of the Virgin can all be understood in relation to the Arc: Aaron (window 101), Moses and Isaiah (window 102), Ezekiel and David (window 103), Daniel and above all Jeremiah who prophesies God's new covenant with mankind (window 104). The censing angels (windows 101 and 102) and the cherubs (windows 103 and 104) who also surround Mary make further allusion to the Arc of the Covenant, as do the typological scenes of the life of St Peter (window 105) and of St John the Baptist (window 106). Ivo Rauch also compares the lords leaving for war represented in the rosettes of the windows of the straight bays of the choir (windows 107–112, and 114) with the tribes of Israel prepared to conquer the Promised Land, carrying with them the Arc of the Covenant to be placed in the tabernacle of the Temple.

Such a theological explanation of the program of the upper choir is convincing, but one can also tie this iconography to the Sainte Châsse containing the Virgin's tunic. In effect, if the Arc of the Covenant is the first reliquary in history, and if it is a type of the Virgin carrying Christ in her womb, the Sainte Châsse containing the garment that clothed Mary on the day of the Annunciation or of the Nativity is a metaphor of the Arc of the Covenant. The axial window at the summit of which the Virgin is enthroned, prefigured by the Arc, and wearing the imperial crown of the relic's donor, Charles the Bald, clearly suggests this metaphor by making the connection between the Arc, the Virgin, the Sancta Camisa that Mary wore on the day of the Incarnation, and the reliquary chasse. Certain salient features of the reliquary chasse assert the comparison: its chest-like shape[64] as well as its materials, that is, wood (acacia

61 Pinoteau, 'Une couronne de Charles le Chauve,' 39–60.

62 Ivo Rauch, 'Die Bundeslade und die wahren Israeliten. Anmerkungen zum Mariologischen und politischen Programm der Hochchorfenster der Kathedrale von Chartres,' *Glas. Malerei. Forschung. Internationale Studien zu Ehren von Rüdiger Becksmann*, ed. Hartmut Scholz, Ivo Rauch, and Daniel Hess (Berlin, 2004), 61–71.

63 Manhes-Deremble, *Les vitraux narratifs*.

64 For a description of the Arc: Ex. 25.10–21.

11.6 Chartres, Cathedral of Notre-Dame, window 100: Enthroned Virgin and Child.

11.7 Chartres, Cathedral of Notre-Dame, window 107AB: Louis of France in battle.

for the Arc, cedar for the Sainte Châsse) covered with plaques of gold worked with repoussé designs.

The Sainte Châsse was placed in the center of the liturgical choir. It was surrounded by the canons and bishop who might also be compared with the true Israelites, that is, the tribes who would carry the Arc to the Promised Land and place it in the tabernacle of the Temple (fig. 11.7).[65] The typological iconography of the stained-glass windows of the upper choir also serves as an iconology proper to the liturgical dispositions of the sanctuary and to the assembly of clerics present around the relic.

In the rosettes of seven windows of the upper choir, *primi nobiles*, who belong either to the royal family or are barons of the highest rank, present their coats of arms. These knights in arms and on horseback refer, as we have seen above, to the tribes of Israel leaving to conquer the Promised Land (fig. 11.7). On another iconographic level, the *primi nobiles* are also placed in the context of the Crusades of that time.[66] It is reasonable to add a third level of meaning,

[65] It should be remembered here that Bishop Renaud de Mouçon was a crusader, having participated in the third Crusade to the Holy Land, as well as the Albigensian Crusade.

[66] Françoise Perrot, 'Le vitrail, la croisade et la Champagne: Réflexions sur les fenêtres hautes du chœur à la cathédrale de Chartres,' in *Les Champenois et la croisade. Actes des*

since the contemporary noble warriors are equally connected to the Sainte Châsse containing the Virgin's *camisa*. In fact, both the *Vieille Chronique* and the *Livre des Miracles de Notre-Dame* report that knights and lords leaving for war came to touch the Sainte Châsse with their own tunics, thus assuring themselves protection against eventual blows.[67] This iconography, with its aristocratic as well as prophylactic associations, was extended during the course of the last glazing campaign between about 1225 and 1235, to the windows of the two transept arms, filling the upper windows and the north and south transept facades.[68] Through their 'portraits,' the noblemen remained in permanent contact with the holy relic, and could hope, thanks to the donation of the windows in which they were represented, to be swept along after their deaths in the Virgin's wake, toward God.

In the upper choir, two other representations of the Virgin are known to have existed aside from the two lancets of window 114 where the scenes of the Incarnation and Infancy of Christ are found again.[69] Of the first, previously in window 108 and destroyed in 1773, there is little that can be said except that it consisted of a standing figure, 'the Blessed Virgin holding a flowering scepter' according to Pintard.[70] The second is found in the left lancet of window 113 (fig. 11.8) at the corner of the north arm of the transept. It depicts a Virgin and Child enthroned a *sedes sapientiae*.[71] Like the Virgin in the summit of the axial window (window 100), and the one just discussed (window 108), she holds a flowering scepter. The Child she holds against her breast blesses with the right hand and holds a closed book in his left. Above his head, in the space below the architectural canopy, descends the dove of the Holy Spirit, just as in the Belle-Verrière (window 30a).

The relationship among these three figures of the Virgin—that placed in the summit of window 100, the Virgin of the Belle-Verrière (window 30a), and the Virgin enthroned in window 113—is problematic. It is tempting to see the repetition of the same iconographic scheme and, consequently, the same allusion to the relic of Mary's tunic preserved in the Sainte Châsse. Two factors prove that this is not the case. This last Virgin in window 113 does not wear the imperial crown like the two others, but a simple royal crown comparable to the one worn by Notre-Dame-sous-Terre (fig. 11.2). Further, her placement

quatrièmes journées rémoises, 27–28 novembre 1987 (Paris, 1989), 110–30; Beate Brenk, 'Bildprogrammatik und Geschichtsverständnis der Kapetinger im Querhaus der Kathedrale von Chartres,' *Arte medievale* IInd Serie V/2 (1991): 71–95.

[67] Lépinois and Merlet, *Cartulaire* I, 59; *Livre des Miracles de Notre-Dame*, chapter XXI; see Kunstmann, *Jean Le Marchant*, 162–66n52.

[68] Figures of aristocratic or ecclesiastical donors in prayer, or their coats of arms, are found at the base of a number of windows in the upper choir and in the transept. The context in which these donations were made is a subject beyond the scope of this paper.

[69] In window 114, the scenes of the Infancy of Christ are as follows: in lancet a, the Adoration of the Magi; in lancet b, the Nativity and the Flight into Egypt.

[70] Delaporte, *Les vitraux de la cathédrale de Chartres*, 460–61. The lower panels are known from a drawing by Roger de Gagnières, which shows the arms of Etienne de Sancerre and the feet and arms of a female figure who is clearly standing.

[71] This window was given by a close relative of Bishop Renaud de Mouçon. Delaporte, *Les vitraux de la cathédrale de Chartres*, 485–86.

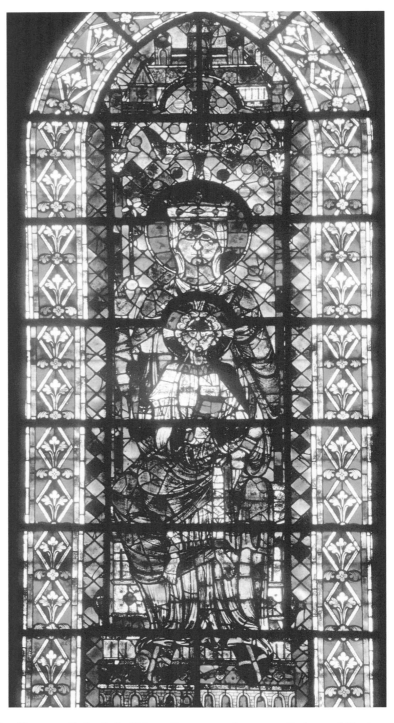

11.8 Chartres, Cathedral of Notre-Dame, window 113a: Enthroned Virgin and Child.

at the corner of the north transept arm situates her almost directly above the crypt where the Romanesque reliquary statue was kept. Rather than being a supplementary reference to the relic of the Virgin's tunic, she is there to recall the presence of the statue of Notre-Dame-sous-Terre in the crypt, itself an object of another pilgrimage to the cathedral. Unlike the Sainte Châsse, which was usually neither physically accessible nor visible to visitors, pilgrims could enter the crypt chapel and make their devotions before the statue, without being held at a distance.

Pilgrims, then, passed in front of the three portals of the north arm of the transept. In the center, the tympanum shows the death of the Virgin, the Assumption of her soul and of her body, and her Coronation by Christ in Heaven. On the right, the Old Testament portal presents in its tympanum the image of Job on the dung heap and the Judgment of Solomon, a prefigurement of the Last Judgment. On the left, the portal depicts scenes related to the Incarnation in the embrasures as well as the tympanum. The Virgin of the Adoration of the Magi in the tympanum, a veritable *sedes sapientiae*, is situated close to the stairway leading to the chapel of Notre-Dame-sous-Terre. Even without wearing the crown, she clearly recalls the reliquary statue in her attitude as well as that of the Christ Child.

In the same portal, the Annunciation in the left door jamb and the Nativity in the tympanum relate to the Sancta Camisa. As has already been noted, the legends of the precious relic recount that the Virgin wore the garment during these events of the Incarnation. But tradition holds equally that Mary still had it on the day of her death and that it later found its way to Byzantium after numerous tribulations. Thus, the tympanum of the central portal and its lintel also make reference to the relic and consequently the Sainte Châsse in the center of the sanctuary.[72]

Certainly, the iconography of the portals of Chartres, like that of the windows, can be analyzed from several simultaneous points of view, and it is not the intention here to propose a univocal explanation for their complex programs. In addition to highlighting the two principal objects of devotion, the Sainte Châsse and Notre-Dame-sous-Terre, it should be noted that the idea of pilgrimage itself is omnipresent in the decorative programs of the cathedral, through the evocation of the great holy sites of Christianity—Rome, Compostella, Tours, Myra—in the representations of the great saints in the windows.[73] The evocation of these sites that attracted multitudes of faithful served as a kind of mirror reflecting back to exalt the pilgrimage to Notre-Dame of Chartres. But

[72] The same theme, surrounded by scenes of the Incarnation and Infancy of Christ, are seen in one of the upper windows of the north transept arm (window 127).

[73] Life of St Peter, window 105. Several windows are dedicated to the life of St James (window 5), to his image as a standing figure (windows 111, 114, 136, and 140), to the reconquest of his tomb recounted in the story of Charlemagne (window 7), or to pilgrims of St James (windows 113b, next to the image of the Virgin). Two windows recount St Martin, in the ambulatory (window 20) and in the upper choir (window 109). St Nicholas is frequently represented, including his life (windows 14 and 39), his miracles (window 29b) or as a standing figure (window 137).

the object of pilgrimage here is fundamentally different: at Rome, Compostella, Tours, or Myra, it was the tomb of the saint that was the goal of the pilgrim; while at Chartres, this goal was the most tangible sign of the Incarnation, the tunic worn by the Virgin, as well as the statue, Notre-Dame-sous-Terre.

Frames of Vision: Architecture and Stained Glass at Clermont Cathedral

Michael T. Davis

'Master Jean Deschamps, who lies with his wife, Marie, and their children in the tomb cut in front of the door of Notre-Dame de Grace, began this church in the year of our Lord one thousand two hundred forty eight.'[1]

Although the epitaph of this master mason provides a summary of a life as a husband, father, and builder, it omits any reference to Jean's birthplace, his professional formation, or the vision that shaped his design of Notre-Dame, the Cathedral of Clermont. However, the gaps in this telegraphic biography raise a series of resonant questions because Jean Deschamps, along with his contemporaries Jean de Chelles and Pierre de Montreuil, working at the Cathedral of Paris and the Abbey of Saint-Germain-des-Prés respectively, played key roles in the creation of the new Rayonnant style of architecture. Their innovations have usually been analyzed in architectural terms as a refinement or mutation of the premises of the previous generation of great church projects exemplified by the cathedrals of Chartres, Soissons, or Reims: structural mass was whittled away, then integrated with patterns of tracery in densely textured, optically complex armatures that appeared fragile and otherworldly.[2] This heightened tone of preciosity relied on both the emulation of the finely scaled forms of ivory and metalwork and the integration of glass, painting, and sculpture to achieve dazzling environments.[3] And it is this

[1] 'Memoria sit quod magister Joannis Decampis incepit hanc ecclesiam anno Domini millesimo ducentesimo quadragesimo octavo qui jacet cum Marie uxore sua et liberis eorum in tumulo incise ante valvas Beatae Mariae gratiae.' This lost epitaph was transcribed and published by Jean Dufraisse, *L'Origine des églises de France prouvée par la succession de ses évêques* (Paris, 1688), 505.

[2] See Paul Frankl, revised by Paul Crossley, *Gothic Architecture* (New Haven, 2000), 22–23; Henri Focillon, *Art of the West* Part 2: Gothic Art, trans. Donald King, (London, 1963), 40–46; Robert Branner, *Saint Louis and the Court Style in Gothic Architecture* (London, 1965); Jean Bony, *French Gothic Architecture of the 12th and 13th Centuries* (Berkeley, 1983) 357–463; and Christopher Wilson, *The Gothic Cathedral* (New York, 1990), 120–40.

[3] Bony, *French Gothic Architecture*, 358, cogently drew attention to Rayonnant architectural changes that 'corresponded in fact to a profound shift in artistic sensibility and one which affected all the fields of art.' See also the important collection of studies in *Artistic Integration in Gothic Buildings*, eds. Virginia Chieffo Raguin, Kathryn Brush, and Peter Draper, (Toronto,

cumulative splendor that Jean de Jandun so evocatively captured in his description of the Sainte-Chapelle written in 1323:

'... (T)he chapel of the King ... is admirable through its strong structure and the indestructible solidity of the materials. The carefully chosen colors of its paintings, the precious gilding of its statues, the transparency of the windows which shine from all sides, the rich cloths of its altars, the marvelous virtues of its sanctuaries, the exotic ornaments of its reliquaries decorated with sparkling jewels, give to this house of prayer such a degree of beauty that upon entering, one feels transported to heaven and one imagines that one has been ushered into one of the most beautiful chambers of Paradise.'[4]

Using the choir of Clermont Cathedral as a case study, my essay argues that this novel Rayonnant sensibility did not arise as an isolated system of forms, but was conceived from the outset with its multimedia context in mind (fig. 12.1). It unfolds against the background of Louis Grodecki's recognition of the symbiotic relationship between architecture, glazing, and coloration, but also draws on Madeline Caviness's investigations of vision and the pictorial frame to present architecture as the vehicle that organized stories and figures into an experience that expressed different modes of seeing.[5] Through its impeccable order and precise articulation of optically penetrable thresholds, Jean Deschamps's design guided viewers in a meditation through space from the material present toward the spiritual timeless.[6]

Background: Clermont and Celestial Architecture

As mentioned in his epitaph, the master mason Jean Deschamps launched construction of the cathedral choir in 1248. In the first building phase he focused on the ambulatory and five chapels whose completion in the early 1260s is

1995), especially the essays by Willibald Sauerländer and Beat Brenk, as well as the thought-provoking caveats offered by Madeline Caviness.

4 'Sed et illa formosissima capellarum, capella Regis, infra menia mansionis regie decentissime situata, integerrimis et indissolubilibus solidissimorum lapidum gaudet structuris. Picturarum colores electissimi, ymaginum deauratio preciosa, vitrearum circumquaque rutilantium decora pervietas, altarium venustissima paramenta, sanctuariorum virtutes mirifice, capsularum figurations extranee gemmis adornate fulgentibus, tantam utique illi orationis domui largiuntur decoris yperbolem, ut, in eam subingrediens, quasi raptus ad celum, se non immerito unam de Paradisi potissimis cameris putet intrare.' Jean de Jandun, *Tractatus de laudibus Parisius*, in *Paris et ses historiens aux XIVe et XVe siècles*, ed. Antoine-Jean-Victor Le Roux de Lincy and Lazare-Maurice Tisserand (Paris, 1867), 45–46; Erik Inglis, 'Gothic Architecture and a Scholastic: Jean de Jandun's *Tractatus de laudibus Parisius* (1323),' *Gesta* 42 (2003): 63–85.

5 Louis Grodecki, 'Le Vitrail et l'Architecture au XIIe et au XIIIe siècles,' *Gazette des Beaux Arts*, ser. 6, 36 (1949): 5–24, esp. 22–24; Madeline Caviness, 'Images of Divine Order and the Third Mode of Seeing,' *Gesta* 22 (1983): 99–120; and Madeline Caviness '"The Simple Perception of Matter" and the Representation of Narrative, ca. 1180–1280,' *Gesta* 30 (1991): 48–64.

6 Paul Crossley, 'The man from inner space: architecture and meditation in the choir of St Laurence in Nuremberg,' in *Medieval Art: Recent Perspectives. A Memorial Tribute to C.R. Dodwell*, ed. Gale R. Owen-Crocker and Timothy Graham (Manchester, 1998), 165–82.

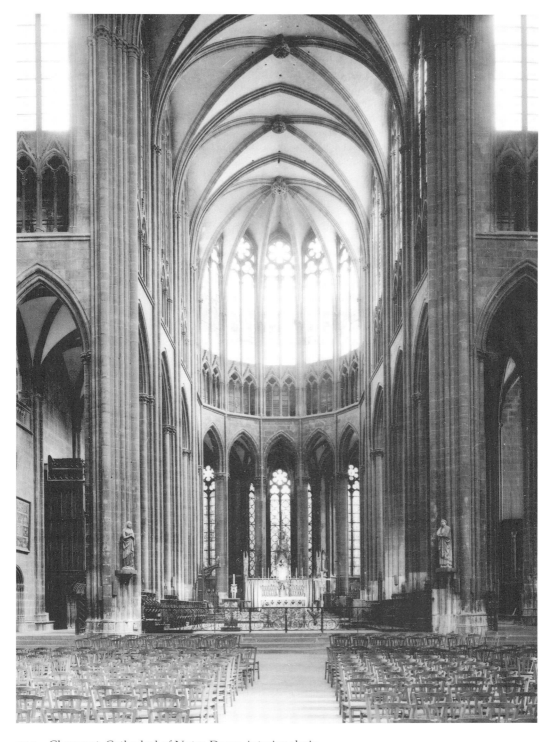

12.1 Clermont, Cathedral of Notre-Dame, interior choir.

signaled by recorded burials in the new edifice and a concentration of endowments (fig. 12.2).[7] He also appears to have begun—then altered—the upper levels of the seven hemicycle bays.[8] During the next decade and following the demolition of the Romanesque chevet, a second master pushed west to encompass the liturgical choir. In 1273 the chapter purchased part of the bishop's garden to continue the project into the south transept, settled questions of access to its portal, and definitively regulated the plan.[9] Once the ground floor of the choir along with the outer walls of the transept and eastern bay of the nave were finished, the choir clerestory was completed. The style of the glass indicates that the high windows were painted and installed during the 1280s.[10]

To date, Clermont's importance in the histories of thirteenth-century architecture has rested on its formal ties to key projects associated with the capital and Louis IX, including the nave chapels of the Notre-Dame in Paris, the Sainte-Chapelle, as well as the abbeys of Saint-Denis and Royaumont. As a result of the appearance of this sophisticated Parisian 'court style' in provincial Auvergne, the cathedral has served as a barometer to measure the expanding political power of the monarchy.[11] It has also been presented as the prototype from which a series of impressive churches—the cathedrals of Limoges, Narbonne, Rodez, and Toulouse—were developed by the industrious Deschamps family of master masons.[12] Scrutinized in biographical terms, Clermont's identity has been defined by its architectural parents and progeny. However useful, this method based on formal taxonomic analysis risks ignoring the building as a coherent whole. As Robert Branner cogently wrote, the 'originality of Clermont does not depend upon the combination of up-to-date details alone … but also on the way such details were made to serve the general conception of the monument.'[13] To understand this 'general conception' of the building as a design intended to anchor painting, glass, and sculpture and to

[7] Anne Courtillé, *La Cathédrale de Clermont* (Nonette: Créer, 1994); Anne Courtillé, *Auvergne, Bourbonnais, Velay Gothiques* (Paris, 2002), 184–205; and Michael T. Davis, 'The Choir of the Cathedral of Clermont-Ferrand: The Beginnings of Construction and the Work of Jean Deschamps,' *Journal of the Society of Architectural Historians* 40 (1981): 181–202; Clermont-Ferrand, Archives Départementales du Puy-de-Dôme hereafter ADPD, 3G, 11 P 9a. In this article, I have adopted the medieval name of the city, Clermont, in preference to the current name, Clermont-Ferrand, that was the result of the administrative union in 1630 of Clermont and nearby Montferrand.

[8] Michael T. Davis, 'On the Drawing Board: Plans of the Clermont Cathedral Terrace,' *Ad Quadratum: the practical application of geometry in medieval architecture*, ed. Nancy Y. Wu (Aldershot, 2002): 188–92.

[9] Davis, 'The Choir of Clermont-Ferrand,' 188 and ADPD 3G, 18 B 22–23.

[10] Henri Du Ranquet, *Les vitraux de la cathédrale de Clermont-Ferrand (XIIe, XIIIe, XIVe, XVe siècles* (Clermont-Ferrand, 1932), 271–86; Louis Grodecki and Catherine Brisac, *Gothic Stained Glass 1200–1300*, trans. Barbara Drake Boehm (London, 1985), 142–44.

[11] Branner, *Saint Louis and the Court Style*, 97–101 and 141–42, attempted to date the beginning of construction to after 1262. This cast the cathedral as a conservative reflection of Parisian architecture of the 1230s and 1240s.

[12] Christian Freigang, 'Jean Deschamps et le Midi,' *Bulletin monumental* 149 (1991): 265–298.

[13] Branner, *Saint Louis and the Court Style*, 99.

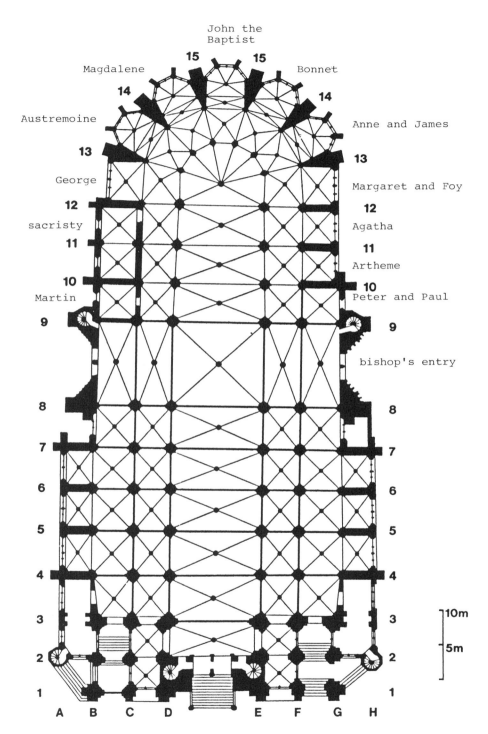

12.2 Clermont, Cathedral of Notre-Dame, plan with medieval dedications of choir chapels.

orchestrate viewing experience is the goal of this essay. Clermont Cathedral, like its contemporaries Saint-Urbain in Troyes or Saint-Thibault-en-Auxois, was driven by a conscious search for a language of form and method of composition that gave tangible articulation to the act of seeing.

In exploring the phenomenological logic of Rayonnant architecture, I do not wish to dismiss other approaches based on formal examination, functional explanation, or structural analysis. Rather, I suggest an additional path of inquiry by which, once a building's autopsy is complete, its constituent forms isolated, studied, and classified, we can recover its body as a whole. For, although the ecclesiastical interior may be semiotically polysemous—columns and piers, for example, may allude simultaneously to the Apostles, the Prophets, Rome, or other prestigious models—it was experienced as an environment.

If we scan the cathedral's interior architecture by panning from the lateral chapels across the choir aisle then into the main vessel, we see an edifice that rises in a terse grid of vertical shafts and horizontal moldings to define the three-story elevation in two equivalent panels: the arcade and the linked zones of the dark triforium and clerestory (figs. 12.1 and 12.3). The stunning unity of the Clermont choir results not only from consistent scale and the attention to formal echoes between its components, but also from what might be called the programmatic modernity of its vocabulary. There is not a single element of the design that retains a legible association with the past.

In calling the Clermont choir 'modern,' I follow ideas raised by Marvin Trachtenberg in his critique of analytical methodologies applied to later medieval architecture.[14] Arguing for a new and expansive 'cultural-historical consciousness paradigm' to replace the limiting criteria of style, he described medieval architecture in terms of shifts between dynamic, often conflicted modalities of historicism and modernism. In his view, by replacing load-bearing wall with glass, by thinning, elongating, and multiplying the columns, and by converting trabeation into pointed arches and sharp gables, Gothic masons such as Jean Deschamps suppressed historicist architectural language to achieve a 'comprehensive, vital, new deep-rooted program of structure and form, which is inherently both modernist and anti-classical in logic and effect, and in signification and self-conscious motivation.'[15]

The motivations behind this shift were doubtless varied and complex. In part they evolved in the practical sphere of workshop methods of production and design. Increasing reliance on serial fabrication in which building elements were put together with a few standardized parts fashioned from smaller more easily quarried blocks promoted the reduction of mass and scale.[16] In fact, the

[14] Marvin Trachtenberg, 'Gothic, Italian "Gothic": Toward a Redefinition,' *Journal of the Society of Architectural Historians* 50 (1991): 22–37, and especially, Marvin Trachtenberg, 'Desedimenting time: Gothic column/paradigm shifter,' *Res* 40 (2001): 5–28.

[15] Trachtenberg, 'Desedimenting time,' 19. See also Anne-Marie Sankovitch, 'The myth of the "myth of the medieval:" Gothic architecture in Vasari's *rinascita* and Panofsky's Renaissance,' *Res* 40 (2001): 46–50.

[16] Dieter Kimpel, 'Le développement de la taille en série dans l'architecture médiévale et son rôle dans l'histoire économique,' *Bulletin monumental* 135 (1977): 195–222; and 'Ökonomie,

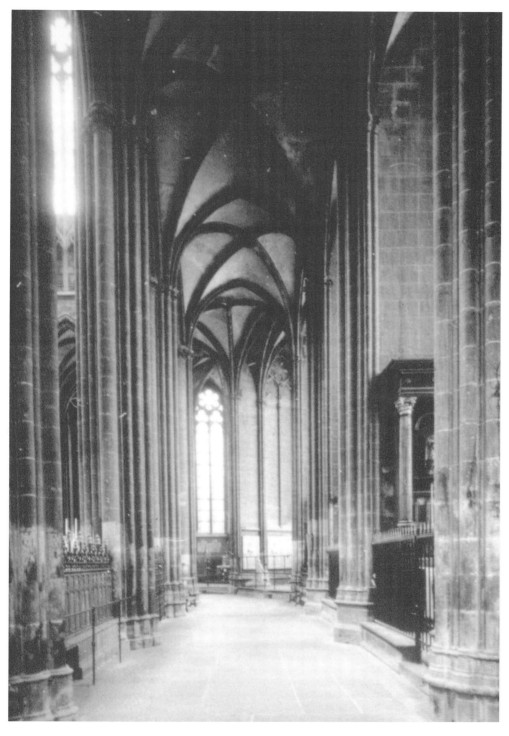

12.3 Clermont, Cathedral of Notre-Dame, south choir aisle, view facing east.

term *opus francigenum* may have been, first and foremost, a *technical* term that referred to rationally planned and superbly cut ashlar wall masonry rather than a set of particular *stylistic* requirements.[17] Further, the rise of drawing as an integral tool of design may have contributed to the intensification of the overall linearity of forms. At Clermont, window tracery patterns, flying buttresses, and portal gables were all worked out graphically in full-scale plans before actual construction.[18]

Beyond the confines of the lodge, architecture also translated the visions of patrons into the physical fabric of the church. The metallic character of Rayonnant architecture, seen at Clermont in the appliqué of delicate gables on the interior over the triforium, replicated effects and forms of shrines to imbue the building with the aura of a sacred object, while at the same time, reliquaries such as the Grand Châsse of the Saint-Chapelle, the châsse of Saint Gertrude, formerly in Nivelles, or that of Saint Taurin in Evreux faithfully miniaturized the details of monumental architecture.[19] More than a manifestation of craft practice or period taste, the church and the shrine represented a shared theological image of the *tabernaculum admirabile*, the 'wondrous tabernacle,' that provided entry to the Heavenly Jerusalem through the Church, its sacraments, and saints.[20]

The aesthetic, technical, and symbolic strands that coalesced into Rayonnant architecture created a language that shifted the direction of its referents away from the past and Rome, the embodiment of the earthly city, to the immaterial future.[21] Thus, the visible architecture of the Clermont cathedral interior

Technik und Form in der hochgotischen Architektur,' *Bauwerk und Bildwerk im Hochmittelalter* (Giessen, 1981): 103–25.

[17] Günther Binding, 'Opus Francigenum: Ein Beitrag zur Begriffsbestimmung,' *Archiv für Kulturgeschichte* 71 (1989): 45–54; Peter Kurmann, 'Opus Francigenum: Überlegungen zur Rezeption französischer Vorbilder in der deutschen Architektur und Skulptur des 13. Jahrhunderts anhand des Beispiels von Wimpfen im Tal,' *Mitteilungen der Gesellschaft für Vergleichende Kunstforschung in Wien* 33 (1981): 1–5.

[18] Robert Branner, 'Villard de Honnecourt, Reims, and the Origin of Gothic Architectural Drawing,' *Gazette des Beaux Arts*, series 6, 61 (1963): 129–46; Roland Recht, 'Sur le dessin d'architecture gothique,' *Etudes d'art médiéval offertes à Louis Grodecki*, ed. Sumner McK. Crosby, André Chastel, Anne Prache, and Albert Chatelet (Paris, 1981): 233–35; Wolfgang Schöller, 'Ritzzeichnungen. Ein Beitrag zur Geschichte der Architekturzeichnung im Mittelalter,' *Architectura* 19 (1989): 36–61; and Roland Recht, ed., *Les Bâtisseurs des cathédrales gothiques* (Strasbourg, 1989): especially Part V, 'Le Dessin d'Architecture et ses Applications,' 226–85. For the use of drawing at Clermont, see Davis, 'On the Drawing Board,' 183–204.

[19] Branner, *Saint Louis and the Court Style*, 56–59; Bony, *French Architecture*, 398–405; Peter Kurmann, 'Cathédrale miniature ou reliquaire monumental? L'Architecture de la chasse de Sainte Gertrude,' *Un Trésor Gothique: La Châsse de Nivelles* (Paris, 1996): 135–53.

[20] Bernard McGinn, 'From Admirable Tabernacle to the House of God: Some Theological Reflections on Medieval Architectural Integration,' in *Artistic Integration*, 40–56; Kurmann, 'Cathédrale miniature,' 153.

[21] This opposition, of course, underlay Augustine's influential *City of God* and Otto of Freising's *Two Cities*. Even the re-use of antique architectural elements was an ambivalent act, as underlined by Dale Kinney, 'Rape or Restitution of the Past? Interpreting *Spolia*,' in *The Art of Interpreting*, ed. Susan Scott (University Park, Penn., 1995), 53–67. See Alain Schnapp, *The Discovery of the Past*, trans. Ian Kinnes and Gillian Varndell, (New York, 1997), 104–5, for the waning interest in antiquity in northern Europe in the thirteenth century.

consists of structural elements that are so patently inadequate to their apparent job in the 'real' world—the shafts rising to the springing of the vault ribs are more than twenty meters tall, yet only eighteen centimeters in diameter—that we can only echo the thoughts of Jean de Jandun in concluding that we have entered heaven.

Entering the Frame

The heavenly associations triggered by the architecture of the Clermont choir crystallized into a specific identity through the imagery encountered on the portals and in the interior. Arriving at the main public entrance of the north transept, one faced a Last Judgment in the tympanum accompanied by the twelve apostles in the jambs and the Virgin of Grace, patron of the cathedral, on the trumeau. A gable framing an unusual group of male personifications of the Liberal Arts crowned the portal. Its pendant on the south, facing the episcopal palace, displayed the Coronation of the Virgin along with statues of ten bishops and a trumeau occupied by St Austremoine, the apostle of Auvergne and founder of the diocese.[22] Many of these same holy figures, physically present in their relics and brought to life in glass or paint, waited within the cathedral.

Upon entering through one of the transept portals, one faced the long choir aisle corridor and a single glittering window at the end of the vista (fig. 12.3). Expansive lateral views are cut off by the blank walls between the rectangular chapels of the choir's western bays and the intrusion of the diagonal masses of the buttresses that divide the radiating chapels of the ambulatory (fig. 12.4). This scenographic relationship between glass and choir space that reveals the windows' narratives one at a time to a viewer moving down the aisle contrasts sharply with the panorama enjoyed by the celebrant in front of the high altar.[23]

The windows of the ground floor of the Clermont choir assemble both universal and local themes in a multi-layered ensemble. All stylistic indices suggest that glazing correlated with the major campaigns of building outlined above: the windows of the five polygonal chapels were installed between about 1260 and 1265 with the glass in the western bays following a decade later.[24] In the axial chapel, cycles of the Infancy of Christ, the story of Theophilus featuring the Virgin Mary, and a life of John the Baptist constitute a kind of narrative Deesis. Stories of St George, Mary Magdalene, St Margaret, St Foy, and St Agatha along with those of St Austremoine, St Bonnet, St Privat, and St Artheme appear within their respective chapels.[25]

[22] Pierre Audigier, 'Histoire de la ville de Clermont,' Paris, BnF, fonds français MS. 11485, 110r-111r. See also Courtillé, *La Cathédrale de Clermont*, 84–91.

[23] Robert Bork, 'Geometry and Scenography in the Late Gothic Choir of Metz Cathedral,' *Ad Quadratum*, 243–67, especially 245–46.

[24] Grodecki and Brisac, *Gothic Stained Glass*, 142–44.

[25] Du Ranquet, *Les vitraux*; and Courtillé, *La Cathédrale de Clermont*, 111–43.

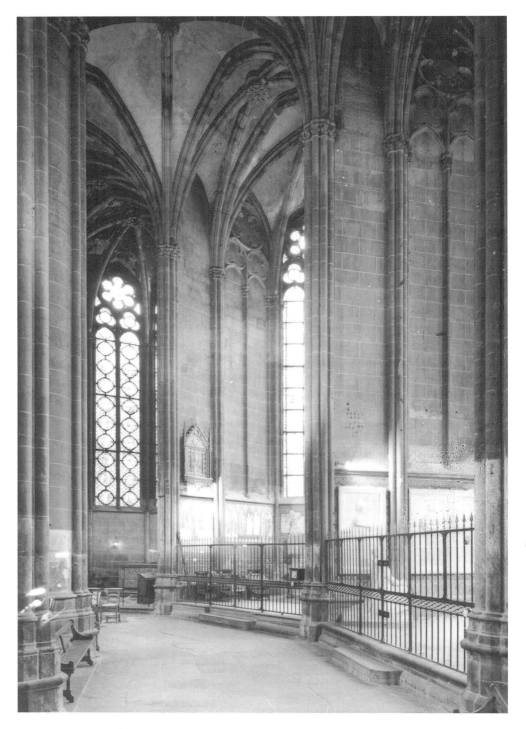

12.4 Clermont, Cathedral of Notre-Dame, ambulatory and radiating chapels; view into chapel of Saint-Bonnet.

Despite the phased execution of the windows, the connections of the chapel dedications to the subjects of their glass and to the relics in the cathedral's possession leave no doubt as to the rationale behind the program. The stories of Christ related to a piece of the True Cross, a fragment of the Crown of Thorns, parts of Jesus's purple robe, and a portion of his swaddling clothes donated by Louis IX. Similarly, the Theophilus narrative might evoke Marian relics in the famous tenth-century wooden Majesty supposedly brought by St Austremoine from the east, while relics of John the Baptist embodied the visual account of his preaching and execution.[26] The châsses of Austremoine, Bonnet, George, Agricol, and Vital all were complemented by chapel dedications or glazed narratives.[27]

The emphasis on sainted bishops weaves Clermont's history into the larger story of salvation to enhance local prestige. Circling the ambulatory we see Austremoine building a church and discover Bonnet, the reluctant bishop, hiding behind a column only to be found by the Virgin, who bestows on him a chasuble and participates in the Mass. This presentation of the past as active and immediate may explain the puzzling (to our preservation-minded age) obliteration of the early medieval crypt, parts of which dated back to around the year 1000, and further underlines the modernist character of the new cathedral.[28] The suppression of the crypt chapels, which served as repositories for relics, led to the transfer of cult activities, perhaps those surrounding the bishop-saints of Clermont, into the thirteenth-century choir. Frequently appearing during the liturgical year, the relics of these venerable pontiffs sanctified their new resting place.[29] Meanwhile, the architecture, by purging all trace of older structures and adopting the character of a shrine, invited the blending of past and present through ritual and visionary experience. Erasing the fabric of the past implicitly transferred the illustrated miracles into the present structure: the edifice that Austremoine built became in effect *this* church, the columns that sheltered Bonnet must be the supports that we see; the Virgin attends Mass in *this* cathedral.

Having surveyed the architecture and glass separately, let us now integrate them to suggest how they may have combined to regulate visual experience. Clermont's five radiating chapels have been noted for the unusual inclusion of a narrow quadripartite bay that fronts the polygonal space (figs. 12.2 and

[26] Pierre Audigier, 'Histoire de la ville de Clermont,' MS 11485, 105v citing the *Canone*, the Cathedral's book of rules and regulations, ADPD 3G, supplement 15 (registres). Louis IX's donation of relics to Bishop Guy de la Tour in 1269 is published in *Exuviae sacrae constantinopolitanae*, ed. Comte P. E. D. Riant, 3 vols (Geneva, 1877–1904), 2:159.

[27] Abbé Raphanel, 'Les Anciens Usages Liturgiques du Diocèse de Clermont,' *Semaine Religieuse de Clermont* 33 (1901): 361–69; Ellen M. Shortell, 'Dismembering Saint Quentin: Gothic Architecture and the Display of Relics,' *Gesta* 36 (1997): 48–64.

[28] Pascale Chevalier, 'La crypte de la cathédrale de Clermont: nouvelles approaches,' *Les Cahiers de Saint Michel de Cuxa* 32 (2001): 133–46; Barbara Abou-El-Haj, *The Medieval Cult of Saints: Formations and Transformations*, (Cambridge, 1994), 19, 48, and 56.

[29] Chevalier, 'La crypte,' 145; Abbé Raphanel, in a series of articles published in *Semaine Religieuse de Clermont* between 1901 and 1914, explored the medieval liturgy at the Cathedral.

12.4).[30] This feature may have had a structural motivation, making deep buttresses possible and may point to sources utilized by Jean Deschamps, the cathedrals of Cambrai or Le Mans for example. However, it also reveals the way he designed the articulation of the structure to establish a gradated matrix for imagery. From a position in the ambulatory, each chapel is introduced by a section of stark, bare wall, followed by a bay of blind tracery then concludes in the luminous glazed walls that surround the altar (figs. 12.4 and 12.5). The vertical vault shafts, together with the horizontal string course and tracery, create compartments through which we look: from our 'real' space in the ambulatory into the chapel accessible only to the clergy. In moving into the chapels, they pass from a world of solid matter into a realm of light animated by the events of sacred history.

Individual donors, primarily the cathedral's canons, added votive paintings to the chapel walls at the end of the thirteenth or beginning of the fourteenth centuries.[31] Located in the lower and outer segments of the unadorned dado, the paintings are situated between the viewer in the ambulatory and the chapel glass beyond. However, the movement, gestures, and gazes of the figures knit the sequence of spaces and pictorial zones together. For example, in the chapel of St Bonnet, adjacent to the axis on the south, a procession of five canons and a priest follows an angel who calls their attention to the legend of the saintly Clermont bishop in the windows beyond (fig. 12.4).[32] In the Magdalene chapel, its pendant on the north, a priest is invited by his celestial guide to view the altar and narrative life of the Magdalene, while in the next bay, a canon kneels in adoration of the enthroned Virgin and Child (fig. 12.6).[33]

If we follow the visual cues of the architecture, the imagery of the chapels unfolds across a series of thresholds of time and space in a measured sequence that approximates the modes of seeing elucidated by Richard of Saint-Victor.[34] The first level, our physical sight, perceives the 'matter' of the chapel, 'the figures and colors of visible things' presented on the walls and in the windows.[35] A second stage leads us into the chapel and into the company of deceased members of the Clermont ecclesiastical community. Functioning in concert with funerary liturgy and anniversary services, the canons' painted

30 Lisa Schürenberg, *Die kirchliche Baukunst in Frankreich zwischen 1270 und 1380* (Berlin, 1934), 18; Branner, *Saint Louis and the Court Style*, 98. In 'The Choir of Clermont-Ferrand,' 198, I suggested Jean Deschamps's knowledge of the Cambrai Cathedral choir of the 1220s and 1230s.

31 Courtillé, *La Cathédrale de Clermont*, 175–93.

32 Anne Courtillé, 'Les peintures murales de style gothqiue en Auvergne,' *Revue d'Auvergne*, 89 (1975): 236; Anne Courtillé, *La Cathédrale de Clermont*, 184–85; and Anne Courtillé, 'Peintures votives et funéraires à la cathédrale de Clermont,' *Bulletin historique et scientifque de l'Auvergne*, 97 (1995): 330–31.

33 Courtillé, *La Cathédrale*, 179–83; and 'Peintures votives,' 331–36.

34 Caviness, 'Images of Divine Order,' 115–116; Michael Camille, '"Him Whom You Have Ardently Desired You May See": Cistercian Exegesis and the Prefatory Pictures in a French Apocalypse,' *Studies in Cistercian Art and Architecture*, vol. 3, ed. Meredith Parsons Lillich (Kalamazoo, 1987): 137–60, esp. 142–47; and Jeffrey Hamburger, *The Visual and the Visionary: Art and Female Spirituality in Late Medieval Germany* (New York, 1998), 131–34.

35 Caviness, 'The Simple Perception of Matter,' 48–64.

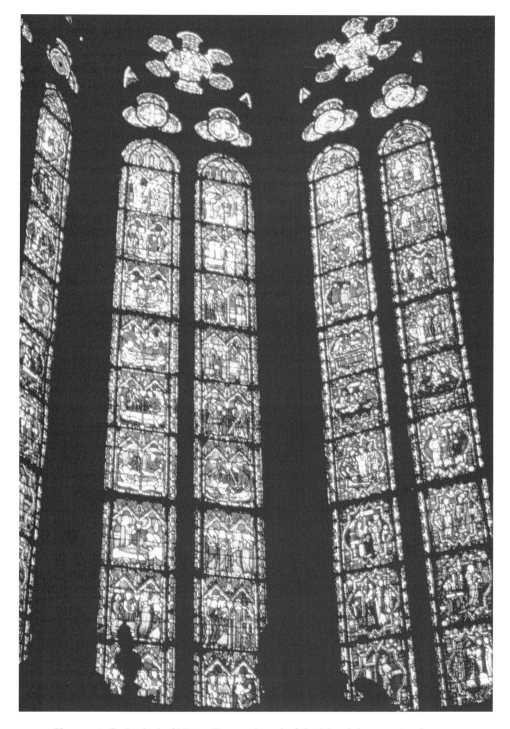

12.5 Clermont, Cathedral of Notre-Dame, chapel of the Magdalene, stained-glass windows.

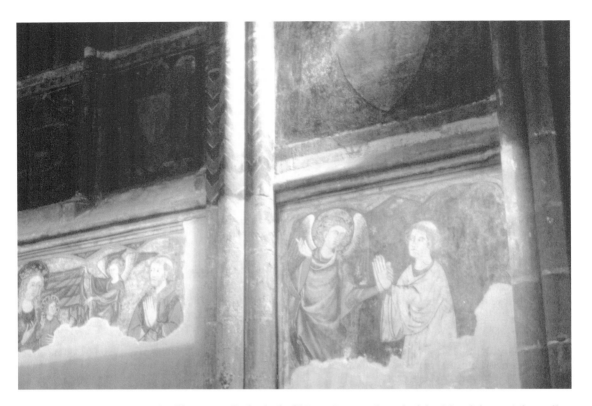

12.6 Clermont, Cathedral of Notre-Dame, chapel of the Magdalene, right wall, votive paintings.

effigies moved beyond sensate experience to enlist viewer memory in the quest for salvation.[36] A final step reaches the luminous sacred stories in the glass whose contemplation, in the words of Heinrich Suso, may lift one 'from this false, downward-dragging world to a higher godly one.'[37]

While almost every medieval church design aimed to coordinate images, relics, and ritual, the special character of Jean Deschamps's design for Clermont lies in its perspicuous network of shafts, moldings, and mullions that defined a hierarchy of pictorial compartments. However, the repetitive matrix of wall panels, arches, and lancets did not dictate either the specific content or temporal sequence of the subject matter. Rather the cathedral architecture set up a template to order different categories of images—memorials and votive panels in paint on the solid lower walls, saints' lives and biblical histories in the

36 Courtillé, *La Cathédrale*, 175–76; and 'Peintures votives,' 329–33; Michelle Pradelier-Schlumberger, 'L'Image de la Vierge de la Chandeleur au XIII^e et au XIV^e siècle,' *De la création à la restauration. Travaux d'histoire de l'art offerts à Marcel Durliat* (Toulouse, 1992): 341–50.

37 Caviness, 'Images of Divine Order,' 115–16; Wolfgang Kemp, 'The Narrativity of the Frame,' *The Rhetoric of the Frame*, ed. Paul Duro, (Cambridge, 1996): 11–23; Wolfgang Kemp, *The Narratives of Gothic Stained Glass*, trans. Caroline Dobson Saltzwedel, (Cambridge, 1997), esp. 3–88 and 154–59; and Crossley, 'The man from inner space,' 174.

windows above—one that retained its programmatic legibility while admitting additions made over time. It also accommodated the multiple viewing itineraries of its diverse audience. The description above adopted the fixed perspective of a spectator stationed in the ambulatory or within the chapel itself. To the priest at the altar or the supplicant seeking spiritual aid, the window could be read in its entirety complemented by the panoply of chapel *ornamenta*. However, these spaces were as often seen in motion, by clergy in procession, by strolling laity, as fragments approached along different routes that scrambled that temporal order, and in association with other stories.[38] As in the imagined memory house of ancient and medieval rhetoric, the uniform visual tempo laid down by the Clermont chapel architecture, along with repeating colors, compositions, and gestures within the glass invited the viewer to organize myriad narrative and thematic connections.[39] Although the ability of the uninformed viewer to navigate this meditative environment toward a state of spiritual illumination was not automatic, as shown by the muddled readings of the Canterbury windows by pilgrims loose in the cathedral, the network of shafts, moldings, and tracery at Clermont orchestrated thresholds through which the engaged participant could step by the power of sight into worlds of sacred history and celestial visions.[40]

At the Gates of Heaven

Visual ascent into the upper levels of the choir carries us into a new realm and mode of viewing. The most frequently noted feature of the interior, the dark triforium, has been explained, rather dubiously, on the basis of Clermont's southerly location or, more credibly, by Jean Deschamps's incorporation of an element drawn from conservative or monastic models (fig. 12.7).[41] But when considered in terms of its *optical* role in the elevation, the triforium inserts a forceful horizontal break between two glazed vertical zones. Crowned by miniature gables that mask a mural transition to windows above, it appears as a frieze of delicately framed aedicules conceptually similar to the celestial gazebos in the Orthodox Baptistery at Ravenna.[42] It is the gateway to the heavenly realm above.

38 Bettina Bergmann, 'The Roman House as Memory Theater: The House of the Tragic Poet in Pompeii,' *Art Bulletin* 76 (1994): 225–56; Crossley, 'The man from inner space,' 174–77.

39 Mary J. Carruthers, *The Book of Memory: A Study of Memory in Medieval Culture* (Cambridge, 1990), 71–79 and 122–55.

40 Quoted in Michael Camille, 'When Adam Delved: "Laboring on the Land in English Medieval Art,"' *Agriculture in the Middle Ages: Technology, Practice, and Representation*, ed. Del Sweeney (Philadelphia, 1995), 247–76; For the full text, see also 'The Canterbury Interlude and Merchant's Tale of Beryn,' *The Canterbury Tales: Fifteenth-Century Continuations and Additions*, ed. John M. Bowers (Kalamazoo, 1992), 64, beginning at line 145; my thanks to Professor Glending Olson of Cleveland State University for the latter reference.

41 Frankl, *Gothic Architecture*, 136; Branner, *Saint Louis and the Court Style*, 99–100.

42 Spiro Kostof, *The Orthodox Baptistery of Ravenna*, (New Haven, 1965), 76–82; Rüdiger Becksmann, 'Le Vitrail et l'Architecture,' *Les Bâtisseurs des cathédrales gothiques*, 297–305.

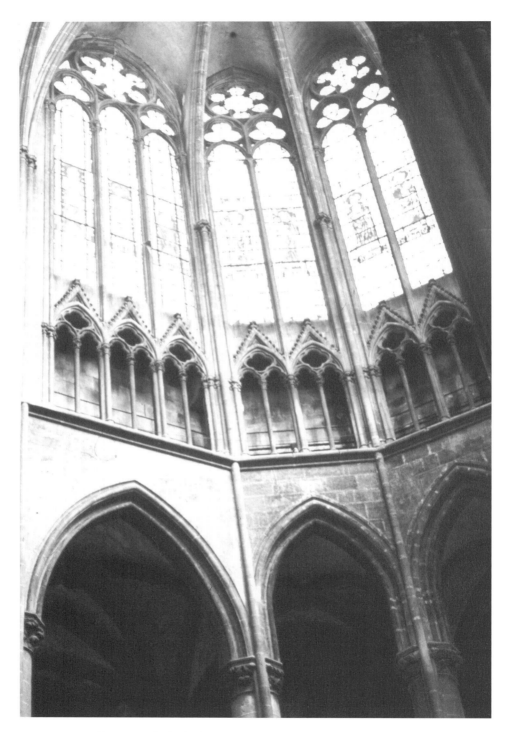

12.7 Clermont, Cathedral of Notre-Dame, triforium and clerestory of choir hemicycle.

12.8 Clermont, Cathedral of Notre-Dame, axial windows of choir hemicycle, Assumption of the Virgin.

Featuring the Assumption of the Virgin, the clerestory lights hover above the shadowy band of the triforium (fig. 12.8). Dramatic shifts of color and scale signal the passage into a world distinct from that of the ground floor of the choir. The switch from the heavily saturated palette of the chapels to isolated panels in fields of grisaille, rather than a product of sequential glazing campaigns, serves as a metaphor of the transformation of terrestrial perception and light (*lumen*) into the primary and white light (*lux*) of the divine.[43] In addition, the bustling activity of earthly events contained within the small medallions of the chapel windows gives way to the iconic figures of Christ, the Virgin, Apostles, and Prophets standing within gabled tabernacles identical to those of the triforium below. As we approach the Assumption while looking

43 See Michael Camille, 'Before the Gaze: The Internal Senses and Late Medieval Practices of Seeing,' in *Visuality Before and Beyond the Renaissance: Seeing as Others Saw*, ed. Robert S. Nelson (Cambridge, England, 2000), 207; and Cynthia Hahn, '"Visio Dei": Changes in Medieval Visuality,' in *Visuality Before and Beyond the* Renaissance, 169–96; John Gage, 'Gothic Glass: Two Aspects of a Dionsyian Aesthetic,' *Art History* 5 (1982): 36–59, esp. 46–49; John Gage, '*Lumen, Alluminar, Riant*: Three Related Concepts in Gothic Aesthetics,' *Europäische Kunst um 1300* (XXV International Congress of the History of Art, Vienna, 1983) (Vienna, 1986): 11–18.

up through the multiple levels of the cathedral's interior, the material stone structure metamorphoses into canopies of light.

There is also a change in the architectural *parti* that divides the length of the choir into two distinct areas. An essentially continuous cylinder of glass envelops the seven hemicycle bays around the altar. Mary and Christ of the Assumption float in the axial lancets flanked by Peter, John, James the Major, Thomas, Bartholomew, Paul, Andrew, James the Minor, Matthew, and the prophets Zephaniah, Isaiah (twice), Joel, and Abraham.[44] A prominent mural caesura separates the altar area from the three bays to the west inhabited by Old Testament kings and prophets. The 'recessed windows' framed by a border of masonry in these western choir bays have been interpreted as alterations introduced by a second mason. To the contrary, analysis of architectural details suggests that Jean Deschamps planned these distinctive clerestory rhythms during the first phase of construction.[45] And within the visual logic of the design the changes in pattern, used in the clerestory to distinguish the territory of the Old Testament figures from the region of the Virgin, serve in the choir below to demarcate the space of the high altar from the area of the canons' stalls.

Jean *did* apparently revise his clerestory design by modifying the tracery pattern from four lancets to three and thereby reducing the total number of lights from forty-two to thirty-four.[46] Yet there is no hint that the bishop or chapter ever expressed concern that cutting the population of the windows in any way compromised the meaning of the pictorial program. After all, an Assumption with nine apostles instead of twelve was still an Assumption. Nevertheless, this alteration of the clerestory, like the composition of the chapels, implies that the Rayonnant architectural frame was not an inflexible system, but a scheme in which the process of planning and the experience of perception remained fluid.

As in the contemporary shrines of Saints Elisabeth, Marburg, or Saint Gertrude, Nivelles, the Apostles and Prophets in the doorways of their mansions in the Clermont clerestory act as guardians of the gates of paradise and embody the triumph of the church in Heaven represented by the Assumption of the Virgin.[47] However, this eternal victory is given a pronounced local accent through the inclusion of the deeds of Clermont bishop-saints in the chapel windows below. According to ideas developed in thirteenth-century theology, the souls of these saints entered paradise immediately after death where they enjoyed the direct sight of the divine, the *visio Dei* that is the fourth and highest level of vision. Because of this unmediated access to God, their intercession was particularly effective for those Christians who sought out their

44 Du Ranquet, *Les vitraux*, 271–86, esp. 279; Courtillé, *La Cathédrale de Clermont*, 144–49, for the clerestory windows.

45 Davis, 'The Choir of Clermont-Ferrand,' 198–200.

46 Davis, 'On the Drawing Board,' 188–92.

47 Bruno Boerner, 'Interprétation du programme iconographique de la châsse de sainte Gertrude à Nivelles,' *La Châsse de Nivelles*, 225–33, esp. 230 and 232–33.

relics.[48] At Clermont, the cathedral offered a space for this encounter through an architecture inhabited by holy bodies, activated by liturgy, and elucidated by imagery.

Conclusion

Long ago, Lisa Schürenberg and Louis Grodecki underscored the reciprocal relationship between architecture and glass that was a primary factor in the development of the Rayonnant aesthetic: the widespread adoption of grisaille glass triggered new effects of fine scaling and thinness in the modeling of the church that in turn pushed glaziers to modify the conditions of illumination.[49] Extending their observations, I have proposed that the diagrammatic architectural scaffolding erected at Clermont was conceived to provide an impressive number of compartments for images and to order their perception through visible boundaries and penetrable screens as a metaphorical equivalent for spiritual ascent.[50]

This reading of Clermont does not negate either the political prestige or the visual magnetism of French thirteenth-century architecture, for we certainly know from familiar citations that it sparked both admiring imitation and competitive emulation.[51] Nevertheless, the appeal of the style may also have been due to its success as a frame for images and devotional experience. It was perhaps the recognition of its visual efficacy that led the prior of Wimpfen-im-Thal, Richard von Dietensheim, to rebuild his monastery 'opere francigeno' with traceried lights and panels, statue niches, and gables—a veritable riot of frames—installed in a package otherwise untouched by Parisian fashion.[52] The prior's directive also underscores the fact that the distinctive character of rayonnant architecture was not the sole creation of master masons, but was also informed by the clergy's knowledge and vision.

More than offering a passive enclosing envelope whose surfaces and openings offered fields for pictorial representation, Rayonnant architecture

[48] Boerner, 'Interprétation ,' 233.

[49] Schürenberg, Die kirchliche Baukunst, 17–20, emphasized the importance of the gradation in light at Clermont, from the saturated light ('prägnante Aufhellung') below to the stronger illumination of the clerestory above. Also see 281–84 and Grodecki, 'Le Vitrail et l'Architecture,' 5–24, esp. 22–24.

[50] See Eamon Duffy, The Stripping of the Altars: Traditional Religion in England c. 1400–c. 1580 (New Haven, 1992), 97–100; Michael T. Davis, 'Splendor and Peril: The Cathedral of Paris, 1290–1350,' Art Bulletin 80 (1998), 44–52; Jacqueline Jung, 'Beyond the Barrier: The Unifying Role of the Choir Screen in Gothic Churches,' Art Bulletin 82 (2000): 622–57; Achim Timmermann, 'Eucharistie und Architektur: Sakramenshäuser der Parlerzeit,' Das Münster 55 (2002): 2–13; and Achim Timmermann, 'Ein mercklich köstlich und werklich sacrament gehews: Zur architektonischen Inszenierung des Corpus Christi um die Mitte des 15. Jahrhunderts,' Kunst und Liturgie : Choranlagen des Spätmittelalters – ihre Architektur, Ausstattung und Nutzung, ed. Anna Moraht-Fromm (Stuttgart, 2003): 207–30.

[51] Branner, Saint Louis and the Court Style, 112–37; Bony, French Gothic Architecture, 415.

[52] For Richard von Dietensheim and Wimpfen-im-Thal: Branner, Saint Louis and the Court Style, 1; Kurmann, 'Opus Francigenum,' 1–5.

embodies divine order in tangible form through an explicit physical organization of viewer, images, and liturgical performance. In edifices such as the Clermont Cathedral, the architectural frame established material thresholds, approached through physical sight and crossed in meditation, which, according to Richard of Saint-Victor, led the attentive viewer 'by means of forms and figures and the similitudes of things, to the spiritual vision of the celestial.'[53]

53 Caviness, 'Images of Divine Order,' 115–16, quoting Richard of Saint-Victor, *In Apocalypsim* Joannis.

'The Widows' Money' and Artistic Integration in the Axial Chapel at Saint-Quentin

Ellen M. Shortell

At the base of the Glorification of the Virgin window in the axial chapel of the collegiate church of Saint-Quentin (figs. 13.1, 13.2), four figures kneel at altars in two facing donor panels (fig. 13.3). Those on the left present a miniature replica of the window itself, with its distinctive armature; those on the right, a sack of coins. The gifts are described with simple labels below the figures: 'ISTA VITREA' (this window), and 'AES VIDUARUM' (the widows' money), respectively. The individuals are unnamed, but their gift is transformed by this image into a perpetual gesture, as though the women themselves hold the real window in place above the altar.

A number of 'integrated' studies of Gothic buildings have sought to tie the main subjects in stained-glass windows, whether single figures or narratives, to altar consecrations, relics, liturgical celebrations, and the movements of people within an architectural space.[1] Donor panels, often found in the lowest registers of windows, recorded the social and economic transactions that surrounded the construction of a church, and have been studied above all as evidence of patronage and political relationships.[2] Indeed, surviving donor panels at Saint-Quentin are the remnants of a social network of the local elite, which dominated life in the collegiate precinct when construction of the Gothic chevet began. The panels also preserve a visual record of the way that members of the elite pictured themselves, and were pictured by the clergy, within the

[1] See the preceding papers in this volume by Lautier and Davis; Madeline Caviness, 'Stained Glass Windows in Gothic Chapels, and the Feasts of the Saints,' in *Römisches Jahrbuch der Bibliotheca Hertziana: Kunst und Liturgie im Mittelalter*, ed. Nicolas Bock, Sible de Blaauw, Christoph Luitpold Frommel, and Herbert Kessler, *Akten des Internatinalen Kongresses de Bibliotheca Hertziana und des Nederlands Institut te Rome, Rom, 28–30 September 1997* (Munich, 2001), 135–48, esp. 142; Peter Kurmann and Brigitte Kurmann-Schwarz, 'Chartres Cathedral as a Work of Artistic Integration,' in *Artistic Integration in Gothic Buildings*, ed. Virginia Raguin, Kathryn Brush, and Peter Draper (Toronto, 1995), 131–52.

[2] For example, James Bugslag, 'Ideology and iconography in Chartres Cathedral: Jean Clement and the Oriflamme, *Zeitschrift für Kunstgeschichte* 61 (1998): 491–508; Madeline Caviness, 'Anchoress, Abbess, and Queen: Donors and Patrons or Intercessors and Matrons?' in *The Cultural Patronage of Medieval Women*, ed. June Hall McCash (Athens, Georgia, 1996), 105–53.

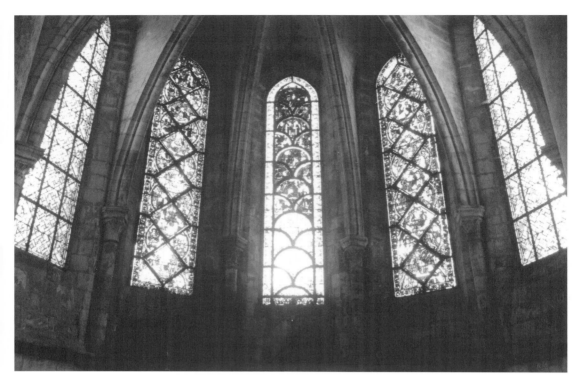

13.1 Saint-Quentin, former collegiate church, Virgin Chapel, interior.

building. The donor image thus suggests a further dimension for an 'integrated' or 'holistic' interpretation of the church.

Saint-Quentin offers two distinct visual and spatial experiences to the visitor. The first is the towering and expansive interior that has come to define Gothic architecture in modern discourse. On entering the late Gothic nave, one's attention is drawn to the distant hemicycle where tall figures of saints hover in deeply colored stained glass above the sanctuary. Advancing toward that sanctuary, however, one turns to the choir aisles, as the presence of a jubé would originally have necessitated. The tall enclosing wall built in the 1320s separates the aisles from the choir and darkens them, no doubt replicating the effect of tapestries that would have decorated the perimeter of the choir in the thirteenth century. Continuing east to the ambulatory, one moves through a series of spaces delineated by chapel walls that bow out from the main arc of ambulatory passage. The chapels are accessed through a triple arcade supported on thin colonettes, which partially block the view of the stained-glass windows. One must enter these relatively intimate spaces to see the glass clearly.

To the modern eye, the church as a whole may appear to be a disharmonious collection of Gothic styles from different periods. While one could describe a kind of integrated experience from the point of view of reception, there is no question of a singular artistic vision for the building, but rather an accretion of

visions that took the preexisting architecture into account to a greater or lesser degree. The Gothic church as it stands today was built, and many of its original windows and furnishings replaced, over a period of nearly three hundred years, but the radiating chapels were built and glazed quickly. In these relatively small and discrete spaces, where architecture and imagery are connected by contemporaneity and patronage, an integrated reading seems both clear and reasonable, the result of an interaction of patrons, clergy, and artisans.[3]

Date and Artistic Context

The stained glass that is the starting point of this study was installed with the earliest construction campaigns in the chevet of Saint-Quentin. While estimates of the dates of construction have ranged over several decades, a number of factors point to the early 1190s for the start of the radiating chapels, the first part of the chevet to be built.[4] First, the closest formal comparisons for this architecture are found in the south transept and chevet of Soissons Cathedral and the chevet of Chartres, built in the 1180s and 1190s. Second, one of the key documents usually cited for Saint-Quentin is an obit for a treasurer named Matthew, who is credited with 'laying the first stone' in the reconstruction of the church; additional documentary evidence shows that this treasurer can be identified as Matthew le Sot, and that his tenure ended shortly before 1197.[5] Third, the renewed presence of the foundation's original patron family in the person of Eleanor of Vermandois, beginning in about 1192, may have provided the impetus for rebuilding. This interpretation of the architectural chronology provides a time frame of about 1195–1205 for the donation of the chapel windows.

The widows' panel belongs to a small group of surviving images from around 1200 that show the donors holding the window they have given; only a handful among them show the presentation taking place at an altar, and each of these was installed directly behind an actual altar in a choir chapel. The latter include another panel found at Saint-Quentin, in the St Stephen window, and the better-known panel in the St Stephen window of Chartres Cathedral, which is thought to represent shoemakers (figs. 13.4 and 13.5).[6] In the chartrain panel, like that of the Saint-Quentin widows, the identities of the individual figures

3 Such a reading was also suggested for chapels at Chartres by Peter Kurmann and Brigitte Kurmann-Schwarz, 'Chartres Cathedral as a Work of Artistic Integration,' 131–52.

4 The argument about the dating of Saint-Quentin pitted Pierre Héliot, who proposed a date of about 1205 in his work, including *La Basilique de Saint-Quentin et l'architecture du Moyen Age* (Paris, 1967), esp. 23–41, against Jean Bony and Robert Branner, who preferred a date between 1215 and 1225, as outlined in the latter's review of Héliot's monograph in *Speculum* 43 (1968): 728–32 and in Bony, *French Gothic Architecture of the 12th and 13th Centuries* (Berkeley, 1983), 281–82 and 506n29.

5 Martyrology of the chapter of Saint-Quentin, Saint-Quentin, Bibliothèque Municipale, unnumbered manuscript, fol. 159 vo.

6 Another example, dated to the mid-thirteenth century, shows a clerical donor before an altar at Saint-Martin-Aux-Bois in the Oise. See Corpus Vitrearum France, *Recensement des*

13.2 Saint-Quentin, former collegiate church, Maternity (left) and Glorification (right) of the Virgin windows.

13.3 Saint-Quentin, former collegiate church, left and right donor panels: detail, Glorification of the Virgin window.

are subordinated to that of the group—although in both cases the nature of the group remains something of a mystery—while the second panel at Saint-Quentin depicts a named family. Similarities in composition may be partly explained by the fact that the glass painters who created the Saint-Quentin panels also worked at Chartres, although the chartrain St Stephen window itself is not generally associated with their workshop.[7]

Vitraux Anciens de la France, vol. I: *Les vitraux de Paris, de la region parisienne, de la Picardie, et du Nord-Pas-de-Calais* (Paris, 1978), 208 and fig. 116.

7 Louis Grodecki, 'Le maître de Saint-Eustache de la cathédrale de Chartres,' in *Gedenkschrift Ernst Gall*, ed. Margarete Kühn and Louis Grodecki, (Berlin, 1965), 171–94; Claudine Lautier, 'Les peintres-verriers des bas-côtés de la nef de Chartres au debut du XIIIe siècle,' *Bulletin monumental* 148 (1990): 7–45.

As at Chartres, no written records of stained-glass donations to Saint-Quentin survive for this period. Most of the records of gifts that have been preserved provide proof of perpetual rents that provided annual income, and other items that needed to be replenished periodically, such as lamp oil.[8] The glass may have been considered, in a way, its own record, obviating the need for written proof. However, in the seventeenth and eighteenth centuries many documents that are now lost were copied into encyclopedic compendia of the history of

[8] Original documents include the Martyrology of Saint-Quentin and Archives nationales de France, L 738–39, Charters of the Chapter of Saint-Quentin, dated 1140–1625. Medieval copies are bound into two cartularies, Archives nationales de France, MS LL 985B, Cartulary of the Chapter of Saint-Quentin, copied after 1382, and Bibliothèque nationale de France, Paris, MS lat. 11070, Cartulary of the Chapter of Saint-Quentin, a late fourteenth-century copy.

13.4 Saint-Quentin, former collegiate church, Relics of St Stephen window, detail, donor panel.

the church and region of Saint-Quentin.[9] Among these was a codex known as 'the old revenue book,' one chapter of which included the names of chapel founders. It began with a series that must be related to the construction of the radiating chapels, as the first name on the list is Matthew le Sot.[10] One of the other names on this list, Rogo of Fayel, can be identified with some certainty as the donor of the St Stephen window at Saint-Quentin.

9 Quentin Delafons, *Extraits originaux d'un manuscrit de Quentin de la Fons intitulé 'Histoire particulière de l'Eglise de Saint-Quentin,'* ed. Charles Gomart (Saint-Quentin, 1854); Claude Hémeré, *Augusta Viromanduorum Vindicata et Illustrata duobus libris quibus Antiquitates Urbi, et Ecclesiae Sancti Quintini, Viromandensiumque Comitum series explicantur,* (Paris, 1643); and Louis-Paul Colliette, *Mémoires pour servir a l'histoire ecclésiastique, civile, et militaire, de la province de Vermandois,* 4 vols (Cambrai, 1772).

10 Delafons, *Histoire particulière de l'église,* 415. The donation of a chapel, or 'capella,' often refers to the institution of a chaplaincy rather than the construction of a chapel. In this case, dates can be assigned to many of the donors, and they fall close enough in time to the beginning of construction that it is reasonable to assume that the gifts were linked to the physical fabric of the chapels as well as their furnishings and rituals.

13.5 Chartres, Cathedral of Notre-Dame, shoemakers' donor panel, detail of St Stephen window.

Chapel Foundations and Window Donations

The donors of the St Stephen window at Saint-Quentin (fig. 13.4) are shown holding a lancet that bears part of a name, 'ROG,' and part of an E or, more likely, an F—the lower portion has been repainted. Added to the documentary evidence, this partial name allows the family to be tentatively identified as that of Rogo of Fayel, a prominent member of the nobility of the region and a signator on many of the documents issued by the Counts of Vermandois from

the early 1140s onward; he died in 1200.[11] A surviving martyrology records other gifts given to the collegiate church in its obits; Rogo is found here as well, among the more generous donors.[12]

Until the nineteenth century, the St Stephen window was installed in the central light of the chapel adjacent to the axial chapel on the north side, which was consecrated at the end of the thirteenth century to St Louis, but which is the only possible location for the altar of St Stephen mentioned several times in documents.[13] Since the central light depicting the saint's story contained the donor panel, we may assume that Rogo's chapel foundation was located here. The panel commemorates not just the gift of the window, but the foundation of the St Stephen chapel itself by the individuals pictured there. The family includes two standing figures framed by the architecture of a chapel, holding the lancet above the altar, in an image that may rather literally represent the combined donation of chapel and window.

In addition to the standing figures, two others kneel outside the chapel, a man on the left and a woman on the right. It is impossible to identify the individual figures in the panel with certainty. The nobleman on the left may be Rogo himself, holding the lancet with his name on it, or his son and heir, Odo. Replaced and repainted glass makes the gender and status of the second standing figure unclear, so that a number of combinations of children and spouses are possible. Rogo had three wives, one of whom survived him, and at least four children: Odo, who confirmed his father's gifts to the church, and three daughters, the youngest of whom was a member of the convent of Fervaques which had a close association with the collegiate chapter and with Eleanor of Vermandois.[14] No mention of another son has been found in the charters of the region; however, a canon named Henricus de Fayel appeared in lists of members of the chapter made in 1207 and 1227.[15] Henricus was probably the same canon referred to as 'physicus', who served as personal physician to Countess Eleanor. The fact that he also contributed to a chaplaincy at the altar of St Stephen strengthens the likelihood that Henricus was a close relative of Rogo of Fayel, possibly a younger son.[16]

Whichever is meant to be represented, the St Stephen window preserves the memory of a family that had close ties to both the counts of Vermandois, traditionally the founders and patrons of the collegiate chapter of Saint-

[11] Rogo's son Odo confirmed his gifts to the chapter in a charter dated August 1200, Paris, AN LL 985 B, fol. 226; Colliette, *Mémoires* vol. 2, 271; Documents with Rogo as signatory appear in the Cartulary of the Abbey of Longpont, BnF Coll. de Picardie vol. 24, 139–40; Hémeré, *Augusta Viromanduorum*, 43–44; and Cartulary of Saint-Quentin, BnF nouv. acq. fr. 2591, fol. 80.

[12] Martyrology of Saint-Quentin, fol. 37.

[13] Delafons, *Histoire particulière de l'Eglise*, 56.

[14] William Mendel Newman, *Les seigneurs de Nesle en Picardie, XIIe-XIIIe s.: Leurs chartes*, vol. 2 (Philadelphia, 1971), 101–103 gives a partial genealogy and source documents for the seigneurs of Fayel.

[15] Colliette, *Mémoires*, vol. 2, 396 and 600.

[16] The chaplaincy donation is described in Laon, Archives Departementales de l'Aisne G785, 1279–81. Henry the Physician also appears in the Martyrology on 25 January, fol. 27.

Quentin, and to the chapter itself. As was common among collegiate and cathedral chapters at the time, the secular canons of Saint-Quentin were for the most part drawn from the noble families of the region, and several of the early chapel foundations specifically mention the name of a son or nephew who is to be supported as chaplain at that altar.[17] The political and economic ties between canons and their families remained strong and supported the activities of the collegiate church throughout the twelfth century and into the first decades of the thirteenth.

The list of chapel founders reveals that the patrons included the clergy themselves, their close relatives and other members of the local nobility. With the other radiating chapels tied to specific, named donors, it seems likely that the donors shown in the Glorification window would also be found listed in the revenue book and the martyrology. Some issues raised by the condition of the glass need to be addressed first, however.

The donor portraits in the Glorification window are of four kneeling figures, two women and two others who appear to be men. The women present the window while the 'men' hold a large sack of money. As with the donor panel of the Fayel family, there is much restoration in the glass. All the figures are similarly dressed, and we read the gender by looking at the heads. However, only the head of the woman who holds the lancet is original. Pierre Bénard, architect of the fabric, described the figures in 1859 as four women.[18] The modern heads probably were made by either Jean Talon or Edouard Didron, who worked at the collegiate church in the 1860s and 1870s; the male heads were in place by 1882, when Edouard Fleury published his description of the panels, accepting the male heads as original.[19]

The inscription referring to 'widows' in the feminine plural does focus our attention on the women as the active parties and suggests that Bénard was correct. Bénard was a resident of Saint-Quentin and oversaw the restoration of the collegiate church over four decades; his publications included a lengthy study of the stained glass, published in installments in the local newspaper between 1859 and 1861.[20] While Fleury's descriptions of monuments are invaluable, on the other hand, he visited each site briefly and made a number of mistakes. It remains possible that Bénard only assumed that the figures, whose heads were certainly quite deteriorated, were female and that the restorer, having dismantled the glass, was able to trace the original painting. However, not only is Bénard more reliable than Fleury for such details, but the type of donor group implied by the mixed gender may be more a nineteenth-century ideal than a thirteenth-century reality.

[17] Delafons, *Histoire particulière de l'Eglise*, 415–16.

[18] Pierre Bénard, 'Les vitraux de la Collégiale,' *Journal de Saint-Quentin* (7 September 1859), 3.

[19] Edouard Fleury, *Antiquités et Monuments du département de l'Aisne*, 4 vols, (Paris, 1877–82), vol. 4, 127n1.

[20] Bénard, 'Vitraux,' 3.

Widows, Property, and Charity

Two types of gifts are depicted: the window itself, and the sack of coins, presumably the original form of the gift that was put toward the cost of the glass. If the original figures on the right were men, they appear to offer the money on behalf of the widows. One might imagine that they represent the women's deceased husbands or perhaps their sons. The first case suggests that the window was given as part of a memorial donation for the men, and implies that the money had been inherited from the husbands who in some way continued to control it after death. The 'widows' money' in this case would really be the late husbands' money of which they had use. Alternatively, if we read the men as the widows' sons, we might imagine them approving of and supervising their mothers' donations. They might be protecting their mothers or guarding their own inheritance. However, widows legally controlled their property, and other donor images show individual women offering windows without male mediation.[21]

In the decades leading up to the year 1200, the right of the conjugal family to sell or give away property began to replace the rights of extended kinship groups that had dominated through the eleventh and early twelfth centuries. As Stephen White has shown, a concurrent tendency was to attach the idea of ownership of property to individuals, particularly property brought to a marriage by husbands and wives.[22] A son might inherit his father's property, but would not automatically have power over his mother's lands while she lived, although he might well try to claim it.[23] Along with the gendered inscription in the donor panel, the realities of French property laws around 1200 suggest that the original panels showed four female figures as Bénard described them; one can imagine Edouard Didron, faced with virtually illegible heads, imposing his own conception of property ownership and gender roles on a medieval family group.

The appearance of two women's names, Rassendis Crassa and Rassendis Waukins, in the list of original chapel founders may provide a key to the nature of this group of donors. The martyrology records that Rassendis Crassa gave to the chapter a house with land, gardens and fields, as well as perpetual rents on several other properties.[24] Several men with the family names of Crassus, Walcisus, and Wauchisus are remembered in the martyrology, but neither their obits nor Rassendis Crassa's mention a spouse, making it unlikely that the donation was made in memory of the widows' husbands; several other women

[21] At the cathedral of Bourges, for example, Countess Mathilda of Courtenay appears, presenting a stained-glass window with her name inscribed, in the eastern windows of the lower clerestory. See Corpus Vitrearum France, *Recensement des Vitraux Anciens de la France*, vol. II: *Les Vitraux du Centre et des pays de la Loire* (Paris, 1981), 175 and fig. 149.

[22] Stephen D. White, *Custom, Kinship, and Gifts to Saints: The laudatio parentum in Western France, 1050–1150* (Chapel Hill, 1988), esp. 7–9, 80–85, 124–29, and 177–209; Robert Fossier, *La terre et les hommes en Picardie jusqu'à la fin du XIIIe siècle*, 2 vols, (Paris, 1968), vol. 1, 262–73.

[23] Hajdu, Robert, 'The Position of the Noblewoman in the Pays des Coutumes, 1100–1300,' *Journal of Family History* 5 (1980): 122–44, esp. 128–33.

[24] Martyrology, fol. 38, 1 February.

named Rassendis are mentioned, but none with surnames.[25] The search for more information about these two female chapel donors yields nothing and suggests that their husbands' deaths predated the compilation of the existing martyrology by a significant period of time.

The image itself tells us, however, that the status of the figures as widows may have been more important to their relationship with the chapter than their separate identities. It is their membership in a particular social group that is explicitly conveyed by the inscriptions that accompany their portraits, as well as the uniformity of dress and pose. Better-documented circumstances in Saint-Quentin and in Northern Europe in general suggest contexts for their donations and for their communal identity.

The fact that it was relatively uncommon for a widow to administer her estates herself may reflect the very real dangers and difficulties involved in overseeing agricultural property and collecting rents. One alternative to remarriage was to place oneself in the care of the local clergy, who were bound by canon law to protect widows.[26] Clearly, widows who could pay for the founding, decoration, and maintenance of a chapel did not need financial support, but the need for legal protection not limited by class or economic status was recognized as well.[27] A widow might protect her rights by giving her property to the church, preserving its use for herself for the rest of her lifetime. Rassendis Crassa's donation of her house and land is in keeping with this pattern. In the idealized view of a number of medieval writers at least, such an act on the part of a widow was a sign of her virtue: she gave her property over to the care of the church and thus avoided the pressure to remarry, turning her attention instead toward a spiritual life.[28] Many women in such circumstances took up charitable works.

[25] Martyrology, fol. 106 vo. 107, 27 June.

[26] Patricia Skinner, 'Gender and Poverty in the Medieval Community,' in *Medieval Women in their Communities*, ed. Diane Watt (Toronto, 1997), 204–21, cautioned against too literal an acceptance of the idea that widows were always poor or vulnerable, noting that their protection by both clergy and princes is an ancient *topos*, not necessarily supported by contemporary legal documents. Benoît-Michel Tock, 'L'image des veuves dans la littérature médiolatine belge du VIIIe au XIIe siècle,' in *Veuves et veuvage dans le haut moyen âge*, ed. Michel Parisse (Paris, 1993), 37–48, also noted the paucity of specific information about the lives of widows in all types of documents; even those that describe real widows (in contrast to legendary women or the state of widowhood in general) repeat the same formulas about the widow's condition and virtue. During the early thirteenth century, clerical responsibility toward wealthy widows under canon law was debated. The clerical obligation to care for *miserabiles personae* stated in Gratian's *Decretum* was clarified by Stephen of Tournai and other legal scholars, and by the Third Lateran Council in 1179 as including both financial and legal support for orphans, widows, and the indigent. See James Brundage, 'Widows as Disadvantaged Persons in Medieval Canon Law,' in *Upon my Husband's Death: Widows in the Literature and Histories of Medieval Europe*, ed. Louise Mirrer (Ann Arbor, 1992), 193–206, esp. 193–97, 201–2, and notes 1–18.

[27] Brundage, 'Widows as Disadvantaged Persons,' 197–201.

[28] See, for example, Gilbert of Nogent's comments about his mother in *Self and Society in Medieval France: the Memoirs of Abbot Guibert of Nogent*, ed. Janetta. F. Benton (New York, 1970); and Tock, 'La littérature médiolatine,' esp. 45–46. The *Ecclesiastical History* of Orderic Vitalis

Women's Communities

Regular women's houses, as well as hospitals and leprosaria, were the favored beneficiaries of many wealthy widows, including Eleanor of Vermandois, the most important widow in the region.[29] The Saint-Quentin widows' costumes belie any possibility that they could have belonged to a regular religious order. If, however, they had joined a hospital-based community, both the costumes and their anonymity would make sense. In Saint-Quentin as elsewhere in France, a number of loosely organized communities of women were found attached to hospitals and leprosaria around 1200.[30] Many of these sites apparently included both men and women who took no permanent vows; they would later become established as beguinages, but in these early years it does not appear that such houses were understood as part of an organized movement.[31] During the thirteenth century, the collegiate church asserted progressively more control over these groups, and established chapels for them with presbyters from the chapter. The communities must have grown to be a

also provides anecdotes of several widows entering monastic life under various circumstances; see Bruce Venarde, *Women's Monasticism and Medieval Society* (Ithaca, 1997), 95–100.

[29] Louis Duval-Arnold, 'Les aumônes d'Alienor, dernière comtesse de Vermandois et dame de Valois,' *Revue Mabillon* 60 (1984): 395–463; Skinner, 'Gender and Poverty,' 210, and Michel Mollat, *The Poor in the Middle Ages: an essay in social history*, trans. Arthur Goldhammer (New Haven, 1986), 22, note the importance of widows' donations to hospices for the poor.

[30] Venarde, *Women's Monasticism*, 45–46 and note 103, and Elisabeth Magnou-Nortier, 'Formes féminines de vie consacrée dans des pays du Midi jusqu'au début du XIIe siècle,' *Cahiers de Fanjeaux* 23 (1988): 193–216, found evidence of women living in quasi-religious communities in southwestern France a century earlier and believe that this was due to a lack of opportunities to enter into established convents. Although there were certainly more foundations in Picardy by the mid-twelfth century, the problem was a persistent one with the reluctant establishment of Cistercian houses for women, and the expulsion of communities of women from Premonstratensian double houses around 1200. The establishment before 1200 in Saint-Quentin of five hospitals (the Hôpital des Enflés for pilgrims, in the church precinct; the Hospital of Belle-Porte; the Hôpital Saint-Lazare; the Hôtel-Dieu; and the Hospital of Saint James in the center of the town, later known as the Beguinage of Fonsomme) is documented in Delafons, *Histoire de l'Eglise*, 66–68, 164; Charles Gomart, *Extraits originaux d'un manuscrit de Quentin de la Fons intitulé 'Histoire particulière de la Ville de Saint-Quentin*, 2 vols, (Saint-Quentin, 1856), vol. 1, 286 and 293–97; Laon, Archives departementales de l'Aisne G787, 1751; G 799, 959–61; and Martyrology, fol. 156.

[31] At least two of the hospital communities in Saint-Quentin—Saint-Lazare and the Hôtel-Dieu—included both men and women, according to Laon, Arhives departementales de l'Aisne G 787, 751; Colliette, *Mémoires*, vol. 2, 313; Delafons, *Ville de Saint-Quentin* vol. 1, 71 and 312–14. Penelope Galloway, '"Discreet and Devout Maidens": Women's Involvement in Beguine Communities in Northern France, 1200–1500,' in *Medieval Women in their Communities*, ed. Diane Watt (Toronto, 1997), 96–99, discusses this development and provides some examples, including foundations in Lille, Douai, and Saint-Omer; Bernard Delmaire, 'Les béguines dans le Nord de la France au premier siècle de leur histoire (vers 1230–vers 1350),' in *Les religieuses en France au XIIIe siècle*, ed. Michel Parises (Nancy, 1989), 121–62, was one of the first to investigate beguinages in this region following Ernest McDonnell's comprehensive work from documents for the Low Countries, *The Beguines and Beghards in Medieval Culture* (New Brunswick, NJ, 1954). Walter Simons, *City of Ladies: Beguine Communities in the Medieval Low Countries, 1200–1565* (Philadelphia, 2003), provides new insights and a wealth of evidence.

sufficiently important factor in the life of the city that they appeared to the chapter to be in need of closer supervision.

The leprosarium of Saint-Lazare seems to have been of particular interest to noblewomen in Saint-Quentin. Oda Coldetor, the widow of Hubert Coldetor and mother of at least one canon of Saint-Quentin, not only gave a mill to this hospital, but also retired there in her last years.[32] Members of the Coldetor family, like that of Fayel, were important benefactors of the collegiate church and included several canons.[33] It appears that Oda died near the beginning of the thirteenth century and was a contemporary of Rassendis Crassa and Rassendis Waukins. It may also be of interest that the knight Symon Wauchisus, possibly a relative of chapel founder Rassendis Waukins, left the chapter the income of his domains, and part of this income was to be turned over to Saint-Lazare.[34] The identification of the anonymous widows in the donor panels with a hospital community such as Saint-Lazare provides one plausible explanation for their group identity.

A Literal Reading: The Office of the Dead

Each of the donor panels at Saint-Quentin shows the donation of a window at an altar. Each of these windows was itself placed above an altar in a chapel apparently founded by the same donors. A further link between the donors and the chapels in which they are commemorated lies in the annual remembrance of the anniversaries of their deaths. Obituary gifts from noble families were a major source of revenue for the chapter, and they obligated canons and chaplains to attend an increasing number of memorial rites; while the chapel donations were not tied to memorials *per se*, the same individuals were remembered annually after their deaths, and it was a widespread practice to use an endowed altar for the donor's anniversary mass.[35] The chapter's martyrology shows an accretion of obits so that by 1220 there were usually two or three such memorials for each day in the calendar. They were eventually consolidated at the altar of the dead in the sanctuary when the number became too great for separate celebrations.

The canons were reminded of the donors when the entry for that day in the martyrology was read aloud. The obituary for Rassendis Crassa may serve as an example of the formulaic text:

... Rassendis Crassa who gave us half of one *mensa* and other property plus two *modii* of wheat as well as money toward the cost of the *mensa* for non-feast days, to

32 Colliette, *Mémoires*, vol. 2, 307–13.

33 Martyrology, fol. 166 vo., 18 October, records a memorial gift for Oda by her sons Hubert and canon Robert Rufus; and fol. 8 vo., 25 December, contains the obit for Jean Coldetor, who donated and decorated a small chapel on the north choir aisle.

34 Martyrology, fol. 88 vo., 16 May.

35 For votive masses in general, see Cyrille Vogel, *Medieval Liturgy: An Introduction to the Sources*, transl. and rev. William Storey and Niels Rasmussen (Washington D.C., 1986), 156–58.

be distributed on pain of anathema to those who attend her vigil and memorial mass, as follows: for each canon, six loaves; for the chaplains, three; for the choir boys, one.[36]

The parallel transformations of wheat into bread and bread into the eucharist in the memorial mass would be hard to miss. In the same place where the body of Christ descended into the sacramental bread, the prayers of the canons rose up out of the material world for the good of the souls who had given them the wheat for the earthly bread they would have for their own dinners. Above the altar where this exchange took place, donors were shown in a perpetual act of giving.

As Madeline Caviness has noted, the stories in historiated windows of saints' lives do not correlate directly with liturgical readings.[37] An altar nearby might serve as a liturgical station on appropriate feast days, in which case the subject of the window could serve as a reminder of the altar's dedication. But the choice of specific subjects for the images has little to do with the stories told in the liturgy. Similarly, a direct connection between the Office of the Dead and the donor images above an altar would be made only a few days each year. In some cases, however, a more allegorical or tropological reading might be apt in a liturgical context.

Allegorical and Tropological Readings

In the Virgin chapel at Saint-Quentin, the widows kneel beneath scenes of the Glorification of the Virgin; the pendant window to the left, the Maternity of the Virgin, was probably also their gift (figs. 13.1, 13.2). The latter reads from the top down, beginning with the Annunciation, so that the events of Christ's incarnation read as though they progress in steps from heaven to earth. The events in the Glorification window follow an equally emphatic vertical axis, but from bottom to top, as the Virgin's material body and her soul are lifted up and transformed into the spiritual body of the Queen of Heaven. In these directional readings, the Incarnation might evoke the idea of the descent of Christ into the specie of the eucharistic bread, while the Assumption would serve as a reminder of the hoped-for resurrection of those for whom the mass is offered.

If the narratives of the two lancets can be tied to material and spiritual exchange, there may also be a moralizing element in the glass. The similarities in the compositions of the Saint-Quentin widows' panels and that of the shoemakers in the lower right panels of the St Stephen window at Chartres (fig. 13.5) was noted at the outset of this essay. In addition to these groups of donors, both the St Stephen window at Chartres and the paired lancets of Maternity and Glorification at Saint-Quentin display images of shoemakers at

[36] Martyrology, fol.38 vo., 1 feb.

[37] Caviness, 'Stained Glass Windows in Gothic Chapels and the Feasts of the Saints,' 135–48.

work to the left of the images of the window donations. What remains of the original composition at Saint-Quentin again bears a striking resemblance to that at Chartres (fig. 13.6).[38]

At Chartres, the multiple images of shoemakers at work among a variety of other trades are seen in relation to images of window donations by groups identified as shoemakers. But at Saint-Quentin, no such groups of merchant donors are evident; presumably the widows gave both windows in this pair. Are we then to read some connection between the widows and shoemakers? Anne Harris has argued that images of such merchants and their customers at Chartres reflect the clergy's attempt to reconcile the new money economy of artisan merchants with traditional moral ideas about labor and humility, an idea reflected in sermons and theological tracts dealing with the concept of the just price.[39] The widows and the family of Rogo of Fayel gave their earthly possessions to support the spiritual labor of the canons; might the shoemakers' monetary exchange be understood as a kind of parable here, one that echoes the more abstract exchanges of wheat, bread, and salvation?

Several possibilities suggest themselves. At the time the radiating chapels were glazed, the canons of Saint-Quentin had recently been found guilty of charging unfairly for baptisms and purifications, as well as neglect of their ministerial duties. Each obit that was read reminded them that the wheat that made their bread was the gift of the person for whom they were bound to pray that day, under pain of anathema, in order to receive that bread. In this light, the images of shoemakers could suggest that the canons, too, should accept the just price, laboring in prayer and ministry in exchange for their benefices. As more donations to the church began to come in the form of cash, like the sack offered by the widows, the canons' labor might be equated more directly to that of just merchants.

Alternatively, the image might be a reminder of the repeated clashes between clergy and commune that took place in these years. As Harris suggests for Chartres, the placement of images of shoemakers in a liturgical space at Saint-Quentin could be an attempt by the clergy to bring the new urban economy and its practitioners into their moral purview.

Since the shoemakers were depicted in the same two panels within the Maternity lancet that were used for the widows in the pendant Glorification window, one might also consider the significance of these figures as parallel representatives of two different social stations. On the one hand, the images suggest that both groups were subject to the authority of the church, while, on the other hand, they were owed the ministerial attention of its canons. One clear difference distinguishes the widows from the shoemakers, however. The

38 Fleury, vol. 4, 1882: St-Quentin, 127, described the figures in both panels of the Maternity window at Saint-Quentin as shoemakers.

39 Anne F. Harris, 'The Spectacle of Stained Glass in Modern France and Medieval Chartres: A History of Practices and Perceptions,' Ph.D. Diss. (University of Chicago, 1999), 131–39. Harris's ideas, like my own, start from the critique of traditional interpretations of the trade windows offered by Jane Welch Williams, *Bread, Wine, and Money: The Windows of the Trades at Chartres Cathedral* (Chicago, 1993).

13.6 Shoemakers at work: *A*, Chartres, St Stephen window.

widows themselves chose to have their images placed above an altar in the church, while either a clerical advisor or an artist inserted the shoemakers. And while their names cannot be known for certain, the identities of the widows were known to the clerical audience who saw the glass; the shoemakers are generic types.

Conclusion

Many elements of the original artistic programs of two radiating chapels at Saint-Quentin survive. The historiated glass depicts the central events in the stories of the saints celebrated at their respective altars, that is, the story of the relics of St Stephen, and the Maternity and Glorification of the Virgin. The

13.6 *B*, Saint-Quentin, Maternity of the Virgin window.

donors who founded the chapels are celebrated in the lower panels of the windows, which were apparently part of their donations. These individuals had close ties with the canons, and their images, holding the unique gift of a stained-glass window above an altar, served as a reminder of their gifts of perpetual income, and inscribed those gifts as an act of devotion.

While the programs of the chapels maintain some coherence in terms of altar consecration, narrative imagery, and patronage that we might connect with an original program, further connections in meaning could be drawn by the viewer. The windows of the axial chapel depict transformations: money into glass and stone, God into flesh, and fleshly mother into Queen of Heaven. These images were before the canons during the offering of mass when bread was transformed into the flesh of God, and prayers were offered as a payment toward salvation. Thus in the discrete architectural spaces of the chapels, the

elements of space, light, image, sound, and word that once surrounded anyone who entered may be discerned as an artistically integrated environment with specific cues to deeper contemplation.

PART FOUR

Multiple Readings

The Center Portal on the West Façade at Reims: Axes of Meaning

Dorothy Gillerman

Of the great Gothic façades that were erected in France during the thirteenth century, Reims issues the greatest interpretive challenge to the viewer.[1] With at least ten separate narrative ensembles, several typological series, and thousands of individual figures, the effort to define a unifying idea frequently turns on the mystique that surrounds the cathedral as Coronation Church of France.[2] Yet when we consider the west façade as a whole, including the reliefs of the outer buttresses and the inner 'verso' wall, it is difficult to fit the great number of sculptural elements into a coherent program that lays specific claim to its status as the Coronation Church. In particular, the overwhelming preponderance of Apocalyptic references needs to be integrated into an understanding of the west façade's program as a whole. Thus, although recent scholarship has vastly increased our knowledge of the history and construction of the cathedral, a full analysis of the west façade program must still be considered a work in progress.

Research on the meaning and reception of the façade, of which this paper forms a part, has led me to examine different modes of narrative, as well as allegorical and typological imagery that coexist within a program where survival and revival of twelfth-century elements have been repackaged to suit a new age and a new generation of viewers. This effort to deconstruct the imagery of the three

[1] Major recent contributions to the vast literature on Reims contain essential bibliography and include: Peter Kurmann, *La façade de la Cathédrale de Reims: architecture et sculpture des portails. Etude archéologique et stylistic*, 2 vols, (Lausanne, 1987), hereafter cited as Kurmann; Richard Hamann-Mac Lean and Ilse Schüssler, *Die Kathdrale von Reims*, 8 vols (Stuttgart, 1993–96), hereafter cited as Hamann-Mac Lean; and Patrick Demouy, Robert Neiss, Walter Berry, Bruno Chauffert-Yvart, Bruno Decrock, Sylvie Balcon, *Reims* (La Pierr-qui-vire, 2001), hereafter cited as Demouy. My work at Reims has benefited from these works and from the experience and kindness of Peter Kurmann, Walter Berry, Syvlie Balcon, Bruno Decrock, Nancy Wu, Danielle Johnson, and Michael Davis.

[2] A large and varied scholarship is noted by Donna L. Sadler, 'Lessons Fit for a King: The Sculptural Program of the Verso of the West Façade of Reims Cathedral,' *Arte medievale* 9 (1995): 49–68; idem, 'The King as Subject, the King as Author: Art and Politics of Louis IX' in *European Monarchy*, ed. Heinz Duchhardt, Richard A. Jackson, and David Sturdy (Stuttgart, 1992), 53–68; William W. Clark, 'Reading Reims, I. The Sculptures on the Chapel Buttresses,' *Gesta* 39 (2000): 143.

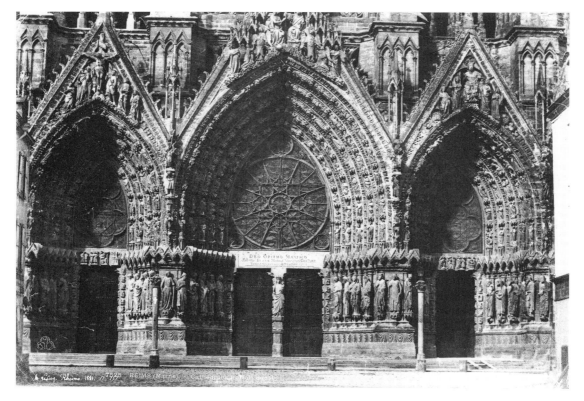

14.1 Reims, Cathedral of Notre-Dame, west façade portals.

western portals owes much to ideas first presented by Madeline Caviness in 1983.[3] Her use of modal distinctions within styles and above all her use of geometric schemata to structure meaning within twelfth-century images introduces a cartographic element into iconographical interpretation that has led me to discern axes in the placement of sculpture, and points of intersection between what we might call the revelation of the final times and the shifts and ongoing progress of human history.[4] As I hope this study will demonstrate, within this grand scheme the idea of sacred monarchy finds a place within the over-arching vision of the Church triumphant after the defeat of her enemies.

The Virgin portal, the engine that drives its meaning, is at the center of the program. As at Paris and Amiens, her standing figure appears on the trumeau as the New Eve (fig. 14.1); as at Chartres, events from her life are portrayed in three groups of standing figures on the jambs—the Annunciation and Visitation

[3] Madeline Caviness, 'Images of Divine Order and the Third Mode of Seeing,' *Gesta* 22 (1983): 99–119.

[4] Suzanne Lewis, quoting Roland Barthes, discusses the process of reading allegory in these terms: *Reading Images. Narrative Discourse and Reception in the Thirteenth-Century Illuminated Apocalypse* (Cambridge, 1995), 13. For a historian's discussion of some of these ideas, see John Lewis Gaddis, *The Landscape of History* (New York, 2002).

on the south side, and the Presentation on the north. On the outer corners of the portal two unidentified figures are usually assumed to represent a prophet, possibly Isaiah, and King David. The statue series is completed by the figures of Solomon and the Queen of Sheba mounted on the front face of the flanking buttresses. Reliefs decorating the outer surface of the door posts comprise a calendar and seasons cycle, while on the inner face standing angels seem to direct their prayers toward the Virgin. Again Paris seems to be the model. Above this lower zone, however, the portal breaks with these received models. In the gable that surmounts a glazed tympanum Christ crowns his mother in heaven (fig. 14.2), their figures flanked by seraphim and angels. In the voussoirs, reading from the inside, are angels, a Sleeping Jesse, and music-making kings, scenes from the life of the Virgin on the right side and Old Testament types of her virginity on the left. Originally, as we know from the 1625 engraving of de Son, the Coronation theme was augmented by reliefs on the lintel representing further scenes from her life (fig. 14.3).[5] The verso of the central portal follows somewhat the same sequence with more scenes from the Virgin's early life and additional typological scenes. Lastly, reliefs from the story of John the Baptist amplify the cycle of his martyrdom which is located on the inner lintel of the south portal.

Architecture and Pre-history of the Façade

Since the 1977 publication by Ravaux, there has been general agreement about the dating of the façade.[6] Kurmann, citing an earlier huge money-raising effort, agrees that by 1252 the construction of the west façade, so long delayed, was about to become an actuality, and recent French scholars agree in suggesting a starting date for the western massif of about 1255.[7]

[5] The engraving appears as the frontispiece of Nicolas de Son, *Nr dame de Reims*, 1625; see Kurmann, 32n131.

[6] Jean-Paul Ravaux, 'Les campagnes de construction de la cathédrale de Reims au XIIIe siècle,' *Bulletin monumental* 137 (1977), 9–66, esp. 11 and 45.

[7] Kurmann, 22–24; Demouey, 196. See also Robert Branner, 'Historical Aspects of the Reconstruction of Reims Cathedral,' 1210–41, *Speculum* 36:1 (1961): 23–37. Early versions of the west façade portals are discussed by Robert Branner, 'The North Transept and the First West Façades of Reims Cathedral,' *Zeitschrift für Kunstgeschichte* 23 (1961): 220–41; by Kurmann, 102–3; Hamann-Mac Lean, I.1, 276–305; Hans Kunze, *Das Fassadenproblem der französischen Früh- und Hoch-gotik* (Leipzig, 1912), 66–68. For reactions to Kunze's ideas which were largely accepted by Hans Reinhardt, *La Cathédrale de Reims* (Paris, 1963), see William M. Hinkle, 'Kunze's Theory of an Earlier Project for the West Portals of the Cathedral of Reims,' *Journal of the Society of Architectural Historians* 34 (1975): 208–14 and Branner's review of Reinhardt in *Art Bulletin* 45 (1963): 375–77. The projects of Doris Schmidt, 'Portalstudien zur Reimser Kathedrale,' *Münchner Jahrbuch der bildenden Kunst*, ser. 3, 9/2 (1964), are discussed by Hinkle, *The Portal of the Saints of Reims Cathedral; A Study in Medieval Iconography* (New York, 1965), 68–69; see also Branner, 'The Labyrinth of Reims Cathedral,' *Journal of the Society of Architectural Historians* 21 (1962): 18–25; idem, 'Reims West and Tradition,' *Amici Amica: Festschrift für Werner Gross*, (Munich, 1968): 55–58; and Robert Didier, 'Les christophores de la cathédrale de Reims. Hantise d'un "West I" ou Transept Nord?' *Revue des archéologues et historiens d'art de Louvain* 12 (1979): 28–103.

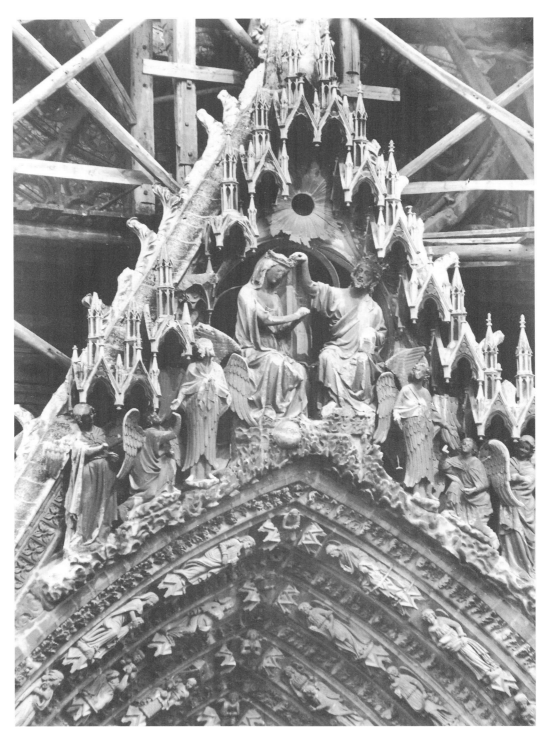

14.2 Reims, Cathedral of Notre-Dame, west façade, center portal, gable.

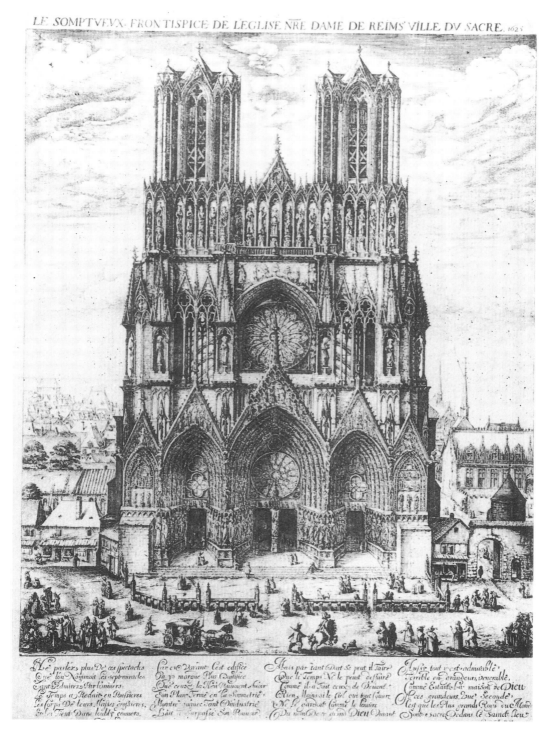

14.3 Reims, Cathedral of Notre-Dame, engraving of Nicolas de Son.

At that time the eastern bays of the nave were virtually complete and perhaps already vaulted, but the twelfth-century façade block might still have been visible, because it probably remained standing during the decades that the eastern church was under construction. Work might even have begun on the outer walls of the western nave before the earlier façade finally was removed.[8] A major characteristic of the present façade is the expansive width and depth of the portal zone which, stepping out from the plane of the façade wall, creates a virtually independent screen across the lowest level of the building. The commitment to this arrangement was confirmed by setting of foundations. With the footprint established, certain aspects of the façade's evolution became inevitable, and although, as we shall see, changes did occur as the work proceeded upward, Kurmann and others have found no evidence that alterations were made at the ground level, noting that the regularly coursed masonry indicate that the entire portal zone went up in a single continuous effort.[9]

With regard to sculpture already executed for a west façade, the 1255 master faced a more complex situation. Primary, and most problematic, would have been portal sculpture associated with renovations undertaken to the western portions of the early medieval church in 1152 by Archbishop Samson.[10]

The six Old Testament figures, now located on the right jamb of the south portal, have been compared to the Old Testament types of Christ's crucifixion on the jambs of the south transept at Chartres, and are usually attributed to a first façade project.[11] It is more likely, however, that they were part of renovations to the twelfth-century façade where they would have formed an ensemble similar and perhaps not too much later than the Coronation portal at Senlis, roughly contemporary with the north transept at Chartres. Stylistically, there is nothing at the present cathedral that relates to these figures and therefore no reason to relate them to the first post-1211 workshop responsible for sculptures on the east end.[12]

8 Kurmann, 117–29.

9 Branner, 'Reims West,' 55; the absence of any vertical breaks in the masonry is most recently repeated in Peter Kurmann, 'Hypothèses archéologiques et découverts réelles; A propos des projets successifs der la façade de Reims au XIIIe siècle,' *Monumental Revue scientifique et technique de la sous-direction des Monuments Historiques du Patrimoine* 10/11 (1995), 82–89.

10 Kurmann, 42. Assumptions concerning the form of Samson's construction, based on Deneux's excavations, *Dix ans de fouilles dans la cathédrale de Reims*, Conférance donnée à la Société des Amis du Vieux Reims le 1er juin, 1944, s.d. have been modified by more recent investigations under the western parts of the cathedral by Walter Berry and Sylvie Balcon, 'Reims et le quartier de la cathédrale' *Archéologia* 326 (September, 1996): 20–32 and in Demouy, 32–60.

11 Adolph Katzenellenbogen, *The Sculptural Programs at Chartres Cathedral: Christ, Mary Ecclesia* (Baltimore, 1939), 63; Willibald Sauerländer, *Gothic Sculpture in France, 1140–1270*, trans. J. Sondheimer (New York, 1972), 482–83; Kurmann, 164, notes that they may have been preserved by the thirteenth-century architects as 'architectural relics,' a memory, therefore, of the earlier building.

12 For sculpture of the east end, Teresa G. Frisch, 'The Twelve Choir Statues of the Cathedral at Reims. Their Stylistic and Chronological Relation to the Sculpture of the North Transept and of the West Façade,' *Art Bulletin* 42 (1960): 1–24 and Clark, 'Reading Reims,' 135–45.

In addition to the typological series, other figures, presumably kept in some sort of protected area, were ready for deployment in whatever context was finally to be decided upon. Although there is some disagreement among scholars concerning jamb figures carved before 1255, Kurmann's careful analysis is probably the best guide to their stylistic groups and dating. The earliest among his groups, the 'antiquizing' group, comprises the Visitation pair of Mary and Elizabeth (M Jr III, M Jr II), a figure usually referred to in the literature as the man with the head of Ulysses (M Jl I, probably a prophet), and the angel with censer (M Jl III).[13]* The activity of a second workshop, Kurmann believes, probably overlapped for a couple of years with the first. He attributes five jamb figures to this group, Mary of the Annunciation (M Jr IV), Mary and Simeon of the Presentation (M Jl III, M Jl IV), a King (M Jr I), and a Saint bearing his skull (either Denis or Nicaise, N Jl IV).[14] In comparisons made with statues mounted on the upper transept, Kurmann establishes a date just after 1230 for this second group.

The other sixteen jamb figures Kurmann divides between two workshops contemporary with the existing west façade, the first active after or slightly before 1255, and the second arriving in the early 1260s.[15] The figures of Joseph, the second female figure of the Presentation group, and the Virgin and Child of the trumeau are included in this group along with a group of saints which Kurmann relates to sculpture of the south transept of Notre-Dame where a new expressive stylistic language was worked out in the 1260s.[16]

The existence of the pre-1255 figures as 'givens' has implications beyond issues of style and placement.[17] Two questions arise. First, how did these relics of the past influence choices concerning the final program? The available model of Samson's façade as well as the reverent reinstallation of the typological jamb series suggest that the center doorway was always intended to be dedicated to the Coronation, and it is unlikely that an Amiens-type scheme with a Last Judgment in the center and Virgin portal on the side was ever seriously

[13] For a slightly different take on these stylistic differences, Willibald Sauerländer, '*Antiqui et moderni* at Reims,' *Gesta* 42 (2003): 19–38, esp. 30–35.

* For ease of location I am using the numerating system adopted by Kurmann where *M* stands for the middle doorway, *Jl* stands for the left jamb and *I-VI* stand for the figures reading from the outermost.

[14] Kurmann, 174–79.

[15] Kurmann, 245–59. This late dating of some of the jamb figures, notably the Joseph, and the pair of Solomon and Sheba, represents a rejection of earlier views, by Panofsky and Medding who have made the Joseph figure the key to establishing an artistic personality known as the 'Joseph Master,' Erwin Panofsky, 'Über die Reihenfolge der vier Meister von Reims,' *Jahrbuch für Kunstwissenschaft* (1927), 55–82; Wolfgang Medding, 'Der Josephmeister von Reims,' *Jahrbuch der Preussischen Kunstsammlungen* 50 (1929): 299–318.

[16] This hypothesis was fully and convincingly illustrated in 'Die Pariser Komponenten in der Architektur und Skulptur der Westfassade von Notre-Dame zu Reims,' *Münchner Jahrbuch der bildenden Kunst*, 35 (1984): 41–82.

[17] For discussions regarding the appearance and implications of placement marks carved on some of these figures, Henri Deneux, 'Signes lapidaires et épures du XIIIe siècle à la cathédrale de Reims,' *Bulletin monumental* 84 (1925): 99–131, Schmidt, *Portalstudien*, 14–58; Hamann-Mac Lean, I, 1:267–75, and I, 2, Pls. 349–69; Demouy, 240–45.

considered at Reims. At Laon the Last Judgement is located on the lateral portal, and perhaps such a scheme was briefly under consideration at Reims.[18] Certainly the examples of Laon and of Saint-Nicolas at Amiens, where a typological portal includes the additional figures of Solomon and Sheba, suggest that the decision to locate the Coronation on the center doorway was probably made prior to 1255.[19]

A second question regards the upper zones of the portals, including the archivolts and gables, as well as the north and south buttress reliefs. Should we imagine that this program, where unusual and extensive narrative sequences frame glazed tympana—an original concept and composition—was planned in 1255 or was there a change somewhere along the line? Kurmann's most recent remarks, although concerned primarily with the architecture of the façade, suggests that changes observable around the level of the lintels indicate the arrival of a second master.[20] A first project, he argues, combined ideas derived from Soissons and Laon with the difference that the north and south corner buttresses would have been more salient, acting as a frame for the three-portal unit. Later, it seems, the north and south buttresses were cut back at the level of the lintel, eliminating a slice of the *massif* which terminates now in a sloping glacis.[21] With gables surmounting the corner buttresses now in the same plane as the gables above, the portals, the block façade, set out in the footprint of the building, is transformed to a screen façade that derives from more current models on the transepts of Notre-Dame. A second consequence of this change was to make the north and south faces of the outer buttresses assume dimensions equal to their front faces, thus creating larger fields for sculpture.

Further evidence of a break in program appears in the emphatic horizontal string of baldachins which, quite independent of the figures beneath them, effectively draw a line across the façade separating the upper from the lower zone. Gothic architecture, in its lining up of socle, figure and baldachin, is usually scrupulous about preserving both the form and meaning of the aedicule.[22] There is something rather cavalier in the way the frieze of gabled baldachins seems to ignore the vertical divisions established in the previous plan.

The Definitive Façade Project

Any interpretation of the portal programs, devised in or around 1260, must take account of drastic restorations undertaken in the seventeenth, eighteenth, and nineteenth centuries.[23] Reworking and replacement of individual works

[18] Sauerländer, *Gothic Sculpture*, 425–26 and 430.

[19] Sauerländer, *Gothic Sculpture*, 430; Katzenellenbogen, *The Sculptural Programs*, 65.

[20] Kurmann, 'Hypothèses archéologique,' 89.

[21] Kurmann, 'Hypothèses archéologique,' 83.

[22] John Summerson, *Heavenly Mansions* (New York, 1963), 1–29.

[23] Isabelle Pallot-Frossard and Bruno Decrock, 'Les voussures du portail central: Histoire des restaurations anciens,' *Monumental. Revue scentifique de la sous-direction des Monuments historiques, Direction du Patrimoine*, 10/11 (1995): 66–81.

have necessarily blurred, or in some cases destroyed, their original meanings. It is also possible that, especially on the lintels, irregularities and anomalies may be the result of haste or even lack of oversight in the final installation of individual reliefs and statues. In spite of these difficulties, the sculptural ensemble of the portal zone, which includes the narrative cycles of the inner façade wall, bears the signs of a complex and well-thought-out message delivered in images that would have been more or less familiar to the thirteenth-century viewers of Reims.[24]

The theme of the Coronation of the Virgin with its connections to her bodily Assumption had been fully realized at Senlis in the 1170s. Above, the crowned Christ shares his throne with the Virgin, already crowned and holding a book and scepter, while on the lintel are scenes of her entombment and awakening by angels who prepare to carry her body to heaven.[25] Flanking the royal pair are standing and seated angels, and in the archivolts a stem of Jesse traces the Virgin's ancestry through Old Testament kings, patriarchs, and prophets. On the jambs a series of Old Testament figures prefigure the sacrifice of Christ.[26] The Senlis program had a long life; reproduced with only slight changes at both Laon and Chartres around 1200, it was also the presumed model for the façade of Samson's church at Reims, probably executed at about the same time.[27] By then, however, a second type of Virgin program was coming into use. This scheme, which depicted events from the Virgin's life, appeared on the left portal at Laon and on the north transept at Chartres as a second Virgin portal beside the Coronation portal. Paris also has two portals dedicated to the Virgin but, increasingly, the earlier type of Virgin portal with Old Testament types was giving way to portals which combine elements from both these programs in an ensemble that places the Incarnation within the context of the triumph of the Church.

At Amiens, during the 1230s, ideas emanating principally from Paris and Chartres are reworked in a Marian program that is more expansive than coherent, while a decade later at Villeneuve-l'Archevêque the Coronation tympanum is combined with infancy scenes on the lintel and Annunciation, Visitation and Old Testament figures on the jambs in a reduced version of that earlier layout.[28]

[24] The expectations of medieval viewers, their ability to 'read' images, and to locate constant versus innovative formulations of familiar themes involve issues of reception that are beyond the scope of this article; see remarks by Lewis in the *Introduction to Reading Images*, 2–6, and Hans Robert Jauss, *Toward an Aesthetic of Reception*, trans. Timothy Bahti (Minneapolis, 1982).

[25] For Senlis, Sauerländer, *Gothic Sculpture*, 406–8, ills. 41–45; for the relationship between the Virgin as type of the church and the role played by the liturgy of the Assumption and the Birth of the Virgin, Valerie I. J. Flint, 'The Commentaries of Honorius Augustodunensis on the Song of Songs,' *Revue bénédictine*, 84 (1974): 199, connections between Honorius and the 'School of Laon' are mentioned on p. 205.

[26] Philippe Verdier, *Le Couronnement de la Vierge. Les origines et les premiers développements d'un thème iconographique* (Montreal, 1980), 116–8.

[27] Sauerländer, *Gothic Sculpture*, 425–27, ills. 48–52, for Laon; 430–31, Pls.76–86, and p. 435, Pl. 76, for Chartres; see also Katzenellenbogen, *The Sculptural Programs*, 46–65.

[28] Sauerländer, *Gothic Sculpture*, 463–64, Pl. 160, for Amiens; and 468–69, Pls. 178 and 179, for Villeneuve.

At Reims, by the time the new façade was in the planning stage, the Old Testament types, with their reference to the sacrifice of Christ, had lost their inevitable connection with the Coronation and were remounted on the south portal under the Apocalypse. It seems from de Son's engraving that the traditional scenes of the Death and Assumption of the Virgin were also abandoned. Richard Hamann-Mac Lean's theory, that at one time two Marian portals were intended at Reims, as they appear at Laon, has some validity if we imagine the Last Judgment forming the third element in the program.[29] But by 1230, when the Last Judgment portal was installed on the north transept, the influence of Laon must already have been waning, and by 1260 the whole west façade was due for an update which was to include and convert motifs drawn from various earlier sources, now integrated into a brilliant new context.

The jamb figures of the Visitation Group and the Virgins of the Presentation and Annunciation predate the mid-century project and there is evidence of some shifts in the placement of these and other jamb figures, made sometime during construction or at a later date.[30] In addition, in the eighteenth century, the canopy over the trumeau Virgin and the reliefs on either side were removed.[31] As de Son's engraving shows (fig. 14.3), on the left edge of the right half of the lintel was a seated figure with others approaching, probably the Adoration of the Magi, and on the right side three figures appear behind a rectangular form that might be a table represented at the Wedding at Cana.[32] Together these lintel reliefs belong to the Life of the Virgin cycle.

Kurmann notes that the reliefs of the life of Saint Paul, now mounted on the north and south lintels, belong to a style group apart from the reliefs of Paul preaching, shown on the face of the south outer buttress.[33] Perhaps all three lintels should be assigned to the same workshop, representing, like some of the jamb figures and the reliefs of the doorposts, a first version of the program that was altered in the upper zone of the portals and in the enlarged outer buttresses with the arrival of a second master.

When completed, the great originality of the Reims Virgin portal lay in the interweaving of narrative, typological, and allegorical subjects to achieve a profound alteration of the traditional aspect and emphasis of the Coronation.[34] The program begins in the voussoirs of the left side, where we can recognize scenes of the Presentation of the Virgin (M Al I-III 1), her Betrothal (M Al I-III 2), including an unusual scene of the rejected suitors breaking their rods (M Al III 2), the Annunciation (M Al I and II 3), the Nativity (M Al III 7), and two scenes from the story of the Magi (M Al I-III 55).[35] In reliefs located on the upper

[29] Hamann-Mac Lean, I, 1: 277–85.

[30] Kurmann, 178 and 253–57 and see above, n. 17.

[31] These changes are well illustrated by Schmidt, 'Poratlstudien,' ills. 15, 17, and 18.

[32] Demouy, 112–14.

[33] Kurmann, 192–96.

[34] For remarks on 'modernity' at Reims, Sauerländer, '*Antiqui et moderni*,' 30, outermost archivolt as *I* and individual voussoirs 1–8 up from the bottom.

[35] Some of these identifications involve a certain amount of guesswork since so many of the outer archivolts are later replacements. The recent examination of the portal distinguishes between Baroque inventions (mostly of popular saints) and those voussoirs which can be

zone of the verso, the story is continued with the Massacre of the Innocents and the Flight into Egypt. These lively scenes are spread over two or three neighboring voussoirs, or relief panels in the case of the inner wall, and involve three to five figures, an arrangement which treats the three archivolts as a single field for narrative.

The right archivolts are arranged in a more conventional manner, with figures of prophets and apostles in the two outermost and, on the third archivolt, a group of typological references to the virginity of Mary. These Old Testament types include God in the Burning Bush (M Ar III 3), the Three Hebrew Children in the Fiery Furnace (M Ar III 5) (fig. 14.4), and the *Porta clausa* of Ezekiel (M Ar III 5). In the interior the typological series is completed by a second pair of reliefs of Moses before the Burning Bush, and Gideon and the Fleece, located at the top of the south side of the verso wall. These types are traditionally associated with the life of the Virgin. The series, which had appeared around 1190 on voussoirs at Laon, was first associated by Mâle with commentaries of Honorius Augustodunensis.[36] They were also included in the quatrefoils under the jamb figures of the Virgin portal at Amiens.[37]

The fourth archivolt seems at first more conventional. On the lowest left voussoir (M Al IV 1) Jesse asleep in an arbor suggests that the archivolt comprises a cycle of the ancestry of the Virgin.[38] At Senlis, Braine, Laon, and Chartres, the Stem of Jesse is part of the Coronation program, but at Reims the vine-scroll is absent, and all the figures are kings who play musical instruments (fig. 14.4), suggesting that they should be interpreted as the Elders of the Apocalypse.[39] On the innermost archivolt, the Apocalyptic reference is again specified by the figures of two angels that hold disks representing the sun (fig.

assumed to be to some degree an accurate copy of the medieval works they replaced, Pallot-Frossard and Decrock, 'Les voussures,' 76 and 79n10. The two other figures to the right of Joseph were restored in the seventeenth century as Saint Louis (Ml V II/3, holding a scepter) and an unknown female saint (Ml V I/2) turned toward the other figures). Again, I am using Kurmann's numbering system and count the outermost archivolt as I and individual voussoirs 1–8 up from the bottom.

36 Emile Mâle, *L'art religieux de XIIIe siècle* (Paris, 1958), x-xxx; see also Katzenellenbogen, *The Sculptural Programs*, 130n55.

37 Stephen Murray, *Notre-Dame Cathedral of Amiens* (Cambridge, 1996), 106–8.

38 At Braine the Jesse tree included one female figure traditionally identified as Bathsheba, Madeline H. Caviness, *Sumptuous Arts at the Royal Abbeys in Reims and Braine* (Princeton, 1990), 94.

39 The Reims Coronation with Elders of the Apocalypse appears to be unique in French Gothic sculpture. The Virgin and Child with Elders occurs rarely: on a twelfth-century tomb at St-Julien (Haute-Vienne) with an inscription naming the Virgin as *santa dei genetrix*, and in the thirteenth century in glass, the rose at Laon and, perhaps, on the portal of St Anne at Notre-Dame, Yves Christe, *L'Apocalypse de Jean. Sens det développements de ses visions sythétiques*, Bibliothèque des Cahiers Archéologiques XV (Paris, 1996), 149–50. See also William M. Hinkle, 'The Iconography of the Apsidal Freso at Montmorillon,' *Münchner Jahrbuch für bildende Kunst* 23 (1972): 37–62. The Apocalyptic context of the Coronation has been investigated in later devotional manuscripts by Jeffrey F. Hamburger, *The Rothschild Canticles. Art and Mysticism in Flanders and the Rhineland circa 1300* (New Haven, 1990), ch. 7. Also see Verdier, *Le Couronnement*, which discusses the manuscript in New Haven, Yale University, Beineke Library, MS 404, p. 95, in the light of Bernard's sermons for the Assumption.

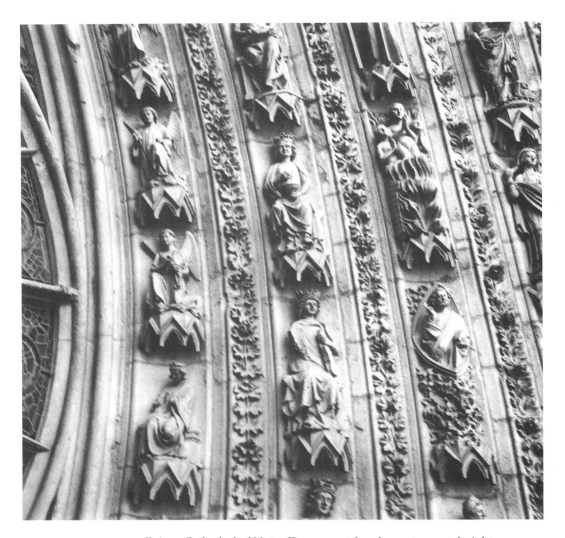

14.4 Reims, Cathedral of Notre-Dame, west façade, center portal, right archivolts.

14.4) and the moon (M Ar V 4 and M Al V 4). Thus an Apocalyptic setting is evoked for the Coronation and a role for the Virgin that equates her with the woman clothed in the sun with the moon at her feet (Rev. 12.1), evoking an image not only of triumph but of warning. The idea of the Virgin/Church beset by peril surfaces more explicitly in reliefs from the inner west wall in the contiguous scenes of the Massacre of the Innocents and the Flight into Egypt where the figure of a fleeing mother from the first episode is paralleled by the unusual images of Mary holding the swaddled Christ close to her breast (fig. 14.5). Lest the point be missed, a third mother, the woman clothed in the sun, clasps a swaddled infant on the Apocalypse reliefs of the south verso wall.

14.5 Reims, Cathedral of Notre-Dame, west façade, center portal, verso,
Massacre of the Innocents and Flight into Egypt.

Donna Sadler has demonstrated the layered associations between baptism and coronation as well as the complex allusions to the idea of *rex et sacerdos* in the paired Christ and John the Baptist, Abraham and Melchizedek (the Knight's Communion), and Priest and King, that appear in the upper zones of the exterior rose and in reliefs of the verso.[40] She concludes that, taken together, the reliefs constitute a manual for the Kings whose appearance after the Coronation took place facing the west inner wall. But everyday viewers might have been more moved by the Apocalyptic references that place these scenes within an eschatological context. The contrast Sadler draws between good and evil kings, and good and bad counsel sound a note of struggle that prefaces the end of time. I would go further to suggest that the figures of warriors, characterized as evil by their 'pagan' armor, who appear in the scene of the Knight's Communion, the Massacre of the Innocents and the Martyrdom of Nicaisius refer to more specific and immediate enemies of the Church. 'The axe lies ready at the roots of the trees: every tree that fails to produce food fruit is cut down and thrown on the fire,' (Matt. 3:10): John's words to the Pharisees and Sadducees, implied in the verso relief, seem to resound to all who remain outside the faith.

The Four Brides

The iconography of the Coronation of the Virgin, with its long life in Gothic art, takes its precise meaning from its broader context.[41] The meaning of the *synthronon*, the form of coronation and the precise moment chosen, as well as the number and attributes of the angelic attendants, combine with the identity of figures and scenes in the jambs, lintels, and archivolts to provide a gloss on her ascension to a position next to Christ, by evoking aspects of the rich bridal imagery that medieval commentary derived from the Song of Songs.[42] At Reims (fig. 14.2), the Virgin is shown in profile inclining toward Christ, who touches the crown he has just placed on her head. A bank of clouds under their feet and the complex baldachin overhead suggest a vision of the heavenly city irradiated by the rays of the sun, which appears as a disk above their heads.[43] On either side seraphim gesture toward pairs of angels.

Philippe Verdier, in his important study of the subject, makes the point that the Coronation represents a theophany, more lyrical and humane than the

[40] Sadler, 'Lessons Fit for a King,' 49.

[41] The overall theme of the Braine Coronation is considered by Jeraldean McClain to be 'the conflict between good and evil under the Old Law,' as quoted by Caviness who differentiates this program from those at Senlis, Mantes, Laon, and Chartres (Caviness, *Sumptuous Arts*, 94–95). The Coronation gets another reading at Notre-Dame, Katzenellenbogen, *The Sculptural Programs*, 61.

[42] For a discussion of this imagery, Verdier, *Le Couronnement*, ch. VI; Ann W. Astell, *The Song of Songs in the Middle Ages* (Ithaca, N.Y., 1990), 42–72.

[43] From de Son's engraving, it appears as a sphere within a trefoil. It has been restored as a radiant disk.

apocalyptic vision of Christ that prevailed in twelfth-century portal programs.[44] Although some recent discussions of the *sponsa* image have stressed the idea of personal bride-ship derived from Cistercian and Victorine sources, at Reims the theophany, with its specific references to the Virgin as Apocalyptic Woman, clearly announces an idea of a Final Church.[45] Thus, the center portal is framed by other references to the *Eschaton* in reliefs of the Exaltation of the Cross on the north buttress and the Apocalypse cycle on the south buttress and portal. The entire portal zone is bracketed on the lateral sides of these outer buttresses by scenes from the lives of Paul and John, setting the whole program within a visionary and prophetic perspective. Paul and John, who, like Moses 'saw' God, are shown in these reliefs as preachers, underscoring their mediating role between the viewer and the vision of the Coronation.[46]

The reference to last things is most clearly stated in the two representations of *Synagoga* and *Ecclesia* that appear on the west façade. The lower pair occupied pinnacles located between the center and side portals. As represented in photographs taken before 1914, Syngoga is shown blinded, her head bent and crown askew; she holds her broken lance broken and the tablets of the law.[47] This is the traditional image of the fallen Synagoga that appears opposite Eccclesia on the south transept portal at Strasbourg, flanking scenes of the Death and Coronation of the Virgin. The two had also appeared earlier in a similar guise at Reims, located on either side of the south transept rose.[48]

Paul in his epistle to the Romans speaks of the blindness of Israel but, he continues, the false step of the Jews could lead to the enrichment of the Gentiles, and the whole of Israel would be saved at the end of time (Rom. 11. 11 and 25–27). This seems to be the explanation for the second pair of women who are located in the gables of the north and south buttresses. On the south the crowned figure is usually considered to represent Mary or Ecclesia, but the identity of figure on the north side is more ambiguous (fig. 14.6).[49] Located near reliefs of the preaching of Paul, the figure wears a simple veil drawn back

44 Verdier, *Le Couronnement*, p. 9; Katzenellenbogen, *The Sculptural Programs*, 56–78 and 130n55. The Marian exegetical tradition is discussed by Astell, *The Song of Songs*, 42–72, 77–80, and 89–91.

45 For the twelfth-century monastic interpretation of the Song of Songs, E. Ann Matter, *The Voice of My Beloved: The Song of Songs in Western Medieval Christianity* (Philadelphia, 1990), 123–38; Verdier, *Le Couronnement*, 91–96.

46 Paul and John are joined in the inner lintels by scenes from the lives of Stephen and John the Baptist to emphasize that the triumph of the Church is supported by preaching and prophesy. I have explored the role of Paul as preacher and intermediary in the portal program in a lecture given at the symposium 'Notre-Dame of Reims, the Coronation Cathedral of France,' held at The Metropolitan Museum of Art in October, 2001. For the view of the Apocalypse as a book of prophesy, see Lewis, *Reading Images*, 11. For John and Moses and 'ways of seeing,' see also Barbara Nolan, *The Gothic Visionary Perspective* (Princeton, 1977), 36–37.

47 This figure is illustrated by Kurman, Pl. 27 and by Hamman-Mac Lean, II, 6, Pls. 1711, 1712.

48 For Strasbourg, Sauerländer, *Gothic Sculpture*, Pl. 130; for Reims, ibid, p. 479 and Pl. 262.

49 The figure was considered by Plantar to represent the Magdalene, and by Vigny part of an Annunciation. Although restored in 1831 by Plantar and damaged by the bombardments

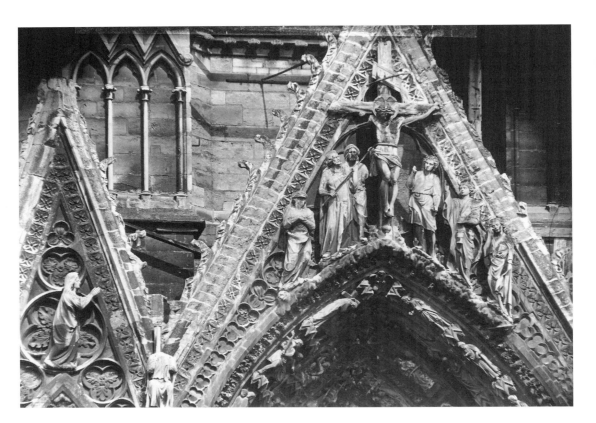

14.6 Reims, Cathedral of Notre-Dame, west façade, north portal gable, and north buttress.

from her face. The two figures rise on clouds toward the heavenly city. Their rapturous gaze upward and their prayerful gestures indicate their participation in the Coronation and suggest that they represent Ecclesia and *Synagoga conversa*, the latter saved in fulfillment of Paul's prophesy.

In the twelfth century the theme of the redeemed Synagogue had been addressed in the second of his two commentaries on the Song of Songs by Honorius Augustodunensis. In the *Expositio in Cantica canticorum*, composed in Regensberg in 1135, Honorius's allegorical reading of the Canticle privileges an institutional over a personal reading of the Bride as individual soul which, originating in Origen, was the core of Bernard's interpretation.[50] In the allegorical illustrations that appear in several twelfth-century and fourteenth-century manuscripts of Honorius's text, Synagoga conversa is identified with Sunamitis, the Shulamite woman who rides in the quadriga of Abinadab

of 1914, de Son's engraving and photographs taken before 1914 attest to the accuracy of the gestures and attributes of these two figures.

[50] Flint, 'The Commentaries,' 209. Although some scholars tend to group the various commentaries on the Canticle together, Flint is at pains to discriminate between the position of Honorius and Bernard in this particular respect.

symbolizing the New Testament. [51] The portrayal of the quadriga of Abinadab, containing an image of Christ on the Cross, had been the subject of one of the roundels from Abott Suger's 'anagogical' window at Saint-Denis by Suger where it is also usually assumed to represent the New Testament.[52] A second roundel from this window, which most scholars understand as a Pauline invention, shows Christ unveiling Synagoga and leads closer to the figures at Reims and returns to the Pauline use of the veil metaphor in second Corinthians (2 Cor. 3.14–16).[53]

In the *Expositio* Honorius, like many of his contemporaries, injects an Apocalyptic meaning into the Song of Songs and the bridal Synogoga is introduced as part of a system that divides the history of salvation into four phases represented by four Brides.[54] In this scheme the Queen of Sheba, as bride of Solomon, represents the primitive church, the second bride is the Shulamite, the church of the Jews, and the third bride, which Honorius names the Mandrake, stands for the church of the Incarnation. The fluidity of Honorius's four-part system invites interpretation at several levels which are clearly beyond easy transformation into images; the Mandrake, in particular, resists easy visualization.[55] Nevertheless, the importance of his exegesis of the Canticle rests in the conflation of the Brides and a view of history to be completed at the end of time, after the defeat of the Antichrist, with the Final Church. Such a view seems to explain the paired bridal figures that are located on the Virgin portal at Reims, where, moving upward along the central vertical axis, the historical figures of Solomon and Sheba give way to the allegorical pair of Ecclesia and Synagoga, and culminate in the anagogical vision of the Coronation on the gable.

Within the larger context of the west façade, the Coronation scene on the gable acts as a point of convergence between the axes of history and revelation. A narrative that begins with the Passion and Crucifixion on the left portal and moves to the right portal with the defeat of the Antichrist intersects image cycles located on the upper rose and the Gallery of Kings that tie vision of

[51] Michael Curschmann, 'Imagined Exegesis: Text and Picture in the Exegetical Works of Rupert of Deutz, Honorious Augustodunensis, and Gerhoch of Teicherberg,' *Traditio* 44 (1988), 145–69. Curschmann notes four manuscripts, the most interesting for Reims's iconography are two from the fourteenth century, MS St Florian XI, 80 (dated 1301) and St Paul (im Laventhal) 44/1 from which he reproduces fol. 53r, showing the Church as the Shulamite Woman, idem, Fig. 7. See also Jeremy Cohen, '*Synagoga conversa*: Honorius Augustodunensi, the Song of Songs, and Christianity's "Eschatological Jew,"' *Speculum* 79 (2004): 309–40.

[52] Louis Grodecki, 'Les Vitraux allégoriques de Saint-Denis,' *Art de France* I (1961), 19–46; Madeline H. Caviness, 'Suger's Stained Glass at Saint-Denis: The State of Research,' ed. Paula Lieber Gerson, *Abbot Suger and Saint-Denis*, (New York, 1986), 257–72; Verdier, *Le Couronnement*, 33.

[53] Allegorical versus anagogical readings of this window are discussed by Conrad Rudolph, *Artistic Change at Saint-Denis: Abbot Suger's Program and the Early Twelfth-Century Controversy over Art* (Princeton, 1990), 57.

[54] Curschmann, 153–60. For the four Brides see also Matter, *The Voice of My Beloved*, 63–75.

[55] Matter, *The Voice of My Beloved*, 65 and Pl. 3.

sacred monarchy into a final triumph of the Church.[56] Such a conception of the Coronation inevitably de-emphasizes the Christ as merciful Judge and Virgin as intercessor, central ideas at Amiens and on the south transept at Chartres. However, Peter Klein reminds us that Apocalypse means Revelation, not end of the world but the beginning of the next. For medieval millenarianists as well, the apocalyptic view of history, with its promise of eternal peace, was supremely optimistic.[57]

No discussion of the apocalyptic aspects of the Virgin portal and its reflection of what Bernard McGinn has called an 'apocalyptic mentality' can be complete without a reopening of the investigation of the sources and meaning of the south portal.[58] Furthermore, the words of Paul and John must find their proper place within the prophetic and visionary view of human history that was prevalent in the middle decades of thirteenth-century France. Finally, the ideas presented here need to be measured against the actual situation in Reims during the 1260s where a long history of conflict between the town and the cathedral clergy had left both sides in confrontational positions. In the meantime, this examination of the Virgin portal suggests how the innovative façade program devised in about 1260 transcends traditional symbols of the Heavenly Jerusalem in order to set forth a more specific image of Ecclesia as the final Church, the Church of the future, the present, and the past.

56 Peter Klein, 'The Apocalypse in Medieval Art,' in *The Apocalypse in the Middle Ages*, ed. Richard K. Emmerson and Berbard McGinn (Ithaca, N.Y., 1992), 162.

57 Peter Klein, 'Programmes eschatologiques, fonction et réception historiques des portails du XIIe s.: Moissac—Beaulieu—Saint-Denis,' *Cahiers de civilasation médiévale* 33 (1990), 317– 33, esp. 329–33.

58 Bernard McGinn, 'Introduction: John's Apocalypse and the Apocalyptic Mentality,' in *The Apocalypse in the Middle Ages*, 3–19. Peter Kurmann, 'Le portail apocalyptique de la cahtédrale de Reims. A propos de son iconographie,' in Yves Christe, *L'Apocalypse de Jean: traditions exégçtiques et iconographiques, IIIe-XIIIe siècles* (Geneva, 1979), 245–313.

Seeing and Understanding Narrative and Thematic Method in the Stained Glass of the Choir of Königsfelden ca. 1330–40

Brigitte Kurmann-Schwarz

The stained glass in the choir of the former abbey church of Königsfelden comprises several narrative cycles (fig. 15.1): a Christological cycle in the apsidal windows (I, n/s II);* scenes of the Death of the Virgin (s III); the Annunciation and the Beheading of John the Baptist (n III); the Stoning of St Stephen, the Conversion and the Martyrdom of St Paul (s III), the Martyrdom of St Catherine (n III), scenes from the lives of SS Francis and Clare (n V, s VI), the Miracle of St Nicholas (s V), as well as a Virgin and St Ann cycle associated with Old Testament scenes and figures of saints (n VI).[1] The glass fills tripartite windows, each lancet comprising ten rectangular panels and a header. The glazing follows two compositional schemes: windows structured through architectural frames or in series of large medallions. While the painted architectural framework underscores the vertical divisions created by the mullions, the medallions and quatrefoils engage the entire width of the windows, and use the mullions to draw attention to the main figures within the painted compositions. This essay will demonstrate how the visual structure of this stained glass and its interplay with the architecture shape the mode of narration and the way in which the viewer perceives the images and image sequences.

These windows have not previously been the object of an investigation that focuses on how the narratives of the illuminated images are to be 'read' or seen and how the form and content interplay, so that the meaning is made visually evident.[2] A comprehensive analysis of the narrative theory and the aesthetic reception of the entire choir glazing exceed the scope of this article. Nor can

Translated from the German by Julien Chapuis and Timothy Husband

* These numbers are the international Corpus Vitrearum system for locating any stained-glass window in a given site. I thank Julien Chapuis and Timothy Husband for their excellent translation.

[1] For an overview of the research on the stained glass at Königsfelden with bibliography and color illustrations of the medieval glass in the choir, see Brigitte Kurmann-Schwarz, *Königsfelden—Zofingen—Staufberg, Glasmalerei im Kanton Aargau*, I (Aarau, 2002).

[2] Attempts at such considerations can only be found in Emil Maurer, 'Habsburgische und franziskanische Anteile am Königsfelder Bildprogramm,' *Zeitschrift für schweizerische Archäologie und Kunstgeschichte* 19 (1959): 220–25 and 'Königsfelden, Meisterwerk zyklischer Komposition, Eine Nachlese,' *Unsere Kunstdenkmäler* 20 (1969): 94–102.

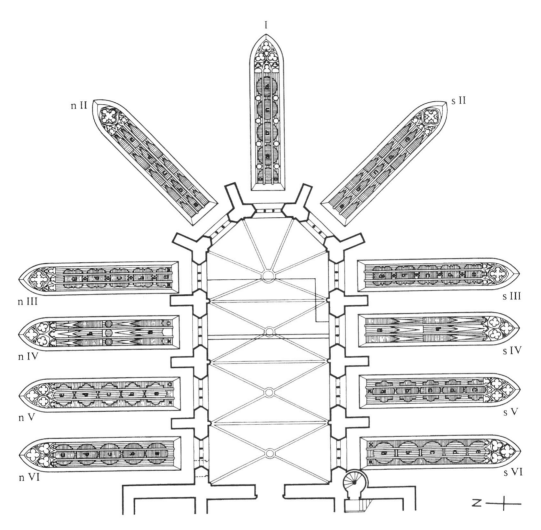

15.1 Königsfelden, former abbey church, plan of the windows in the choir.

the function of the choir and its intended audience be thoroughly discussed here.[3] Therefore, the following remarks are devoted to an investigation of the

[3] Views on this matter have been expressed elsewhere: Peter Kurmann and Brigitte Kurmann-Schwarz, 'Das religiöse Kunstwerk der Gotik als Zeichen der Übereinkunft zwischen Pfaffen und Laien,' in *Pfaffen und Laien, ein mittelalterlicher Antagonismus?*, Fribourg Colloquium 1996, ed. Eckart Conrad Lutz and Ernst Tremp (Fribourg, 1999), 77–99; Brigitte Kurmann-Schwarz, 'Les vitraux du choeur de l'ancienne abbatiale de Königsfelden. L'origine des ateliers, leurs modèles et la place de leurs oeuvres dans le vitrail alsacien,' *Revue de l'Art* 121 (1998): 99–120; Brigitte Kurmann-Schwarz, 'Die Sorge um die Memoria. Das Habsburger Grab zu Königsfelden im Lichte seiner Bildausstattung,' *Kunst und Architektur* 50 (1999): 12–23. For both monasteries at Königsfelden and their joint use of this church, see Brigitte Kurmann-Schwarz, 'ein vrowen chloster sande Chlaren orden und ein chloster der minneren Bru(e)der

stained-glass narratives in the two western bays of the choir and to an analysis of the complex framing systems in which the pictorial cycles are presented. This paper will explicate the manner and means by which the viewer is encouraged to 'read' rather than to merely 'see' the stained-glass panels. In addition, the place that the windows at Königsfelden occupy in the history of narrative glazing cycles between 1200 and the period after 1300 will be investigated. In this paper, it will be argued that the stained glass in the windows of the western choir bays reveals the interplay of self-contained images and encompassing narrative strategies. In addition, the possible interconnection among the independent narrative cycles of Saints Francis, Clare, Nicholas, and Anne will be considered, leading to the reading of the separate images as part of an overarching program.

Madeline Caviness has given considerable impetus to these matters in her two studies on the perception of images in the Middle Ages.[4] While her primary interest lies in works of art of the twelfth and thirteenth centuries, she nonetheless draws attention to the new narrative style that arose around 1300 in the circle of the Franciscans in Italy. Wolfgang Kemp, who studied the great French cycles of around 1200, has taken the lead in the investigation of narrative in stained glass,[5] having set himself no small goal in attempting to free stained glass from art-historical obscurity.[6] He succeeds in shifting stained glass to the center of attention with his argument that the glass cycles produced before the introduction of tracery achieved narrative independence. However, this argument reinforces the long-standing prejudice that later stained glass is merely decorative and of secondary artistic importance except when it drew inspiration from contemporary painting.[7] After 1250, in his opinion, large narrative cycles existed almost exclusively in Italian wall painting of about 1300; but in contrast to glass painting of about 1200, these paintings effected a paradigmatic change from a summary narrative style to a more fully realized narrative (*vom Erzählen in Bildern zum Erzählen im Bild*).[8] In glass painting after 1250, on the other hand, according to Kemp, architecture dominated, effectively underscoring the figure, regimenting its relationships, and repressing narrative. This finding, however, is contradicted by the numerous fourteenth-century glazing programs of high quality found in Alsace, southern Germany and Switzerland, where the windows comprise cycles of multiple scenes framed by medallions or architecture.[9] Among these glazing

orden …' *Glas. Malerei. Forschung. Internationale Studien zu Ehren von Rüdiger Becksmann*, ed. Hartmut Scholz, Ivo Rauch, and Daniel Hess (Berlin, 2004): 151–63.

4 Madeline H. Caviness, 'Images of Divine Order and the Third Mode of Seeing,' *Gesta* 22 (1983): 99–120; Madeline H. Caviness, 'The Simple Perception of Matter and the Representation of the Narrative, ca. 1180–1220,' *Gesta* 30 (1991): 48–64.

5 Wolfgang Kemp, *Sermo corporeus. Erzählungen der mittelalterlichen Glasfenster*, (Munich, 1987).

6 Kemp, *Sermo corporeus*, 9.

7 Kemp, *Sermo corporeus*, 16–19.

8 Kemp, *Sermo corporeus*, 263–72; additionally, Wolfgang Kemp, *Die Räume der Maler. Zur Bilderzählung seit Giotto* (Munich, 1996), 9.

9 To cite only the most important of these cycles: the stained glass in the south aisle of the cathedral of Strasbourg, see Victor Beyer, Christiane Wild-Block, Fridtjof Zschokke, Claudine

programs the choir glazing of the former abbey church at Königsfelden takes an honored place.

From the time of its consecration in 1320 until the onset of the Reformation in 1528 the church, following the wishes of the founders, was the spiritual center of two communities: the sisters of the order of the Poor Clares and the brothers of the order of St Francis. The foundation was occasioned by the assassination of king Albrecht I at the hand of his nephew duke Johann of Austria on May 1, 1308.[10] The German king is said to have suffered a mortal wound on the very site where the high altar of the abbey church was later to stand.[11] In 1311 the widow of the assassinated king, Elisabeth, along with her sons, issued in Vienna the founding documents for both monasteries.[12] The church was constructed in two principal phases: the nave between 1312–13 and 1314 and the choir between 1329–30.[13] At first the nave contained an ornamental glazing program in which the arms of the empire and of Hungary were incorporated (about 1312–13 or, at the latest, 1316)[14] while the figural glass in the choir was executed in several stages between 1329–30 and about 1340.[15] Contemporary sources assign the choir to the brothers so one may assume that this space was primarily intended for the offices of the Franciscans.[16] Queen Agnes of Hungary, daughter of Queen Elisabeth († 1313) and King Albrecht I, had a private entrance to this part of the church. She lived out her widowhood in Königsfelden, inhabiting a house to the east of the church and the nuns' abbey from 1316–17 until her death in 1364.[17]

The glass did not survive nearly seven hundred years unscathed. By 1508, a glazier from Bern had already replaced the figure of Eve in the first register of

Lautier, *Les vitraux de la cathédrale Notre-Dame de Strasbourg*, Corpus Vitrearum, France 9–1, Département du Bas-Rhin 1 (Paris 1986), 201–56. Regarding the stained glass now in the west window of Saint-Guillaume in Strasbourg, see Françoise Gatouillat, Michel Hérold, *Les vitraux de Lorraine et d'Alsace*, Corpus Vitrearum, France, Recensement des vitraux anciens de la France 5 (Paris, 1994), 221; the stained glass in the Liebfrauenkirche and in the Franziskanerkirche in Esslingen, see Rüdiger Becksmann, *Von der Ordnung der Welt. Mittelalterliche Glasmalereien aus Esslinger Kirchen*, exhb. cat., (Esslingen 1997); or the axial window of Sankt Jakob's in Rothenburg ob der Tauber, see Hartmut Scholz, *Die mittelalterlichen Glasmalereien in Mittelfranken und Nürnberg extra muros*, Corpus Vitrearum Medii Aevi, Deutschland 10, part 1 (Berlin, 2002), 417–65.

[10] Kurmann-Schwarz, *Königsfelden—Zofingen*, 11–3.

[11] Aarau, Staatsarchiv, Königsfelden, Cartulary AA/0428, f. 52r: The writer commences the history of the foundation with the comment that all the property previously itemized in the Cartulary had been purchased with funds given by Queen Elisabeth and her donations were in honor of the 'Edeln un(d) hochgeborenen fürsten künig Albrehs von Rome irs h(er)ren sel willen der sin lip hie verlor uf eim ofen velde in sinem eigen lande von sines bru(o)der son h(er)zog Johans der in an den trüwen erslu(o)g an der stat da nu fronaltar stat in der bru(o) der Cor dur des sele willen si ouch dü Closter ze kunsvelt stift mit groser begirde und andacht.'

[12] Founding charter: Aarau, Staatsarchiv U.17/0020a, 1311 IX.29, Vienna.

[13] Kurmann-Schwarz, 'ein vrowen chloster,' 151–63.

[14] Kurmann-Schwarz, *Königsfelden—Zofingen*, 99–101.

[15] Kurmann-Schwarz, *Königsfelden—Zofingen*, 101–4.

[16] See note 11 above; also, Kurmann-Schwarz, 'ein vrowen chloster,' 160–61.

[17] Queen Agnes' entrance from the residence to the choir must have been walled up after her death. See, Aarau, Staatsarchiv, U.17/0332a, 1366 I. 25, Vienna.

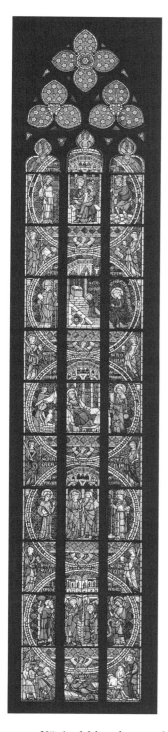
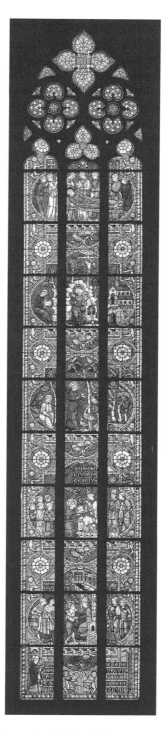

15.2 Königsfelden, former abbey church; general views of: *n VI*, the St Anne and, *n V*, St Francis windows.

the Anna window (fig. 15.2). Documents since then refer to repairs, replacements, and cleanings in the choir windows. In the seventeenth and eighteenth centuries, storms caused damage on several occasions. The reports are so vague, however, that it is impossible to date precisely the nearly complete destruction of three windows on the south side (s III, IV, and V). The young glazier Richard A. Nüscheler restored the windows from 1896 until 1900. He systematically replaced earlier restorations and retouched the medieval paint in numerous areas. This is particularly true of the Anna window, which he almost entirely overpainted and whose first register he nearly entirely replaced. Because so little had survived of the south windows, he reconstructed their compositional frames (fig. 15.3), but not their figural representations. Nüscheler also filled the missing fields with Latin inscriptions. The second Corpus volume for Switzerland will contain a thorough discussion of the restoration history and present condition of the glass at Königsfelden.[18]

Two of the stained-glass windows in the choir recount key events in the lives of SS Francis (n V)[19] and Clare (s VI),[20] the founders of the order. Here the artists employ a scheme, which, using individual images, traces a linear ascent from the Conversion to the Apotheosis. Although this format is found also in the St Anne window (n VI),[21] scenes from the life of Anne and the Virgin Mary here constitute less an ascent toward perfection than they do of the history leading up to the Incarnation of Christ. In accordance with its meaning, the actual narrative is embedded in an action framework and accompanied by early Christian witnesses of the faith. Saints also appear as witnesses to events in the images themselves. The Nicholas cycle represents not the life of an individual but a series of miracles that God has wrought through His great thaumaturgy. The chronological sequence plays no role in this window;[22] the placement of the windows opposes scenes from the life of St Nicholas with those of St Francis and scenes from the life of St Anne with those of St Clare. The identical tracery patterns and their compositional arrangements underscore the interrelated meanings of the narrative cycles facing each other in each bay.[23] Given the placement of the choir stalls beneath the two pairs of windows, the designer of the windows took into account the correspondence of imagery between both facing and flanking windows. Throughout the holy services, the brothers on the north side would be facing the miracles of St Nicholas and scenes from the life of St Clare while those on the south would view scenes from the lives of Anne and the Virgin and of St Francis.

The stained-glass panels, however, present not only references from one window to another but also, through an articulation governing every window, an internal reference system that is reinforced with numerous figurative motifs

[18] Brigitte Kurmann-Schwarz, *Die mittelalterlichen Glasmalereien der ehemaligen Klosterkirche von Königsfelden*, Corpus Vitrearum, Schweiz 2 (forthcoming in 2008).

[19] Kurmann-Schwarz, *Königsfelden—Zofingen*, 246–47.

[20] Kurmann-Schwarz, *Königsfelden—Zofingen*, 252–53.

[21] Kurmann-Schwarz, *Königsfelden—Zofingen*, 250–51.

[22] Kurmann-Schwarz, *Königsfelden—Zofingen*, 248–49.

[23] Kurmann-Schwarz, *Königsfelden—Zofingen*, color pls. 44, 50, 56, and 62.

15.3 Königsfelden, former abbey church; general views of: *s V*, St Nicholas, and
s VI, St Clare windows.

(figs. 15.2 and 15.3). In three of the windows, founders of the monastery appear in the lowest register (n V, s V, and s VI)[24] while the sleeping Jesse, the drunken Noah and the Creation of Eve occupy this position in the Anne window (n VI). The spandrels between both the medallions and quatrefoils are likewise inhabited: martyred female saints and angels respectively populate the Anne and Clare windows, while rampant lions assume the analogous position in the life of St Francis window and bearded, wide-eyed heads with leafy tendrils emanating from their mouths fill the spandrels of the Miracles of St Nicholas window.

Both windows of the Franciscan saints (nV, sVI) have five large medallions or quatrefoils, and within each of the five compartments is a single scene. The Francis window (fig. 15.2) commences with the rejection of the saint by his own father and continues with the recognition of the first rule of St Francis by Pope Innocent III, the Preaching to the Birds and the Stigmatization. The death of the saint closes out the history.[25] The life of St Clare begins with bishop Guido of Assisi handing over the consecrated palm frond, and the day she leaves her father's house to join the Franciscans. Saint Francis asked her to do so on Palm Sunday. The cycle continues with Clare vowing obedience to Francis. In the third scene her relatives attempt to tear her away from the altar and compel her to lead a worldly life. Finally Clare is seen in front of her cloister outside of Assisi begging Christ for protection against Emperor Friedrich II's forces. The final medallion, which in all probability represented the death of the saint, is missing.[26]

The comparison of the legends of the two saints proves that they follow the same model. Both legends begin with a conversion scene that plays out in the presence of a bishop.[27] Then each continues with a formal act that marks the entering of religious life or the founding of the order. While Innocent III's approval of Francis's Order more strongly emphasizes the new foundation, the second medallion in the Clare cycle represents the saint taking her habit: St Francis cuts off Clare's luxuriant hair as a nun approaches carrying the habit of her new sister over her arm. In the third scene, both young saints are given the opportunity to prove themselves: St Francis appears as a preacher before an unlikely audience of birds. Going against their normal habit of fleeing men, the birds listen to the words of the saint with great attention. Clare resists the

24 In window n V: Duke Otto von Österreich (1301–39); s V: Rudolf (Raoul) of Lorraine (1318–46); s VI: Katharina of Savoy, Duchess of Austria (1298–1336) und Duke Leopold I of Austria (1293–1326).

25 Brigitte Kurmann-Schwarz, 'Das Franziskusfenster von Königsfelden. Bild- und Texttradition,' in *Pierre, lumière, couleur. Etudes d'histoire de l'art du Moyen Age en l'honneur d'Anne Prache*, ed. Fabienne Joubert and Dany Sandron (Paris, 1999), 297–307.

26 Brigitte Kurmann-Schwarz, 'Die heilige Klara in den Glasmalereien der ehemaligen Klosterkirche von Königsfelden,' in *Chiara d'Assisi e la memoria di Francesco, Attti del Convegno per l'VIII centenario della nascita di s. Chiara, Fara Sabina 1994*, ed. Alfonso Marini and M. Beatrice Mistretto (Città di Castello, 1995), 129–47.

27 The image in Königsfelden departs from traditional depictions of this episode in that Francis turns to the bishop and not to God the Father. See Kurmann-Schwarz, 'Das Franziskusfenster', 302–3.

authority of her relatives who force their way in to the sanctuary and seize her (fig. 15.4). The conspicuously dressed youth at the right of the scene who passively observes the event and communicates with his companion by hand gesture may well be Clare's betrothed.[28] This scene and the corresponding one in the Francis legend demonstrate the differing gender roles: the nun must decide to live the contemplative life within cloistered walls, while the mendicant brothers (during the lifetime of St Francis most brethren were lay-brothers) must roam the land and preach.[29] In the fourth images, the saints put the power of prayer to the test. During his forty-day fast on Monte La Verna, a seraph in the form of a crucified man appears before Francis. In the course of deep contemplation of the apparition the saint receives the wounds of Christ on his hands, feet, and side.[30] Like Francis, Clare also prayed before Christ who is present, however, not as a vision but rather in the form of a consecrated host. Clare's entreaties protect the city of Assisi and her undefended nunnery from attacking enemies. The figure of the nun holding the vessel with the consecrated host before Clare no longer exists at Königsfelden. Francis in prayer becomes an *alter Christus* (or second Christ) through her entreaties; Clare, on the other hand, is a mediator between this world and the world beyond.[31]

Both cycles most likely concluded with the death and apotheosis of the saint, a scene that survives only in the Francis window, which represents the giving of the last rite at the saint's deathbed (fig. 15.5). A small figure kneels in front of the bed of the deceased and gropes for the wound in his side. Earlier research identifies this kneeling figure as the knight Hieronymus, who is modeled on the Doubting Thomas and must see and probe in order to believe. However, as the figure is so small it might also represent the son of Giacoma dei Settesoli, the Roman matron and friend of the saint, who, according to the *Tractatus de miraculis* of Thomas of Celano (1250–53), was at the bedside of the dying saint along with his mother. Brother Elia showed the mother and her son the stigmata of the Saint whereupon the boy acknowledges the miracle.[32]

The lost death scene of St Clare could have been similar to that of a somewhat later retable (about 1350) from the Klarakloster in Nuremberg that depicts the saint on her deathbed.[33] The Virgin embraces the dying figure as three female saints cover her with precious fabric. As in the initial scenes of the Königsfelden window, an angel holds a crown over the saint even though the Virgin and

[28] The refusal of marriage is a common topos in the lives of the saints. See Kurmann-Schwarz, 'Die heilige Klara,' 141.

[29] Although there are many examples, reference is made here only to St. Clare. See Helmut Feld, *Franziskus von Assisi und seine Bewegung* (Darmstadt, 1994), 423–33.

[30] Feld, *Franziskus von Assisi*, 268–77 (with earlier related literature); Chiara Frugoni, *Francesco e l'invenzione delle stimmate. Una storia per parole e immagini fino a Bonaventura e Giotto* (Turin, 1993), 137–201.

[31] Brigitte Degler-Spengler, 'Die Klarissenklöster in der Schweiz,' *Helvetia Franciscana* 23 (1994): 44–61, esp. 50; Michel Lauwers, *La mémoire des ancêtres, le souci des morts. Mort, rites et société du Moyen Age (diocèse de Liège, XIe–XIIIe siècles)* (Paris, 1997), 425–59.

[32] Kurmann-Schwarz, 'Das Franziskusfenster', 305.

[33] Peter Strieder, *Tafelmalerei in Nürnberg 1350–1550* (Königstein im Taunus, 1993), 22, Fig. 12.

15.4 Königsfelden, former abbey church; *s VI, 5–7a–c*, St Clare besieged by her relatives.

15.5 Königsfelden, former abbey church; *n V, 10/11a-c*, Death of St Francis.

Christ have already crowned her soul in Heaven. The format of the Königsfelden panels does not allow for such an expansive scene; instead of the coronation, it is possible that two angels elevated the soul of the saint to Heaven on a cloth, of which fragments survive in the headers of the outer lancets.[34]

In contrast to the narrative imagery in many glazing programs produced around 1200, the appearance and gestures of figures at Königsfelden do not propel events from one image to another. The compositions of the individual scenes are self-contained and adjusted to the action of the principal figure in the center. In this manner no far-reaching dynamic is set in motion beyond the frame of the image; rather the viewer is invited to contemplate and reflect on its content. Angels, lions, or donors hold up each self-contained scene for the viewer to see. Small rings link the quatrefoil fields of the Francis window,[35] as though they were independent elements joined in a greater whole. Through the merging of these intricate but separately framed units, the unity of the narratives is achieved collectively, image by image. The dominant dynamic that allows the narrative to progress from one episode to another, however, is produced by the figures and creatures outside of the frames which assume a directing function, leading the viewer from one image to another. The dukes, the duchesses, the tree growing from the sleeping Jesse's body in the first panels of their respective windows draw the eye upwards until it is lead by the angels, masks, saints, and lions to the peaks of the lancets.

These observations are reified by the scenes from the lives of the two Franciscan saints where glance, movement, and gesture all direct attention toward the figures in the center of the medallion. In the Clare window,[36] Katharina of Savoy, duchess of Austria, kneels in the lower left corner. Her hands are held up in prayer and her glance is angled upward toward the first scene. The positioning of her body leads the eye of the viewer over both musical angels in the middle of the first register to her similarly kneeling husband, Duke Leopold I. He intercepts the focal direction and by raising his hands toward the tendril that encircles the medallion and, casting his glance upwards, invites the viewer to do likewise. The individuals in the first scene are so arranged that they turn toward the middle and both observe and comment on the conversation between Clare and the bishop of Assisi. The strong verticality accentuated by the palm fronds likewise urges the viewer to raise his glance. On the way to the next image one encounters the angel bearing a crown and then the elegant heavenly denizen who supports the next scene, his arms extended upwards while his gaze engages the viewer. His entire posture and gesture move upward and invite the eye to glide from the first image to the second. An even clearer upward movement comes from the angels inhabiting the left-hand spandrels between the medallions. These strengthen the upward

34 Kurmann-Schwarz, *Königsfelden—Zofingen*, color pl. 62.

35 In the Nicholas window (s V) extensive passages of the lost composition were reconstructed in 1900 based on the Francis window opposite. The motif of the ring is therefore only employed with certainty in the Francis window. In the St. Anne window the images are connected to the borders by loops.

36 Kurmann-Schwarz, *Königsfelden—Zofingen*, color pls. 57–62.

dynamic both through the inward turning of their torsos and their upward looking profiles. These heavenly creatures energetically indicate the direction that the course of the narrative takes.

In the Francis window (fig. 15.2) a similar system exists which draws the eyes of the viewer up and indicates the narrative direction.[37] Here again, one originally would have discovered the kneeling founders first, of whom only Duke Otto is preserved. Like his older brother, Duke Leopold, he grasps the frame of the first image over him. Instead of the angel in the Clare window, rampant lions command the spandrels between the quatrefoil fields. The scenes of the life of St Francis are likewise arranged in the center of medallions, which are ordered in a repetitive system spanning the entire window. The lions, as part of this system, support the images and cast their gaze in different directions compelling the eyes of the viewer to move from bottom to top. This visualization of progressive steps in the unfolding narratives in the lives of both saints does not correspond to the compositions of a century earlier; rather secondary figures, here the lions in the case of the Francis window, give the viewer clear directions.

Aspects of each scene, however, offer the beholder additional assistance. Each scene comprises figures that are not the immediate conveyors of action but are merely observers and commentators. In the first two scenes of the Francis window a cleric and a layman appear in the one and three courtiers of the curate in the other. Franciscans assume the role of observers in three other scenes. Two women and a cleric in the first scene, and two Franciscans and two women in the second scene of the Clare legend appear as commentators, while in the third scene two laymen observe the events in discussion. Kemp's Narrative research has revealed that in examples of other works of art these figures are not simply space fillers, but rather they fulfill a specific function: they give the viewer indications of how the images should be seen.[38] They therefore fulfill a similar task within the individual scenes as the secondary figures do in the exterior framing system. Thus the viewer is informed not only of the course the narrative follows but also is advised to weigh carefully the intent and the deeper meaning of the images.

Hagiographic research has shown that since late Antiquity and the early Middle Ages the compilers of the lives of the sainted confessors had developed narrative models based on a spiritual ascent.[39] In contrast to the *passions* of martyrs, which for the most part illustrate conflicts between an old and a new norm, the lives of the confessors achieve a state of spiritual contemplation through exceptional personality. They realize this goal not so much through virtue but rather through the grace of God. Such an ascent need not always follow in a linear fashion as at Königsfelden, where the brief narratives present themselves to the observers as representative models of Christian lives:

37 Kurmann-Schwarz, *Königsfelden—Zofingen*, color pls. 39–44.
38 Kemp, *Die Räume der Maler*, 33–35, known as *ancillae narrationis*.
39 Charles F. Altman, 'Two Types of Opposition and the Structure of Latin Saints' Lives,' *Medievalia et Humanistica* 6 (1975), 1–11; von der Nahmer, *Heiligenvita*, 72–79.

conversion, entering a monastery, leading a life agreeable to God, achieving salvation. This model addresses a monastic audience consisting for the most part of princes of the church, clerics, brethren or sisters, as indicated by the commentators who appear in the images.

The Nicholas window (fig. 15.3), (insofar as the 1900 reconstruction is accurate) establishes that miracles, worked by God through the saints, serve as the conceptual anchor of the program. The subjects of four of the five scenes are determined solely on the basis of the little that is preserved. Emil Mauer identified the first scene as that of the resurrection of the three students who had been killed and pickled by a criminal landlord.[40] The second scene recounted how St Nicholas acquired a dowry for the three daughters of an impoverished nobleman, thus sparing them from prostitution.[41] This is followed by the episode of the poisoned Mydiacon that Diana gave to a group of pilgrims on their way to the grave of St Nicholas. This concoction was so powerful that it could set stone and water on fire. The fourth image represented the three army commanders wrongly condemned by the emperor Constantine and saved from execution by St Nicholas, who appeared to the emperor in his sleep and informed him of his mistake. The final scene, as in the Clare window, is completely lost. Based on traditions of the pictorial representations of the miracles of St Nicholas,[42] and the surviving scenes at Königsfelden, it can be assumed that the figures in the center of the image were always the ones experiencing the miracles—whether the three were the resurrected students, the virgins, the pilgrims on their ship, or the field commanders. Their place corresponds to those of the heroes and heroines in the Francis and Clare windows. What little has survived from the Nicholas window suggests that, once again, it did not present a chronological narrative, but rather that it presented isolated images of thaumaturgy; the repetition of this type of image reinforced a single meaning.

The subject matter of the St Anne window (fig. 15.2) is of a more complex arrangement in that two Old Testament scenes and a figure appear at the bottom in place of monastic founders. The sleeping Jesse appears in the center with the Drunkenness of Noah at the left and the Creation of Eve on the right. The three panels have suffered considerable restoration since the sixteenth century but enough survives to confirm that they were part of the original ensemble.[43] Represented in the medallions are the Annunciation to Anne and Joachim, the Meeting at the Golden Gate, the Birth of the Virgin, and the Virgin Entering the Temple. The narrative series ends with this latter scene and a strictly iconic group is depicted in the final medallion: the *Anna Selbdritt*. The

40 Emil Mauer, *Das Kloster Königsfelden, Die Kunstdenkmäler des Kantons Aargau* 3 (Basel, 1954), 195.

41 This is the only scene belonging to the life of the saint; all others depict posthumous miracles.

42 On the Nicholas miracles, see Gabriela Dreßler, *Strukturen mittelalterlicher Mirakelerzählungen in Bildern. Ausgewählte Beispiele der französischen Glasmalerei des 13. Jahrhunderts*, (Munich, 1993), 14–80, 123–63.

43 See the restoration charts in Kurmann-Schwarz, *Königsfelden—Zofingen*, 250.

four previous scenes do not present models of exemplary lives such as the model monastic community that appears in the Clare and Francis windows. Rather, they move to the Birth of the Virgin, which like the Anna Selbdritt, is a reference to the Virgin as the mother of Christ and a descendant of the Biblical patriarch Jesse, the father of David. As observers, the brethren, sisters, or other anonymous onlookers would be inadequate; rather early Christian saints, martyrs, and sainted Franciscans were enlisted for this purpose. Thus, SS. Anthony and Louis of Toulouse flank the Meeting at the Golden Gate; St Verena appears as witness to the Birth of the Virgin, as St Martin observes the Virgin Entering the Temple. The final medallion is conceived as a triptych with the Anna Selbdritt flanked by SS. Lawrence and Christopher. Pairs of female saints populate the spandrels between the medallions.[44]

Up to this point most scholars have interpreted the initial Old Testament scenes in the St Anne window as Marian and moralistic,[45] which does not entirely convey the full meaning of the narrative. Recent scholarship, by contrast, has recognized the sleeping patriarch Jesse as a visionary who encounters his prophecy in his dreams.[46] The literary source, the Book of Isaiah (Is.11.1–2) explains the promise but not the form it took. It was up to artists to give the concept visual form. The text mentioning the root rising out of Jesse thus dictated the tall format of the composition. This corresponds to the structure of dreams involving promises such as that of Jacob's ladder, which serves as a model for the appearance of the Tree of Jesse.[47] The designer of the Königsfelden stained glass also followed the vertical format in which the sequence of images, one over another, ends with the Anna Selbdritt with Christ, the flower promised by Jesse, in its middle. Although the visionary keeps his eyes shut, he invites the viewer to participate in his vision.

Wolfgang Kemp and other scholars have stated that it was the outstanding achievement of medieval narrative art to make progressive action accessible, and to indicate how its unfolding history fulfills the Divine revelation.[48] The scenes and other visual markers are meaningfully composed and related to one another. Artists thus give a glimpse into Divine providence, the plan that is fulfilled in the histories of the saints. At Königsfelden the chronological series of the narrative scenes are broken into geometric fields reading from bottom to top. At the same time they are part of the overarching system that admittedly no longer has the compositional complexity of stained glass around 1200, but as we have seen is nonetheless enriched through figural and decorative elements. These devices guide our viewing in order to underscore the meaning of the saints' lives. In the Francis window, the lions are not merely glancing

44 SS. Ursula, Christina, Agatha, Cecilia, Lucia, Otilie, Margaret, and Agnes.

45 For Marian interpretations, see Brigitte Kurmann-Schwarz, *Die Glasmalereien des 15.–18. Jahrhunderts im Berner Münster*, Corpus Vitrearum, Schweiz 4 (Bern, 1998), 209–11; for moralizing interpretations, see Maurer, *Königsfelden—Zofingen*, 212.

46 Steffen Bogen, *Träumen und Erzählen. Selbstreflexion der Bildkunst vor 1300* (Munich, 2001), 235–60.

47 Bogen, *Träumen und Erzählen*, 99–110 (on dreams as promises).

48 Wolfgang Kemp, *Christliche Kunst. Ihre Anfänge. Ihre Strukturen* (Munich, 1994), 21–48.

about but at the same time symbolize Christ,[49] and the white rose refers to the Passion.[50] But the scene of stigmatization, and the overall representational context, allow Francis to be seen as the *alter Christus*.[51] His symbols indicate where the saint's entire life is directed, namely to become a second Christ. The motionless stares of the bearded heads of the Nicholas window,[52] out of whose open mouths tendrils with acanthus leaves emanate, can only be understood as those who see and speak about the images. Here, one of the representatives of the founders of the cloister is Duke Rudolf of Lothringen (otherwise known as Raoul de Lorraine; Raoul is not founder, but since females cannot make gifts to religious institutions without the consent of a male family member, he here represents his mother). Like Duke Otto in the Francis window and Duke Leopold I in the Clare, Raoul grasps the frame, presenting the image to the viewer.[53] Both the heraldic shield and the feet of the donor overlap the window border and thus encroach on the space of the viewer, thereby underscoring the immediacy of the image. Additionally a common red ground connects the donor with the seeing and 'speaking' masks in the spandrels whose gaze provides the viewer direction. The system of imagery opens into real space and is so constructed that a connection with the intended audience was envisioned from the start.[54] The architecture and the stained glass it contains create a vessel that at once constitutes and incorporates the space of the viewer.

In both the Clare and Anne windows, forms within the compositions—such as the feet of the angels—make considerable incursions into the viewers' space.[55] Clare's role as a mediator between this world and the next casts her as a heavenly emissary. Likewise the palm fronds held by the female saints in the Anne window overlap the white fillet and thus emerge from the world of the picture plane. More striking are the half-length angels who reach over the edge of the frame below thus loom into the viewer's space, and, in sequence, hold the frame below. Concerning the ambiguity of image and viewer space in the Old Testament 'marginal narrative' of the Anne window, little can be said since these scenes were practically reconstructed in the restoration of 1896–97.[56]

As we have seen, each narrative unit with each window functions as a self-contained image, but at the same time is embedded with a compositional system at play across all the windows. The stained glass exhibits a surprising similarity with winged retables, the oldest surviving examples of which are

49 On Lions: *Lexikon der christlichen Ikonographie* 3, 1971, 116–17 (lions as Christ and Messiah, by Peter Bloch).

50 Jeffrey F. Hamburger, *Nuns as Artists. The Visual Culture of a Medieval Convent* (Berkeley, 1997), 63–100.

51 Feld, *Franziskus von Assisi*, 256–68.

52 An original field with this motif is preserved (s V, 3c, before 2001 9c; see Kurmann-Schwarz, *Königsfelden—Zofingen*, color pl. 48).

53 Kurmann-Schwarz, *Königsfelden—Zofingen*, color ill. 45, restoration chart, 248.

54 Wolfgang Kemp, 'Kunstwerk und Betrachter: Der rezeptionsästhetische Ansatz,' in *Kunstgeschichte. Eine Einführung*, ed. Hans Belting, Heinrich Dilly, Wolfgang Kemp, Willibald Sauerländer, and Martin Warnke, 6th ed. (Berlin, 2003), 247–65.

55 Kurmann-Schwarz, *Königsfelden—Zofingen*, color pls. 51–62.

56 Restoration chart in Kurmann-Schwarz, *Königsfelden—Zofingen*, 250.

contemporary with the present glazing program.[57] The comparison with retables is all the more compelling because late Gothic stained-glass painting north of the Alps was often directly connected with contemporary altarpiece painting. Individual cycles of panels establish internal references as well as inherent connections to the stained glass in the adjacent and opposite windows.[58] Entering the choir of the former abbey church through the choir screen, the viewer sees in the first bay to his right the life of St Clare and to his left scenes from the lives of the Virgin and her parents. In the apposition of the two windows at Königsfelden, as in the cross vaults of Santa Chiara in Assisi, St Clare takes her place in the realm of the Virgin and the great early Christian martyrs. [59] In the next pair of windows, SS Francis and Nicholas face each other. Here the relatively young saint is shown beside the most powerful intercessor and helpers.[60] The lives of both saints are thereby anchored into a tradition of particular veneration; these stained-glass windows were not only to be seen across the choir, but also as pairs. The proximity of St Nicholas underscored Clare's role as a helper and intercessor, a role illustrated by the only miracle in her cycle. Finally, as *alter Christus*, Francis appears next to the window with the history of the Virgin's parents.[61] Noah and Eve as Old Testament figures typologically foreshadow Christ and Mary. These observations indicate that the glass painters were aware of contemporary pictorial developments and exploited them, but that they relegated to figures in the framing structure certain tasks that the image would later take on, also north of the Alps. The various modes, narrative exposition and strategic placement (*Erzählung und Disposition*),[62] thus do not appear at Königsfelden separated in the image or the framing structure. Rather, components of both modes inform the overall composition as well as the image. This concluding remark affords us the opportunity to invoke the words of Madeline Caviness: '… the modes of seeing … are in fact seldom isolated in art.'[63]

57 Nobert Wolf, *Deutsche Schnitzretabel des 14. Jahrhunderts* (Berlin, 2002).

58 Hilmar Frank and Tanja Frank, 'Zur Erzählforschung in der Kunstwissenschaft,' in *Die erzählerische Dimension: eine Gemeinsamkeit der Künste*, ed. Eberhard Lämmert (Berlin, 1999), 35–51, esp. 41–42.

59 Jeryldene Wood, 'Perceptions of Holiness in Thirteenth-Century Italy: Clare of Assisi,' *Art History* 14 (1991): 301–28, esp. 318.

60 On several occasions the new saint, Francis, is placed in the company of major saints, in particular the apostles. See Dieter Blume, *Wandmalerei als Ordenspropaganda. Bildprogramme im Chorbereich franziskanischer Konvente Italiens bis zur Mitte des 14. Jahrhunderts* (Worms, 1983), 22–28.

61 In the Lateran basilica, he generally appears in the side of the Virgin. See Blume, *Wandmalerei als Ordenspropaganda*, Fig. 234.

62 Kemp, *Christliche Kunst*, 21–48.

63 Caviness, 'Images of Divine Order,' 115.

Modes of Seeing Margaret of Antioch at Fornovo di Taro

Elizabeth C. Parker

In the relief of the life of St Margaret of Antioch carved around 1200 for the church of Santa Maria Assunta at Fornovo di Taro (fig. 16.1), some twenty-two kilometers northwest of Parma, the most arresting image is surely the one of Margaret, nude, being tortured in a crucified pose.[1] What did this relief mean to contemporary travelers to the now sleepy town of Fornovo di Taro, then an important stop on the Via Francigena, the pilgrimage road through northern Italy from France to Rome? Although his documentation is sketchy, Italo Dall'Aglio claimed that Santa Margherita's name was added for a time to the title of the church of Santa Maria Assunta at Fornovo, after it had acquired her relics. An altar dedicated to her stood beneath an 'ambo' that still existed in 1579.[2] More famous were the translations of her relics from Antioch to San Pietro della Valle in 908, and then to the cathedral at Montefiascone in 1145.[3] Today, the Margaret relief serves as an altar frontal at Fornovo, as was the case in 1831 before its removal to the north wall of the narthex.[4]

[1] See most recently, Dorothy F. Glass, 'Saint Margaret of Antioch at Fornovo di Taro,' in *Medioevo: immagine e racconto: Atti del convegno internazionale di studi, Parma, 27–30 settembre 2000*, ed. Arturo Carlo Quintavalle (Milan, 2003), 334–39. I am indebted to Dorothy F. Glass for her generous help on this study.

[2] Italo Dall'Aglio, *La diocesi di Parma*, 2 vols (Parma, 1966), 1:497–8; Valeria Moratti, 'La Pieve di Santa Maria Assunta a Fornovo di Taro,' in *Medioevo i modelli: Atti del convegno internazionale di studi, 27 settembre-1 ottobre 1999*, ed. Arturo Carlo Quintavalle, I convegni di Parma 2 (Milan, 2002), 555–66, esp. 556. For a reference to the altar in 1258, see Francesco Barocelli, 'La Stele Devozionale di Santa Margherita d'Antiochia nella pieve di Fornovo: Un'Ipotesi di lettura iconologica,' *Parma nell'arte*, 12 (1980), 7–30; 13 (1981), 29–67, esp. 12:13, n. 9.

[3] Maria Chiara Celletti and Joseph-Marie Sauget, 'Marina (Margherita),' in *Bibliotheca Sanctorum*, 9 vols (Rome, 1967), 8: col. 1155. For a particularly full account of these translations in the fifteenth century, see 'The Life of St. Margaret Virgin and Martyr,' in *A Legend of Holy Women, a Translation of Osbern Bokenham's Legends of Holy Women*, trans. and ed. Sheila Delany (Notre Dame, 1992), 19–27. For the spread of vernacular versions of her story in the West after the conquest of Constantinople in 1204, see Wace, *La Vie de sainte Margherite*, ed. Hans-Erich Keller; Commentary on the illuminations of MS Troyes [Bibliothèque municipale] 1905 by Margaret Alison Stones, *Beiheft zur Zeitschrift für Romanische Philologie* 229 (Tübingen, 1990), 10–12.

[4] Arthur Kingsley Porter, *Lombard Architecture*, 4 vols (New Haven, 1915–17), 2:429; Lorenzo Molozzi, *Vocabolario topografico dei ducati di Parma, Piacenza e Guastalla* (Parma, 1832–34), 146.

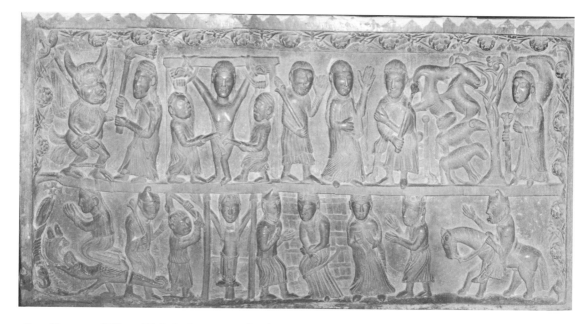

16.1 Fornovo di Taro, S Maria Assunta, Life of St Margaret, ca. 1200.

The St Margaret panel measures 1.83 meters in width and .98 meters in height. It is linked to two contemporaneous reliefs of about the same size from the nearby church of Santa Maria Assunta at Bardone (eight kilometers southwest of Fornovo), which like Fornovo di Taro was part of the diocese of Parma and also an important stop on the Via Francigena. The Bardone panels depict a Christ in Majesty with a Coronation of the Virgin (fig. 16.2) and a Deposition of Christ with the Expulsion of Adam and Eve (fig. 16.3), which derives from Benedetto Antelami's Deposition, for the Cathedral of Santa Maria Assunta at Parma, dated by inscription to 1178.[5] The Expulsion of Adam and Eve together with their Temptation appear on a narthex capital at Fornovo (fig. 16.4). [6] All three sculpted reliefs share the rosette border with Antelami's Deposition, as do several smaller fragments, including a hell scene embedded in the facade of the church at Fornovo (fig. 16.5). Although the original disposition of these elements can only be imagined, they all date to

[5] Arturo Carlo Quintavalle, *Benedetto Antelami*, ed. Arturo Calzona and Giuseppa Z. Zanichelli (Milan, 1990), Fig. 1 and pl. 16. The Expulsion in the Bardone Deposition relief reflects the subject of one of the column capitals for the cathedral attributed to Antelami (pl. 18b). For a damaged fragment of a Christ in Majesty, now also in the Galleria Nazionale in Parma, see pl. 17. The measurements of the Bardone Christ in Majesty are 2.01 × .95 meters, and the Deposition 1.56 × .92 meters.

[6] For Genesis scenes also paired with the life of St Margaret in the only monumental depiction of her life earlier than the Fornovo relief, the nave fresco cycle of 1007, see Giulio R. Ansaldi, *Gli Affreschi della Basilica di S. Vincenzo a Galliano* (Milan, 1949), 48–49.

16.2 Bardone, S Maria Assunta, Christ in Majesty with Coronation of the Virgin, ca. 1200.

around 1200, when the narthex of the church at Fornovo was extended.[7] For the most part, art historians who have their eye on Parma and the master works of Antelami tend to dismiss the Fornovo reliefs, like those at Bardone, as mere stylistic country cousins of their more famous precursor. But, for both their novelty and complexity, the striking depictions of the passion of St Margaret of Antioch at Fornovo di Taro deserve a closer look. In order to appreciate the different levels on which these images may be understood, I begin this analysis by using as a framework the 'modes of seeing' of Richard of Saint-Victor that Madeline Caviness discussed.[8]

7 For the relief as part of a choir enclosure, see Arturo Carlo Quintavalle, 'Una recinzione presbiteriale a Fornovo,' in *Romanico padano, civiltà d'Occidente* (Florence, 1969), 173–83; idem, *La Strada Romea* ([Milan], ca. 1974), 108–17, 172–73, and 193–97. For a review of the questions concerning the building campaign ca. 1200, see Moratti, 'La Pieve di Santa Maria Assunta,' 565 n 18.

8 Madeline H. Caviness, 'Images of Divine Order and the Third Mode of Seeing,' *Gesta* 10 (1991), 99–120.

16.3 Bardone, S Maria Assunta, Deposition of Christ with Expulsion of Adam and Eve, ca. 1200.

The First Mode of Seeing

Richard's first mode corresponds to the depicted narrative. Right away the complexity begins. In 1916, Arthur Kingsley Porter recognized that scenes from the life of St Margaret at Fornovo come closest to the earliest preserved Latin account, with episodes drawn from the ninth-century Greek text.[9] But there are interesting deviations, as we shall see, not least the omission of the end of her story—in which she is burned with torches, thrown bound into a vat of cold water, and finally beheaded. Furthermore, the format itself is very unusual in Romanesque Italy in two important respects. Not only are the scenes all disposed in two registers, but the narrative unfolds 'backwards,' moving from

9 Porter, *Lombard Architecture*, 2:27–33. For the tenth-century Latin text, Boninus Mombritius, *Sanctuarium seu Vitae Sanctorum* (Paris, 1910), 2:190–96. For a critical edition and translation of the Mombritius text, see Mary Clayton and Hugh Magennis, *The Old English Lives of St Margaret*, Cambridge Studies in Anglo-Saxon England 9 (Cambridge, 1994), 191–223. For the ninth-century Greek text, Hermann Usener, *Acta S. Marinae et S. Christophori* (Bonn, 1886), 15–47. For the Marina cycle based on the *Passio a Theotimo* from a lost eighth-century Greek version, see Brigitte Cazelles, *The Lady as Saint: A Collection of French Hagiographic Romances of the Thirteenth Century* (Philadelphia, 1991), 216.

16.4 Fornovo di Taro, S Maria Assunta, Temptation and Expulsion of Adam and Eve, narthex capital, ca. 1200.

right to left and up and down, in what Dorothy Glass has identified as the form of a 'loose boustrophedon.'[10]

The story thus begins in the upper right hand corner (fig. 16.1), where the fifteen-year-old Margaret, alone (unaccompanied by other girls as in the text) is tending a flock of sheep and goats (there are no goats in the text).[11] In the register just below, the Roman prefect Olibrius sits on horseback, wearing a Phrygian cap—an orientalism to mark his Eastern origin. Having seen Margaret as he was traveling to Antioch 'to persecute Christians,' Olibrius wanted her as a wife or concubine (197). The next scene below shows her facing forward holding a book with her hand upraised, motionless before the entreaties of Olibrius now imperially crowned, who questions her as to her social status and

[10] For the rarity of the two-register format, see Glass, 'Saint Margaret of Antioch,' 339 n 4; for the boustrophedonic reading, 337.

[11] Margaret, the rejected daughter of the pagan priest Theodosius, was raised outside of Antioch as a devoted Christian by her 'fostermother' (195), whose servant she became at the death of her own mother. The quotes from the Latin *passio* are taken from the translation in Clayton and Magennis, *Old English Lives of St Margaret* (page numbers in the text). For extensive details of this relief, see Quintavalle, *La strada romea*, 82–89, Figs. 128, 129–37, and 140.

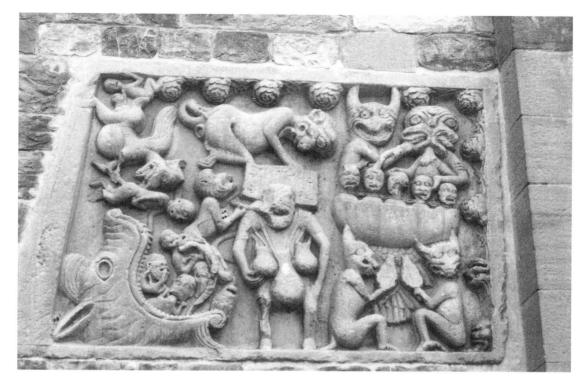

16.5 Fornovo di Taro, S Maria Assunta, Hell scene relief in facade, ca. 1200.

her faith. Just to the left on the lower register she is shown, hands bound and tied to a grille, before Olibrius who imprisoned her 'until he might discover by what device he could destroy her chastity'(199). Diagonally above, Margaret, with her left arm raised in a gesture of speech, responds to Olibrius, who, seated 'in the official place of justice,' wants her to 'give in' to him and worship his gods (199). The sword of justice in his right hand crosses his left arm to suggest a negative response to Margaret's defense.[12] The figure behind Margaret, who echoes her gesture with his left hand and holds what looks like a scepter, may be Theotimus, the learned Christian, eye-witness to her passion, who carried her relics to Antioch and told her story (195 and 217). Diagonally below, a male flays Margaret, who is stripped to the waist with her feet bound to a rack and her arms extended upwards, in compliance with Olibrius's order that she be 'suspended in the air' and beaten (201). Olibrius, again wearing a Phrygian hat and carrying a staff, is seen behind the figure with the flail (canes in the text). Directly above, Margaret, again fully frontal, is now completely nude with only

[12] Madeline H. Caviness and Charles G. Nelson, 'Silent Witnesses, Absent Women, and the Law Courts in Medieval Germany,' in *Fama: The Politics of Talk and Reputation in Medieval Europe*, ed. Thelma Fenster and Daniel Lord Smail (Ithaca, NY, 2003), 67 and Fig.13.

her braids to cover her pubic area. Two males pull at the ropes by which she is suspended as they tear at her flesh with metal hooks (rods in the text).[13] The final two scenes of this relief depict Margaret's triumph over the devil. In the lower left, Margaret is first shown being swallowed by the dragon which entered her prison cell—only her skirt and feet are visible. Then in profile she kneels in prayer on the dragon's back before a Greek cross held by a large hand in the far left, an allusion to her means of escape. The final scene in the upper left shows a hideous nude devil, with upside down wings, horns and a tail, and 'his hands fastened to his knees' (207: described only as a 'black man'). Margaret attacks him with what looks like a flail with a serpent's head (not in the Latin; a hammer in the Greek text).[14]

There have been other readings of the characters and the sequence of this story.[15] The identity of Olibrius has proved especially confusing because of the diverse headgear worn by a man with the same curly beard. But this, like the decision to omit the ending of Margaret's story, implies a conscious choice that points to layered meanings of the work. The repetition and reversal in pose between Margaret, bound and imprisoned before Olibrius in the center of the lower register, and with the devil in chains in the upper left corner allow the possibility for Olibrius to represent the devil in various guises. The way the dragon's tail extends across Olibrius's legs and then wraps around those of the torturer is further evidence of his complicity with the devil (fig. 16.1, lower left). In the *passio*, Margaret flatly tells him that he performs 'the works of Satan' (201).

Stylistic anomalies also tend to complicate an initial reading. A deceptively naive figure style features overly large heads with big eyes, hands like semaphores, and legs that bend along with drapery pleats to convey motion. The counter-swing of her skirt reveals the tense nature of Margaret's encounters with her various tormenters (fig. 16.1, lower and upper center). Yet, subtle stylistic shifts punctuate the narrative flow with iconic stasis, which signals the coexistence of the two different modes of visual discourse that Madeline Caviness discussed in another important article.[16] This coexistence is most pronounced on the lower left side of the relief, where the viewer's eye might look for the beginning of the narrative but instead finds its climax arrested by Margaret's serenely kneeling profile and her strict frontality in the double image of her torture.

[13] Details of the torture come from the martyrology of Rabanus Maurus of 845: 'in eculeo suspensum ingulis aceruissimis', Keller, ed., *La Vie de sainte Margherite*, 8.

[14] Lois Drewer, 'Margaret of Antioch the Demon-Slayer, East and West: The Iconography of the Predella of the Boston *Mystic Marriage of St. Catherine*,' *Gesta* 32 (1993), 11–20.

[15] Porter, *Lombard Architecture*, 2:429–33; Barocelli, 'La Stele Devozionale,' 12:10–11; Glass, 'Saint Margaret,' 334–37.

[16] Madeline Caviness, '"The Simple Perception of Matter" and the Representation of Narrative, ca. 1180–1280,' *Gesta* 30 (1991), 48–64.

The Second Mode of Seeing

These representational devices point to the second, allegorical, mode of seeing, in which the passion of St Margaret can be read as a potent example of an *imitatio Christi*. In the venerable tradition of all Christian martyrs, Margaret's words verify this reading: 'Christ committed himself to death for us, and I do not hesitate to die for him' (199). Monastic in origin, the Latin passio is laced with biblical references that seem to have a visual parallel in the Fornovo relief. Scriptural passages in her prayer when she first sees Olibrius announce the theme of hostility and danger: 'I see myself as a sheep in the midst of wolves … I am caught like a she-goat in a snare … Do not abandon me into the hands of the wicked' (197).[17] The liturgy of Holy Week allows Christ's passion to resonate through hers. After her first torture, Margaret's defiance of Olibrius is drawn from the psalm which foreshadows Christ's passion and begins the Good Friday liturgy: 'Christ will rescue my soul out of your hands' [Ps. 21.21] (201–02). The passion of Christ, the Good Friday Gospel of John 18–19, is mirrored in the depictions of Margaret's arrest, her imprisonment, her appearance before a judge, and her scourgings. Her final triumphant claim: 'Behold, I have defeated the world' (217), is Christ's assertion in John 6.33. The dragon's devouring of Margaret extends her imitation of Christ through his Old Testament antetype (fig. 16.1, lower left). Christ himself compared his passion to Jonah's descent into the belly of the whale (Mt 12.40); it is an allegory of Christ's descent into hell, which is the theme of Holy Saturday Matins.[18] Margaret's triumph over the dragon by means of the cross is analogous to Christ's triumph over the devil by his sacrifice on the cross.[19]

An equally important theme in this mode of seeing is as an *imitatio Mariae*. Like all virgin martyrs, Margaret follows the chaste example of the Virgin. She asserts: 'I will commit my body to my Lord Jesus Christ, so that I may receive the heavenly crown with the just virgins' (199). But the equation of the status of Margaret with that of the Virgin is also implicit in the Fornovo relief. Her pose in the lower register when she first confronts Olibrius is that of the Annunciate Virgin (fig. 16.1, lower right). The Virgin's reply to Gabriel (Lk 1.38) is reflected in hers to the devil in the final scene (fig. 16.1, upper left), when in the passio she says: 'I am a handmaid of the Lord' (207). 'Blessed are you among women' (Lk 1.28) is the heavenly dove's pronouncement to Margaret just before her execution (215).

It is possible to see the link between Margaret and the Virgin spelled out in the relief from the church at Bardone, where the Coronation of the Virgin is incorporated into an image of Christ in Majesty (fig. 16.2). The angel in the upper right is handing a crown to Christ, which is destined for the Virgin bowing in prayer beneath his right hand extended in blessing. The candles and censers

[17] Clayton and Magennis, *Old English Lives*, 220 n 18, 21, and 24.

[18] O. B. Hardison, Jr., *Christian Rite and Christian Drama in the Middle Ages* (Baltimore, 1965), 83 and 95.

[19] For the power of the cross, see Valerie I. J. Flint, *The Rise of Magic in Early Medieval Europe* (Princeton, 1991), 173–84.

other angels hold may well signal the association of the Coronation of the Virgin by Christ in Heaven with the liturgical celebration of the Feast of the Assumption of the Virgin on August 15, particularly inasmuch as this church, like Fornovo, was dedicated to the Virgin as Santa Maria Assunta. The physical as well as the spiritual reality of the Virgin's Assumption into Heaven were matters of some importance in twelfth-century Rome.[20] Astute observers might see in Mary's profile pose a near reversal of Margaret's kneeling in prayer on the dragon's back (fig. 16.1, lower left), and that Mary here wears the braids distinctive to Margaret in the Fornovo relief.[21] If so, these modest visual links might assure her devotees that Margaret shares the Virgin's intercessory powers. Not only did she, too, in the tradition of virgin martyrs receive the 'crown of life' (213), but her passio states that angels carried her body to heaven (217).

Seen together with the shamefully nude Eve in the Expulsion scene to Christ's left in the Deposition relief at Bardone, the humbly praying Virgin on Christ's right takes on the added meaning of the New Eve who redeems the Old (figs. 16.2 and 16.3). At Fornovo, Margaret as the allegorical surrogate for the Virgin as the New Eve, is implicit in the themes of the Temptation and Expulsion on the narthex capital (fig. 16.4).[22] The inclusion of the Expulsion at both Fornovo and Bardone relates to its crucial sacramental meaning for the penitent pilgrim: Adam's Expulsion from Paradise and its consequences for the believer is central to the Ash Wednesday liturgy, when the Genesis story is read, after which penitents are excluded from the church. They are only readmitted following their reconciliation by the bishop on Holy Thursday.[23]

The Third Mode of Seeing

Despite the assertions of a historical context for the life of St Margaret (Marina in Greek) in the early fourth century, and her widespread adoption as a saint in the Western Church by the ninth, her feast day on July 20 was deleted from the official Church calendar in 1969: devotion to her is now optional.[24] She

[20] Marie-Louise Thérel, *Le Triomphe de la Vièrge-Église* (Paris, 1984), esp. 73–95 and 229–40. William Tronzo, 'Apse Decoration, The Liturgy and the Perception of Art in Medieval Rome: S. Maria in Trastevere and S. Maria Maggiore,' in *Italian Church Decoration of the Middle Ages and Early Renaissance*, Villa Spelman Colloquia, vol. 1 (Bologna, 1989), 167–93.

[21] For a detail of the Virgin, see Quintavalle, *La strada romea*, Fig. 161. She does not wear the braids in the Bardone Deposition (Fig. 3), but see Quintavalle's Fig. 150 for the separate female figure (Margaret?) supporting a holy water basin at Bardone.

[22] For a similar juxtaposition at San Vincenzo at Galliano, see Ansaldi, *Gli Afreschi*, where the Genesis story is in the upper register, that of Margaret in the lowest. For an illustration, watercolors by Carlo Anoni made in 1835, see Glass, 'Saint Margaret of Antioch,' Fig. 3. The link with the Virgin as the New Eve is established in Margaret's final encounter with the devil (fig. 16.1, above left). In the passio, she 'seized him by the hair and smashed him to the ground … [placing] her right foot on his neck,' (207) recalling God's words to the serpent in Gen. 3.25: the woman shall 'crush thy head, and thou shalt lie in wait for her heel.'

[23] *Dictionnaire de Théologie catholique*, ed. E. Amann, 16 vols, (Paris, 1933), 12.1:904.

[24] Wendy R. Larson, 'The role of patronage and audience in the cults of Sts Margaret and Marina of Antioch,' in *Gender and Holiness: Men, Women and Saints in Late Medieval Europe*, ed.

would seem to have succumbed to the distinction between historical 'truth' and hagiographic 'legend' that began to emerge with the rise of scholasticism in the twelfth-century schools. If we can set aside this enduring construct that did not exist at the time that Margaret's story was written,[25] it is easier to recognize a third, tropological, mode of seeing even if it opens up para-liturgical realms of popular piety that may well be more than Richard of Saint-Victor had in mind.[26]

The first clue to such a hermeneutic is the change of name from Marina in the Greek to the Latin *Margarita*, meaning pearl.[27] According to Jacobus de Voragine in *The Golden Legend* of around 1260, like the pearl, Margaret is 'shining white by her virginity, small by humility, and powerful in the performance of miracles. The power of the pearl is said to work against the effusion of blood and against the passions of the heart, and to effect the strengthening of the spirit.'[28] The pearl was thought to be produced when the shell of the oyster opens to receive dew, a phenomenon which can explain her association with the Virgin, whom St Bernard characterized as '*margarita pretiosa*, mystically fertilized by the heavenly moisture.'[29] William Heckscher tracks the association of the Virgin with dew into popular piety, which turned to the Virgin Mary in times of drought. A failed rain procession in Belgium in the thirteenth century, for example, was blamed on the clergy's omission of Mary's name in the invocation of saints.[30] The characteristics of the pearl are

Samantha J. E. Riches and Sarah Salih (London, 2002), 32. For a useful summary of Margaret's cult in the West, see Keller, ed. *La Vie de sainte Margherite*, 6–10; Leanne Gilbertson, 'The Vanni Altarpiece and the Relic Cult of Saint Margaret: Considering a Female Audience,' in *Decorations for the Holy Dead: Visual Embellishments on Tombs and Shrines of Saints*, ed. Stephen Lamia and Elizabeth Valdez del Alamo, International Medieval Research 8: Art History Subseries 1 (Turnhout, 2002), 179–90. For Marina's feast day in the Eastern Church on August 16, see Jaroslav Folda, 'The Saint Marina Icon: *Maniera Cypria, Linqua Franca*, or Crusader Art?' in *Four Icons in the Menil Collection*, Menil Collection Monographs 1, ed. Bertrand Davezac (Houston, 1992), 107. Prosper Gueranger, *The Liturgical Year*, 15 vols (Westminster, Md., 1949), 13:154.

[25] Felice Lifshitz, 'Beyond Positivism and Genre: "Hagiographical" Texts as Historical Narrative,' *Viator* 25 (1994), 95–113.

[26] Caviness, 'Images of Divine Order,' 20–21.

[27] For a comparison of the two cults, see Celletti and Sauget, 'Marina (Margherita),' 8:col.1150–56; Larson, 'The role of patronage and audience,' 23–35. For the elision of other Eastern saints with Marina, especially Pelagia of Tarsus (nicknamed 'Margarito'), see Hippolyte Delahaye, *The Legends of the Saints*, trans. Donald Attwater (Dublin, 1998), 151–52. He also (154–55) discusses Pelagia as a transformation of Aphrodite, goddess of the sea, whose symbol was also the pearl; Diane Apostolos-Cappadona, *Encyclopedia of Women in Religious Art* (New York, 1996), 387. Marguerite, the daisy, symbolizes 'the suffering and death of Christian martyrs, and in Western Christian art has come to be associated with pearls and drops of blood' (256).

[28] Jacobus de Voragine, *The Golden Legend*, trans. William Granger Ryan, 2 vols (Princeton, 1993), 1:368.

[29] Cited by William S. Heckscher, 'Is Grete's Name Really So Bad?' in *Art and Literature: Studies in Relationship*, Saecula Spiritualia 17, ed. Egon Verheyen (Durham, N.C., 1985), 58. See 59 n 9, where Petrus de Mora (thirteenth century), equates 'the heavenly moisture' with Christ.

[30] Heckscher, 'Is Grete's Name,' 59, thus making her, as he puts it, 'dangerously close to the earth goddess Ceres.' He also cites (60) a practice condemned by the Church where a

qualities Margaret shares with the Virgin:[31] chief among them is her chastity, her 'pearl' (197).

Margaret is equally bound to Christ in the tropological or moral mode. In the Latin *Physiologus*, the oyster at the bottom of the sea is associated with the Virgin's womb and Christ is the pearl, thus linking Margaret to Christ.[32] A similar linkage occurs in the Bestiary accounts of the encounter of the Hydrus with the crocodile, which offers insight into the way in which Margaret's encounter with the dragon moves beyond the allegory of Jonah and the whale to be the direct analog of Christ's Descent into Hell:

... when [the Hydrus] sees a crocodile sleeping on the shore with its mouth open, it dashes off and rolls itself in the mud. By means of the slippery mud it is easily able to slide down the crocodile's throat. The crocodile then, suddenly waking up, gulps it down, and the Hydrus, splitting all the crocodile's guts into two parts, not only remains alive but comes out safely at the other end.

Thus is the crocodile symbolical of Death and Hell, whose hydrus-enemy is our Lord Jesus Christ. For it was he who, assuming human flesh, descended into hell and breaking asunder all its internal arrangements ...[33]

Margaret's escape by means of a cross she had made, which 'grew in the mouth of the dragon and split it into two parts' (205–7), extends her total imitation of Christ beyond the suffering of her physical passion common to martyrs.[34]

The primary meaning of the dragon is as an incarnation of the devil. Dragons, huge winged serpents living in water, were pestilential and horrible.[35] Trouble-making as they were in human affairs, dragons, among other manifestations of the devil in the early medieval period, were understood to exist with 'divine permission.'[36] The conquest of the devil could only be achieved by Christ's

young virgin was substituted for the Virgin Mary in a 'forbidden rain-ceremony in the diocese of Worms in the second decade of the eleventh century.' In it, a *virgo* is stripped naked and leads a group of girls in a ritual performed by a river in an effort to obtain rain.

[31] Apostolos-Cappadona, *Encyclopedia of Women*, 289. For the association of Marina with the Virgin, see Celletti and Sauget, 'Marina (Margherita),' 8:col. 1153. That her body rested in the Church of the Virgin Mary 'bahhàrah', 'that is Marina, del mare' in Constantinople is seen as the source of the etymology of her Greek name. For the pearl: Louis Réau, *Iconograpie de l'art chrétien*, 3 vols (Paris, 1958), 3.2:880.

[32] Jean-Pierre Albert, 'La Legende de Sainte Marguerite: Un mythe maieutique?' *Razo. Cahiers du centre d'études médiévales de Nice* (1988): 22 and 24.

[33] T. H. White, ed. and trans., *The Bestiary: A Book of Beasts: A Translation from a Latin Bestiary of the Twelfth Century* (New York, 1960), 179–80.

[34] Albert, 'La Legende de Sainte Marguerite,' 24: 'it is thus a virtual descent into hell.' For the elision of the Descent into Hell represented by a hell mouth with the Jonah story, see Réau, *Iconographie*, 3.2:878.

[35] Henri Leclercq, ' Dragon,' in Fernand Cabrol, *Dictionnaire d'Archéologie chrétienne et de liturgie* (Paris, 1921), 4.2: cols. 1537–40. See also Flint, *The Rise of Magic*, 146–57. Dragons also encompassed physical predators, such as raptors, snakes, and felines, to whom women, especially pregnant women, were particularly vulnerable: Stephen Morris, 'Dragons in *The Golden Legend*: The Lives of Saint George and Saint Margaret,' *The History Review* 13 (2002): 22–29.

[36] Flint, *The Rise of Magic*, 153.

sacrifice on the cross.[37] For this reason, the sign of the cross became a potent force against demonic spirits, beginning with the writings of Lactantius in the early fourth century,[38] perhaps not coincidentally at the same time that Margaret's story unfolds. Margaret continues to vanquish the dragon with the sign of the cross in many Western texts, including *The Golden Legend*.[39] At Fornovo, Margaret kneels before a Greek cross beneath which is a crouching mini-devil, thus aligning her triumph over demons directly with that of Christ (fig. 16.1, far lower left).

At Fornovo, the scaly winged dragon's defeat is indicated by its severed tail, a fate suggestive of the Minor Rogations, processions of fasting and prayer for the harvest in the week before Ascension Day since the late twelfth century. In Siena and Verona, on the first two days, a dragon with an erect tail stuffed with straw leads the procession; on the third, submissive and ashamed, tail down and deflated, he follows behind.[40] The dragon's role seems to be an embellishment of processions that transpired in the three days before the Ascension, as reported in the mid-tenth century *Ordo Romanus L*.[41] It is thus likely, even without direct evidence from elsewhere in Italy, that this frankly sexual allusion would not be lost on those making the pilgrimage to Fornovo.[42] They were certainly familiar with the Church requirement of abstinence at the forty days 'three Lents'—before Easter, Christmas, and Pentecost, and at other penitential times, including while on a pilgrimage.[43]

The tail, the dragon's greatest weapon, places it as the agent of sexual temptation and central to the theme of Margaret's chastity.[44] Although she is able to endure Olibrius' brutal tortures through her commitment to Christ as his bride (207), her ultimate test of sexual temptation is the dragon that

[37] Flint, *The Rise of Magic*, 174–78. Flint cites (174) Saint Athanasius, *De Incarnatione* 26.

[38] *Lactantius: Divine Institutes*, trans. and intro. Anthony Bowen and Peter Garnsey (Liverpool, 2003), 4.27; 'Exorcism,' *New Catholic Encyclopedia*, 2nd ed. (Washington, D.C., 2003) 5:551–53.

[39] Voragine, 'The Golden Legend', 1:369. In the passio, she, too, makes the sign of the cross to dispatch the successor of Beelzebub, after he describes its effectiveness for all who use it against his demonic powers (209).

[40] Augustine Thompson, *Cities of God: The Religion of the Italian Communes 1125–1325* (University Park, PA, 2005), 153. My thanks to Professor Dorothy Glass for this reference. For France, see Marie-France Gueusquin, *Les Mois des Dragons* (Paris, 1981), 79–81 and André Vauchez, *The Laity in the Middle Ages: Religious Beliefs and Devotional Practices*, ed. Daniel Bornstein, trans. Margery J. Schneider (Notre Dame, 1993), 134–39. For similar processions in England, see Eamon Duffy, *The Stripping of the Altars: Traditional Religion in England 1400–1580* (New Haven, 1992), 279.

[41] Vauchez, *Laity in the Middle Ages*, 134; Michel Andrieu, 'Ordo Romanus L,' in *Les Ordines Romani du haut moyen âge*, vol. 5, *Les textes*, Spicilegium Sacrum Lovaniense, Études et documents 29 (Louvain, 1961), 317.

[42] See Barocelli, 'Le Stele Devozionale,' 13:46–52, for the idea that veneration of St Margaret at Fornovo taps into pre-Christian cult traditions, which associate water, fertility, and prosperity, thereby adhering to a pattern observable in other sites where Margaret was worshiped.

[43] James A. Brundage, *Law, Sex and Christian Society in Medieval Europe* (Chicago, 1987), 198–99.

[44] LeClerq, 'Dragon,' col. 2459.

swallowed her innately sinful female body. Margaret's deliverance unscathed from the belly of the dragon is an image of conquest over her corporeality.[45] It is thus not only a representation of the physical birth process, including that of Christ from the Virgin's womb.[46] It also allows a final understanding of the scene on the fourth, anagogical, mode of seeing, 'an ascent or elevation of the mind for supernatural contemplation.'[47] Margaret in prayer on the back of the dragon is an image of her spiritual birth.

While Jacobus de Voragine is the first to dismiss the dragon as 'apocryphal and not to be taken seriously,'[48] it is her escape from it that gave Margaret the power to protect women at childbirth, at this most dangerous time of a woman's life when she did not have access to a church.[49] In the passio, for those who build a basilica in her name or furnish a manuscript of her passion, Margaret had promised to pray that 'in his home let there not be born an infant lame or blind or dumb' (215). But Margaret's prayer in *The Golden Legend* is for the first time specifically addressed to all mothers: 'she asked in especial that whenever a woman in labour should call upon her name, the child might be brought forth without harm.'[50] In making this change, Jacobus de Voragine seems to be acknowledging existing practices at childbirth: the reading of her life by midwives, or the placing of the book itself on the belly of the pregnant woman.[51] Just when a similar use of Margaret's belt (an elision with that of the Virgin) became a third option is not clear,[52] but the book that Margaret holds in her first encounter with Olibrius is suggestive of its use in her cult when the relief at Fornovo was carved (fig. 16.1, above).

45 Elizabeth Robertson, 'The Corporeality of Female Sanctity in *The Life of Saint Margaret*,' in *Images of Sainthood in Medieval Europe*, ed. Renate Blumenfeld-Kosinski and Timea Szell (Ithaca, N.Y. 1991), 268–87. For 'the conception of the spiritual woman recast as a man,' see Martha Easton, 'Pain, Torture and Death in the Huntington Library *Legenda Aurea*,' in *Gender and Holiness* (as in n. 24), 51–52. Although she is depicted as making a 'masculine' attack on the son of Satan (fig. 16.1, above), in the passio it is clear from the devil's lament of his defeat 'by an insignificant girl' (203) that she maintains her feminine gender.

46 Albert, 'La Legende de Sainte Marguerite,' 25.

47 Caviness, 'Images of Divine Order,' 21, citing Richard of Saint-Victor on the Apocalypse of St John (PL 196:col. 687).

48 Voragine, 'The Golden Legend', 1:369.

49 Brundage, *Law, Sex and Christian Society*, 156: following any contact with a pregnant woman, a cleric must fast for forty days.

50 Voragine, 'The Golden Legend', 354.

51 Réau, *Iconographie*, 3.2:879; Albert, 'La Legende,' 25–29. See also Renate Blumenfeld-Kosinski, *Not of Woman Born: Representations of Caesarean Birth in Medieval and Renaissance Culture* (Ithaca, N.Y., 1990), 7–9.

52 Réau, *Iconographie*, 3.2:879 (four relics of her belt); Jacqueline Marie Musacchio, *The Art and Ritual of Childbirth in Renaissance Italy* (New Haven, 1999), 142–44; Gilbertson, 'The Vanni Altarpiece,' 180, for *vitae* where she used her belt to lead the dragon. This detail seems to be borrowed from the life of St George: *Golden Legend*, 232–38. Margaret's belt can also be seen in relation to that of the Virgin, also used to protect women in childbirth. See Brendan Cassidy, 'A Relic, Some Pictures and the Mothers of Florence in the Late Fourteenth Century,' *Gesta* 30 (1991): 91–99.

The 'Short Side of the Triangle'

Much of the recent scholarship on Margaret is devoted to images and texts of the late Middle Ages created, like the earlier ones, by men but addressed to nuns as a model for chastity and to married women for their protection at childbirth. As depicted at Fornovo di Taro, however, Margaret's life possesses particular messages for male travelers of the Via Francigena. A further focus on the contemporary social context is thus offered as fodder for the 'short side of the triangle' that Madeline Caviness describes in her recent model for getting at ideological underpinnings of medieval art.[53] She herself supplied the critical theory for the 'longer side of the triangle' in a discussion that included mid-thirteenth century images of St Margaret in stained glass.[54]

What then of other political and devotional concerns specifically at play in Northern Italy around 1200? While the acquisition of St Margaret's relics may have occasioned the carving of the Fornovo relief, also underlying the renovations of the Church of Santa Maria Assunta at Fornovo, and at Bardone as well, were the goals of their presumed commissioner, Obizzo Fieschi, bishop of the Parma diocese. As the agent of the pope, he would not only want to assert the newly standardized liturgical practices emanating from Rome,[55] but also to strengthen papal control through the standardized body of canon law developing at this time.[56] Initiated in 1140 at the school of law at Bologna with Gratian's *Decretum*, Rome's sweeping reform of ecclesiastical law evolved as canonists in the schools of law and theology responded to a series of papal decrees that considerably extended the Church's legislative reach.[57] The continued tension with imperial forces, long after the resolution of the Investiture Controversy in Rome's favor in 1122, played out in a contest between the enactment of civil law and Church law.[58] The power struggle between the bishop and the commune backed by the German emperor in the Parma diocese may be reflected in the Fornovo relief. Given her exemplary faith, Margaret's fate is a clear inversion of

[53] Madeline H. Caviness, *Reframing Medieval Art: Difference, Margins, Boundaries* (http://nils.lib.tufts.edu/Caviness, 2001), 'Introduction: Soundings/Sightings,' 15–17.

[54] Madeline H. Caviness, *Visualizing Women in the Middle Ages: Sight, Spectacle and Scopic Economy* (Philadelphia, 2001), 101–3 and Figs. 45a, b, and c (mid-thirteenth images of Margaret in the Collegiate Church at Ardagger, Austria). See the review by Corinne Schleif of this book and that cited in n. 53 in *Speculum*, 79 (2004): 149–52.

[55] Michel Andrieu, *Le Pontifical romain au Moyen Age, 1: Le Pontifical romain du xii siècle*, Studi e Testi 86 (Vatican, 1938), 13–19.

[56] Stephan Kuttner, 'The Revival of Jurisprudence,' in *Renaissance and Renewal in the Twelfth Century*, ed. Robert L. Benson and Giles Constable (Cambridge, 1982), 299–323.

[57] Kuttner, 'The Revival of Jurisprudence,' 300–306 and 316–22; Giulio Silano, 'Of Sleep and Sleeplessness: The Papacy and Law, 1150–1300,' in *Religious Roles of the Papacy: Ideals and Realities: 1150–1300*, ed. Christopher Ryan (Toronto, 1989), 343–61.

[58] While Roman law was also injected into Germanic customary law in the twelfth century, the first formal law book was promulgated by Pope Innocent III in 1209: Kuttner, 'The Revival of Jurisprudence,' 316–17. The German *Sachsenspiegel* was compiled in 1224–25: Madeline H. Caviness, 'Putting the Judge in his P(a)lace: Pictorial Authority in the Sachsenspiegel,' *Österreichisch Zeitschrift für Kunst und Denkmalpflege (Festschrift für Ernst Bacher)* 54 (2000): 308–30; Caviness and Nelson, 'Silent Witnesses,' 47–72.

a heresy trial. The crown worn by Olibrius, who is just a prefect after all, when he confronts Margaret may be a swipe at imperial attempts to undermine the temporal aspect of episcopal power (fig. 16.1, below right).[59] The 'scepter' that the figure of Theotimus otherwise inexplicably holds as he stands behind Margaret in the judgment scene may be an assertion of the bishop's right to preside in the courts (fig. 16.1, above right), a right that was under constant attack by the commune of Parma.[60] The eastern accent contained in the Phyrgian hat that Olibrius wears in the prison and torture scenes carries a specific reference to the Jews who tortured Jesus (fig. 16.1, below left), as emblematic of all heretics.[61] Cathars rather than Jews were the chief targets of heresy in the region, but Maureen Miller argues that Pope Lucius III's bull of 1184 extending the use of torture to heretics was a move that was as much political as religious, and thus aimed at any opposition to ecclesiastical authority.[62]

The Fornovo relief, as a visual equivalent of a text book of Roman law as applied to early Christian martyrs in the third and fourth centuries, thus has relevance for the prosecution of canon law in the ecclesiastical courts in the early thirteenth century. Margaret's appearance before Olibrius with her crossed hands tightly bound in her first stint in prison shows a common torture for many, including women and children, under Roman law. Public scourgings on the rack were among the tortures reserved for outcasts of Roman society, including Christian martyrs, in the first 'golden age' of lurid accounts.[63] Further papal decrees in the second half of the thirteenth century would open the second golden age of such public measures for the extraction of confessions, but no longer for women.[64] The unprecedented image of the starkly nude Margaret (fig. 16.1 above), mythically relocated from a distant time and place yet edgily current by the disjunction of cruel flesh hooks and her fashionable braids, thus begs Madeline Caviness's question as to a sado-erotic aspect of a male viewing.[65] To men who risked subjection to this kind of public punishment, Margaret's parallel of Christ's passion is ostensibly presented as a new therapeutic rationale for judicial torture as a means of inquisition, correction, and reform that leads to salvation.[66]

[59] Nestor Pellicelli, *I Vescovi della Chiese Parmense*, 2 vols (Milan, 1936), vol. 1:165–9 and 172–4; *Dizionario Biografico degli Italiani* (Rome, 1997), vol. 47:506–08.

[60] Pellicelli, *I Vescovi*, 1:178–86. The intensity of this complicated power struggle was such that Obizzo was exiled from Parma for several months in 1221.

[61] For Jews identified by their Phrygian hats in a flagellation scene, see the bronze doors at San Zeno in Verona: Stefan Rohrbacher, 'The charge of deicide: An anti-Jewish motif in Christian art,' *Journal of Medieval History* 17 (1991): 297–31, esp. 306, Fig. 4.

[62] Maureen C. Miller, *The Bishop's Palace: Architecture and Authority in Medieval Italy* (Ithaca, 2000), 163–69; Thomas H. Bestul, *Texts of the Passion: Latin Devotional Literature and Medieval Society* (Philadelphia, 1996), 155.

[63] Bestul, *Texts of the Passion*, 150 and 155–57.

[64] Bestul, *Texts of the Passion*, 145–64. Bestul (155) cites those of Innocent IV in 1252, extended by Alexander IV in 1256. Passion narratives of Christ begin to be depicted in similarly gruesome detail at this time; Easton, 'Pain, Torture,' 49–64.

[65] Caviness, *Visualizing Women*, 80–124.

[66] Esther Cohen, *The Crossroads of Justice: Law and Culture in Late Medieval France* (Leiden, 1993), 150–55.

The images of Margaret's torture contained a broader devotional message for significant numbers of lay penitents in northern Italy around 1200 who were voluntarily seeking to emulate the *vita apostolica* adopted by the reformed monastic communities a century earlier. For men as well as women, the suffering of Margaret in imitation of Christ was a direct model for their own.[67] For both, moreover, Margaret's female body represented the worldly, a condition which all share and which must be punished in order to overcome the temptations of the flesh and, hence, the devil.[68] The flail used on the semi-nude Margaret in the lower register appears to be made of leather thongs; an instrument of self-flagellation that had become particularly popular with the laity in northern Italy after Peter Damian in the mid-eleventh century advocated its usefulness as a voluntary penitential practice and a means of imitating Christ.[69] As a private method of bodily mortification for both monastic and lay, at Fornovo it is emblematic of a heightened sense of sin cultivated by the Church that transformed a relatively local and small-scale phenomenon of penitential pilgrimage of the late eleventh century into the international mass movement it was by 1200.

The equation of greed with lust in the central figure of a devil with testicular money bags, in the hell scene now on the facade of Santa Maria Assunta at Fornovo (fig. 16.5), speaks to newer forms of transgression in contemporary urban society that demanded the attention of the 'internal forum of conscience and penance' of canon law.[70] The unsubtle message can be read as a successful fund-raising device given the new bridge over the Taro River and a hospital for pilgrims erected nearby around 1200.[71] Obizzo Fieschi may also have used Margaret's promise, to reward those who build a basilica in her name or commission a manuscript of her story, as a means of penitential commutation for the renovations to the church and its sculptural program. The carved relief of Margaret's life might allow an indulgence for the artist as well as for the pilgrims who contemplated it,[72] based on her further promises: '… if anyone reads this book of my deeds or hears my passion read, at that hour may that

[67] See Glass, 'Saint Margaret of Antioch,' 337–38, for the concept of *Christus nudem sequere*, which was Jerome's call to give up worldly possessions and lead the penitent monastic life, now alive for lay piety as well; Giles Constable, 'The Imitation of the Body of Christ,' in *Three Studies in Religious and Social Thought* (New York, 1995), 194–217.

[68] Carolyn Walker Bynum, 'The Female Body in Religious Experience,' in *Fragmentation and Redemption: Essays on Gender and the Human Body in Medieval Religion* (New York, 1992), 93–102.

[69] Giles Constable, 'Attitudes Toward Self-Inflicted Suffering in the Middle Ages,' in *Culture and Spirituality in Medieval Europe* (Aldershot, 1996), IX: 7–27. John Howe, 'Voluntary Flagellation: From Local to Learned Tradition?' (unpublished paper), argues that Dominic Loricatus, Peter Damian's source for the voluntary, as opposed to penal, practice, drew on pre-Christian pagan rites rather than monasticism. Dominic is also the source for the whip made of leather thongs. I am grateful to John Howe for letting me see his study.

[70] Joseph Goering, 'The Internal Forum and the Literature of Penance and Confession,' *Traditio* 59 (2004): 175–227, esp. 200–202.

[71] Pellicelli, *I Vescovi*, vol. 1:177; Dall'Aglio, *La Diocesi di Parma*, 1:493.

[72] See Nancy Patterson Sevčenko, 'The Vita Icon and the Painter as Hagiographer,' *Dumbarton Oaks Papers* 54 (1999): 149–65.

person's sins be blotted out; whoever comes with his light to the church where my relics are, likewise may his sins be blotted out. … Whoever is found at the terrible judgement and is mindful of my name, deliver him from torments' (213–15).

The gentle reader may well claim that a further indulgence is required to believe that Obizzo Fieschi and the artist could possibly have had these multiple objectives in mind. I suggest, however, that these associations both 'high' and 'low' were 'in the air,' and that the zest for 'visual exegesis' among the lay population, as well as the cloistered, is a recognized phenomenon in an age of orality when a sophisticated visual literacy could rival the verbal.[73] Particularly with the spiritual stakes as high as they were for devotion to St Margaret, the unusual format of the modest relief dedicated to her at Fornovo is a clear signal that the possibilities for even further visual connections, back and forth, up and down within this relief and with others are open ended.

73 See Harvey Stahl, 'Narrative Structure and Content in Some Gothic *Ivories* of the Life of Christ,' in *Images in Ivory*, ed. Peter Barnet (Princeton, 1997), 94–114; Ilene Forsyth, 'Narrative at Moissac: Schapiro's Legacy,' *Gesta* 41 (2002): 71–93.

Archbishops Named and Unnamed in the Stained Glass of Reims

Meredith Parsons Lillich

In 1990, Madeline Caviness published her sumptuous, elegant and stupendous volume devoted to the stained glass related to the abbey of Saint-Remi in Reims. She established a date of around 1175–80 for the great series of archbishops of Reims in the abbey chevet and provided a meticulous appendix of the names assigned to those prelates, on the basis of mid-nineteenth-century witnesses.[1] In the abbey's impressive stained-glass ensemble, the canonized archbishops probably were grouped in the hemicycle, though all of them—canonized or not—received haloes. The series ran from the earliest prelates of the late third century, long before the establishment of the Benedictine abbey of Saint-Remi, to Archbishop Henri de France († 1175), with an honored group (those sainted and those buried in the abbey) filling the hemicycle and less celebrated archbishops in the straight bays. Caviness's appendix lists the name inscriptions recorded by witnesses before and after the extensive restorations of the late nineteenth century. Names were renewed and added at that time, and figures moved around, in the apparent goal of imposing a stricter chronological order on the sequence of archbishops.[2]

Glazing programs traditionally said to be influenced by Saint-Remi's great procession of bishops include Bourges, the abbey of Orbais, Châlons-en-Champagne, and, preeminently, the cathedral of Reims.[3] In a manner of speaking, this paper will attempt to prove the opposite: that Saint-Remi—as it has appeared at least since 1895—copies Reims Cathedral. The plot thickens, however. Only six archbishops in the cathedral nave, those grouped on the

[1] Madeline Caviness, *Sumptuous Arts at the Royal Abbeys in Reims and Braine: Ornatus Elegantiae, Varietate Stupendes* (Princeton, 1990), 25, 58, and Appendix 3, 142–44. Although the title of archbishop first appears in the eighth century, for Abel (twenty-eighth bishop), all are so designated here since the distinction was not significant in thirteenth-century Reims. The list of early prelates is established in Louis Duchesne, *Fastes épiscopaux de l'ancienne Gaule* (Paris, 1915), 3:86.

[2] Caviness, *Sumptuous Arts*, 32 and 58.

[3] Caviness, *Sumptuous Arts*, 17–18 and 131–35 passim. Besides the literature provided in her notes see Meredith Lillich, 'St. Memmie, Apostle of Châlons, and other Bishop Saints in the Gothic Windows of Châlons Cathedral,' *Studies in Iconography* 19 (1998): 75–103, rpt. Meredith Lillich, *Studies in Medieval Stained Glass and Monasticism* (London, 2001), 168–201.

south at the transept, have inscriptions, and this paper will argue that these names are post-medieval in origin.

The Program of Reims Cathedral

The choir clerestories of Reims Cathedral, dated in the 1230s, present two rows of seated figures, apostles above and bishops below, reflecting the arrangement of the Saint-Remi hemicycle. However, the cathedral's bishops are identified by inscription as generic suffragans of the archbishop of Reims: the bishop of Laon, the bishop of Noyon, the bishop of Soissons, and so on. Thus they form a different iconographic sequence from that in the abbey. It was the later program in the cathedral's nave that displayed, before the destruction of World War I, a lengthy series of archbishops of Reims—that is, the same group pictured and named in the Saint-Remi chevet. Accompanying each prelate in the cathedral nave was a French king, seated above him, and further relating the glazing programs of cathedral and abbey. Frankish kings—one identified as Chilperic, grandson of Clovis whose anointing is a constant theme of the cathedral's decoration—filled the nave clerestories of Saint-Remi.[4]

Following the extensive losses of World War I, stained glass in the cathedral nave is limited to eight doublet-and-rose clerestories located in the first four eastern bays, those adjoining the transept (bays 121–128 in the numbering of the French Corpus Vitrearum, Recensement 4; see fig. 17.1). Fifteen archbishops survive in these bays but, unlike those at Saint-Remi, only six bear name inscriptions: those in bays 122, 124, and 126 on the south.[5] Although the nave previously contained thirty-six archbishops, no others were named according to François de Guilhermy (observations from 1828–64) and publications of Victor Tourneur (ca. 1855) and Charles Cerf (1861).[6] To compound the puzzle, it can be noted that the six named archbishops are fairly insignificant prelates in the cathedral's past. The question is thus posed: just why should these six have been singled out for naming, and in this particular location?

4 Reims Cathedral: *Les Vitraux de Champagne-Ardenne*, Corpus Vitrearum, France–Recensement 4 (Paris, 1992), 383–90 (cited below as Recensement 4). On the nave of Saint-Remi: Caviness, *Sumptuous Arts*, 55–56.

5 There are of course sixteen lancets in the present eight bays, but bay 127 (left lancet, below) contains a seated king salvaged from the otherwise destroyed bay 129. On bay 129, see nn. 10 and 34 below. Many of the present nave figures were largely remade following World War I, using surviving leads and Simon's tracings (see n. 35 below).

6 Guilhermy: Paris, Bibliothèque nationale de France, MS n.acq.fr. 6106, fols 398r–399v (hereafter cited as Guilhermy). Tourneur: *Histoire et description des vitraux et des statues de l'intérieur de la cathédrale de Reims* (Reims, 1857), 31–38. Cerf attempted to complete and correct Tourneur's observations in *Histoire et description de Notre-Dame de Reims* (Reims, 1861), 2:287–98.

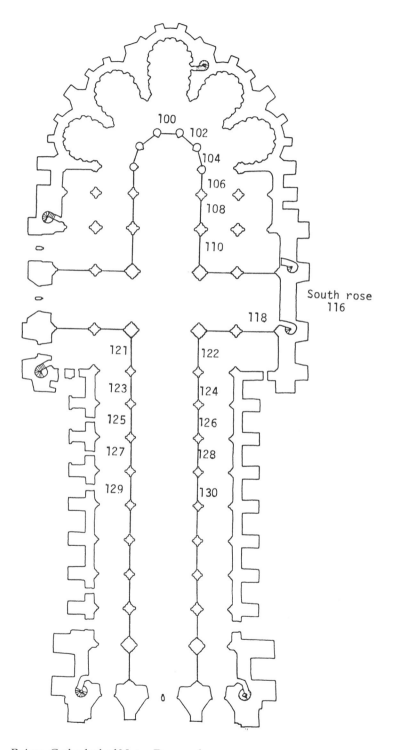

100
102
104
106
108
110

South rose
116

118

121 122
123 124
125 126
127 128
129 130

17.1 Reims, Cathedral of Notre-Dame, plan.

The Six Named Archbishops of the Cathedral Nave

Listed below are descriptions of the six named prelates, occupying the bottom rows of bays 122, 124, and 126 on the south side of the nave at the transept.[7] The numbering of archbishops comes from Flodoard († 966), *Historia Remensis ecclesiae*, whose catalog, Duchesne has established, had already become traditional by the time of Archbishop Hincmar († 882) and was recited in the Mass at Reims.[8] Comparisons below are made to other cathedral glass, surviving or known from pre-destruction photographs, as well as from the witness of Guilhermy, Tourneur, and Cerf.

BAY 122, LEFT LANCET: ST DONATIANUS, SEVENTH ARCHBISHOP (LATE FOURTH CENTURY) (FIG. 17.2).[9]

Although Donatianus was the seventh archbishop chronologically speaking, here he commences the series in the nave. His body and cult, however, had been transferred to Bruges in the ninth century, centuries before this window was painted. The figure in the window, haloed and beardless, sits on a high-backed throne and holds a crozier. Several details of this image are peculiar. His pose is rigidly frontal, unlike that of any other prelate in the entire nave, but similar to some bishops in the earlier choir series. His blessing hand differs from those of all other bishops in the cathedral glass including those of the choir and south transept; it is placed far to the side against the ground, while all other blessing hands are contained within the body silhouette. Like a few other archbishops in the nave—those of bays 127 and 129, now lost[10]—he wears the breastplate called a rational. However, it is not rectangular but almost square, and peculiarly decorated in a lozenge pattern colored alternately like a checkerboard.

The rational in use at Reims was an uncommon type, 'a rectangular pectoral studded with twelve jewels that continued in use until late in the fifteenth

7 A seventh bishop, Discolius, appears between Donatianus and Viventius in Étienne Povillon-Piérard, *Description historique de l'église métropolitaine de Notre-Dame de Rheims* (Reims, 1823), 137 and, presumably following him, in Prosper Tarbé, *Notre-Dame de Reims* (Reims, 1852), 82–83 and Ferdinand de Lasteyrie, *Histoire de la peinture sur verre* (Paris, 1853–57), 88. De Lasteyrie erroneously cites Antoine Gilbert, *Description historique de l'église métropolitaine de Notre-Dame de Reims* (Reims, 1825) but gives the correct reference from Povillon-Piérard (a nonexistent page in Gilbert). According to Duchesne, *Fastes* (see above, n.1), 81n2, Dyscolius was among the signatories of a forged document of the false 'council of Cologne.' At any rate, 'Discolius' was unknown in Reims in the Middle Ages.

8 Duchesne, *Fastes*, 76. Flodoard: *Historia Remensis ecclesiae / Die Geschichte der Reimser Kirche*, ed. Martina Stratmann, MGH SS 36 (Hannover, 1998). On Flodoard: *Dictionary of the Middle Ages*, ed. Joseph Strayer (New York, 1985), 5:90–91. Authors in the nineteenth century numbered them differently: Guilhermy, fol. 399v; Tourneur, *Histoire*, 35; Cerf, *Histoire*, 292.

9 Flodoard, *Historia*, 5.72; Alfred Baudrillat et al., eds, *Dictionnaire d'histoire et de géographie écclesiastique* (Paris, 1912), 14:col.654. Guilhermy, Tourneur and Cerf number him eighth.

10 Cerf, *Histoire*, 293, states that the bishops of bays 127 and 129 had rationals. For bay 129 see a lost Rothier photo, published twice: Arthur J. de Havilland Bushnell, *Storied Windows* (London, 1914), opp. 293; Louis Demaison, *La Cathédrale de Reims* (Paris, 1919?), 113.

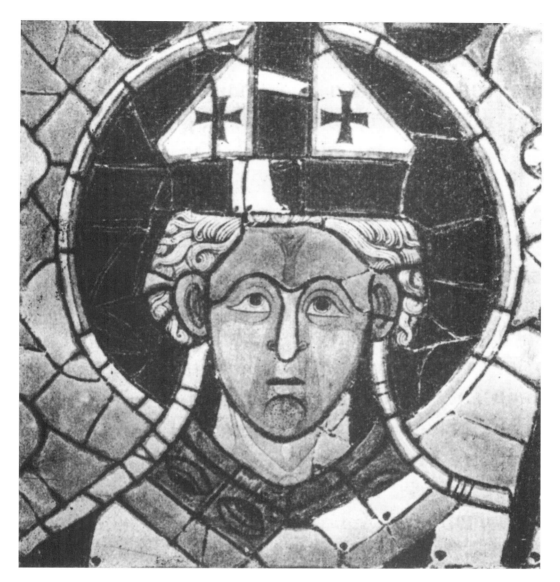

17.2 Reims, Cathedral of Notre-Dame, bay 122, Archbishop St Donatianus.
Tracing made before 1911 by Paul Simon from the exterior, here printed in
reverse.

century, as indicated in the 1470 inventory of the cathedral.'[11] The archbishop
wore it only on solemn feast days. Sculpted examples appear on the north
transept facade, where jamb statues of the archbishop-saints Remi and Nicaise
wear rationals on the Calixtus Portal, as well as the pope St Calixtus there on

[11] William Hinkle, *The Portal of the Saints of Reims Cathedral: A Study in Mediaeval Iconography*
(New York, 1965), Appendix C, 70, figs. 5, 8, 9, and 42.

the trumeau as well as on the west facade. In stained glass, besides the now lost archbishops of bays 127 and 129, the rational appears on the highly visible image of Archbishop Henri de Braine († 1240) in the cathedral's axial bay. At Saint-Remi, the rationals worn by several archbishops are somewhat smaller than the typical cathedral type but they always have twelve jewels clearly indicated.[12] The rational worn by Donatianus in bay 122 resembles none of these.

Bay 122, right lancet: St Viventius, eighth archbishop (late fourth century) (fig. 17.3).[13]

According to Flodoard, Viventius's body was transferred to Braux (Ardennes) in the ninth century, where his posthumous miracles included restoration of sight to the blind and, to drunkards, the ability to walk. Viventius is slightly bearded and, like Donatianus in the left lancet, is haloed, sits on a high-backed throne, blesses, holds a crozier, and wears a rational. He turns toward the altar, as do the prelates in bays 121, 123, and 125 on the opposite side of the nave. His rational is the standard type with twelve jewels. This figure was restored in the studio of Benoît Marq in 2000, when it was discovered that, except for the ground, the figure itself is the work of a sixteenth-century restoration.[14] The question of whether or not it replicates a medieval original is considered below.

The archbishops following Viventius—Severus (ninth) and the important *rémois* St Nicaise (tenth)—are skipped over in the group of named prelates under discussion. This is particularly surprising since the thirteenth century 'witnessed the heyday of the cult of St Nicaise,' particularly from mid-century onward—that is, precisely when the stained glass of the nave was produced.[15] The chapels of Sts Nicaise and Remi flanked the axial chapel on the north and south; Nicaise was featured opposite St Remi on the wings of Hincmar's golden jeweled retable on the cathedral's high altar; and their stories appeared similarly balanced on the lintel of the Calixtus portal on the north transept. The nave, moreover, was the real site of Nicaise's cult in the cathedral, as Hinkle has established. The so-called *rouelle*, the round marble stone set into the pavement marking the spot of his martyrdom, was situated in the middle of bay 129–130, just west of the *jubé*. A wrought-iron grill surrounded it and a chandelier directly above it was lit on all feast days when processions moving from the high altar, passing through the *jubé*, paused for a station at the *rouelle*.[16]

[12] Caviness, *Sumptuous Arts* (see above, n.1), color pl. 6, pls. 147 and 158.

[13] Flodoard, *Historia*, 5.72; Henri Platelle, 'Vivenzio,' in *Bibliotheca sanctorum* (Rome,1969), 12:col.1318. Nineteenth-century authors number him ninth.

[14] Sylvie Balcon, 'Les vitraux de la cathédrale d'après les documents du fonds Deneux conservés à la Bibliothèque municipale de Reims,' in *Mythes et réalités de la cathédrale de Reims de 1825–1975* (Paris, 2001), 53.

[15] Hinkle, *Portal*, 21 and n. 98; also 11–12, 14–22, and 52.

[16] Hinkle, *Portal*, 21–22. The *rouelle* appears on Jacques Cellier's cathedral plan of the 1580s: Patrick Demouy et al., *Reims: la cathédrale* (La Pierre-qui-vire, 2001), 79.

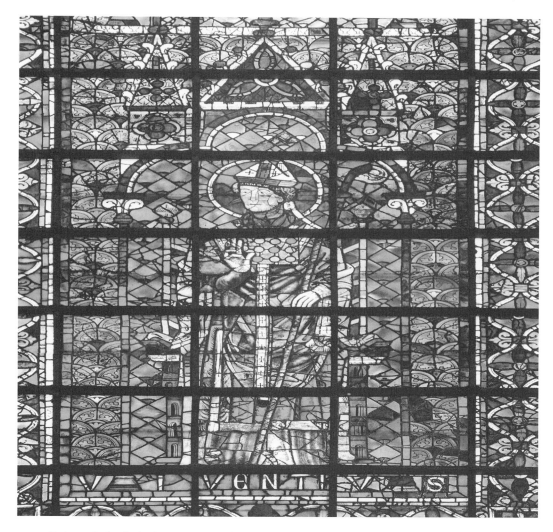

17.3 Reims, Cathedral of Notre-Dame, bay 122, Archbishop St Viventius.
Cleaned in 2000 and found to be sixteenth-century, except for the ground.

If the group of named archbishops in the southeastern nave windows was indeed of medieval origin, St Nicaise—and St Remi, who would immediately follow the last named one—are inexplicable omissions. But succeeding Donatianus and Viventius in bay 122, bay 124 presents two archbishops named Baruc (Barucius), about whose reigns nothing whatsoever is known.

BAY 124, LEFT LANCET: BARUC, ELEVENTH ARCHBISHOP (CA. 408–20) (FIG. 17.4).

Flodoard lists Baruc and Barucius as separate prelates, though modern scholars believe the two names refer to the same individual.[17] The figure of Baruc, like the others listed above, is haloed though in his case he was not a saint. He has a short beard and sits on a high-backed throne, holding a crozier in his left hand. His right hand, palm up, holds an object that has hitherto elicited no scholarly attention. Only Guilhermy remarks on the hand, with a long finger extended, saying that it points to the bishop in the paired lancet. But there is clearly an object in the hand. It is yellow, and was more clearly distinguishable from the vestment behind it in the Deneux autochrome made in 1915 (fig. 17.4) than it is at present. It resembles a small balloon or bladder, and I suggest that it was intended to represent the *Sainte Ampoule* that held the miraculous chrism used at coronations of the French kings. There is no reason why this obscure, early fifth-century archbishop holds this object, and indeed historically he could not have done so, since the Sainte Ampoule first appeared in history at the baptism of Clovis by St Remi on Christmas day of the year 496.

The yellow object held by Archbishop Baruc in bay 124 can be compared with several depictions of the Sainte Ampoule in the so-called 'Ordo of 1250,' the coronation ordo probably produced at Reims in the 1240s (Paris, Bibliothèque nationale de France, MS lat 1246).[18] On fol. 4r, in the miniature depicting monks of Saint-Remi bringing the Ampoule to the cathedral, the abbot carrying the golden Ampoule holds it in his palm, extending his fingers forward as in the window; in fol. 17r, the archbishop anoints the king, holding the Ampoule in an upturned palm. This resemblance, however, need not establish the medieval authenticity of the design of bay 124. Indeed, no other prelates in the nave carry any kind of object specifically associated with the coronation ritual; specificity seems to have been consciously avoided in the great parade of thirty-six kings and thirty-six bishops originally gracing the nave.

Richard Jackson has established that the earliest appearance of the Sainte Ampoule in the coronation rite occurs in the Ordo of Reims, which he dates around 1230.[19] As Jackson has noted:

Until the Revolution, the legend of Remigius and the Holy Ampulla continued to be embedded at the heart of the coronation liturgy, where it had been placed in the

[17] Flodoard, *Historia*, 9.79; Duchesne, *Fastes* (see above, n. 1), 81 follows Flodoard, adding a note that they might be identical. Baudrillat, *Dictionnaire* (see above, n. 9), 6:col.1055, considers them as the same individual.

[18] On this unique ordo see Richard A. Jackson, ed., *Ordines Coronationis Franciae* (Philadelphia, 2000), 2:341–66. Color illustrations: Patrick Demouy, *Notre-Dame de Reims, sanctuaire de la monarchie sacrée* (Paris, 1995), 113; Jacques Le Goff et al., *Le sacre royal à l'époque de saint Louis* (Paris, 2001), pls. II, VI, where lat.1246 is dated in the 1260s (16, 34). Le Goff's previous dating, in the 1240s, is preferable: Le Goff, 'A Coronation Program for the Age of Saint Louis: The Ordo of 1250,' in *Coronations: Medieval and Early Modern Monarchic Ritual*, ed. Janos Bak (Berkeley, 1990), 46–57. Lat.1246 was erroneously referred to previously as the Châlons Pontifical following Leroquais, a view no longer supportable.

[19] Jackson, *Ordines*, 2:291–305.

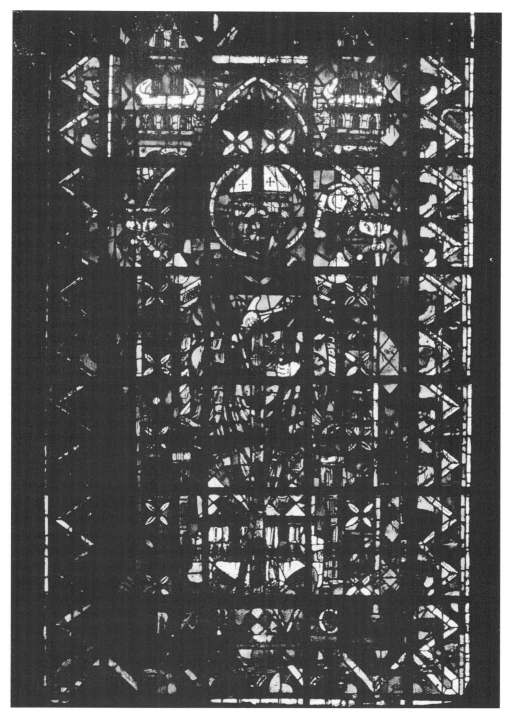

17.4 Reims, Cathedral of Notre-Dame, bay 124, Archbishop Baruc. Autochrome
photo by Henri Deneux, 1915.

late Middle Ages after completing its rise from the centuries-long obscurity in which it had lain before the early thirteenth century had brought it back to light.[20]

The Sainte Ampoule was one of a number of specific additions to the coronation liturgy in the thirteenth century, such as the participation of the peers of France, that made the rite peculiarly French for the first time. The Ampoule grew in centrality during succeeding centuries. For Charles VIII's 1484 coronation, two new additions to the liturgy specify it, one a processional hymn as the ampulla was borne from the cathedral door to the altar, and the second a text when it was placed upon the altar.[21] Also in 1484 a *tableau vivant* was staged during the king's pre-coronation entry into the city, depicting the original transmission of the Ampoule to earth. At the entry of Louis XIII for his coronation in 1610, one of the city gates received a painting showing the dove bringing the Ampoule to the altar.[22] Thus it is possible, even likely, that the depiction of the Ampoule in Reims bay 124 is post-medieval. Of course it goes without saying, and is irrelevant to the argument, that neither of the Barucs ever used it in a coronation.

Bay 124, right lancet: Barucius, twelfth archbishop (ca. 408–20) (fig. 17.5, right).[23]

Like Baruc I, he is haloed though not a saint. The figure, slightly bearded, sits on a high-backed throne, holds a crozier, and blesses. Like St Donatianus in bay 122, he wears a very strange rational, small and square rather than rectangular in shape, with a 'tic-tac-toe' pattern that is colored like a nine-square checkerboard.[24] No thirteenth-century depiction of the rational in the cathedral looks like this.

Bay 126, left lancet: Barnabas, thirteenth archbishop (ca. 421–30) (fig. 17.6, left).[25]

Nothing is known about his reign except that he left a silver vase to his successor Bennadius, whose own testament refers to Barnabas *sanctae recordationis*. The figure, like those of bay 124, is haloed though he was not a saint; he is beardless, sits on a high-backed throne, holds a crozier, and blesses.

[20] Richard A. Jackson, *Vive le Roi! A History of the French Coronation from Charles V to Charles X* (Chapel Hill, 1984), 43, also 31–32, 188–89, 195, and 204; Hinkle, *Portal*, 37–40.

[21] Jackson, *Vive le Roi!*, 43.

[22] Jackson, *Vive le Roi!*, 176–77.

[23] See above, n. 17.

[24] Cerf, *Histoire* (see above, n. 6), 293, states that on the south only Donatianus and Viventius (bay 122) wear rationals. Perhaps the rationals in bays 124 and 126 are so odd that he did not recognize them as such. He does mention the typical rationals in north bays 127 and 129.

[25] Flodoard, *Historia* (see above, n. 8), 9.79; Duchesne, *Fastes* (see above, n. 1), 81; Baudrillat, *Dictionnaire* (see above, n. 9), 6:col.852. Tourneur, *Histoire* (see above, n. 6), 36 and Cerf, *Histoire*, 292–93, report that the two bishops in bay 126 were reversed with Barnabas on the right, but Guilhermy (see above, n. 6), fol. 399v. and the Deneux photomontage of war damage in 1918 have Barnabas on the left (Arch. phot., Deneux 02892 N).

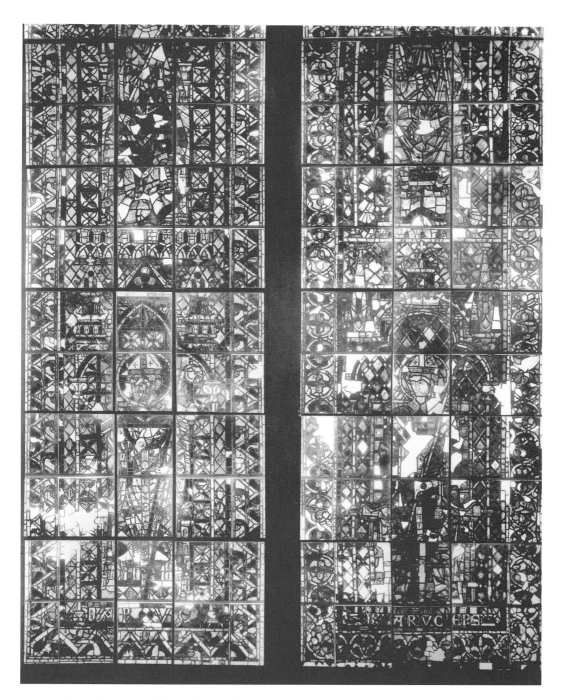

17.5 Reims, Cathedral of Notre-Dame, bay 124, Archbishops Baruc and
Barucius. Photomontage of war damage by Henri Deneux, after 1918.

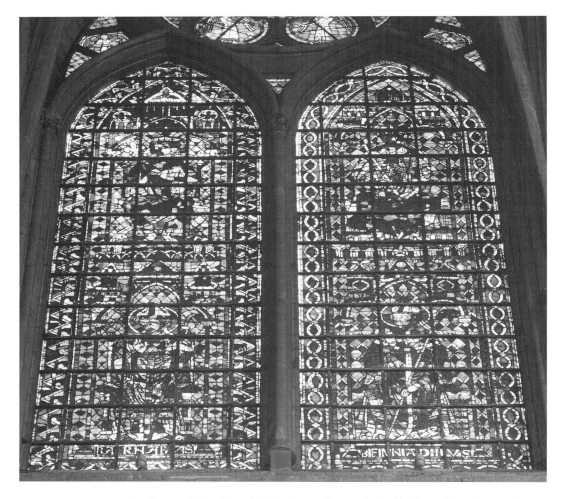

17.6 Reims, Cathedral of Notre-Dame, bay 126, Archbishops Barnabas and Bennadius.

He wears another of the very peculiar 'rationals' found in these bays having inscriptions; in this case it is small, square, and formed of decorated lozenges.[26]

BAY 126, RIGHT LANCET: BENNADIUS, FOURTEENTH ARCHBISHOP (CA. 430–59) (FIG. 17.6, RIGHT).[27]

Flodoard states that his testament, in his own hand, gives his name as Bennagius. Like Barnabas, he is haloed though not a saint; he is bearded, sits

[26] See above, n. 24.
[27] Flodoard, *Historia*, 9.79; Duchesne, *Fastes*, 81; Baudrillat, *Dictionnaire*, 7:col.1351.

on a low throne, holds a crozier, and blesses. Nothing is known about him except his testament, leaving money to repair the cathedral as well as sums to its many officers. He was buried in the cathedral. He was the immediate predecessor of the cathedral's most famous saint, Remi, who—like St Nicaise—is not among the six prelates identified by inscription in an ensemble that, until 1914, contained thirty-six of them.

Funny Foldstools

One purpose of indicating the anomalies in the iconography of the six named archbishops is to establish that any post-medieval restoration (to be addressed below) did not simply reproduce original medieval designs. A word might be added here about similar anomalies in the images of the six unnamed kings enthroned above them. The bare sword held point-up by the left king of bay 122 could be, like Baruc's Sainte Ampoule·, a reference to the coronation.[28] Only Karolus in bay 128 holds such a sword; all other kings of the nave hold scepters. Bay 128, immediately adjoining the three south bays discussed in this study, is an obvious patchwork of disparate figures salvaged from elsewhere and Karolus is the oddest of the four, not just the only named king in the cathedral but rigidly frontal and smaller in scale. A hypothesis can be entertained that he was not originally in the nave, and that he was moved here as part of sixteenth-century repairs discussed below.[29] The left king of bay 122 thus may copy him.

The most striking anomaly is the type of throne provided for three of the kings, notably the left monarch in bay 126, also the kings in the right lancets of bays 122 and 124.[30] The king in bay 126 (fig. 17.6, left) sits on an animal-headed foldstool, but one provided with a high back; the monarchs of bays 122 and 124 (fig. 17.5, right) seem to have straight-sided thrones with high backs, from the sides of which animal heads jut out incongruously. The combination of foldstool and high back does not seem to have existed in the middle ages. Dagobert's throne from Saint-Denis, a foldstool that later was provided with low sides and a back, cannot even be considered an exception to this rule, as the reduced sides and back gable in no way form a 'high-backed throne.'[31] Thus the odd thrones of these three kings at Reims, like the peculiar rationals in these

[28] On the sword and other regalia in the coronation liturgy: Jackson, *Ordines* (see above, n. 18), 2:352–3. The bare sword appears several times in the 'Ordo of 1250' miniatures but never with the king holding it: Le Goff, *Le Sacre* (see above, n.18), pls. VI, X, and XV.

[29] The identity and origin of Karolus are beyond the scope of this essay. The figure was destroyed in 1918 and remade thereafter; there is a pre-destruction Deneux autochrome of it (Reims, Bibliothèque municipale). See now Recensement 4 (see above, n. 4), fig. 369.

[30] Cerf, *Histoire*, 291, states that all four kings of bays 124 and 126 have foldstools, but these figures survived with little damage and prove that Cerf was mistaken. Deneux autochrome photos of 1915 exist for the three discussed here; see Balcon, 'Les Vitraux' (see above, n. 14), 50 (bay 122, right king).

[31] It now is dated late eighth century, with the later additions possibly added by Abbot Suger. See *Le trésor de Saint-Denis* (Paris, 1991), 63–68, no. 5; Brigitte Bedos-Rezak, 'Suger and

south bays, can only be a post-medieval misunderstanding of a medieval object that was no longer current or in use.

Madeline Caviness's investigation of the history and use of the foldstool notes that traditionally it was associated both with rulers and with sacred imagery, including Sts Jerome, Augustine, the evangelist John, and the Virgin Mary. Several bishops in the Saint-Remi windows are enthroned on foldstools. In the cathedral, the early bishop relocated to bay 118 in the south transept sits on a particularly dramatic one.[32] The association of rulers with foldstools is seen in the seals of numerous Capetian kings including Phillip Augustus and Louis IX.[33] Only two kings in the cathedral's nave windows, however, had foldstools, and they also were the only kings with haloes. These were the monarchs in bay 129, the most elaborate and impressive of the nave series, occupying a pivotal location adjoining the *jubé*. Its pre-1914 appearance is recorded in a Rothier photograph and the king that survived World War I has now been relocated to the lower left lancet of bay 127.[34]

Kings on high-backed thrones were much more common in the nave, most obviously all those in the northern bays (121, 123, and 125) facing the three bays under discussion in this study. The anomalous combination of foldstool and high-backed throne in these three southern bays thus conflates two medieval types that existed independently in the cathedral and carried somewhat different meanings.

SIXTEENTH-CENTURY REPAIRS?

If the three nave bays containing named archbishops do include, as here suggested, extensive sixteenth-century repairs, these designs clearly were intended to meld with the medieval ensemble, and have done so quite successfully. The search for evidence of the post-medieval artist's 'handwriting' is complicated by the windows' present obscured condition and tortured history. Their designs were recorded by Paul Simon from 1875–86 in colored tracings made in situ. In 1911 he warned that they were obscured by dirt and

the Symbolism of Royal Power: The Seal of Louis VII,' in *Abbot Suger and Saint-Denis: A Symposium*, ed. Paula Gerson (New York, 1986), 95–99.

32 Caviness, *Sumptuous Arts* (see above, n. 1), 59–61; pls. 121, 124, and 125 (sacred figures on foldstools); pls.114 and 158 (archbishops on foldstools). The archbishop in bay 118, the cathedral's south transept: Demouy, *Notre-Dame* (see above, n. 18), 78, color ill.

33 Caviness, *Sumptuous Arts*, 58, pl. 115. The seal of Phillip Augustus: Demouy, *Notre-Dame*, 91. The seal of Louis IX: *La France de Saint Louis* (Paris, 1970), 17. On the foldstool see Ole Wanscher, *Sella curulis: the Folding Stool, Ancient Symbol of Dignity* (Copenhagen, 1980); Meredith Lillich, 'The Stained Glass Spolia in the South Transept of Reims Cathedral and Rémois Ecclesiastical Seals,' 46 (2007)11–13.

34 Tourneur, *Histoire* (see above, n. 6), 35, says that only two kings have haloes, no doubt those of bay 129. Guilhermy (see above, n. 6), fol. 398r, notes for bay 129 that the kings have both haloes and foldstools. Both kings are visible in the lost Rothier photo of bay 129; see n. 10 above. The surviving king from the right lancet of bay 129 (now left lancet of bay 127) was photographed by Deneux (Balcon, 'Les Vitraux,' 52, fig. 7); originally he turned to honor his fellow monarch in the paired lancet, and thus at present he gazes resolutely out at the facade.

held precariously by weak eighteenth-century leading.[35] Deneux's post-1918 documentation of war damage indicates minor loss to bay 124 (fig. 17.5) and more extensive loss in bay 126. Jacques Simon remade the bays from 1922–26 using his father's tracings. Deposed in 1939, they were reinstalled from 1945–47. The glass is again darkening, and many details seem to differ from Deneux's photos made in 1915. Since both Paul and Jacques Simon commanded an archaizing style that has been taken for medieval work,[36] an accurate assessment must await the eventual publication by the French Corpus of restoration charts.

In 2000, bay 122 was restored by the Simon-Marq atelier, and the recently cleaned figure of Viventius provides the clearest evidence of a post-medieval hand (fig. 17.3). The face and hands are modeled softly, the arms and fingers stubby and ill-formed, and most noticeable is the shaded modulation of folds in the lower draperies. Other draperies are indicated by crude, thick, black stripes or smears accompanied by thinner mat streaks, apparently imitating the shaded spoon-folds of medieval costuming. In general the ornament is based on medieval designs but applied with a heavier hand and post-medieval taste, as revealed, for example, in the three-dimensional crockets, and the illogical alternation of left/right perspective in jewels, niches, and such decorative motifs.

The need for such repairs over the years can be posited. One catastrophic event in the sixteenth century received mention in the otherwise laconic chronicles of the cathedral's past, and also left an indelible mark on the cathedral fabric. This event was the destruction of the south transept rose, both tracery and glass, as described in the seventeenth-century manuscript of Pierre Cocquault:

On Easter day [1580] a great and very injurious windstorm caused a number of great ruins in several regions, and great buildings were brought down. In the church of Reims, the rose or O window on the side of the palace [the south] was violently blown in. The gable of the palace chamber with the large window was cast down. The pinnacles of the gables of the Augustinian and Carmelite churches were destroyed as well.[37]

It is certainly arguable that such a violent wind would have damaged nearby windows facing south, and bays 122, 124, 126, and 128 are directly west of the destroyed rose and at the same elevation. The more intense disorder of the

35 Paul Simon, 'Notes sur les vitraux de la cathédrale de Reims,' *Congrès archéologique* 78/1 (1911), 294; Recensement 4 (see above, n. 4), 384.

36 Caviness, *Sumptuous Arts*, 34, 107–8, n. 60.

37 'Le jour de Pâques [1580] se fit un grand vent fort à oultrages qui causa plusieurs grandes ruines en plusieurs pays, et furent grands bâtiments mis par terre. En l'église de Reims, la rose ou l'O du côté du palais [the south] fut emporté par violence. Le pignon de la salle du Palais où est la grande vitre fut jeté en bas. Les sommets des pignons des églises des Augustins et des Carmes le furent également. …' Pierre Cocquault, 'Histoire de l'église, ville et province de Reims,' Reims, Bibliothèque municipale, MS 1609, 4:453, as recorded by Tourneur, *Histoire* (see above, n. 6), 40. All translations into English, unless otherwise noted, are by the author.

southern clerestories of the Saint-Remi chevet, noted by Tourneur, might also suggest the same explanation.[38]

The cathedral's south rose was remade the following year and the new glass, lost in World War I, bore the date 1581 and the name Nicolas Dérodé. His rose was in the Renaissance style, as attested by nineteenth-century observers and affirmed by the drawing published by de Lasteyrie; Guilhermy judged that 'this window doesn't lack elegance.'[39] Did Dérodé also repair the three south clerestories but in a very different, and successful, quasi-medieval style? If so, he presumably did so in order to maintain the integrity of the nave glazing.[40] Tourneur comments that Dérodé had been ignored by local biographers but that, besides his rose window, a self-portrait in oils owned by his descendants provided evidence of his talent; Cerf notes that Dérodé executed 'peinture au portail' in 1612, that is, thirty-one years after the rose glazing of 1581.[41] Certainly, such a long career in art would allow him to develop a 'medieval' style, though this hypothesis must remain pure conjecture.

WHY THESE ARCHBISHOPS?

The question remains: why begin the nave sequence with the cathedral's seventh archbishop (Donatianus) and continue with the obscure prelates succeeding him? Dom Guillaume Marlot, the 'genial antiquarian' who was a seventeenth-century prior of the abbey of Saint-Nicaise in Reims, offers a clue.[42] Contrasting with Marlot's description of the cathedral's sculpture, furnishings, relics, and so on, his mention of the stained glass is brevity itself. He states that there are windows at two levels and that their glass, 'pour estre espais et peints de diverses couleurs, causent quelque obscurité dans l'église.'[43] As for the subjects, he devotes only the following paragraph, as remarkable for what it does not say as for what it does. It will therefore be quoted *in toto*:

In the windows are represented a whole series of ancient archbishops pontifically vested with their pallium, crozier and mitre, images which attract, by the light that shines through them, the eyes and spirit of those who come to pray, when considering them carefully, they recall the great virtues that they practiced well

[38] Caviness, *Sumptuous Arts*, 144 note j, citing Victor Tourneur, 'Mémoire,' *Congrès archéologique* 28 (1861), 93–94.

[39] De Lasteyrie, *Histoire* (see above, n. 7), pl. XCII; Guilhermy (see above, n. 6), fol. 403r; Tourneur, *Histoire*, 40–41 quoting Prosper Tarbé. See also Lillich, 'The Genesis Rose Window of Reims Cathedral,' *Arte medievale* n.s. 2, no. 2 (2003), 55–56 (Appendix I: The Program of the Lost South Rose).

[40] A similar post-medieval repair in 'medieval' style has been hypothesized at Chartres by Roger J. Adams, 'The Chartres Clerestory Apostle Windows: An Iconographic Aberration?,' *Gesta* 26 (1987): 141–50.

[41] Tourneur, *Histoire*, 54; Cerf, *Histoire* (see above, n. 6), l:70 n.1 and 2:284 n.1.

[42] The phrase is Hinkle's: *Portal* (see above, n. 11), 8.

[43] Guillaume Marlot, *Histoire de la ville, cité et université de Reims* (Reims, 1843–47), 3:524. He wrote in French but only published it in a shortened Latin version (1666–71); the much longer original French text was published in the nineteenth century.

during their lives, God having established by his holy grace that the first bishops of each town were very eminent in holiness and like mirrors of perfection, so that posterity coming to contemplate them, would be induced by affection to imitate them; which is why one has depicted them thus in the highest reaches of our churches, in imitation of those heroes that the ancients placed in the most eminent place in their chambers, and that St. Charles [Borromeo] has revived at the council of Milan, charging his suffragans to put portraits of their predecessors at the entry to the episcopal palace, removing all other representations made rather for the pleasure of the eye than for edification.[44]

In sum, at a moment when Reims Cathedral still retained nearly its entire Gothic glazing program, Marlot gives not a nod to the glass of the aisles and chapels, the north and west rose windows, the thirty-six kings in the nave, or the unique series of suffragan cathedral façades in the clerestories of the chevet. For him the windows present the cathedral's 'anciens archevesques,' as per the widely disseminated teachings of St Charles Borromeo.

Borromeo († 1585, canonized 1610) was recognized as one of the great leaders of the Counter Reformation. Bishop of Milan from 1563, he held provincial councils there noteworthy for promoting religious renewal conforming to the decrees of the Council of Trent; 'the amazing results [of his councils] are described in the *Acta ecclesiae Mediolanensis*, whose many editions published since 1582 have become the patrimony of the whole Church.'[45] Looking at the windows of Reims through the eyes of the Counter Reformation, Marlot sees a procession of the cathedral's archbishops. Indeed, if one begins counting in the chevet following the axial bay 100 (with its clearly labeled image of Archbishop Henri de Braine, † 1240), the southern choir presents images of six prelates: one each in bays 102, 104, 106, and 108, and two in bay 110. Bay 110 is the last clerestory in the chevet, and over the crossing in the first clerestory of the nave (bay 122), Marlot would have seen Donatianus, the seventh. The idea can be entertained that the repairs required by the storm of 1580 were made following the published instruction of the great contemporary reformer-saint, Cardinal-Bishop Charles Borromeo.

In Marlot's defense one must allow that the inscriptions of the choir clerestories, identifying their prelates as bishops of Laon, Soissons, Beauvais, Noyon and so on, were possibly in a state of disarray. These inscriptions usually

44 'Dans les vitres sont représentés tout d'une suite les anciens archevesques revestus pontificalement avec leur pallium, croce et mitre, dont les portraits attirent, par la clarté qui brille à travers, les yeux et l'esprit de ceux qui viennent pour prier, lorsque les considérant avec attention, ils se souviennent des hautes vertus qu'ils ont heureusement pratiquées pendant leur vie, Dieu ayant fait par sa sainte grâce que les premiers évesques de chaque ville fussent très-éminents en sainteté et comme des miroirs de perfection, afin que la postérité venant à les contempler, fût portée d'affection à les imiter; d'où vient qu'on les a dépeints ainsi au plus haut de nos églises, à l'exemple de ces héros que les anciens plaçoient au lieu plus éminent de leurs cabinets, et que saint Charles [Borromeo] a renouvellés au concile de Milan, enjoignant à ses suffragants de mettre les portraits de leurs devanciers à l'entrée du palais épiscopal, en éloignant toutes autre figures faites plustost pour le contentement des yeux que pour l'édification.' Marlot, *Histoire*, 3:524.

45 Mols, R., 'Borromeo, Charles, St.,' *New Catholic Encyclopedia*, 2nd ed. (Washington D.C., 2003), 2:540.

occupy the bottom of the window, and from 1637, if not earlier, it was the custom to remove the lowest two panels of the clerestories to provide increased viewing of the coronation ceremony. Tourneur notes that these panels were 'beaucoup plus brisés, endommagés et raccommodés que les autres …'[46] As he states, engravings of the coronations of Louis XIV and Louis XV illustrate this practice; see for example Le Pautre's engraving made in 1654, during Marlot's lifetime, of the *sacre* of Louis XIV, showing numerous witnesses hanging out of the clerestories of both choir and nave.[47]

Meanwhile back at the Abbey …

Caviness's appendix establishes that the windows of Saint-Remi, before extensive late nineteenth-century restorations, included none of the six archbishops named in the cathedral's bays 122, 124, and 126.[48] Following the restoration, which altered and added names and reordered the prelates, three of those six archbishops appeared at Saint-Remi: Donatianus (bay N.IIb), Viventius (S.IIb) and Bennadius (N.IVc).[49] Flodoard is certainly the ultimate source, of course, but as Caviness points out, 'a selection of archbishops had to be made, since the thirteenth-century list … includes forty-eight primates down to William of Champagne, whereas there was room for only thirty-three in the retrochoir. …'[50] The almost unknown Barnabas and the two Barucs, listed in Flodoard, were rejected in favor of St Donatianus and St Viventius, and of Bennadius who was buried in the cathedral. It is arguable that the restorers' selection of names for Saint-Remi was influenced by the named archbishops among the otherwise anonymous procession of thirty-six then visible in the nave of the cathedral. In the cases of both abbey and cathedral, the Gothic visitor would have seen something else.

Caviness has explained that the original line-up of archbishops at Saint-Remi formed a 'program [that] promoted the abbey as the *archimonasterium*.'[51] The unique privileges of the coronation cathedral of France were promoted no less intensely in the program of the series of nave windows towering above the actual location of the ceremony of anointing and crowning the monarch. While the destruction of over two-thirds of the nave glass in World War I dampened scholarly interest in that program, pre-war descriptions, drawings and photographs—some newly made available—provide evidence of an

46 Tourneur, *Histoire*, 56. He quotes from the cathedral's 1637 ceremonial, and notes that the most glaring misplacements of panels had been corrected four or five years before his writing.

47 *Les lieux de mémoire*, ed. Pierre Nora (Paris, 1992), 2:154. A nineteenth-century lithograph shows people standing on the exterior ledge: Demouy, *Notre-Dame* (see above, n. 18), 28.

48 Caviness, *Sumptuous Arts* (see above, n. 1), 142–44.

49 Donatianus and Viventius have been lost since ca. 1895; see the fold-out plan of Saint-Remi in Caviness, *Sumptuous Arts* (inside rear cover).

50 Caviness, *Sumptuous Arts*, 58.

51 Caviness, *Sumptuous Arts*, 58.

iconographic program that was intellectually sophisticated and thematically multivalent.[52] But that is another story.

[52] I have discussed the program of the nave rosaces in 'King Solomon in Bed, Archbishop Hincmar, the Ordo of 1250, and the Stained Glass Program of the Nave of Reims Cathedral,' *Speculum* 80 (2005): 764–801. My study of the enthroned kings and archbishops filling the nave lancets beneath the rosaces was presented at the International Medieval Congress at Leeds in July 2004, entitled 'Coronation Liturgy and the Nave Clerestory Windows of Reims Cathedral.'

PART FIVE

Gender and Reception

Subjection and Reception in *Claude of France's Book of First Prayers*[1]

Pamela Sheingorn

In her pathbreaking article on *The Hours of Jeanne d'Evreux*, Madeline Caviness argued that the visual program in the manuscript's marginalia aimed to teach young Jeanne to be sexually submissive to her much older royal husband.[2] In Caviness's words: 'my aim was to "imagine" the impact of this imagery on Jeanne at the age of fourteen, given her background and education, and the specific context of the Capetian court at the time.'[3] This article participated crucially in a sea change in the scholarly reading of illustrations in religious manuscripts, from a generally accepted view that major miniatures performed narrative and devotional functions and that marginalia were merely decorative, toward a widespread acceptance of the idea that virtually all illustrations worked to forward ideologies that shaped the behavior of the early owners and readers of such manuscripts. Such an approach depends on a shift from studying sources to studying reception; in Caviness's words, studying the 'responses by the generation or two that viewed the work in its original cultural and spatial context. …' In this way, '[W]e can attempt to contextualize the medieval experience of a work of art by constructing an individual viewer (for instance, the young queen who owned it) …'[4] Caviness's choice to study a manuscript owned by a young queen signifies her own unwavering commitment to feminist art history. She reminds us that every recipient reads through his or her gender.

[1] An earlier version of this paper was presented at a session entitled 'Religiosity, Literacy, and Late Medieval Latinity,' organized by Marilynn Desmond for the International Medieval Congress held at Leeds in July 2003. I would like to thank her for inviting me to participate, and to thank Michael Clanchy for comments at that session and for materials and offprints that he subsequently sent to me.

[2] Madeline H. Caviness, 'Patron or Matron? A Capetian Bride and a *Vade Mecum* for her Marriage Bed,' in *Studying Medieval Women : Sex, Gender, Feminism*, ed. Nancy F. Partner (Cambridge, Mass., 1993), 31–60. This book is a revised version of a special issue of *Speculum* for April 1993. See also Madeline Harrison Caviness, A Feminist Reading of the Book of Hours of Jeanne d'Evreux in *Japan and Europe in Art History: Papers of the Colloquium of the Comité International d'Histoire de l'Art, Tokyo, 1991*, ed. Shuji Takashina (Tokyo, 1995).

[3] Madeline H. Caviness, 'Reception of Images by Medieval Viewers,' in *A Companion to Medieval Art: Romanesque and Gothic in Northern Europe*, ed. Conrad Rudolph (New York, 2005).

[4] Caviness, 'Reception of Images.'

Inspired by Caviness's exemplary contributions to the use in art history of ideology critique, reception theory, and gender theory I offer to her an homage in the form of my reading of a *Book of First Prayers*, Fitzwilliam manuscript 159, made for Claude of France, a French princess who was to become a queen of France. Claude's mother, Anne of Brittany, who commissioned this book for her, was a formidable figure in the culture and politics of her day. She worked to preserve the autonomy of her duchy, Brittany, after her marriage to the French king Louis XII, Claude's father, and she opposed his support for an independent Gallican church with her own 'pro-papalist piety.'[5] The miniatures in this book suggest that Anne must have wanted her daughter to follow in her footsteps and to learn from it how to maintain a space of at least limited agency for herself. Although the miniatures in her manuscript, a beginning prayer book, overtly taught the child Claude the basic Christian narrative of salvation history, the ideology embedded in them, I argue here, aimed to form her as a subject both of the Father-God and of the Church. Offering her models of class and gender appropriate to her station, the book worked to shape her in imitation of its construction of the Virgin Mary.

Judith Butler's theories of gender as performative and of subject formation as subordination to power supply the lenses through which I interpret Claude's book. In her foundational article, 'Performative Acts and Gender Constitution,' Butler writes:

The act that one does, the act that one performs, is, in a sense, an act that has been going on before one arrived on the scene. Hence, gender is an act which has been rehearsed, much as a script survives the particular actors who make use of it, but which requires individual actors in order to be actualized and reproduced as reality once again.[6]

Claude's book offers itself as such a script. If we adopt Butler's definition of performativity as the 'power of discourse to produce effects through repetition,'[7] that is, through 'a stylized repetition of acts,' then the repeated use of a particular prayer book by a young girl might contribute substantively to the production or constitution of her gender identity.[8]

Claude, however, had to be taught not only how to be a *woman*, but also how to be a royal daughter, one of her father's subjects. In *The Psychic Life of Power*, Butler articulates a model of subjection, 'the process of becoming subordinated by power as well as the process of becoming a subject.'[9] Butler describes the creation of the subject as follows: 'Whether by interpellation, in Althusser's sense, or by discursive productivity, in Foucault's, the subject is initiated through a primary submission to power.'[10] Claude's book works to form

5 Emmanuel Le Roy Ladurie, *The Royal French State, 1460–1610* (Oxford, 1994), 94–95.

6 Judith Butler, 'Performative Acts and Gender Constitution: An Essay in Phenomenology and Feminist Theory,' in *Performing Feminisms: Feminist Critical Theory and Theatre*, ed. Sue-Ellen Case (Baltimore, 1990), 277.

7 Judith Butler, *Bodies That Matter: On the Discursive Limits of 'Sex'* (New York, 1993), 20.

8 Butler, 'Performative Acts,' 270.

9 Judith Butler, *The Psychic Life of Power: Theories in Subjection* (Stanford, 1997), 4.

10 Butler, *The Psychic Life*, 2.

Claude's subjectivity in accordance with Althusser's model of power, which 'attributes performative power to the authoritative voice, the voice of sanction,' and is based on 'divine authority.'[11] According to the ideology embodied by the representation of the Virgin Mary in Claude's book, such subjects usually conform in both their gender performance and their will to the powers that create them and to the representatives of those powers. In the miniatures in Claude's book, God the Father subordinates Mary to his will, producing the first Christian subject as a highly privileged wife and mother. From this model, Claude could learn that even though she as a female child was subordinate to the will of her mortal father, it was God the Father, as represented by the Church, who stood as the ultimate authority in an issue of primary concern. Virtually from the moment of her birth in 1499, each of her parents began making separate and conflicting plans for her marriage. I suggest here that the visual program in Claude's *Book of First Prayers* participated in preparing her for her future role as Anne saw it.

M. R. James called Fitzwilliam 159 a primer and associated it with Claude of France in his catalogue of Fitzwilliam manuscripts published in 1895.[12] Stella Panayotova confirms that association in her entry on Fitzwilliam 159 in the 2005 exhibition catalogue, *The Cambridge Illuminations*, stating that Anne commissioned the book, and pointing out the presence of the same prayers in two other manuscripts associated with Claude's siblings.[13] Thus Anne, who was in general quite concerned with the education of her children, had a set program of prayers that each was to learn. The programs of illustration, however, were unique to each child.

Claude's slender volume is best known by the full-page miniatures of its opening and closing pages. John Harthan reproduced these pages in *The Book of Hours*, where he dated the manuscript to the years between about 1505 and about 1510.[14] These pages are also reproduced in my essay on St Anne teaching the Virgin to read,[15] where I interpreted them as a visualization of the idea that children's literacy was a mother's responsibility. The miniature, *p. 1*, (fig. 18.1) invokes the name saints of both mother and daughter: St Anne, name saint of Anne of Brittany, and bishop-saint Claude (Claudius), name saint of Claude of

[11] Butler, *The Psychic Life*, 6.

[12] M. R. James, *A Descriptive Catalogue of the Manuscripts in the Fitzwilliam Museum* (Cambridge, Eng., 1895), no. 159, pp. 356–59. I avoid the word 'primer' in this essay because its use is specific to English language texts. Roger Wieck is preparing a fascimile of this manuscript.

[13] Stella Panayotova, 'The Primer of Claude of France,' entry 105 in *The Cambridge Illuminations: Ten Centuries of Book Production in the Medieval West*, ed. Paul Binski and Stella Panayotova (London, 2005), 229–31. These are Morgan Library M. 50, Anne's own prayer book, 'which doubled as an ABC for her son Charles-Orland (1492–95),' and Modena, Bibliotheca Estense, Lat. 614, a primer for Renée, Claude's younger sister and only sibling to live beyond early childhood.

[14] John Harthan, *The Book of Hours* (New York, 1977), 136–37. Panayotova follows this dating (229).

[15] '"The Wise Mother": The Image of St. Anne Teaching the Virgin Mary,' *Gesta* 32 (1993): 73–85. This essay has been reprinted in Mary C. Erler and Maryanne Kowaleski, eds, *Gendering the Master Narrative: Women and Power in the Middle Ages* (Ithaca, N.Y., 2003), 105–34.

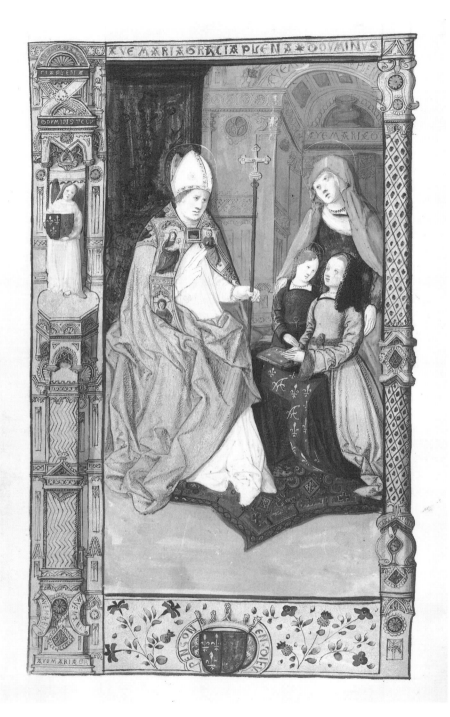

18.1 St Anne presenting the Virgin Mary and Claude of France to St Claude from *Claude of France's Book of First Prayers*, Cambridge, Fitzwilliam, MS 159, ca. 1505–10, p. 1.

France. In the miniature, St Anne presents her daughter, the Virgin Mary, and Queen Anne's daughter, Claude, to St Claude. The closed book on which Claude rests her folded hands signifies that she has not yet learned to read. The same four figures appear on the last page in Claude's book, *p. 14*, but in a significant rearrangement: St Anne and Mary enact the familiar iconographic subject of St Anne teaching the Virgin Mary to read, while St Claude stands protectively behind the kneeling Princess Claude, whose folded hands are placed on her open book. The transfer of Princess Claude from St Anne to St Claude suggests that as part of learning to read, Claude has become a subject of male ecclesiastical authority. But Claude's clothing reveals that between page one and page fourteen she was also to have been completely formed as her mother's daughter; on page one, she wears a Breton headdress, and on page fourteen her entire costume is Breton. As Panayotova notes with regard to the miniature, *p. 14*, 'Claude's black gown and Breton headdress display the fashion Anne of Brittany introduced in the royal court. It may also represent an attempt to clothe the young girl in her mother's role, in anticipation of her future as planned around 1504–1505.'[16] My reading of Claude's book suggests that its program of illustrations did indeed carry that ideological function.

In a subsequent article I emphasized the ideological contents of page one, [17] pointing out the repeated emphasis on the Virgin Mary. Though she is represented as a child in the miniature, Mary's future is spelled out not only in the image of the Virgin and Child embroidered on the bishop-saint's vestments, but also in the motto at the top of the page, 'Ave, Maria, gratia plena' (Hail, Mary, full of grace), the beginning of a familiar prayer that is continued on the fanciful column framing the left side of the image, 'Dominus tecum' (the Lord is with you). The obsessive repetition of these words on the opening page of Claude's book corresponds to her repetition of them in her devotional practices and reinforces her shared positionality with the Virgin Mary that is visualized in the first and last miniatures of her book. In this context repeated recitation of that prayer activates the effect of femininity within normative heterosexuality; that is, Claude's repetition of the prayer that refers to Mary's acceptance of the Incarnation produces Claude's sexed and gendered body as one prepared to accept her role as her mother's daughter and as daughter of the Church.

Claude's marriage was in the minds of both of her parents. In December 1501, when Claude was just two years old, they formalized an agreement with

[16] Panayotova, 'The Primer,' 230.

[17] 'The Maternal Behavior of God: Divine Father as Fantasy Husband,' in *Medieval Mothering*, ed. John Carmi Parsons and Bonnie Wheeler (New York, 1996), 77–99. For a survey of surviving images of 'ladies with prayer books' in relation to literacy, which includes a consideration of the representation of St Anne teaching the Virgin, see Michael Clanchy, 'Images of Ladies with Prayer Books: What Do They Signify?' in *The Church and the Book. Papers Read at the 2000 Summer Meeting and the 2001 Winter Meeting of the Ecclesiastical History Society*, ed. R. N. Swanson, Studies in Church History 38 (Woodbridge, Suffolk, 2004), 106–12. For an exemplary study of books of hours owned by women, see Kathryn A. Smith, *Art, Identity, and Devotion in Fourteenth-Century England: Three Women and Their Books of Hours* (London, 2003).

Philippe le Beau and Jeanne le Folle stating that Claude would marry their son Charles of Austria (younger than Claude) when the children reached puberty. Anne strongly favored this marriage; Le Roy Ladurie characterizes Louis's agreement to the betrothal as 'concessions which she—bitter and haughty—extracted from Louis XII in his weaker moments on behalf of their daughter, Claude of France.'[18] Instead, when Claude was seven she was officially betrothed to Francis of Angoulême, who would succeed her father on the French throne; they were married when she was fourteen. Thus, during the time that Claude would have been learning to read Latin from her book of first prayers, she was well aware that the role of wife and mother had been prescribed for her.

Not only in its opening and closing miniatures, however, but also in the pages between them, this manuscript presents a carefully-shaped model of the Virgin Mary, both in relation to God the Father, and in relation to her earthly husband, Joseph the Carpenter. Using Judith Butler's theories of subjection, I argue here that Claude's book presents salvation history in a way that teaches her both how to perform as the daughter of a Christian king and of the Church. To explore this relationship, we need to look at the pages between one and fourteen, the contents of which led Nicole Reynaud and François Avril to refer to this manuscript as 'le charmant *Livre des premières prières de Claude de France*' (the charming *Book of First Prayers* belonging to Claude of France).[19] These first prayers are the basic Latin prayers that a child would learn by heart at an early age: the Pater Noster, Ave Maria, and Creed; short prayers to say before and after eating; prayers for the dead and for forgiveness of sin; and the *Confiteor*, *Agnus Dei*, and *Sanctus*.

In contrast to the simple layout of the first and last pages, pages two through thirteen, which contain the texts of the prayers, follow a design in which elements compete for the reader-viewer attention in a visual barrage of information. This competition for attention extends to the language of the textual material as well: the 'official' contents of the book, as indicated by the size of the text panel and its placement, *p. 2*, begin with the alphabet and a few common abbreviation signs (fig. 18.2),[20] then continue with a sequence of prayers in Latin. What we know about Latin literacy in this period suggests that the user of this book would already have been taught to say these prayers and had memorized them. Their function here was to offer the beginning reader words that represent a sequence of familiar sounds, an excellent way to begin attaching meaning to written words. Once this process was complete, the owner of the book would have internalized both words and meaning so completely

[18] Le Roy Ladurie, *The Royal French State*, 97. On the initial negotiations for this marriage and Anne's leading role, see Georges Minois, *Anne de Bretagne* (Paris, 1999), 412–13.

[19] François Avril and Nicole Reynaud, *Les Manuscrits à Peintures en France: 1440–1520* (Paris, 1993), 393 and 397.

[20] For a color reproduction of pp. 1–2, see Panayotova, 'The Primer,' 230. The alphabet reproduced on p. 2, with more than one form of the letter *a*, the first *a* capital, as well as two different forms of *r* and of *s*, is common at the end of the Middle Ages. On late medieval and early modern alphabets, see Nicholas Orme, *Medieval Children* (New York, 2001), 246–51; and Paul F. Grendler, *Schooling in Renaissance Italy: Literacy and Learning 1300–1600* (Baltimore and London, 1989), 142–61.

that she will not need to see these prayers in writing in her adult prayer books.[21] The miniatures in this book were designed, I suggest, to perform a similar function, that is, to install in Claude a specific interpretation of salvation history relevant to her own position in life, with the goal that Claude would perform her gendered role as a royal Christian subject as effortlessly and automatically as she recited these basic prayers.

Page two (fig. 18.2) is typical of those that follow: above the text panel a low rectangle encloses a non-narrative image—here, the emblems of the Passion, dominated by a large cross that extends into the text panel below it. Texts that M. R. James calls 'mottoes' appear in the borders of some of these non-narrative images. These texts are not only in a different language, French, than the 'main' text but also in a different script. The motto, *p. 2*, reads:

A MON * PROMIE * COMENCEMEN * SOIT
DIEU * LE PERE * TOV*PVISSEM * AMEN
[May God the Father, all powerful, be {present/with me} as I begin].

This invocation and the cross function in connection with the alphabet below. According to Nicholas Orme, in a book such as this one a cross usually preceded the alphabet and 'triggered' for the reader words to be spoken before reading the alphabet. An English reader would say 'God me speed,' 'Cross Christ me speed,' or expanded versions such as 'Christ's cross be my speed, in all virtue to proceed.'[22]

I suggest that the invocation of God the Father in Claude's book performs the same function. Claude's book teaches her to call on God the Father, a lesson enforced by the book's images.

More than half of the space on pages two through thirteen is filled with a visual narrative, three scenes per page. Consistently, two of the scenes are accompanied by captions on the double-arched frames. These captions are entirely in French and in the same script as the motto. To James's eye, 'The legends of the miniatures are in an odd barbarous orthography, sometimes wellnigh unintelligible,'[23] but in fact the consistent use of capitals, in spite of their orthography, makes these texts fairly legible. It is possible that, at the time the manuscript was presented to her, Claude had already learned capital letters, since the alphabet, *p. 2*, with the exception of the initial A, is entirely in lower case. Perhaps she could even read French written in what we might call block letters. Looking back, *p. 1*, we note that this same script is used for the text of the 'Ave Maria' in the top border and on the architectural elements of the side column. The book's first page thus appears to offer Claude a transition from French literacy to Latin literacy by employing a familiar script for the unfamiliar Latin words.

[21] On prayer books made for children, see Roger S. Wieck, 'Special Children's Books of Hours in the Walters Art Museum,' in '*Als ich can.' Liber Amicorum in Memory of Professor Dr. Maurits Smeyers*, ed. Bert Cardon, J. Van der Stock, and D. Vanwijnsberghe (Leuven, 2002), 1629–39.

[22] Orme, *Medieval Children*, 251–54.

[23] James, *A Descriptive* Catalogue, 357.

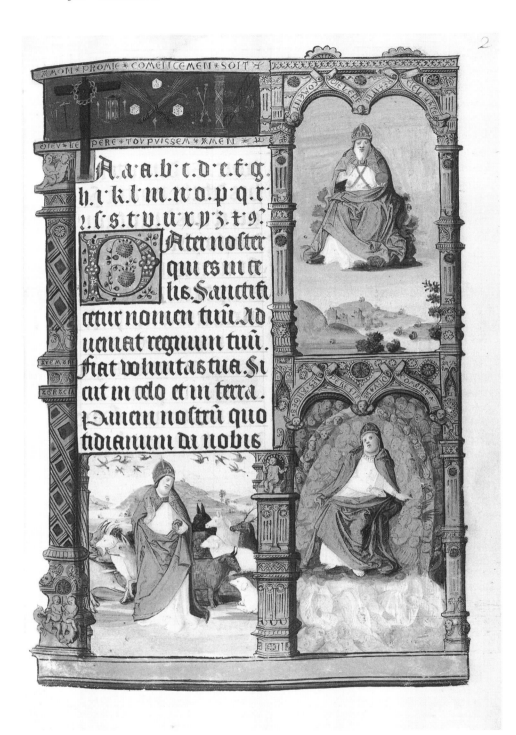

18.2 Alphabet and beginning of *Pater Noster*; Creation scenes from *Claude of France's Book of First Prayers*, Cambridge, Fitzwilliam, MS 159, ca. 1505–10, p. 2.

The visual narrative that begins on page one and continues through page thirteen could be understood as a kind of third language. It opens with the Creation sequence, *pp. 2–3*, moves on to the Temptation, Fall, and Expulsion, *p. 4*; the labors of Adam and Eve, Adam's final illness, and Seth's journey to Paradise, *p. 5* (fig. 18.3); the burial of Adam, the souls in Limbo pleading for salvation, and the debate of the daughters of God, *p. 6*; the resolution of the debate, an angel instructing a bishop, and the bishop sending out messengers, *p. 7*; a messenger greeting Mary, Mary appearing before the bishop, and a messenger summoning the men of Israel, *p. 8*; the miracle of Joseph's rod, the marriage of Mary and Joseph, and Mary and Joseph laboring, *p. 9* (fig. 18.4); the Annunciation, the Visitation, and Joseph accusing Mary, *p. 10* (fig. 18.5); Mary praying, God the Father sending an angel, and Joseph's first dream, *p. 11* (fig. 18.6); Joseph begging Mary's pardon, Mary and Joseph searching for a room in Bethlehem, and Mary and Joseph adoring the Christ Child, *p. 12* (fig. 18.7); the Annunciation to the Shepherds, the Adoration of the Shepherds, and one of the Virtues (Sapientia or Caritas?) addressing the souls in Limbo, *p. 13*. Pages are designed so that each opening presents a wide border of images framing the inner panels of text (figs.18. 4 and 18.5, for example), and on each page the narrative begins with the image in the upper corner.

Each of the three creation scenes, *p. 2*, centers on the figure of God the Father, whose headgear resembles the papal tiara. The scenes surround the first text Claude was to learn to read, the Pater Noster or Our Father. This page also features three repetitions of the French words 'Dieu le Pere,' one in an eye-catching location just above the ABCs. Thus an instructor could point to French, Latin, and visual renditions of this same concept, God as Our Father. Connections between the visual and the verbal include the way the first caption, 'COMENT DIEU LE PERE FIT LE CIEL & LA TER[RE]' contains the French equivalent 'ciel' of the Latin 'celis' that occurs in the first sentence of the prayer, 'Pater noster qui es in celis,' as well as the words 'le ciel & la terre' repeated in the phrase of the prayer, 'Sicut in celo et in terra.' As this example shows, much thought must have been given both to enhancing the appeal of learning to read these Latin prayers and to incorporating basic religious lessons as well.

The design encouraged Claude to linger over each page and challenged her to decipher each of its details. A closer look at the captions, for example, reveals that at the upper right the words alternate in direction. The caption to the miniature below precisely reverses this format, so that the opening word, 'COMENT' is right-side-up but placed at the right, requiring that the caption be read from right to left. Such variety made each page a new challenge, a kind of game.

The bright colors and intricate details of the miniatures would hold the child's attention while a teacher, perhaps Anne of Brittany herself, perhaps one of the women responsible for Claude's care, such as Madame de Tournon or Michelle de Saubonne, helped her to understand the narrative.[24] The miniature at the lower right, *p. 2*, for example, could be used to learn that there are

24 Minois, *Anne de Bretagne*, 433.

different kinds of angels, perhaps even the names of the orders of angels, as well as the narrative of the fall of the rebel angels. The third miniature, God creating the animals, makes this even more like a child's 'activity book.' Within the miniature the artist has carefully distinguished a variety of animals, all of them recognizable to a small girl growing up in early sixteenth-century France. Because of the conceit that the text panel overlaps the frame of this miniature, it has no caption. A teacher thus would have the opportunity to review the French names of the animals, to introduce their Latin names, and even to ask the pupil to supply the missing caption, a kind of 'fill-in-the-blanks' exercise. The same design characterizes all of the pages through thirteen, offering a way for the pupil to engage in active narration of sacred history.

Although such tight text-image relationships do not occur on every page, examples may easily be multiplied. The border of the small rectangular panel, *p. 3*, repeats the beginning of the Pater Noster on the previous page and thereby serves as a running head for the text below. In the miniature at the upper left, God the Father stands to create the sun and the moon, pointing up not only to these heavenly bodies but also to the words 'Pater noster' in the adjoining border. Throughout this book, both the visual narrative of the miniatures and the verbal narrative of the French captions help the student to remember the meanings of the Latin words on the same pages.

In the upper rectangular frame, *p. 7*, the personified virtues called the daughters of God agree to a plan of salvation for humankind: Mercy and Truth embrace, and Justice and Peace kiss each other. Next, the implementation begins as an angel sent by God instructs a bishop (a clear statement that God works through the institutional Church and perhaps a reminder of Claude's patron saint, Bishop Claude) and, in the next panel, the bishop sends out a messenger. On the facing page, *p. 8*, the messenger summons first Mary, who reports obediently to the bishop, and then a group of men including Joseph, who listen carefully to the messenger's words. The Father-God's power to create and discipline subjects is emphasized throughout this sequence. Both Adam and Eve and Mary and Joseph come into being as God's subjects. As Butler writes, '"Subjection" signifies the process of becoming subordinated by power as well as the process of becoming a subject.'[25] This dual meaning inherent in subjection is crucial. The mechanism by which power is exerted over Adam and Eve is at first direct, then mediated by God's angel, who expels them from Paradise. In the case of Mary and Joseph, God's angel employs a further intermediary, the bishop. They are subjected to ecclesiastical discipline, discipline that must have appeared to the young Claude as that of the Christian Church; the bishop's power over them creates Mary and Joseph as Christian subjects. Not only does the bishop appear repeatedly as the central figure in scenes, but Mary and Joseph visibly subordinate themselves to his authority: Joseph bends one knee and leans forward in response to the bishop's messenger, and Mary repeats the same posture and gesture when she presents herself to the bishop.

25 Butler, *The Psychic Life*, 2.

Joseph's rod flowers in the presence of the ecclesiastical authority, as the miniature in the upper left corner, *p. 9*, illustrates (fig. 18.4). In the miniature beneath it, Mary and Joseph obey God's will by marrying. On Mary's head is a crown, symbol of her superior status and perhaps reminder to Claude that she herself as queen of France will have a status on earth parallel to that of the queen of heaven. Still, the couple is subject to the punishment of Adam and Eve, that is, to work, and the next miniature shows them at their domestic labor. The composition strongly parallels the miniature of Adam and Eve at work, *p. 5* (fig. 18.3), but reverses the emphasis: Adam, in the foreground, works the earth with a hoe, while Eve, in the distant background, sits in front of their house, spinning with her distaff. By contrast, Mary is the foreground figure, but she sits and weaves, thus continuing Eve's work of making cloth. Joseph, in the background, swings a hammer over his head as he engages in his work of carpentry.

According to Butler, 'no subject emerges without a passionate attachment to those on whom he or she is fundamentally dependent.'[26] The Annunciation at the top right, *p. 10* (fig. 18.5) visualizes Mary's acceptance of God's plan, that is, her willingness to participate in the Incarnation, a willingness that can only be explained by her passionate attachment to God the Father. Mary's agency, as demonstrated by her ability to choose, is often emphasized by medieval Christian writers who see Mary as the new Eve. Such agency might appear to contradict her subjection, but Butler explains that 'Subjection consists precisely in this fundamental dependency on a discourse we never chose but that, paradoxically, initiates and sustains our agency.'[27] Mary's choice, which undoes Eve's decision to eat the fruit, conforms to the will of the Father and demonstrates the appropriate submissiveness of normative femininity.

The Visitation, portrayed in the lower left corner, *p. 10*, is unusual in showing Elizabeth kneeling before Mary, the older woman revering the younger in a reversal of social norms. Elizabeth's passionate attachment to Mary arises from her recognition of Mary's role in salvation history, that is, it affects Elizabeth's emergence as a Christian subject. This scene indicates how exalted Mary has become as a consequence of conforming to God's will.

The next scene reverses Mary's position. Far from exalting her, Joseph accosts Mary, having just learned of her pregnancy. The scene, which appears just below the text panel on page ten containing the opening of the *Confiteor*, has no caption. In this miniature Mary sits with head bowed, an open book on her lap, and her left hand raised to her cheek. Joseph, who has just walked in and neglects to remove his hat, makes a disdainful gesture of rejection, indicating that the subject of the miniature is Joseph's berating Mary for her pregnancy. Joseph exercises his agency, which as Butler puts it, 'exceeds the power by which it is enabled. One might say that the purposes of power are not always the purposes of agency. To the extent that the latter diverge from the former, agency is the assumption of a purpose *unintended* by power, one that could not

[26] Butler, *The Psychic Life*, 7.
[27] Butler, *The Psychic Life*, 2.

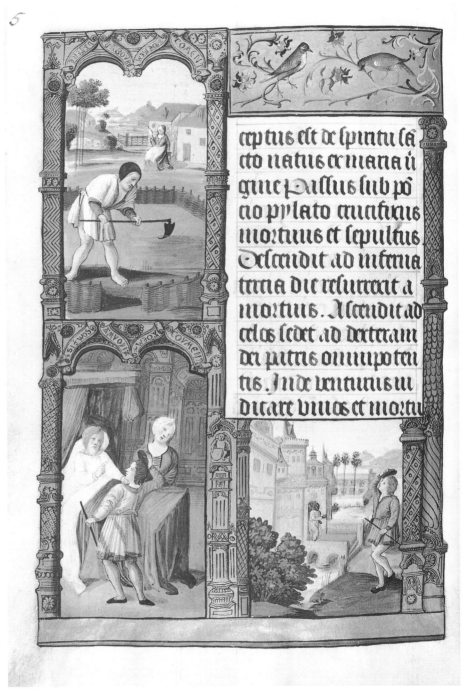

18.3 Portion of *Credo*; Labors of Adam and Eve, Adam's final Illness, and Seth's Journey to Paradise from *Claude of France's Book of First Prayers*, Cambridge, Fitzwilliam, MS 159, ca. 1505–10, p. 5.

9

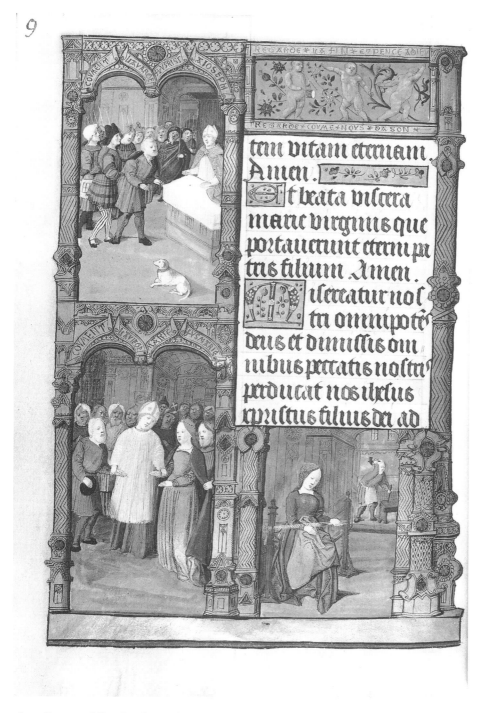

18.4 Prayers; Miracle of Joseph's Rod, Marriage of Mary and Joseph, and Mary and Joseph Laboring from *Claude of France's Book of First Prayers*, Cambridge, Fitzwilliam Museum, MS 159, p. 9.

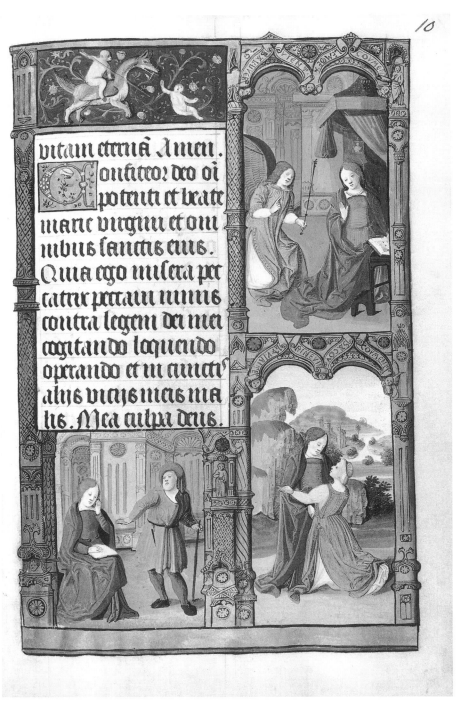

18.5 *Confiteor*; Annunciation, Visitation, and Joseph Accusing Mary from *Claude of France's Book of First Prayers*, Cambridge, Fitzwilliam, MS 159, ca. 1505–10, p. 10.

have been derived logically or historically, that operates in a relation of contingency and reversal to the power that makes it possible, to which it nevertheless belongs.'[28] It was not part of the purposes of heaven that Joseph should either abandon Mary or expose her to be punished for adultery. But Joseph behaves here in accordance with normative masculinity; a heterosexual man would be expected to react strongly and negatively to being cuckolded. M. R. James suggests that Mary is weeping in this scene.[29] If so, I know of no other such example, but it is an intriguing possibility. The emphasis in the visual narrative is on Mary as the one sinned against and on her silent, humble bearing, which shows her acceptance of God's plan as well as her properly submissive behavior as Joseph's wife.

But this does not mean that Mary had no recourse. The miniature at the upper left, *p. 11* (fig. 18.6) is captioned: 'COVMENT LA VIEGE MARIEE PRIA DIEV' and centers on Mary, dressed entirely in blue and kneeling in prayer in front of a classicizing canopy, perhaps representing the Virgin's *'hortus conclusus.'* Joseph has implemented his decision to leave Mary rather than to expose her pregnancy and exits the garden at the left rear. Meanwhile, his abandoned and maligned wife appeals directly to her powerful father. Pictured as a mighty ruler wearing the papal tiara and surrounded by hosts of angels in the miniature below, the Father God acts in response, raising his right hand in a gesture of command as he instructs an angel to go to Joseph.

In the third miniature on this page, Joseph lies asleep on the ground, while in the background Mary sits patiently reading. She is framed within the doorway of a very ornate building, resembling a church more than a house, and reminiscent of early Netherlandish painting. Joseph's placement is unusual: in the art of this period, his dream-visions more frequently take place in a comfortably furnished bedroom. Here, his recourse to resting on the bare ground reinforces the idea that he has abandoned Mary as well as rendering him literally abject. Though no angel is visible, this is the miniature overlapped by the text panel, and the opening words of the prayer, 'Sanctus, sanctus, sanctus' obscure the top of the image. Since these words originate in Ezekial's vision of heaven, in which angels surrounding God's throne chant these very words, the reader-viewer might imagine that the angel who appears to Joseph in his dream is present 'beneath' the text panel. It may also be significant that Joseph is placed at the left edge of the miniature, that is, as close as possible to the miniature of God the Father instructing the angel. This juxtaposition represents, I would argue, the moment when Joseph is called into being as a Christian subject, one who will from this point forward conform his will to that of the Father.

In the next miniature at the upper right, *p. 12* (fig. 18.7), Joseph shows that he has absorbed the lesson and knows how to be an obedient subject. The caption puts it this way: 'COVMENT IOSEP * VIENT CRIEME [How Joseph came to cry mercy].' Here the setting is clearly domestic: in the background we

28 Butler, *The Psychic Life*, 15.
29 James, *A Descriptive Catalogue*, 358.

18.6 End of *Confiteor* and beginning of *Sanctus*; Mary praying, God the Father sending an angel, and Joseph's First Dream from *Claude of France's Book of First Prayers*, Cambridge, Fitzwilliam, MS 159, ca. 1505–10, p. 11.

18.7 End of *Sanctus* and beginning of *Agnus dei*; Joseph Begging Mary's Pardon, Mary and Joseph searching for a room in Bethlehem, and Mary and Joseph Adoring the Christ Child from *Claude of France's Book of First Prayers*, Cambridge, Fitzwilliam, MS 159, ca. 1505–10, p. 12.

see a female servant in a room with a red-covered bed. Seated with a book on her lap, Mary gazes solemnly at the humble Joseph, who has entered from the left and bends on one knee. His hands are joined in supplication and his head is bared. He has now been disciplined into obedience by God, not by Mary, who performs only one action in her four appearances in this sequence, the action of invoking her father on the facing page. Otherwise she sits calmly, patiently, neither berating nor pleading with her husband.

Joseph's role in the other two miniatures on this page puts him in subordinate positions. First in the interaction with the innkeeper in the scene below right, Joseph, partially obscured by Mary's donkey, leans forward on his staff, betraying his age, but he makes no speech gesture. Mary and the innkeeper, with each of their faces in profile, appear to engage directly with each other, reducing Joseph to a secondary figure. Mary's gesture, with palms pressed together as if begging a favor, is answered by the innkeeper's downturned right hand. And in the Adoration of the Child, which substitutes for the Nativity in art of this period, Joseph bends forward and bows his head whereas Mary, though kneeling, holds her torso straight and shoulders back. After the brief rebellious episode in which he decided to exercise his agency and abandon Mary, Joseph has returned to his subordinate masculinity. He has a passionate attachment to the Father-God and assumes his role as *nutritor* of God's child.

As I noted above, the basic purpose of the book was to teach Claude to read Latin. But just as is true for first readers intended for modern children, ideology is part of the package. The *Dick and Jane* books instructed children in heteronormativity as well as basic English, just as this book instructed Claude in the behavior of a royal daughter, subject of a Christian king and queen, as well as in reading Latin. The simplified story tells how an all-powerful father, through the mechanism of the Church, chooses his daughter for a crucial role and finds a husband for her. She does what he asks of her, in spite of the extremely unusual nature of his request. In return, he listens to her and takes immediate corrective action when her husband causes her grief.

It is quite clear that Anne commissioned this manuscript and gave it to Claude. Eberhard König has identified the artist, who was previously known from the name of one of his patrons as the Master of Antoine de Roche.[30] König has shown that he was the Italian artist Guido Mazzoni of Modena, who accompanied Charles VIII on his return from Italy to France, and after 1498, continued a professional association with Charles's widow, Anne of Brittany.

The timeframe for the production of Claude's *Book of First Prayers*, 1505–10, overlaps with the period of struggle between Claude's parents over her marriage.[31] Since soon after Claude's birth, her mother Anne had favored Charles of Austria, the future Charles V, grandson of Emperor Maximilian and

[30] Eberhard König, *Das Guémadeuc-Stundenbuch. Der Maler des Antoine de Roche und Guido Mazzoni aus Modena*, (Rotthalmünster and Bibermühle, 2001). Avril first noticed that this artist also made Claude's *Book of First Prayers*. Antoine de Roche, an important churchman, was the grand prior of Cluny, a member of the Royal Council, and a close associate of the royal family. See Avril, catalogue entry 226 in Avril and Reynaud, *Les manuscrits*, 397–98.

[31] On this struggle see Minois, *Anne de Bretagne*, 465–503.

King Ferdinand of Aragon. In selecting the Austro-Spanish-Flemish Charles, Anne was expressing her 'old territorial and noble view,' her 'specifically feudal and ultra-Catholic … cast of mind,' according to Le Roy Ladurie.[32] Negotiations with Charles's father began in 1501, and Claude and Charles were betrothed by the terms of the Treaty of Blois, which was concluded in 1504. This treaty would have lead to the partitioning of French territory into the possessions of the Valois house, to remain with the French crown, and lands that would include Burgundy and Brittany, to be ruled by the young couple.

Claude's father, Louis XII, had other plans. Before negotiations over the marriage with Charles had even opened, Louis XII signed a secret document nullifying in advance the engagement of his daughter to anyone other than Francis of Angoulême. In 1506 Louis XII allowed 'an assembly of great lords and representatives of towns in the Touraine' to persuade him to break the Treaty of Blois and instead to marry Claude to her cousin and the heir to the throne. As Le Roy Ladurie puts it, 'This francocentric solution of marriage between Claude and Francis would thus unite the kingdom's cat with its mouse.'[33] Claude's dress on page fourteen of her book finally signified only regional dress. Anne had lost her struggle to protect Breton autonomy, because from the beginning Louis XII had preferred the match that would consolidate the kingdom of France and pass it to the next ruler intact.

No instructions remain that specify the contents of the illustrations in Claude's book. Furthermore, the selection of episodes generally follows that of late medieval French passion plays, in for example, the inclusion of the debate among the personified virtues. Both the early fifteenth-century *Mystère de la Passion* usually attributed to Eustache Marcadé,[34] and its rewriting by Arnoul Gréban in the mid-fifteenth century,[35] include Mary's prayer to God the Father after Joseph accuses her. However, none of the illustrated manuscripts of these plays includes a miniature of this scene.[36] A lavishly illustrated manuscript of Marcadé's play, the late fifteenth-century manuscript, Arras, Bibliothèque Municipale MS 697, includes three miniatures for the sequence that enacts Joseph's doubt: Joseph rebukes Mary for her pregnancy (18r); Joseph's dream (19r); and Joseph begs Mary's pardon (19v).[37] What is striking is that this sequence does not include miniatures of Mary's prayer or

32 Le Roy Ladurie, *The Royal French State*, 98.

33 Le Roy Ladurie, *The Royal French State*, 97.

34 Eustache Mercadé, *Le Mystère de la Passion: Texte du Manuscrit 697 de la Bibliothèque d'Arras*, ed. Jules-Marie Richard (Arras, 1891).

35 For editions using different base manuscripts, see Arnoul Gréban, *Le Mystère de la Passion d'Arnould Greban*, ed. Gaston Paris and Gaston Raynaud (Paris, 1878); Arnoul Gréban, *Le Mystère de la Passion*, ed. Omer Jodogne (Brussels, 1965; 1983).

36 On illustrated manuscripts of Gréban's play, see Robert L. A. Clark and Pamela Sheingorn, 'Performative Reading: The Illustrated Manuscripts of Arnoul Gréban's *Mystère De La Passion*,' *European Medieval Drama* 6 (2002): 129–54.

37 All of the miniatures in *Arras 697*, in pen and ink with color washes, are paste-downs, that is, each has been cut out and pasted into this paper manuscript. On their method of production and its significance, see Laura Weigert, 'Illuminating the *Arras Mystery Play*,' in *Excavating the Medieval Image: Manuscripts, Artists, Audiences: Essays in Honor of Sandra Hindman*, ed. David S. Areford and Nina A. Rowe (Burlington, Vt., 2004), 81–106.

God's response. Thus the decision to include miniatures representing these events in Claude's book appears to have been a deliberate, ideologically laden choice.

The miniatures in Fitzwilliam 159 shape the young female reader to take up her gendered position as a Christian subject under the protective power of the Father-God, who, in this reading, also stands for the father of the Church, the pope. That power will extend, if necessary, to the disciplining of Claude's future husband. Claude's book teaches her that if she adopts her mother's pro-papalist piety, her future husband will be a subject under the operation of disciplinary power, a man who, like Joseph, learns to perform a subordinate masculinity.

'Why Can't a Woman Be More Like a Man?' Transforming and Transcending Gender in the Lives of Female Saints

Martha Easton

A highlight of *My Fair Lady*, Lerner and Loewe's musical retelling of the Pygmalion tale, is Henry Higgins' blustering song, 'A Hymn to Him,' in which he peevishly asks his sidekick Colonel Pickering, 'Why can't a woman be more like a man?' Eliza Doolittle has just run off in tears after the two men congratulate each other for their success at passing the lowly flower girl off as a princess at a London ball, oblivious to her contributions to the proceedings. In the eyes of Higgins and his like, the transformation of Eliza Doolittle allows her to move from one class to another, but her perceived emotionality and whimsy firmly characterize her as female, and thus not worthy of notice. She can transcend her class, but not her gender; she can pass as a lady, but not as a man.

In contrast, despite the relatively rigid social roles assigned to ordinary men and women in the Middle Ages, there are many instances of female saints who did become 'more like men,' and because of this shift in gender roles, they were lauded in hagiographic writings ranging in date, function, and audience from the *vitae* of the early church to later compilations of saints' lives such as Jacobus de Voragine's *Legenda aurea*. This latter work, a compendium of hagiographic and liturgical material organized according to the Church calendar, was compiled in the second half of the thirteenth century and quickly became the most widely-reproduced text outside of the Bible in the later Middle Ages, bringing the stories of these saints to a large audience.[1]

[1] The best recent translation is Jacobus de Voragine, *The Golden Legend: Readings on the Saints*, 2 vols, trans. William Granger Ryan (Princeton, 1993), based on the second edition of the Latin transcription published by T. Graesse in 1850. The edition was reprinted in 1890 and later a photo-offset reproduction produced: T. Graesse, ed., *Jacobi a Voragine Legenda Aurea Vulgo Historia Lombardica Dicta*, (Osnabrück, 1969). See also Sherry L. Reames, *The Legenda aurea: A Reexamination of Its Paradoxical History* (Madison, Wis., 1985); Brenda Dunn-Lardeau, ed., *Legenda aurea: Sept siècles de diffusion* (Montreal, 1986); Brenda Dunn-Lardeau, ed., *Legenda aurea—la Légende dorée (XIIIe–Xve s)*, (Montreal, 1993); Barbara Fleith, *Studien zur Überlieferungsgeschichte der Lateinischen Legenda aurea*, Subsidia Hagiographica 72 (Brussels, 1991); and Giovanni Paolo Maggioni, *Ricerche sulla composizione e sulla trasmissione della Legenda aurea*, Biblioteca di Medioevo latino 8 (Spoleto, 1995).

The method of the female-to-male transformation varied, but was usually successful through an abandonment of characteristics deemed to be 'feminine' and an appropriation of those typically recognized as 'masculine;' this latter could be accomplished through social, spiritual, or even physical transformation. One of the most effective ways women could become more like men was by adopting male dress; there are close to forty cross-dressing female saints who lived between the earliest days of Christianity and the sixteenth century.[2] Here I propose to examine both textual accounts and artistic representations of female saints who are 'masculinized' both in word and image in order to connote their uncommon spirituality; while I intend to focus on female saints included in the *Legenda aurea*, I will contextualize this discussion with an examination of the gender-bending potential of the lives of other female saints as well as certain romances featuring women who cross-dress as men. Yet despite the best efforts of these women to take on masculine roles, both the hagiographic and romantic 'heroes' paradoxically enact their gender transformations through their bodies, typically gendered feminine in medieval discourse.

Most of the discussion about medieval cross-dressing in recent scholarship has focused on its treatment in medieval texts, with almost no consideration of the role images play in the medieval and modern perception of this phenomenon.[3] By the very nature of the narrative form, both hagiographic and romantic texts present a more ambivalent view of cross-dressing women. The stories follow similar arcs during which the protagonists embrace cross-dressing as the solution to a narrative crisis. The women then successfully pass (usually for long periods of time) as men, until at the climax of the tale their gender is revealed and the extent of their accomplishments is fully realized. The reader experiences the narrative progression of the text, where the tension between embodied sex and gendered performance is constantly in play. In contrast, medieval images illustrating the lives of transvestite saints, as well as other female saints who are 'masculinized' in hagiographic texts, often freeze them in activities or attitudes that are explicitly female-gendered in medieval culture. In the end, despite its potential for transgression, the cross-dressing of

[2] Valerie Hotchkiss, *Clothes Make the Man: Female Cross Dressing in Medieval Europe* (New York, 1996) includes an appendix with synopses of the lives of thirty-four female cross-dressed saints.

[3] Hotchkiss, *Clothes Make the Man*; John Anson, 'The Female Transvestite in Early Monasticism: The Origin and Development of a Motif,' *Viator* 5 (1974): 1–32; Vern Bullough, 'Transvestites in the Middle Ages,' *American Journal of Sociology* 79 (1974): 1381–94; Marjorie Garber, *Vested Interests: Cross Dressing and Cultural Anxiety* (New York, 1992); Vern L. Bullough and Bonnie Bullough, *Cross Dressing, Sex, and Gender* (Philadelphia, 1993); Vern L. Bullough, 'Cross Dressing and Gender Role Change in the Middle Ages,' in *Handbook of Medieval Sexuality*, ed. Vern L. Bullough and James A. Brundage, Garland Reference Library of the Humanities (New York, 1996), 223–42; E. Jane Burns, 'Refashioning Courtly Love: Lancelot as Ladies' Man or Lady/Man?' in *Constructing Medieval Sexuality*, ed. Karma Lochrie, Peggy McCracken, and James A. Schultz, Medieval Cultures 11 (Minneapolis, 1997), 111–34; E. Jane Burns, *Courtly Love Undressed: Reading Through Clothes in Medieval French Culture* (Philadelphia, 2002); Stephan J. Davis, 'Crossed Texts, Crossed Sex: Intertextuality and Gender in Early Christian Legends of Holy Women Disguised as Men,' *Journal of Early Christian Studies* 10:1 (2002), 1–36.

saints, along with other methods of gender transformation, simply underscores typical gender roles and normative heterosexuality; in hagiography, the only ones doing the cross-dressing are women.

The differences between men and women were evident in medieval medical beliefs and practices. The Galenic idea that women were 'colder' than men, and therefore necessarily more passive, was given great credence in medical thought. According to this theory, the greater warmth of the male allowed the male sexual organs to develop fully and extend outside the body, whereas the female sexual organs stagnated in a more primitive state.[4] Even more influential was the idea that a women's reproductive system was but a man's turned outside in; medieval medical literature calls the ovaries 'female testicles.'[5]

This latter belief is particularly illuminating in suggesting how the binary system of gender might be made flexible in medieval thought.[6] Although the male and female were associated with particular properties and characteristics, the fact that women were perceived as essentially inside-out men implies that gender is not irreversibly inscribed on the body, but might be transformed. Women who spread their legs too far might even risk having their reproductive organs fall out; Pliny had described a few such incidents in which women turned into men,[7] and such tales can be found in ancient, medieval and early modern folk literature.[8]

According to Philo, in order to progress, to become more 'masculine,' a woman had to give up her natural connection to the body; the easiest way to achieve such an evolution was through celibacy.[9] The connection between female sanctity and celibacy, and even better, virginity, is a long-standing one in the Christian hagiographic tradition; the denial of bodily appetites is an important first step in the move from feminine to masculine, even if virginity is not nearly as common a leitmotif in the lives of male saints.[10] The oft-quoted

4 Galen, *On the Usefulness of the Parts of the Body (De usu partium)*, trans. Margaret Tallmade May, 2 vols (Ithaca, N.Y., 1968) 14.6 in 2:628–30; Jacqueline Murray, 'Hiding Behind the Universal Man: Male Sexuality in the Middle Ages,' in *Handbook of Medieval Sexuality*, 127.

5 Vern Bullough, 'Mediaeval Medical and Scientific Views of Women,' *Viator* 4 (1973): 493.

6 For more on medieval attitudes towards gender, which extend back to Aristotle, see: Bullough, 'Mediaeval Medical and Scientific Views,' 484–501; Joan Cadden, *Meanings of Sex Difference in the Middle Ages*, Cambridge History of Medicine (Cambridge, 1993), 169–227; Vern L. Bullough, 'On Being a Male in the Middle Ages,' in *Medieval Masculinities*, ed. Clare Lees, Medieval Cultures (Minneapolis, 1994), 31–45; and Martha A. Brozyna, *Gender and Sexuality in the Middle Ages: A Medieval Source Documents Reader* (Jefferson, N.C., 2005). Also on the ideas of the influential Egyptipan Jewish philosopher Philo, Richard A. Baer Jr., *Philo's Use of the Categories Male and Female* (Leiden, 1970).

7 Pliny, *Natural History*, trans. H. Rackham (London, 1968), 7.4, 31.23, and 17.37.

8 Bullough and Bullough, *Cross Dressing*, 49. See the discussion of the one-sex model in Thomas Laqueur, *Making Sex: Body and Gender from the Greeks to Freud* (Cambridge, Mass., 1990), but also the review by Katherine Park and Robert A. Nye, *The New Republic* 204, no. 7 (1991), 53–57.

9 Baer, *Philo's Use*, 46–51.

10 But see Samantha J. E. Riches, 'St. George as a male virgin martyr,' in *Gender and Holiness: Men, women and saints in late medieval Europe*, ed. Samantha J. E. Riches and Sarah Salih (London, 2002), 65–85. Also on virginity see Cindy L. Carlson and Angela Jane Weisl, eds,

statement by Saint Jerome crystallizes this idea; as 'long as woman is for birth and children, she is different from men as body is from the soul. But when she wishes to serve Christ more than the world, then she will cease to be a woman and will be called a man.'[11] In the later Middle Ages, arguably the most popular saints were the virgin martyrs, who possessed the irresistible combination of the beauty and sexual naiveté of the maiden and the loquacious wit of the philosopher, capped by an eroticized torture and death.[12] Not only are the virgin martyrs celibate, but many of them are represented in both text and image having their breasts cut off (most notably, Agatha, Barbara, and Margaret), which I have argued elsewhere is a potent indicator of their move toward masculinity and a more advanced spiritual state through the removal of their most visible physical symbol of both femininity and sexuality.[13]

Other female martyrs are not virgins, but in their heroic passage to sainthood reject female roles, or change their physical appearance in a manner even more dramatic than those who have their breasts removed. Saint Perpetua is the mother of a newborn at the time of her martyrdom in the arena at Carthage in the third-century CE. A first-person account of the events leading up to her death describes how she abandons one by one all aspects of her femininity; her breast milk evaporates, and in a strikingly poignant detail, Perpetua flings her infant away from her.[14] The ultimate displacement of gender occurs during a vision Perpetua has of her coming death in the arena; her clothes are stripped from her body in the usual ritual of humiliation, but Perpetua suddenly realizes that she has physically become a man. Like Perpetua, Saint Paula abandons four of her five children; she sails away to the Holy Land as her children cry with outstretched arms on the shore. Paula remained unmoved, '… putting her love of God above her love for her children. She knew not herself as mother in order to prove herself Christ's handmaid.'[15] To a modern reader, particularly a female one, these voluntary denials of maternal obligation typically included in accounts of female saints seem particularly callous, but it is clear that the (invariably male) hagiographers applauded such acts as indicative of spiritual

Constructions of Widowhood and Virginity in the Middle Ages (New York, 1999); and Anke Bernau, Ruth Evans, and Sarah Salih, eds, *Medieval Virginities* (Toronto, 2003).

[11] Jerome, 'Commentarius in Epistolam ad Ephasios,' in *Patrologiae Latina*, ed. J. P. Migne (Paris, 1884), bk. 16, col. 56.

[12] Martha Easton, 'Pain, torture and death in the Huntington Library *Legenda aurea*,' in *Gender and Holiness: men, women and saints in late medieval Europe*, ed. Samantha J. E. Riches and Sarah Salih (London, 2002). For more on virgin martyrs see Karen A. Winstead, *Virgin Martyrs: Legends of Sainthood in Late Medieval England* (Ithaca, N.Y., 1997); Cynthia Hahn, *Portrayed on the Heart: Narrative Effect in Pictorial Lives of Saints from the Tenth through the Thirteenth Century* (Berkeley, 2001).

[13] Martha Easton, 'Saint Agatha and the Sanctification of Sexual Violence,' *Studies in Iconography* 16 (1994): 83–118.

[14] Herbert Musurillo, ed., *The Acts of the Chrisian Martyrs* (Oxford, 1972), 106–31; see also Elizabeth Castelli, '"I Will Make Mary Male": Pieties of the Body and Gender Transformation of Christian Women in Late Antiquity,' in *Body Guards: The Cultural Politics of Gender Ambiguity*, ed. Julia Epstein and Kristina Straub (New York, 1991), 33–43; and Joyce E. Salisbury, *Perpetua's Passion: The Death and Memory of a Young Roman Woman* (New York, 1997).

[15] Jacobus de Voragine, *The Golden Legend: Readings*, vol. 1, p. 122.

fortitude and readiness; Augustine describes Perpetua as 'neither male nor female, so that even in them that are women the manliness of their souls hideth the sex of their flesh.'[16]

Some of the most compelling female saints are those who are associated with sexual excess, such as Mary of Egypt and Mary Magdalene, who subsequently abandon themselves instead to lives of piety, chastity, and extreme asceticism; the fulfillment of bodily pleasure gives way to a denial of even bodily nourishment.[17] Mary of Egypt leads an austere life in the desert for forty-seven years, after having repented of her seventeen years as a prostitute.[18] She lives on bread, surviving miraculously on the three loaves she brought with her into the desert; in this way she divorces herself from the vices of the flesh, sex and food, both associated with the female.[19] Mary Magdalene is the most well-known case of the penitent sensualist; Jacobus de Voragine describes her not as a prostitute but as a well-born woman 'known for the way she gave her body to pleasure—so much so that her proper name was forgotten and she was commonly called "the sinner."'[20] After her repentance, she lives a chaste life and for a time travels, preaches, converts, and performs miracles. Eventually she too retires to the wilderness, in her case for thirty years. Unlike Mary of Egypt, the Magdalene was nourished on celestial delights and required no food of any kind.[21]

In spite of the emphasis in these stories on the rejection of the sinful feminine body and its various functions, medieval images of Mary of Egypt and Mary Magdalene ironically often emphasize the body and particularize its very femaleness. Because of the parallels in and conflations of their legends, texts often describe both Marys as experiencing miraculous growths of hair to cover their nudity while in the desert, but visual images more typically depict them nude, with an ineffectual swag of hair coursing down their back, or with hair growing in short, luxurious tufts all over their bodies so to some modern viewers at least they resemble nothing so much as giant female pudenda. A favorite scene from the legend of Mary of Egypt is illustrated in one fifteenth-century Flemish manuscript (a variation of the *Légende dorée*, the French translation of the *Legenda aurea*),[22] depicting the first meeting between Mary of

[16] See Jo Ann McNamara, 'Sexual Equality and the Cult of Virginity in Early Christianity,' *Feminist Studies* 3 (1976): 154

[17] Ruth Mazo Karras, 'Holy Harlots: Prostitute Saints in Medieval Legend,' *Journal of the History of Sexuality* 1, no. 1 (1990): 3–32.

[18] Onnaca Heron, 'The Lioness in the Text: Mary of Egypt as Immasculated Female Saint,' *Quidditas: Journal of the Rocky Mountain Medieval and Renaissance Association* 21 (2000): 23–44.

[19] Gail Ashton describes how the holy fasting woman becomes spirit rather than flesh, becomes a 'non-excreting, non-menstruating, non-sexualised body.' See *The Generation of Identity in Late Medieval Hagiography: Speaking the Saint* (London, 2000), 143.

[20] Jacobus de Voragine, *The Golden Legend: Readings*, vol. 1, p. 375.

[21] The identity of the various Marys mentioned in the Gospels is disputed; Jacobus connects some incidents to Mary Magdalene that are associated with other women by other authors. For Mary Magdalene see Susan Haskins, *Mary Magdalen: Myth and Metaphor* (New York, 1994); Theresa Coletti, *Mary Magdalene and the Drama of Saints: Theater, Gender and Religion in Late Medieval England* (Philadelphia, 2004).

[22] Jean de Vignay undertook this translation in 1333 at the instigation of the French queen Jeanne de Bourgogne. For other notable exceptions to the largely unillustrated Latin texts of

Egypt and the monk Zozimus of Palestine, who comes across her in the desert clothed in nothing more than the miraculous growth of hair and therefore gives her his cloak. Only rarely is Mary shown with the cloak on; here she kneels before Zozimus with her long hair streaming down her back, clearly separate from the abbreviated curls that cover her body from her neck to her ankles (fig. 19.1; New York, The Pierpont Morgan Library, MS M 672–5, fol. 206v).[23] Ironically, these images of the hair-covered Mary of Egypt and Mary Magdalene are particularly reminiscent of those of the wild men and women associated in medieval culture with sexual excess.[24]

While the hairiness of Mary of Egypt and Mary Magdalene seems to underscore their connection to the female body they repudiate, the hirsutism of certain saints ties them more explicitly to the masculine body, especially if the hair is facial. Saint Wilgefortis is the most popular of several female bearded saints.[25] Daughter of the pagan king of Portugal, Wilgefortis is horrified to learn that her father has negotiated a treaty with his enemy, the king of Sicily, with her as the prize. She refuses to marry, saying that only Christ crucified will be her husband, and is tortured by both her father and her spurned bridegroom. Praying for the preservation of her virginity, she asks God to make her undesirable to men; she then miraculously grows a beard. After further tortures, she is ultimately crucified. Yet Wilgefortis is commonly depicted with but the faintest trace of facial hair, with the emphasis much more on her long, flowing, feminine hair and her close-fitting woman's garment; a typical example of this appears in a Dutch Book of Hours dated around 1500 (fig. 19.2; Princeton, Princeton University Library, MS Garrett 59, fol. 161r.)[26] This minimization of the beard is particularly interesting when considered against the anecdote of Raymond of Capua's vision of Catherine of Siena; concerned about the authenticity of the visions reported by Catherine, Raymond has his own vision in which Catherine's face transformed into that of a bearded man. He assumed that the bearded face was Christ's, and therefore Catherine's visions were

the *Legenda aurea*, see Martha Easton, 'The Making of the Huntington Library *Legenda aurea* and the Meanings of Martyrdom,' unpublished Ph.D. diss. (New York University, 2001), 24–29. For the illustrations of the *Légende dorée*, see Hilary Maddocks, 'Pictures for Aristocrats: The Manuscripts of the *Légende dorée*,' in *Medieval Texts and Images: Studies of Manuscripts from the Middle Ages*, ed. Margaret M. Manion and Bernard J. Muir (Chur, Switzerland, 1991), 1–23; and Hilary Maddocks, 'Illumination in Jean de Vignay's *Légende dorée*,' in Dunn-Lardeau, *Legenda aurea*, 155–70.

[23] For this manuscript, see Jean Caswell, 'Double-Signing Method I the Morgan-Mâcon Golden Legend,' *Quaerendo* 10 (1980), 97–112; Figs. 1–3; and Maddocks, 'Pictures for Aristocrats,' 8, 13; Figs. 9–10.

[24] Richard Bernheimer, *Wild Men in the Middle Ages: A Study in Art, Sentiment, and Demonology* (Cambridge, 1952); John Block Friedman, *The Monstrous Races in Medieval Art and Thought* (Cambridge, Mass., 1981).

[25] Elizabeth Nightlinger, 'The Female *Imitatio Christi* and Medieval Popular Religion: The Case of St. Wilgefortis,' in *Representations of the Feminine in the Middle Ages*, ed. Bonnie Wheeler (Dallas, 1993), 310 and 313–16; Ilse E. Friesen, *The Female Crucifix: Images of St. Wilgefortis Since the Middle Ages* (Ontario, 2001).

[26] See Philip E. Webber, 'Medieval Netherlandic Manuscripts in Princeton University Library,' *Archives et bibliothèques de Belgique*, LIII (1982), 101–5.

Ofire comme tes puielles nous font sentir doulces dy
ses a nos bouches. Jupice donna lors sentence et cõ
manda que sexont seust decole enla ate daft Et que caloteren senst mã
a alberdame pour la estre pum selon sa voulente. Mais
quant sexont fu decole les angeles de nostre seigneur enpor
terent le corps et le mirent asepulture a moult grans lo
enges. Le quel souffir mort en la tierce kalende dapuril.
Senseut la vie de sainte marie egypciane.

Arte egypciane qui fu appellee pecherresse
mena moult destroite vie en ung desert
par lespace de xlvm ans. Si aduint que
quant elle estoit en celui desert. vng
abbe nomme zozimas si passa le fleuue de iourdain. Et
ainsi comme il alort parmy ce grant desert pour sauuor
se par aulaine aduenture il trouueront aulaun sant pere
Si vex alant par celin desert vne creature qui estoit

19.1 Mary of Egypt, *Morgan-Mâcon Golden Legend*, The Pierpont Morgan
Library, MS M 673, fol. 206v Flanders, 1445–65.

Een gebet van sinte ontcommer [...] uer schone margarijt bli kende rade in des conincs. troen met gh looue hope en minne. O. daer schynende sterre heilige sin

19.2 Wilgefortis, *Book of Hours*, Princeton University Library, MS Garrett 59, Netherlands, ca. 1500, fol. 161r.

legitimized.[27] As a bearded figure on a cross, Wilgefortis is even more closely connected to Christ, but without a visible beard, the Christological and masculine transformation of Wilgefortis is compromised.

The origin of the legend of Wilgefortis is probably tied to the 'feminine' appearance of certain images of Christ on the cross, where Christ was depicted with long hair and a tunic as opposed to the more typical loincloth; because the tunic was associated with women's clothing, the story of the bearded female saint developed in order to explain the aberration in dress. The significance of clothing as a marker and constructor of gender can also be seen in the lives of the transvestite saints; while the physical transformation of saints such as Wilgefortis was a particularly dramatic method of gender transformation, perhaps the most effective method of becoming more like men was simply to don men's clothing.

Examining texts and images featuring women who cross-dress as men is a particularly useful way to tease out medieval attitudes regarding gender, and

[27] Caroline Walker Bynum, '"… And Woman His Humanity": Female Imagery in the Religious Writing of the Later Middle Ages,' in *Gender and Religion: On the Complexity of Symbols*, ed. Caroline Walker Bynum and Stevan Harrell (Boston, 1986), 257–88.

the possibility of transforming or transcending gender. Although in the early years of Christianity holy women who cross-dressed or cut their hair in order to pass their lives as monks were condemned by the mid-fourth-century church Council of Granga, nothing was done to prevent this and throughout the Middle Ages there are numerous accounts of female saints who cross-dressed with at least tacit approval for their motivations.[28] These women usually cross-dressed to maintain their virginity, to escape marriage, to live lives of pious asceticism, often passing as clerics in monasteries. In this way they aspired to become 'more like men' by giving up their feminine sexuality, by denying the body, theologically and culturally associated with the feminine. The female transvestite saints gave up their social identity as women in order to lead a more spiritual life, and cross-dressing became the means of achieving that goal as well as a hagiographic device connoting their uncommon faith and devotion as evidenced by their separation from society and their prescribed social roles. In most cases their performances were so successful that their true biological sexes were often only revealed upon their deaths.

The sympathetic treatment of cross-dressing women in not only medieval hagiography, but also literature allows for possibilities of rethinking and redefining restrictive categories of gender, suggesting that gender is not essentially inscribed on the body but instead socially perceived and performed.[29] This juncture between 'nature' and 'nurture' is explicitly addressed in one of the so-called 'transvestite romances' popular during the later Middle Ages. *Le Roman de Silence*, written by Heldris de Cournuälle in the third quarter of the thirteenth century,[30] describes incidents in the life of the girl Silence, who is dressed and raised as a boy in order to protect the family inheritance. Not only does Silence completely pass as a man, she surpasses other men during her social 'performances' as a jongleur and a knight. At one point in the narrative, the allegorical figures Nature and Noreture debate the identity of Silence, Nature insisting she is a woman because of her female anatomy, Noreture countering that she is a man because of her dress and social role. Later, Eupheme, the promiscuous queen of King Ebain (responsible for the law prohibiting female inheritance), falls in love with the cross-dressed Silence, believing she is a man. When she is rebuffed by Silence, the queen first decides to have her executed, but then relents and instead sets her the seemingly impossible task of capturing the magician Merlin and bringing him to court. Much to everyone's shock, Silence succeeds. In his appearance at court, Merlin

[28] Bullough, 'Cross Dressing and Gender Role Change,' 228.

[29] Judith Butler, *Gender Trouble: Feminism and the Subversion of Identity* (New York, 1990).

[30] Heldris de Cornuälle, *Le Roman de Silence*, trans. Regina Psaki, vol. 63, Garland Library of Medieval Literature (New York, 1991). See Peter Allen, 'The Ambiguity of Ambiguity of Silence,' in *Sign, Sentence, Discourse: Language and Medieval Thought in Literature*, ed. Julian N. Wasserman and Lois Roney (Syracuse, 1989), 98–112; Simon Gaunt, 'The Significance of Silence,' *Paragraph* 13, 2 (1990), 202–16; Peggy McCracken '"The Boy Who Was a Girl": Reading Gender in the *Roman de Silence*,' *The Romanic Review* 85, no. 4 (1994): 517–36; Lorraine Stock, 'The Importance of Being Gender "Stable": Masculinity and Feminine Empowerment in *Le Roman de Silence*,' *Arthuriana* 7 (1997): 9–16; Robert L. A. Clark, 'Queering Gender and Naturalizing Class in the *Roman de Silence*,' *Arthuriana* 12, 1 (2002), 50–63.

makes two public revelations. First, he declares that he cannot be seized by men, but is vulnerable to capture by women, thus exposing Silence as a woman and explaining her success. Next, he divulges that a nun living as part of Queen Eupheme's entourage is actually a man, and the queen's lover. As a result of these disclosures, the cross-dressers are exposed, Silence quite literally as her male clothing is removed in front of the court and her woman's body revealed to all. Queen Eupheme and her disguised lover are executed; Silence is redressed as a woman and married to King Ebain, and thus returned to her 'natural' social role as a woman, thereby forfeiting her father's inheritance and insuring that it will be properly disposed of through male heirs.

Certain plot elements of the story of Silence and other transvestite romances are also present in the lives of the cross-dressing saints. The *Legenda aurea*, dating from approximately the same time as the *Roman de Silence*, includes five accounts of cross-dressing female saints: Marina, Theodora, Eugenia, Pelagia, and Margaret called Pelagius.[31] In donning men's clothing, both Silence and the saints are transformed not only in appearance but also in action. Silence becomes a great knight, surpassing other men; the cross-dressed clerics are often the most virtuous monks in their order. It is as if the outward disguise affects not only social perception but also public performance, with the performance not just an impersonation but an interior transformation. Yet in both transvestite romance and transvestite hagiography, the emphasis on the female body belies the masculine roles that the heroines inhabit. Even if female cross-dressers pass their lives as men, their female bodies are intimately involved in their *vitae*, and overtones of eroticism are often present in their legends.

The story of Marina in the *Legenda aurea* contains many elements found in both transvestite romances and other legends about cross-dressing female saints. Like Silence, Marina first cross-dresses at the instigation of her father, who wishes her to enter a monastery with him upon the death of his wife. She dresses like a boy and is brought up in the monastery as Marinus. She remains disguised at the monastery even after her father's death, until she is accused of fathering the child of a local innkeeper's daughter. Rather than denying her responsibility, she is exiled from the monastery and spends five years living outside the gates and begging for food for herself and the child. Ultimately, the monks relent and Marinus reenters the monastery, only to die a few days later. In preparation for burial, the monks discover her 'true' sex and both they and the innkeeper's daughter repent of their false accusations.

These false accusations of seduction are common in both hagiographic and literary accounts of female cross-dressing, with their attendant overtones of same-sex desire. Other women fall in love with the cross-dressed heroes or

[31] The stories of Marina and Margaret called Pelagius are so similar that the saints are probably identical; Margaret's legend also contains some elements of Pelagia's story. Jacobus' account of the Virgin of Antioch also includes a cross-dressing scene, but it differs from the others in that it is not a lifestyle choice but rather a temporary accommodation. Sent to a brothel and fearful for her purity, the Virgin switches clothes with a knight so that she may escape.

monks, and when their overtures are rebuffed, often accuse them of seduction, rape, or fathering a child. Interestingly, in the few romances where there is some suggestion that the desire might be reciprocated, the heroine miraculously transforms into a man, diluting the subversive potential of the female-female pairings.[32]

With the exception of Pelagia, female cross dressers in the *Legenda aurea* all suffer such false accusations of paternity; both Marina and Theodora are not only expelled from their monasteries but also spend many years caring for their 'children.' In fact, most later medieval images of Marina and Theodora, although they are represented tonsured and in male dress, depict them with their children. In one fourteenth-century image of Theodora, she plays the role of both sexual and saintly woman; in the foreground she is seduced by a suitor (it is this adulterous act that makes her disguise herself as a man, leave her husband, and enter a monastery). In the background, she accepts the illegitimate baby from another monk as other monks, the devil, and the kneeling accuser watch (fig. 19.3; Paris, Biblothèque nationale de France, MS fr. 244, fol. 195v.) Here Theodora is imaged in two incidents which connect her most explicitly to her feminine body as opposed to her masculine performance; first she is depicted as the gullible, easily seduced adulteress, and then as a woman who cannot escape her maternal instincts, even for a child who is not her own.

The climax of the stories of the female cross-dressers is the moment when their secret is uncovered and their female bodies are exposed. This disclosure of sex is cast as a literal uncovering of truth, a triumph of Nature over Nurture, anatomy over social performance. In most cases this does not occur until after the death of the cross dresser, but in the notable case of Eugenia, the revelation is made in dramatic fashion by the saint herself. The cross-dressed cleric Eugenia is accused of rape after she rejects the overtures of the noblewoman Melanthia; she exposes herself to the Roman prefect Philip in order to prove her innocence. She reveals her biological identity in two ways, exposing herself as both a woman and also as the daughter of the unaware Philip. This moment of revelation serves as the ultimate scene in a painted altar frontal containing four scenes of Eugenia's life (fig. 19.4).[33] The image is fraught with visual allusions and ambiguities; the scene of a half-naked female saint standing before a seated, cross-legged man raising an accusatory finger greatly resembles contemporary images of virgin martyrs standing before their spurned accusers.

32 Blanchandine in *Tristan de Naneteuil* and Yde in *Yde et Olive*, both from the fourteenth century, experience such biological transformations. This also happens in Ovid's Iphis-Ianthe pairing. See Diane Watt, 'Behaving Like a Man? Incest, Lesbian Desire, and Gender Play in *Yde et Olive* and Its Adaptations,' *Comparative Literature* 50, no. 4 (1998): 265–85; and Francesca Canadé Sautman, 'What Can They Possibly Do Together: Queer Epic Performances in "Tristan de Nanteuil,"' in *Same Sex Love and Desire Among Women*, ed. Francesca Canadé Sautman and Pamela Sheingorn (New York, 2001), 199–232. For more on the transvestite romances of the thirteenth and fourteenth centuries, see Hotchkiss, *Clothes Make the Man*, 105–24.

33 The thirteenth-century Spanish altar frontal by the Master of Soriguerola was originally from the Church of St Eugenia in Saga and is now at the Musée des Arts Décoratifs in Paris; see Walter Cook, 'Catalan Altar Frontal in Paris,' *Studies in the History of Art* (1959): 17–20; Figs. 1–9.

s. theodore

19.3 Theodora, *Légende dorée*, Paris, BnF MS fr. 244, fol. 195v, France, fourteenth century.

19.4 Eugenia, Master of Soriguerola, Altar frontal of Saint Eugenia, Spain,
thirteenth century, Paris, Musée des Arts Décoratifs.

Yet unlike the scenes of female martyrs, whose involuntary nudity is a
humiliating part of their torture, and perhaps a titillating sight for viewers both
inside and outside the frame,[34] here Eugenia herself has removed her own
clothing and controlled the circumstances under which her body may be
viewed. Eugenia, unlike her more passive transvestite sisters, rejects the false
accusations, chooses the moment of revelation rather than waiting for others
to discover her sex upon her death, and fully assumes the active, masculine
role. Perhaps in support of this masculine behavior, the moment of anatomical
clarification when imaged leads to further visual ambiguity, as the tiny tubular
breast of Eugenia looks like nothing so much as a flaccid penis, blurring the
boundaries even of her biological sex. Yet even so, it is through the body that
Eugenia expresses her true identity, ambiguous or not.

In contrast to the generally tolerant view of women who cross-dress as men,
traditionally in medieval theology, literature, and social practice men who
cross-dress as women are treated with suspicion and distaste, or even
considered buffoons.[35] The vastly different treatment of Silence, cross-dressed

34 For strategies of the gaze and its theoretical implications, see Madeline H. Caviness,
Visualizing Women in the Middle Ages: Sight, Spectacle, and Scopic Economy (Philadelphia,
2001).

35 Bullough, 'Cross Dressing and Gender Role Change,' 231–37.

as a man, and the queen's lover, disguised as a nun, suggests how differently such gender-bending performances were perceived. Silence is simply placed in a new social role corresponding to her female anatomy while the cross-dressed nun is killed, although the lover is executed for his illicit liaison with the queen and not for his transvestism alone. Although there are many accounts of men cross-dressed as women in medieval texts, they are often accused of base motives, such as easy access to gullible women for seduction; they are even sometimes accused of witchcraft.[36] It was in fact acceptable for men to dress as women in medieval theater as well as during festivals or carnivals, but in most of these instances the male-cross dressing serves to emphasize the masculinity of the heroes, with quite opposite effects and intentions of female cross-dressing.[37] It is telling that both the theatrical and the carnivalesque instances of cross-dressing are merely temporary masquerades, the latter in particular underscoring the inappropriateness of this type of behavior in everyday life.

Significantly, there are no male transvestite saints, and in the *Legenda aurea* there is only one incidence of a man cross-dressing as a woman. Upon rising for matins, Saint Jerome inadvertently puts on a woman's robe left at his bedside by his enemies, who hoped to give the impression that the holy man had been with a woman the night before. Although Jerome could be viewed with some amusement for his absent-mindedness, the impression given by the text is that Jerome is concerned with spiritual matters and cannot be bothered with the mundane details of everyday dress. Further, the emphasis is on the duplicity of Jerome's enemies rather than the effect of the cross-dressing saint; the intention of his enemies was to cast doubt upon his celibacy rather than to expose him as a cross-dresser. Interestingly, this incident is almost never illustrated in medieval art.[38]

The implication is that women who cross-dress as men, particularly for religious purposes, are commendable for their desire to 'better' themselves, to take on the trappings of a spiritually upright, 'masculine' gender role. In hagiographic convention, there would be no worthy reason for a man to cross-dress as a woman. Perhaps this is why the one female saint whose contemporaries viewed her cross-dressing with ambivalence is Joan of Arc.[39] Unlike the other cross-dressers, Joan made no attempt to conceal her sex. She herself seemed unable to account for her decision to don male clothing; during both her ecclesiastical investigation at Poitiers and her trial at Rouen she gave

36 Bullough and Bullough, *Cross Dressing*, 61.

37 Ad Putter, 'Transvestite Knights in Medieval Life and Literature,' in *Becoming Male in the Middle Ages*, ed. Jeffrey Jerome Cohen and Bonnie Wheeler (New York, 1997), 321–47.

38 An exception is the The Belles Heures of Jean, Duke of Berry (New York, The Metropolitan Museum of Art, The Cloisters Collection, MS 54.1.1, fol. 184v); see Millard Meiss, *The Belles Heures of Jean, Duke of Berry* (New York, 1974), and Jean Porcher, ed., *Les Belles Heures de Jean de France, Duc de Berry* (Paris, 1953).

39 Susan Crane, 'Clothing and Gender Definition: Joan of Arc,' *Journal of Medieval and Early Modern Studies* 26, no. 2 (1996): 297–319; Susan Schibanoff, 'True Lies: Transvestism and Idolatry in the Trial of Joan of Arc,' in *Fresh Verdicts on Joan of Arc*, ed. Bonnie Wheeler and Charles T. Wood (New York, 1996): 31–60; Susan Crane, *The Performance of Self: Ritual, Clothing, and Identity During the Hundred Years War* (Philadelphia, 2002).

a variety of answers to questions about her transvestism.[40] At times she suggests that she was directed to do so by God or by St Michael; at others she suggests that male dress is most efficient in the performance of the male-gendered tasks she is set to do. She often replies to questions about her costume with irritation, suggesting that it is a minor detail. But because she never attempts actually to pass as a man, questions about her gender pursue her through her life and even after her death. The Poitiers council directs that some women at court examine Joan to confirm not only her virginity, but also her sex. Questions about her identification as a woman were such that her body was displayed to the crowd during her execution. The only surviving contemporary illustration of Joan depicts her in a side view, dressed in a garment reminiscent of armor, but with a skirt, ample breasts, and long hair.[41] This feminization of her image is particularly interesting since it directly contradicts the way her masculine appearance was condemned at her trial: 'You even wear your hair cut round above the ears, not displaying anything about you that confirms or demonstrates sex, except what nature has given you ... you are suspected of idolatry and blasphemy of yourself and your clothing, according to the customs of the heathens.'[42] As one of the most popular female saints depicted in art, this tendency to feminize Joan has persisted. Regardless of the date, most artistic representations of Joan focus on her biological sex rather than her cross-dressed performance; even if she wears armor, she is generally represented in some way that underscores her 'true' nature, through her youthful beauty, long hair, flowing skirt, and other cultural markers of the female sex.

The female bodies of the cross-dressing saints both save and betray them in the end. Both transvestite hagiography and romances play with undermining the binary system of gender, but through the revelation of the protagonist's true anatomy put it back into place. In the end, these gender transformations are transgressions, and must be reversed to maintain the status quo. The bodily exposures in hagiography and romance are usually involuntary; Silence is stripped in front of the court, Joan's clothes are burned off and her body displayed to a crowd, the bodies of the transvestite saints are revealed as other monks prepare them for burial. Only Eugenia maintains her own agency, but in the end, it is her body that proves her innocence and her identity. Cross-dressing female saints write their spirituality with their bodies in a way that men do not. They are commended by their hagiographers for their desire to lead a 'masculine,' ascetic life; only through a revelation of their true sex can the enormity of their sacrifice and subsequent spirituality be appreciated. So in spite of their efforts to become 'more like men,' in the end, their masculine aspirations are temporary ones, and their biological 'nature' wins the battle with their gendered performance, fixing them once and for all as women.

40 Hotchkiss, *Clothes Make the Man*, 49–68.

41 Journal of Clément de Fauquembergue, May 10, 1429. (Paris, Archives nationals, MS XIA 1481, fol. 12.)

42 Jules Quicherat, ed., *Procès de condamnation et de rehabilitation de Jeanne d'Arc dite La Pucelle*, (Paris, 1841–49), 1:432–3; Hotchkiss, *Clothes Make the Man*, 59–60.

Women in English Royal Genealogies of the Late Thirteenth and Early Fourteenth Centuries*

Joan A. Holladay

In their recent work, Madeline Caviness and Charles Nelson have shown how women were silenced in medieval German legal proceedings and in the illustrated law books in which these proceedings were codified. Their conclusions rest on compositional analysis of the images and on detailed consideration of how texts and images work with and against one another.[1] A similar kind of analysis can be productively applied to other groups of objects, namely, some little-known genealogical rolls made in England in the late thirteenth and early fourteenth centuries.[2] As in the *Sachsenspiegel* manuscripts

* This article derives from a chapter of the book I am writing on imagery with genealogical content in the High and late Middle Ages. I delivered a shorter version as a paper at the Sewanee Medieval Colloquium in April of 2004. I thank Sue Ridyard for the invitation to participate in the colloquium and Madeline Caviness, Elizabeth Pastan, and other members of the audience, as well as Susan Ward and Daniel Hofmann, for their questions and comments. I am also grateful to Richard and Mary Rouse for the opportunity to examine their MS 53, a late fourteenth- or early fifteenth-century roll, and I am deeply indebted to Marigold Norbye for a lively discussion of her recently completed dissertation on fifteenth-century French genealogical chronicles (University College, London, 2004), many of which also occur in roll form, for alerting me to the work of Olivier de Laborderie, and for a copy of the catalogue cited in n. 2 below.

[1] Madeline H. Caviness and Charles G. Nelson, 'Silent Witnesses, Absent Women, and the Law Courts in Medieval Germany,' in *Fama: The Politics of Talk and Reputations in Medieval Europe*, ed. Thelma Fenster and Daniel Lord Smail (Ithaca, N.Y., 2003), 47–72. Caviness also presented related material as a plenary talk at the Sewanee Medieval Colloquium in April 2004. See also Madeline H. Caviness, 'Putting the Judge in his P(a)lace: Pictorial Authority in the Sachsenspiegel,' *Österreichische Zeitschrift für Kunst und Denkmalpflege (Festschrift für Ernst Bacher)* 54 (2000): 308–20.

[2] The published art-historical bibliography on these works is limited to three short articles and an exhibition catalogue: W. H. Monroe, 'Two Medieval Genealogical Roll Chronicles in the Bodleian Library,' *The Bodleian Library Record* 10 (1981), 215–21; Olivier de Laborderie, 'Les généalogies des rois d'Angleterre sur rouleaux manuscrits (milieu XIIIᵉ siècle-début XVᵉ siècle): Conception, diffusion et fonctions,' in *La généalogie entre science et passion*, ed. Tiphaine Barthelemy and Marie-Claude Pingaud (Paris, 1997), 181–99; Judith Collard, 'Gender and Genealogy in English Illuminated Royal Genealogical Rolls from the Thirteenth Century,' *Parergon* 17 (2000): 11–34; and Alixe Bovey, *The Chaworth Roll: A Fourteenth-Century Genealogy of the Kings of England* (London, 2005). Monroe's unpublished dissertation is cited in note 4 below. I am grateful to M. de Laborderie for sharing with me a copy of his unpublished

that interest Caviness and Nelson, the images on these rolls are not 'simply' illustrations of the text: they occupy an unusually prominent position. Not only do they give the object its specific visual structure, but they also create a relationship between text and image that is more mutually interdependent than in 'illustrations' properly speaking.

I will consider here two different types of English genealogical chart from the second half of the thirteenth century and the roles women play in them. Although these works are primarily genealogies of office,[3] they combine this central interest in a succession of office holders with a family genealogy. In this latter function women appear among the king's children, at least in the cases of the later kings for whom more information is available. I am particularly interested in the small number of cases where the portrayal of women deviates from this modest standard and what these deviations might reveal about the context in which these objects were created and functioned.

Of the thirty related genealogical rolls that have survived, the earliest dates back to the late 1250s or 1260s. Although derived from a single conceptual model, the rolls display considerable variety (figs. 20.1 and 20.2).[4] Some are unillustrated and others have images. The illustrations may be simple line drawings or may include color and gold leaf. The text may be in Latin or French; although each version is remarkably consistent, the French version is not a direct translation of the Latin.[5] The rolls are small in format; most measure

dissertation, '"Ligne de reis": Culture historique, représentation du pouvoir royal et construction de la mémoire nationale en Angleterre à travers les généalogies royales en rouleau du milieu du XIIIe siècle au début du XVe siècle' (École des Hautes Études en Sciences Sociales, Paris, 2002).

3 I borrow this term from the German; see, for example, Ursula Nilgen, 'Amtsgenealogie und Amtsheiligkeit: Königs- und Bischofsreihen in der Kunstpropaganda des Hochmittelalters,' in *Studien zur mittelalterlichen Kunst 800–1250: Festschrift für Florentine Mütherich zum 70. Geburtstag*, ed. Katharina Bierbrauer, Peter K. Klein, and Willibald Sauerländer (Munich, 1985), 217–34.

4 I have been able to study the following manuscripts, mostly in the original: Princeton, Princeton University Library, MS 57; London, British Library, Add. 30079; Oxford, Bodleian Library, Broxbourne Roll 112.3 (formerly 435); *BL Cotton Roll XV.17; BL, Lansdowne Roll 3; BL Add. 47170; BL Add. 11713; BL Royal 14.B.v; BL Royal 14.B.vi; *BL Royal 13.A.xviii; BL Cotton Roll XIII.7; *BL Add. 24026; *BL Add. 29504; *BL Harley C 10; Oxford, Bodleian Library Fr. D. 1; *BL Add. 21368; and *BL Sloane XXXI.1. I list them here in loose chronological order. On the Harvard roll (Cambridge, Mass., Houghton Library, MS Typ 11), see Michael T. Clanchy, *From Memory to Written Record: England 1066–1307*, 2nd ed. (Oxford, 1993), pl. XIII. W. H. Monroe, '13th and Early 14th Century Illustrated Genealogical Manuscripts in Roll and Codex: Peter of Poitiers' *Compendium*, Universal Histories and Chronicles of the Kings of England' (unpublished diss., University of London, Courtauld Institute of Art, London, 1989), 276–95, includes eleven further manuscripts, but does not know those marked preceded by a *, all with non-figural charts, in the list above. I discovered Monroe's dissertation, which he does not cite as being in progress in either of his published articles, after completing the talk on which this article is based. Laborderie, 'Les généalogies des rois d'Angleterre,' 185, says he knows forty rolls, but he neither identifies them nor stipulates the time period he considers. I am interested here only in those that fit in the early period of this genre, when the political context that I think gave rise to them was an issue.

5 In a series of articles published between 1975 and 1998, Diana Tyson refers to the text on several of the French rolls as a *Brut*; see, for example, Diana B. Tyson, 'An Early French Prose History of the Kings of England,' *Romania* 96 (1975): 1–26. She includes some of the same rolls

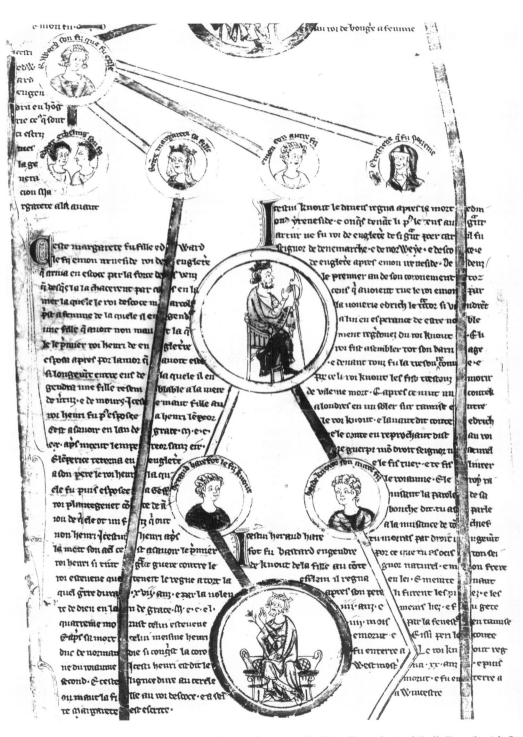

20.1 London, British Library, Cotton Roll XV.7: Genealogical Roll. Detail with St Margaret, King Cnut and his sons.

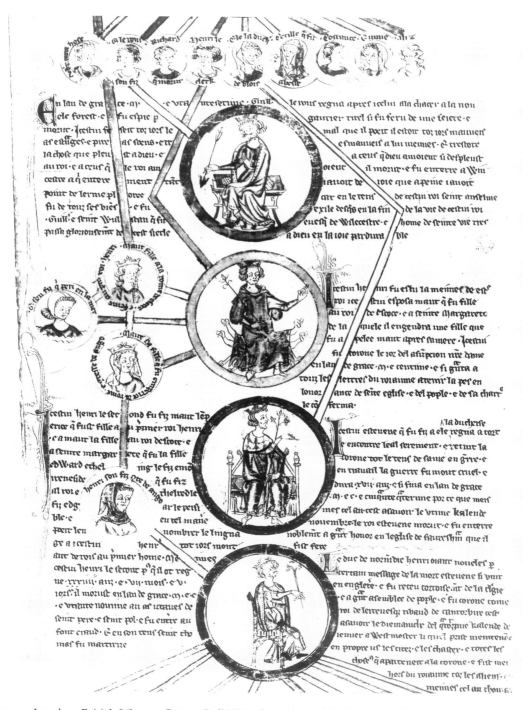

20.2 London, British Library, Cotton Roll XV.7, Genealogical Roll. Detail with Kings William Rufus, Henry I, Stephen, and Henry II, and the two Mauds, the wife and daughter of Henry I.

only 20–30 cm (8–11 in.) across.[6] The textual and visual material on each roll is structured around a genealogical chart that runs down its center.[7] Squeezed into the available spaces around the tree are paragraph-length texts describing the kings: their birth, descent, death, burial, and sometimes major events from their reigns.

The conception of genealogy on these rolls links in an innovative way the genealogy of office with the blood relationships described in family trees properly speaking. The kings, who are represented on axis, are distinguished from their children by the larger size of their medallions and by the way they are represented. On the Princeton roll (Princeton University Library, MS 57), for example, the smaller medallions for royal children contain names only, while the kings are represented by heads. On the Harvard roll (Cambridge, Houghton Library, MS Typ 11) the children are represented in head-length whereas the kings are enthroned and frontal. In an ingenious variation on the standard family tree, each king is represented twice, once in a small medallion with his father's other sons and daughters in proper birth order, and a second time on axis in the larger medallion reserved for kings and thus marking his place in the succession of office-holders. A line connects the two. This 'double-entry system' allows distinctions between succession and descent and between royal history and family genealogy that become particularly interesting when a new dynasty begins or when brothers succeed one another as with the sons of William the Conqueror or Henry II.

The rolls typically open with a circular diagram of the Heptarchy, the seven small kingdoms that existed simultaneously between the fifth and the ninth centuries. On most, the genealogy proper opens with the king who united those petty kingdoms, Egbert (here called Ethelbert);[8] it proceeds through his sons, their descendants, and changes of dynasty down to the king at the time the roll

discussed here although for the most part, she does not note whether they are accompanied by genealogical schemata or not. Because even the texts she discusses have different starting places and a number of variant forms and because of the possibility of confusion with the more famous *Brut* text by Wace, I prefer to leave the text on the rolls discussed here unnamed. Furthermore, I see an essential difference in both conception and function between some of the rolls she discusses, which contain several parallel genealogies (popes, Roman emperors, French and English kings) side by side, and those I discuss here.

On the problem of the *Brut* nomenclature, see also de Laborderie, 'Les généalogies,' 183.

[6] Many of the rolls have lost their beginnings and/or ends or been added on to, so their original length is harder to measure. The largest number seems to have been between about 4 and 5 m (13–16 ft) long. In the catalogue appended to his dissertation, Monroe gives the dimensions of those he studied; '13th and Early 14th Century Illustrated Genealogies,' 527–79.

[7] On BL Add. 11713 the genealogical diagram runs down the right side, while the accompanying text appears at the left. This roll is something of an exception in other ways as well.

[8] The seeming discontinuity between these two names is explained by a line in Cambridge, Corpus Christi College, MS 469, where 'Aeilbricht ke Bede apele Ecgbricht' unites the realms. See Diana B. Tyson, 'Les manuscrits du *Brut* en prose française (MSS 50, 53, 98, 133, 469),' in *Les manuscrits français de la bibliothèque Parker, Parker Library, Corpus Christi College, Cambridge: Actes du colloque 24–27 mars 1993*, ed. Nigel Wilkins (Cambridge, 1993), 114. A few of the rolls begin with Egbert's more famous grandson, Alfred.

was made. Internal evidence dates the earliest of the rolls between 1259 and 1272. This *terminus post quem* derives from the label in the roundel of Beatrix, the daughter of Henry III; she would only have been referred to as *Comitissa Britannie* after her marriage to the count of Brittany in 1259.[9] The failure to mention Henry's death, the length of his reign, and his burial at Westminster, information that is recorded on all the other rolls I know, suggests that this earliest version dates before 1272. Some of the rolls continue into the reign of Henry's son Edward I or beyond either in the same hand or in one or more additions by a different scribe or scribes.[10] The prototype for these rolls may be found in no less a source than Matthew Paris's two-volume manuscript, *Chronica majora*. Included among the supplementary materials in both volumes (Cambridge, Corpus Christi College, MSS 26 and 16) are genealogical trees of the English kings.[11] That in the first volume is preceded by a diagram of the Heptarchy (fol. iv v) at the head of the genealogy, which starts with Alfred.[12] The two genealogical charts in the second volume, which run from the *prothomonarcha* Alfred (r. 871–99) to Henry III (r. 1216–72), are particularly close in format and content to those on the rolls (fig. 20.3). The texts accompanying the diagrams in Matthew's book also closely resemble those on the Latin rolls, for example, Princeton, MS 57, in both content and often in specific wording. Matthew's charts, however, show some irregularities, suggesting that they are original inventions in the process of being worked out.[13] The more consistent and developed rolls, even the early ones, suggest a functional context for these objects.

9 BL Add. 30079. The British Library catalogue dates this non-figural roll 'late thirteenth century.' See *Catalogue of the Additions to the Manuscripts in the British Museum in the Years MDCCCLXXVI-MDCCCLXXXI* (London, 1882), 32. It is not possible to say whether it was executed itself between 1259 and 1272 or written slightly later on the basis of a prototype of 1259–72. A second hand has appended a statement about the length of Henry's reign to the original text.

10 BL, Cotton Charter XV.7, for example, originally ended with the death of Henry III and an empty roundel for Edward I, but it was then continued to Edward III.

11 The genealogical diagrams appear in MS 26 on fol. ivv and p. 285, and in MS 16 on fols iiir-iiiv. On the subjects of the supplementary materials, their codicological and authorial relationships to the rest of manuscript, and the problems with dating these pages, see, most recently, Nigel Morgan, *Early Gothic Manuscripts 1250–1285*, A Survey of Manuscripts Illuminated in the British Isles 4, 2 vols (London, 1988), 1:136–38, no. 88. Morgan, 138, ascribes the pages with the genealogical diagrams in both volumes to Matthew's hand. He notes that they 'lack any textual evidence for dating,' but places the itinerary on fol. ii r in MS 16 ca. 1253 and the drawing of the elephant on fol. iv r in the same manuscript after the animal's arrival in London in 1255. Similarly the genealogical diagram in MS 16 must have been completed after Christmas 1251 when Margaret, the daughter of Henry III, who is noted as 'r Sco' [*regina Scotie*], married Alexander III of Scotland.

12 A second, slightly different example of the diagram of the Heptarchy appears in Matthew's *Abbreviatio chronicorum* (BL, Cotton Claudius D. VI, fol. 5); see Suzanne Lewis, *The Art of Matthew Paris in the Chronica Majora* (Berkeley, 1987), Fig. 93.

13 The 'double entry system' is not used consistently, for example: the three sons of Edward the Elder who came to the throne each appear twice, but the two sons of Cnut do not. The small medallion of Edward, in which he appears as the son of Edgar the Peaceable, is not attached to his larger roundel in the line of kings. Neither Edward the Confessor nor Harold is portrayed, perhaps for lack of space: it may have been important to place William the Conqueror at the top of the verso page.

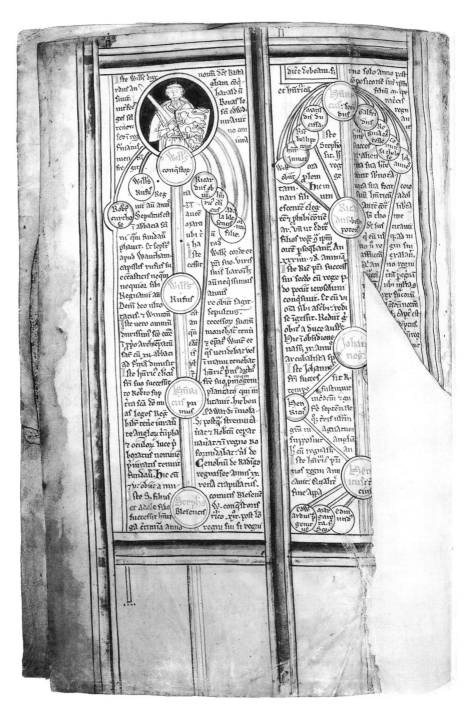

20.3 Cambridge, Corpus Christi College, MS 16, fol. iiiv: Matthew Paris, *Chronica majora*, vol. 2. Prefatory material with genealogy of the kings of England from William the Conqueror to Henry III.

In several places the rolls, which are fairly consistent among themselves, differ in both image and text from the version in Matthew's chronicle; the most striking of these divergences are in the portrayals of women. Whereas the genealogical diagram in the *Chronica majora* includes daughters either by name—St Edith or St Margaret of Scotland, for example—or lumped together in a single roundel, like the *v filie* of Alfred's son Edward, it gives no woman a descriptive text of her own. In two cases, however, the rolls allot such texts to figures other than kings, an enhancement of their place on the roll that marks their importance; both of these exceptions are women. The first, King Alfred's daughter Alfled, also known as Aethelflaed, appears near the top of the roll. The composition gives her unusual prominence, in some versions according her a medallion larger than those normally reserved for children, although not as large as those occupied by kings. The text accompanying her roundel reads:

This Alfled was the wisest of all secular women, so that by her sense and by her knowledge she aided much her brother Edward to govern the kingdom. She, when she was married to earl Edred, and her father had given her to him, gave birth to [a son]. And she never afterwards suffered her lord to touch her carnally. For she said that the lineage of a king should never use or like such fondling where there was so much anguish in giving birth.[14]

The proximity of this text, once again, to the text of Matthew's chronicle, reinforces the sense of these rolls' dependence on that source.[15]

The short text describing Alfled highlights three duties of the proper princess: to marry according to her father's wishes, to aid the king, and to bear a son. The texts relating the deeds of kings make it seem likely that the rolls must have served in some sense as Mirrors of Kings, a type of didactic text intended to instruct princes and kings in the political and moral duties of their office. The inclusion of this image and text passage near the top of these rolls suggests that they may have served a similar didactic purpose for princesses as well.

The only other woman to receive her own text is St Margaret (fig. 20.1). Unlike the biographical text describing Alfled, the text for Margaret is prospective, describing her descendants as they appear further down the roll:

[14] Thomas Wright, ed., *Feudal Manuals of English History: A Series of Popular Sketches of Our National History, Compiled at Different Periods, from the Thirteenth Century to the Fifteenth, for the Use of the Feudal Gentry and Nobility* (London, 1872), 7–8, transcribes and translates a roll in the possession of Joseph Mayer. I have not been able to identify this specific roll among those that I know. I have corrected what is almost certainly an error in his reading: he writes *vii fiz* (seven sons) rather than *un fiz* (one son).

Wright transcribes the slightly variant version in London, British Library, Add. 21368, on pp. 69–70, without a translation. Here he reads correctly 'un enfaunt.'

This text is not included on the early Latin roll, Princeton, MS 57.

[15] Matthew Paris, *Chronica Majora*, ed. Henry Richards Luard, 7 vols (London, 1872–83), 1:445. Luard notes Matthew's sources for this passage in the *Chronicon ex chronicis* of Florence of Worcester, in *Monumenta Historica Britannica or Materials for the History of Britain from the Earliest Period*, ed. Henry Petrie and John Sharpe (London, 1848), 1:572, and William of Malmesbury, *Gesta regum anglorum*, ed. Thomas Duffus Hardy, Publications of the English Historical Society, 2 vols (London, 1840): 2:125.

This Margaret was the daughter of Edward, the son of Edmund Ironside, king of England … whom Malcolm, king of Scotland, took to wife, upon whom he begat a daughter who was named Maude. Whom the first king Henry of England married afterwards, for the great love which had been long between them. Of whom he begat afterwards a daughter resembling her mother in virtues and in name. This Maude, daughter of King Henry, was afterwards married to Henry the emperor, that is, in the year of grace a thousand and one hundred and ten. Afterwards the emperor died without heir, and the empress returned into England to her father king Henry, who was afterwards married to Geoffrey Plantagenet, [count] of Anjou. Of whom she had a son, who was named Henry. This Henry, after the death of his grandfather, that is, the first king Henry, held great war against king Stephen, who held the kingdom wrongfully. … After his death, this same Henry, duke of Normandy, conquered the crown of the realm. This Henry is called the second. And this line lasts to the circle where Maude, daughter of the king of Scotland by St. Margaret, is inscribed.[16]

Margaret is distinguished visually on these rolls by two devices. First, she is crowned, indicating her marriage to Malcolm of Scotland. Second, a long line descends from her medallion. The attentive reader who notices the mention of the line at the end of the text near her medallion is encouraged to follow it to see how these events play out below. In doing so, she bypasses the lengthy interlude represented by the Danish king Cnut and his sons, Edward the Confessor, who appears himself at the end of a long line, Harold Godwinson, and William the Conqueror and his son William Rufus. The viewer who is not so engaged with the text tends to work the other way: on arriving at the diagram of the complex interrelationships portrayed near the roundel of Henry I (fig. 20.2), he or she has forgotten where that line originated and is forced to backtrack a meter or so to find its origin. The fact that the two Maudes, mother and daughter, are both crowned attracts attention, especially as queens do not otherwise appear, and the lengthy descriptive labels in the borders of their roundels further emphasize their status: 'Maude, daughter of the queen of Scotland and wife of the first king Henry,' and 'Maude, her daughter, who was empress of Rome and countess of Anjou.'[17] In case the diagram is not clear, the text for Maude's son Henry repeats his genealogy, again using text from Matthew's chronicle:

This Henry the second was the son of Maude, the empress, who was the daughter of the first king Henry and Maude, the daughter of the king of Scotland and St. Margaret, who was the daughter of Edgar Etheling, the son of Edmond Ironside, who was the son of the king Ethelred, the son of Edgar the Peaceable, and in this manner one can enumerate the lineage of this Henry going back to the first man.[18]

[16] Wright, *Feudal Manuals*, 20–21. He reproduces the slightly variant version from Add. 21368 on p. 51.

[17] On Cotton Roll XV.7, for example: 'Maut fille a la roine de Escoce e femme au premier roi Henri' and 'Maut sa fille qui fu emperice de Rome e contesse de Ango.'

[18] For Mayer's roll, Wright, *Feudal Manuals*, 29–30, includes only a more biographical text describing Henry's accession and reign. BL Add. 21368 includes this same description of events followed by the genealogical text cited here, which Wright transcribes on p. 84. The translation here is mine. On BL Cotton Charter XV.7, the two texts are separated: Henry's descent appears

Whether one reads the text, studies the images, or both, the message is clear. The most striking pictorial passage on the roll, an extended straight line leading to a unique multi-part diagram, points up the fact that Henry II, and all the kings of England from this point on, are descended not only from the earlier Norman kings but, through a female line, from the Anglo-Saxon kings as well. Those who read the text would have understood that the kings of England were also descended, through this same female line, from the royal house of Scotland. The descent of the kings of England from the Anglo-Saxons returned the line of Edward the Confessor to the English throne. I argue, however, that the participation of the kings of England in the bloodline of the kings of Scotland and its obvious consequence—an English claim to the throne of Scotland—is crucial to the understanding of these objects. That the underlying subject of the rolls is a unified realm of the entire island under a single English king is also visible from the starting place with Egbert or Alfred unifying the Heptarchy and from subtle insertions in the Latin text of the Princeton roll, for example, where various kings are noted as having ruled *totius Anglie* or having subjugated Scotland.[19]

The earliest of the rolls, then, should be seen against the backdrop of Henry III's relationship with Scotland in the 1250s, when the first of these rolls appear. In 1251, at the age of eleven, Henry's daughter Margaret, the sister of the future King Edward I of England, had married the ten-year-old king of Scotland, Alexander III. During the period of their minority, Henry kept close watch out for their interests—and his own. In 1251, the child Alexander paid homage to Henry, but the two would later dispute the nature of that homage. In 1255, Henry staged a kind of coup d'etat on Alexander's behalf, replacing some of the guardians of the minor with men more sympathetic to the English cause. He was able to hold sway over his young neighbor and son-in-law in this fashion until 1257, when the anti-English party returned to power. As late as 1259, however, Henry had not returned to Alexander the document of 1255 by which he had installed the new pro-English advisers of the young king, and Alexander had to ask for it.[20]

The execution of the largest number of rolls after the death of Henry III, during the reign of his son, Edward I, when the Scottish question reached the point of crisis, suggests the continued understanding and function of these

on the left side of the line of kings, below the bust of his mother and around his representation as her son, while the description of his reign is recorded to the right of the line of kings.

For the closely related text in Matthew Paris, see *Chronica majora*, 2:209–10, where Matthew enumerates Henry's ancestors all the way back to Noah.

[19] Alfred is said to have ruled *totius Anglie*; similar wording is used for Edred and Edwin. Athelstan is noted as having compelled the kings of Wales and Scotland to have ceded their kingdoms to him, and Edward Martyr is labeled as having ruled *solummodo*. Cnut is listed as the ruler of all Denmark, Norway, Scotland, and England, and William the Conqueror's subjugation of Scotland is mentioned.

Similar wording is used in the French versions for Alfred, Athelstan, Edred, Cnut; see Wright, *Feudal Manuals*.

[20] On these events, see, for example, Frederick Maurice Powicke, *The Thirteenth Century 1216–1307* (Oxford, 1953), 581–82 and 589–93.

objects in this context. In 1290, the child Margaret, the heiress to the throne of Scotland, had died; she was the granddaughter of Alexander III, who had died in 1286, and Edward I's sister Margaret. Edward, claiming overlordship over Scotland, decided the succession in favor of John Balliol. Balliol, who was installed as king in 1292, ruled only until 1296, when he was deposed and exiled. Edward claimed Scotland for the English throne, a political stance that seems to be directly supported by the descent from St Margaret explicated on the rolls.

Two fifteenth-century rolls support the relationship of these objects to the English kings' interest in Scotland even more strongly. British Library, Additional 24026 includes in the left margin near the roundels for Henry III and Edward I a short lineage of circles connected by lines; inscribed in the circles are the names of the Scottish kings Alexander II, Alexander III, John Balliol, and Balliol's son Edward (fig. 20.4). Additional 29504 notes which Scottish kings paid homage to their English overlords and cites directly the words by which John Balliol paid homage to Edward I. So that these deviations from the standard text will not be missed, marginal drawings of hands draw attention to these passages (fig. 20.5).[21] Whether or not these rolls rely on earlier prototypes, they indicate the continued association of these objects in the English kings' claim to the throne of Scotland.[22]

Our entire knowledge of these genealogical rolls depends on the objects themselves, and they yield no firm conclusions about either their place of production or their original owners.[23] Some of the rolls were held in monasteries at an early date, but the fact that the largest number of the preserved rolls is in French rather than Latin suggests a lay readership as well.[24] The roll form,

[21] These hands highlight references to Scotland in the texts for the following kings on the original part of the roll: Edgar and his son Edward, Cnut, Edward the Confessor, William the Conqueror, William Rufus, Henry I, Stephen, Henry II, Richard the Lionhearted, John, Henry III, and Edward I. The textual notices pertaining to Scotland are very close in wording to those in the letter sent by Edward I to Pope Boniface VIII in 1301; see below. Appended text for later kings in a different scribal hand also includes the *maniculae* to indicate passages in the texts for Edward III and Henry IV.

[22] François Fossier, 'Chroniques universelles en forme de rouleau à la fin du moyen-âge,' *Bulletin de la Société nationale des antiquaires de France* (1980–81), 174–75, groups these two manuscripts with eight others whose Latin text he dates in the thirteenth century.

[23] Monroe, '13th and Early 14th Century Illustrated Genealogical Manuscripts,' 330, attributes the continuation to Oxford, Bodleian Library, Broxbourne Roll 112.3 to the same scribe and artist who executed Bodley Rolls 3, which would put the manufacture of this roll in the circle of the court. See n. 25 below.

[24] Monroe, '13th and Early 14th Century Illustrated Genealogical Manuscripts,' 535–36 and 537–39, locates BL, Additional MSS 30079 and 47170, respectively, at Norwich Cathedral Priory and Peterborough Abbey by about 1325. These provenances are particularly interesting in the light of Edward's appeal to these and other monasteries of his realm for evidence for his claims to Scotland in both 1291 and 1300; see E. L. G. Stones and Grant G. Simpson, *Edward I and the Throne of Scotland 1290–1296*, 2 vols (Oxford, 1978), 1:138–44, and Ralph A. Griffiths, 'Edward I, Scotland and the Chronicles of English Religious Houses,' *Journal of the Society of Archivists* 6, no. 4 (October 1979): 194.

On the possible public for these rolls, see de Laborderie, 'Les généalogies des rois d'Angleterre,' 194, and Bovey, *The Chaworth Roll*, 25–28.

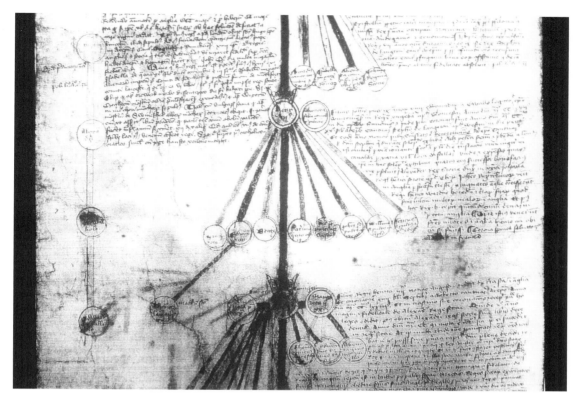

20.4 London, British Library, MS Add. 24026: Genealogical Roll. Detail with Kings Henry III, and Edward I, with secondary genealogy of the kings of Scotland in the left margin.

which saved the expense of binding, might have made these objects accessible to a wide public, as is otherwise suggested by the sheer number of rolls preserved. The lightweight and easily portable form would have further increased access to them.[25]

A slightly later and spectacularly different roll, Bodley Rolls 3, is generally assumed to have been designed for a court audience and perhaps at court, however.[26] The connection to Edward's claims to Scotland has been convincingly drawn for this more majestic object, which differs from the smaller, more modest rolls in nearly every respect.[27] At 52.3 cm (20 in.) across, it is twice as wide as the smaller rolls; in its original state it measured nearly 4.9 m (16 ft.)

[25] Richard H. Rouse, 'Roll and Codex: The Transmission of the Works of Reinmar von Zweter,' *Paläographie 1981: Münchener Beiträge zur Mediävistik und Renaissance-Forschung* 32 (1982): 120–21.

[26] Lucy Freeman Sandler, 'Genealogical Roll of Kings of Britain,' in *Age of Chivalry: Art in Plantagenet England 1200–1400*, ed. Jonathan J. G. Alexander and Paul Binski (London, 1987), 200–201, and Monroe, 'Illustrated Genealogical Manuscripts,' 49 and 329–30.

[27] Monroe, 'Two Medieval Genealogical Roll Chronicles,' 220.

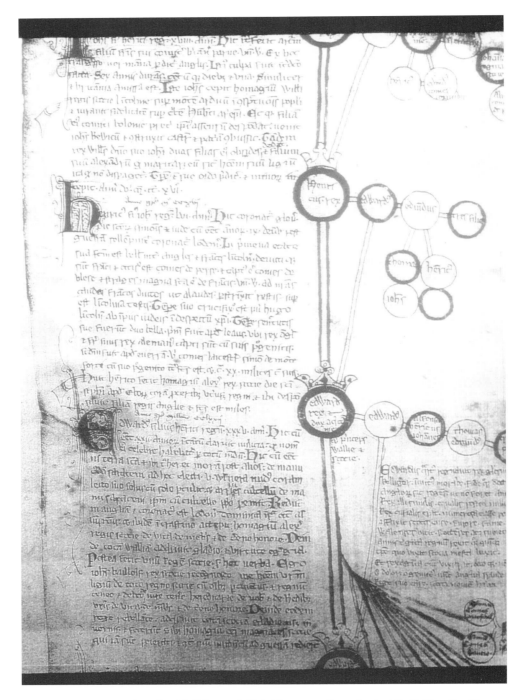

20.5 London, British Library, MS Add. 29504: Genealogical Roll. Detail with Kings John (cropped at the top), Henry III, Edward I and Edward II (cropped at the bottom), with small marginal hands pointing out the texts describing homage of the Scottish kings.

in length. It is heavily decorated; the images in colored washes and gold leaf overwhelm the increasingly short texts. A family tree, properly speaking, closed the roll (fig. 20.6), but it was preceded by four other sections.[28] In the first, twenty narrative medallions portray the mythical events leading up to Brutus's founding of Britain according to Dares the Phrygian.[29] The smaller medallions of the second section represent the sequence of the legendary early kings according to Geoffrey of Monmouth's *Historia Regum Britanniae*. They are followed by a chart of the kings of the Heptarchy after Henry of Huntingdon's *Historia Anglorum*, and in the fourth section, roundels bearing the more modern kings portray, again, a sequence of office-holders rather than blood relations. Although they do not start in the same place, the kings in the family tree duplicate those of this last section, the first instance of duplication on the roll. Except for the narrative in the first part of the roll, text is very limited, indicating that the sequence of rulers is more important than the deeds of their reigns.

The texts of Dares the Phrygian on the Trojan War and the events leading up to it and, in the last line of roundels, Geoffrey of Monmouth, in the first section of the roll are heavily abridged.[30] The Greeks' preparations for the war are omitted, and the Sack of Troy is described in short order: twenty-nine chapters devoted to this material in Dares's forty-two-chapter work are skipped over. This allows the scenes of Telamon and the Trojan princess Hesione, Alexander (today known better as Paris) and Helen, and Brutus and the daughter of King Pandrasius more play than the textual source devotes to them. Further, the first two of these scenes is strategically arranged in the visible positions at the beginnings and ends of registers. This decision to downplay the lengthy treatments of battles changes the tenor of the story and places a stronger emphasis than the original authors intended on two kinds of episodes. The first is the idea, seen in the stories of Jason and Hercules at beginning of the narrative and of Aeneas and Brutus at the end, of travel to distant lands—to conquer, settle, and establish a genealogical succession. The second resultant emphasis is on the role of women in this story, exemplified

[28] The family tree is now detached. Monroe, 'Two Medieval Genealogical Roll Chronicles,' 217–18, has identified it as London, British Library, Cotton Galba Charter XIV.4.

[29] The short catalogue entries that, with the exception of the article by Monroe cited in the previous note, constitute the entire published scholarship on this astounding work, uniformly cite Geoffrey of Monmouth's *Historia Regum Brittaniae* as the source for the narrative roundels of this first part of the roll; see *Art and the Courts: France and England from 1259 to 1328*, ed. Peter Brieger and Philippe Verdier (Ottawa, 1972), 93, no. 21; Lucy Freeman Sandler, *Gothic Manuscripts 1285–1385*, Survey of Manuscripts Illuminated in the British Isles 5, 2 vols (London, 1986), 1:26; and Sandler, 'Genealogical Roll of Kings of Britain,' 200–201. As far as I know only Monroe correctly notes Dares as the source for the first four rows of narrative roundels; 'Illustrated Genealogical Manuscripts,' 299 and 567.

[30] The most accessible version of Dares' text is available online at http://www. thelatinlibrary.com/dares.html. Geoffrey's text is available in numerous print versions; Acton Griscom, *The Historia Regum Britanniae of Geoffrey of Monmouth with Contributions to the Study of its Place in Early British History* (London, 1929), includes the Latin text and an English translation of a Welsh manuscript by Robert Ellis Jones. The Penguin edition is more accessible and more recent: Geoffrey of Monmouth, *The History of the Kings of Britain*, trans. Lewis Thorpe (1966; reprint, Harmondsworth, 1979).

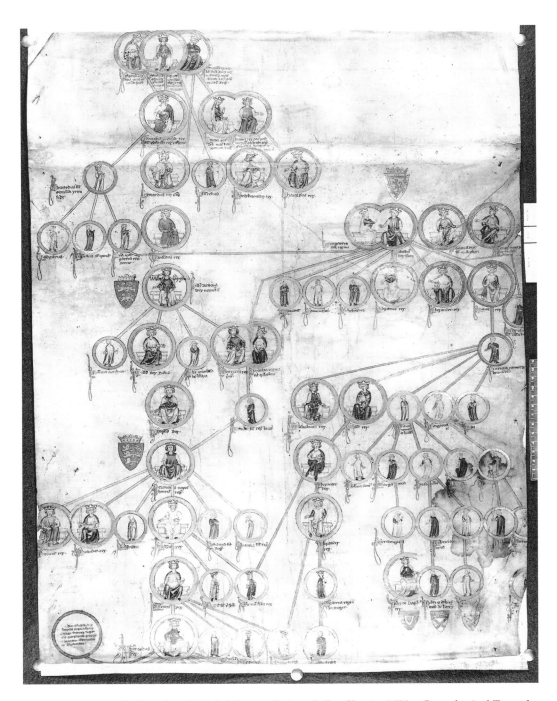

20.6 London, British Library, Cotton Galba Charter XIV.4: Genealogical Tree of the kings of England and Scotland, once attached to Oxford, Bodley Rolls 3.

by the three scenes in which men take foreign brides in order to establish their family lines.

These same themes are emphasized in the genealogical tree originally located at the bottom of the Bodley roll. The tree here deviates from those of the earlier type studied above. Although most of the kings of England are represented in a single vertical line at the left side of the tree, Cnut and his sons and Henry I are not, so it is more difficult to read accurately the sequence of kings from this tree. Each king is represented only once. Two figures do appear twice, and both are women. At the top, Emma, who was married first to King Aethelred, then, after his death, to his successor Cnut, is portrayed almost as if she were her own child.[31] Only the reader who notes the *predicta* in the label to the second medallion is the wiser. St Margaret is the only other figure on the chart who is portrayed twice. She appears first as the daughter of Edward the Exile in the smaller medallion reserved for children and then again as the wife of Malcolm III of Scotland. In this second instance she is given the full-size medallion that marks rulers, and it is linked to that of her husband. The two images of Margaret are joined by a long horizontal line, an unusual eye-catcher in the overall composition.

In addition to Emma and Margaret, only one other woman is allotted this larger size medallion: Margaret's daughter Maude or Matilda, the wife of Henry I, whose roundel is also joined to that of her husband. It seems clear that Emma and Margaret earn double billing as the mothers of kings of two ruling dynasties. The large roundel devoted to Margaret's daughter Maude marks her role not just as the progenitrix of the Angevin kings of England, but as the link between the English and the Scottish ruling houses. That the production of heirs is responsible for the emphasis on these women can be seen by the different portrayal of English princesses who married Scottish kings nearer the bottom of the roll; here the medallions of Alexander II and Alexander III and small roundels of the women they married are joined by long diagonal lines, rendered necessary by the fact that the women are portrayed only in their natal line. Joan, wife of Alexander II, did not produce an heir. Of the children of her niece Margaret, the wife of Alexander III, only a daughter continued the line; her daughter, however, died in 1290 before she could assume the Scottish throne. A cursory study of the tree would seem to suggest that these English princesses are descendants of the Scottish kings and the label for Joan does nothing to set the viewer straight: 'Joan, daughter of the king.'[32] The Scottish line thus appears to merge into the English, an idea that is further supported by the general movement of the lines of the diagram toward the lower left. This idea would have been particularly appealing to Edward after the deposition of John Balliol in 1296, when Edward himself claimed Scotland. If Edward had a rightful claim to Scotland, it was by virtue of his descent from St Margaret.

[31] The two inscriptions read:
Emma regina filia Ricardi ducis normanorum mater Alfredi et Sanct Edwardi regis.
Emma predicta mater Hardecnuti regis.

[32] Johanna filia regis.

The Scottish kings in the tree end with John Balliol, suggesting the manufacture of Bodley Rolls 3 during his reign, 1292–96. The genealogical chart seems to fit better with Edward's claims to Scotland after Balliol's removal from the throne in 1296, however. It indicates equally well the idea that, with Balliol, the independent line of Scottish kings had come to an end. This slightly later date can be supported too by the narrative material in the uppermost portion of the roll. The legendary early history of Britain going back to Brutus was not used in 1291–92 when Edward built his case for the overlordship of Scotland, which he demanded the Scots recognize before he decided the relative merit of the thirteen claimants to the empty throne. Nor did it show up in the official record of those events, the Great Rolls of John of Caen, completed by May of 1297.[33] It is traditionally said to have been in his 1301 letter to Pope Boniface VIII that Edward first associated this legendary early history with his claims to Scotland.[34] Since Bodley Rolls 3 must date before 1300, however, it was actually here in the images and text at the top of the roll that the mythical distant past was first used in support of Edward's claims, portrayed in the genealogical chart at the bottom.[35]

The role of women in Edward's claim to the Scottish throne, however, had been spelled out earlier, in the more modest rolls that should be understood as the popular predecessors to the more elegant, programmatically complicated, and better-known later example. In these apparently straightforward genealogies of the royal succession, once so numerous that even today they still exist in large numbers, the exceptional treatment accorded to two women highlighted women's roles in general and in specific. Athelflaed's inclusion near the beginning of the roll indicates the importance of daughters in marrying and ensuring the succession of their husbands' lines. The greater place accorded to Margaret in both text and image emphasizes her place in the return of the throne of England to the Anglo-Saxon line and explains the descent of the rulers of this amalgamated Norman-Anglo-Saxon line from the kings of Scotland in such a way as to justify their claim to that throne as well.

[33] E. L. G. Stones, 'The Records of the "Great Cause" of 1291–92,' *The Scottish Historical Review* 35, no. 120 (October 1956): 93, discussing London, Public Records Office, E.39/15/2.

[34] The text of this letter is printed and translated in E. L. G. Stones, *Anglo-Scottish Relations 1174–1328: Some Selected Documents* (London, 1965), 96–109.

[35] The unusual placement, heavier script, and darker ink of the roundel with the names of the children of Edward's second marriage to the left of his medallion indicates that it was added sometime after the birth of the youngest of the named children, Eleanor, in 1303. That the name of Thomas, who was born in 1300, is also included here indicates that he was not among the children of Edward I originally included on the chart, and thus that the roll dates before 1300.

PART SIX

Performativity

Mirror, Mirror on the Wall: Reflections on the Performance of Authority in Eike von Repgow's *Sachsenspiegel*[1]

Charles G. Nelson†

The *Sachsenspiegel*, or *Saxon Mirror*, is a law book composed in the late thirteenth century by Eike von Repgow (around 1180–1235). Its name comes from a passage in the rhymed preface attributed to Eike.

> The Mirror of the Saxons
> Shall this book be called.
> For from it Saxons will learn their law
> As a woman does her countenance in a mirror.[2]

The Sachsenspiegel has been thoroughly researched for some two hundred years, primarily by German legal historians, who rightly recognize it as one of the most important monuments in the history of German law. My project in this essay is to remove it from this constricting frame by postponing its quasi-documentary status and recognizing that, for all its achievement as a record of Saxon customary laws, it shares many of the same characteristics inherent in so-called 'literary' texts. Its ambiguously generic constitution has been mentioned occasionally in passing, but the insight has not led to any consequent change in analyzing the text itself as a discursive practice. After some attention to theoretical

[1] The ideas and interpretations in this paper will become part of a developing argument in a joint project on the illustrated fourteenth-century manuscripts of the Sachsenspiegel undertaken with Madeline Caviness, my colleague in the Department of Art History at Tufts University. Together and separately we have published, delivered conference papers on, and team-taught the illustrated manuscripts for a number of years. We curated an exhibition at Tufts University in 1998, now a website: http://dca.tufts.edu/features/law/index.html. This paper is based on one I presented in a session on New Research in German Studies IV, Session 525, 33rd International Conference on Medieval Studies, May, 1998, Western Michigan University, Kalamazoo, Michigan, entitled 'Spiking the Canon: The *Sachsenspiegel* as (Literary?) Text.' Here, with different emphasis, it becomes a companion piece to Madeline Caviness's 'Putting the Judge in His P(a)Lace: Pictorial Authority in the *Sachsenspiegel*,' *Österreichische Zeitschrift für Kunst und Denkmalpflege (Festschrift für Ernst Bacher)* 54 (2000). The occasional 'we' of my text reflects our collaboration.

[2] 'Spegel der Sassen/ Scal dit buk genant,/ went Sassen recht is hir an bekannt,/ alse an eneme spegele de vrowen/er antlite scowen.' Clausdieter Schott, ed., *Eike Von Repgow: Der Sachsenspiegel* (Zurich, 1984), ll. 178–82, 18. Unless otherwise indicated, all translations are the author's.

considerations basic to this observation, I will introduce aspects of speech act theory to show how the concept of performitivity can tell us something about the law book's life as a text: the necessity for and the prominence of performatives in the language its author uses to communicate. Finally, I will turn to some pictures from the illustrated manuscripts and their techniques for pictorially performing notions of gender inscribed authoritatively in the articles of the law.

The Sachsenspiegel incorporates both regional or rural law (*Landrecht*) affecting principally the peasantry and feudal law (*Lehnrecht*) affecting the gentry. Composed sometime between 1220–1235 in eastern Saxony, it was enormously influential in its time and into the sixteenth century, when the manuscripts gave way to printed versions. Before printing it was copied into some 460 manuscripts spreading west, south, and to the non-German-speaking east.[3] Its author, Eike von Repgow, was an educated knight who moved among the upper Saxon nobility and was familiar with the law. His name appears as a witness on a number of legal documents.[4] Four spectacularly illustrated redactions of the Sachsenspiegel from the fourteenth century survive.[5] A law book, a term attested as early as 1397, is a private undertaking by legal experts who claim to have written down all the valid laws of their time or place, doing so without any official commission. The resulting text lacks any statutory or legislative authority.[6] The Sachsenspiegel is the earliest German vernacular example of a European-wide phenomenon, the committing to writing of prevailing customary laws;[7] it is also one of the

[3] Heiner Lück, *Über den Sachsenspiegel: Entstehung, Inhalt und Wirkung des Rechtbuches*, Veröffentlichungen der Stiftung Dome und Schlösser in Sachsen-Anhalt, ed. Boja Schmuhl, vol. 1 (Saalkreis, 2005), 25; Ulrich-Dieter Oppitz, *Deutsche Rechtsbücher des Mittelalters*, 3 vols Beschreibung der Rechtsbücher, (Cologne, 1990–92), 1:3.

[4] Lück, *Über den Sachsenspiegel*, 18–19. German scholarship refers to him as *rechtskundig*, familiar with the law. The precise source of his knowledge has long been the subject of speculation but Peter Landau, 'Der Entstehungsort des Sachsenspiegels Eike von Reipgow,' *Deutsches Archiv für Erforschung des Mittelalters* 61:73–101, has put an end to that.

[5] Karl von Amira, ed., *Die Dresdner Bilderhandschrift des Sachsenspiegels*, 1 ed., vol. 1 (Leipzig, 1902); Walter Koschorreck, *Der Sachsenspiegel. Die Heidelberger Bilderhandschrift Cod. Pal.Germ. 164* (Frankfurt am Main, 1989); *Eike von Repgow: Sachsenspiegel. Die Wolfenbütteler Bilderhandschrift Cod. Guelf. 3.1 Aug. 2°. Faksimile*, ed. Ruth Schmidt-Wiegand, 3 vols (Berlin, 1993); Ruth Schmidt-Wiegand, ed., *Der Oldenburger Sachsenspiegel: Vollständige Faksimile-Ausgabe im Originalformat des Codex Picturatus Oldenburgensis CIM I 410 Der Landesbibliothek Oldenburg*, 3 vols (Graz, 1995); Heiner Lück, ed., *Vollständige Faksimile-Ausgabe im Originalformat des Dresdener Sachsenspiegels: Mscr. Dresd. M32 Der Sächsischen Landesbibliothek—Staats—Und Universitätsbibliothek Dresden*, vol. 107 (Graz, 2002). The Dresden manuscript was damaged in the bombing during WWII and was recently restored. The Amira facsimile is of the undamaged manuscript; the Lück facsimile is of the restored manuscript. See Dag-Ernst Petersen, 'Zur Erhaltung ues Dresdener Codex Picturatus: Die Schäden und Ihre Geschichte; Konservierung und Restaurierung,' in *Die Dresdner Bilderhandschrift des Sachsenspiegels. Interimskommentar*, ed. Heiner Lück (Graz, 2002) for an account of this process.

[6] Here I am paraphrasing part of the entry in Adalbert Erler, Ekkehard Kaufmann, and Dieter Werkmüller, eds, *Handwörterbuch zur Deutschen Rechtsgeschichte*, 5 vols (Berlin, 1971 through 1998), 4:col. 277–78. See also the entry 'Law and Lawbooks' in John M. Jeep, et al., ed., *Medieval Germany: An Encyclopedia* (New York, 2001).

[7] Franz Wieacker, *A History of Private Law in Europe with Particular Reference to Germany*, trans. Tony Weir (New York, 1995), 71–72. For an excellent summary on the custumal, see *The*

most important examples of the genre as a model, notably for municipal law books.[8]

It attracted vigorous scholarly interest from very early on and continues to do so to this day.[9] In the modern period it stands as a giant among sources for writing the history of German law. It has long been the object of intensive research in Germany, but interest peaked at certain times: at the turn of the nineteenth century, and from the 1930s to 1945. Interest in it surfaced again in the 1960s and picked up in the 1970s and 1980s.[10] Most noteworthy in more recent work in the 1990s is the attention devoted to the production of facsimile editions of the four illustrated recensions, each with a comprehensive scholarly apparatus.[11] The production of these facsimile volumes laid the groundwork for making the work accessible to scholars. Ruth Schmidt-Wiegand, primarily a philologist, has worked most visibly as editor of the Wolfenbüttel and Oldenburg facsimiles, primarily to create this accessibility for the express purpose of attracting scholars from other disciplines to its study.[12]

Because it is such a rich and richly illustrated text, the Sachsenspiegel offers literary scholars, art historians, and others a chance to bring to its study

Saxon Mirror: A Sachsenspiegel of the Fourteenth Century, trans. Maria Dobozy, The Middle Ages Series, ed. Ruth Mazo Karras (Philadelphia, 1999), 9–28.

[8] Rolf Lieberwirth, 'Über die Glosse zum Sachsenspiegel,' *Sitzungsberichte der Sächsischen Akademie der Wissenschaften zu Leipzig. Philologisch-Historische Klasse* 132.6 (1993), 3.

[9] Judge Johann von Buch, learned in Roman and Canon law, sought sometime after 1325 to reconcile the articles of the Sachsenspiegel with Roman and Canon law. Erler, Kaufmann, and Werkmüller, eds, *Handwörterbuch zur Deutschen Rechtsgeschichte*, vol. 1, col. 526–27.

[10] For bibliography see Guido Kisch, 'Sachsenspiegelbibliographie,' *Zeitschrift für Rechtsgeschichte* 90 (1973); Ulrich-Dieter Oppitz, *Deutsche Rechtsbücher des Mittelalters*, 3 vols (Cologne, 1990–92), 1: 88–94; and Ruth Schmidt-Wiegand, ed., *Text-Bild-Interpretation: Untersuchungen zu den Bilderhandschriften des Sachsenspiegels*, 2 vols (Munich, 1986), 1:280. Amira produced his facsimile in 1902 and two commentary volumes in 1925 and 1926: Karl von Amira, ed., *Die Dresdener Bilderhandschrift des Sachsenspiegels: Erläuterungen*, 3 vols, (Osnabrück, 1969). For political rather than scholarly reasons, the National Socialists wanted to claim Eike for their own in 1933. See Peter Landau, 'Die Deutschen Juristen und der Nationalsozialistische Juristentag 1933,' *Leipziger Juristische Vorträge* 19 (1996); and Heiner Lück, 'Mummenschanz für "Deutsches Recht" Die Eike-von-Repgow Feiern auf Burg Falkenstein und in Reppichau/Dessau 1933 und 1934,' in *Rechtsgeschichte in Halle: Gedächtnisschrift für Gertrud Schubart-Fikentscher* (1896–1985), ed. Rolf Lieberwirth, vol. 5, Hallische Schriften Zum Recht (Cologne, 1998). In the same year Karl Eckhardt published his edition of the Quedlinburg manuscript of the Sachsenspiegel: Karl August Eckhardt, ed., *Sachsenspiegel: Quedlinburger Handschrift* (Hannover, 1966). Though it is widely cited, scholars have found serious problems with it. See especially 19–20. The 1980s and 1990s saw the costly production of the facsimile editions cited in n. 3. Translations into modern German have accompanied this activity, e.g. Hans Christoph Hirsch, ed., *Eike von Repgow: Der Sachsenspiegel [Landrecht] in Unsere Heutige Muttersprache Übertragen und dem Deutschen Volke Erklärt* (Berlin 1936); Schott, ed., *Eike von Repgow: Der Sachsenspiegel*, in the 1980s, and a most welcome one into English. See Maria Dobozy, trans., *The Saxon Mirror: A Sachsenspiegel of the Fourteenth Century*, The Middle Ages Series, ed. Ruth Mazo Karras (Philadelphia, 1999).

[11] Ruth Schmidt-Wiegand and Wolfgang Milde, eds, *Gott ist Selber Recht. Die Vier Bilderhandschriften des Sachsenspiegels: Oldenburg, Heidelberg, Wolfenbüttel, Dresden*, 2nd improved edition, (Wolfenbüttel, 1993). Source for a recent dating is Lück, *Über den Sachsenspiegel*, 32.

[12] Schmidt-Wiegand and Milde, eds, *Gott ist Selber Recht*, 10–11.

methods appropriate to their respective disciplines. As their approaches vary, so will the outcomes. The consequence in the world of post-modern criticism will not be a juxtaposition of competing claims about what we can say about the Sachsenspiegel. At best it will produce a number of associated interpretations reflecting (to employ the metaphor of its own title) the multivocal character of the text through its connections to the culture--and by no means only the legal culture—of which it is a part.

Most of the voluminous research of the last two centuries on Eike's book has been carried out by legal historians. With the advent of the facsimiles, philologists, codicologists, linguists, lexicographers, dialect geographers, and of course historians have joined in. Their approach has been to understand the book as an innocent record of the legal customs and practices that up to that time had been transmitted orally in the Saxon community.[13] Generically it has been considered a custumal,[14] and as noted above, it initially had no legal standing.[15] But in the course of time it acquired the force of written law so that it gradually took on the character of a legal document, though somewhere in a limbo between a direct and an indirect source for the law.[16] I will come back to this phenomenon below.

As I noted above, the Sachsenspiegel is one of the oldest prose works written in German.[17] As prose, it affords an opening to interrogate the text *qua* text and raise questions that do not arise if the prose component is taken for granted and one goes straight to the 'law book.' As the maker of a text, Eike is also in the construction business. When he recorded Saxon legal practices, he first produced a text which also and inevitably inscribed values, attitudes, prejudices, and biases of the essentially male, landed, knightly class which had retained him, and to which at some level he also belonged.[18] Their interests, and so his, were to legitimize and stabilize the past in a time of political uncertainty,[19] and to preserve the legal culture by textualizing it. In order to

[13] Karl Kroeschell is sensitive to the difficulty distinguishing between 'lawbooks' (*Rechtsbücher*) and law literature (*Rechtsliteratur*). See Karl Kroeschell, *Deutsche Rechtsgeschichte bis 1250*, Wv Studium Rechtswissenschaft, 3 vols (Hamburg, 1972–99), 8:248.

[14] A book or document containing the legal customs of a locality.

[15] Cf. the article under 'consuetudo' in Peter Dinzelbacher, ed., *Sachwörterbuch der Mediävistik*, vol. 477 (Stuttgart, 1992), col. 1, p. 151.

[16] For examples of these categories and a discussion of these concepts, see Rudolf Gmür and Andreas Roth, *Grundriss der deutschen Rechtsgeschichte*, Juristische Arbeitsblätter, 9th rev. ed. (Neuwied, Austria, 2000), 7–8.

[17] Among other examples are Notker III, 980–1020 with his translations and commentaries and the anonymous *Lucidarius*, ca. 1190–95.

[18] Karl Kroeschell, 'Rechtswirklichkeit und Rechtsüberlieferung: Überlegungen zur Wirkungsgeschichte des Sachsenspiegels,' in *Text-Bild-Interpretation: Untersuchungen zu den Bilderhandschriften des Sachsenspiegels*, ed. Ruth Schmidt-Wiegand, vol. 1, Münstersche Mittelalter-Schriften (Munich, 1986). 'Thus he was personally acquainted with the most important Imperial princes of his area' ['Mit den wichtigsten Reichsfürsten seines Raumes war er also persönlich bekannt'], 2–3.

[19] In Eike's lifetime Henry IV had died in 1197; he witnessed the rise of the Hohenstauffen Emperor, Frederick the II; he was familiar with the Fourth Lateran Council of 1215, which was to settle the issue of the secular rule of the Pope in his role as a judge. As to his subject, customary law, the consensus is that it was undergoing rapid change. See Kroeschell, *Deutsche*

record this tradition, he elected to write in prose, but in a rambling, freely-associative, unsystematic style further complicated by difficult syntax.[20] Further, his writing is replete with subjective asides and commentary, references to the Bible, historical figures and events, and proverbial wisdom. Compared with the language of an official statute from about the same date, the Imperial Land Peace of Mainz (1235), it is not at all a stretch to think of the Sachsenspiegel as being on the borderline between ordinary and literary language.[21]

Roland Barthes in a 1971 essay sets up a useful opposition between 'Work' or 'Book' and 'Text' in which he distinguishes between them on a number of different points.[22] He speaks of the text as a 'new object,' one that speaks simultaneously with many voices. In the process of making these claims ('*nonciations*') he identifies a new understanding of the nature of textuality and of the subjective relations that obtain among author, text, world, and reader. According to John Sturrock:

'… the Book is an entity enclosed between two covers and complete in itself—a unity susceptible of an exhaustive interpretation or reducible to a manageable source of meanings (or even a single or overall meaning). The Text, on the contrary, is not enclosed but open to the four winds of language, spawning meanings with the utmost generosity and standing in close relation to other texts. It does not have the unity of the book, nor the singleness of purpose. And rather than being interpretable as the utterance of a single person, the Author, it is to be read as a chorus. The text is, in Bakhtin's term for it, 'polyphonic.'[23]

Thus Sturrock sums up the post-structuralist (and Barthes's) position on the work-text distinction. It is on these terms that the reader transforms the Sachsenspiegel into a text, and is thus licensed to listen for its other voices. So when I pose the question of the Sachsenspiegel as a 'literary' text, it is this dimension of textuality I am invoking. I am suggesting that literariness exists in the eye of the beholder. And when the medievalist scholar-critic, reading the past from contemporary theory, focuses on this thirteenth-century legal text, it is transformed into a different discourse by the nature of the analysis applied.[24]

Rechtsgeschichte bis 1250 315–16; and Rolf Lieberwirth, 'Eike von Repgow und sein Sachsenspiegel. Entstehung, Inhalt, Bedeutung,' (1980), 34.

[20] See Dobozy's remarks on Eike's style in *The Saxon Mirror*, 37.

[21] Cf. Dobozy's translation of the Land Peace, pp. 43–49. It is devoid of any editorializing. See Schmidt-Wiegand's analysis of several aspects of Eike's style in Ruth Schmidt-Wiegand, 'Sprache und Stil der Wolfenbütteler Bilderhandschrift,' in *Die Wolfenbütteler Bilderhandschrift des Sachsenspiegels: Aufsätze und Untersuchungen. Kommentarband zur Faksimile-Ausgabe*, ed. Ruth Schmidt-Wiegand, vol. 3 (Berlin, 1993), 201–18, esp. 207–208 on the similarity with the spoken language. The correspondences she finds with the Land Peace of Mainz are limited to the phonological level.

[22] 'De l'oeuvre au texte' in *Revue d'esthétique* 3 (1971), trans. Stephen Heath as, 'From Work to Text,' in Roland Barthes, *Image Music Text*, trans. Stephen Heath (New York, 1977), 155–64.

[23] John Sturrock, *Structuralism*, (London, 1993).

[24] The following observation is especially significant for my argument. '"Non-literary" texts produced by *lawyers* [emphasis mine], popular writers, theologians, scientists, and historians should not be treated as belonging to a different order of textuality. Literary works should not be regarded as sublime and transcendent expressions of the "human spirit," but

While this process never denies the text's historical status as a monument belonging to legal history, it no longer uncritically accepts the Sachsenspiegel as a neutral, objective, and transparent record of and commentary on customary law. Instead, it seeks to understand it as a text doing significant ideological work that is inscribed in the particular style of its author-compiler's prose. It is on this basis that I will proceed to read the Sachsenspiegel, traditionally considered a 'law' book, as if it were (also and simultaneously) some other kind of writing, something between an essay and a story about the Saxons' legal customs, which it describes, justifies, and explains.

Between the contemporary user of the Sachsenspiegel and the text itself stands the towering figure of Eike. The brief identification supplied above requires some elaboration, especially in connection with a number of questions about issues of authority.[25] The Sachsenspiegel does not proceed from any authority constituted to establish laws or statutes. So where does the institutional authority come from to make the book in the first place? Who authorized Eike to author the book? Eike himself spoke on these matters in a rhymed preface to the book on which his name does not appear, but which is attributed to him:

> Now let us all thank the Lord of Falkenstein
> called Count Hoyer
> that this book has been translated into German at his request:
> Eike von Repgow did it.[26]

These lines have launched an extensive debate about the relationship between Hoyer and Eike (lord and vassal?), and about the existence of an original Latin version (true or topos?). Peter Johanek's findings are most convincing, especially on the Hoyer-Eike relationship: Eike was a *miles literatus*, (a literate, educated knight) associated with Hoyer, both actively engaged as administrators who assisted in the promotion and enhancement of the political and economic programs of the Counts of Anhalt.[27] His view on the question of the Latin original is left somewhat open, though he is convinced there was one.[28]

as texts among other texts.' Raman Selden and Peter Widdowson, *A Reader's Guide to Contemporary Literary Theory*, 3rd ed. (Lexington, Ky., 1993), 162–63.

[25] Here I will be following the possibly definitive account of Peter Johanek in Peter Johanek, 'Eike von Repgow, Hoyer von Falkenstein und die Entstehung des Sachsenspiegels,' *Was Weiter Wirkt: Recht und Geschichte in Überlieferung und Schriftkultur des Mittelalters*, ed. Antje Sander-Berke and Birgit Studt (Münster, 1997).

[26] 'Nu danket al gemeine/ deme von Valkensteine/ De greve Hoier is genant,/ dat an dudisch is gewant/ Dit buk dorch sine bede:/ Eike von Repchowe it dede;' Schott, ed., *Eike von Repgow: Der Sachsenspiegel*, 24, 2:261–6.

[27] As in n. 25, esp. 137–38.

[28] It is based in part on an analysis of the wording in the Rhymed Preface, and thus is somewhat speculative compared to his evidence for the relationship between the two men. pp. 138–39. Cf. Carl Erdmann, 'Der Entschluß zur deutschen Abfassung des Sachsenspiegels,' *Deutsches Archiv für Erforschung des Mittelalters* 9 (1952), E. Rosenstock, 'Die Verdeutschung des Sachsenspiegels,' Zeitschrift der Savigny-Stiftung für Rechtsgeschichte. Germanistische Abteilung 37 (1916), and Karl Zeumer, 'Über den Velorenen lateinischen Urtext des Sachsenspiegels,' in *Festschrift Otto Gierke zum siebzigsten Geburtstag* (Weimar, 1911).

The historical situation of this particular law book enhances the possibility of identifying its ideological and political underpinnings. It also explains the allusions, in Eike's frequent asides to his book's prospective users, to authority and authorities: from God, to secular rulers ancient and contemporary, to the Bible, and to 'historical' events. These will have been prompted, in part at least, by concerns for its reception. They begin, as we have seen, with the 'Rhymed Preface.' (*Reimvorrede*) Prefatory remarks by medieval authors cite sources and patrons regularly and sometimes extravagantly. Here Eike gives credit to Hoyer for persuading him to translate his (Eike's) own Latin Sachsenspiegel into German to make it available presumably to practitioners involved in the administration of Saxon law. But this leaves him without a traditional source text, because the Latin one is also by Eike. I contend that his ubiquitous appeals to authority throughout the text could be the consequence of an anxiety about the reception of the book. He makes this abundantly clear in some additional prefatory material, the two prologues referred to in the scholarship as *Prologus* and *Textus Prologi*.[29]

Eike opens with a prayerful invocation of the Holy Spirit, thus linking his enterprise to the possibility of Divine inspiration. By the time painters come to render this pictorially (around mid-fourteenth-century in *W* and *O*),[30] they trump the text and depict the Holy Spirit as already on the scene[31] (figs. 21.1 and 21.2). The seated kings (only authority figures are shown seated in these books) exhibit speaking gestures.[32] Eike's gesture may signal acceptance. Thus the artists foreshorten and personalize the connection between Eike and authorities 'providing the Law.' The banner is empty, pointing to a void in the execution of Law and Justice which Eike is being authorized to fill. The picture places Eike in direct proximity with Divine and royal authority.

The situation in *O* is remarkably different (fig. 21.2). The kings are absent, replaced by the counts of Oldenburg, not as human figures, but by their arms, a more effective representation of authority and power. They point to a more parochial and local authority, one closer to the population in their county (*Grafschaft*) than that of the historically distant emperors. Here Eike replaces the seated kings and is himself frontally seated, a powerful signal of his status as author. The cruciform composition of the picture pairs the book with secular authority and Eike with divine inspiration, an unbeatable combination.

After calling upon the Holy Spirit, Eike then seeks to co-opt prospective users by inviting them, perhaps flattering them, to do better than he did, with better

[29] For the complete text, see the appendix. The translations are from Dobozy, p. 67.

[30] These are conventionally named for the locations of the libraries where the manuscripts are now preserved: W=Wolfenbüttel, 1348–62/71, O=Oldenburg, 1336, D=Dresden, 1295–1363, and H=Heidelberg, 1295–1304. References to these mss. will adopt this shorthand.

[31] See Fig. 1, Wolfenbüttel, Herzog August Bibliothek, MS Cod. Guelph. 3.1 Aug. 2° fol. 9v, reg. 1, left). I will be looking at text-picture relationships in greater detail below.

[32] See Karl von Amira, *Die Handgebärden in den Bilderhandschriften des Sachsenspiegels*, Abhandlungen der Königlichen Bayerischen Akademie der Wissenschaften, I. Kl., vol. 23/2 (Munich, 1905), esp. 165–203. According to the chart of gestures on p. 264, Eike would seem to be blessing the kings, not a likely event. But Amira's seminal analysis in 1905 is subject to some revision. He himself speaks often of overlapping and exceptions.

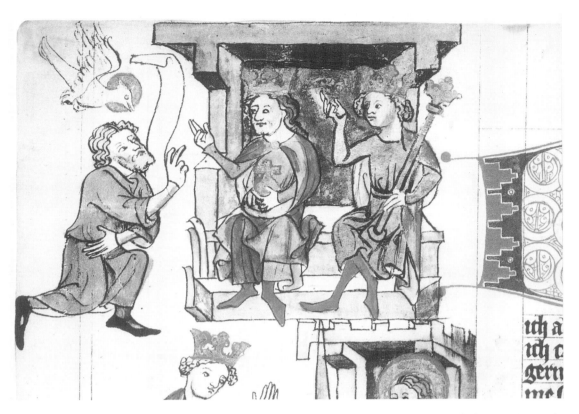

21.1 Inspired by the Holy Spirit, Eike kneeling converses with Constantine and Charlemagne about the law yet to be inscribed on the empty banner. The inspiring Holy Spirit with nimbus hovers. Sachsenspiegel W, fol. 9v u.f. 85, Reg. 1.

information. Then, in what may be the most famous line of the whole book, he equates the law with God himself. 'Got ist selber recht,' God himself is Law. It is a short distance from 'Law' to Saxon law and Eike's 'law book.' What written source could compete with that tradition? Finally, apparently calling on judges and *Schöffen* (judgment finders in legal proceedings) to do their work well, he would here be recommending his book as an authoritative reference to spare them God's wrath should they err. In the second prologue, he refers to divine law, and then to the laws provided by the emperors Charlemagne and Constantine, and finally to Saxon law, thus establishing a direct line from what *he* will be writing to imperial, then Divine authority. The legal historian rightly understands these prologues as incorporating Eike's philosophy of law; the literary critic notices their organization: each opens and closes with a reference to the Divine (preceded in the *Textus Prologi* by ultimate secular authority); these openings and closings each bracket error-prone, inadequate humanity. Justice, the Law, and Eike's book are conflated: the text performs its own authority by associating itself with ultimate divine and secular authority.

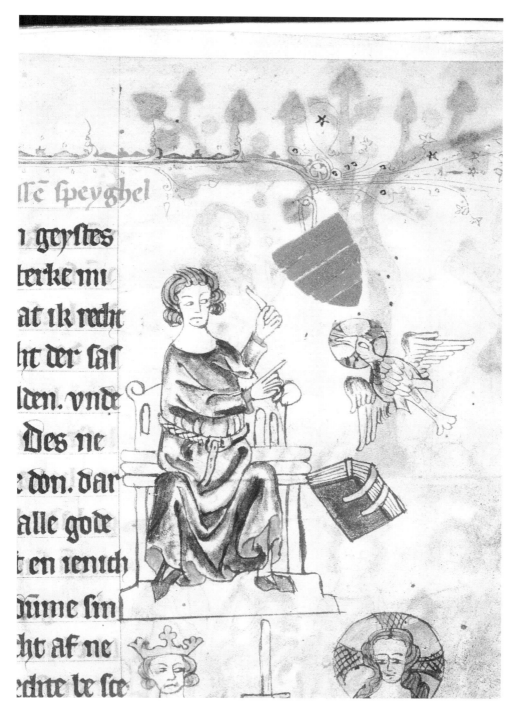

21.2 Eike, seated as author under the arms of the Counts of Oldenburg, points to a dove with nimbus (Holy Spirit), the source of his inspiration for the book in the lower foreground. Sachsenspiegel O, fol. 6r, Reg. 1.

Virtually nothing is known about how Eike went about doing his work or what his sources might have been. Scholars have extrapolated from the text areas where he obviously had considerable knowledge, such as ecclesiastical writing, Canon Law, the Bible, and imperial laws. There is evidence that he was well acquainted with the legal culture and judicial practices of eastern Saxony.[33] As he committed these to writing, Eike was bent on advancing the welfare of the counts of Anhalt and with them the class of landowning gentry of which they (and he) were a part. In the absence of any written sources to consult, his peers were obliged to take him at his word in a changing legal world.[34]

Ruth Schmidt-Wiegand has pointed to linguistic evidence, suggesting that Eike's style incorporates aspects of spoken language. Although these indications are not immediately apparent to the lay reader,[35] it is clear that Eike appears to be directly talking to his readers of his book. He frequently introduces a custom with a 'Now hear about' or 'Now hear how.' He also explains the laws as he goes along in what amounts to asides.[36] These descriptions of the law and statements he makes about it, are in the discourse of the philosophy of language, speech acts.

In what follows I will make minimal but sufficient reference to speech act theory.[37] It will enable insights at the fundamental level of Eike's speech into what appears to be a personal anxiety concerning both his and his book's authority in the Saxon world. For example, an analysis of certain speech acts will provide clarification, in philosophical terms, of the distinction between Eike's law book and statutory law, a central issue in Sachsenspiegel scholarship. John L. Austin famously distinguished between constative statements, those that describe a state of affairs in the world (Eike: 'God left behind on earth two swords for the protection of Christianity'),[38] and performative utterances that actually perform the actions they describe (Mainz Imperial Land Peace: We establish and decree by the power of our imperial authority and in conjunction

[33] There are six legal documents on which his name is recorded as a witness. Lück, *Über den Sachsenspiegel*, 18.

[34] The issue as to whether Eike was at least in some instances making new law has been raised and will be addressed in the book Madeline Caviness and I are writing.

[35] See n. 21.

[36] It is irresistible to revisit, if only for one observation, the speech-writing hierarchy addressed by Derrida. Eike's text shares the phono- and logocentric commitment of traditional (Western) philosophy. But one might argue that, as he pursues the transcendental signified (in this case 'Law,' he is deconstructing his own project. For a brief and lucid discussion of these concepts, see Madan Sarup, *An Introductory Guide to Post-Structuralism and Postmodernism*, 2nd ed. (Athens, Ga., 1993), 34–38.

[37] Here I follow the standard sources from philosophers of language J. L. Austin, *How to Do Things with Words*, 2nd edition ed. (Cambridge, Mass., 1962), and John Searle, *Speech Acts: An Essay in the Philosophy of Language* (Cambridge, 1969), and their explicators Jonathan Culler, *Literary Theory: A Very Short Introduction*, 1st ed. (New York, 1997), 24–26, 71–74, and 90–104; and Sandy Petrey, *Speech Acts and Literary Theory*, (New York, 1990), 3–41, and Selden and Widdowson, *A Reader's Guide*, 148. For a more complete recent bibliography, see Yueguo Gu, 'The Impasse of Perlocution,' in *Humanities: Chinese Academy of Social Sciences Forum* (1999), 199–200.

[38] Dobozy, *The Saxon Mirror*, 68.

with the loyal men of the realm …)[39] Eike's statement is either true or false; the emperor's utterance has no truth value; rather, it performs the action it describes. Austin further identified three degrees of linguistic force. The first: simply to speak a sentence is a 'locutionary act;' the utterance *qua* utterance in isolation from what the speaker intends by it and from any effects it might bring. (Example: 'The ice on the pond is thin.') Second: utterances that perform what they say are illocutionary acts with illocutionary force (the statement about the ice implies a warning); if a speech act has an effect, this is due to its perlocutionary force (the speaker's companion avoids the ice on the pond). (Thus by 'establishing,' the emperor empowers, intimidates, instructs, and so on.) Performatives require certain conditions for them to work. The *Landfrieden* becomes law because the appropriate conditions for the performative to work are in place (an elected emperor, the support of loyal men of the realm). The effect is to institutionalize what the emperor decreed said. His words create institutional facts.[40] If Eike had uttered the same words, they would have failed as a performative expression; they would not have had the effect of creating a law because the appropriate conditions were not present.

The line between constatives and performatives blurs, however,[41] when the performative verb (establish) is not present ('I will meet you tomorrow' implies 'I promise that …') so that it counts now as a (implicit) performative. Thus Eike's 'God left behind' becomes: 'I assert that …', and when he describes a law, custom, or judicial process ('People with diminished legal capacity have no wergeld'), the implicit performative ('I state that …').[42] It is at this point that the question of authority arises. Eike's descriptions in their constative capacity are subject to the true or false test. As a practical matter, this could only be carried out by those of his contemporaries who were as familiar with the law as he. As we have seen, he was aware of this and invited such a test in the first prologue.[43] Some would have known that he was a *Schöffe*, an expert on legal matters, or been impressed by his associates and patrons, and so conceded his authority to speak.[44] In fact his primary audience was most probably those members of rural society charged with administering and enforcing the law in this period before learned jurists were on the scene. To varying degrees, they would have been already familiar with at least some of the practices described in the book and would have brought their own (imperfect) memories of them to it.[45] Post-Austin theorizing on

[39] Dobozy, *The Saxon Mirror*, 43.

[40] See John Searle, *The Construction of Social Reality* (New York, 1995), 34 on the use of performatives in the creation of institutional facts.

[41] There is a vexing circularity involved here which is not evoked in my application of the theory. See Culler, *Literary Theory*, 96–97.

[42] Culler, *Literary Theory*, 127.

[43] See appendix.

[44] He was a *Schöffe*, a judgment finder who sat alongside the judge in court proceedings.

[45] Imperfect memory or even no memory might have been a reason to write down the customs. Cf. the colophon for the Oldenburg illustrated Sachsenspiegel, in which the scribe attributes to the book's patron the motive of addressing the ignorance of the legal customs on the part of younger vassals. Ruth Schmidt-Wiegand, ed., *Der Oldenburger Sachsenspiegel*, 2:331–2.

performitivity finds that 'Language is performative in the sense that it just doesn't transmit information but performs acts by its repetition of *established* discursive practices or *ways of doing things* [emphasis mine].'[46] Eike's (not so) silent voice registers a performative every time his speech is perceived as describing an established practice. Furthermore, each time a new manuscript is made, these familiar ways of doing things are re-performed. Out of this iterativity the text acquires authority and depends less on the standing of the author, though ironically, his name as part of the text also assumes a corresponding authority. This accumulating authority, then, is one way to explain the book's phenomenal spread throughout Germany and beyond German-speaking territories.[47] This explanation of its spread augments earlier imaginative historical explanations of this phenomenon.[48] More recent explanations attribute its quick rise to fame simply to a need for written law in this period.[49]

Modern scholarship is the not the only source for historical perspective on the Sachsenspiegel's gradual acquisition of authority. As Eike brings his book to a close, he writes more confidently of the *Lehnrecht* (feudal law):[50]

... a lengthy explanation is necessary for people to understand what is lawful conduct. ... A person who speaks justice in all things wins the anger of many. May the righteous man console himself with this thought for the sake of God and his own honor. This book shall make many an enemy, for all those who strive against God and Law will be enraged because it pains them to see that the law is always revealed. (W Lnr. 84)[51]

The illustrators of *D* (1295–1363) and *W* (1348–62/71) come more than a century later. We saw in the illustrating gloss to the Prologue (fig. 21.1) just how far the illustration went beyond Eike's appeal for Divine guidance. Figs. 21.3 and 21.4 reflect the same practice. The 'God and Law' of this text has been collapsed into the 'God is Law itself' of the Prologue. The image could even work as an allusion to the authority of the Bible. The enemies are represented as vulgar, ill-mannered boors, and as such unenlightened and unlettered. There may also be a reference to Jews in the drawing of the noses. Though Jews would not normally be represented as boors, the medieval representations often condense events, chronologies, and concepts in one depiction.[52] The illustrations for the prologue (figs. 21.1 and 21.2) coupled with those of the enemies-of-the-

46 Culler, *Literary Theory* 94.

47 For an analysis of the spread, see Elisabeth Nowak, 'Die Verbreitung und Anwendung des Sachsenspiegels nach den Überlieferten Handschriften,' unpublished diss., Hamburg, 1965.

48 Mariella Rummel, *Die Rechtliche Stellung der Frau im Sachsenspiegel-Landrecht*, Germanistische Arbeiten zu Sprache und Kulturgeschichte, ed. Ruth Schmidt-Wiegand, vol. 10 (Frankfurt am Main, 1987), 39, citing earlier scholarship.

49 See Oppitz, *Deutsche Rechtsbücher*, 19.

50 Of the picture associated with this text, Karl von Amira remarks in his commentary volume on D, that it is not clear just what one is to make of it: does it get at the 'master's' objectivity (*Unbefangenheit*) and daring (*Verwegenheit*), or his accuracy (*Treffsicherheit*).

51 Dobozy, *The Saxon Mirror*, 178.

52 Karl von Amira on p. 25 of his introduction to the 1902 facsimile of *D* notes that, when the drawing is carefully done, the bent nose of Jews is evident. Karl von Amira, ed., *Die*

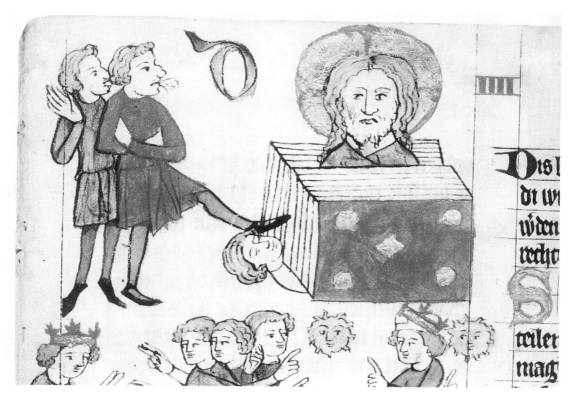

21.3 Eike under his book with closed eyes. Two low-born men kick and spit on the book from whose pages emerges a bust of God with nimbus. Sachsenspiegel W, fol. 85r, Reg. 1.

book span Eike's professional life. His closed eyes and unpainted head in *D* (see caption to fig. 21.4) suggest a deceased Eike, with the law book standing as his headstone. Coming as they do at the beginning and end of his book the illustrations act as bookends shoring up his contribution to the life of the law in Medieval Saxony and work beyond the illocutionary force of his words to confirm and enhance his and his book's authority.

 This paper has been concerned both with method and with specific conclusions. The method employed here enables us to reach conclusions that are not intended to be at odds with the formidable work of the traditional historians, but meant to augment and complement their foundational scholarship with the benefit of contemporary theory. My goal is not only to invite the attention of medievalists from other disciplines to the Sachsenspiegel, but also to invite the attention of legal historians to the work of those medievalists, and their methods, as well.

Dresdner Bilderhandschrift des Sachsenspiegels. Faksimile der Handschrift, 3 vols (Leipzig, 1902).

21.4 Eike under his book, with eyes closed and unpainted, is represented as deceased. Sachsenspiegel D, from Karl von Amira, *Die Dresdner Bilderhandschrift des Sachsenspiegels*, vol. 1 (Leipzig, 1902, reprinted Stuttgart: Anton Hiersemann KG Verlag 1968.)

More specifically, the focus has been on Eike's authority to write his text and on the authority his law book acquired. The 'Mirror, Mirror' in my title is a partially playful allusion to the fairy tale and the queen's insecurity about her claim to being the most beautiful; she was fairly confident, but still had to ask. For Eike, it was not beauty he sought; it was legitimacy, a combination of standing to author(ize) the law book and veridicality, the rightness of his observations. The queen was disappointed; Eike was vindicated.

Appendix

Prologus

Des heiligen geistes minne sterke mine sinne, daz ich recht unde unrecht den Sachsen bescheide nach gotis hulden unde nach der werlde vromen. Des en kan ich alleine nicht getun, dar umme bete ich zu helfe alle gute lute, die rechtes geren, ab in eine rede beiegent, die min tummir sin vermiden habe unde da diz buchelin nicht abe en spreche, daz sie ez bescheiden nach irme sinne, so si ez rechtest wissen.

Von rechte en sal nimande wisen lib noch leit, noch zorn noch gabe. Got ist selber recht. Dar umme ist im recht lip. Dar umme sen se sich vor all, den gerichte von gotishalben bevolen si, daz si also richten, daz gotis zorn unde sin gerichte genedicliche obir se gen muze.

May the love of the Holy Spirit sharpen my mind so that I may pronounce what is lawful and unlawful among the Saxons for the grace of God and the benefit of the world. I cannot accomplish this project alone. Therefore, I request the support of all law-abiding people who desire justice. Should they encounter a juridical dispute that I have omitted from this book because of my limited knowledge, I request that they reach a just determination to their best knowledge and discretion. No one should let himself be diverted from the law, not for love or jealousy, wrath or gain. God is Law itself; therefore, justice is dear to him. Consequently, all those to whom God has given the task of judging shall strive to reach judgments in such a manner that God in His wrath and judgment may treat them mercifully. (Dobozy, *The Saxon Mirror*, p. 67.)

Textus Prologi

'Got, der da iz begin unde ende allir dinge, der machte zuerst himel unde erde unde machte den menschen uf ertriehe unde satzte in in daz paradis. Der brach den gehorsam uns allen zu schaden. Darumme ginge wir erre alse die hertelosen schaf biz an die zit, daz uns got erloste mit siner martere. Nu abir wir bekart sin unde uns got wider geladen hat, nu halde wir sine e unde sin gebot, daz uns sine wisagen gelart haben unde gute geistliche lute unde ouch kristene koninge gesat haben, Constantin unde Karl, an den noch Sachsen lant sines rechtes zut.'

God who is the beginning and the end of all worthwhile things created heaven and earth first, then formed man on earth and placed him in paradise. Man broke the commandment to the ruin of us all. That is why we all went astray like shepherdless sheep until the day He saved us with His martyrdom. But now that we have been converted, and God has summoned us, we keep His law and His commandments—the ones His prophets and pious spiritual people taught us, and also the ones the Christian kings, Constantine and Charlemagne, provided—in Saxony to the advancement of His law. (Dobozy, *The Saxon Mirror*, p. 67.)

Editors' note: Charles G. Nelson passed away shortly after making the final corrections to this essay. A dear friend who collaborated with Dr Caviness on several projects, Professor Nelson provided invaluable advice and encouragement during the compilation of this volume. We are deeply saddened that he did not live to see its completion.

St Hedwig's Personal Ivory Madonna: Women's Agency and the Powers of Possessing Portable Figures

Corine Schleif

[Hedwig] possessed many images and relics of saints, to which she showed due reverence; when she went to church she had them carried openly and set up there where she prayed so that by the sight of these saints, whom she loved, their merits would be recalled to memory in a more lively fashion, and through their self-same intercession, she would be prepared to be set aflame in greater devotion. As was proper, she truly venerated the Mother of the Lord above all the other saints. Therefore she always carried with her a small ivory image, which she often took up in her hands in order to envelop it in love, so that out of passion she could see it more often and through the seeing could prove herself more devout, inciting her to even greater love of the glorious Virgin. When she once blessed the sick with this image they were cured immediately. Thus it was confirmed and made known to all through the power of miracles, what greatness of merit she had already achieved, who, out of fervent love, diligently carried with her this image of the Mother of the Son of God ...[1]

This passage from the *Codex of St Hedwig* vividly narrates the ways in which one woman used portable sacred objects—particularly an ivory Madonna. She was not just any woman; Hedwig was a woman of station. Born between 1175 and 1180 to the Bavarian house of Andechs-Meran; in 1190 she married Duke Heinrich of the family of Piast, who later became known as Heinrich the Bearded. Hedwig thus became Duchess of Silesia, at the time a largely German-speaking territory, now part of Poland.[2]

The manuscript was not just any book. In 1353, a descendent of Hedwig, Ludwig I of Liegnitz, together with his wife Agnes of Glogau, commissioned

[1] Los Angeles, J. Paul Getty Museum, 83. MN. 126, MS Ludwig XI, fol. 49r; Peter Moraw, 'Vollständige textkritische Wiedergabe der lateinischen Texte mit deutscher Übersetzung,' in *Der Hedwigs-Codex von 1353*, ed. Wolfgang Braunfels (Berlin, 1972), vol 2, 53–224, here 94; See also Joseph Gottschalk, 'Die älteste Bilderhandschrift mit den Quellen zum Leben der hl. Hedwig,' *Aachener Kunstblätter* 32 (1966), 61–161.

[2] Ortrud Reber, *Die Gestaltung des Kultes weiblicher Heiliger im Spätmittelalter. Die Verehrung der Heiligen Elisabeth, Klara, Hedwig und Birgitta* (Hersbruck, 1963); *Herzöge und Heilige: Das Geschlecht der Andechs-Meranier im europäischen Hochmittelalter* (exhb. cat. Haus der Bayerischen Geschichte, in Kloster Andechs, 1993), esp. 145–64; Gisela Muschiol, 'Zur Typologie weiblicher Heiliger vom frühen Mittelalter bis zur "Legenda Maior,"' in *Das Bild der hl. Hedwig in Mittelalter und Neuzeit*, ed. Eckhard Grunewald and Nikolaus Gussone (Munich, 1996); *Die Andechs-Meranier in Franken* (exhb. cat. Historisches Museum Bamberg, 1998).

and donated it to sanctify their own lineage and thus legitimate their territorial claims. Its written and illuminated texts were based on sources now lost that had established Hedwig's saintliness prior to her canonization in 1267, only twenty-four years after her death. Its main components, the *Legenda Maior* and the *Legenda Minor*, were authored by an unnamed priest from Trzebnica (Trebnitz) around 1300.[3] Today housed in the J. Paul Getty Museum in Los Angeles, the *Hedwig Codex* provides the oldest illuminated version of Saint Hedwig's *vita*. It was followed by several others, of which two manuscripts and a postincunabulum illustrated with woodcuts survive.[4]

In the full-page dedication miniature (fig. 22.1), Ludwig and Agnes, almost subsumed within the elaborate architectural framework of a monumental throne, kneel to the right and left of St Hedwig who stands in the foreground, rising to grand proportions. The youthful saint's slight build and graceful bearing is accentuated by long Parleresque drapery folds that lend no illusion to any corporeality beneath. She is clad not in contemporary aristocratic dress like that of the female donor but in the classical garb of the Virgin with a loose white veil as her only head covering, bare neck, slightly exposed hair framing her face, and, over her tunic, a red-lined gray mantle, its delicate braids and borders at the edges serving as a hint of noble finery. Somewhat in contradiction, the vita praises her for shunning red robes, silken fabrics, and other useless ornaments that women employ 'to please the world and men.'[5] Almost awkwardly, Hedwig clutches four attributes: a rosary; a small prayer book into which she has slipped three fingers of her left hand in order not to lose her place in the text; and draped over her right arm, the boots that she removed from her feet in order to walk barefoot even over the snow and ice during the Silesian winter. With her right hand she tightly grasps the fourth attribute—her most precious possession—a small ivory statuette of the Madonna and Child, holding it to her bosom. The representation is so specific in detail that close observation reveals a figurine assuming one of the most distinctive poses of images of the Virgin and Child that emerged around the middle of the century and continued to appear in the so-called *schöne* or 'beautiful' Madonnas of the end of the century. Following the traditional Byzantine icon type known as the *glycophilusa* or 'sweet kissing' Madonna, the infant raises his hand to caress his

3 Joseph Gottschalk, 'Der historische Wert der Legenda major de beata Hedwigi,' *Archiv für schlesische Kirchengeschichte* 20 (1962): 84–125.

4 Josef Krása and Klaus Kratzsch, 'Beschreibung der Handschrift und kunsthistorische Einordnung der Miniaturen,' in *Der Hedwigs-Codex von 1353*, ed. Braunfels, vol. 2, 9–51. On Augsburg, Universitätsbibliothek, Cod. I.3.2° 7 and Cod. I. 2.2° 30, see: Marion Karge, '"Ein buch von sant hedwigen gemalet": Die Hedwig-Handschriften in der Bibliothek der Grafen von Oettingen-Wallerstein,' in *Das Bild der Heiligen Hedwig* ed. Grunewald and Gussone, 79–87. On Wrocław, Biblioteka Uniwersztecka we Wrocławiu IV F 192, see *Legenda o św. Jadwidze / Legende der hl. Hedwig* (Wrocław, 2000). On the postincunabulum of 1504 see *Die große Legende der heiligen Frau Sankt Hedwig*, ed. Joseph Gottschalk (Wiesbaden, 1963); See also Eckhard Grunewald, 'Die Hedwig-Bilderzyklen des Mittelalters und der frühen Neuzeit,' *Berichte und Forschungen* 3 (1995): 69–106; Romuald Kaczmarek, 'Das Bild der heiligen Hedwig,' in *Das Bild der heiligen Hedwig*, ed. Grunewald and Gussone, 137–57. I wish to thank Otto Gast for bibliographic information and Max Löwe for help with the recent literature in Polish.

5 Fol. 141v; Moraw, 'Vollständige textkritische Wiedergabe,' 157.

22.1 Dedication Miniature, Hedwig Codex. J. Paul Getty Museum, Los Angeles, fol. 12v.

mother gently under the chin.[6] The Hedwig Codex of 1353, together with many later hagiographic texts and images associated with Hedwig, shows that numerous sponsors, authors, and artists produced the picture of a saintly woman who was important in part for her possession of portable sacred objects and figures that she employed devotionally, liturgically, and theurgically.[7]

In 1987 I was pleased to be able to use the above passage and illumination together with others from the Hedwig Codex in a paper that Madeline Caviness accepted for her session on 'Affective Aspects of Works of Art in the Middle Ages' at the meeting of the College Art Association in Boston. I explained all three functions of Hedwig's ivory Madonna but stressed the theurgic properties underscoring the power and authority that she exuded in using it to perform miracles.[8] Subsequently, in 1993, I presented a paper in a session on 'Art that Moves: Portable Objects and Liturgy' organized by Elizabeth Lipsmeyer for the Congress on Medieval Studies at Kalamazoo, in which I examined the texts and images in order to demonstrate the authority that Hedwig assumed in affecting liturgical modulations through her portable figures. When, shortly thereafter, many of the same selections of texts and images from the Hedwig Codex, together with those contemporary figurines I had associated with them, were adopted by another author in print, no observations were made regarding the implications of the agency that Hedwig assumed through her figurines. Instead, they were pressed into the context of 'private' devotional aids, and the author associated the figures with the triptychs and tiny figures mentioned anecdotally in a well-known treatise written by Johannes Meyer over a hundred years after the Hedwig Codex, in order to further the reformation of Dominican women's monasteries in the fifteenth century.[9] In the 1997 exhibition *Images in Ivory: Precious Objects of the Gothic Age*, the material from the Hedwig Codex, including a portion of my rather free translation of the Latin passage into English, was employed to explain by example, the uses of the many small ivory Madonnas that have survived from the thirteenth, fourteenth, and fifteenth centuries within what was framed as realms of mysticism and private devotion.[10] Thus as the rich and revealing material from the Hedwig Codex has entered the pages of American art history it has been used to reinscribe long-held assumptions that connected women with private devotion. Further, it substantiates reciprocally

[6] An ivory Madonna and Child in this pose and dating from the same era as the codex is preserved in the Chicago Art Institute, illustrated in Richard Randall, Jr., *The Golden Age of Ivory: Gothic Carvings in North American Collections* (New York, 1993), 20.

[7] For references to the numerous *vitae* and other literature on the saint see Eckhard Grunewald and Nikolaus Gussone, 'Vorwort,' in *Das Bild der Heiligen Hedwig*, 7–22 and W. Mrozowicz, 'Eine unbekannte "Vita beate Hedewigis" aus den Sammlungen der Universitätsbibliothek Breslau/Wrocław,' in *Das Bild der Heiligen Hedwig*, 55–78.

[8] 'Saint Hedwig's Personal Devotional Image,' Abstracts and Program Statements for Art History Sessions, 75th Annual Meeting, College Art Association of America (1987) 48.

[9] Jeffrey Hamburger, *The Visual and the Visionary: Female Spirituality in Late Medieval Germany* (New York, 1998), 427–40.

[10] Charles Little, 'Gothic Ivory Carving in Germany,' in *Images in Ivory*, ed. Peter Barnet (exhb. cat. Detroit Institute of Arts and Walters Art Gallery, 1997), 80–93, esp. 87.

the long-standing mystique and aura of the two-fold object of the voyeuristic colonizing gaze: women and art.

I would like to take this opportunity to return to my analysis of the texts and images of the Hedwig Codex that focus on the saint's use of portable images. When in 1987 Madeline Caviness endeavored to publish the papers from her session no press expressed willingness. In the years that have ensued Professor Caviness has developed a number of critical methodologies that will aid me in my interrogation of the material from the Hedwig Codex, so that, in addition to stressing Hedwig's agency through images, I will now be able to add an additional layer of observations regarding Hedwig's roles in what Caviness has called the scopic economy. I will reflect and speculate on the three contexts for the use of images as suggested by the material: in public enactment of liturgical rituals, in public performance of miracles, and in private exercise of personal devotion. It need not be emphasized that the Hedwig Codex presents the imaginings of fourteenth-century sponsors, writers, and illuminators, rather than a factual record of objects once in possession of the Duchess of Silesia during the early thirteenth century. Nonetheless, audiences were certainly expected to accept these notions surrounding a saintly woman's use of sacred objects and images. These texts and images reflected contemporary beliefs, and they promoted corresponding practices. Both existing collections and inventories show that small images of saints made of various materials proliferated during the last centuries of the Middle Ages. These included of course ivory figurines of the Madonna and Child.

The passage translated at the beginning of this essay is among those in the *Legenda Maior* that were chosen for pictorial amplification in the Hedwig Codex (fig. 22.2). With the exception of the full-page dedication miniature, all illuminations in the book appear in two registers with the corresponding content from the verbal narrative in summary form lettered in red above the respective image. In the middle of the pictorial narrative, a double image of St Hedwig rises from the lower edge of the picture. Represented in the figure kneeling to the left, Hedwig prays before an altar. A small reliquary casket rests inconspicuously near the rear of the altar *mensa*. Towering over Hedwig and turning toward her as if to engage her in conversation, two large figures of SS. Vincent and Bartholomew appear as living human beings, fulfilling the function claimed for them by the author of the text. Certainly, at least in this illustration, the figural representations appear more compelling than the actual parts or particles of saints' bodies locked away in the little casket.

Although the codex does not state whether Hedwig had the objects placed on the altar for the public celebration of the mass, the Latin text stresses that they were brought there openly. It thus becomes clear that she sought and achieved institutional sacrality for the objects. By employing the sacred images and relics in her own possession she could choose her own/owned saints and images of them. As intercessors, these advocates would represent her interests, and as benefactors, these patrons would be receptive to her needs. Her personal sanctoral inventory would be more efficacious than the saints and images already in the church, to whom altars were dedicated, and whose attention and

22.2 Lower register of miniature showing St Hedwig with her sacred objects, Hedwig Codex. J. Paul Getty Museum, Los Angeles, fol. 46v.

largesse had to be shared with others. The implication is that Hedwig had honored these saints by acquiring their representations through purchase or commission, and so these saints were, at least in these particular manifestations, born of her and exuded the familiarity of family.

A very different story regarding the use of small portable images by religious women at the convent of Neuwerk in Erfurt is reported in the *Liber de reformatione monasteriorum* of 1475 written by Johannes Busch, the Augustinian canon from Windesheim who was conducting a visitation: '... we saw that in the choir behind the altar where they stand and in their seats most of the sisters each had images of Christ and the saints, both sculpted and painted, for their own devotion, all of which we thence removed and replaced toward the east in the space between their choir and church, so that all could see them equally, have devotion from them in common and not in private in the manner to which they were accustomed.'[11] The canon's displeasure at these individual private devotional foci within the church belies the unsettling effect that the practices of these nuns had on the clerical

[11] *Des Augustinerpropstes Iohannes Busch Chronicon Windeshemense und Liber de reformatione monasteriorum*, ed. Karl Grube, Geschichtsquellen der Provinz Sachsen und angrenzender Gebiete 19 (Halle, 1886), 609–11; translation by Jeffrey Hamburger, 'Art, Enclosure and the *Cura monialium*: Prolegomena in the Guise of a Postscript,' *Gesta* 31 (1992), 108–34; reprinted in *The Visual and the Visionary*, 87–89.

establishment. Each woman had dared to maintain a private domain for herself by addressing chosen saintly partners (saints and images) rather than merely submitting to the prescribed rhythms of the ecclesiastical year or the established constellation of altar dedications and pictorial furnishings. A similar source from the thirteenth century prohibits religious women from having images in their choir stalls, in their chapels, and even from celebrating those saints who were not prescribed for local usage.[12] As a solution to the unwelcome situation in Erfurt, the canon struck a compromise, betraying the seriousness with which he and the other visitors viewed the matter. They did not order the images removed from the church entirely, nor did they have the objects placed on an altar, which would have implied a modulation in the dedication of that altar. Rather they displaced the images, taking them from the individually assigned spaces in the nuns' stalls and the locations where the nuns stood, and placing them in a communal space. It thus became clear that the figures were not the private property of the sisters but the communal possession of the monastic church and at the disposal of all in the community. In this way the clergy also reauthorized the saints and images that these religious women had appropriated for themselves.

The text of the Hedwig Codex asserts that Hedwig had many images and relics, conjuring up a picture of a vast collection reminiscent of the miniature universe of figurines that absorbed all the attention of Laura Wingfield, the physically disabled character in the Tennessee Williams play *The Glass Menagerie*. The illumination, however, shows only two figures: Vincent, identifiable because he is wearing the dalmatic of the deacon and holds the grill of his martyrdom, and Bartholomew, displaying his own flayed skin on a pole as if it were his banner. These two were important patrons within the diocese of Wrocław (Breslau) and in the Cistercian monastery at Trzebnica (Trebnitz) where Hedwig had lived out her days and where her relics were venerated. Apparently the painter could only imagine images of those saints who already belonged here by virtue of their official integration in ecclesiastical dedications and the liturgical calendar.

A rather raucous account reveals the extreme tensions rooted in gender and class anxieties that surrounded the use of portable images by lay women in church at the time of the Reformation in the northern German city of Stralsund. According to a chronicle from 1525, the poor of the area were requested to gather in the church of St Niclas in order that a decision could be made as to who was eligible to receive charity. When a sizeable crowd amassed, including young craftsmen who had come out of curiosity, a certain Frau Friesesch came to the mistaken assumption that they had assembled in the building with the intention of destroying the sacred images there. It is clear from the chronicler's words that anxiety ran high among the women of the parish, who had a lot at stake:

[12] E. Ritzinger and H. C. Scheeben, 'Beiträge zur Geschichte der Teutonia in der zweiten Hälfte des 13. Jahrhunderts,' *Archiv der Deutschen Dominikaner* 3 (1941), 11–95, esp. 26; Hamburger, *The Visual and the Visonary*, 87 and n. 248.

Now there was in Stralsund the particular custom that every woman had a locked cabinet full of images, in front of which she prayed and burned candles. Commonly the cabinets are called the 'saints cabinets,' of which all the pews are full in this church. Being especially pious and possessing two cabinets, Frau Friesesch felt particularly threatened and so she called her 'lawless' maid and told her, 'Run to the church fast and bring my "saints cabinets" home, for the Martinians [Lutherans] are in the church and they want to destroy all of them.' ... So the maid went into the church, holding in each hand an open knife, of the kind that maids usually carry. And she fell over the little cabinets and cried out and called loudly without stopping, 'These are the cabinets of my lady! These are the cabinets of my lady! Don't touch them, or murder will strike you, and these knives will enter your bodies.' Provoked and angered by her screams, a journeyman removed himself from the crowd and rebuked her, 'What are you shouting and crying out? Go to the devil with your cabinets!' Then he raised his foot and kicked one of the cabinets over. When the maid wanted to unfasten the other cabinet she could not because it was affixed to the pew; whereupon the man kicked it so hard that not only this one but several others in the pews fell down as well. Running out of the church and across the old market square with the cabinet in her hands, the maid cried out, 'The Martinians are breaking up the cabinets!' Thereafter everyone who had a cabinet ran into the church and had it removed and taken home, in order that it would not be destroyed.[13]

Thus it appears that many women had erected their own personal altar-like setting in miniature, each featuring her own chosen dedicatory saints, prayers, and candles.[14] Late medieval ivories that have come down to us worn, darkened, and damaged by candles and soot, such as the French example of the seated Virgin and child measuring a little less than six inches today in the Walters Art Gallery in Baltimore, might have been used in such a setting.[15]

Each of the above accounts treats small images owned by pious women, either kept in immediate personal possession or located in spaces assigned to or associated with individuals within the church interior. We turn now to reports of portable figures that were part of church or altar inventories. Such usages must have been nearly ubiquitous since references have survived in archival sources and visual representations from many parts of Europe.[16]

Extraordinary sources from the parish church of St Lorenz in Nuremberg document specific late-medieval liturgical uses of portable figures. The sacristan's manual that was compiled in 1493, with a few subsequent notes and entries, mentions twenty-six figures or figurines as well as reliquaries usually

[13] Gottlieb Mohnike and Ernst Zober, *Johann Berckmanns Stralsundische Chronik* (Stralsund, 1833), 259–61; mentioned by Rudolf Berliner, *Die Weihnachtskrippe* (Munich, 1955), n. 441.

[14] The cabinets were possibly similar to the little boxes known in Flanders as *besloten hofjes*. See Anton Legner, *Reliquien in Kunst und Kult zwischen Antike und Aufklärung* (Darmstadt, 1995), 316–20.

[15] Richard Randall, Jr. 'Gothic Ivories,' *Masterpieces of Ivory from the Walters Art Gallery* (New York, 1985), 204.

[16] See for example: Carl Friedrich Wehrmann, 'Verzeichnis der im Jahre 1530 aus den Kirchen weggenommenen und in die Trese gebrachten Gegenstände,' *Zeitschrift des Vereins für Lübeckische Geschichte und Altertumskunde*, 2 (1867): 133–45 and Max Hasse, 'Kleinbildwerke in deutschen und skandinavischen Testamenten des 13., 14., und frühen 15. Jahrhunderts,' *Niederdeutsche Beiträge zur Kunstgeschichte* 20 (1981): 60–72.

in the shape of heads or arms.[17] The last pre-Reformation inventory, dated 1524, lists thirty-nine metal figurines and reliquaries.[18] The following examples are gleaned from the manual: On the day commemorating the Dormition of the Virgin two silver images were placed on a small pedestal set on the main altar. On St Bartholomew's Day the saint's silver arm reliquary was placed on the altar dedicated to the Twelve Apostles. Also on other occasions a portable figure was used to draw out one member of a shared dedication. When St Jerome's Day was celebrated at the altar dedicated to all four church fathers, the *mensa* was prepared with his image flanked by two angels. Similarly, when it was St Augustine's turn, a single figure was set on the altar in order to augment his importance, temporarily diminishing that of his three compatriots. Small portable figures were likewise used to alter or expand the dedication of an altar beyond its titular saints. For example, the altar of the Holy Cross became the stage for the celebration of John the Baptist's Day when a gilt silver figure of the saint carrying a lamb was placed on the *mensa*.

The majority of portable objects were presumably small standing figures, most of which were silver, some gilt; reliquaries are mentioned less frequently. A high quality gilt and silver figure of St Bartholomew from the neighboring parish at Wöhrd survives today in the Germanisches Nationalmuseum (fig. 22.3). Only two figures in the instructions are described as wooden: the figure representing St Cunegund is of wood and the figure used to represent St Othmar is referred to as a 'wooden bishop.'

It is clear from the record that the sacristan had the objects at his disposal. These were not figurines and reliquaries that individuals kept in their personal possession and brought into church with them as the Hedwig vita relates. Clearly matters of ownership or categories of belonging—whether an object belonged to the treasury of the church or to one or another altar prebend—would have been of little or no consequence to the sacristan who was concerned with locating the appropriate objects and setting up the altars correctly for each occasion.

Perhaps the most intriguing aspect of the sacristan's manual are the changeable accoutrements that were added to many of the figures. On St Cunegund's Day a figure was placed on the altar, a veil was put on the figure, a crown on the veil, and finally a church with two towers—intended to portray Bamberg Cathedral—was placed as an attribute in the hands of the figure. To the image of St Mary Magdalene was added a veil, on the veil a crown, on the crown a wreath, and into her hands an ointment jar. To St Elizabeth, who had cared for the ill and fed the hungry, a veil and a crown were added; a pitcher was placed in her left hand and a hard roll in her right. The portable figure of St Agnes received a crown and a tiny lamb. A dragon was provided to accompany both St Margaret and St Martha. The statuette of St Vincent of Saragossa was given a tongs, the instrument of his martyrdom and the attribute

[17] Albert Gümbel, *Das Mesnerpflichtbuch von St. Lorenz in Nürnberg vom Jahre 1493* (Munich, 1928), *passim*.

[18] Corine Schleif, *Donatio et memoria* (Munich, 1990), 237–41.

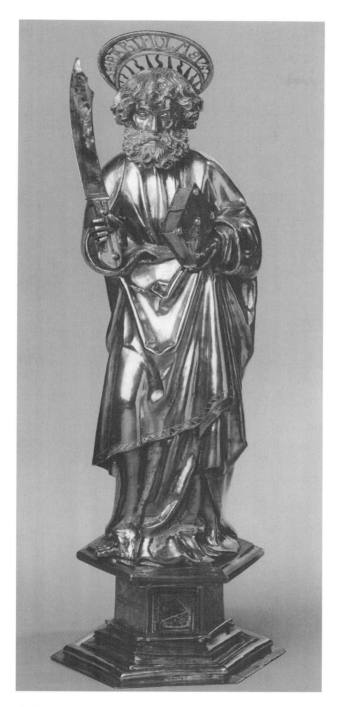

22.3 St Bartholomew, silver, partially gilt, from the parish church at Wöhrd, Germany, 1509, 45 cm.

common in Nuremberg representations of this saint, since the gridiron, used in the Hedwig Codex (fig. 22.2), was employed to distinguish St Lawrence. Undoubtedly these accessories were of varying materials. The veil that was to be placed over the head of St Lucy was to be black, probably of black fabric.

According to mid-fifteenth-century records from Siena Cathedral, portable figures were commonly brought out of the sacristy and used on the main altar for high feast days. A silver figure of the risen Christ, commissioned for use on Easter in 1444, stood two feet tall and weighed twenty-six pounds.[19] In 1523, Nikolaus Glockendon depicted Cardinal Albrecht von Brandenburg celebrating mass before an array of reliquaries and figures, some less than a foot in height.[20] Perhaps some of the Nuremberg figures were of more substantial size in order to accommodate the various attributes. If the sculptures were only ten inches to two feet tall, some of the accessories must have been very tiny indeed, which may explain why such items have not survived. The figure of St Barbara was to be placed on an altar on top of a socle with two angels flanking it, a crown was to be set on her head; then a chalice was to be placed in her hands and a host was to be placed in the chalice. If the figure was small and all of these objects were made to scale it would have been necessary to borrow St Vincent's miniature tongs in order to place St Barbara's tiny host in her chalice! Johannes Meyer's chronicle purports that the ivory figure for which the nuns of the monastery at Schönensteinbach had made a shrine was only as large as one's little finger.[21] A mid-fourteenth-century ivory Madonna in the Walters Art Gallery measures less than two inches.[22]

The use of auxiliary attributes suggests that some of the figures were generic and could be employed on different occasions to play various roles. The reference 'a wooden bishop' might imply that the figure could function with equal credibility as St Othmar, St Nicholas, or St Augustine. Or the words, 'One takes the image of one out of the sacristy …' may likewise imply the use of a non-specific figure. A source records that one small silver figure commissioned for Bamberg Cathedral in 1513 cost two hundred guilders.[23] Thus, economically speaking, it was advantageous to configure festival days using generic images that could be endowed with multiple identities.

[19] Jakob Burckhardt, 'Randglossen zur Skulptur der Renaissance,' *Jakob Burckhardt— Gesamtausgabe*, ed. Felix Stähelin and Heinrich Wölfflin (Berlin and Leipzig, 1934), 277.

[20] Aschaffenburg, Hofbibliothek, MS 10, fol. 430v, reproduced by Ulrich Merkl, *Buchmalerei in Bayern in der ersten Hälfte des 16. Jahrhunderts* (Regensburg, 1999), 451–55.

[21] Johannes Meyer, *Buch der Reformacio Predigerordens*, book 3, chap. 2, ed. Benedictus Reichert, Quellen und Forschungen zur Geschichte des Dominikanerordens in Deutschland, vol. 2 (Leipzig, 1909), 56–57; mentioned by Rudolf Berliner, *Die Weihnachtskrippe* (Munich, 1955), 200–201 n. 441; Thomas Lentes, 'Bild, Reform und Cura monialium: Bildverständnis und Bildgebrauch im Buch der Reformatio Predigerordens des Johannes Meyer (†1485),' in *Dominicains et Dominicaines en Alsace (XIIIe-XXe siècle): Actes du colloque de Guebwiller, 8–9 avril 1994*, ed. J. L. Eichenlaub (Colmar, 1996), 177–95, esp. 184; Hamburger, *The Visual and the Visionary*, 580.

[22] Randall, 'Gothic Ivories,' 202.

[23] Renate Baumgärtel-Fleischmann, 'Georgs-Reliquien im Bamberger Domschatz' in *St. Georg: Ritterheiliger, Nothelfer, Bamberger Dompatron* (exhb. cat. Historisches Museum Bamberg, 1992), 115–30, esp. 127.

Another rare document from Nuremberg offers a glimpse of the furnishing and staging of a saint's day from the vantage point of its donor. In 1504 the prior of St Lorenz, Sixtus Tucher, initiated and financed the observance of St Monica's Day.[24] Appropriately, this festival for the mother of St Augustine was to be celebrated at the altar dedicated to the Four Church Fathers. The donor stipulated '... the same altar shall be decorated with the image of a widow ...,' implying that a figure already existed in the church at the time the mass was donated and that the figure presumably could have functioned for any saintly widow, for example Anne, Elizabeth, or Monica. Since the day was celebrated on an already extant altar and made use of an available figure, Sixtus Tucher was able to finance the entire donation with the endowment capital of three guilders, the annual interest from which remunerated the clergy, choir boys, choir master, and sacristan who participated. Through this relatively modest sum it was possible for Sixtus Tucher to focus public veneration on his chosen saint one day every year. By contrast, the donation of an altar mandated the establishment of a prebend to support a priest, necessitating a capital endowment of ten to twelve hundred guilders at this time. Any and all furnishings: retable, missal, textiles, *vasa sacra*, and candles, required additional capital outlay.

Nuremberg records that reveal generic figures taking on a variety of particular identities on the basis of their changeable attributes demonstrate that late medieval viewers could also be flexible in projecting various holy personalities from vastly different settings and life situations onto a single figure. Perhaps the generality of the figure served to endow it with the authenticity of common attitudes or shared values, while the individual accoutrements and attributes related it to the predilections of the donor who endowed the particular feast day.

I do not want to trivialize the matter, but our own culture manifests examples of this duality in the famous or infamous Barbie doll. A general type reflects and promotes feminine ideals that have obtained in the industrialized world for fifty years, although also modulating with the vagaries of fashion within this time span. Although authorized socio-economically through its brand name, it is particularized to express the aspired lifestyle of its youthful owner or adult donor. Of Barbie too, both variants were available: general dolls whose personalities were to be filled in by the imaginative predilections of their users, and the later theme dolls that came packaged with an array of outfits already matched to a very specific career or avocation.[25] Interestingly, in the late Middle Ages and the late twentieth century, the limits of authorized interpretation for non-specific female figures appear to be defined by marital status: in the case of the generic liturgical figures, widows comprise one prominent category; the Barbie was usually marketed as a 'single girl.'

The text and the image in the Hedwig Codex tell of no sacristan placing the figures on the altar, no priest celebrating mass, no monks, nuns, or choir boys

24 Schleif, *Donatio et memoria*, 254–55.
25 Laura Jacobs, *Barbie, What a Doll* (New York, 1998).

singing the offices or sequences that celebrated the lives, deaths, and deeds of SS. Bartholomew and Vincent. In text and image Hedwig replaces all the usual liturgical agents, and she functions as owner and donor. Thus in the codex, Hedwig uses the figures and relics to create modulations that amounted to inversions or small domains of difference within the otherwise male-dominated and male-controlled liturgical realm.

It would appear that Hedwig, as well as perhaps some of the nuns in Erfurt and lay women in Stralsund, perceived in the figures in their possession specific identities with particular characteristics and abilities. Hedwig's ivory Madonna performed miracles; indeed most miracle-working images had personalities with individual affinities and propensities more sharply defined than even the distant historical persons whom they signified and (re)presented.[26]

The text of the Hedwig Codex does not specify whether Hedwig placed her ivory Madonna on the altar or not. The painters of the narrative show her holding it (for example, fig. 22.2); only the artist responsible for the 1504 woodcut imagines the Madonna standing on the altar in front of the other objects (fig. 22.4). Indeed here it appears as if the larger figures of Vincent and Bartholomew belong to the permanent features of an altar retable. The position of the ivory Madonna not on the altar but in Hedwig's hands suggests that she has a closer bond with this figure and therefore does not share it with others and allow it to become the focus of communal scopic adoration in the liturgical context—such shared spectation was ordered for the nuns in Erfurt, as mentioned above. Rather, as a lay woman of high birth and substantial political power, she keeps it under her own gaze and her own control.

The saint's double participates in another scene (figs. 22.2, 22.4) that likewise appears to occur in a public place. Here she extends her arms holding her ivory Madonna to occasion contact—visual and tactile—between the figure and three individuals, who, as we learn from the texts, are weak or infirm. This is the first visual reference in the Hedwig Codex to the theurgic properties of the ivory Madonna. According to the summary text in the picture's caption and the longer narrative passage, Hedwig used the ivory figure to bless them and their cures ensued.[27] In a strict theological sense neither the material nor the figure, and neither Hedwig nor even the Virgin could perform miracles; only God could do that. Careful scrutiny of the representation shows indeed that it is the figure of the Christ child that touches the face of one of the infirm (fig. 22.2). That a miracle could be wrought *through* a saint was nonetheless not only possible but deemed a prerequisite to canonization.

Chronicled cases of wonders worked through images abound. Many occurred in places that had become pilgrimage sites, or where it was hoped that images might attract pilgrims. The faithful thronged, sometimes from great distances,

[26] See for example: Pamela Sheingorn, *The Book of Sainte Foy* (Philadelphia, 1995) and Kathleen Ashley and Pamela Sheingorn, *Writing Faith* (Chicago, 1999).

[27] Ivory was believed to have intrinsic powers associated with the alleviating of pain, particularly in childbirth. A medieval medical handbook prescribes a drink containing pulverized ivory to ease a delivery. See Karl Olbrich, 'Elfenbein,' in *Handwörterbuch des deutschen Aberglaubens*, ed. Bächtold-Stäubli, vol. 2 (Berlin and Leipzig, 1930), col. 781.

22.4 St Hedwig with small portable figures in *Die große Legende der heiligen Frau Sankt Hedwig*.

to approach sacred images face to face with their petitions. Known in German as *Gnadenbilder*, literally 'images that grant grace,' such figures most often represented the Madonna and Child. At many of the sites authorities maintained power by controlling access. Wings, shutters, or veils on shrines were opened and closed, as were gates or portals of chapels.

In the case of certain miracle-working images, the figures, although larger than Hedwig's ivory figurine, were physically brought out from their usual places of domicile or safe keeping in order to work miracles. In the case of *Nostra Donna of Impruneta*, whose cult flourished from the *trecento* to the *cinquecento*, the signoria of Florence voted to determine if a particular situation were dire enough to require the intervention of Our Lady, who was usually invoked either to cause rain or to induce its cessation. In these cases the panel

painting was brought from its residence in the suburb, and with its veil removed, it was carried in procession through the streets, allowing the gathering crowds visual access and physical proximity.[28]

Hedwig circumvented male hegemonic systems. She, a woman, assumed a role like that of the signoria in Florence, intervening to manipulate the scopic (and tactile) economy. She determined who would have access to her ivory figurine and for how long; just as in Florence scopic supply was kept to a minimum thus increasing demand and focusing theurgic efficacy. Stated differently, the mystical aura that was perceived to exude from the object through limited access intensified desire for its concentrated numinous power.

Not only the Hedwig vita attributes miraculous recovery to an ivory figure in the possession or control of a woman or women. According to the report of Johannes Meyer, the tiny ivory Madonna in the Dominican monastery at Schönensteinbach in Alsace was also responsible for miracles, including the healing of a sister suffering from a foot malady.[29]

The next appearance of the ivory within the illuminations of the *Legenda Maior* of the Hedwig Codex occurs after the saint's death. These posthumous appearances reflected back on the figure's efficacy during Hedwig's lifetime and portended the future potency of her relics. In two depictions of the dead Hedwig, both occurring on the same folio, the ivory again appears in her hands (fig. 22.5). In the upper register a posthumous miracle is illustrated: The nun Jutta, whose arm and hand had swelled after being bled, touches Hedwig's clothing as the saint lies on the bier. In the lower register Hedwig is placed in the grave. In order to revere the saint's veil as a relic, a nun, probably Hedwig's daughter, removes it from her head. The veil was believed to have first belonged to Hedwig's niece, the previously sainted Elizabeth. It is noteworthy that the veil was thus purportedly passed from one saintly member of the family to the next, not only as a secondary relic but also almost as a sign of female succession. The ivory figure, however, remained with Hedwig, and, as an extension of herself, never became a secondary relic. The explanation for the depiction of the ivory posthumously in the saint's hands is provided as a flashback in the text of the vita that describes the exhumation of her body: 'As the remains of the saint were pulled out of the earth, the flesh was decayed and the individual members were loosened from each other. Only three fingers of the left hand were found completely intact. They surrounded a small image of the Mother of God, which Hedwig during her lifetime often carried with her. It was buried with her because at death she held it so tightly between her fingers, that it could only have been removed by force.'[30]

In the context of the festive events of the translation of Hedwig's relics, the ivory figure is represented for the last time (fig. 22.6). After removing her body from the grave, depicted in the upper register, members of the ecclesiastical

28 Richard Trexler, 'Florentine Religious Experience: The Sacred Image,' *Studies in the Renaissance* 19 (1972): 7–41, reprinted in idem., *Church and Community 1200–1600: Studies in the History of Florence and New Spain* (Rome, 1987).

29 Meyer, *Buch der Reformacio Predigerordens*, bk. 3, ch. 2, pp. 56–57.

30 Moraw, 'Vollständige textkritische Wiedergabe,' 154.

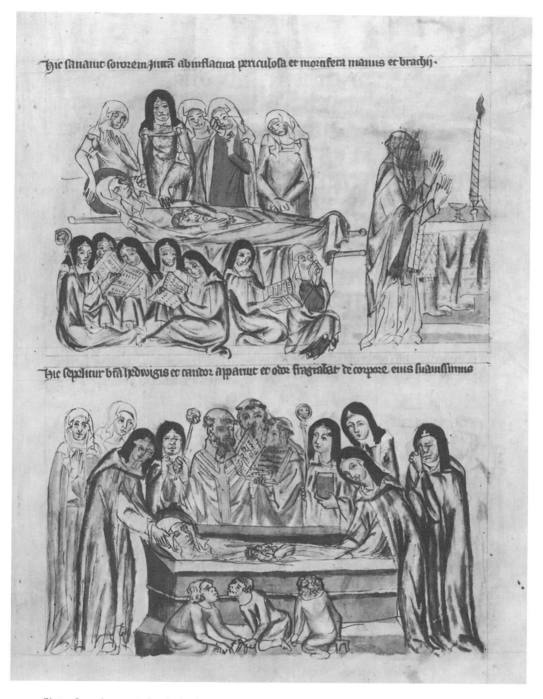

22.5 Sister Jutta's arm is healed when she approaches St Hedwig's funeral bier;
St Hedwig is buried with the ivory Madonna, and her veil, believed to have
belonged to St Elizabeth, is removed as a relic, Hedwig Codex. J. Paul Getty
Museum, Los Angeles, fol. 87r.

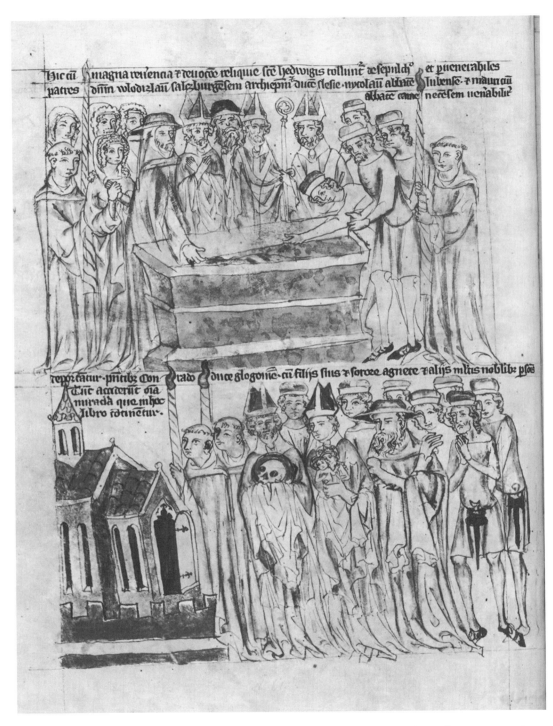

22.6 St Hedwig is exhumed and her relics are translated in a festive procession,
Hedwig Codex. J. Paul Getty Museum, Los Angeles, fol. 137v.

hierarchy are shown processing into church, carrying various parts of her earthly remains reverently as relics, taking care to receive them with hands draped in order not to allow their bodies to come in contact with Hedwig's body. To the left a bishop holds her nimbed skull. To the right a cardinal similarly grasps assorted arm and leg bones. Most prominently in the center, a bishop displays Hedwig's left forearm and hand, flesh still intact, the fingers tightly closed around the ivory Madonna. The painter and the writer of the miracles crafted the relationship between the saint and the ivory Madonna. She controls it: Hedwig uses the figure to bless the infirm; Hedwig clutches the sculpture so tightly that it cannot be removed from her grasp. In both cases the miraculous ensues. Only posthumously does it affect her: by preserving her hand, the Madonna enables Hedwig to maintain her grasp on the Madonna, a wondrously reciprocal bond.

Most scholarly attention has centered on the third function of the figure, as focal point for Hedwig's private devotion, yet the specific words and images of the codex have not been analyzed in this regard. A great deal of mirroring is evident: the Virgin and the Christ child hold and caress each other; Hedwig holds the Madonna and child close to her body; the infirm are allowed direct physical contact, that which is disallowed to the high ranking clergy when Hedwig's relics are translated. Through the figure, Hedwig can produce an operational split: she acts out her roles from the inside, but she also is aware of her performance by watching herself from the outside. She can objectify herself mirrored in the figure: exhibiting the facial characteristics of the Virgin; dressing like the Virgin; acting like the Virgin; assuming the roles of bride, mother, widow, and saint; being the Virgin. The whiteness of ivory was considered particularly appropriate for images of the Madonna because of its associations with virginal purity.[31] Indeed, according to the chronicle account from Schönensteinbach, the nuns placed their tiny Madonna in the sun on a window ledge in order to bleach it.[32] Perhaps here too the twentieth-century adult doll called Barbie provides an apt comparison. In many of Barbie's manifestations radiating an overdetermined femininity and drag-queen-like appearance, M. G. Lord observes an example of homotransvestism, in other words, a constructed identity that runs counter to Barbie's lived realities as an active self-supporting career woman.[33] Hedwig, according to her vita, was energetic and enterprising. She intervened to bring back to life a man who had been hanged in a miscarriage of justice; she was the force behind her husband's decision to rebuild the Trzebnica (Trebnitz) monastery; she convinced her husband to live a life of chastity and enforced it after the conception of their seventh child. Yet the frail youthful Madonna-like image of her on the dedication page (fig. 22.1) and the small pale figurine after which she objectified herself are passively attractive focal points for male eyes.

[31] Danielle Gaborit-Chopin, 'The Polychrome Decoration of Gothic Ivories,' *Images in Ivory*, 47–61, esp. 47.

[32] Meyer, *Buch der Reformacio Predigerordens*, bk. 3, ch. 2, pp. 56–57.

[33] M. G. Lord, *Forever Barbie* (New York, 1994), 213–214.

But what of the devotional attachment to the object? The full text, written and pictorial, tells us that the figure was ever present in order to offer possibilities for visual contemplation, tactile veneration, and so that Hedwig could 'envelop it in love.' Here, as in many religious texts of the Middle Ages, the author adopts sexually charged imagery in order to describe devotion in terms that are the most vigorous, intimate, and compelling. The figure was more than an extension of Hedwig and more than an image onto which she could project feminine sanctity. Although the sense of touch is facilitated through the largest sense organ of the human body, it is the most analytically neglected of the senses by cultural historians. Indeed the fact that some surviving ivories show signs of wear consisting not only of partially damaged polychrome (fig. 22.7), but a diminution of the profile on the surface of the ivory, particularly on the head of the figurine, may indicate that those who kept them sought and found aesthetic satisfaction in fondling them, and in the process partially consumed the figures.[34] It has been observed that the pursuit of tactile pleasures entices everyone from cardinals to kindergarteners to indulge in secret activities that they would never allow themselves in public.[35] One need only think of the mentally challenged character Lenny in John Steinbeck's *Of Mice and Men*, who, uninhibited by social constraints, keeps a tiny mouse in his pocket so that he can have the ever-ready satisfaction of stroking its fur.

In the histories of the arts, the neglect of the haptic is exacerbated through the hegemony of a separate and dominant visual culture promoted by art history, and a less dominant but equally separate acoustic culture espoused by musicology. Tactual veneration was more personal and intimate than visual adoration or acoustic adulation; few rituals anchored it within public worship. In the western church only the medieval *pax* can be viewed as a liturgical object, the main function of which pertained to touching through the kiss of peace. On special feast days, however, reliquary busts, most notably that of St Just in Flums, were removed from their cabinets or tabernacles by ecclesiastical authorities in order that the faithful could venerate them by kissing them.[36] Late-medieval Paternoster chains or rosary beads can also be recognized as more personal devotional objects that furthered tactile gratification while serving as a mnemonic aid. Ivory's smooth organic surfaces beg to be touched; unlike the refulgent surfaces of precious metal, they do not exude an aura that keeps them at a safe viewing distance; unlike those of stone carvings they warm quickly in response to body heat.

34 *Images in Ivory*, no. 7; Robert Suckale, 'Eine unbekannte Madonnenstatuette der Wiener Hofkunst um 1350,' *Österreichische Zeitschrift für Kunst und Denkmalpflege* 49 (1995): 147–59. Professor Suckale first kindled my interest in these figures in a class lecture in 1986.

35 Gero von Randow, 'Neue Lust am Tasten,' *Die Zeit*, April 11, 1997; See also Elizabeth D. Harvey, 'Introduction: "The Sense of All Senses,"' *Sensible Flesh: On Touch in Early Modern Culture* (Philadelphia, 2003).

36 Scott Montgomery, '*Mittite capud meum ... ad matrem meam ut osculetur eum*: The Form and Meaning of the Reliquary Bust of Saint Just,' *Gesta* 36 (1997): 48–64.

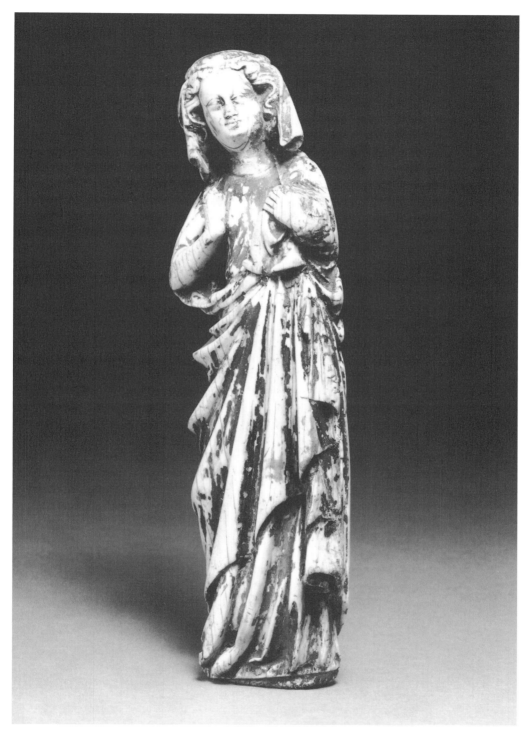

22.7 Virgin and Child, Ivory, French, ca. 1250, 70.19 cm.

Hedwig's three uses for her ivory Madonna are intertwined. The liturgical cult context of the figure that brought it into the arena of public display legitimized the figure for devotional purposes and gave the image approbation as a *Gnadenbild*. The intimate association of the object with the saintly duchess likewise hallowed the ivory figure, just as, conversely, the miniature Virgin provided a reflective image for Hedwig. The relationship between Hedwig and her small ivory Madonna presented in the codex confounds categories and defies boundaries, queering notions about devotion and material objects. The tight bond between Hedwig and the tiny Virgin is a same-sex relationship, and it developed during a period in which Hedwig had distanced herself from her husband, not only living in sexual abstinence but refusing even one-on-one conversation with Duke Heinrich since, according to the account in her vita, they had agreed never to be alone together. Once again, the same-sex aspects of relationships between adolescent girls and their Barbie dolls has spawned theoretical discourses that stress the doll's potential for transgressive uses, assertive resistances, and sub-cultural queerings.[37]

Was the small ivory Madonna an aesthetic object, a work of art or craft, a devotional representation of the Virgin and Child, a saintly role model, a faithful companion, an object of affection or even desire, a numen, a fetish, a talisman? Many of these classifications are challenged in the art that has come to valorize or subvert the ideology of the Barbie doll.[38] Holger Scheibe confounds many notions of the doll in his photograph *The Kiss*, in which a man is portrayed raising her in front of his parted lips.[39] Was Hedwig's ivory Madonna a sacred donation, a precious possession, or a piece of property? Much current political rhetoric idealizes private ownership as an unassailable and absolute good for all of society. Donations, however, during the Middle Ages (and often today) had to be approved by authorities and maintained by their donors; laws or conventions did not allow one side to discard, destroy, or alter them. Hedwig, according to her vita, was aware of the powers of ownership and responsibilities of donorship insofar that she asserted that she never took vows in order to maintain control of her lands and estates so that she could make donations of their proceeds.[40] Was Hedwig's control over the ivory figure absolute? Was the little Madonna hers to maintain or to neglect at her pleasure; to maim, destroy, or dispose of at will? Despots have cultural artifacts destroyed at their bidding. Humans dispose of other animate creatures at their discretion. Big people abuse little people. In her story, 'A Real Doll,' A. M. Homes's narrator inserts Barbie's whole head into his mouth as if he wished to consume her in a moment of passion.[41] Laura Wingfield, however, was

37 Valerie Steele, *Art, Design and Barbie: The Evolution of a Cultural Icon* (New York, 1995), Fig. 11; Erica Rand, *Barbie's Queer Accessories* (Durham, N.C., 1995); Jeannie Thomas, *Naked Barbies, Warrior Joes, and Other Forms of Visible Gender* (Urbana, Ill., 2002), esp. 120.

38 *The Art of Barbie*, ed. Craig Yoe (New York, 1994).

39 Steele, *Art, Design and Barbie*, Fig. 12.

40 Wolfgang Braunfels, 'Sinn und Funktion des Codex im Bewußtsein des Zeitalters,' in *Der Hedwigs-Codex von 1353*, vol 2, 225–30, esp. 227.

41 Steele, *Art, Design and Barbie*, 81.

saddened at the loss of one of the figures in her glass menagerie that proved to be as fragile as she was when distracted by a gentleman caller, and Steinbeck's Lenny was full of remorse when he inadvertently crushed his companion mouse. According to the Hedwig Codex, the saint's relationship with the Madonna was reciprocal, and Hedwig gained great agency through this Virgin. Perhaps this is why mainstream art history feels most comfortable when the doll-like medieval figures, tagged with acquisition numbers, are securely locked in museum vitrines, or when their stories are classified as curious incidents of female spirituality that manifested themselves behind monastery walls during the Middle Ages.

Boniface VIII and his Self-Representation: Images and Gestures

Agostino Paravicini Bagliani

Ideally, a study of the ways a medieval sovereign staged his own image must utilize sources well beyond the narrow frame of *Staatsymbolik*, or the symbols of state involved in traditional ruler iconography, to which older scholarship has confined the topic. As for the representation of the popes of the thirteenth century, the pontificate of Boniface VIII recommends itself to historians as a singular opportunity because many of the statues that concern him (above all those that were realized under his impetus) present a very complex view of the papacy and reflect a desire for self-affirmation which is without equal in the period. This self-affirmation should also be analyzed with the aid of textual sources that present their own vision of the pope in the year 1300. The comparison between visual and textual sources is all the more necessary because there are disquieting analogies between these two kinds of production.

In order to analyze the self-representation of Boniface VIII, it is necessary to return to the period before his pontificate, when Cardinal Benedetto Caetani, in the company of Cardinal Gerardo Bianchi of Parma, was papal legate to Paris.[1] In early October 1290, the legates had been called to Reims in order to resolve a conflict between the canons and the archbishop in which the bishop's functionaries had been accused of withholding the goods of the chapter. The canons had reacted by prohibiting all liturgical celebration—even the organs were silent—and the situation had become grave. Because October 1 was the feast day of St Rémi, the patron saint of the cathedral, the legates were able to delay the interdict until they had pronounced their judgment. As promised, the

Translated by Anne F. Harris and Nancy Thompson

[1] On the self-representation of popes in the thirteenth century, see my work, *Le Chiavi e la Tiara* (Rome, 1998), in which Boniface VIII plays an important role. Concerning Boniface VIII and his self-representation, see also my recent biography, *Boniface VIII* (Paris, 2003), translated from the Italian publication, *Bonifacio VIII* (Turin, 2003). Concerning the statues of Boniface VIII, the studies of Julian Gardner are still fundamental. See his 'Boniface VIII as a Patron of sculpture,' in *Roma anno 1300*, ed. Angiola Maria Romanini, Atti della IV Settimana di Studi di Storia dell arte medievale dell'università di Roma 'La Sapienza,' 19–24 May, 1980 (Rome, 1983), 513–27, and also 'Patterns of Papal Patronage circa 1260–circa 1300,' in *The Religious Roles of the Papacy: Ideals and Realities*, 1150–1300, ed. Christopher Ryan, Papers in Mediaeval Studies 8 (Toronto, 1989), 439–56.

legates delivered their judgment within two months on December 4 at the abbey of Saint-Cloud. The cardinals instructed the archbishop and the canons to build two statues of silver, one of a bishop cardinal (Gerardo) and the other of a cardinal deacon (Benedetto). Each sculpture was to be identified by their name and rank and to wear the liturgical habit of his rank: the cardinal bishop the chasuble and pontifical robes and the cardinal deacon the dalmatic. Both were to wear the miter, according to common practice. An even stranger specification indicated that both statues had to be worth at least five hundred *livres tournois* and be placed upon the main altar during mass and upon all major feast days of the liturgical year. Furthermore, they could neither be sold nor loaned.[2]

Exactly eleven years later, on December 4, 1301, Cardinal Caetani, now Boniface VIII summoned the bishop and canons of Amiens to Rome, delivered an arbitration judgment, and decreed that two statuettes be made, not only of silver, but also of gilded silver. The bishop was assigned the statue of the pope and the canons the statue of the Virgin Mary. Each statue had to be worth one thousand *livres parisis*, double the value assigned earlier when Boniface was cardinal. As at Reims, the statues had to be placed on the main altar of the cathedral for all major liturgical occasions. The bishop and the canons were required to deposit two thousand *livres* at the abbey of Saint-Corneille in Compiègne as a form of guarantee.[3]

We are dealing with two audacious decisions, unique within the history of the papacy. The fact that Boniface VIII gave the same commission in 1301 indicates that he may have been the instigator of the 1290 decision. In both cases, the goal was to perpetuate the memory of an arbitration reconciling a conflict within ecclesiastical institutions that had led to a *cessatio a divinis*—this would explain the placement of the statuettes on the altar during mass. The statuettes represent the living authority of the Roman Church in its function as supreme magistrate, and, in specific cases, in its role as the guarantor of the unity of the Church. Boniface VIII created the same correlation in 1301 by commissioning a statuette of the Virgin Mary, as symbol of the Church, and a statuette of the pope, as the head of the Church, representing Christ next to the Virgin Mary.[4] The statuettes of Reims also have an ecclesiological implication. They could well materialize the conception according to which cardinals are *pars corporis pape*, in ecclesiological intimacy with the Pope, in the representation of the Roman Church.[5] According to the commission given by Gerardo Bianchi

[2] The document published by Pierre Varin, *Archives administratives de la ville de Reims*, I, 2 (Paris, 1839), 1045–50 was long overlooked but has been rediscovered by Tilmann Schmidt, 'Papst Bonifaz VIII. und die Idolatrie,' *Quellen und Forschungen aus italienischen Archiven und Bibliotheken* 66 (1986), 75–107, esp. 91. See also Paravacini Bagliani, *Boniface VIII*, 56–57.

[3] *Les registres de Boniface VIII: recueil des bulles de ce pape publiées ou analysées d'après les manuscrits originaus des archives du Vatican*, 4 vols, ed. Georges Digard, Maurice Faucon, Antoine Thomas, and Robert Fawtier (Paris, 1884–1939), 3, 247–53, Reg. 4299. See my discussion of these statues in *Boniface VIII*, 246.

[4] The statues were apparently carried out; they are mentioned in a 1347 inventory of Amiens Cathedral. Paravacini Bagliani, *Boniface VIII*, 246.

[5] Agostino Paravacini Bagliani, *The Pope's Body*, trans. David S. Peterson (Turin, 1994; Chicago, 2000), 222–24.

and Benedetto Caetani, the statuettes of Reims represented the authors of the arbitration with their names and the liturgical vestments of their titles. In this instance, the production of memory was both institutional (to perpetuate the memory of a judicial act) and personal (to commemorate the magistrate who produced the arbitration). This last aspect is of utmost importance: the production of these statues bespeaks a profound, if not exalted, sense of self.

The boundary between the institutional and personal production of memory is therefore ambiguous. A further ambiguity is created because the statues of cardinals Bianchi and Caetani and pope Boniface VIII resemble images of *saints*.[6] The low-relief carving of a pope resembling Boniface VIII wearing a tiara, still visible today in the basilica of San Clemente in Rome, similarly resembles a saint. Near the end of 1298, the Franciscan cardinal Giacomo Caetani Tommasini, the son of Boniface VIII's only sister, commissioned a tabernacle, perhaps from Arnolfo di Cambio, for San Clemente. In the tympanum, a pope with halo and tiara kneels before the Virgin and Christ child in the center (fig. 23.1). This pope-saint could only be Pope Clement, patron of the church. But his face bears the physiognomic traits of Boniface VIII, which leads to the conclusion that the statue of Clement is actually a crypto-portrait of Boniface VIII; indeed, an ornamental jewel corresponds to the ruby in the tiara that crowned the Caetani pope. The low-relief carving of St Clemente would then represent Boniface VIII as a pope-saint with his own living physiognomy and the attributes of his power, an idea present in the statuette of Reims, designed to represent him as a cardinal and to be placed upon the main altar of the cathedral.[7] These images of the pope could well be what incited Guillame de Plaisians to levy the accusation, presented on June 14, 1303 to an assembly at the Louvre, that Boniface VIII, 'in order to perpetuate his already damned memory for perpetuity, commissioned silver statues of himself for churches, thus leading men into idolatry.'[8] The accusation of de Plaisians would be taken up again in 1306, without commentary, by Cardinal Pietro Colonna, indicating that the cardinal had few details. In another instance, however, the cardinal specifically accused Boniface VIII of having put statues representing himself 'in doorways or city gates, there where, in antiquity, idols were consistently found, as is the case in Orvieto and many other places.'[9] The

[6] This situation remains ambiguous even if one attempts to resolve it by claiming that the statuettes can be justified according to the Gregorian reform, which proposes that the pope (and thus also his cardinals) are *saints* in exercising their function.

[7] Leonard E. Boyle, 'An Ambry of 1299 at San Clemente, Rome,' *Mediaeval Studies* 26 (1964): 329–50. For further discussion of the San Clemente portrait, see Paravicini Bagliani, *Boniface VIII*, 243–44.

[8] Jean Coste, *Boniface VIII en process: articles d'accusation et dépositions des témoins (1303–1311), Edition critique, introductions et notes* (Rome, 1995), 148 (B 16).

[9] Coste, *Le procès de Boniface VIII*, 277 (H 43) (and n. 5 for a textual problem), 277–80 (H 44–47) and 419n35. Commentaries on Heinrich Finke, *Aus den Tagen Bonifaz VIII. Funde und Forschungen*, Vorreformationsgeschichtliche Forschungen 2 (Münster, 1902) 255–356; and C. Sommer, *Die Anklage der Idolatrie gegen Papst Bonifaz VIII. und seine Porträtstatuen*, (Freiburg im Breisgau, 1920). The question of idolatry has been recently reexamined by Schmidt in 'Papst Bonifaz VIII.'

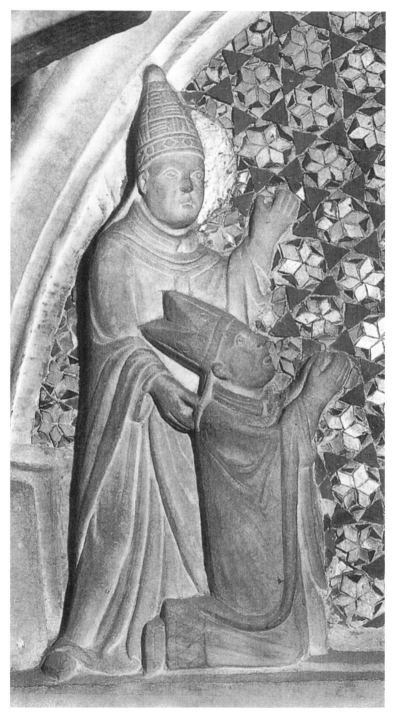

23.1 Detail, tympanum with image of a pope resembling Boniface VIII, wall tabernacle ca. 1299, church of San Clemente, Rome.

argument is tendentious, since only in Orvieto were statues of Boniface VIII placed upon city gates. The cardinal asserts, furthermore, that Boniface VIII commissioned the statues in Orvieto in response to the concession of the lands of Val di Lago, 'to the shame of the Church and of all the faithful of the Church in this region.' Here, too, the accusation does not correspond to reality. Colonna does not seem to have known that Boniface VIII's concession at Orvieto, contrary to the papal politics of recent decades, had been the object of a secret agreement arranged for the commune by Benedetto Caetani long before he had become pope.[10]

The statue of Boniface VIII now in the Museo Civico of Bologna (fig. 23.2) has an analogous history.[11] The city had been in conflict with the marquis Azzo d'Este since 1296. After several attempts at mediation, the two parties gave the pope the charge of mediating their disagreement. On 24 December 1299, the pope announced his decision, favorable to Bologna, that the city would regain possession of the castles of Bazzano and Savignano, which it held before the conflict. The commune immediately organized festivals, games, and celebrations, and the goldsmiths' guild dressed one young man as Charles II of Anjou and another as the pope! A few months later (on July 15, 1300), the commune decided to raise three marble statues in Boniface's honor, the first representing the pope, the second the king, and the third, the leader of the people. The commune protested a shortage of marble and the difficulty of finding competent artists, and accepted the proposal of two goldsmiths to make a single statue, measuring five feet in height, in copper, covered in very fine gold.[12] A few months later, in February of 1301, the statue, covered by a *baldacchino* also made of gilded copper, was placed, with an inscription honoring the pope, on the façade of the Palazzo della Biada, across from the communal palace, 'in order to be seen clearly by all.' It was the first time that a statue adorned a public place in Bologna. Of all the statues of Boniface VIII, the one in Bologna is the only one to represent him standing. The hieratic effect underscores the sacrality of the pope: his right hand is raised in blessing, and his left, resting upon his chest, held keys which are missing today. The beardless face of the pope is youthful; his tiara is high and adorned by a single diadem at its base.[13]

[10] D. P. Waley, 'Pope Boniface VIII and the Commune of Orvieto,' *Transactions of the Royal Historical Society* 32 (1950), 121–39. For a recent reproduction, see Anna Maria D'Achille, 'La tomba di Bonifacio VIII e le immagini scolpite del Papa,' in *La storia dei Giubilei* I (Florence-Rome, 1997), 224–38, Figs. 8 and 9.

[11] The documents have been published by Beretta M. Cremonini, 'Il significato politico della statua offerta dai Bolognesi a Bonifacio VIII,' in *Studi di storia e di critica dedicati a Pio Carlo Falletti* (Bologna, 1915), 421–31. The statue of Boniface now has only one crown; but it held others at one time, although it is impossible to determine if those belonged to the original. See Gerhart B. Ladner, *Die Papstbildnisse des Altertums und des Mittelalters*, Monumenti di antichità cristiana 2, 4 (Vatican City, 1970), 296–302. For a recent reproduction, see *Duecento. Forme e colori del Medioevo a Bologna*, ed. Massimo Medica (Venice, 2000), 398–400n133.

[12] In the end, the work was consigned to only one of the two goldsmiths, Manno di Bandino (on the October 28, 1300), who may have worked with his colleague.

[13] I discuss the Bologna sculpture in the chapter 'Boniface VIII en images' in Paravacini Bagliani, *Boniface VIII*, 248–49.

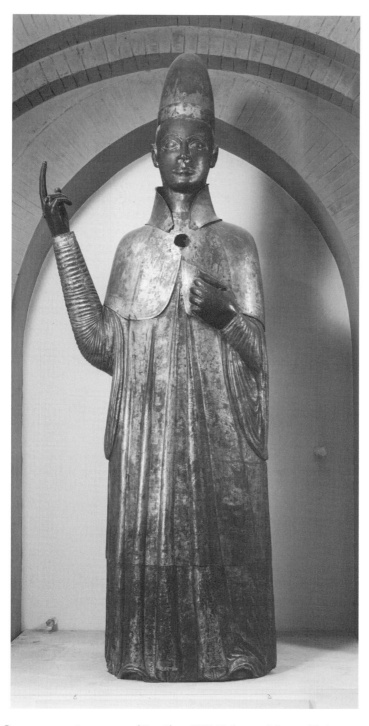

23.2 Commemorative statue of Boniface VIII, Bologna, Museo Civico.

On March 6, 1303, the leading council of the commune of Padua had decided to celebrate the yearly anniversary of Boniface VIII's proclamation that took the Inquisition tribunal for the dioceses of Padua and Vicence away from the Dominicans and gave it to the Franciscans of the convent of Padua. As a result, 'in order to show, in perpetuity, the great joy of the commune of Padua for these things that were done by the pope for the communes of Padua and of Vicence,' the commune had commissioned the fabrication of 'a very beautiful statue of gilded stone which is to be sculpted in his likeness.' The Padua sculpture it is the last one dedicated to Boniface VIII's memory discussed in documentary sources.[14]

The statuettes of Reims and Amiens, as well as those of Orvieto, Bologna and Padua establish an institutional memory of the supreme governance and unity of the Roman Church, which is at the same time a personal glorification of Boniface VIII as the author of arbitration and reconciler of conflict, an enactor of peace, and a guarantor of the unity of the Church. The use of statuary allows for both individual and institutional meaning, which is made more complex by the chosen designs for the statues: the Reims and Amiens statuettes recall those of saints; and the Italian sculptures evoke the antique—indeed, this is why Pietro Colonna was able to make references to antique idols.

Benedetto Caetani's commission of the statuette of Reims before his pontificate reveals that his strategy of self-representation cannot be explained as being motivated exclusively by his needs of self-legitimation. Several other popes— Gregory VII, Nicolas II, Innocent III, Honorius III, Gregory IX, and Nicolas III—played fundamental roles in the self-representation of the papacy. Boniface VIII's innovation, however, consisted in the material quality of this ideological program, a three-dimensional materiality that allowed its protagonist to simultaneously represent his body, and thus his identity, as well as a vision of the papacy, represented by the sculptural bust, carried to the extreme.

This staging, extraordinary in and of itself and unique in the history of the medieval papacy, is affirmed by an uncommon focus on gesture.[15] No other pope in the Middle Ages produced as many accounts of himself staging his own power and its attributes as did Pope Boniface VIII. I will limit myself here to two examples.

In 1298, Boniface VIII was forced to stay in Rome until the beginning of August due to the organization of the crusade against the Colonna. This was the second time that the pope ordered the transfer of the Curia so late in the year. In the first three years of his pontificate, he had left Rome by June at the latest. Already in 1297, tensions with the Colonna forced him to delay his

[14] C. Gasparotto, 'Il convento e la chiesa di S. Agostino dei Domenicani in Padova,' *Memorie Domenicane* 42 (1966): 188 no. IX, added the name of Alexander IV to the words *ad similitudinem*. This reading was corrected by E. Dupré Theseider, 'Note Bonifaciane,' *Archivio della Società romana di storia patria* 92 (1969): 1–3. Concerning the statue of Padua, see also Ladner, *Die Papstbildnisse*, 339–40.

[15] I have limited myself to those statues whose origins are linked to motivations of a public order (arbitrations, etc.) and have thus set aside private self-representation (funerary chapel), which I discuss at length in *Bonifacio VIII*.

departure for Orvieto to the first of June. Beginning in 1299, Boniface would no longer wait until summer, as he did in 1298, to leave the city. Instead, he left Rome every year between mid-April and the beginning of May.[16] Thus, in 1298, Boniface VIII thus left Rome on August 5 and arrived on the nineteenth at Rieti, a city that was the setting for several remarkable events. At some point in September, the pope received the envoys of Albert of Hapsburg, who had been elected king of Germany in Frankfurt, on July 27. According to Ferreto de Vicence, the new king had been among the first to send emissaries to the pope, to ratify the election and to entreat him to fix a date for the imperial crowning.[17] Pietro Colonna recounts that in 1306, the pope received Albert's ambassadors 'in full assembly,' examined the would-be king and found him unworthy: Albert was deemed guilty of treason towards King Adolphe, whom Albert rebelled against and killed like a traitor. The pope also withheld his blessing and refused to confirm Albert's royal election and his royal title and to fix a date for the coronation. Colonna adds that the pope 'proffered forth many more indecent proposals for Albert in the presence of his ambassadors.' And yet, he continued with malice, Boniface VIII claimed, 'to have spoken in a manner befitting the pope.'[18] This comment brings to mind a verse by Iacopone di Todi accusing Boniface VIII of having 'a butcher's tongue to say these nasty things.'[19] Boniface VIII was impulsive and known to enact brusque and at times violent gestures, even towards powerful prelates. The Annals of Genoa tell the tale of the Franciscan Porchetto Spinola, who came to Rome in order to receive the confirmation of his election as archbishop of the city, presenting himself to the pope on the first day of Lent (probably in 1299) in order to be marked by ashes. Believing that Porchetto had granted hospitality to the deposed Colonna cardinals, Boniface VIII did not apply the ashes to his forehead, but instead threw them in his eyes, justifying his act with a parody of the ritual words: 'Remember that you are Ghibelline and that you will return to ashes with Ghibellines.' 'But the same year,' reports the Annals, 'having learned the truth, he restored this same Porchetto to his archiepiscopal office.'[20]

[16] Agostinio Paravicini Bagliani, 'La mobilità della Curia Romana nel Duecento: riflessi locali,' in *Società e istituzioni nell'Italia comunale: l'esempio di Perugia (secoli XII-XIV). Congresso storico internazionale, Perugia, 6–9 novembre 1985*, II (Perugia, 1988), 155–278; reprint in *Itineranza pontificial: La mobilità della curia papale nel Lazio (secoli XII-XIII)*, ed Sandro Carocci (Rome, 2003), 3–78. The following discussion of the crusade against the Colonna and the confirmation of Albert can also be found in the chapter, 'Les clefs, la tiare et l'épée,' in Paravacini Bagliani, *Boniface VIII*, 205–9.

[17] We can assume that they immediately set course for the pontifical courts, and that they arrived there in late August, early September. *Ferreti Vicentini Historia rerum in Italia gestarum ab anno 1250 ad annum usque 1318, Le opere di Ferreto de' Ferreti* I, ed. C. Cipolla (Rome, 1980), 132–34; Franciscus Pipinus, *Chronica*, in RIS IX, col. 738–39 et col. 745; and Paolino Pieri, *Chronica delle cose d'Italia dall'a. 1080–1305*, ed. Anton-Filippo. Adami (Rome, 1755), 64. The best examination of the question of the political plan can be found in A. Niemeier, *Untersuchungen über die Beziehungen Albrechts I. zu Bonifaz VIII*, (Berlin, 1900), 43–52.

[18] Coste, *Le procès de Boniface VIII*, 341–42 (H 172).

[19] Iacopone da Todi, *Laudi, trattato e detti*, ed. F. Ageno (Florence, 1953), 231 (*Laude* VIII, v. 59).

[20] 'Annales Genuenses,' in *Rerum Italicarum Scriptores* 17 (Milan, 1730): col. 1019 B.

The manner in which the pope received Albert of Hapsburg's ambassadors left its mark on his contemporaries, and the chronicles are emphatic on this point. According to Pipino, who twice repeats the event in his chronicle, the pope was seated on his throne, girded with a sword. He wore the 'diadem of Constantine' upon his head, that is, the tiara, and brandished the sword in his right hand. It was in speaking to the ambassadors that he would have uttered the famous words: 'Am I not the sovereign pontiff? Is this throne not the seat of Saint Peter? Am I not within my rights to protect the rights of the Empire? I am Caesar; I am the emperor.'

The first question resembles very closely that of the decree of May 4, 1297 levied at the Colonna cardinals. Can we draw from this statement that Boniface VIII was in the habit of asking it publicly? Ferreto de Vicence adds other details: the pope apparently met with Albert's envoys in a 'more secret' place, and ordered his servants to bring his 'sword and the diadem;' the pope armed himself with the sword and placed the tiara on his head with pride. Having remained seated for a while, he apparently rose and brandished the keys of St Peter in his left hand, 'so that they be venerated,' and the sword in his right. Then, in a firm voice, he proffered a speech of pronounced eloquence: 'The imperial throne remains vacant,' he said, 'Albert is not worthy of it.' How could he even imagine becoming king of the Romans, he who had killed a righteous king? Did he think that the 'universal shepherd,' the pope, 'had fallen asleep,' instead of closely following the problems of the world? Does he purport to ignore 'the force of our power,' which has nevertheless been 'known for a long time'? Before receiving the title of Caesar, he will have to ask for forgiveness with humility for his crimes, and may not obtain such an honor without a 'pastoral decree,' that is, without the permission of the pope. Guilty of *lese majesté* and of having disregarded papal laws, Albert could only receive the title of Caesar if the pope was willing to grant it. The accusations levied against Albert are thus the same, but the tone is more nuanced on the issue of papal authority in that Boniface VIII does not affirm himself as emperor. It is true that near the end, in an exercise of authority, he turns his thoughts to Italy and the tone hardens. Having admitted that Albert now governs 'amongst the Germans,' he imparts a challenge: we are those who 'govern according to our good will and, like a king, have submitted the Italian people to our will.'

Albert's envoys were stupefied to have heard a speech of such grandiloquence and to have seen these 'unusual gestures.' Without adding another word, they left the pontifical court, not without having noted in writing what they had seen, heard and witnessed 'of the prince of priests.' The text, which seems to constitute the base of Ferreto's account (and perhaps those of other chroniclers who relate this event), has unfortunately not come down to us. But the fact that it probably existed lends a certain validity to Ferreto's account, especially since the concordances with Pipino's chronicle are relatively significant. Certain details may well have been amplified but, as stupefying as they are, these accounts seem at the very least to reveal Boniface VIII's propensity to place himself upon a stage, brandishing symbols of pontifical power. And what of

the matter of suddenly seizing a sword from one of the knights who surrounded him as his armed guards? Boniface VIII was, like other popes of the thirteenth century, surrounded by two chamberlains, one a Knight Templar and the other a Knight Hospitaler. In a miniature from the beginning of the fourteenth century, two knights dressed in green, holding a sword and a shield, frame the pope to his left and right. Two wings adorn the first knight's helmet; the shield of the second knight, all in red, bears the pontifical keys. When Nogaret, at Anagni in 1303, burst into the chambers of the pope, he found himself surrounded by 'Templar and Hospitaler brothers, his chamberlains.' Pietro Colonna's accusation that, in 1300, during the course of a procession from the Lateran to St Peter's more than fifty pilgrims were killed by 'armed men who went before the pope' is likely unfounded. The presence of armed men preceding pope Boniface VIII during a procession, however, is possibly an accurate detail.[21]

In 1302, Maundy Thursday fell on April 19. The night before, Boniface VIII made his way to Saint Peter's and then to the Lateran. According to a letter addressed by an officer of the king of Aragon, Arnau Sabastida, to his lord, the pope delivered a sermon that day before 'all the cardinals and bishops and abbots and religious men who were in the region.' The text of this letter is convoluted and cannot be taken literally.[22] The first piece of information is plausible, however, since the pope was in the habit of celebrating Maundy Thursday in the presence of the curial prelates, especially the 'general proceedings' ceremony against the rebels of the Church, at the end of which he was usually obligated to preach.[23]

The following excerpt from Sabastida's letter merits attention: 'As of the first words that he spoke, he asked them who he was, and he asked them this three times; no one answered until a cardinal stood up and told him that he was the one who kept God's realm here on earth and that he occupied the seat of St Peter and that what bound him to the earth bound him to the heavens.' The scene is a powerful one: did the pope ask this question in the guise of Christ to his apostles, with the cardinal there taking the place of Peter when he answered Christ: 'You are the Messiah, the living son of God' (Matt. 16.15–16; Mark 8.29–30; Luke 9.19–20)? That Boniface VIII asked such a question three times to cardinals in attendance could reflect one of his habits. On May 4, 1297, at the end of the decree of convocation addressed to the Colonna cardinals,

[21] The miniature is in a manuscript belonging to the Communal Library of Trent. Giuseppe Gerola, 'La iconografia di Innocenzo IV e lo stemma pontificio,' *Archivio della Società romana di storia patria* 52 (1929), 471–84. On Nogaret, see Heinrich Schmidinger, 'Ein vergessener Bericht über das Attentat von Anagni,' in *Mélanges Eugène Tisserant* 5, Studi e testi 235 (Vatican City, 1964), 373–88, and *Patriarch im Abendland: Beiträge zur Geschichte des Papsttums, Roms und Aquileias im Mittelalter. Ausgewählte Aufsätze von Heinrich Schmidinger, Festgabe zu seinem Geburtstag* (Salzburg, 1986), 89 and 97. On the Colonna accusation, see Coste, *Le procès de Boniface VIII*, 302 (H 89).

[22] For textual problems related to this document, see Paravicini Bagliani, *Boniface VIII*, 291n32.

[23] The following discussion can also be found in the chapter 'L'épée à la main et habillé de noir,' in Paravacini Bagliani, *Boniface VIII*, 312–16.

Boniface VIII wished 'to know if he is the pope?' At Rieti as well, he asked Albert of Hapsburg's ambassadors 'Am I not the sovereign pontiff? Is this throne not the seat of St. Peter?'

On the Maundy Thursday of 1302, Boniface VIII asked about his identity as pope simply out of habit, indicating his emotion when faced with a challenge to his legitimacy, which marked his entire pontificate. It may also have been, more simply, a way for him to put himself on stage, conscious that power does not exist unless it is validated externally. The claim that 'the pope kept God's realm here on earth' corresponds to what cardinal Matteo d'Acquasparta had said in the piazza of the Lateran during the celebration of Epiphany in 1300: 'the pope exists above all the temporal and spiritual sovereigns that might be in the realm of God ...'

Even after receiving a positive reply, Boniface VIII insisted yet another time to the prelates present to know if they really believed that he was pope: 'And when he said these words, all the others said the same thing, and when all had answered, the Holy Father said to them: You really believe it then? All replied with one voice that yes, they did.'

Boniface VIII apparently then stripped all the cardinal prelates, bishops, and abbots present of their offices, even though they had consented to answer very positively to his questions on several occasions: 'After which he told all those present that he wanted them all stripped of their offices and that they should render unto him their hats and rings; and each one did just this. Then, the Holy Father preached a sermon to them and told them that they were obedient to the Holy Church and that they were worthy of the offices of which they had been stripped, and he returned the offices to them and gave them new titles.' Because such an extraordinary event would likely be noted in documents, we must note it with hesitation. The pope apparently then let loose another verbal assault, playing with language, to establish that he had the authority to strip and confirm all offices within the Church. It is based on the veracity of such assaults that Cardinal Pietro Colonna was able to levy the accusation that Boniface VIII had threatened to strip four cardinals of their office. The sudden about-face of Boniface VIII described in Sabastida's letter should not surprise us: had he not stripped the elected bishop of Genoa of his office, only to then reestablish his title?

The letter continues by stating that the pope withdrew in order to dress and gird himself with a sword: 'And having done this, he left the room and told them to wait for him a moment. He entered into a room, and, once inside, he dressed himself in leggings of red *presset*,[24] and golden shoes with golden spurs, and a vest of red *presset*. He then took a sword and left, asking all whether they believed that he was emperor, and they answered yes. As for me, he said, I have dressed in this fashion because I am above all things within Christianity. I carry the cross that I bear on my back because I am pope. The sword that I am holding with my hands, you must all believe was given by our Lord to St. Peter to signify that with one edge he was granted heavenly power and with the other

[24] A type of oriental fabric of red color.

he was granted earthly power, and it is for that reason that he took the sword.' The descriptions above support the likelihood that at Rieti, in the fall of 1298, the pope did in fact wield a sword when he received the ambassadors of Albert of Hapsburg. And perhaps during this incident in Saint Peter's, Boniface VIII wanted to give the impression that he desired to bear a sword. Did Boniface VIII wear golden shoes with golden spurs inside Saint Peter's? On this issue the account seems rather fantastic, but what he may have said with a sword in hand recalls what he declared in the month of August in 1300, while receiving the bishop of Winchester: 'the pope carries a double-edged sword, meaning one for temporal and one for spiritual power.'

The many sculpted images of Boniface VIII created during his papacy could indicate that the sculptures were commissioned to defend the legitimacy of the pope; however, the statuette of Reims, commissioned by Benedetto Caetani when he was papal legate in France, reveals the situation to be of a larger scope. With these statues, Boniface VIII promoted the idea that as long as he was pope (and even cardinal) he incarnated the Roman Church. More than legitimating his power as pope and cardinal, the statues' mission, as with the Roman emperors, was to make that power visible, by putting it on stage and perpetuating its memory. In Reims and Amiens, but also in Orvieto, Bologna, and Padua, the pope is portrayed as supreme magistrate, judge, arbitrator and enforcer of the judicial power of the Roman Church.[25]

This richness of the new sculpted forms and their symbolic content allowed Boniface VIII to distinguish himself from all his predecessors. Crucial elements in the production of his memory and quest for legitimacy, inventiveness and creativity were particularly rich when in the service of his authority or image. This no doubt explains his preference for statuary, a three-dimensional medium that assures, better than any other medium, the public presentation of the personal and institution aspects of the pope's persona.[26]

However, a study of the self-representation of Boniface VIII only through an analysis of sculpture and its meaning is not sufficient. His habits of gesture, which can be understood through an analysis of textual sources, must also be considered. On this issue, the documents recalled in these pages constitute extremely important witness accounts. Even though their textual history is convoluted and complex,[27] they contain kernels of truth that are instrumental to an understanding of Boniface VIII's self-representation.

The contents of Sabastida's letter, discussed above, which recount for us the production organized by Boniface VIII at the time of Holy Week (Thursday and Friday) could be doubted,[28] the history of the text having been torturous and its authenticity thus hardly assured. However, this text describes, as we have just seen, gestures and deeds that coincide perfectly with the events attested to elsewhere or with standard ceremonial practices of the period. Given this

[25] Paravacini Bagliani, *Boniface VIII*, 251.
[26] Paravacini Bagliani, *Boniface VIII*, 252.
[27] Coste, *Le procès de Boniface VIII*, 279n5; Paravicini Bagliani, *Bonifacio VIII*, 291n32.
[28] See n. 22.

context, Sabastida's letter should therefore be considered a valuable source for the self representation of Boniface VIII, in as much as the message, whether a description of historical events or a literary creation, corresponds precisely to what a careful reading of the statuary of Boniface VIII reveals. In both cases, one learns of a conspicuous and indeed extraordinary sense of self and of a parallel affirmation of the function of the papacy, which compares the pope to Christ.

PART SEVEN

Text and Image

Paris and Paradise: The View from Saint-Denis

Elizabeth A. R. Brown

Thirty detailed images of Paris showing the city's bridges and inhabitants adorn the lavishly illustrated *Vita et miracula sancti Dyonisii* that Abbot Gilles of Pontoise offered to Philip V of France (r. 1316–22). Commissioned by Philip V's father, Philip the Fair (r. 1285–1314), the book was composed by Yves, a monk of Saint-Denis. It was not finished until after Philip the Fair's death, and at some point before its presentation to his son a French translation was added to the original Latin text. A plethora of illustrations adorn not only the book given to the king, now divided into four parts (Paris, Bibliothèque nationale de France, fr. 2090–92, lat. 13836), but also another copy of the full work (BnF lat. 5286), which I believe served as a prototype for the presentation volume. The illustrations in BnF lat. 5286 were executed not in color, like those of the presentation volume, but rather in pencil and pen and ink; its text is corrected throughout in several different contemporary hands. This copy remained at the abbey into the fifteenth century and was often consulted.[1]

[1] Considerations of space prevent my justifying here each statement in this paragraph; I hope to publish a fuller study at a later date. I have found useful for background and bibliography the work of the following scholars, whom I list in alphabetical order: Ingeborg Bähr, *Saint Denis und seine Vita im Spiegel der Bildüberlieferung der französischen Kunst des Mittelalters* (Worms, 1984); Virginia Wylie Egbert, *On the Bridges of Mediaeval Paris: A Record of Early Fourteenth-Century Life* (Princeton, 1974), esp. 3–17, for provenance and artists; the fundamentally important study by Charlotte Lacaze, *The 'Vie de St. Denis' Manuscript (Paris, Bibliothèque Nationale, Ms. fr. 2090–2092* (New York, 1979); Charlotte Lacaze, 'Parisius – Paradisus, an Aspect of the Vie de St. Denis Manuscript of 1317,' *Marsyas: Studies in the History of Art* 16 (1972–73), 60–66; Charles J. Liebman, Jr., *Étude sur la vie en prose de Saint Denis* (Geneva, N. Y., 1942); Cornelia Logemann, 'Heilsräume-Lebensräume. Vom Martyrium des heiligen Dionysius und einem paradiesischen Paris (Paris, BN, Ms. fr. 2090–92, Ms. lat. 13936),' *Mahrburger Jahrbuch für Kunstwissenschaft* 30 (2003): 53–91; Camille Serchuk, 'Images of Paris in the Middle Ages: Patronage and Politics' (Unpublished diss., Yale University, 1997); Camille Serchuk, 'Paris and the Rhetoric of Town Praise in the *Vie de St. Denis* Manuscript (Paris, Bibliothèque Nationale de France, ms. fr. 2090–2),' *Journal of the Walters Art Gallery* 57 (1999): 35–47. Still helpful is Léopold Delisle, 'Notice sur un recueil historique présenté à Philippe le Long par Gilles de Pontoise, abbé de Saint-Denis,' *Notices et extraits des manuscrits de la Bibliothèque impériale et autres bibliothèques* 21, part 2 (1865), 249–65. Because the book was written in Latin and only later translated, I refer to it by the Latin title, rather than as the *Vie de saint Denis*, as it is often designated. Study of Yves's text has convinced me that Lacaze was

In the thirty pictures featuring Paris's bridges and citizens, the scenes of Paris accompany and are subordinated to the illustrations' chief and central subjects. The first such miniature is the initial illustration, which shows Abbot Gilles offering the book to Philip V (figs. 24.1 and 24.2). The remaining twenty-nine are clustered in the second of the work's three books, consisting of 134 chapters devoted to Saint Denis's teachings and writings, his apostolate to the Gauls and martyrdom, and the subsequent veneration of his remains.[2] The initial book commences with the first chapter of the venerable Passion of Denis and his companions composed between 835 and 840 by Abbot Hilduin of Saint-Denis (r. 814–40) (known from its first words as *Post beatam ac salutiferam*), continues with 'a commendation of the city of Athens, which fostered the greatness and nobility of lineage of the blessed Denis,' and then devotes seventeen chapters to Denis's life up to the moment of his baptism. The third part of the work deals, in a hundred and seventy-four chapters, with the miracles Denis wrought after his death, especially for France and its kings.

The significance of the manuscript's scenes of Parisian life has long been debated. In 1974 Virginia Wylie Egbert concentrated on the bridge scenes apart from their larger contexts, and declared that they 'commemorated' France's chief city, by depicting 'ordinary people engaged in their daily occupations and amusements.'[3] She reproduced and discussed each scene of city life, often

correct in concluding that the illustrations in BnF lat. 5286 served as a model for those of the presentation copy; see the apparatus to the texts edited in the Appendix, below; and also Logemann, 'Heilsräume-Lebensräume,' 78n8. Anne D. Hedeman disagrees with this position, and Charlotte Lacaze and I hope to work closely with her and others to resolve the problem. See Hedeman's *The Royal Image: Illustrations of the Grandes Chroniques de France, 1274–1422* (Berkeley, 1991), 11, 35, and 55–60, but note the reservations she expressed on p. 285. I am analyzing the complex relationship between the texts of BnF lat. 5286 and the presentation copy, and, for the third book, among these manuscripts and a roughly contemporary copy of the third book of Yves's work (unillustrated), Berlin, Staatsbibliothek zu Berlin—Preussischer Kulturbesitz, MS fol. 53 (Rose no. 808); on this manuscript, see Oswald Holder-Egger, 'Ueber eine Handschrift des Guillelmus Scotus,' *Neues Archiv* 8 (1883): 184–87. Bernard Grémont's important study, 'La chronique d'Yves de Saint-Denis' (thesis, Paris, Ecole nationale des chartes, 1952) can be consulted at BnF, Richelieu, Impr. 40 1599 [Don 86–807].

[2] The numbering of chapters 99–118 in the second book of Yves's work varies between the presentation copy and BnF lat. 5286. In the presentation volume, chapter 99 is divided into two chapters whereas chapters 117–18 are combined into a single chapter. For similar reasons, the presentation copy of the third book of Yves's work contains 168 chapters (BnF lat. 13836, fol. 131v), whereas in BnF lat. 5286, it is divided into 174 chapters (BnF lat. 5286, fols 117v–21r, 215r–16v; this division is found also in Berlin MS lat. fol. 53, fols 1v–4r).

[3] Egbert, *On the Bridges of Mediaeval Paris*, 21. Similarly, Michael Camille described the scenes as a 'social survey of the very heart of medieval Paris' and commented that they 'seem at odds with the saints and their Latin speech-scrolls above': *Image on the Edge: The Margins of Medieval Art* (Cambridge, Mass., 1992), 128–32. Likewise, introducing a facsimile of the illustrations of the first two books of the presentation copy, Henry Martin presented these miniatures as showing 'la vie de la cité,' and he analyzed the various activities depicted in them for the light they cast on 'l'histoire archéologique et anecdotique de la ville de Paris.' He concluded by praising 'ces tableaux si vivants, si pittoresques et qui nous montrent mieux qu'aucun autre document que était l'aspect des rues de notre ville il y a quelque six cents ans.' See Henry Martin, *Légende de Saint Denis. Reproduction des miniatures du manuscrit original présenté en 1317 au roi Philippe le Long* (Paris, 1908), 32–36, 40–41. Jules Quicherat took a similar approach when he published the figures that populate the illustrations, in an article entitled

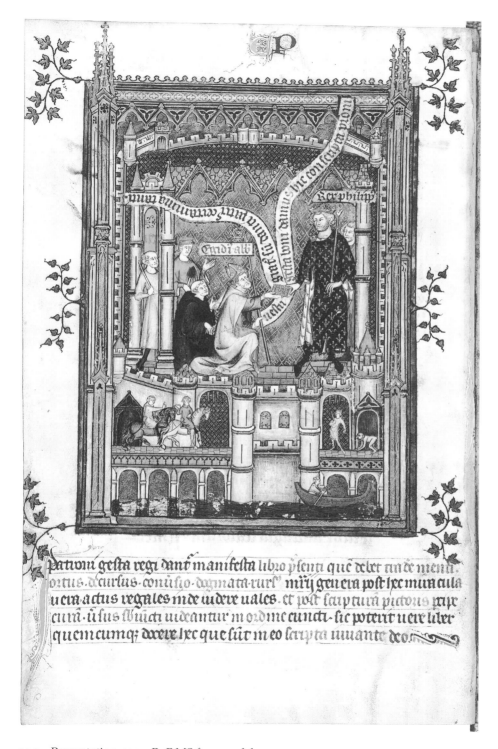

24.1 Presentation page, BnF MS fr. 2090, fol. 4v.

24.2 Presentation page, BnF MS lat. 5386, fol. 1r.

drawing on contemporary texts, including Jean of Jandun's encomium of Paris (completed on November 4, 1323), to elucidate the activities portrayed.[4] She described the image of Paris presented in the scenes as 'generally accurate, but not 'flattering,' and thus contrasted the approach taken in the manuscript's illustrations with that of the anonymous eulogist who praised Paris as 'Paradise,' and thus stimulated Jandun to write his own *Laudatio*.[5]

Egbert did not cite and seems not to have known an article that Charlotte Lacaze published in 1973, whose contents Lacaze incorporated in slightly altered form, five years later, into her dissertation on the presentation copy of the *Vita et miracula*; the dissertation was published a year afterwards, in 1979.[6] Discussing the same bas-de-page scenes, Lacaze firmly denied that they were 'simply anecdotal.' Rather, she declared them 'an integral part of the main miniature[s],' which '[represent] episodes from the life of St. Denis in Paris.' She did not, however, discuss precisely how she believed the scenes related to the depictions of the saint's activities or to Yves's text.[7] More generally, she argued that the scenes constituted 'a kind of *speculum urbis*,' recalling and commending 'the good government' France had enjoyed during the reign of Philip the Fair, and that they presented 'the earliest surviving image of *buon governo*.'[8] Citing Jean of Jandun, and alluding to the anonymous author who prompted his *Laudatio*, she suggested—in contrast to Egbert—that the scenes depicted Paris as an earthly Paradise.[9]

'Le commerce et les métiers de Paris au Moyen-Age,' in *Le Magasin pittoresque* 14, no. 28 (July, 1846), 217–22. In like manner, Charles Sterling described the pictures as 'les plus anciennes représentations de la vie quotidienne de Paris' and a 'chronique de la vie populaire.' As in Egbert's book, two plates show only the lower portions of the miniatures: Charles Sterling, *La peinture médiévale à Paris 1300–1500*, 2 vols (Paris, 1987–90), 1:56, and 60–61, where (p. 61) he endorsed Lacaze's interpretation. In *Civitas terrena: Staatsrepräsentation und politischer Aristotelismus in der französischen Kunst 1270–1380*, Kunstwissenschaftliche Studien, 124 (Munich and Berlin: Deutscher Kunstverlag, 2005), Wolfgang Brückle argued that the bridge scenes celebrated the daily, earthly existence of the Parisians, and were mere adornments to the presentation scene and representations of Saint Denis's activities depicted above. He compared the scenes to the depictions of crafts in the windows of Chartres, and judged them 'unwillkürliche Zeugnisse einer Säkularisierungstendenz' (p. 123).

4 The panegyric is edited, together with the anonymous tract that elicited it, in Antoine-Jean-Victor Le Roux de Lincy and Lazare-Maurice Tisserand, ed. and trans., *Paris et ses historiens aux XIVᵉ et XVᵉ siècles. Documents et écrits originaux*, Histoire générale de Paris 16 (Paris, 1867), 3–79 (with the anonymous tract on pp. 22–29, and Jean de Jandun's *Tractatus de laudibus Parisius* on pp. 32–79).

5 Egbert, *On the Bridges of Mediaeval Paris*, 84.

6 Lacaze, 'Parisius'; Lacaze, *The 'Vie de Saint Denis' Manuscript*, 126–38.

7 Lacaze, 'Parisius,' 60 and 62; cf. Lacaze, *The 'Vie de Saint Denis' Manuscript*, 126 and 128–29.

8 Lacaze, *The 'Vie de Saint Denis' Manuscript*, 129 and 134–38, and also Lacaze, 'Parisius,' 63n15, where she acknowledged the counsel of Florens Deuchler on this point.

9 Lacaze, *The 'Vie de Saint Denis' Manuscript*, 136–37; Lacaze, 'Parisius,' 65–66, especially n. 29. Drawing on Lacaze's work, in 1978 François Avril called attention to the 'theory' that '[the illustrations] may have been intended as a kind of homage to the "good government" which Paris enjoyed under the Capetian dynasty': *Manuscript Painting at the Court of France: The Fourteenth Century* (New York, 1978), 40. He endorsed this idea again in 1998 and, following Lacaze and Charles Sterling (n. 3 above), proposed that 'les panégyriques de l'époque rédigés à la gloire de Paris, dont l'un attribué à Jean de Jandun' provided a

Two decades later, in a dissertation defended in 1997 and in an article published in 1999, Camille Serchuk interpreted the scenes as generally positive affirmations of the material blessings Paris enjoyed. She proposed that they were intended 'to remind the king of St. Denis's importance to Paris, and, by extension, to France,' and thus persuade him to continue the monarchy's traditional support of Saint-Denis, which she believed was threatened by the cult of St Louis.[10] In her article Serchuk asserted that the scenes of Paris 'do in fact relate to the main scenes above them,' but she denied them 'an allegorical function.' She went on, however, to comment on the aptness of the fact that Saint Denis 'built a bridge, if you will, between God and France.'[11] She also suggested that the presence of the handicapped in the scenes might be 'a pictorial reminder of the failings of the population before it embraced Christianity.' Her citation of two sections of Yves's comments on Paris revealed her awareness of his text's potential importance as a key to the scenes' meaning, an issue she did not further explore.[12]

Most recently, Cornelia Logemann has persuasively argued that the bas-de-page illustrations are intimately related and conjoined as commentary to the chief subjects of the miniatures. More pointedly than any of the earlier scholars who have studied Yves's work, she has stressed the links, symbolic and allegorical, that bind the genre scenes to Yves's text, while also emphasizing that the text and textual tradition have been studied only superficially.[13] She

'contrepartie' to the illustrations: see his notice on BnF fr. 2090–92, in *L'art au temps des rois maudits: Philippe le Bel et ses fils, 1285–1328: Paris, Galeries nationales du Grand Palais, 17 mars – 29 juin 1998* (Paris, 1998), 185–86, no. 190.

[10] Serchuk, 'Images of Paris,' 40–44, 52–53, 62–63, and 80–82; Serchuk, 'Paris and Rhetoric,' 35, 39, 41, 46, and 47, n. 21.

[11] Serchuk, 'Paris and Rhetoric,' 41 and 44.

[12] Serchuk, 'Paris and Rhetoric,' 42. In her thesis (p. 80) Serchuk cited the initial part of Yves's comparison of Paris to Paradise ('O iterum & iterum felix parisius'), which she believed signified that God had planted Paris itself 'as a terrestrial paradise.' I shall discuss the passage in detail below.

[13] Logemann, 'Heilsräume-Lebensräume,' esp. 77n2, commenting on the compilation concerning Denis completed at Saint-Denis sometime after 1233, which she correctly suggested 'vermutlich als Vorlagen für unsere Dionysiusvita dienten,' but mistakenly indicated that Liebman edited in its entirety; the compilation is preserved in two MSS, BnF lat. 2447 (the original MS, heavily mutilated) and BnF n.a.lat. 1509; see also Logemann, 'Heilsräume-Lebensräume,' 73 and 87, n. 108. Without making clear the priority of BnF lat. 2447, Liebman (pp. viii–xxvi) discussed the two MSS and their contents, dating them, curiously, to 'la deuxième moitié du XIIIe siècle' (p. xxi), although he demonstrated that the collection was being cited at the abbey in 1254 (p. xxiii). Liebman hypothesized that part of the compilation was completed before mid-1224 because the historian Guillaume le Breton cited a miracle recounted in it in a work he finished in 1224 (pp. xxiv–xv); Liebman did not consider the possibility that Guillaume learned of the miracle from another source. The contents of BnF lat. 2447 are also listed in *Catalogus Codicum Hagiographicorum latinorum antiquiorum saeculo XVI qui asservantur in Bibliotheca Nationali Parisiensi Ediderunt Hagiographi Bollandiani*, 4 vols (Brussels, 1889–93) 1:120–25. On the two MSS, see Robert Branner, *Manuscript Painting in Paris during the Reign of Saint Louis: A Study of Styles* (Berkeley, 1977), 89 and 224 (where Branner misleadingly declared it only 'probable' that BnF n.a.lat. 1509 was copied from BnF lat. 2447). Pierre Gandil has studied these MSS and their sources in detail, in 'Les études grecques à l'abbaye de Saint-Denis au XIIe siècle,' a thesis defended at the École nationale des chartes in 2003, a summary of which is available on the Internet site: http://theses.enc.sorbonne.fr. I

published two important segments of Yves's text that relate directly to Paris, taking them from the presentation copy.[14] Like Serchuk, she noted the importance of one of his sources, the so-called *Vita et actus sancti Dyonisij*, a collection of Dyonisian texts made at the abbey not long after 1233, and preserved in two luxurious thirteenth-century manuscripts, BnF lat. 2447 (the original) and n.a.lat. 1509.[15]

In this essay, dedicated to a scholar who has insisted repeatedly on the importance of viewing images in context, and especially textual context, I will propose a reading of the scenes of Paris that links them to and anchors them in their textual as well as pictorial matrix. I shall argue that this was the sort of reading those who planned the manuscript aimed to encourage. I devote an initial section to the presentation miniature and the legends that accompany it, an image and text that instruct the book's readers on its proper use and function. A second section concerns the miniatures with scenes of Paris in the second book and sets forth my interpretation of the illustrations as testimony to the involvement of the Parisians in the salvific work that Denis and his holy companions, Rusticus and Eleutherius, accomplished for them. In a third section I analyze the attitude of Yves of Saint-Denis to France, Paris, and Saint-Denis itself, and propose that Yves equated Saint-Denis—not Paris—with Paradise, chiefly because the precious relics of Denis, his companions, and many other saints reposed within the abbey church. I also argue that although Yves insisted on the spiritual benefits that Denis had gained for France, he laid surprising stress on Denis's role in bringing material riches and earthly prestige to the country and its capital. This third section begins by examining Yves's use of and departure from traditional Dyonisian sources, especially the post-1233 compilation, the *Vita et actus sancti Dyonisij*. I emphasize the special importance of an encomium of Saint Denis written in the ninth century by Abbot Hilduin's contemporary, Michael the Syncellus of Jerusalem (about 761–846).[16] Translated at the abbey at the end of the twelfth century,[17] the encomium was one of the principal sources for the expanded version of Hilduin's Passion in the *Vita et actus*, which also

am grateful to M. Gandil for giving me a copy of his thesis, and for many profitable and informative discussions.

[14] Logemann, 'Heilsräume-Lebensräume,' 89–91, whose transcription often differs from my reading of the texts.

[15] Serchuk, 'Paris and Rhetoric,' 40–41; and n. 13 above.

[16] On Michael the Syncellus, see Raymond J. Loenertz, 'Le panégyrique de S. Denys l'Aréopagite par S. Michel le Syncelle,' *Analecta Bollandiana* 68 (1950), 94–107; and Christian Förstel's notice on the translation of the Syncellus's encomium published in Paris in 1547, in *Byzance retrouvée: érudits et voyageurs français (XVIe–XVIIIe siècles). Chapelle de la Sorbonne – Paris, 13 aout – 2 septembre 2001* (Paris, 2001), 24–25, no. 2.

[17] The monk Guillaume dedicated his translation to Abbot Yves of Saint-Denis (r. 1169–72): see Léopold Delisle's review of the first volume of Montague Rhodes James, *The Western Manuscripts in the Library of Trinity College, Cambridge. A Descriptive Catalogue*, in *Journal des savants* (1900), 722–39, esp. 725–32 ('Traductions de textes grecs faites par les religieux de Saint-Denis au XIIe siècle'); and Gandil, *passim*, where he argued that Guillaume also translated the *Laudes* that were assigned to Denis and included in the *Vita et actus*: see below at n. 70. Gandil is currently preparing an edition of the Greek, Latin, and French texts of the *Laudes*.

included a full copy of Michael's work.[18] In a brief coda, I end by comparing the ideas that Yves of Saint-Denis, Jean of Jandun, and the anonymous critic who provoked Jean to write about Paris and Paradise, and considering the relevance of their ideas to the depictions of Paris in the *Vita et miracula sancti Dyonisij*.

The Functions of Image and Text in Yves's Book

The presentation miniature and the verses elegantly written beneath it provide precious access to the intentions of those who created Yves's book (figs. 24.1 and 24.2). Particularly important is the stress the legend places on the close relationship that exists among illustrations, text, and the verses[19] set below most of the miniatures (which accompany all but five of the illustrations with scenes of Parisian life). The caption accompanying the presentation miniature is unusually long, and it deserves to be considered in full:

> Patroni gesta regi dantur manifesta
> Libro presenti quem debet tradere menti
> Ortus. decursus. conuersio. dogmata. rursus
> Martirij genera. post hec miracula uera.
> Actus regales inde uidere uales
> Et post scripturam pictoris percipe curam
> Versus subiuncti uideantur in ordine cuncti
> Sic poterit uere liber quemcumque docere
> Hec que sunt in eo scripta iuuante—or, in BnF lat. 5286, *docente*—deo.[20]
>
> The patron's deeds, made manifest, are given to the king
> In the present book, which he should commit to mind:
> His birth, his career, his conversion, his teachings, and then
> The trials of his martyrdom. After this his true miracles,
> And then the acts of king and kingdom you can see.
> And after the text, perceive the care of the painter.
> The verses, subjoined, should all be seen in order.
> Thus the book will truly be able to teach every person
> The things written in it, God helping (or, in BnF lat. 5286, 'God teaching').

[18] BnF lat. 2447, fols 21r–76v; BnF n.a.lat. 1509, pp. 42–152; and for the Syncellus's encomium, BnF lat. 2447, fols 81r–114r; BnF n.a.lat. 1509, pp. 161–231.

[19] Lacaze, *The 'Vie de Saint Denis' Manuscript*, 153–54, calling the verses *tituli*. Yves himself used the word *titulus* to signify 'title' or 'explanatory label' or 'sign' (such as the signs identifying the various gods on the Areopagus or the inscription giving the names of Denis and his companions and details concerning their martyrdom that was carved on their tomb); see BnF lat. 5286, fols 10v, 103v–4r; BnF fr. 2090, fol. 37; BnF fr. 2092, fols 67v and 69r.

[20] BnF lat. 5286, fol. 1r; BnF fr. 2090, fol. 4v (Egbert, fig. 1), with the translation on fol. 5r. On the verses see Martin, 45–46; also Grémont, pp. cxlvi-ii n. 2. Lacaze, *The 'Vie de Saint Denis' Manuscript*, quoted 'Et post scripturam … cuncti' (p. 154; and see p. 258 for her transcription and translation of the Latin legend, which differ from mine); Serchuk, 'Images of Paris,' 43, and Logemann, 53, each cited the first line, 'Et post scripturam pictoris percipe curam.'

The French translation, included on the facing page in the presentation copy, is slightly different, and lays even more emphasis on the importance of the verses (as does the translation of the abbot's words to the king):[21]

> Du patron au roy sont les gestes.
> donnees toutes manifestes.
> Dedenz ce liure ci present.
> sen doit faire a son cuer present.
> Cours. conuersion. nessement.
> derechef son ensaignement.
> les manieres de son martire.
> aprez ce. les miracles lire.
> les faiz de la roial lignee.
> pues ueoir aprez ensaignee.
> et aprez toute lescripture.
> aparcoit du paintre la cure.
> les uers aprez soient ueus.
> touz conioins par ordre et leus.
> ainsinc pourras uoir cesti liure.
> chascun ensaigner a deliure.
> ces choses qui sont en ce lieu.
> escriptes; aidant li dieu.
>
> The deeds of the patron are
> Given to the king, all manifest
> Within this present book.
> To his heart he should make it [and them] present:
> Career, conversion, birth,
> And also his teaching,
> The manner of his martyrdom.
> After this, read the miracles.
> The acts of the royal line
> You can then see taught.
> And after all the writing
> Perceive the painter's care.
> The verses then should be seen,
> All linked in order, and read.
> Thus you can see that this book
> Is ready to teach everyone
> The things that in it are
> Written, with God's aid.

These verses direct the king to take the text to heart, and to reflect equally on the accompanying pictures and verses. The close ties between verses and picture are emphasized. Finally the author—and it seems likely that Yves

[21] In translation, the words of the abbot, 'Vestri gesta boni damus hic conscripta patroni' ('The deeds of your good patron we give, recorded here'), become 'Les uers de lystoire Ci uous donnons, les gestes dites de uostre bon patron escriptes' ('The verses of the history here we give you, the deeds related of your good patron written down'). The translation of the Latin verses beneath the presentation miniature on fol. 4v is given in the bottom margin of fol. 5r, whereas the translation of the texts of the banderoles is placed in the upper right margin of that page.

composed the verses[22]—insisted on his desire that all encountering the book should understand it.

The verses make no special reference to the words recorded in banderoles that in many pictures (as in the presentation miniature) contain the protagonists' declarations and comments.[23] Nor do they allude to the small labels included in most of the illustrations to enable readers to identify the individuals and sites that are shown.[24] But like the verse captions and the pictures themselves, these unusual features were evidently intended to facilitate readers' comprehension of Yves's text.

The first verse caption is set underneath the presentation miniature, in which the bridges and citizens of Paris appear below the king and abbot, who offers the book. This placement may have led readers to conclude that those responsible for the manuscript were eager for special attention to be paid to 'the care taken by the painter' in executing this two-tiered illustration and those in which analogous scenes are similarly depicted (fig. 24.1). Without relating the miniature to the verses below, Cornelia Logemann has demonstrated the close interaction between the two levels of the picture, with the small figures on the lower left and right directing the viewer's eye upwards to the king and abbot (the angle of the rod held by the man with a monkey on the right mirroring that of the abbot's crozier). Positioning the monkey and the man leading him directly beneath the king suggests that the monarch is being instructed to 'ape,' or imitate and learn, from the exempla in the book. As Logemann noted, this message is driven home in the dedicatory letter of Gilles of Pontoise. Describing Saint Denis as 'dominice passionis feruentissimus imitator' ('dedicated imitator of the Lord's Passion'), the letter declares the universal value of studying and emulating the deeds of saints who can respond

[22] Lacaze, The 'Vie de Saint Denis' Manuscript, 154.

[23] Lacaze, The 'Vie de Saint Denis' Manuscript, 160–74, noted the extraordinary profusion of banderoles in the manuscript, and the fullness of the texts they contain. She suggested the possibility that they 'derived from a miracle play of the life of St. Denis.' Although I consider this unlikely, their presence in the manuscript provides additional evidence that those who prepared the manuscript wanted it to be readily comprehensibile. Two illustrations in the virtually contemporary Livres de Fauvel in BnF fr. 146 (fol. 28[ter]–v) have scrolls containing a verse of a song copied on the same page on which the miniature appears: see Le Roman de Fauvel in the Edition of Mesire Chaillou de Pesstain. A Reproduction in Facsimile of the Complete Manuscript, Paris, Bibliothèque Nationale, Fonds Français 146, with introduction by Edward H. Roesner, François Avril, and Nancy Freeman Regalado (New York, 1990), 45; and also Joseph Charles Morin, 'The Genesis of Manuscript Paris, Bibliothèque nationale, fonds français 146, with Particular Emphasis on the Roman de Fauvel' (Unpublished diss., New York University, 1992), 156–65. The slightly later Roman de Fauvain in BnF fr. 571, 'an early exemplar of the bande dessinée,' as Jane Taylor has described it, has no scrolls but contains verses like those in Yves's work (although Fauvain's are exclusively in French) : Jane H. M. Taylor, 'Le Romain de Fauvain: Manuscript, Text, Image,' in Fauvel Studies. Allegory, Chronicle, Music, and Image in Paris, Bibliothèque Nationale de France, MS Français 146, ed. Margaret Bent and Andrew Wathey (Oxford, 1998), 569–89.

[24] Lacaze, The 'Vie de Saint Denis' Manuscript, 358–59, pointed out that in BnF lat. 5286, many of these labels have been erased. This feature seems to me to confirm her hypothesis that the book served as a model for the presentation copy, since the monks of Saint-Denis, who retained BnF lat. 5286, would hardly have needed such flags.

to human intercession. Naturally Gilles emphasizes the particular wisdom of studying, imitating, venerating, and invoking those like Saint Denis 'who by their preaching and teachings have transported us from the death of sin to the life of grace, [releasing us] from the power of darkness to become sons of light and of God, and who have poured forth their blood not only to save themselves but also to save us.'[25] All three books of Yves's work contain advice in plenty for all who read it—and especially for the king.[26]

The connection between the two levels is even more apparent in the pen-and-ink illustration in BnF lat. 5286, where a frowning figure behind the king points downwards with his mace toward the monkey and his master (who here has no staff) (fig. 24.2). On the left, in place of the riders in the presentation volume, two men examine a horse's hoof (perhaps lamed because of a lost shoe), and the man holding the horse's bridle clasps a staff aimed directly at the king. The image of the horse needing assistance to proceed forward into the city suggests that the king at whom the horse's master gestures requires the advice contained in the book in order to govern properly. The horse preparing to enter Paris might also have reminded Philip V and his courtiers of that fictional horse of falsehood and iniquity, Fauvel, who was said to have ascended to power during the reign of Philip the Fair and to have tyrannized 'le lis et le iardin de France,' 'ou dieu par especiaute planta la flour de loiaute et y sema par excellence la franche grene et la semence de la fleur de crestiente' ('the lily and the garden of France,' 'where God especially planted the flower of loyalty and particularly sowed free shoots and the seed of the flower of Christianity').[27]

As the verses emphasized, Yves wanted not simply to instruct the king, but also to make what he had written comprehensible to everyone who opened his book. At the end of a chapter discussing Denis's intention in writing *On the Celestial Hierarchy*,[28] Yves emphasized this aim. Here, once more, he expressed his hope that pictures would help those who could not fully grasp the text:

[25] BnF lat. 5286, fol. Ar; BnF fr. 2090, fol. 1v (with the reference to Denis on fol. 2r) ('Et si laude dignas patrum memorias inuestigare nos conuenit quibus instructi possimus animemurque proficere ac etiam emulari [*proficere emularique*, in fr. 2090] semper karismata meliora … Illos tamen eorum inquirendo et imitando memorias exempla uenerari deuotius inuocare confidentius nos condecet qui nos de morte culpe ad uitam gracie de potestate tenebrarum in lucis et dei filios transtulerunt suis predicationibus & doctrinis quique non solum pro sua sed & pro nostra salute proprium sanguinem fuderunt [*effuderunt*, in fr. 2090]'). Logemann cited this passage (71–72) from the transcription given by Lacaze, The '*Vie de Saint Denis*' *Manuscript*, (341–42), which differs in several respects from my own; Serchuk (41–42) quoted part of it, again relying on Lacaze. Delisle ('Notice,' 262) omitted the passage from his edition of the letter.

[26] I hope in future to explore the *admonitiones* with which Yves larded his work. See below, n. 87, for Yves's insistence on the importance of learning and education for rulers.

[27] *Roman de Fauvel*, fols 41v, 44v; see also Elizabeth A. R. Brown, '*Rex ioians, ionnes, iolis*: Louis X, Philip V, and the *Livres de Fauvel*, in *Fauvel Studies*, 53–72.

[28] 'De intentione quam habuit beatus dyonisius in scribendo predictum librum': BnF lat. 5286, fol. 31v (with illustration on fol. 32r); BnF fr. 2090, fols 106v–7r (with corresponding illustration on fol. 107v). Yves devoted ten chapters of the second section of his book to this work: BnF lat. 5286, fols 27v–31v, chs. 13–22; BnF fr. 2090, fols 96r–107r.

Verum ne de celi spiritibus hic inserta sint legentibus minus clara eorumdem spirituum uni et trino[29] deo subiectorum. ordines in sequenti pagina secundum possibilitatem artificis depinguntur. ut que non patent pluribus in scriptura. pro parte saltem pateant in pictura. quem modum in hoc opere conseruamus. Nam plerumque quos scriptura non reficit. ad supernorum desiderium per picturas eorum animus inardescat. Amen.

But lest the things expressed here concerning the spiritual beings of heaven be unclear to readers, the orders of the same beings subject to the one and triune God are portrayed on the next page to the best of the artist's ability, so that what cannot be understood in words will in part at least be apprehended through picture, which is the way we have proceeded in this work. For often the souls of those who are not moved by words are roused to yearn for the heavenly by pictures. Amen.[30]

This aim is consonant with the desire Yves voiced throughout his work to persuade his readers to alter their lives. In this case, Yves declared, he hoped his summary of Dyonisius's treatise would lead all who 'read or heard what Dyonisius had recorded to find the lives they were living disgusting and yearn for a life of such blessedness' as Dyonisius described.[31]

Scenes of Paris and Salvation

The other twenty-nine illustrations depicting the bridges and citizens of Paris accompany thirty-nine chapters of Yves's second book, which treat Denis's conversion of the Parisians and the trials and martyrdom he and his companions, like many of their converts, suffered there.[32] The first of these chapters describes St Denis's arrival in Paris and 'the condition of the people and city of Paris.'[33] The last of the thirty-nine chapters explains how the three saints were beaten yet again before being led from Paris to be decapitated with dull hatchets, the customary Roman punishment for noble traitors—and thus appropriate for Denis, who, of course, 'was particularly graced by earthly nobility.'[34]

[29] In lat. 5286, 'uni et eterno' ('one and eternal').

[30] This passage is translated in fr. 2090, fol. 132v, 'Uraiement que les choses entees ici des esperiz du ciel. ne soient mains cleres aus lisans. Les ordres de ceulz meismes esperis subgies a un seul et treible dieu sont paintes en la page ensuiuante. selonc la possiblete de louurier. Si que les choses qui naperent pas a pluseurs en escripture. Si apparoissent pour partie en painture quel maniere nous gardon en ceste œuure. Si que ceulz que lescripture ne refait pas plainnierement. Le courage deulz eschaufe par painture au desir des souuerainnes choses.'

[31] 'ut etiam quicumque ista legeret uel audiret uita presens ei fieret fastidiosa et ad sortem tante beatitudinis hanelaret': BnF lat. 5286, fol. 31v; BnF fr. 2090, fol. 106v.

[32] BnF lat. 5286, fols 58v–94r, chs. 73–109; BnF fr. 2091, fols 97v–133v, chs. 73–89; BnF fr. 2092, fols 1r–41v, chs. 90–110; for the discrepancy in chapter numbers, see n. 2 above.

[33] 'De aduentu sancti dyonisij parisius. & de conditione gentis & ciuitatis parisiace': BnF lat. 5286, fol. 57v; BnF fr. 2091, fols 93v–94v. The title recalls those of the chapters of the first book describing Paul's advent to Athens, and Denis's own arrival in Heliopolis, where he witnessed the eclipse at the moment of Christ's death that was critical to his later conversion: BnF lat. 5286, fols 4r, 6v, and 11v, chs. 1, 8, and 12; BnF fr. 2090, fols 20r, 28v, and 39r.

[34] BnF, lat. 5286, fol. 93v; BnF fr. 2092, fol. 39r–v ('Hac igitur romana consuetudine sanctus domini dyonisius. utpote qui terrena nobilitate pollebat quam plurimum suique consortes post omnia tormenta hebetatis decollandi securibus uirgis publice flagellantur').

Thirty-five miniatures illustrate these pages, and depictions of Paris's bridges and citizens accompany all but six of them. Such scenes are absent from four illustrations that show the emperor Domitian and the army that the prefect Fescennius Sisinnius led against the saints.[35] These scenes do not take place in Paris, although Paris's walls (clearly labeled in two of the pictures) appear in the background in three of them, designating the target of the persecution Domitian was launching. The two other miniatures that lack bridge scenes depict incidents in Paris recounted in the accompanying chapters. Each of them is composed of two tiers of equal size, with each segment illustrating a centrally important event.[36] One of the miniatures shows Denis consecrating the church he built on land he purchased from Lisbius, his first convert, and then Denis's baptism of Lisbius. The second two-tiered miniature portrays Denis consecrating prelates, and also blessing figures who kneel before him. Bridges and citizens could not easily have been fitted into miniatures consisting of two equally significant (and equally large) scenes.

The chapters illustrated by these thirty-five miniatures recount the arrival of Denis and his companions Rusticus and Eleutherius in Paris and their fatal success in transforming a thoroughly pagan town into an eminently Christian city. The holy men's triumph, recounted in nine chapters, attracted the emperor's ire, and the remaining thirty chapters describe the persecution he forced the Christians to endure, while stressing the impressiveness of the results that Denis achieved. Yves's narrative makes clear that Denis and his companions were far from being the only Christians to suffer in Paris.

Yves's account emphasizes the number of Denis's converts, their loyalty to Denis and the Christian faith, and Denis's dedication to them. As Yves's narrative makes clear, Denis continued his ministry until he died. Even when he was fixed to a cross, Yves reported, Denis 'did not cease to preach the name of God to the faithful.'[37] Imprisoned with his companions, he 'did not cease to

[35] The first of these pictures, accompanying ch. 81, shows the emperor in Rome receiving messengers; Rome is not identified, but walls at the top of the illustration are designated *parisius*, to indicate the place from which the envoys were dispatched (BnF lat. 5286, fol. 63r; BnF fr. 2091, fol. 117r). There are no verses, but the words the messengers utter, recorded in the banderoles, call attention to Paris, where Dyonisius was 'destroying the cult of the gods and converting the multitudes by fraud' ('Degens parisius dijs querit tollere cultum, fraude dyonisius populum iungens sibi multum'). The second of the four miniatures, illustrating ch. 82, shows Domitian receiving troops (BnF lat. 5286, fol. 66r; BnF fr. 2091, fol. 119r); it is structured similarly, but neither the city where the ruler sits nor the city in the background is identified; the verses mention neither Paris nor Denis. In the third, accompanying ch. 83, Domitian commissions Fescennius Sisinnius (BnF lat. 5286, fol. 67r; BnF fr. 2091, fol. 121), and here *parisius* is again labeled. Domitian's words to the prefect refer to Denis, as the emperor orders Sisinnius to make him sacrifice to the gods or die, and to pursue his companions in crime ('Diis fac seruire dyonisium ue perire complicibusque doli sisinni parcere noli'). The two segments of the fourth of these pictures, illustrating ch. 84, show Sisinnius leaving a city (below) and traveling through verdant countryside (above). The prefect alone is identified (BnF lat. 5286, fol. 68r; BnF fr. 2091, fol. 123r), although the text shows that the army is leaving Rome and traveling through Gaul; the verses mention neither place.

[36] BnF lat. 5286, fols 61r, 62r; BnF fr. 2091, fols 100v, 102v.

[37] 'Quomodo sanctus dyonisius crucis patibulo appensus nomen dei predicare fidelibus non cessabat': BnF lat. 5286, fol. 88v; BnF fr. 2092, fol. 28v.

issue holy admonitions to the absent faithful as well as to those who were present.' Elaborating Hilduin's Passion, the core of his own narrative, Yves described how Denis's followers broke into the prison in order to see and hear him. In communicating with his disciples, Yves wrote, Denis resembled his teacher Paul, who had written to the Philippians and others from prison.[38] Yves noted that a host of his followers (and other curious people, including the pagan Larcia, wife of Denis's first convert, Lisbius) were with Denis in prison when he celebrated communion and Christ himself appeared to offer Denis bread.[39]

As Yves showed, numerous followers of the three holy men suffered martyrdom before Denis and his companions were executed. The first to die was Denis's earliest convert, Lisbius. Interrupting the story of the savage torments inflicted on Denis and his companions, Yves described Lisbius's interrogation and death in three chapters, illustrated by three miniatures with bas-de-page scenes of Parisian life (fig. 24.3).[40] In a later chapter, accompanied by the penultimate illustration with scenes of Paris, Yves recounted Denis and his companions' praise of God's judgments as the horde of Christian bodies slain at Sisinnius's command was displayed to them (fig. 24.4).[41] Elaborating Hilduin's account, comparing the Roman prefect to the Old Testament tyrant Manasses, Yves insisted on the plight of the Christians of Paris:

Just as [Manasses] shed an abundance of innocent blood until the holy city of Jerusalem was filled to overflowing with blood, so [the prefect] filled the city of Paris to overflowing with the blood of Christians. For in those days such a great multitude of the faithful, who through the holy Dyonisius's healthful proofs had believed in Christ, had been cut down and stricken with him in and near Paris by the harshest and most outrageous torments, that Paris seemed to exemplify what had been prophesied of Jerusalem: 'The dead bodies of thy servants have they given

[38] 'De eo quod sanctis domini in carcere retrusis sanctus dyonisius fideles absentes & presentes sanctis non cessabat monitis informare': BnF lat. 5286, fol. 89v; BnF fr. 2092, fol. 30v. The verses beneath the accompanying illustration declare 'Sepius illusus in carcere nuncque reclusus, Rupta clausura secum trahit agmina plura, Non cessans monita de celi tradere vita': BnF, lat. 5286, fol. 90r; BnF fr. 2092, fol. 32r. Here too Yves followed Hilduin, PL 106:45. Of Denis, Yves wrote: 'tanta dilectione tantoque feruoris zelo populum sibi coniunxerat ut multi eum ut patrem dulcissimum insequti carcerem irrumperant ipsius absenciam seu iniuriam non ferentes eiusdem mellifluis confirmari sermonibus affectantes. Pater autem pijssimus filiorum suorum salutem cupiens in uisceribus ihesu christi etiam in carcere positus eos salutaribus documentis & exhortationibus informare nullatenus omittebat. Ad absentes uero instituta & precepta secundum que deberent in christo uiuere seu mori secundum quod sibi erat possibile dirigebat. Ecce quam gloriosus domini predicator dyonisius magistri sui pauli doctoris gentium imitator est uerus qui etiam rome detentus in carcere philippenses ceterosque fideles non cessabat per epistolarum suarum monita in bonis operibus confirmare': BnF lat. 5286, fol. 89v; BnF fr. 2092, fol. 30v.

[39] BnF lat. 5286, fol. 90v; BnF fr. 2092, fols 32v–33r. In the accompanying miniature, many heads appear behind Denis and his companions, on the left: BnF lat. 5286, fol. 91r; BnF fr. 2092, fol. 33v; Martin, pl. LXII. Cf. Hilduin's Passion (PL 106:45).

[40] BnF lat. 5286, fols 75r, 76r, and 77r, chs. 92–94; BnF fr. 2092, fols 4v, 6v, and 8v.

[41] 'Quomodo uisis interfectorum pro christi fidelium corporibus gloriosi martyres diuina iudicia laudauerunt': BnF lat. 5286, fol. 92v; BnF fr. 2092, fol. 37. Cf. BnF lat. 2447, fol. 65r–v (BnF n.a.lat. 1509, 130–31), expanded from Hilduin's Passion (PL 106:47) by adding a portion of Michael the Syncellus's encomium; partly edited from BnF n.a.lat. 1509, in Leibman, *Étude*, 177.

24.3 Martyrdom of Lisbius, BnF MS fr. 2092, fol. 8v.

24.4 Eleutherius, Rusticus, and Denis with the bodies of slain Christians, BnF
MS fr. 2092, fol. 37v.

to be meat unto the fowls of the heaven, the flesh of thy saints unto the beasts of the earth. Their blood have they shed like water round about Jerusalem; and there was none to bury them'.[42]

The Christian faithful who were martyred with Denis and his companions were destined to receive the same heavenly rewards. Recounting Lisbius's execution, Yves declared, 'O happy Lisbius, who, casting away the earthly dignity with which he shone as first among the citizens of Paris, following Christ's footsteps, through the palm of martyrdom, enjoys the dignity of Paradise.'[43] Reenforcing this, the verses beneath the accompanying miniature declare, 'Lisbius passes from the world, enduring death; Once a citizen of Paris, now of Paradise.'[44] The many Christians who died later were no less blessed. When shown the bodies of the dead Christians, 'still marked with the signs of miserable death,' as Sisinnius remarks in the picture,[45] Denis and his companions praised God, 'who determined to bring low in the present those whom he decided before the beginning of time should be exalted in the kingdom of heaven.'[46] The verses beneath the illustration reiterate this notion, reporting that in his heart Denis blesses God, who thus permits to be cast down and scorned in this present time those whom he already knew will be exalted and blessed in the kingdom that will freely be given, for eternity, to the blessed.[47]

42 'Etenim sicut ille sanguinem innoxium fudit multum nimis donec sanguine usque ad os illa sancta ciuitas iherusalem impleretur. Sic iste ciuitatem parisiacam [*corrected from* pasiriacam] usque ad os repleuit sanguine christianorum. Tanta namque multitudo fidelium qui per sancti uiri dyonisij documenta salubria in christo crediderant illis in diebus et cum illo in circuitu ciuitatis parisiace pro christi nomine cesa et durissimis et antea inauditis supplicijs est affecta / vt parisius uideretur impletum / quod de iherusalem prophetico uaticinio fuerat peroratum. Posuerunt mortalia seruorum tuorum domine escas uolatilibus celi carnes sanctorum tuorum bestijs terre. Effuderunt sanguinem eorum tanquam aquam in circuitu iherusalem et non erat qui sepeliret': BnF lat. 5286, fol. 92v, ch. 107; BnF fr. 2092, fol. 37r, ch. 108. The text elaborates Hilduin's account (PL 106:47), which was included in BnF lat. 2447, fol. 65r (BnF n.a.lat. 1509, p. 130). For Manasses, see 4 Reg. 21:1–18, esp. verse 16: 'Insuper et sanguinem innoxium fudit Manasses multum nimis, donec impleret Ierusalem usque ad os: absque peccatis suis, quibus peccare fecit Iudam, ut faceret malum coram Domino' (cf. in the King James' translation, 2 Chron. 33:1–18); see also Ps. 78/79:2–3. Logemann, 'Heilsräume-Lebensräume,' 75 and 88. n. 119, quoted part of this passage in stressing the ennobling effect of the martyrs' blood on the city of Paris and arguing that '[z]wischen Lebensbeschreibung und Ortsbeschreibung ist an einigen Stellen der Vita offenbar nicht zu differenzieren'; her transcription differs in some respects from my own.

43 'O felicem lisbium qui abiecta dignitate terrena qua pollebat primus inter ciues parisij xpisti sequens uestigia per martyrij palmam dignitate fruit paradysi': BnF lat. 5286, fol. 76v; BnF fr. 2092, fol. 8r, with the illustration on the following page. Cf. Hilduin's declaration that Lisbius 'transmissus est vitæ perpetuæ' (PL 106:44).

44 'Lisbius ex mundo transit mortem subeundo. Quondam parisij conciuis nunc paradysi': BnF lat. 5286, fol. 77r; BnF fr. 2092, fol. 8v.

45 'Occisos multos per vos nondumque sepultos. Mortis adhuc misere cum signis ite uidere': BnF lat. 5286, fol. 93r; BnF fr. 2092, fol. 37v.

46 'Ipsi uero omni timore abiecto ampliorique spiritu uirtutis assumpto funeribus sibi sanctorum ostensis diuina iusta et occulta laudauere iudicia qui sic eos in presenti humiliare disposuit quos in celesti regno tam gloriose exaltari ante omne tempus decreuit': BnF lat. 5286, fol. 92v; BnF fr. 2092, fol. 37r.

47 'Funera dum uidit que presidis ira cecidit, Terrores abicit. et corde deum benedicit, Qui sic prosterni sinit hoc et tempore sperni, Quos exaltandos quos prescijt ipse beandos, In regno

The textual context of the scenes of Paris focuses on and emphasizes the success of Denis's ministry in Paris. The images themselves are intimately related to the story of Denis's massive conversion of the faithful. Cornelia Logemann has demonstrated what close symbolic ties link the activities of the Parisians to the heroic deeds depicted above them. The men hauling in a catch of fish as Denis enters Paris not only recalls (as will soon be seen) the abundance of fish the Passions of Denis attribute to Paris and the Seine, but also, and in context even more pertinent, Jesus's words to Simon and Andrew, 'Venite post me, et faciam vos fieri piscatores hominum.'[48] The small figures on the right in the picture in the presentation copy may be repairing Paris's paved roads in anticipation of Denis's arrival, or may (as Logemann suggested) represent Denis as a gardener tilling the soil of Paradise; in BnF lat. 5286, they are replaced by a man who, like his fellow citizens on the river, has caught a fish and is preparing to throw it into the basket by his side (figs. 24.5 and 24.6).[49] Accompanying Denis's conversion of Lisbius, a boatload of singers rejoices, as a noble Parisian displaying his bird rides into the city, recalling the noble pastimes that Lisbius renounced for Christ's sake.[50] When Christ is shown administering communion to Denis, four Parisians in a boat elevate a chalice, while a porter brings bread into the city, and a man makes a bear (surely signifying Satan) stand on his head.[51] Equally telling is the depiction of three watermills grinding grain, set beneath the depictions of Denis and his companions before the gates of Paris as they gaze on the severed heads of the Christians they have converted (fig. 24.4). As Logemann pointed out, this image recalls Paul's mystic mill of conversion, which was depicted in one of Abbot Suger's windows at Saint-Denis.[52]

The small figures in the other miniatures suggest equally varied interpretations and parallels. These images can be read in many different ways and on many different levels. One reading does not preclude another and none can be declared solely authoritative or especially privileged. As the initial verses suggest, the images were introduced to stimulate readers to ponder them and consider their relationship to the scenes of the saints above.

Whatever their other functions, these illustrations make inescapably clear the dynamic involvement and participation of the Parisians in the redemptive work that Denis and his companions wrought for them. The actions the people perform in their daily lives symbolically complement and advance the three saints' mission. Thus the Parisians' work on earth prepares them for and

gratis dando sine fine beatis.': BnF lat. 5286, fol. 93r (reading *Terrorem reicit &*); BnF fr. 2092, fol. 37v.

[48] Mark 1:17; see Logemann, 'Heilsräume-Lebensräume,' 58, 60–61. See BnF lat. 5286, fol. 58r (Fig. 6); fr. 2091, fol. 97r (fig. 5).

[49] BnF, lat. 5286, fol. 58r; BnF fr. 2091, fol. 97r. Logemann, 'Heilsräume-Lebensräume,' 60.

[50] BnF, fr. 2091, fol. 99r; cf. BnF lat. 5286, fol. 60r (where the figures lack the roll of music displayed in the presentation miniature). See Logemann, 'Heilsräume-Lebensräume,' 59 (fig. 4), and 61–62.

[51] BnF, lat. 5286, fol. 91r; BnF fr. 2092, fol. 33v. Logemann, 'Heilsräume-Lebensräume,' 68–69.

[52] BnF, lat. 5286, fol. 93r; BnF fr. 2092, fol. 37v. Logemann, 'Heilsräume-Lebensräume,' 69–71.

24.5 Denis entering Paris, BnF MS fr. 2091, fol. 97r.

24.6 Denis entering Paris, BnF MS lat. 5286, fol. 58r.

prefigures the life they will enjoy in heaven after they have died for their faith. The verses below the scene of Lisbius's martyrdom declare that he is being transmuted from citizen of Paris to citizen of Paradise, and beneath him a money-changer and goldsmith, hard at work, signify and share in the happy change of status Lisbius has merited, as, at their benches, the changer converts one currency to another and the goldsmith fashions raw metal into a beautiful and precious object (fig. 24.3).[53]

Yves of Saint-Denis on France, Paris, and Saint-Denis

Do Yves's own views of Paris and its inhabitants support other, alternative interpretations of the scenes of Parisian life presented in his book? The ideas expressed in two long sections devoted to Paris and to France cast light on this issue. Yet determining precisely what Yves himself thought is not easy, since he drew freely on the writings of those who had treated the subject before him. Thus, to assess his position, it is necessary to determine his sources and the use he made of them—how he edited and how he expanded them.

Yves presented reflections on Paris in recounting the commencement of Denis's mission in France and again in a long chapter ending his second book. For both sections, Yves drew on the compilation of sources relating to Denis known as the *Vita et actus sancti Dyonisij*, assembled at Saint-Denis not long after 1233. For Yves, the three most significant texts in the compilation were, first, the expanded Passion of Denis and his companions composed for the volume (which drew on a variety of sources to expand and elaborate Hilduin's Passion); second, a collection of *Laudes* of Denis that had been translated from Greek invocations honoring various saints and assigned to St Denis at the end of the twelfth century; and third, an encomium of Denis written by Michael the Syncellus of Jerusalem around 833–34, which was also translated at the end of the twelfth century.[54]

The positive portrait of the city that Abbot Hilduin included in his Passion provides the core of the description of Paris in the *Vita et actus*.[55] Hilduin's account was itself inspired by the first of Denis's Passions, the so-called *Gloriosae* of around 500. This first Passion lavished praise on Paris, while still acknowledging that the space available for the city's growing population was becoming cramped.[56] Hilduin himself dwelled on the city's attractions, omitting

53 BnF, lat. 5286, fol. 77r; BnF fr. 2092, fol. 8v. Logemann, 'Heilsräume-Lebensräume,' 64–65 suggested that the two sleeping figures signified that the Parisians were 'sleeping off' ('verschalfen') the sacrifice of the first Christian, although she later proposed (p. 68) that a similar figure evoked 'the sleeping Adam,' prefiguring Christ's sleep on the Cross. The figures also evoke the peaceful repose Lisbius was destined to enjoy in heaven after his earthly death.

54 On these sources, see nn. 13, 16, and 17 above.

55 Liebman edited the text in *Étude*, 164–65, from BnF n.a.lat. 1509, pp. 105–107, preferring this manuscript to the original, BnF lat. 2447, fols 52r–53r.

56 For *Gloriosae*, see MGH Auct. Antiq. 4²:103 (PL 88:580–81) ('Tunc memorata civitas et conventu Germanorum et nobilitate pollebat, quia esset salubris aere, iocunda flumine,

Gloriosae's comments on the congestion in Paris. He rejected as well the far more hostile and ambivalent picture painted in the second of Denis's Passions, *Post beatam et gloriosam*,[57] composed around 826 and soon thereafter translated into Greek—and hence available to admiring compatriots of Dyonisius the Areopagite.[58] This second Passion declared in turgid and involuted prose that Paris:

although small, was befouled by the errors and filth of the gentiles. Covered by heaps of the pagans' excrement, it was still fertile in lands, well-wooded by trees, exceedingly rich in and crowded with vines, and mighty because of the business of money-changers. It profited from the protection of the Seine, and it provides from the river's streambed an abundance of fish to its citizens, and is known to furnish considerable protection by its walls, and [surrounded] by the river's water it includes the space of an island rather than a city's.[59]

Hilduin knew this Passion, but as regards Paris he cited only the comment on the lavish supply of fish the Parisians enjoyed.[60]

The *Vita et actus* presented Hilduin's positive description but prefaced it with a section declaring that whereas Paris's population was modest in comparison with the other cities of Gaul, the superstition found there was appalling, a result of the varied multitude of people the city attracted. The statement was probably taken from a Latin translation of the tenth-century *Life of Denis* by Simeon Metaphrastes.[61] It echoes the sentiments expressed in *Post beatam et gloriosam*,

fecunda terris, arboribus nemorosa et venetis uberrima, constipulata populis, referta commerciis, ipsumque insulae potius quam urbis spatium quod habitatione circumfusa fluminis unda praestabat crescentibus consistentium catervis reddebatur exiguum et iocunditatis sollicitatione in unum plebs acta commigrans pene territorium suum intra murorum conclusionem contraxerat').

57 I discuss Hilduin's use of the two previous Passions in '*Gloriosae*, Hilduin, and the Early Liturgical Celebration of St. Denis,' in *Medieval Paradigms: Essays in Honor of Jeremy duQuesnay Adams*, 2 vols, ed. Stephanie Hayes-Healy (New York, 2005), 2:39–82.

58 Loenertz, 'Le panégyrique de S. Denys l'Aréopagite,' 97–101.

59 'ipse vero sanctus Dionisius Parisius remanebat; quæ ciuitas, quamvis parva, gentilium tamen erat erroribus & squalore fœdata. Nam licet magnis esset paganorum fecibus involuta, fecunda tamen terris, arboribus nemorosa, vineis uberrima ac referta, pollebat commerciis trapazetarum quæ, Sequanæ vallata perplexit, & copiam piscium alvei sui civibus unda ministrat & non parvum muris noscitur præstare munimen ipsumque insulæ potius quam urbis spatium laticis sui unda concludit': *Acta Sanctorum* Oct. 4:793.

60 'Tunc memorata **Parisiorum** civitas, **ut sedes regia**, et conventu **Gallorum ac Germanorum**, et nobilitate pollebat: quia erat salubris aere, jucunda flumine, fecunda terris, arboribus nemorosa, et vineis uberrima, constipata populis, referta commerciis **ac variis commeatibus, unda fluminis circumfluente. Quae siquidem inter multimoda commoditatum genera, etiam alveo suo magnam piscium copiam civibus ministrabat**': PL 106:40. Hilduin's additions to *Gloriosae* are set in bold type.

61 'Porro supradicta parisiorum ciuitas erat multitudine quidem ciuium respectu ceterarum gallie magnarum urbium modica. sed supersticione tanto potentior omnibus atque crudelior; quanto diuersarum tocius gallie gentium concursu uelut portus celeberrimus frequentabatur': BnF, lat. 2447, fol. 5r (BnF n.a.lat. 1509, p. 105). Liebman suggested (p. 164n1) that this passage was based on Metaphrastes's Life of Denis, for which see PG 4:589–608 (also in PG 115:1031–50). Pierre Gandil has shown (see n. 13 above) that this is doubtless the case; he has found other, even more striking parallels between passages in the *Vita et actus* and in Yves of Saint-Denis's *Vita et miracula sancti Dyonisij*, on the one hand, and, on the other, the Greek text of

and ideas voiced as well (as will shortly be seen) in the encomium of Michael the Syncellus.[62] Then followed Hilduin's encomium. Finally came a far more guarded testimonial taken from a Greek Passion ascribed to Methodius, allegedly translated into Latin by Anastasius the Librarian around 876, known as *Sermo gratiarum coronat*.[63] This Passion begins by celebrating the abundance of food and delicacies available to the city's inhabitants, but then, changing tone, contemptuously denounces the unbridled desire such riches and delights provoke, and declares the Parisians 'trapped in a snare' and guilty of taking haughty pride in their city.[64] Thus the picture of Paris in the *Vita et actus*, fashioned of texts written over four centuries, presented a charged and ambivalent view of the city, emphasizing the material blessings of life there but contrasting them with the city's spiritual failings and the vainglory its wealth fostered.[65]

In his work, Yves quoted the long and complex passage from the *Vita et actus*, and then amplified its criticism of the Parisians' pride by adding his own denunciation. Decrying the vanity, stupidity, and deceptiveness of the Parisians'

Metaphrastes's Life (which was itself influenced by Michael the Syncellus's encomium). I appreciate Pierre Gandil's counsel on this point and am grateful for the impressive list of passages (a number of them unidentified by Liebman) which he was kind enough to send me. We are attempting to locate the full Latin translation of Metaphrastes's Life of Denis that was used at Saint-Denis in the thirteenth and fourteenth centuries.

[62] The Latin translation of Michael the Syncellus's description of Denis's arrival in Paris omits his reference to Paris as 'a small town' but insists on its dedication to the pagan gods, referring to Denis as 'caliginem ydolatrie dissipantem,' and saying that he 'sedentes in tenebris ignorantie ad lumen uocabat scientie & salutis' ('dissipating the fog of idolatry'; 'those sitting in the shadows of ignorance he called to the light of knowledge and salvation'): BnF lat. 2447, fol. 109r; BnF n.a.lat. 1509, pp. 219–20; and see PG 4:659–60 for the Greek.

[63] The compiler of the *Vita et actus* used this work often; note, e.g., the long passage included in the praise of Denis's head which was incorporated into the expanded Life (following a sentence taken from Michael the Syncellus), in BnF lat. 2447, fol. 67r–v (BnF n.a.lat. 1509, pp. 133–35); for the sentence from Michael the Syncellus, see BnF lat. 2447, fol. 112r (BnF n.a.lat. 1509, p. 226), and for the passage from *Sermo gratiarum coronat*, see BnF lat. 5569, fols 12–13v (a tenth-century manuscript from Saint-Remi of Reims). Johannes Cornelis Westerbrink edited the Greek text of the *Sermo*, with facing Latin translation as published by Pierre-François Chifflet in 1676, in *Passio S. Dionysii Areopagitae, Rustici et Eleutherii* (Alphen a.d. Rijn, 1937).

[64] For the Greek text, see Westerbrink, *Passio S. Dionisii*, 45–63, and for the letter of Anastasius that introduces it, PL 129:737–9. I quote the entire passage from BnF lat. 5569, fols 8v–9r, with the portion included in the Life in the *Vita et actus* in boldface: 'Ipse [Dyonisius] uero solus apud parisios et alios crudeliores remansit. qui quidem muti plus erat quam pisces. et irrationabiliores ad diuinae receptionem cognitionis. Furore uero uenenoso ac ira immitia quaeq. omnium bestiarum atq. reptilium ferocium superabant. paruo decentis homines astutie ac Inspectionis Intellectu . Indomitos motus propria manu uariantes. **habebant autem aescarum e terra & fluminibus hi qui per locum illum Inhabitabant multam copiam. & carnis delicias. presentata uero conspectui refectio gulosius exhibet desiderium. & data dulcedo gutturi. Immoderatiorem efficit appetitum. Intra hunc autem laqueum habitatores parisiaci oppidi detenti. Cum refectionem hinc Inuenirent & fluuio post murum obstruerentur. Non Imaginabantur esse nec aestimabant aliud quid gloriosius.**'

[65] In 'Paris and Rhetoric,' 40–41, Serchuk quoted simply the positive parts of the description of Paris in the *Vita et actus*. She did not note that the text was taken from Hilduin's Passion, and although she cited Liebman's ed. of the full passage, she wrote (p. 41) that '[the] moralizing tone [later found in Yves's work] is absent from the earlier versions of the legend of St. Denis that include brief descriptions of Paris.'

arrogance he cited the example of Dives and Lazarus, and reminded his readers of the sad fate Nebuchadnezzar suffered because of his trust in material fortifications. Then, echoing the words of Hilduin (and *Gloriosae*), Yves continued, 'God's servant chose to seek out this place, the source of false and empty boasting, so that by the illumination of his advent and the sowing of divine seed it could be made richer than all other places in spiritual wealth.'[66] The image of Denis as sower recalls Yves's earlier praise of Denis for accepting the simple teachings of Paul, 'receiving it like seed cast on the earth' and then himself 'bringing forth the life- and health-giving fruit of religious faith.' From Paul, Yves said, Denis had learned to reject 'rhetorical embellishments' and 'sophistical artifice' (*rethoricis fugatum allegationibus neque sophysticis artifitiosum propositionibus*), 'earthly power and philosophical glory' (*principatus aut doctrine phylozophice gloria*), 'multiplicity of things and possessions' (*rerum aut possessionum multiplicitas*) and 'bodily pleasure' (*corporalis uoluptas*). These he had cast aside in order to pursue 'the way of salvation (*salutis via*).'[67] Thus Yves set the stage for the inspiring story of Denis's evangelization of Paris that followed.

Yves's fullest comments on Paris and Gaul appear at the end of the second book. After the saints were taken from Paris to their deaths, the scene of action shifted away from the city to the site of their martyrdom and then to their burial at the place to which Denis had transported his head, which would come to be known as Saint-Denis. There, in due course, a wooden church was erected, described by Yves as 'honorable enough,' and containing an *eminens mausoleum* honoring the saints that, he said, still existed.[68] In a short but important chapter

[66] 'Hunc ergo parisij locum dei famulus elegit expetendum. ut eundem quem in predictis cernebat falso [*sic*] & inaniter gloriantem aduentus sui illustratione & diuini seminis erogatione spiritualibus bonis reddere posset pre ceteris diciorem': BnF lat. 5286, fol. 57v; BnF fr. 2091, fols 93r–94v. See also BnF lat. 2447, fol. 52v; BnF n.a.lat. 1509, p. 105; Liebman, p. 165. This section reflects the influence of the encomium of Michael the Syncellus, as translated in BnF lat. 2447, fols 108v and 112v, especially his characterization of Paris as *angusta* and *modica*.

[67] 'Qui tam facile & prompte pauli simplicem suscipiens sermonem viri ydiote & pauperis cuiusdam non rethoricis fugatum allegationibus neque sophysticis artifitiosum propositionibus sed uelut semen quoddam in terra iactum optime recipiens & sensuum profunditati committens tempestiue uitales & salutiferos religiose fidei protulit fructus': BnF lat. 5286, fol. 21v. Yves then quoted a passage from the Syncellus's encomium (included in the *Vita et actus*), which enumerated all that Denis had renounced: BnF lat. 2447, fols 30–v, 87 (BnF n.a.lat. 1509, pp. 60–61, 173–74). In the illustration showing Pope Clement dispatching Denis, the pope tells him 'Ad gallos uade diuinaque semina trade,' and the verses repeat this theme ('Gallis directus summus fit apostolus horum, Ut spe subuectus gerat illis semina morum, Papa clemente dyonisius iste iubente, Adiunctis pariter patribus hijs ad iter') ('Go to Gaul and dispense the divine seed'; 'Dispatched to Gaul, he is made the chief apostle of these people, so that buoyed up by hope he may carry to them seeds of good conduct, this Denis, ordered by Pope Clement, with these fathers also joined to him for the journey'): BnF lat. 5286, fol. 54bis; BnF fr. 2091, fol. 80v.

[68] BnF lat. 5286, fol. 105v; BnF fr. 2092, fol. 71v ('super sanctorum corpora basilicam edificare cepit ligneam pro tempore satis honesta' ['over the bodies of the saints he began to build a wooden basilica, honorable enough for the time']). Hilduin had described the earliest church itself as *eminens mausoleum* (PL 106:49), and this passage was included in the *Vita et actus* (BnF lat. 2447, fol. 72v; BnF n.a.lat. 1509, p. 145; Liebman, p. 182). Yves, in contrast, distinguished between the wooden *basilica* that he identified as the first church and an *eminens*

giving the date of the saints' martyrdom (ch. 127), Yves signaled that he would later present 'a great discourse' on the miracles the saints worked in the basilica where they rested.[69] But for the moment he continued to describe the spread of the saints' renown and the growth of veneration for them. He wrote of the adventures of Sts Sanctinus and Antoninus in carrying word of the saints' martyrdom to Rome, and finally offered a lengthy account of the proofs of the identity of Denis of Paris and Dyonisius the Areopagite.

The penultimate chapter of Yves's second book (ch. 133) consisted of thirty-seven *Laudes* of Denis translated from the Greek, which Yves took from the *Vita et actus*.[70] The final chapter Yves devoted to 'the praise of Gaul, which merited being honored by the patronage and presence of such great martyrs.'[71] This structure departs from that of the *Vita et actus* and follows Michael the Syncellus's encomium.[72] The encomium's penultimate narrative chapter offers

mausoleum which he said was installed in the church later and remained there to his day. See BnF lat. 5286, fol. 106v; BnF fr. 2092, fol. 75r: 'ipsumque locum eminentis mausolei qui et usque hodie perdurare uidetur edificatione signauit in predicta uidelicet basilica quam ut prediximus de lignis edificauit quamque sanctus Regulus in honore sanctorum martyrum consecrauit' ('he marked the place by building a striking mausoleum—which is seen to endure to the present—in this basilica, which, as we said before, he built of wood and which St Regulus consecrated in honor of the holy martyrs'). Yves did not refer to the 'basilicam super beatissimorum martyrum corpora magno sumptu cultuque eximio' ('the basilica over the bodies of the most blessed martyrs, with great expense and noteworthy reverence') which Hilduin in his last chapter (included in the *Vita et actus*) declared was constructed later, evidently because he intended to deal at length in his third book with the church Dagobert was said to have erected there. See n. 77 below.

[69] BnF lat. 5286, fol. 107v; BnF fr. 2092, fol.77r ('Quomodo prefati martyres eos deuote poscentibus salutem impetrant corporum & animarum & de loco et tempore passionis eiusdem'; 'Sed de huiusmodi omni dei auxilio nobis restat in sequentibus grandis sermo' ['How the said martyrs grant health of bodies and souls to those devoutly calling on them, and concerning the place and time of the same passion'; 'But concerning all this, with God's help, there remains a great discourse for us to deliver in the following pages']). After lauding the miracles worked by the saints, Yves ended with Hilduin's termination of his Passion (slightly edited), also found in the *Vita et actus*, BnF lat. 2447, fol. 74r–v; BnF n.a.lat. 1509, p. 148; Liebman, p. 183.

[70] BnF lat. 5286, fols 114r–15v; BnF fr. 2092, fols 89–93 (with a French translation on fols 102v–7r; in BnF lat. 2447, fols 76v–80v (BnF n.a.lat. 1509, pp. 152–60), where they were included between the end of the expanded Life of Denis and the encomium of Michael the Syncellus; they neatly fill the remainder of the quire containing the final portion of the Life, in lat. 2447. Comparison of the texts suggests that the *Laudes* in fr. 2092 were copied directly from lat. 2447. Following his source, Yves identified Denis as *athenarum archiepiscopus* in the rubric preceding the *Laudes*.

[71] 'De laude gallie que tantorum martyrum meruit patrocinio et presentia honorari': BnF lat. 5286, fol. 115v (reading *patrocinijs*); BnF fr. 2092, fol. 93r. In the expanded Life in the *Vita et actus*, the title of the chapter on which Yves drew featured *patrocinia* in the plural rather than the singular: BnF lat. 2447, fol. 73r; BnF n.a.lat. 1509, p. 46.

[72] The amplified Life in the *Vita et actus* contains no separate chapter praising Denis, and in this Life the section lauding Gaul and Paris is inserted into the middle of Hilduin's last chapter, the text of which Yves had used earlier. The story of Sanctinus and Antoninus and the prayer that ends Michael the Syncellus's encomium terminate the expanded Life in the *Vita et actus*. The thirty-seven *Laudes* of Denis follow. See BnF lat. 2447, fols 74v–80v; BnF n.a.lat. 1509, pp. 148–60; Liebman, pp. 183–84 (omitting the prayer of Michael the Syncellus, which appears twice in the *Vita et actus*, first at the end of the expanded Life and again in the encomium itself: BnF lat. 2447, fols 76r–v, 113v–14r; BnF n.a.lat. 1509, pp. 150–52, 230–31).

praise 'of the holiest Areopagite Dyonisius, with admiration for his many virtues'; following the *Vita et actus*, Yves had used most of this chapter earlier, in describing Denis's martyrdom.[73] The last chapter of the encomium presents a 'Commendation of the city of Paris, which merited being consecrated by the martyrdom of such great martyrs.'[74]

Unlike Michael the Syncellus, who focused on Paris, Yves followed the *Vita et actus* in directing his praise first at Gaul—or France. After Gaul, Paris is featured prominently. But the culmination of the chapter is the acclaim Yves reserved for Denis's own temple—his basilica at Saint-Denis, graced with the saint's bodily remains and many other priceless relics.[75]

In crafting this chapter Yves continued to rely on the text of the expanded Life of Denis in the *Vita et actus*. However, as the structure of the end of his second book shows, Yves was also directly influenced by the encomium of Michael the Syncellus. To be sure, Yves found most of Michael the Syncellus's praise of Paris in a chapter at the end of the expanded Life of Denis, in which 'the author offered congratulations to Gaul and especially the city of the Parisians, since it merited obtaining the patronage of such great martyrs.'[76] The compiler of the Life in the *Vita et actus* inserted this chapter between the first and last halves of Hilduin's final chapter, the first section dealing with the fine church that was eventually erected to shelter the martyrs' bodies and the miracles that occurred there, and the end giving the date of the martyrs' death.[77]

73 'Preconium sanctissimi ariopagite dyonisij cum admiratione ex diuersis eius uirtutibus': BnF lat. 2447, fols 111v–12v; BnF n.a.lat. 1509, pp. 225– 27. In the *Vita et actus*, much of this section was used in chapters on Denis's head and the elevation of the martyrs' souls to heaven, BnF lat. 2447, fols 67r, 68v–69r (BnF n.a.lat. 1509, pp. 134, 137). Yves employed the passages in his corresponding chapters, ch. 113/4, describing the angels transport of the martyrs' souls (BnF lat. 5286, fol. 96v; BnF fr. 2092, fol. 48v), and ch. 114/5, on the cephalophora (BnF lat. 5286, fol. 97v–98; BnF fr. 2092, fols 50r–52r), in which Yves also incorporated a portion of *Sermo gratiarum coronat* used in the *Vita et actus* (BnF, lat. 5569, fol. 12–v), as well as a new section (which the exhortation 'Ecce fratres' suggests he may have taken from a sermon).

74 'Commendatio parisiorum ciuitatis que tantorum martyrum meruit martyrio consecrari': BnF lat. 2447, fols 112v–13v (BnF n.a.lat. 1509, pp. 225–30). These two chapters precede the author's prayer to Denis 'for the state and peace of the universal church' ('finito tractatu orationem facit auctor ad ieromystam & ieromartyrem dyonisium pro statu & pace uniursalis ecclesie'): BnF lat. 2447, fols 113v–14r; BnF n.a.lat. 1509, pp. 227–32.

75 In her discussion of this passage, Logemann, 'Heilsräume-Lebensräume,' 75–76, focussed on Paris rather than on Gaul or Saint-Denis. She usefully emphasized the contrast between the material walls depicted in the illustrations in Yves's work and the spiritual fortification provided through Denis's martyrdom. Logemann edited the chapter from the presentation copy of the manuscript (89–91); in many instances her readings differ from mine.

76 'Congratulatur auctor gallie & maxime parisiorum ciuitati. quia tantorum patrocinia martyrum meruit optinere': BnF lat. 2447, fols 72v–73 (BnF n.a.lat. 1509, pp. 146–48).

77 PL 106:49–50. In the *Vita et actus*, these sections became separate chapters ('De ecclesia que longo tempore post super corpora sanctorum edificata est. & de miraculis ibidem perpetratis'; 'De tempore passionis sanctorum martyrum & de morte impiissimi domitiani' ['Concerning the church that was built over the bodies of the saints a long time afterwards'; 'Concerning the time of the passion of the holy martyrs and concerning the death of the most impious Domitian']): BnF lat. 2447, fols 72v–73r, 74r–v; BnF n.a.lat. 1509, pp. 145–46. Liebman

In the *Vita et actus*, the chapter congratulating Gaul and Paris commences with a passage drawn from a sermon written in praise of Denis, which was substituted for the initial statements of Michael the Syncellus. Thus the chapter commences:

O how happy are you, O Gaul, who merited receiving such great and such [outstanding] priests. Happy are you, O Paris, whose fields merited being watered by the blood of such great martyrs. Lo, you are strengthened by the glory of the three martyrs. Lo, in gleaming ranks their blessed glory has surrounded you and has crowned you with honor, as if with a diadem fashioned of a multitude of gems.[78]

The bulk of Michael the Syncellus's chapter follows. Addressed to Denis, it enumerates the reasons for Paris's blessedness, and deserves being presented in full:

Truly happy city of the Parisians, which although among the other towns of the Gauls it may seem constricted and modest, because of the treasure more precious than all material wealth that it has gained in you, O most outstanding of doctors, is rightly praised as more splendid and blessed than all others. For you are given to the city for sanctification, sanctifying the assemblage of citizens and of the crowds of foreigners flocking in, all loving Christ, and for the whole country you have become the summit of spiritual riches, bringing forth abundance and happiness, not that which increases bodily constrictions and which for a time sweetens the gullet and the palate and then perishes and is corrupted, as is that which earth and sea bring forth, and the river, copious in its variety of fish, which fortifies and surrounds the city like walls, and furnishes the inhabitants with many sorts of conveniences and delights. Rather, you minister fullness without aversion, and immutable happiness which fears no defect, to its citizens and to those who dwell nearby, nay rather to the faithful and devout people coming together from all sides. That city also, O most blessed [Denis], trusts in and is defended not by walls and towers and battlements, but rather by its foundation in your and your co-athletes' sanctity, as in stones that are precious and living and cut and squared, and is girded and protected by your intercessions, most acceptable to God, which can easily bring down fire from heaven to consume squadrons and battalions and generals with their troops and barbaric trappings. A life-giving port has been established in you [Denis], safest of all, weathering and repelling the onslaught of the storms of this world, and preserving and saving those taking refuge in it from every tempest of this life. And in your temple has been set a most holy paradise of delights like the one in Eden, providing refreshment of every sort to the faithful through singular

edited these chapters (pp. 182–83), with ellipses indicating his omission of the Syncellus's praise of Gaul and Paris, which would have been section 76 according to his numeration of the divisions of the expanded Life in the *Vita et actus*. See above, nn. 68–69, for Yves's treatment of the material Hilduin presented in his final chapter.

78 'O quam felix es gallia. que tantos ac tales meruisti suscipere sacerdotes. Felix es parisius. cuius glebe meruerunt tantorum martyrum cruore rigari. Ecce trium martyrum gloria polles. ecce rutilantibus agminibus eorum te beata gloria ambiuit; & quasi ex multarum honore gemmarum conserto diademate coronauit': BnF lat. 2447, fol. 73r; BnF n.a.lat. 1509, p. 146. For the source, a sermon that includes a translation of the famous letter of Aristarchus concerning Denis, see BnF, lat. 11753, fol. 251, a twelfth-century lectionary that belonged to Saint-Germain-des-Prés; the sermon reads *beata premia* rather than *beata gloria*, and the following verbs are changed accordingly.

grace; where an immense table full of food has been set for those needing sustenance, renewing the soul, making the mind drunk with spiritual drink, and offering toasts to the uncorrupted life.[79]

Thus, in his encomium of Paris, Michael the Syncellus focuses squarely on Denis. He acknowledges Paris's relative smallness but emphasizes its spiritual wealth, the gift of St Denis. He contrasts these enduring spiritual riches with evanescent material abundance. He insists on the protection afforded to the city by the holiness of Denis and his companions, and then goes on (rather paradoxically) to point out the material benefits that heavenly intercessors can supply. In the end, however, he returns to the spiritual, equating Denis's temple with the first paradise east of Eden, and describing this temple as the constant source of spiritual nourishment for all in need.

Here, in his discourse, Michael the Syncellus introduced the notion of Paradise, the Garden of Eden, the *paradisus voluptatis* that God planted in the beginning (Gen. 2:8) in a context suggesting its relevance to Paris. In his encomium, however, it is not Paris, but rather Denis's sanctuary that he calls the site of a *paradisus deliciarum*, and the delights this Paradise provides to the faithful are spiritual, not material. Michael the Syncellus was, of course, Greek, not French, and he doubtless did not distinguish between the site of Denis's temple and Paris, as would all have done who lived in France. Michael did not mention Saint-Denis or *Catuliacum* or *vicus Catulacensis* or indicate that he knew Denis's temple lay some distance from Paris. He may indeed have invoked Paradise because of the word's similarity to 'Paris.' The play on Paris/Paradise was in any case a familiar conceit in the ninth century—and a double-edged one. In the hands of Abbot Hilduin, it redounded to the city's detriment, not

79 'Felix inquam parisiorum ciuitas. que licet inter quasdam galliarum urbes angusta uideatur & modica; propter thesaurum tamen omnibus materialibus preciosiorem opibus quem in te sortita est o doctorum prestantissime. splendidior iure predicatur & omnibus uere beatior. Pro sanctificatione enim illi datus es. tam ciuium uidelicet quam confluentium aduenarum cetum sanctificans christum dumtaxat diligentium; & opum spiritalium cumulus patrie toti factus es; abundantiam pariens et iocunditatem. non illam que corporales auget angustias. & ad modicum fauces & palatum indulcat deinde perit & corrumpitur; ut est illa quam tellus et mare proferunt. & fluuius piscium uarietate copiosus. qui murorum instar oppidum munit et circuit; & habitatoribus multa prestat commodorum & deliciarum genera. Saturitatem quin potius absque fastidio. & iocunditatem immutabilem. et que defectum non metuit ministras ciuibus & circumiacentibus accolis; immo undecumque concurrentibus populis fidelibus & deuotis. Ciuitas quoque ipsa o beatissime non tam muris ac turribus aut propugnaculis confidit & munita est; quam quod in tua tuorumque coathletarum fundata est sanctitate. uelut in lapidibus preciosis & uiuis & sectis & quadris. uestrisque apud deum acceptissimis uallata & circumsepta [*sic*] interuentionibus; que facile possunt ignem de celo deponere. ad quinquagenarios & centuriones seu chiliarchos cum sua milicia & barbarico apparatu concremandos. Portus etiam salutaris in te constitutus est omnum tutissimus. Procellarum mundi huius sustinens impetus & repellens; atque ab omni uite presentis turbine ad se confugientes conseruans et saluans. In templo autem tuo sacratissimo paradysus quidam deliciarum uelud in eden est consitus. omnimodum fidelibus per singularem graciam prestans refrigerium; ubi spiritalibus plena dapibus mensa largissima proposita est sumere cupientibus. animas reficiens. & potu spiritali mentes inebrians; & uitam propinans incorruptam': BnF lat. 2447, fols 73r–74r (BnF n.a.lat. 1509, pp. 146–48); cf. for Michael the Syncellus's encomium, BnF lat. 2447, fols 112v–13v (BnF n.a.lat. 1509, pp. 112–3).

its credit. Writing to Louis the Pious about the Passion of Denis he was sending him, Hilduin declared that all he recorded had been taken 'from the ancient writings of the ancients, as from a meadow not Parisian but paradisaical.'[80] Here Hilduin drew a sharp contrast between Paris and Paradise, linking the former with the unreliability of earthly things and the latter with the dependability and incorruptibility of the celestial.

In fashioning his own praise of Gaul, Yves commenced with the initial sentence of Michael the Syncellus's commendation of Paris, which was omitted from the expanded Life in the *Vita et actus*. Here Michael, addressing Denis, called down a blessing on the city that had received the saint and his companions and that sheltered their relics, the source of healing for the sick.[81] Substituting 'the fatherland Gaul' for 'the city,' Yves could thus begin his tribute by emphasizing the continued presence of the saints in France and the miracles their relics worked, the subject he had promised to develop when, in an earlier chapter, he had lauded the miracles worked by the relics their basilica housed.[82]

Yves next included the first of the exclamations addressing and exalting Gaul with which the author of the Life in the *Vita et actus* had begun his congratulatory chapter. Yves then added a new section, his own work, proclaiming Gaul's blessedness in having been turned from error by Denis, and in having been protected by him as a hen protects its chickens—an exceedingly common and popular metaphor in fourteenth-century Paris.[83] Thanks to Denis, Yves declared, 'you [o Gaul] have always been mother [or nourisher] [*matrix, nutrix*] and also defender of the faith.' Here Yves stressed themes dear to Michael the Syncellus. His designation of Gaul as mother/ nourisher and defender of the faith echoed terms Michael and also Hilduin had applied to Athens as patron of secular knowledge.[84]

[80] 'praesertim cum haec, quae scribimus, de Antiquariorum antiqua scriptura sint, velut ex prato non Parisaco, sed Paradisiaco': PL 106:20.

[81] BnF lat. 2447, fol. 112–v; BnF n.a.lat. 1509, pp. 227–28 ('Unde tandem o dei predicatorum & pontificum apex & martyrum omnium acceptissime illam decet ciuitatem beatificare. que te tocius gallie caput inclitum a deo coronatum & pretiosas reliquias tuas tuorumque consortum lipsana sorte suscipit hospicio. uelut sacrificia immaculata; & tymiama boni odoris domino. Que uelut palmis uictricibus ita uestris ornata est sacris sanguinibus & cineribus. ex quibus sanitates manat his qui ad uestra confugiunt patrocinia; & dolorum & languorum expetunt medicinam').

[82] See above, n. 69.

[83] Cf. the extended comparison of Philip V of France to a cock guarding his chickens, in the contemporary poem, *Un songe*, ascribed to Geffroi de Paris, found in BnF fr. 146, following the *liuvres de Fauvel*, edited in *Six Historical Poems of Geffroi de Paris Written in 1314–1318, Published in their Entirety for the first time from MS fr. 146 of the Bibliothèque Nationale, Paris*, ed. and trans. Walter H. Storer and Charles A. Rochedieu, University of North Carolina Studies in the Romance Languages and Literatures, 16 (Chapel Hill, 1950), pp. 70 and 72. I discussed this passage and others in *Fauvel* using the same imagery, in 'Rex ioians,' in *Fauvel Studies*, pp. 67–69.

[84] For Hilduin, PL 106:25 ('fandi et eloquentiF nutrix, philosophorum et sapientium genitrix, artium liberalium et divitiarum omnium copia præ urbibus cunctis emicuit'); in the *Vita et actus*'s expanded Life, BnF lat. 2447, fol. 24r; BnF n.a.lat. 1509, p. 48. For Michael the Syncellus, see BnF lat. 2447, fol. 84r; BnF n.a.lat. 1509, p. 167, a passage included in the

Shifting from Gaul to Paris, Yves inserted the remaining two exclamations used at the commencement of the chapter in the *Vita et actus*, which declared Paris's good fortune in having its soil watered by the blood of the three martyrs and in being crowned by their glory. Then Yves introduced a long section that he himself composed.

Yves began by playing on the etymology of Paris's original name, Lutetia, and its derivation from the word for 'dirt.' He first expressed his joy at the city's escape 'from the filth of foulness.' Then, following Michael the Syncellus, he likened its release by Denis to Moses' deliverance of the people of Israel from their servitude 'in mud and brick' in Egypt.[85] Changing tack, he lauded Paris's establishment as a center for the diffusion of knowledge divine and human. Here, doubtless inspired by Michael the Syncellus, Yves compared Paris to 'the earthly Paradise planted by God in the beginning of the world, from which a river flows forth into four heads'—clearly the Paradise of pleasure or the Garden of Eden, although Yves termed it simply *paradisus* and not *paradisus uoluptatis*. Similarly, Yves continued, at the beginning of the Gallican church, Denis, like a gardener, rooted out all the evil weeds of heresy and error from Paris, and thus allowed a river to pour forth 'as if from a place of all spiritual pleasure—*spiritualis uoluptatis*—to the four climates of the world,' spreading health-giving wisdom, faith, truth, and theology. Yves likened Denis to the emperor Augustus, who had found Rome brick and left it marble,[86] noting that Denis's accomplishment was to have brought Paris increase 'in bonis omnibus,' endowing it not only with marble but also with mines of gold and silver—that is, Yves explained, divine and human knowledge, for all to discover there.

expanded Life, BnF lat. 2447, fols 23v–24r (BnF n.a.lat. 1509, pp. 47–48) ('Aut quis athenas ignorauerit elladis gloriam. urbem artium inuentione & propagatione inclitam. philosophorum specialiter fertilem. disceptandi & agendi locum. controuersiarum terminum & declamatorum gymnasium?'). Michael the Syncellus had earlier described Athens as 'patria militie insignis gloria. facundie & literarum [*sic*] alumpna. agrorum fertilitate. montibus & uallibus undique munita. omnigenis arboribus & uirgultis consita. marinis portibus circumclusa. fluminibus & fontibus stagnisque circumflua. spatio & specie decorata,' a passage that was not included in the *Vita et actus*'s elaborated Life (BnF lat. 2447, fol. 83v; BnF n.a.lat. 1509, pp. 166–67). The expanded Life of Denis in the *Vita et actus*, rather, passed from the statement of Michael ('Aut quis gymnasium') to the description of Athens in Hilduin's Passion (PL 106:25; 'Quæ una urbium magnarum metropolis ... præ urbibus cunctis emicuit'). Later, recounting Paul's arrival in Athens, Michael portrayed the city as 'urbem ipsam pre ceteris grecie ciuitatibus cernens mancipatam ydolis & uariis deorum culturis' (BnF lat. 2447, fol. 86r; BnF n.a.lat. 1509, p. 171).

[85] In his encomium, Michael the Syncellus declared (BnF lat. 2447, fol. 93r; BnF n.a.l. 1509, p. 187): 'Nam & iste alius quidam proculdubio demonstratus est moyses; qui egyptum tenebrosum dico ydolatrie errorem non solum decem plagis sed decem milibus acutissimis & ignitis sacrorum dogmatum sententijs transfigens ut spiculis; atque intelligibilem pharaonem cum perituris exercitibus id est superseminatis a demonica seductione heresum zizanijs.....' Note also the passage in which Michael the Syncellus compared Denis to Joshua (BnF lat. 2447, fols 93v–94r; BnF n.a.lat. 1509, pp. 187–88; cf. Joshua 10:12–14): 'uelut ille qui solem stare fecit & lunam in adiutorium populi preliantis. terram promissionis ad delendos hostes ingressuri; & possessionem sibi repromissam sorte accepturi.'

[86] Suetonius, *Divus Augustus* 28.3.

Continuing, Yves reverted to the first section of the encomium of Michael the Syncellus that was incorporated into the expanded Life in the *Vita et actus*. He cited it virtually verbatim, although he identified the *thesaurus* with which Paris was blessed (which Michael did not describe) —as 'a treasure of Catholic faith and wisdom.' This led him to compare Paris and Athens, and declare Paris the mother of wisdom, promoter of the liberal and philosophical arts, and of Catholic truth, and thus inspirer not only of France but also of all Christianity. Thus Yves asserted Paris's preeminence as a center of learning, a theme he developed at length in his third book (and one that is absent from Michael the Syncellus's encomium).[87]

[87] Discussing the notion of *translatio studii*, Logemann (p. 61) mentioned the development of the idea in the work of Guillaume de Nangis († ca. 1303), monk and historian of Saint-Denis, on whose work Yves relied and whom he had probably known. Guillaume de Nangis discussed this idea not only in his Life of Saint Louis but also in his Universal Chronicle: *Chronique latine de Guillaume de Nangis de 1113 à 1300, avec les continuations de cette chronique de 1300 à 1368*, ed. Hercule Géraud, 2 vols, Publications de la Société de l'Histoire de France 33, 35 (Paris, 1843), 1:182. Logemann did not comment on the fact that Yves himself devoted much attention to the subject and to France's intellectual preeminence in his third book. Discussing Charlemagne, he demonstrated 'by many authors and examples that it is fitting for a king to be lettered' and to possess wisdom and learning (BnF lat. 13836, fols 24v–26r; BnF lat. 5286, fols 173r–74r; Berlin MS lat. fols 53 and 35). He then showed in the next chapter that Charlemagne 'was learned in letters' (BnF lat. 13836, fols 26v–28v, with the chapter division occurring later in both BnF at. 5286, fol. 174r–v, and Berlin MS lat. fols 53 and 36r–v). Finally, and most important for the notion of *translatio studii*, Yves devoted the ensuing chapter to the question 'Quomodo temporibus karoli quamplurimum est augmentatum in francia studium litterarum et quomodo per sanctum dyonisium francie regnum in fide scientia et milicia regna cetera antecellit' (BnF lat. 13836, fols 28v–31r; BnF lat. 5286, fols 174v–75r; Berlin MS lat. fol. 53, fols 36–37v [with *antecessit*]). According to Yves, in Charlemagne's time 'the study of letters had fallen into oblivion,' and thus it was the emperor who revived the study of letters, and translated it from Rome to Paris (as before the Romans had translated it from Greece). Then, abruptly, Yves turned to Saint Denis, noting Denis's reputation for learning in Greece, and implying that he—not Charlemagne—had brought this (as well as military virtue and faith) to France. Without pursuing Charlemagne's role in the revival of learning, Yves passed in the following chapter to the topic 'Quomodo fides sapientia militia per signum regis francie scilicet per lilium designantur' (BnF lat. 13836, fol. 31r–v; BnF lat. 5286, fol. 175r–v; Berlin MS lat. fol. 53, fols 37v–38r). Again he credited Denis with endowing France with these strengths, represented by the fleur de lis, before returning in the next chapter to Charlemagne's military exploits and his gift of relics to Saint-Denis. He reverted to the theme of the *translatio studii* in treating the reign of Saint Louis, in a chapter entitled 'De eius litteratura & de eius zelo & assiduitate circa studium litterarum' (BnF lat. 13836, fols 100r–101r; BnF lat. 5286, fol. 204r–v; Berlin MS lat. fol. 53, fols 68v–69r; ed. in HF, 20:45–57 [47]). Here he credited Louis, not Denis, with preserving the *thesaurum sciencie* in Paris because of his realization that *sapiencie studium* was one of the three leaves of the fleur de lis and that the flower would be 'non mediocriter deturpatum' should that study be lost. In treating these subjects, Yves may have drawn on a tract written by Thomas of Ireland, fellow of the Sorbonne, entitled *De tribus sensibus sacre scripture*, which Yves seems to have cited for the verses on the fleur de lis it included (BnF lat. 13836, fol. 31r–v; BnF lat. 5286, fol. 175v; Berlin MS lat. fols 53 and 37v), and which treated the same themes: I hope to study the relationship of the tract and Yves's work in a future publication. For the moment, on Thomas and the tract, see Bernard Hauréau, 'Thomas d'Irlande, théologien,' in *HLF* 30, part 2 (1888), pp. 398–408 (404–6); and, for Thomas's life, Richard H. Rouse and Mary A. Rouse, *Preachers, Florilegia and Sermons: Studies on the* Manipulus florum *of Thomas of Ireland*, Studies and Texts 47 (Toronto: Pontifical Institute of Mediaeval Studies, 1979), pp. 93–112. Yves's use of the tract suggests that it was in circulation in 1316 or early 1317.

Yves then included the remainder of Michael the Syncellus's commendation, inserting '& tota ipsa gallia' to emphasize that Gaul, as well as Paris, was founded on and protected by the sanctity of the saint and his companion. In repeating the words of Michael the Syncellus, Yves again emphasized the importance of spiritual delights over earthly riches. Still, by emphasizing Paris's importance as a center of learning and attributing its eminence to Denis, Yves suggested that the advantages Denis brought to France were not exclusively spiritual. Later, in his third book, he affirmed this position.

The final sentence of Michael the Syncellus's chapter, devoted to Denis's 'most holy temple,' gave Yves an opportunity to expatiate on Saint-Denis and to shift his focus yet again. Having treated Gaul and then Paris, he finally turned to his own abbey, Denis's church, Saint-Denis. Following Michael the Syncellus, Yves declared that in this basilica, at Saint-Denis, a Paradise of delights like the Garden of Eden flourished because of the spiritual refreshment the church offered to the faithful. Yves commenced his own elaboration of Michael the Syncellus's statement by declaring that he would have much more to say about Denis's temple later on. Yves concluded the chapter by insisting on and explaining the justice of terming Denis's church Paradise. In the basilica, Yves said, Denis himself is surrounded by a plethora of relics—of martyrs, confessors, virgins, and also the Lord himself. There Denis stands, like the tree of life in the middle of the first Paradise, ministering long life to those seeking his intercession. Denis was indeed more beneficent than the original tree of life, since after the fall the approach to that tree had been completely blocked by a fiery sword.[88] In contrast, surrounded in his church by the relics of a host of saints, Denis was a munificent and generous mediator for all, 'just and unjust, saints and sinners.' Yves ended by addressing Denis as 'most benign' and declared him 'the true imitator, disciple, and herald of the most benign Jesus, who descended into the world to seek out sinners, and who is forever blessed.'

[88] Yves was here paraphrasing Gen. 3:24, 'et collocauit ante paradisum voluptatis cherubim, et flammeum gladium, atque versatilem, ad custodiendam viam ligne vite.' In an earlier chapter, describing Denis's prayer to Christ while he was suffering in a fiery furnace, Yves said Denis addressed Christ as you 'qui rumpheam ignitam in custodiam paradysi cruoris tui latice fidelibus tuis ad uiam prebens transitum extinxisti' ('who extinguished the fiery sword guarding Paradise with the liquid of your blood and thus furnished your faithful passage to the way [of the tree of life]'): BnF lat. 5286, fol. 87v; BnF fr. 2092, fol. 26r–v. The word *rumphea* derives from the Greek *rhomphaea*, a long Thracian spear. In a still earlier chapter praising the profundity of Denis's ideas and writings, Yves had hailed Denis as 'tree of life to all who have grasped his teachings' ('O magistri huius lingua placabilis lignumque uite cunctis qui eius apprehenderint documenta'): BnF lat. 5286, fol. 47v; BnF fr. 2091, fol. 40v. In his chapter on the three saints' simultaneous execution, Yves quoted Michael the Syncellus's commendation of Denis's companions' devotion to him, 'pro quo omnem tam corporis quam anime didicerant abstinentiam. ut eo solo **qui reuera uite lignum est** alerentur': BnF lat. 5286, fol. 95v; BnF fr. 2092, fol. 44v; the passage was included in the expanded Life in the *Vita et actus*, BnF lat. 2447, fol. 65r; BnF n.a.lat. 1509, p. 130; and for the encomium, BnF lat. 2447, fol. 111r–v; BnF n.a.lat. 1509, p. 224. In the first book, Yves had quoted Simeon Metaphrastes's description of Jesus as 'in ligno vite dator et iudex': BnF lat. 5286, fol. 12v; BnF fr. 2090, fol. 42r; I am grateful to Pierre Gandil for providing me with this reference (and identifying its source, for which see Gandil, 'Les études grecques à l'abbaye de Saint-Denis au XIIᵉ siècle,' 4:591–92).

Thus Yves confirmed the vision of Carpus (reported in one of the writings attributed to the Areopagite and recounted in full by Yves), to whom 'benign Jesus' declared his willingness to come again and suffer in order to redeem all sinners.[89]

In the third and final book of his *Vita et miracula sancti Dyonisij*, Yves amply fulfilled the promise he made toward the end of his second book to present a 'great discourse' (*grandis sermo*) on the miracles worked by Saint Denis and his companions. Having designated Denis's church as Paradise, Yves proceeded in his third book to relate:

the signs and miracles through which omnipotent God has declared to all the faithful, far and wide, the merits of this martyr, his most invincible champion, and the greatness of the virtue and power he exercises before omnipotent God in supporting those devoted to him and in punishing those who injure and attack him.[90]

Yves wrote these words in the preface to the third book, where he presented the themes that would inform the remainder of his work.

The most wondrous of the miracles Denis had performed for the kings and people of France, Yves proclaimed, was to make them—once the most pagan of all nations—most Christian, well-provided 'with abundant tokens of earthly and celestial riches,' and 'committed and strong defenders of the Christian faith, and in war most victorious champions of their patron Denis, who always protects them with that power with which he shines before God.'[91] Yves laid special stress on the aid Denis gave the French in battle, and he described the visits kings made to Denis's church before going to war, to lift from the altar the relics of the three martyrs (and, he added, 'in our own days, the most

89 Michael the Syncellus's encomium ended with a prayer invoking Jesus Christ, God the Father, and 'sanctissimo benignoque ac uiuifico eius spiritu': BnF lat. 2447, fol. 114r; BnF n.a.lat. 1509, p. 231; see above n. 72, for the prayer's inclusion at the end of the expanded Life in the *Vita et actus*. The word *benignus* was particularly powerful because of its association with Jesus in the description of the vision of Carpus in a letter attributed to Dyonisius. I discuss Carpus and his vision in a paper entitled 'The Prospect of Salvation at Twelfth-Century Saint-Denis: Saint Denis, Saint Carpus, Benign Jesus, and Abbot Suger' which I presented at a conference on Saint-Denis at the Index of Christian Art in Princeton on October 25, 2003, and which will appear in a volume of essays on Saint-Denis edited by Grover Zinn.

90 'signa & miracula per que deus omnipotens longe lateque prefati martyris agoniste sui inuictissimi merita quanteque uirtutis et potestatis apud deum omnipotentem in reuelandis sibi deuotis iniuriosisque sibi [et] rebellibus puniendis existat cunctis fidelibus declarauit / & si non omnia quorum non est numerus pauca tamen ex innumeris eiusdem confisi precibus accedentes': BnF lat. 5286, fol. 117r; Berlin MS lat. fol. 53, fol. 1r; ed. in Delisle, 'Notice,' 264 (from the Paris MS); and, less carefully, in Ernest Renan, 'Missions en Italie,' *Archives des missions scientifiques et littéraires, choix de rapports et instructions publié sous les auspices du Ministère de l'Instruction publique et des Cultes* 1 (1850), 429–34 (432) (from the Berlin MS).

91 'interque facta per eum mirabilia mirabilius existit quod francorum reges & populi pre ceteris olim nationibus gentilitatis erroribus ardentius astricti. per eum facti sunt christianissimi amplioribusque diuitiarum terrenarum & celestium honorum que tytulis dilatati sed quod maius est fidei christiane assidui defensores et strenui. In rebus que bellicis pugnatores uictoriosissimi eiusdem patroni sui dyonisij protegente eos in omnibus ea qua apud deum precellit potencia': BnF lat. 5286, fol. 117r; Berlin MS lat. fol. 53, fol. 1r; Delisle, 'Notice,' 264; Renan, 'Missions,' 433.

blessed Louis') and receive there the 'most sacred banner' of the Franks 'in hopes that by the suffrages of the saints they will be able to crush their enemies' haughtiness and conquer them.' 'Ancient authors,' Yves claimed, reported that those who attacked the kingdom or the church and caused the relics to be lifted from the altar would perish within the year. It was therefore fitting, Yves declared, for 'the kings and peoples of the Franks to entrust themselves to those powerful enough to permit them to triumph over their enemies'[92]—in short, to St Denis and his companions, their special patrons.

Addressing the 'royal serenity' to whom his volume was offered, Yves informed him that the third book would show 'the beginnings of [the royal serenity's] origin, and to what great increase of temporal and spiritual goods, and dignities and honors [that serenity] had been advanced by its patron'— Saint Denis. Yves added that he also intended to describe when and from whom the abbey had received its 'priceless treasure of diverse relics,' those relics that, surrounding those of the three martyrs, made the abbey church a Paradise, and the source of wondrous miracles. He did so, he declared, since 'this pertains to the glory and honor of the blessed Denis.'[93]

The introduction to the third book thus made clear Yves's conviction that Denis was for France the well-spring of benefits earthly as well as heavenly, material as well as spiritual—and most important of all, victory over all the kingdom's enemies. The preface and the contents of the third book thus provide some warrant for viewing the images of Paris in the second book as evidence of the material benefits Denis and his companions have brought to their devotees, descendents of the saints' first converts. But Paris as Paradise is another matter.

Paris and Paradise

In Yves's eyes, it was Denis's church that represented and in a sense was the Paradise that God had planted at the beginning of time. He likened Paris to Paradise because of the rivers of wisdom that emanated from it, but Yves never

92 'desuperque eiusdem dyonisij altare sacratissimum de pastoris eiusdem loci manibus commune tocius francorum exercitus uexillum accipiant benedictum sperantes per sanctorum suffragia predictorum & hostium superbiam deprimere ac de ipsis uictoriam obtinere … Antiquorum enim ueridicam legimus sentenciam neminem nobilem aut ignobilem regni aut ecclesie turbatorem cuius causa aut controuersia sanctorum corpora subleuentur anni fore superstitem sed interea uel infra deperire. Illis ergo reges francorum et populos tota se conuenit deuotione committere qui dare ualent eis de hostibus triumphare': BnF lat. 5286, fol. 117v; Berlin MS lat. fol. 53, fol. 1r (reading *culpa* in place of *causa*, and *ita* for *interea*); Delisle, 'Notice,' 264–65; Renan, 'Archives,' 433.

93 'Sic enim in hoc libello regalis serenitas cui ob amorem patroni specialis sui dyonisij liber ipse legendus porrigitur contemplari poterit & uidere sue originis initia ad quantaque temporalium ac spiritualium bonorum dignitatum[que] honorum per eundem patronum suum prouecta fueri[n]t incrementa. Sed & impreciabiles diuersarum reliquiarum thesauri quando & a quibus ad uenerabile beati dyonisij monasterium sint translati declarare intendimus. Hoc enim ad beati dyonisij gloriam pertinet & honorem': BnF lat. 5286, fol. 117v; Berlin MS lat. fol. 53, fol. 1r–v; Delisle, 'Notice,' 265; Renan, 'Archives,' 433–46.

equated the city, whatever its material riches and blessings, with Paradise itself.

Others' perceptions were different. An anonymous tract written in 1323 contains statements that resemble but are far more effusive, exuberant, and grandiose than Yves's praise of Paris. If the author had not read Yves's work, he surely knew Yves's sources, although he never attributed Paris's advantages to the influence of Saint Denis. Without restriction or hesitation the tract's author likened the city to Paradise, and the wisdom that flowed forth from it to the rivers issuing from Paradise. Using the metaphor Yves had taken from Michael the Syncellus, he described these streams as 'intoxicating' (*inebriare*) the whole world of Christ's faithful, as well as 'making it fruitful' (*fecundare*). Generous in distributing the epithet, he associated the Church universal with Paradise and said that 'the health-giving knowledge' pouring forth from Paris watered and fertilized it as well.[94] A simple change of letters, he remarked, would turn Paris into Paradise, and this, he said, should be accomplished, since 'not in actuality but only in name' did the two differ.[95]

Jean of Jandun took offense at this writer's hyperbolic equation of Paris and Paradise (and at his attack on Senlis, where Jean was then living). Hence Jean responded with a far more concrete and detailed account of the merits of Paris (and of Senlis), which he completed on November 4, 1323. Jean began by expatiating on Paris's merit as a center of learning, and lauding its University. He applauded its citizens' other activities and labors, in effect providing a useful guide to the many occupations depicted in the bas-de-page illustrations in the *Vita et miracula sancti Dyonisij*. As to Paradise, Jean used the word sparingly. Entering the glass-filled Sainte-Chapelle could make people think, he said, that they were in 'one of the most splendid chambers of Paradise.'[96] Again, the Paris basin was so fertile that 'the Almighty seems to have granted it the privilege of playing the role of an earthly Paradise.'[97] And finally, linking Paradise and Senlis, he declared that that city—not Paris—'seemed to represent the beauty of the heavenly fatherland and the felicity of the joy of Paradise.'[98] Thus, in his

94 'hec est illa nutrix collegii tam celebris et famosi, quod, velud alterum voluptatis castissime Paradisum, sacris plantariis consitum, agrum plenum, cui benedixit Altissimus, procul dubio dextera Domini coluit et plantavit. Ad quem quidem amenitatis locum plenius irrigandum, a fonte sapientie in excelsis habundanter aque vive confluunt; et in loco confluentie efficiunt mare magnum, a quo velud per diversos alveos flumina scientie salutaris ad omnia mundi climata derivantur, universamque terram Christi fidelium inebriant et fecundant ... quasi fluvio de loco deliciarum egresso, non solum regnum predictum irrigatur et fecundatur, per Spiritus Sancti gratiam, verum et Paradisus Ecclesie generalis, cujus alveus illa civitas, ymo civitatum mater et domina antedicta, ex eo quod generale studium ibidem viguit, hactenus noscitur extitisse,' Le Roux de Lincy, *Paris et ses historiens*, 24.

95 Le Roux de Lincy, *Paris et ses historiens*, 26 ('cum non re, sed solum nomine a Paradiso discrepes').

96 Le Roux de Lincy, *Paris et ses historiens*, 46 ('quasi raptus ad celum, se non immerito unam de Paradisi potissimis cameris putet intrare').

97 Le Roux de Lincy, *Paris et ses historiens*, 56 ('illud fecundissimum declivum Parisius, cui ab Excelso concessum fuisse videtur terreni vices gerere Paradisi').

98 'universa genera bonorum, que Deus, natura et ars pro humanis usibus et commoditatibus produxerunt, exhilarant, per Dei gratiam, Silvanectum; in tantum quod celestis patrie

work he invoked Paradise only three times. His comparisons were guarded, and he did not elaborate them. He praised Paris as 'most fertile parent,' 'town of towns,' 'most lofty,' and 'surpassing all other towns.'[99] But he never described Paris as Paradise, and he denounced as 'excessive praise' and 'adulation' (*nimia laudatio, adulatio*) the anonymous author's commendation.[100]

Like Jean of Jandun and his anonymous instigator, Yves celebrated Paris for features that were distinctly material and earthbound, far removed from the heavenly and truly paradisaical. He also held out the promise that St Denis would bring France and Paris even greater prosperity and renown than they currently enjoyed.

As a man of God and monk of Saint-Denis, Yves found himself caught between conflicting and contradictory values. As cleric, Yves affirmed and surely believed that the saint's preeminent gifts to France were spiritual, and, with Michael the Syncellus, he praised Denis for rejecting the philosophies of Athens and clinging to the simple teachings of Paul. Similarly, Yves decried the deceptive evanescence of earthly riches and the pride they engendered. His denunciations were doubtless heartfelt and sincere. On the other hand, Yves was devoted to his abbey, his abbey's well-being, and the pursuit of learning that flourished at Saint-Denis and in Paris. He appreciated the renown the writings attributed to Dyonisius the Areopagite had gained for Saint Denis and for the abbey. He prized the fame Paris enjoyed as a center of learning, and also the victories and renown of the kings of France. He valued as well the material support the kings of France, their courtiers, and all the faithful lavished on the abbey in return for the favors, material as well as spiritual, that Denis was believed to shower on them.

Yves and those who transformed his text into the book presented to Philip V may have intended the images of contemporary Paris that adorn the scenes of Denis's ministry to convey, first and foremost, spiritual and symbolic messages, associating the Parisians, once pagan, with the accomplishment of their salvation for which Denis and his companions labored. Still, in view of their esteem for temporal riches and worldly preeminence, and their concern for the well-being of the abbey of Saint-Denis, they would probably not be entirely dismayed—or surprised—at the more earthbound and material interpretations the depictions of Paris's bridges and citizens have inspired.

pulcritudo et paradisiace jocunditatis amenitas per eam representari videntur.' In the end, however, he acknowledged that one of the chief advantages of Senlis was its proximity to Paris, describing his tract as he did 'de laudibus urbis urbium Parisius, cujus una pars est de utilitatibus Silvanecti, propinquitatis ad ipsam Parisius confinia gratulantis,' Le Roux de Lincy, *Paris et ses historiens*, 78.

99 'fecundissima parens Parisius,' which 'urbes supergreditur universas' (Le Roux de Lincy, *Paris et ses historiens*, 32); 'urbs urbium' (ibid., 34 and 78); 'inclitissima' (ibid., 66).

100 Le Roux de Lincy, *Paris et ses historiens*, 66.

Appendix: Yves of Saint-Denis on Paris

These two texts are edited from BnF lat. 5286, with emendations from the presentation copy, BnF fr. 2091–92.

I. BnF lat. 5286, fol. 57v, and BnF fr. 2091, fols 93v–94v.

.lxxij. De aduentu sancti dyonisij parisius & de conditione gentis et ciuitatis parisiace.

Idem[101] autem macharius dyonisius qui sedis apostolice priuilegio tradente beato Clemente petri apostoli successore. uerbi diuini semina gallicis gentibus eroganda susceperat beatissimi principis apostolorum & magistri sui informatus exemplo qui Romane crudelitati / se propter ihesu christi nomen inmerserant. quo amplius apud gallias gentilitatis feruere cognouit errorem. illuc intrepidus & calore fidei armatus accessit. ac luteciam parisiorum. cum sanctis Rustico. & eleutherio. Luciano. Sanctino & antonino. alijsque multis;[102] domino[103] ducente peruenit. non ueritus incredule gentis expetere feritatem quia uirtutem suam preteritarum penarum recordatio roborabat. Tormentis etenim expertus multis utpote per annos iam plurimos multis[104] milibus opprobrijs & temptationibus & periculis uexatus & tum ab extraneis / tum etiam[105] a contribulibus suis & pristine suspitionis cultoribus [&] ab hijs quoque cum quibus educatus fuerat. & una[106] eruditus phylosophis aduersusque[107] multitudinem barbarorum & gentium ydolis seruientium. contraque hebreorum pertinacium dispersionem incessanter & constanter dimicans. totque[108] maris enauigans [94r] pericula terrarumque tot labores percurrens & itinera morte[109] tandem assequturum se

[101] 'Idem …. lutetia parisiorum,' is taken from Hilduin's Passion (PL 106:39–40), included in BnF lat. 2447, fol. 52r; BnF n.a.lat. 1509, pp. 104–105; see Liebman, *Étude sur la vie en prose de Saint Denis*, 164.

[102] Yves added the names of these saints, which are mentioned in a passage in the expanded Life of Denis in the *Vita et actus* that Yves did not incorporate into his own work: BnF lat. 2447, fol. 52v; BnF n.a.lat. 1509, p. 106; Liebman, *Étude sur la vie en prose de Saint Denis*, 165.

[103] 'domino … expertus multis,' is adapted from Hilduin's account (PL 106:40), which was used in Bnf lat. 2447, fol. 52r; BnF n.a.lat. 1509, p. 105.

[104] The following passage, 'milibus opprobrijs … dimicans,' is quoted and at the end ('totque … itinera') paraphrased from a passage in the encomium of Michael the Syncellus that was not used in the expanded Life in the *Vita et actus*; for the passage, see BnF lat. 2447, fols 107v-8r; BnF n.a.lat. 1509, pp. 107–108) ('decem milibus obprobriis & temptationibus & periculis uexatus. et tum ab extraneis tum etiam a contribulibus suis & pristine superstitionis cultoribus. ab his quoque cum quibus educatus fuerat et una eruditus philosophis. magis autem a sophis nuncupandis impugnatus; aduersus tantam multitudinem barbarorum & gentium ydolis seruientium. contraque ebreorum pertinatium dispersionem incessanter & constanter dimicans; & cursum currens duplo quam paulus celi cursor & multorum certaminum uictor cucurrerit. utpote qui post enauigatum mare. post transitum alpium. post immensitatem itinerum fines hesperios & galliarum penitissima penetrauit').

[105] *tum etiam*, corrected in BnF lat. 5286.

[106] *una*, supplied from BnF fr. 2091; in BnF lat. 5286, *ima*.

[107] *aduersusque*, in BnF fr. 2091; *aduersus*, in BnF lat. 5286.

[108] *totque*, in BnF fr. 2091; corrected (from *terque*) in BnF lat. 5286.

[109] 'morte … ciuitas,' is taken from Hilduin's Passion (PL 106:40), included in the Life in BnF lat. 2447, fol. 52r; BnF n.a.lat. 1509, p. 105; Liebman, *Étude sur la vie en prose de Saint Denis*, 164.

uitam tota nichilominus intentione desiderabat[110] ut qui iam erat christi nominis inter multa[111] tormentorum flagella perfectus confessor fieri mortis multatione mereretur[112] & martyr.[113]

Porro supradicta parisiorum ciuitas antiquitate quidem satis notabilis utpote ante uerbi dei incarnacionem septingentis nonagintaque octo annis fundata[114] erat multitudine quidem ciuium respectu ceterarum gallie magnarum urbium modica sed superstitione tanto potentior omnibus atque crudelior quanto diuersarum tocius gallie gentium concursu uelut portus celeberrimus frequentabatur. Eadem[115] namque ciuitas ut sedes regia & conuentu[116] gallorum ac germanorum ac nobilitate pollebat quia erat salubris aere. iocunda flumine. fecunda terris. arboribus nemorosa & uineis uberrima constipata populis referta commercijs. ac uarijs commeatibus unda fluminis circumfluente. Que siquidem inter multimoda commoditatum genera etiam alueo suo magnam piscium copiam ciuibus ministrabat. Habebant[117] enim escarum e terra & fluminibus hij qui per locum illum inhabitabant multam copiam & carnis delicias. Presentata uero conspectui refectio gulosius exhibet desiderium. & data dulcedo gutturi immoderatiorem. efficit appetitum. Intra hunc autem laqueum habitatores parisiaci opidi[118] detenti. cum refectionem hinc inuenirent. & fluuio post [94v] murum obstruerent non ymaginabantur esse[119] nec estimabant aliud quid gloriosius.

110 *desiderabat*, in BnF fr. 2091; *desiderans*, in BnF lat. 5286.

111 Following *multa*, in BnF lat. 5286, *flagellorum* is crossed out.

112 In BnF lat. 5286, *mereretur* is added from the margin; BnF fr. 2091 reads *mulctatione mereretur*.

113 Following this, *Divisio* is inserted in red in BnF fr. 2091; in BnF lat. 5286, undulating lines fill the space to the end of the line, and *Porro* starts a new line. 'Porro … frequentabatur,' following, was probably taken from a Latin translation of the Greek Life of Denis by Simeon Metaphrastes; the passage is found in the expanded Life in BnF lat. 2447, fol. 52v; BnF n.a.lat. 1509, pp. 105–6; Liebman, *Étude sur la vie en prose de Saint Denis*, 164–65. See n. 61 above.

114 *antiquitate … fundata*, inserted from the margin in BnF lat. 5286. As Serchuk noted ('Paris and Rhetoric,' 41), the French translation (BnF fr. 2091, fol. 95v) gives the year as 788 ('vij^c. lxxxviij.'). Yves himself is responsible for this phrase, which he inserted into the text he copied from the *Vita et actus*: BnF lat. 2447, fol. 52r; BnF n.a.lat. 1509, p. 105; cf. Liebman, *Étude sur la vie en prose de Saint Denis*, 164. In the third part of his work, Yves originally assigned to 898 BCE the foundation of Lutetia by the Trojans: BnF lat. 5286, fol. 122v, where the figure was later corrected to 798 BCE, the reading in Berlin MS lat. fol. 53, fol. 5r. Yves dated the fall of Troy 1180 BCE, the foundation of the Trojans' first city Sycambria 1152 BCE, and the establishment of Lutetia 354 years later. See BnF lat. 5286, fol. 122r–v; Berlin MS lat. fol. 53, fol. 5r.

115 'Eadem namque … ministrabat,' taken from Hilduin's Passion (PL 106:40), is found in the expanded Life in BnF lat. 2447, fol. 52r; BnF n.a.lat. 1509, p. 105; Liebman, pp. 164–65.

116 BnF fr. 2091 reads *Eadem namque ciuitas parisiensium conuento*, omitting *ut sedes regia et*, found in Hilduin and the *Vita et actus*, BnF lat. 2447, fol. 52r; BnF n.a.lat. 1509, p. 105; Liebman, *Étude sur la vie en prose de Saint Denis*, 164.

117 'Habebant enim … gloriosus,' a passage in the Passion *Sermo gratiarum coronat*, is included in the expanded Life in BnF lat. 2447, fol. 52r–v; BnF n.a.lat. 1509, p. 106; Liebman, *Étude sur la vie en prose de Saint Denis*, 165.

118 *opidi* in BnF lat. 5286.

119 *esse* is omitted in BnF lat. 5286; the verb is found in BnF fr. 2091, as well as in the expanded Life in the *Vita et actus*, BnF lat. 2447, fol. 52v; BnF n.a.lat. 1509, p. 105; Liebman, *Étude sur la vie en prose de Saint Denis*, 165.

O quam uana. o quam stulta. o quam fallax gloriatio. Quid enim confert superba diuiciarum iactancia cum omnia transeant uelud[120] umbra. Cum etiam pauper in celum ab angelis delatus diues autem[121] superbus in inferno cum demonibus sit sepultus? Sed & carnalium deliciarum peculancia quid proficit quia quantum unusquisque in delicijs fuerit gloriatus. tantum tormenti sibi dabitur atque luctus. Sed et quis[122] spreta dei uirtute de turrium & murorum robore gloriatur. cum nabugodonosor in babylonis fortitudine superbe & inaniter gloriatus deo agente de regno sit expulsus ut que bos cum bestijs conuersatus.[123]

Hunc[124] ergo parisij locum dei famulus elegit expetendum. ut eundem quem in predictis cernebat falso [sic] & inaniter gloriantem aduentus sui illustratione & diuini seminis erogatione spiritualibus bonis reddere posset pre ceteris diciorem. Hunc locum ceteris galliarum urbibus digniorem dei famulus elegit expetendum sibi gallie tocius apostolo. non tam humanitus quam diuinitus assignatum. Hunc locum ydolatrie cultibus deditum elegit dei famulus expetendum non tam sua quam dei pijssima electione ut ibidem per eum superhabundaret gratia ubi superhabundauerat[125] delictum. Hunc etiam elegit locum ut dum crudelioribus gentibus se immergeret ex hijs que in eis dicturus facturus. passurusque esset coram deo gloriosior appareret.

II. BnF lat. 5286, fols 115v–17r, and BnF fr. 2092, fols 93r–96v.

ch. .vj[xx].xiiij. De laude gallie que tantorum martyrum meruit patrocinio[126] & presencia honorari.

Tandem[127] o dei predicator & pontificum apex & martyrum omnium acceptissime illam decet patriam uidelicet galliam beatificare que te sui tocius caput[128] inclitum a deo coronatum & preciosas reliquias tuas tuorumque consortum lipsana sorte suscepit hospitio uelut sacrificia immaculata & tymiama boni odoris domino que uelut palmis uictricibus ita uestris ornata est

[120] *uelut* in BnF fr. 2091.

[121] In BnF fr. 2091, *diues uero*. See Luke 16:19–26, the parable of Lazarus and the rich man.

[122] In fr. 2091, *quis* rather than *quid*, the reading in BnF lat. 5286.

[123] 4 Reg. 25. 8–22; for Daniel's interpretation of Nebuchadnezzar's dream, and for Nebuchadnezzar's thanks to God, see Dan. 4.21–22 [King James' translation 4:24–25] ('haec est interpretatio sententiae Altissimi, quae pervenit super dominum meum regem. Eiicient te ab hominibus, et cum bestiis ferisque erit habitatio tua; et foenum, ut bos, comedes, et rore caeli infunderis; septem quoque tempora mutabuntur super te, donec scias quod dominetur Excelsus super regnum hominum, et cuicumque voluerit det illud').

[124] 'Hunc …. expetendum,' here and below, is found in Hilduin's Passion (PL 106:40), and in the expanded Life in the *Vita et actus*, in BnF lat. 2447, fol. 52v; BnF n.a.lat. 1509, p. 105; Liebman, *Étude sur la vie en prose de Saint Denis*, 165.

[125] In BnF fr. 2091, *et* is added.

[126] In BnF lat. 5286, *patrocinijs*.

[127] 'Tandem … medicinam,' is taken from the encomium of Michael the Syncellus, for which see BnF lat. 2447, fol. 112v; BnF n.a.lat. 1509, pp. 227–28, with *emanant* in place of *manant*, and *ciuitatem* rather than *patriam uidelicet galliam*.

[128] In BnF lat. 2447, fol. 112v (BnF n.a.lat. 1509, p. 227), *tocius gallie caput*.

sacris sanguinibus & cineribus [93v] ex quibus sanitates emanant hijs qui ad vestra confugiunt patrocinia & dolorum & langorum expetunt medicinam.

O[129] quam igitur felix es gallia que tantos et tales meruisti suscipere sacerdotes. O quam felix es gallia cui gallum istum ariopagitem uidelicet dyonisium cui & ipse deus profundissimam secretorum suorum dedit intelligentiam patronum precipuum mirabilemque predicatorem prebuit & doctorem cuius sonoris clamoribus de mortis sompno excitata & a profundo noctis[130] ydolatrie scilicet & infidelitatis nubilo es [116r] penitus absoluta.[131] Q quam iterum felix es gallia quam patris huius tenera sollicitudo de errorum scismate in vnitatem fidelium christi congregauit quemadmodum gallina sub alas suas congregat[132] pullos suos. sicut enim hoc animantis genus affectum magnum circa pullos suos gerens eos dispersos sub alis congregat sicque ne a niso[133] uel a miluo rapia[n]tur[134] protegit & defensat / sic pater iste sanctissimus dyonisius uiscerosis in christo affectibus / o gallia te amplectens in uariorum deorum cultibus dispersam ad vnius veri dei cultum sua predicatione aduocans sub suarum intercessionum alis ne ab humani generis inimico decipi possis te protegit. vt non aliquando deficiat fides tua quin [94r] potius ceteros in documentis fidei firmatura. Q quam felix gallia que monstruosis carens animalibus errores decorem xpiane' fidei monstruose deformantes ab eo quo per istum sanctum patrem es in fide firmiter instituta presertim ubi ipse oretenus predicauit suis meritis non habes & imperpetuum annuente deo suis intercessionibus non habebis que per eum semper fuisti fidei matrix[135] ac etiam defensatrix.

O quam[136] felix es parisius cuius glebe meruerunt tantorum martyrum cruore rigari.[137] Ecce trium martyrum gloria polles. ecce rutilantibus agminibus eorum te beata gloria ambiuit et quasi ex[138] multarum honore gemmarum conserto dyademate coronauit.

129 'O quam … sacerdotes,' appears in the *Vita et actus*, BnF lat. 2447, fol. 73r; BnF n.a.lat. 1509, p. 146. The passage comes from a sermon (containing the famous letter of Aristarchus concerning Dyonisius), preserved in a twelfth-century lectionary of Saint-Germain-des-Prés, lat. 11753, fol. 251r, where the passage reads: 'Felix te gallia. que tantos ac tales meruisti suscipere sacerdotes. Felix te parisius. cuius glebe meruerunt tantorum martyrum cruore rigari. Ecce trium martyrum gloria polles. ecce rutilantibus agminibus eorum te beata premia ambierunt. et quasi ex multarum honore gemarum [*sic*] conserto diademate coronarunt.'

130 *sic*, in both MSS; surely for *nocte*.

131 In his encomium, Michael the Syncellus described Dyonisius as 'calignem ydolatrie dissipantem' and said that he 'sedentes in tenebris ignorantie ad lumen uocabat scientie & salutis': BnF lat. 2447, fol. 109r; BnF n.a.lat. 1509, pp. 219–20.

132 In BnF lat. 5286, fol. 116r, *congregauit*.

133 In BnF fr. 2092, *niso*, in BnF lat. 5286, fol. 116r, *uiso*.

134 *rapiatur* in both MSS.

135 In BnF fr. 2092, *nutrix*.

136 'quam … coronauit,' appears in BnF lat. 2447, fol. 73r; BnF n.a.lat. 1509, p. 146, taken from a sermon that survives in a lectionary of Saint-Germain-des-Prés, BnF lat. 11753, fol. 251r; in the *Vita et actus*, *gloria* replaces the original *premia*, and the following verbs are accordingly modified.

137 In BnF fr. 2092, *rigore*; *rigari* in the *Vita et actus*, BnF lat. 2447, fol. 73r; BnF n.a.lat. 1509, p. 146.

138 *ex* is omitted in BnF fr. 2092.

O quam felix es gallorum lutecia que per istum patronum tuum dyonisium educta de luto fecis.[139] Peccati uidelicet putrida inquinatione supra firmam petram doctrinam scilicet christi solida es fundata. O uere felix es gallorum lutecia que in tenebrosa infidelitatis egypti sub tibi presidentium demonum duricia luto seruiens & lateri per alterum istum moysem de seruitute egyptiaca[140] in signis & portentis apud te per eum exhibitis in ueram es repromissionis terram salubriter introducta. O uere felix es parisius que olim demoniacis decepta delusionibus omnibus gallie urbibus ydolatrie magistra fueras & erroris. nunc istius patris tui [94v] erudita magisterio non solum gallicis sed cunctis mundi partibus facta es non solum ueritatis discipula sed magistra dum omnes ad tuum undique confluentes magisterium uiam dei in ueritate doces salutarisque scientie thesaurum dispensas omnibus & diffundis. O iterum & iterum felix parisius que uelut terrestris paradysus a deo in mundi nascentis plantatus initio de quo fluuius egreditur qui in quatuor capitibus est diuisus.[141] sic tu beata parisius in principio nascentis ecclesie gallicane per ortholanum istum dyonisium omnium heresum & errorum herbas in te mortiferas eradicantem sic es[142] salubriter instituta ut de te quasi de tocius spiritualis loco uoluptatis salutaris sapiencie fidei & ueritatis theologie fluuius mentes ab omni errore purgans & abluens egreditur in quatuor mundi climata deriuatus.[143] Ecce de roma octouianum augustum dixisse legimus quod eam

[139] In ch. 5 of book three of his work, Yves described how Marcomir led the Trojans of Sycambria to Lutetia and was made 'defender of all Gaul': BnF lat. 5286, fol. 125r; Berlin MS lat. fol. 53, fols 5v–6r. In ch. 7 (BnF lat. 5286, fol. 125r; Berlin MS lat. fol. 53, fol. 6r), he explained that the town was called Lutetia because it abounded in 'mud and filth' and recounted how in 420, when Marcomir's son Pharamund was ruling as king, the town's name was changed to Paris: 'Anno domini quadringentesimo vicesimo hic ob honorem paridis filij priami regis troie a quo et parisij nominatos se gloriabantur et ut ipsis parisijs plus placeret ciuitatem eorum que propter luti et fetoris habundanciam lutecia dicebatur predictum nomen abhorrens de predicti Paridis nomine ut sic etiam nomen urbis nomini in ea degentium populorum congrueret parisius nominauit.' In BnF lat. 5286, a marginal notation declares, 'Nota quare Lutecia fuit vocata parisius'; in the Berlin MS the notation is simply 'lutetia parisius.' In BnF lat. 5286, *abhorrens* is corrected from *ab horens*.

[140] In BnF lat. 5286, *egypciata*; *egyptiata* in BnF fr. 2092.

[141] Cf. Gen. 2:8–10 ('Plantaverat autem Dominus Deus paradisum voluptatis a principio, in quo posuit hominem quem formaverat. Produxitque Dominus Deus de humo omne lignum pulchrum visu, et ad vescendum suave: lignum etiam vitae in medio paradisi, lignumquescientiae boni et mali. Et fluvius egrediebatur de loco voluptatis ad irrignadum paradisum, qui inde dividitur in quatuor capita'). In his encomium, Michael the Syncellus referred to Dyonisius as 'nouellam domini plantationem propagans & protegens': BnF lat. 2447, fol. 99v; BnF n.a.lat. 1509, p. 199.

[142] *sic*, in BnF fr. 2092, correcting *sicque*, in BnF lat. 5286.

[143] Cf. Yves's description of Denis's provision for the people of Athens before his departure for Rome: 'Sollerter quidem hoc ne scilicet post pauli magistri sui discessum lupi rapaces et gregi non parcentes diuinas oues inuaderenty quod institutor suus plantauerat quasi vnus de paradysi fluminibus aqua sapiencie salutaris rigare non cessabat. Vnde uicinas et longe positas pertransiens ciuitates predicando …': BnF lat. 5286, fol. 49v (where *plantauerat* is corrected from *plantauit*). Cf. the presentation copy, BnF fr. 2091, fol. 46r, where the text reads, 'quod institutor suus plantauerat quasi unus de paradysi fluminibus aqua sapientie salutaris irrigare habundanti sollicituine non cessabat. Vnde uicinas et longe positas pertranssiens [*sic*] ciuitates predicando …' In BnF fr. 2091, *tauerat* (in *plantauerat*) is added over an erasure, as is the passage 'irrigare … ci[uitates].'

latericiam inuenit & marmoream dereliquit.[144] Verum de te gallorum lutecia quid dicemus nisi quod per augustum dyonisium sic in bonis omnibus es adaucta ut nonimmerito per eum non solum marmorea quin pocius auri & argenti scientie scilicet diuine pariter & humane mineria[145] cunctis in te fodere uel rimari [95r] uolentibus es effecta.

Felix[146] uere felix parisiorum ciuitas que licet inter quasdam galliarum urbes quondam augusta[147] uideretur & modica propter fidei tamen catholice [116v] ac sapiencie thesaurum omnibus materialibus pretiosiorem opibus quem in te sortita est o doctor[148] prestantissime splendidior & omnibus beatior non immerito predicatur. Enim sicut totam greciam decorauit ea que temporalem tibi dedit ortum athenarum ciuitas liberalium artium mater philosophorum matrix[149] et fons omnium scientiarum quam et super omnia tue claritatis ubique terrarum fama peruolans commendauit. Sic et ea que per te spiritalem in christo suscepit ortum ac etiam incrementum parisiorum ciuitas uelud[150] sapiencie mater de omnibus quasi mundi partibus ad se uenientes recolligens omnibus in neccessarijs[151] subueniens omnes pacifice regens liberalium phylozophicarumque[152] artium pre ceterisque[153] ueritatis catholice cultrix debitricem sapientibus & insipientibus se ostendens non solum franciam cuius ciuitas existit quin tocius christianitatis terminos sublimauit per te in quam per te hoc o magistrorum optime dyonisi.

Pro[154] sanctificatione enim illi datus es tam ciuium uidelicet quam confluentium aduenarum cetum sanctificans christum dumtaxat diligentium[155] [95v] et opum spiritualium cumulus patrie toti factus es habundandiam pariens & iocunditatem non illam que corporales auget angustias & admodicum fauces & palatum indulcat deinde perit & corrumpitur. ut est illa quam tellus & mare proferunt. & secane fluuius piscium uarietate copiosius qui murorum instar oppidum munit & circuit et habitatoribus multa commodorum et deliciarum

144 Suetonius, *Divus Augustus* 28.3 ('Urbem neque pro maiestate imperii ornatam et inundationibus incendiisque obnoxiam excoluit adeo, ut iure sit gloriatus marmoream se relinquere, quam latericiam accepisset').

145 *sic*; cf. Logemann, 90, emending this to 'minori a cunctis.'

146 'Felix … beatior,' adapted from a section of Michael the Syncellus's encomium used in the expanded Life of Denis in *Vita et actus*, BnF lat. 2447, fol. 73r–v; BnF n.a.lat. 1509, p. 146; and, for the encomium itself, BnF lat. 2447, fol. 112v; BnF n.a.lat. 1509, pp. 227–28) ('Felix uere parisiorum ciuitas. que licet inter quasdam galliarum urbes angusta uideatur & modica; propter thesaurum tamen omnibus materialibus preciosiorem opibus quem in te sortita est o doctorum prestantissime. splendior iure predicatur. et omnibus uere beatior').

147 *sic* in both MSS; surely for *angusta*.

148 *o doctor*, omitted in BnF fr. 2092.

149 In BnF fr. 2092, *nutrix*.

150 In BnF fr. 2092, *velut*.

151 *necessarijs*, in BnF fr. 2092.

152 *philosophicarumque*, in BnF fr. 2092.

153 *pre ceteris*, in BnF fr. 2092.

154 'Pro sanctificatione … incorruptam,' adapted from a section of Michael the Syncellus's encomium included in the expanded Life of Denis in BnF lat. 2447, fols 73v–74r; BnF n.a.lat. 1509, pp. 146–48; and for the encomium, BnF lat. 2447, fol. 112v–13v; BnF n.a.lat. 1509, pp. 228–30. Yves himself added the name of the river Seine, and inserted *& tota ipsa gallia*.

155 In BnF fr. 2092, *et spiritualia*, following, is crossed out.

genera subministrat saturitatem quin pocius absque fastidio iocunditatem immutabilem & que defectus non metuit ministrans cuilibet[156] et circum adiacentibus accolis immo undecumque concurrentibus populis fidelibus et deuotis. Ciuitas quoque ipsa[157] & tota ipsa gallia o beatissime dyonisi[158] non tam muris ac turribus aut propugnaculis confidit & munita est quam quod in tua tuorumque coathletarum fundata est sanctitate uelud[159] in lapidibus pretiosis & uiuis & sectis & quadris. uestrisque apud deum acceptissimis uallata & circumsepta interuentionibus que facile possunt ignem de celo deponere ad quinquagenarios centuriones seu chyliarcas cum sua milicia & apparatu barbarico concremandos. Portus etiam salutaris in te consitutus est omnium tutissimus procellarum. mundi huius sustinens impetus et repellens atque ab omni presentis uite turbine ad se confugientes conseruans protegens atque saluans.

[96r] In templo autem tuo sacratissimus quidam deliciarum uelut in eden est consitus paradysus omnimodum fidelibus per singularem gratiam prestans refrigerium. ubi spiritalibus plena dapibus mensa largissima proposita est sumere cupientibus animas reficiens & potu spiritali mentem inebrians & uitam propinans incorruptam. tuum inquam tuum de quo ampliora sumus inferius loquturi[160] templum o bone dyonisi non immerito paradysus esse dicitur in quo tu uarijs ac uarijs martyrum[161] confessorum uirginum preciosis membris & corporibus dominicisque & alijs innumeris reliquijs sacrosanctis inferius & superius a dextris et a sinistris circumdatus uelut [sic] lignum in medio paradysi diuersis lignis & arboribus uallatum requiescis ministrans uite incorruptibilis longitudinem hijs qui diuinis subiecti mandatis deuote tuorum querunt suffragia meritorum. lignum inquam uite es benignissime dyonisi illo uite materiali ligno liberalius cunctis expositum cum[162] nec homini post peccatum licitum fuerit de illo sumere ut uiueret in eternum. Cuius etiam[163] genti peccatrici rumphea ignea interposita [117r] totaliter est aditus interclusus. Tu uero iustis & iniustis sanctis [96v] & peccatoribus tibi supplicantibus[164] liberalem & largifluum mediatorem apud deum benignissime dyonisi te exibes[165] & exponis[166] quippe verus illius imitator[167] discipulus & nuncius qui in mundum descendit querere peccatores benignissimi uidelicet ihesu.[168] qui est per omnia benedictus. Amen.

[156] sic; in BnF fr. 2092, ciuibus.

[157] qum, following, in BnF lat. 5286; omitted in BnF fr. 2092.

[158] dyonisi, only in BnF fr. 2092.

[159] uelut, in BnF fr. 2092.

[160] sic in BnF fr. 2092, where sumus, following, is crossed out; loqutus, in BnF lat. 5286.

[161] From BnF fr. 2092, in quo tu uarijs ac uarijs martirum; in BnF lat. 5286, in uarijs scilicet ac uarijs martyrum.

[162] sic, in fr. 2092; ut in lat. 5286.

[163] etiam, only in BnF fr. 2092.

[164] tibi supplicantibus, omitted in BNf fr. 2092.

[165] exhibet, in BnF fr. 2092.

[166] Corrected from exponit, in BnF fr. 2092.

[167] et, in BnF fr. 2902.

[168] sic in BnF fr. 2092; benignus ihesus, in BnF lat. 5286.

PART EIGHT

Collecting and Consumption

Apparitional Aesthetics: Viollet-le-Duc and Villard de Honnecourt[1]

Carl F. Barnes Jr.

'I am Villard de Honnecourt, and I have come to chat with you for a moment …'[2]

Eugène Emmanuel Viollet-le-Duc (1814–79) is arguably the greatest nineteenth-century thinker and writer on the subject of architecture (fig. 25.1).[3] Historians of Gothic architecture view Viollet-le-Duc as the master theorist of structural rationalism as codified in his *Dictionnaire raisonné de l'architecture française du XIe au XVIe siècle*.[4] Although he was not the first to make the claim, Viollet-le-Duc more than anyone else established the idea that French Gothic architecture as exemplified in the cathedrals of Chartres, Reims, and Amiens—the canon of High Gothic—was the standard against which *all* Gothic architecture should be measured.[5] Thus Viollet-le-Duc wrote, 'After a two-year stay [1836–37] in

[1] This essay was developed from a paper delivered at the 2005 meetings of the College Art Association in Atlanta. I thank Professor Elizabeth Pastan of Emory University for including me in her session, 'Viollet-le-Duc and Medieval Architecture.' I have benefited from comments by the respondent for that session, Aron Vinegar, from the paper presented by Stephanie A. Glaser, 'Viollet-le-Duc, the Gothic Cathedral, and the French Revolution,' and from suggestions by the anonymous readers of the first version of this article. I thank them for their insights. Translated quotations from French are mine save for those from Viollet-le-Duc's *Entretiens sur l'architecture*, 2 vols, (Paris, 1863 and 1872) which were taken from the English translation, *Discourses on Architecture*, by the architect Benjamin Bucknall, 2 vols, (London, 1889).

[2] Viollet-le-Duc, 'Première apparition de Villard de Honnecourt, architecte du XIIIe siècle,' *Gazette des Beaux-Arts*, 1st ser., 1 (1859): 287.

[3] Donald Hoffmann, 'Frank Lloyd Wright and Viollet-le-Duc,' *Journal of the Society of Architectural Historians*, 28 (2969), 173–83, esp. 175: 'Viollet-le-Duc's words became a cardinal influence in the formation of Wright's architectural philosophy.' For a partial listing of other significant twentieth-century architects influenced by Viollet-le-Duc's writings, see M. F. Hearn, ed., *The Architectural Theory of Viollet-le-Duc: Readings and Commentary* (Cambridge, Mass., 1990), 13–14.

[4] *Dictionnaire raisonné de l'architecture française du Xie au XVIe siècle*, 10 vols (Paris, 1854–68).

[5] Proof of the canonicity of Chartres is found in Jean Bony's famous article, 'The Resistance to Chartres in Early Thirteenth Century Architecture,' *Journal of the British Archeological Association*, 20/21 (1957–58): 35–52 proposing that Chartres was the standard that some masters/patrons rejected. Never a favorite of mine, this theory supposes an obvious impossibility: that builders and patrons 'everywhere' knew the Chartres formula or elevation.

25.1 Gaspard-Félix Tournachon, known as Nadar (1820–1910): Photo of Eugène
Emmanuel Viollet-le-Duc (1814–79), ca. 1860.

Italy, we were struck even more strongly by the appearance of our French buildings, by the wisdom and science that controlled their execution, by the unity and harmony and the method followed in their construction as in their decoration.'[6] It is no wonder that in his Dictionnaire he wrote with scientific clarity about the most minute details of Gothic architecture: abaci, finials, window jambs, tiles, crockets.

Many think of Viollet-le-Duc as unbending in his advocacy of the structural rationalism of French Gothic architecture.[7] However, there was a less analytical side to him that is rarely noted. He could be inconsistent in his views.[8] For example, while he preferred Gothic architecture of the thirteenth century, he favored the appearance and technique of twelfth-century stained glass over windows from the thirteenth century.[9] His approach to restoration was both eclectic and personal, as exemplified in his definition of restoration: 'Both the word and the thing are modern. To restore an edifice is not to maintain it, or to repair it, or to rebuild it. It is to reestablish it in a completed state that may never have existed at any given moment.'[10] There is fantasy in this definition

See Carl F. Barnes, Jr., review of Jean Bony, *French Gothic Architecture of the 12th and 13th Centuries*, in *The Catholic Historical Review* (April 1986), 262–63. For an overview of the interpretation of Gothic through the centuries, see Paul Frankl, *The Gothic, Literary Sources and Interpretations through Eight Centuries* (Princeton, 1960).

6 Viollet-le-Duc, *Dictionnaire*, 1, i–ii. In a letter to his father dated September 10, 1836 he wrote, 'truly, Italian Gothic and Byzantine [architecture] are [of] pitiful construction and have nothing in common with the execution of our Gothic monuments.' Viollet-le-Duc, *Lettres d'Italie, 1836–1837, adressées à sa famille*, ed. Geneviève Viollet-le-Duc (Paris, 1971), 140. The letter was written in Pisa and one assumes that Viollet-le-Duc was thinking of the cathedral there as Byzantine.

7 Viollet-le-Duc, *Discourses*, 263: 'The secular school of the latter part of the twelfth century abandoned them [traces of Roman and Byzantine architecture] completely, and replaced them by principles based on reflection. These principles may be summarized as follows: equilibrium in the constructive system by opposing active resistance to active pressure, the outward form resulting only from the structure.' For a different take on the rationalism of French High Gothic architecture, see Erwin Panofsky, *Gothic Architecture and Scholasticism* (Latrobe, 1951). For analysis of nineteenth-century writers who believed in the rationalism of French Gothic architecture and who may have influenced Viollet-le-Duc's thinking, see Louis Grodecki, 'Viollet-le-Duc et sa conception de l'architecture gothique,' in *Colloque international Viollet-le-Duc* (Paris, 1980), 115–26. This article also discusses those who vociferously disagreed with Viollet-le-Duc's interpretation, most notably Pol Abraham, *Viollet-le-Duc et le rationalisme médiéval* (Paris, 1934). An overview of Viollet-le-Duc's career is found in Jean-Michel Leniaud, *Viollet-le-Duc ou les délires du système* (Paris, 1994).

8 This conflict between the practical and theoretical is seen in the letter/report he wrote to the Minister of Justice and Culture in 1843 explaining how he proposed to approach the restoration of the cathedral of Notre-Dame in Paris. This letter is translated in Hearn, *Architectural Theory*, 279–88.

9 For an example concerning the glass and an excellent overview, see Elizabeth Carson Pastan, 'Restoring the Stained Glass of Troyes Cathedral: The Ambiguous Legacy of Viollet-le-Duc,' *Gesta* 29 (1990): 155–66.

10 Viollet-le-Duc, *Dictionnaire*, 8, 14. For an English translation of the entire *Dictionnaire* (8, 14–34) entry 'Restauration' see *Foundations of Architecture, Selections from the Dictionnaire raisonné*, introduction by Barry Bergdoll, trans. Kenneth D. Whitehead (New York, 1990), 195–227. Viollet-le-Duc's removing the tall thirteenth-century clerestory windows near the crossing of Notre-Dame in Paris and replacing the original arrangement of shorter clerestory windows and oculi is an example of 'never existed at any given moment,' not because his

which seems so at odds with the careful documentation that characterizes most of the Dictionnaire.

The imaginative side of Viollet-le-Duc is unknown to most because few scholars have read the relevant writings. The purpose of this essay is to examine two lesser-known writings of Viollet-le-Duc that reveal his working methods with startling clarity. In these little-read, rarely-cited fantastical works, Viollet-le-Duc the dreamer comes face to face with Villard de Honnecourt, who in turn becomes his alter ego for his own views on the primacy and merits of French Gothic architecture. Before examining their amiable symbiosis, it is necessary to explain how Viollet-le-Duc became aware of Villard de Honnecourt and his portfolio of drawings.[11]

The earliest serious publications on the Villard drawings date from the 1840s and 1850s, and must be seen in the context of burgeoning French enthusiasm for the country's medieval past. The magnificent series of Baron Isidore Taylor (1789–1879) and Charles Nodier (1780–1844), *Voyages pittoresques et romantiques dans l'ancienne France*, a project to which Viollet-le-Duc contributed over two hundred drawings, began publication in 1820. The very title of the Taylor and Nodier publication indicates how France's medieval architecture was viewed: as picturesque and romanticized, an attitude also reflected in Victor Hugo's (1802–85) *Notre-Dame de Paris*, published in 1831–32. Many mid-nineteenth-century French writers thought of Gothic architecture as revolutionary in both artistic and political terms,[12] Viollet-le-Duc among them. Yet, the perception of this architecture as avant-garde did not originate with him. It reflected earlier writings of Hugo and Ludovic Vitet (1802–73), the first *inspecteur général* of historic monuments (1830–34). Viollet-le-Duc interpreted Gothic architecture as representing a new chapter in French architecture. To him the great buildings of the twelfth and thirteenth centuries were a break from monastic Romanesque architecture that the cathedral clergy initiated. At the same time, the cathedrals were seen as an expression of civic pride and freedom since their construction coincided with the establishment of communes by the Capetian monarchy. Thus, Viollet-le-Duc wrote that Gothic was an 'art of the people,' the native Gallic French, not their conquerors: 'French [Gothic] architecture formed itself

archaeology was false but because, in Hearn's characterization (*Architectural Theory*, 5), 'His decision was all the more questionable because the later windows had involved lowering the roofline, with the result that the roof would no longer cover the roundels, which originally opened into the dark area under the gallery vaults. Undaunted, he filled the roundels with stained glass, thereby treating them in a manner in which they had never been seen in the Middle Ages.'

[11] Paris, Bibliothèque nationale de France, MS Fr 19093. The assemblage is called variously a 'notebook' or a 'sketchbook.' As I have explained elsewhere ('What's in a Name? The Portfolio of Villard de Honnecourt,' *AVISTA Forum Journal*, 12 (2001), 14–15) neither designation is accurate. See also Carl F. Barnes, Jr. and Lon R. Shelby, 'The Codicology of the Portfolio of Villard de Honnecourt (Paris, Bibliothèque nationale, MS Fr 19093),' *Scriptorium*, 47 (1988), 20–48. The first writer to term the assemblage a *portefeuille* was Henri Omont (1857–1940) in *Album de Villard de Honnecourt, architecte du XIIIe siècle* (Paris, 1906), 3, where he called it 'an album in the form of a portfolio.'

[12] See Stephanie A. Glaser, *Explorations of the Gothic Cathedral in Nineteenth-Century France*, unpublished diss., Indiana University, 2002 (Ann Arbor, Mich., 2002).

in the midst of a conquered people, defying its conquerors; it took its inspiration in the bosom of this indigenous group, the majority of the nation. …'[13] Perhaps his most telling observation was: 'Art had reached its *Eighty-nine* in 1170; at that era it had completely freed itself from all that could shackle its independence and its national character. …'[14]

The first major publication on the Villard drawings was by the historian and archaeologist Jules Quicherat (1814–82) in 1849.[15] Viollet-le-Duc knew Quicherat's article, but his main source of information about Villard was the first facsimile edition of the Villard portfolio, published in 1858 in Paris.[16] The text was by the architect Jean-Baptiste Antoine Lassus (1807–57), best known for restoring the Sainte-Chapelle in Paris in the 1840s and 1850s.[17] Lassus died on 15 July 1857 before his facsimile was complete and the project was readied for publication by his pupil Alfred Darcel (1818–93), who claimed to have 'closely conformed to Lassus's manuscripts' and 'with a pious respect for his memory.'[18]

Viollet-le-Duc became acquainted with Lassus as early as 1840 when working with him on the restoration of the Parisian church of Saint-Germain l'Auxerrois,[19] and, later, on the restoration of the Sainte-Chapelle in the 1840s.[20] Between 1845 and 1857 Viollet-le-Duc restored his most famous work, the cathedral of Notre-Dame of Paris, once again with Lassus.[21] During their nearly

[13] Viollet-le-Duc, *Dictionnaire*, 1, 153.

[14] Viollet-le-Duc, *Discourses*, 1, 245. The reference is to the beginning of the French Revolution of 1789.

[15] 'Notice sur l'album de Villard de Honnecourt, architecte du XIIIe siècle,' *Revue archéologique*, 1st ser., 6 (1849): 65–80, 164–88, 209–26 and pls. 116–18. This study remains, more than a century-and-a-half later, an important—and generally unknown—contribution to Villardiana.

[16] J. B. A. Lassus, *Album de Villard de Honnecourt: architecte du XIIIe siècle, manuscrit publié en facsimile* (Paris, 1858). Léonce Laget issued a photographic reprint of the Lassus facsimile in Paris in 1972. For an analysis of the Lassus facsimile, see Carl F. Barnes, Jr., *Villard de Honnecourt, the Artist and His Drawings: A Critical Bibliography* (Boston, 1982), xli–xliii. For more recent bibliography on Villard, visit my website at www.villardman.net.

[17] Lassus became acquainted with the drawings of Villard through the 1849 article by Quicherat cited in n. 15 above. See Lassus, *Album de Villard de Honnecourt*, xv–xvii. The most complete account of Lassus's life and career is Jean-Michel Leniaud, *Jean-Baptiste Lassus (1807–1857) ou le temps retrouvé des cathédrales*, Bibliothèque de la Société Française d'Archéologie 12 (Paris, 1980).

[18] Lassus, *Album de Villard de Honnecourt*, title page and ix. In Lassus's facsimile the original drawings by Villard and others were lithographic reproductions drawn by Gustave Jules Leroy.

[19] In a letter to Madame Lassus dated September 9, 1858 Viollet-le-Duc thanked her for sending him a copy of the *Album de Villard de Honnecourt* and noted 'it is a souvenir of the friendship that has not ceased to unite your husband and me for eighteen years.' Quoted in Leniaud, *Jean-Baptiste Lassus*, 6n50.

[20] Félix Duban (1797–1870) was the first architect of the restoration of the Sainte-Chapelle, beginning in 1840. Lassus worked with him and succeeded him in 1849, working until his death in 1857. The last architect was Emile Boeswillwald (1815–96). Viollet-le-Duc advised on the project but was never in charge of the restoration.

[21] Alain Erlande-Brandenburg, *Notre-Dame de Paris* (New York, 1998), 215–16. Their proposal was submitted January 31, 1843 and approved May 11, 1844, but funding was not in place until July 19, 1845. Following Lassus's death, Viollet-le-Duc was in charge of the

twenty-year collaboration each became aware of the Villard portfolio. Lassus claimed that it was brought to his attention by the 1849 Quicherat article, which seems to be supported by Darcel's statement that Lassus had worked a long time to ready his manuscript for publication in 1858.[22] In turn, Viollet-le-Duc became aware of the Villard portfolio at least as early as 1854 when he wrote an entry on Villard in the first volume of his Dictionnaire. Although this volume appeared four years *before* the Lassus facsimile, it was principally, if not exclusively, through this work that Viollet-le-Duc knew the portfolio. When he described certain drawings of Villard, he designated their locations in the portfolio using Lassus's *planche* numbers.

Viollet-le-Duc admired the Lassus facsimile, as he admired Lassus himself.[23] In one of the articles to be discussed below, Viollet-le-Duc described himself 'leafing through the facsimile ... so judiciously analyzed, so beautifully printed, in which the plates are so faithfully reproduced after the original. ...'[24] In volume one of the Dictionnaire there is a footnote that reads, 'M[onsieur] Lassus, our regretted colleague and friend, annotated the manuscript of Villard de Honnecourt, which has since been published by M[onsieur] Darcel.' When Lassus died, Viollet-le-Duc designed his tomb in the Père Lachaise cemetery in Paris.[25]

Lassus and Viollet-le-Duc shared a messianic belief in the primacy of Gothic architecture as *the* national style of France in its rationalism and logic. In 1845 they both published articles proclaiming the French origins of Gothic architecture.[26] In Lassus's words in the *Album*: 'among these past [architectural] styles we find on our soil, in our tradition, a style more applicable than all foreign styles. This style is that of the thirteenth century. It unites all desirable conditions, is proved by its construction, by its forms appropriate to [our] climate, and by its ornamentation.'[27] At the beginning of the twenty-first century, it seems unbelievable that anyone would have to defend their admiration for, and study of, Gothic architecture but both Lassus and Viollet-

restoration until it was completed in 1864. A rededication of the cathedral took place May 31, 1864. Although their results at Notre-Dame are still criticized as inauthentic and overly thorough, they saved the building; e.g., Stephen Murray, 'Notre-Dame of Paris and the Anticipation of Gothic,' *Art Bulletin*, 80 (1998): 229–53. As Murray notes, there is disagreement about the degree to which Viollet-le-Duc and Lassus were accurate, especially concerning the flying buttresses, but there is no doubt where Murray stands (231): 'In the middle decades of the nineteenth century the edifice was radically rebuilt ("restored" would be too mild a word) by Jean-Baptiste Lassus and Eugène-Emmanuel Viollet-le-Duc.' For detailed bibliography concerning the restoration, see p. 249 n. 22 and Paul Frankl, *Gothic Architecture*, revised by Paul Crossley (New Haven, 2000), 315 ns. 37A and 38.

[22] Lassus, *Album de Villard de Honnecourt*, ix.

[23] Viollet-le-Duc, *Dictionnaire*, 1, 111.

[24] See below, n. 37.

[25] Pierre-Marie Auzas, *Eugène Viollet-le-Duc, 1814–1879* (Paris, 1979), 93, 126, and 300, pl. 58.

[26] Lassus, 'De l'art et de l'archéologie,' *Annales Archéologique* 2 (February 1845), 189–96 and 2 (April 1845), 311–17; Viollet-le-Duc, 'De l'art étranger et l'art national,' *Annales Archéologique*, 2 (May 1845), 285–90.

[27] Lassus, *Album de Villard de Honnecourt*, 41.

le-Duc did just that in their writing. In the dedication of his facsimile to Henri Labrouste (1801–75), his master, Lassus, wrote, 'this book will be considered by many as filled with dangerous heresies, by others even as a web of blasphemies,'[28] a not very subtle reference to the *École des Beaux-Arts* officials. Lassus excoriated 'writers who, crazed by pride or blinded by partisan politics, dare to attack, poor dwarfs, these colossal works [that is, Gothic cathedrals] of human genius, these marvelous edifices that made and will long make the glory of our country.'[29] In the preface to his *Discourses* Viollet-le-Duc wrote:

Certain professors of the *École des beaux-arts* and of the *Bibliothèque impériale* wished to do me the honour of attacking my 'tendencies' by preventive measures. A professional work which I am just publishing [the Dictionnaire], and whose scope embraces only one of the phases of architectural art, was regarded by a Professor of Archaeology, deeply versed in the study of Greek antiquities,—a clever and erudite man—as designed to be a vehicle of exclusive and therefore 'dangerous' dogmas. [30]

In the context of their shared beliefs, Lassus and Viollet-le-Duc became interested in Villardï's drawings, for each saw in them proof of the brilliance of French thirteenth-century architects. They sincerely believed that Villard was a professional architect—a fallacy that distorts Villard studies a century and a half later and is only in recent years being corrected.[31] Initially, each approached the portfolio with scholarly respect. In volume one of his Dictionnaire in the entry 'Architecte,' Viollet-le-Duc wrote about Villard as follows:

The names of those [architects] who built the cathedrals of Chartres and of Reims, of Noyon and of Laon, the admirable façade of the cathedral of Paris, are not preserved, but the precious research of some archaeologists daily reveals information of great interest on these artists, on their studies, and on their manner of working. We have a collection of sketches made by one of them, Villard de Honnecourt, with observations and notes on the monuments of his time. Villard de Honnecourt, who possibly directed construction of the choir of the cathedral of Cambrai, now destroyed, and who was called to Hungary to undertake important works, was the contemporary and friend of Pierre de Corbie, celebrated thirteenth-century architect, builder of several churches in Picardy, and who could well be the author of the radiating chapels of [the cathedral of] Reims.[32] These two artists together designed a church with a very original plan, described by Villard.'[33]

[28] Ibid., i.

[29] Ibid., xi.

[30] Viollet-le-Duc, *Discourses*, 3.

[31] E.g., Alain Erlande-Brandenburg, *Cathedrals and Castles, Building in the Middle Ages* (New York, 1995), 82: '[Villard] never calls himself an architect, and interpretations that assume that he was one only serve to obscure the true man.' See also Carl F. Barnes, Jr., 'Villard de Honnecourt,' *Dictionary of Art*, 32 (London, 1996), 569–71. See also Ch. 3 of *The Portfolio of Villard de Honnecourt, A New Critical Edition and Color Facsimile* (forthcoming, 2008).

[32] The names of the architects of Reims were not known to Viollet-le-Duc in the 1850s. They were first published by Louis Demaison in 1894 in 'Les architectes de la cathédrale de Reims,' *Bulletin archéologique du Comité des travaux historiques et scientifiques*, 3–40. Demaison did not believe that Villard had been one of the architects of Reims.

[33] Viollet-le-Duc, *Dictionnaire*, 1, 111.

This reads as a tidy biography of Villard, but there are several problems. First, no one knows when or why Villard went to Hungary, or what he did while he was there.[34] Second, the attribution of Cambrai to Villard (first proposed by Quicherat in 1849) is no longer accepted.[35] Third, nothing is known about Pierre de Corbie; and certainly not that he was a 'celebrated thirteenth-century architect.' He is known only as a collaborator with Villard on a curious double-ambulatory plan on fol. 15r (Lassus Pl. XXVIII) (fig. 25.2).[36]

In his next two writings Viollet-le-Duc found a very clever way to use Villard to promote his theory of the primacy of Gothic architecture without being or pretending to be scholarly. In the first issue of *Gazette des Beaux Arts*, published in 1859, the year after Lassus's facsimile appeared, Viollet-le-Duc wrote an article called 'The First Apparition of Villard de Honnecourt, Architect of the Thirteenth Century.'[37] One imagines a setting like that in *Le Connoisseur* by Honoré Daumier (1808–79) (fig. 25.3), and it is clear that Viollet-le-Duc intended to have some fun—but fun to a purpose:

The other night I was leafing through the Album of Villard de Honnecourt ... when I felt myself tapped gently on the shoulder. I turned, with a shiver (for when one is alone at night in his study, the doors firmly shut, all the world asleep around him, a tap on the shoulder is quite enough to cause a certain anxiety). I turned around therefore, and saw a tall old man dressed in a gray tunic cinched around his waist by a leather belt. His intelligent eyes, his appearance full of bonhomie, his curly

34 The Hungarian archaeologist/historian Laszló Gerevich excavated the ruined Cistercian abbey church at Pilis, north of Budapest, in the 1960s and found paving tiles that he believed to be the source of Villard's drawing on fol. 15v (Lassus Pl. XXIX) of a pavement accompanied by the text 'I was once in Hungary, there, where I remained many days. There I saw the pavement of a church made in such manner.' The pertinent studies are Gerevich's 'Pilis Abbey: A Cultural Center,' *Acta Archaeologica Academiae Scientiarium Hungaricae*, 29 (1977): 155–98 and 'Ergebnisse der Ausgrabungen in der Zisterzienserabtei Pilis,' *Acta Archaeologica Academiae Scientiarum Hungaricae*, 37 (1985), 111–52. Moreover, on the basis of sculpture fragments found during his excavations, Gerevich proposed that Villard was at Pilis as sculptor of the tomb of Gertrude of Méran (d. 1213), wife of King Andreas II (d. 1235). Some have accepted Villard's association with Pilis (e.g., Hans R. Hahnloser, *Villard de Honnecourt: Kritische Gesamtausgabe des Bauhüttenbuches ms. fr 19093 der Pariser Nationalbibliothek*, 2nd rev. and enlarged edition [Graz, 1972], 393–97) but others have balked (e.g., Roland Bechmann, *Villard de Honnecourt, la pensée technique au XIIIe siècle et sa communication* [Paris, 1991], 138; Nigel Hiscock, 'The Two Cistercian Plans of Villard de Honnecourt,' in *Perspectives for an Architecture of Solitude*, *Essays on Cistercians, Art and Architecture in Honour of Peter Fergusson* [Turnhout, 2004], 157–72, esp. 171–72). See also Hiscock's Foreword in my forthcoming *The Portfolio of Villard de Honnecourt*.

35 Jacques Thiebaut, 'L'iconographie de la cathédrale disparue de Cambrai,' *Revue du Nord*, 58 (1976): 407–33. For a different interpretation of Villard's association with Cambrai cathedral, see Carl F. Barnes, Jr., 'An Essay on Villard de Honnecourt and Cambrai Cathedral,' *AVISTA Forum Journal* 17 (2007), 21–26.

36 Camille Enlart, 'Villard de Honnecourt et les Cisterciens,' *Bibliothèque de l'École de Chartes*, 58 (1895:, 5–20, esp. 7, speculated that Pierre de Corbie might have been the Petrus Petri who was architect of the cathedral of Toledo. However, that Petrus Petri died in 1290, some sixty years after Pierre de Corbie and Villard collaborated on the plan on fol. 15v. It thus seems unlikely that the two Peters were the same individual.

37 Viollet-le-Duc, 'Première apparition,' 286–95. By designating this effort the 'First Apparition' it seems clear that he intended a follow-up piece.

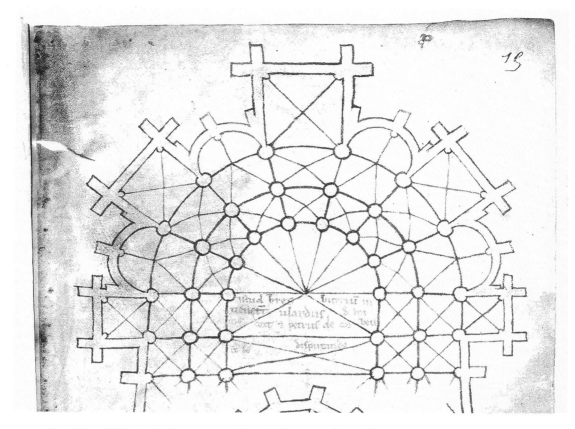

25.2 Portfolio of Villard de Honnecourt, Plan of Chevet with Double Ambulatory devised by Villard and Pierre de Corbie, 1220s/1230s. (Paris, BnF MS fr 19093, fol. 15r, detail.)

gray hair showing in thick tufts below a small green hood, scarcely gave him the air of a ghost. He tentatively offered me his hand, a firm hand. 'Take it,' he said in a pronounced Picard accent (now, a ghost never speaks with a Picard accent). 'I am Villard de Honnecourt, and I have come to chat with you for a moment. …'[38]

In Viollet-le-Duc's fantasy, Villard expressed pleasure at seeing the fine facsimile edition of his album, but also puzzlement, and asked why someone (Lassus is not mentioned by name) went to the trouble of publishing 'drawings that I made here and there during my travels for my friends or my students?'[39] Villard understood that some of Viollet-le-Duc's contemporaries credited the architects of his time with knowledge and judgment whereas others refused them these qualities. He then invited Viollet-le-Duc to leaf through the drawings and to ask questions. Space limitations preclude discussing all the drawings that Villard explained, but he began by saying that the seated apostles

38 Viollet-le-Duc, 'Première apparition,' 287.
39 Viollet-le-Duc, 'Première apparition,' 287.

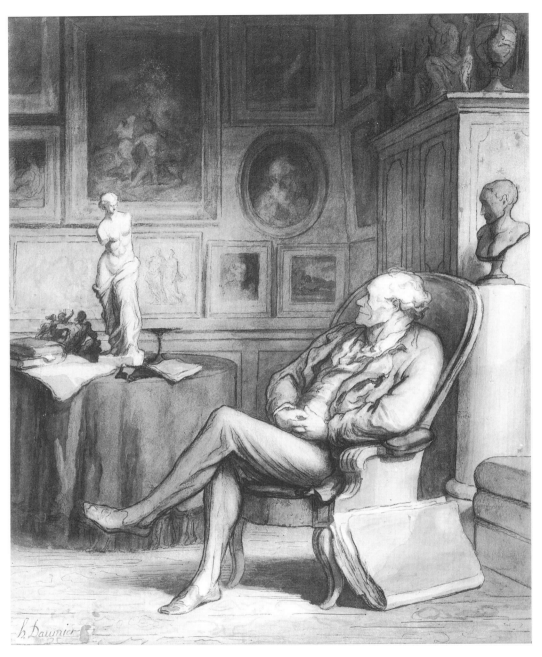

25.3 Honoré Daumier (1808–79), Le connoisseur (pen and ink, wash, watercolor, lithographic crayon, and gouache over black chalk on paper), 1863/1866; New York, Metropolitan Museum of Art.

on fol. 1v (Lassus Pl. II) were drawn from a church lintel, but not Bamberg's (as Lassus had proposed).[40]

Villard explained that his portfolio included a great variety of drawings because Gothic architects had to be masters of many skills; they were responsible for all aspects of building: 'we had not invented what you call "specialities," a word as barbarian as what it describes.'[41] How alike this is to Viollet-le-Duc's rant in his Discourses: 'In the present day, "specialities" alone are recognized. It is not imagined that a savant, an artist, or a man of letters can move in a wide circle. Each is confined within a narrow sphere, beyond which he cannot pass without losing a great part of his importance in the eyes of the public.'[42]

Villard said that he was proud of having studied ancient monuments—but not slavishly so—and he was quick to note that while some of Viollet-le-Duc's contemporaries did try to copy ancient forms exactly, they did not truly understand them. Villard agreed that the moderns could draw more accurately than he, but that literal accuracy was not his aim; instead, he wished to capture a scene, an idea, a pose. 'I do not pretend to pass off these drawings as masterpieces,' he said.[43] Still, being human (or a ghost with very human feelings), Villard was not pleased that one modern critic had judged his sketches harshly, probably a reference to Quicherat rather than to Lassus, although both criticized Villard's draftsmanship.[44]

Villard continued to explain his drawings, for example, that he drew a window from the nave of Reims (fol. 10v; Lassus Pl. XIX) from another drawing after he had been invited to go to Hungary to build the Cathedral of Saint Elisabeth at Kassa[45] because didn't want to forget the details of the Reims window, should he need them.[46] Villard's most amazing 'revelation' was that he and Pierre de Corbie drew a plan (fol. 15r; Lassus Pl. XXVIII) (fig. 25.3) as a project for the cathedral of Reims (fig. 25.4). This was preceded by an explanation of how the cathedral clergy wanted more chapels in their buildings and how, at the time this plan was drawn, cathedrals were either without radiating chapels (Paris) or only had very small ones (Senlis, Bourges). Villard

40 For all his admiration for the Lassus facsimile, the drawings Viollet-le-Duc had Villard comment on were drawings Viollet-le-Duc interpreted differently from Lassus.

41 Viollet-le-Duc, 'Première apparition,' 288. Villard followed this by noting that the architects of his time had to be part musician and part physician, as Vitruvius had called for (De Architectura I, i, 3). In his Dictionnaire 8, p. 480 Viollet-le-Duc wrote: 'It is not without reason that Vitruvius wrote that the architect should possess nearly all the knowledge of his time. ...'

42 Viollet-le-Duc, Discourses, 5.

43 Viollet-le-Duc, 'Première apparition,' 289.

44 Analyzing the seated nude on fol. 22r (Lassus Pl. XLII), Quicherat wrote ('Notice,' 214) there is 'a poverty of execution [compared to the sleeping apostle on fol. 23v; Lassus Pl. XLV] such that one cannot say they are the work of the same individual. Everything is missing: proportion, correction, feeling.' However, Quicherat admired Villard's draped figures.

45 Now Kosice, Czech Republic.

46 This is not what Villard or his scribe wrote next to the drawing. The text reads, 'Here is one of the windows of Reims from the nave bays between two piers. I had been sent to Hungary when I drew it because I liked it best.'

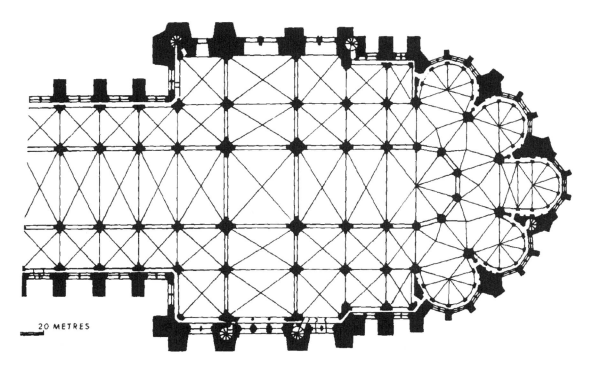

20 METRES

25.4 Reims, Cathedral of Notre-Dame, Plan of Chevet, 1211–41.

claimed that Pierre de Corbie, then an old man, was charged to design a new chevet for Reims and specifically to figure out a way to add new radiating chapels between those that already existed. Intermediate chapels were later added at Meaux, whose chevet plan appears below the plan devised by Villard and Pierre.[47] At Reims Jean d'Orbais designed a compact, sinuously undulating chevet periphery with identical radiating chapels except that the axial chapel is preceded by a shallow transverse bay. Villard and Pierre devised a chevet that is wider than it is long, and the combination of square and rounded radiating chapels, possibly influenced by Vaucelles (fol. 17v; Lassus Pl. XXXII),[48] is an apparition within an apparition—a scheme Robert Branner called 'somewhat monstrous.'[49]

There are close correspondences between things written elsewhere by Viollet-le-Duc and words he put into Villard's mouth, for example: 'Even in the twelfth century, Paris had its schools; and all Europe was flocking to them. It was at

47 On Meaux, see Peter Kurmann, 'Saint-Etienne de Meaux d'après Villard de Honnecourt,' *Bulletin de la société littéraire et historique de la Brie*, 24 (1967): 5–23 and *La cathédrale Saint-Étienne de Meaux, étude architecturale*, Bibliothèque de la Société Française d'Archéologie, 1 (Geneva, 1971).

48 See Wolfgang Schöller, 'Eine Bermerkung zur Wiedergabe der Abteikirche von Vaucelles durch Villard de Honnecourt,' *Zeitschrift fur Kunstgeschichte*, 41 (1978): 317–22.

49 Robert Branner, Review of Theodore Bowie,' *The Sketchbook of Villard de Honnecourt*, in Journal *of Aesthetics and Criticism*, 18 (Summer 1960): 397.

Paris in the thirteenth century that the encyclopaedic movement was commenced ...'[50] and 'from all over Europe students returned [to Paris] again and again ... it was the glory of Paris to hold in its breast the best schools, the greatest masters of letters and knowledge of the arts.'[51]

At the conclusion of this first apparition, Villard promised Viollet-le-Duc, 'I will return to see you again some night when you will be alone, and we will chat,' and his image became vague as he disappeared before Viollet-le-Duc's eyes.[52] Viollet-le-Duc concluded his account of the apparition with the claim that Villard's portfolio should be most interesting to true artists—those who do not live only in the present moment.

Viollet-le-Duc recounted the second apparition of Villard in the *Gazette des Beaux-Arts* in 1860,[53] a year after his account of the first apparition was published. This time Villard appeared in December, when sleet was hitting the windows and snow muffled the noise of traffic. Villard was now aware that the Lassus facsimile had been translated into English by Robert Willis (1800–85),[54] and he also referred to a long article by Prosper Mérimée (1803–70), who had known Viollet-le-Duc as early as 1822 and who became *inspecteur général* of historic monuments in 1834.[55] During this second apparition, Villard wanted to talk about what the 'true renaissance in France' was and, specifically, why people still admired brick buildings with marble revetment. In Villard's words, this taste 'made us believe, still, that brick and stone monuments faced with marble being the most beautiful things in the world, the talent of the architect [only] consists of masking a poverty of body and soul under a splendid revetment.'[56] Compare this with Viollet-le-Duc's statement in his Discourses: 'In architecture art does not consist in the employment of costly marbles, or the accumulation of ornaments, but in distinction of form and the truthful expression of the requirements [of construction]. ...'[57]

As noted above, Villard admired ancient monuments, especially those of the Roman Imperial period. He described to Viollet-le-Duc a visit he made to Rome around 1260, shortly before his death when his affairs were in order, where he

50 Viollet-le-Duc, *Discourses*, 1, 206.

51 Viollet-le-Duc, 'Première apparition,' 290.

52 Viollet-le-Duc, 'Première apparition,' 295.

53 Viollet-le-Duc, 'Deuxième apparition de Villard de Honnecourt à propos de la Renaissance des arts,' *Gazette des Beaux-Arts*, lst ser., 5 (1860): 24–31.

54 Robert Willis, *Fac-simile of the Sketch Book of Wilars de Honecort with Commentaries and Descriptions by M. J. B. A. Lassus and by M. J. Quicherat: Translated and Edited with Many Additional Articles and Notes by the Rev. R. Willis* (London, 1859).

55 Prosper Mérimée, 'Album de Villard de Honnecourt,' *Moniteur universal* (December 20, 1859); reprint: *Études sur les arts du moyen age* (Paris, 1969): 229–70. On the relationship between Viollet-le-Duc and Mérimée, see Pierre-Marie Auzas, 'Viollet-le-Duc and Mérimée,' *Les Monuments historiques de la France*, 2 (1965): 19–32.

56 Viollet-le-Duc, 'Deuxième apparition,' 25. For a lovely explanation of what really interested Villard about Gothic architecture as seen in the cathedrals of Laon and Reims, namely, its linear articulation, see M. F. Hearn, 'Villard de Honnecourt's Perception of Gothic Architecture,' in *Medieval Architecture and Its Intellectual Context, Studies in Honour of Peter Kidson*, ed. Eric Fernie and Paul Crossley (London, 1990), 127–36.

57 Viollet-le-Duc, *Discourses*, 1, 241.

was *ravi d'admiration* for the ancient architectural monuments he encountered.[58] Viollet-le-Duc likewise was *ravi d'admiration* for the ancient monuments he encountered during his 1836–37 tour of Italy, so much so that on Christmas Day 1836 he wrote in his diary: 'O! What Rome is for artists! One cannot understand it unless one has enjoyed the grand fantasy it inspires, the memories that so occupy the imagination, the sweetness of its air, its golden color, its endless treasures. …'[59] Viollet-le-Duc was less favorably impressed by Italian Renaissance architecture. As he confided to one of his traveling companions: 'I say this perhaps to my shame, but I find Palladio, Sansovino, and Vignola beyond boring. In my opinion their architecture is a mélange of antique and rococo, totally cold and without character. They wanted to give order to the Renaissance and they flattened it.'[60]

Villard asked Viollet-le-Duc to render justice on two misunderstandings: that the Gothic ogival style evolved from laced branches of German forests (an idea probably from James Hall [1761–1832][61] that Villard and his contemporaries found laughable), and that the French Renaissance was imported 'already bundled' in September 1486 when the last French troops returned from Italy.[62] Villard demanded to know why the great flourishing of art in France in the thirteenth century is not recognized as a renaissance. He pointedly told Viollet-le-Duc that the French Renaissance began in the twelfth century, and that what passes for the French Renaissance of the sixteenth century is but a superficial importation of a few grandees.[63] Viollet-le-Duc had written much the same in his Dictionnaire: 'what distinguishes the Renaissance of the twelfth century from the Renaissance of the sixteenth century is that the first penetrated the spirit of antiquity while the second let itself be seduced by the form [of antiquity]. …'[64] Villard stressed that French art was native-born: 'our works are native, they came from the people and remain of the people. Our architects, our sculptors, our painters are legion. They gave but a form, a visible support to a great idea of intellectual emancipation that began towards the end of the twelfth century. …'[65] Compare this with what Viollet-le-Duc wrote in his Discourses: 'Art in France, as early as the commencement of the thirteenth century, was an instrument used by royalty to develop its efforts in the direction of national unity. … If there ever was a renaissance in the art of France, it was at this epoch. …'[66] In the words of Villard:

58 There is no evidence that Villard was ever in Italy. The one proposal that he may have been there, based on comparative material, is Maria Laura Gavazzoli Tomea, 'Villard de Honnecourt e Novara: I topoi iconografici delle pitture profane del Broletto,' *Arte Lombarda*, 52 (1979), 31–52.

59 Auzas, *Viollet-le-Duc*, 30.

60 Ibid., 32.

61 'Essay on the Origin, History, and Principles of Gothic Architecture' (Edinburgh, 1797).

62 Viollet-le-Duc, 'Deuxième apparition,' 24–25.

63 Viollet-le-Duc, 'Deuxième apparition,' 28.

64 Viollet-le-Duc, *Dictionnaire*, 1, 147.

65 Viollet-le-Duc, 'Deuxième apparition,' 31.

66 Viollet-le-Duc, *Discourses*, 280.

Our arts were born and of noble birth. They remained to be born for our neighbors. It seems to me that there one has what one can call a renaissance. It's only just. It was, in effect, the renaissance of a great people who began to sense and to agree, after long miseries, all our artists being laymen, all coming from cities that had preserved some flicker of the old Gallic spirit. ...[67]

In a long harangue Villard explained that while in Italy he realized that French artists of his time were more skilled than those he encountered during his visit. By coincidence, a similar claim was made in the earliest published reference to the Villard portfolio, by André Félibien, sire de Avaux (1619–95) in 1666:

Recently there fell into my hands an old parchment book by a French author whose calligraphy and language prove it to be from the twelfth [sic] century. There are in it a number of ink figure drawings that make it known that taste in drawing [in France] was then as good as in Italy in the time of Cimabue.[68]

Conclusion

In 1863, the year volume one of his Discourses was published, Viollet-le-Duc wrote of the Villard portfolio that it was 'neither a treatise, nor an exposition of [architectural] principles arranged in order, nor a theoretical or practical course in architecture, nor the foundation of [such a] work.'[69] In truth, Viollet-le-Duc had little if any interest in Villard's drawings and inscriptions for the technical information they—and in some instances, their inscriptions—provided about Gothic architectural practice.[70] For all his interest in medieval timber construction and his insistence that the crossing spire of Notre-Dame in Paris be rebuilt in timber,[71] Viollet-le-Duc showed no interest in Villard's timber truss roof constructions (fol. 17v; Lassus Pl. XXXIII).

[67] Viollet-le-Duc, 'Deuxième apparition,' 26.

[68] André Félibien, *Entretiens sur les vies et les ouvrages des plus excellents peintres anciens et modernes*, 2nd ed. (Paris, 1696) 1, 520.

[69] Viollet-le-Duc, 'Album de Villard de Honnecourt, architecte du XIIIe siècle,' *Revue archéologique*, nouv. ser., 7 (1863), 103–18, 184–93, 250–58, 361–70, and esp. 104.

[70] Viollet-le-Duc did draw a reconstruction of the truss bridge on fol. 20r (Lassus Pl. XXXVIII). Viollet-le-Duc, *Dictionnaire*, 8, 250. In this article Viollet-le-Duc spelled Villard 'Villars.'

[71] See Lynn T. Courtenay, 'Viollet-le-Duc et la flèche of Notre-Dame de Paris: la charpente gothique au XIIIe et XIXe siècle,' *Journal d'Histoire de l'Architecture*, 2 (1989), 53–68; reprinted in translation as 'Viollet-le-Duc and the Flèche of Notre-Dame de Paris: Gothic Carpentry of the 13th and 19th Centuries,' in *The Engineering of Medieval Cathedrals*, ed. Lynn T. Courtenay, Studies in the History of Civil Engineering, 1 (Aldershot, 1997), 63–80. In restoring the spire of Notre-Dame, Viollet-le-Duc placed a figure representing the apostle Thomas, patron of architects, as the uppermost figure in the southeast angle of the crossing. Sculpted by Adolphe-Victor Geoffroy-Dechaume (1816–92), the figure has the facial features of Viollet-le-Duc and was used as such as the cover illustration of Auzas, *Viollet-le-Duc*. However, Viollet-le-Duc's great-granddaughter (Geneviève Viollet-le-Duc, 'La flèche de Notre-Dame de Paris,' *Les Monuments historiques de la France*, 2 [1965], 43–50, esp. 48–49) insisted that the statue represented the apostle despite its facial features being those of her grandfather and it bearing the name 'Viollet-le-Duc' on the rule held in his hand. Geoffroy-Dechaume sculpted the statue

In short, Viollet-le-Duc used Villard's drawings as fantasy theater. The portfolio became a pretext to hijack Villard's persona, a novelty in the 1850s, as a French *confrère* across time and to stage him as a propagandist for his own views on the primacy and merits of French Gothic architecture.[72]

of St Thomas on Lassus's spire of the Sainte-Chapelle erected in 1853 and gave the figure Lassus's facial features. See François Gebelin, *La Sainte-Chapelle et la Conciergerie*, Petites Monographies des Grandes Édifices de la France (Paris, 3rd rev. ed., n.d.), 33.

[72] At the end of the second apparition, Villard noted that it was late and promised to return again, but he never did. Before disappearing, Villard gave Viollet-le-Duc a small volume bound in calfskin (the portfolio?), telling him that it is of singular interest, having been written a long time after the Renaissance. One of the readers of the first version of this article made the intriguing suggestion that this was Villard's way of indicating that Viollet-le-Duc, not Lassus, should have prepared the facsimile edition of his drawings.

Grosvenor Thomas and the Making of the American Market for Medieval Stained Glass[1]

Marilyn M. Beaven

In 1913 Grosvenor Thomas (1837–1923) brought his collection of 'Ancient Stained Glass' to the Charles Gallery, on New York's Fifth Avenue. Here for the first time Americans saw an exhibition of European stained glass of diverse origin and date in their own country. [2] The exhibition was the beginning of Thomas's effort to expose Americans to 'ancient' stained glass.[3] By the end of his life in 1923, Thomas had become the premiere dealer in medieval and Renaissance stained glass in America and in the course of doing so, he opened a new field of collecting to Americans interested in the medieval.[4] As testament to the quality of glass Thomas brought to America, many of the panels he sold are now valued objects within museums collections. The primary focus of this essay is to document the preparations Thomas made to introduce his collection

[1] In 1985, Madeline Caviness was awarded a grant from National Endowment for the Humanities (NEH) to survey and publish a catalogue of all the medieval and Renaissance stained glass in American collections. From the beginning, information on provenance was inadequate. Caviness borrowed the stock books of Thomas and Drake, Inc. New York—a firm dealing exclusively in medieval and renaissance stained glass—from Sir Dennis King, Norwich, England. They detailed hundreds of American sales. This sparked my interest in the careers of the Thomases, father and son, and of their partners, Maurice and Wilfred Drake. The present study concentrates on Grosvenor Thomas's early ventures in America. Some of this material was presented at Penn State University, in November of 1995 for the symposium, *The Fortunes of Medieval Art in America.* I thank Prof. Caviness for encouraging me in the study Grosvenor Thomas's activities. For the Checklist series see, Caviness et al, *Stained Glass before 1700 in American Collections, Checklists I, II, III, and IV,* (1985–90, Washington D.C.), hereafter *Checklist.*

[2] Maurice Drake, *The Grosvenor Thomas Collection of Ancient stained glass,* pts. 1 and 2 [exhb. cat., Charles Gallery] (New York, 1913), hereafter, Drake 1913. Thomas held two exhibitions at the Charles Gallery in 1913, one beginning in February and one beginning in December. Based on the selection of panels for the first show, I believe that Thomas initially intended to test the reception of 'ancient' stained glass in New York. Pleased with his results, he seems to have returned with another shipment at the end of the year. The second selection includes some panels that did not sell in the spring and twice the number of small heraldic panels.

[3] Partly because of the broad range of periods represented in his stock, Thomas called his panels 'ancient' rather than medieval, gothic, or Renaissance. In descriptions sent to a buyer, a panel would be dated by year or century.

[4] Thomas obituaries: *The Times,* London, February 9, 1923: 12, 5; 'The Late Mr. Grosvenor Thomas,' *Journal of the British Society of Master Glass Painters,* 1 (April 1924): 29–31.

to Americans and to show how he furthered those contacts once they were established. Because this essay's source material is primarily client letters, it also discusses Thomas's response to their demands within the growing interest in medieval collecting. Thomas's American career and his American clients are two sides of the same coin; one story can hardly be told without the other.

Thomas made careful preparations for the February 1913 exhibition opening. Choosing the Charles Gallery meant associating himself with an antiques dealer who specialized in offering Tudor and Jacobean furniture as well as whole rooms of paneled oak from English manor homes in which to display them. The Charles Gallery had an established clientele interested in medieval objects who could be expected to show interest in stained glass of a similar period.

The Gallery exhibition also catered to Thomas's sense of himself as a collector, rather than as a dealer. In a 1915 letter to William Mather, he says, 'I want you to understand that I am not a dealer. I have been forming my collection of old stained glass until it became probably the finest private collection in Europe, but the last two or three years I have been disposing of some panels to different museums etc. I am really a landscape painter.'[5] Every single panel in the Charles Gallery show of 1913 was for sale, but Thomas nonetheless preferred to be thought of as a collector of fine art objects.

Thomas's claim to be a landscape painter was perfectly true. An Australian by birth, he moved to Glasgow around 1885 in order to develop his painting skills. He established himself as a member of the 'Glasgow School,' gaining international recognition as a landscape painter with a moody, impressionistic bent and 'fullness of color and tone.'[6] In the United States, his work was included in exhibitions at Carnegie Institute in 1896, at the Albright Art Gallery of Buffalo in 1908, and illustrated in such art magazines as *Studio* and *Connoisseur*.[7]

The prefatory material in the catalogue furthered the goal of setting a high tone for the exhibition by discussing the antiquarian and art-historical aspects of the stained glass. The most noteworthy series in the collection was a set of five tall, standing figures with accompanying heraldic shields, which had been acquired by Thomas around 1910 from Kilburn Grange, (Derbyshire, England). The next year Thomas invited the antiquarian Aymer Vallance to write an article for *Burlington Magazine*, complete with full-page illustrations.[8] A reprint was attached to the Charles Gallery catalogue. Vallance identified the figures shown

5 Cleveland, Ohio, Western Reserve Historical Society (hereafter WRHS) Mather archive, Box 15, Letter of June 22, 1915. I would like to thank Helen Zakin for sending me copies of the correspondence of William Mather with Grosvenor Thomas from the archives of the Western Reserve Historical Society, Cleveland OH, Mather Collection and Trinity Cathedral archives, Cleveland, Ohio.

6 'The Pool,' *Studio* (April 15, 1897), 192.

7 His obituary, 'The Late Mr. Grosvenor Thomas,' 31 (see n. 4), mentions the painting societies of which he was an associate and the numerous awards he received at international shows.

8 Aymer Vallance, 'Some Flemish Painted Glass Panels,' *Burlington Magazine* (July, 1911): 189–92. Vallance noted that the panels were acquired in April 1910. Now in the collection of the Victoria and Albert Museum, London, the original provenance is cited as the Chapel of

in the panels as Maximilian and members of his royal family, suggesting that Mary of Burgundy and Joanna of Aragon represented the two women. The use of connoisseurship and the blazoning of heraldry by Vallance added scholarly authentication to Thomas's stained glass.

In point of fact the reprint of the Vallance article was one of two prefaces to the 1913 Charles Gallery catalogue. The other was written by Maurice Drake, author of a book on the history of English stained glass.[9] The Drake family had long been associated with the stained-glass business; Maurice's father Frederick was the glazier of Exeter cathedral and the author of a treatise on Exeter glass. Maurice's brother Wilfred was an accomplished stained-glass artist and restorer who eventually formed a partnership known as Thomas and Drake, Inc. with Thomas's son, Roy.[10] While the article by Aymer Vallance provided a scholarly appreciation of the stained glass, Maurice Drake's preface, much like wall texts in a museum, directed the reader to interesting panels in the collection.

Advance publicity was also part of Thomas's strategy. Newspaper notices appeared in *The New York Times* Fine Arts section beginning in January, and were repeated when the shipment of stained glass left England.[11] Primarily written to give notice of the Charles Gallery exhibition, they also sought to stimulate interest by mentioning that Thomas had sold a large English composite window to the Metropolitan Museum of Art in the previous year.[12] This stained glass was composed of several compatible but unrelated English elements; ten tall-standing figures, three half-length figures, panels of tracery, and two shields with passion medallions. The success of the sale to the Metropolitan may have been one reason that Thomas felt encouraged to pursue his American initiatives. His selection for the Charles Gallery included more than 330 panels. Thomas used one more tactic to encourage advance interest in the collection. He sent letters to museum directors announcing the date and place of the exhibit mentioning again that he had recently sold 'quite a quantity of glass,' to the Metropolitan Museum of Art.[13]

the Holy Blood, Bruges, Belgium. Bernard Rackham, *A Guide to the Collections of Stained Glass* (London, 1936) 103, plate 39. The panels may not have been purchased until 1918.

[9] Maurice Drake, *History of English Glass Painting* (London, 1912).

[10] Thomas and Drake, Inc. was incorporated in New York around the Fall of 1922, just prior to Grosvenor Thomas's death in February of 1923. His son, Roy Grosvenor Thomas, lived in the United States and was the contact point for all the later sales to Americans. The stock books were first drawn up as an inventory for the incorporation process and then used to establish the value of Grosvenor Thomas's estate. Notes to this effect are found on page 66 of the stock book.

[11] 'Stained Glass Collection Coming,' *The New York Times*, January 19, 1913, C2, mentions that Thomas is a landscape painter and collector, and that he is bringing three hundred panels for an exhibition; 'Ancient Stained Glass,' *The New York Times*, December 7, 1913, Sunday Magazine, 15, reviews the collection.

[12] MMA 12.210.1. Jane Hayward, *English and French Medieval Stained Glass in the Collection of The Metropolitan Museum of Art*, rev. and ed. Mary B. Shepard and Cynthia Clark, 2 vol. (London and New York 2003), 2: 109–15., ill. pp. 19, 110 and colorplate 33. Hereafter Hayward 2003. Attributions describe parts from Gloucestershire, Cheshire, and London. The original dimensions were probably slightly in excess of 12 × 5.5 ft.

[13] WRHS, Letter to F. Allen Whiting of the Cleveland Museum of Art, simply addressed to 'Director.'

As to the composition of the collection chosen for New York, Thomas may simply have brought most of what he owned, but the exhibition seems more carefully selected. It included a number of large, important windows that would attract museum buyers and also a wide variety of smaller panels that might be bought by private individuals. In the first category was the glass of the Maximilian series, reviewed by Vallance, and still regarded as exceptional, a German panel from Steinfeld Monastery, four windows from the Carmelite Monastery at Boppard on Rhine, and English grisailles from Salisbury Cathedral. The panels most likely to attract individual buyers were those Thomas labeled Flemish. These smaller, often unipartite panels, accounted for one-half the show. English stained glass was well represented, notably the English heraldic panels. Indeed, perhaps Thomas was testing the waters to see how Americans would react to heraldic glass. He presented eighty-three panels in the spring exhibition, and nearly doubled that number to 140 in the fall session.[14] Still, despite these careful preparations, Grosvenor Thomas was taking a risk. There were not many indications that Americans would be eager to buy medieval or Renaissance stained glass.

Yet a few Americans had shown a tentative interest in old stained glass. For example, William Poyntell of Philadelphia was in Paris around 1821 and bought three medallions that came from Louis IX's Sainte-Chapelle,[15] becoming the first known American collector to purchase medieval stained-glass panels. While traveling in Nuremberg in 1875, Boston's avid collector Isabella Stewart Gardner bought from the dealer, A. Pickert, colorful stained glass removed from Milan Cathedral and several luminescent Austrian panels that she mounted in the windows of her Beacon Street home. Later, she bought the large medieval window from Soissons Cathedral showing the *Legend of Saints Nicasius and Eutropia* from Barci Frères in Paris, and installed it in her chapel when she constructed Fenway Court.[16] Mrs William Vanderbilt (Alva Erskine Smith) worked with William Morris Hunt to build Marble House in Newport, Rhode Island between the years 1888 and 1892. In Paris, she and Hunt selected very early gothic figural medallions probably from Allard and Sons for the library.[17] More unusual was the collection of Swiss panels purchased by Dr Francis W. Lewis of Philadelphia. He bought much of it in Zurich in the last quarter of the nineteenth century, some from the collection of Dr Ferdinand Keller.[18] The

[14] Counting all types of panels in the Charles Gallery catalogue, Parts 1 and 2, it is possible to identify American buyers for 113 panels, including those noted above from Steinfeld (Harvard, Bush Reisinger 1951.252); Boppard (MMA 13.64.1–4); and a roundel from Salisbury (MMA 13.64.10). Panels retained in stock and sold after the exhibition closed add about twenty-five more purchases.

[15] Madeline H Caviness, 'Three Medallions of Stained Glass from the Sainte Chapelle of Paris,' *The Pennsylvania Museum Bulletin*, 62 (1967): 245–59.

[16] For the Pickert purchases see Checklist I, 40–44; For Soissons, Madeline H. Caviness, Elizabeth C. Pastan, and Marilyn M. Beaven, 'The Gothic Window from Soissons: A Reconsideration,' *Fenway Court* (1983), 6–25.

[17] Philip F. Miller, 'The Gothic Room in Marble House, Newport, Rhode Island,' *Antiques*, (August, 1994), 176–85.

[18] After his death, his sister Mary Lewis gave thirty-seven of the panels to the Philadelphia Museum of Art in 1907. Arthur E. Bye, *Catalogue of the Collection of Stained and Painted Glass in the Pennsylvania Museum* (Philadelphia, 1925).

complete list of Americans who were purchasing medieval and Renaissance stained glass before Thomas's Charles Gallery sale also includes Henry Walters of Baltimore, who found a cache of clerestory windows from Soissons and Braine with the Paris dealer Raoul Heilbronner.[19] Later, Walters also purchased the stained glass owned by Henry G. Marquand—the second president of New York's Metropolitan Museum of Art—when his small collection was dispersed at auction in 1903 after his death.[20]

All of these collections, however, were purchased abroad and installed in private homes where they were viewable only by a select audience. These collecting patterns did not suggest a broad pool of purchasers. Considering all this, when the architectural firm of McKim, Mead, and White approached Thomas in March with Mrs Whitelaw Reid's order for $37,635 worth of panels, he must have felt a surge of joy and vindication.

The circumstances surrounding Mrs Reid's purchase are worth examining because it typifies one of Thomas's most successful avenues of contact, the one in which an architectural firm initiates the inclusion of old stained glass in a mansion design. Whitelaw and Elizabeth Mills Reid had a longstanding association with McKim, Mead, and White for the design of their country property, Ophir Hall.[21] Shortly after the Reids acquired the estate in 1887, it burned to the ground. Enlisting the full complement of services from the architectural firm they completely rebuilt the house as a gray stone castle with a crenellated tower from stone quarried on the site (1889–92). Stanford White decorated the interior in a sumptuous late nineteenth-century continental style, endearing himself to the Reids, who valued his skills highly.[22] There are even hints suggesting that White installed stained glass on the landing of the grand staircase. This is likely because he kept a warehouse of mostly Renaissance stained glass and dipped into it liberally for his clients.[23]

Around 1904, the Reids decided to add to the west side of Ophir Hall, hoping to make it more suitable for their retirement. The centerpiece was a 60 × 30 ft. library opening onto a terrace with long views of the estate (fig. 26.1). The Reids

[19] Checklist II, Introduction, 10.

[20] 'The Art and Literary Property collected by the late Henry G. Marquand,' [sale cat., *American Art Association*, January 23] (New York, 1903), n.p. lots 946–7B.

[21] A voluminous correspondence between the Reids and McKim, Mead, and White survives. New Haven, Conn., Yale University Library, Manuscripts and Archives, Whitelaw Reid collection HM169 and Washington, D.C., Library of Congress, Manuscript Division, Reid Family Papers, hereafter, Reid Family Papers, D.C.; for an overview of the history of Ophir Hall see the website of Manhattanville College. The property was sold to the College in 1949.

[22] Praise for White is in Reid Family Papers, D.C., letter May 6, 1912, microfilm reel 117; For paneling from the Château de Billennes, see Manhattanville College website.

[23] For Stanford White see, Checklist III, Introduction p. 14; for Stanford White sale catalogues, 'The Artistic Property belonging to the Estate of the late Stanford White ...,' [sale cat., American Art Association, 4–6 April] (New York, 1907) and 'Illustrated Catalogue of Valuable Artistic Property, collected by the late Stanford White,' [sale cat., American Art Association, 25–27 November] (New York, 1907). This 1892 stained glass is not the window in place at the time of the 1935 Ophir Hall sale. The latter is lot 1c in the Charles Gallery sale.

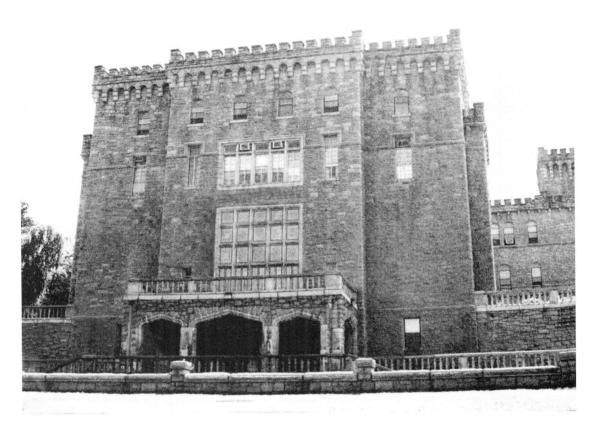

26.1 Ophir Hall, Purchase N.Y., West facade library wing addition, McKim, Mead, and White, built 1911–14, home of Whitelaw and Elizabeth Mills Reid.

were living in London at the time because President Roosevelt had appointed Whitelaw Reid Ambassador to the Court of St James. A record of the exchange of ideas between the patrons and their architect is preserved in the Library of Congress and the Yale University Reid correspondence. The letters reveal that the firm certainly was the originator of the designs but the Reids asked for and got changes in the proposals. Substantive plans emerged in 1910 and were finalized by April of 1911 with work starting that June.[24] Foundations were laid, the quarry on the property was reopened to cut matching stone for the walls, and there were detailed discussions of the terrace design outside the library windows.[25] By 1912, reports on the building progress were sent almost bimonthly. Among plans sent to London was a design for the paneling in the library and samples of the wood. Whitelaw Reid wrote in May of 1912 that his

24 Reid Family Papers, D.C., I, Box 6B–131 Letter of April 22, 1911.

25 'It would destroy entirely the sentimental interest … if the stone did not come from our own quarry.' Reid Family Papers, D.C., Letter of April 19, 1912, microfilm reel 117.

apprehension regarding the proposed size of the paneling vanished when 'I took the opportunity of an afternoon visit at Hatfield House to look through the great library there and the corridor leading to it. This library ... is very nearly of the same length with our new one. The panels there and in the corridor seemed to both Mrs. Reid and myself to be almost exactly the same with the panel of which you sent me a sample, and certainly the effect there was extremely dignified and appropriate.'[26] But in all this correspondence there is no mention of stained glass. Later in the summer, reports from their manager, Mr Blake, left the Reids so anxious that they decided to sail to New York and inspect for themselves. On October 22, they spent the day at Ophir Hall consulting with the architects and making a long list of items that needed prompt attention. Sadly, just a few weeks after their inspection, Whitelaw Reid died and the management of the project fell entirely into Elizabeth Reid's lap.

On January 13, 1913, McKim, Mead, and White presented Mrs Reid with a status report including a list of all subcontractors at Ophir and the cost of their proposed work. Heinigke and Bowen, a well-known glazing contractor from the City, estimated that $3,636 would cover their part of the job.[27] There is still no mention of stained glass. McKim, Mead, and White's April accounting, however shows a startling change. A line item at the end of the report lists, 'Stained glass bought at Charles, $37,360.00.' In the same report the Heinigke and Bowen line item '(revised estimate) is $6,990.00,' more than twice the estimate in January.[28] Between the two reports, Grosvenor Thomas had arrived in America with three hundred panels of 'ancient' stained glass and opened his exhibition at the Charles Gallery by the end of February. In an unplanned move, Mrs Reid had agreed to buy enough stained glass to change the entire character of Ophir Hall. Eleven days later, having initiated this new direction of the work, she left the confusion behind and went to her estate in California.

What seems most likely to have happened is that someone at McKim, Mead, and White had seen the Thomas show. Impressed with the possibilities of heraldic panels for the library and the pair of tall-standing figures of Saint Elizabeth of Hungary and Saint Dorothy for the staircase landing, they proposed the changes. Mrs Reid was in New York at the time and could have seen the glass, but there are no letters in the archive that reflect her decision-making process. Her personal journal lists four installment payments made directly to Grosvenor Thomas; $18,220 and $17,919.76 in March and June of 1913, respectively, and $8,000 and $7,750 in July and October of 1914. Irving Blake accounts for one further payment in January of 1917 for $18,810.[29]

[26] Reid Family Papers, D.C., Letter of May 15, 1912, microfilm reel 117.

[27] Reid Family Papers, D.C., 1, B35, Business Correspondence McKim, Mead, and White, folder 1262.

[28] Reid Family Papers, D.C., 1 B35, Business Correspondence McKim, Mead, and White, folder, 1263.

[29] Elizabeth Reid's Journal is in Reid Family Papers, D.C., 2 Box 12. Her four payments to Grosvenor Thomas are under 'personal' entries p. 135, 141, 163, and 'household' entries p. 89.

Many years later, after Elizabeth Reid died, when the contents of Ophir Hall were being organized for auction, Otto Heinigke wrote to Mr Blake that he was 'lending two catalogues of the old stained glass published in 1913, together with certain three charts showing the location of the panels in the windows in Ophir Hall by lot number. I find that the window on the grand staircase was not included so give it to you below' (fig. 26.2).[30] This letter surely indicates that all the glass Heinigke installed came from the two Charles Gallery exhibitions. Even so, it is not possible to match all 157 panels in the 1935 sale catalogue completed at Mrs Reid's death with counterparts in the Charles Gallery catalogues.[31] A certain vagueness of the descriptions in both catalogues probably accounts for some failures, but only sixty-two panels are securely identifiable. The discrepancy is too large. The $18,801 payment in 1917 to Thomas may account for this and his continuing association with Mrs Reid outlined below offers an explanation.

Other interested visitors to the exhibition included the curators from two museums. Thomas boasted that The Metropolitan Museum of Art and The Brooklyn Museum had bought 'quite a quantity' of his stained glass.[32] The Metropolitan acquired the four fifteenth-century Boppard panels and the thirteenth-century Salisbury Cathedral grisaille roundel. Brooklyn purchased a tall, fourteenth-century English lancet depicting the *Virgin and Child* and a fourteenth-century German *Architectural Canopy*.[33] Certainly, Thomas could be pleased that he had solidified his contact with American museums, but his earlier experience dealing with William Burrell in Glasgow showed him that private collectors were also important customers. In reaching this sector of the buying public the Charles Gallery sale was successful too.

Among the prominent collectors well connected in the art world of the time, George D. Pratt was a notable figure. Mary Shepard credits Pratt's involvement in the affairs of the Metropolitan Museum of Art over the years of his trusteeship with a sizeable increase in the medieval stained-glass collection.[34] This affinity for glass was also displayed in his personal collections. His Glen Cove, Long Island mansion, Killenworth, was embellished with stained glass bought from Thomas in 1913. A list of Pratt's purchases at the 1913 Charles Gallery sale points to his broad interests. This view is supported by mention of Pratt's purchases in the press. *The New York Times* reported that he bought 'three windows for his Long Island home, whither also has gone the Elizabethan

Irving Blake's letter of April 11, 1935, to Helen Rogers Reid, listing the 1917 payment is in Reid Family Papers, D.C.. 2, Box 9, folder 7, 'Art and Antiques.'

30 The April 23, 1935 letter from Otto Heinigke is in Reid Family Papers, D.C., 2, Box 9, folder 7, 'Art and Antiques.'

31 'Art Treasures and Furnishings of Ophir Hall, residence of the Late Mrs. Whitelaw Reid,' [sale cat., *American Art Association Anderson Galleries*], (New York, 1935).

32 WRHS, Mather archive, Box 15, letter to Frederick Alan Whiting, November 13, 1913.

33 For The Metropolitan Museum, MMA 13.64.1–4 (Boppard), and MMA 13.64.10a (Roundel with Berries and Fruit), see, Checklist I, p. 97, 120; for The Brooklyn Museum, 13.28 *Virgin and Child* and 13.29 *Architectural Canopy*, see, Checklist I, p. 87.

34 Hayward, 2003, 1: 21–24, fig. 7.

26.2 Otto Heinigke chart of stained glass in grand staircase of Ophir Hall
marked with lot numbers from the Charles Gallery exhibition catalogue.

room that attracted so much attention last Spring in these same galleries.'[35]
Since the review was written in November, it is tempting to think that the
panels the report mentioned were the three *Prophets* numbers 3a, 3b and 3c
listed on the first page of the Fall catalogue. The full list of Pratt's purchases
from the Charles Gallery catalogue appear in the Appendix. Besides *St Ursula*,
the *Arms of Johnson* can also be seen in the *Country Life* photograph,[36] showing
that Pratt put his purchases on display promptly after acquiring them.

Henry C. Lawrence was also a New Yorker whom Thomas surely hoped
would come to the show. He was known to be a collector of Gothic stained
glass and his collection of medieval objects was well regarded by others. While
Lawrence only purchased two panels at the exhibition, both in the fall

35 'In the Art Galleries,' *The New York Times*, November 27, 1913, 12.

36 *Prophets*, Virginia Museum of Art 68.9.3(1–3); *Arms of Johnson*, MMA 41.170.80–83; *St
Ursula* MMA 41.170.71. For the latter see 'The Best House of the Year,' *Country Life in America*,
26, no. 6 (Oct. 1914), 35–40 and Hayward, 2003, 1: 22, fig. 7. Of Pratt's twenty-six panels
identifiable in the catalogue, fourteen are figural.

presentation, Thomas kept in contact and when he returned with other panels in 1916, Lawrence bought two more.[37] This 1916 meeting was notable for one other event: Henry Lawrence introduced his friend, Raymond Pitcairn, to Thomas. Their meeting is discussed below as it dovetailed with other events of 1916.

We do not yet know much about Frank L. Babbott's collecting or his interest in medieval and Renaissance stained glass—only that what he bought from Thomas was installed in his home. His collection eventually went to The Brooklyn Museum, thus rejoining other stained glass from the Thomas collection.[38] The forthcoming Corpus Vitrearum volume of stained glass from the New York area outside of the Metropolitan Museum will undoubtedly shed more light on this question.

We have evidence that the news of Grosvenor Thomas's 'ancient' stained glass, reached well beyond the confines of New York City. F. Allen Whiting, Director of the Cleveland Museum of Art, had been consulting with William G. Mather on the furnishing of the new Episcopal Cathedral in that city. He passed along Thomas's name in January of 1915, when it came time to think about glass for the Trinity Cathedral windows. But Thomas was no longer in New York, since he had only rented the exhibition space from Charles Gallery. When the show concluded at the end of December 1913 he packed the unsold portion of his glass and returned to London. Mather and Thomas then began a four-year correspondence, and those personal letters enlarge our picture of Thomas.

In 1915, Thomas proposed two possibilities for the Trinity Cathedral windows; the one, a composite window made up of English figures and medallions surrounded by old quarries and the other, 'a window made up of *very fine* Flemish panels of the early 16th Century. I should strongly advise the English window as the glass I have is just the same period as the architecture of your Cathedral.'[39] The Flemish stained glass was recently acquired from Sir Thomas Neave, and Thomas forwarded a description of them written by Maurice Drake probably in 1914 to Mather.[40]

37 Lawrence bought the *Saint Catherine and a Donor* panel (2a) (CMA 21.106) and a Swiss Heraldic panel (251). Thomas kept his exhibition in New York until the end of the month. Early in December, Thomas offered the *Saint Catherine* to the Cleveland Museum of Art. WRHS Box 15, letter of December 5, 1913. At this time the Museum chose not to buy, but by 1921, they had obviously reconsidered, since they got Seligman, Rey & Co. to buy it for them from the sale at Lawrence's death. See also n. 40.

38 Frank L. Babbott married George D. Pratt's sister, Lydia Richardson Pratt Babbott. Both men graduated from Amherst College and had residences outside the New York City in Glen Cove, Long Island.

39 WRHS, Mather archive, Box 15, Letter of June 22, 1915, (first of two on the 22nd); For Trinity Cathedral see, Virginia C. Raguin and Helen J. Zakin with Elizabeth Pastan, *Stained Glass before 1700 in the Collections of the Midwest States*, (London, 2001), vol. 2, 197–219. Hereafter Raguin and Zakin (2001). In the same letter Thomas says, 'three lower panels illustrate the *Life of St. Nicholas*. The three upper panels, two are scenes from the Old Testament and the other is *Jacob's journey into Edom*.'

40 WRHS, Box 15, Letter of June 22 1915, (second of two in the 22nd). Hereafter Drake 1915. The 'introductory note' was written by Maurice Drake who describes nine panels identifiable

With Europe at war, it was impossible for Mather to go to London and judge for himself how the English window compared with the Flemish panels. Instead, Thomas arranged for experts to examine the glass and write appraisals of it.[41] To reassure Mather about the Flemish panels, should those be his choice, Thomas wrote, 'I note that your friends question the desirability of placing Flemish panels in a perpendicular window. I certainly do not think this would matter in a *modern* church built on perpendicular lines. There are many cases in England where Flemish glass has been used … notably at Kings College, Cambridge and St Margaret's Church, Westminster where the work is original glazing. I propose to use scroll work, figures and heraldry of the period [as fill] which I am certain would be in perfect harmony and make a window of great beauty which would certainly defy criticism.' Finally to settle the matter, Thomas sent one of the Flemish windows, probably one of the Saint Nicholas series, to Cleveland.[42] Charles Sherrill, curator, F. Allen Whiting, Museum Director, Charles Schweinfurth, Cathedral architect, and others looked at the window. Mather feared that given the height of the lancet where it would be placed, the Saint Nicholas panel with its palette of uncolored glass, silver stain, and matte paint was too delicate and the scale of its figures would be too small. Consequently, he cabled Thomas in November that, 'I have decided not to buy either English or Flemish window. Will, therefore, return panel.'[43]

Concerned that the Mather commission for Trinity Cathedral might escape him, Grosvenor Thomas took the dangerous step of sailing to New York in wartime, arriving by March 1916. He arranged with the contractor, Frederick Soldwedel, to rent studio space so that he would have a viewing room and a workroom. If he could reconnect with Mather, this space would allow for the assembly of any arrangement of the panels he might choose.[44] After much further consultation, Mather agreed to buy the composite window of English stained glass. The 'suitable' choice framed colorful standing figures and

in present day collections. Three belong to the Saint Nicholas series; *Saint Nicholas Begging Corn to Feed his People*, and *Saint Nicholas Consecrated Bishop of Myra*, the Metropolitan Museum of Art, MMA nos. 17.120.13 and 17, the third *Saint Nicholas Providing a Dowry*, is now lost. The others include; The *Martyrdom of the Mother and her Seven Sons by Antiochus*, Isaac Fletcher gift MMA 17.120.2; *Joseph among his Brothers*, Isaac Fletcher gift MMA 17.120.16; *Elijah Bringing the Widow's Son to Life*, sold to Henry C. Lawrence, 1916, now MMA 21.27.1; *Christ raising Jarius' daughter*, sold to George Pratt, now MMA, 41.170.72; *Death of Saint Nicholas*, Royal Ontario Museum, Toronto; *Jacob departs from Edom*, sold to William Mather now Cleveland Museum of Art, 51.336. The eight others are possibly among rest of the Isaac Fletcher bequest and panels given by Samuel Mather and William Mather to the Cleveland Museum of Art.

41 Trinity Cathedral Archives, Hereafter TC Archives. Evaluation October 29, 1915 from Barnard Rackham and Letter November 1, 1915, from Sir Cecil Smith, of the Victoria and Albert Museum.

42 TC Archives, Letter October 11, 1915 reply by Mather announcing that the glass had arrived.

43 TC Archives, Telegram Nov. 19, 1915.

44 Frederick Soldwedel was a contractor and decorator doing business as Warwick House, Ltd., 45 East 57th Street, New York. He was hired by McKim, Mead, and White for Mrs Reid's project in 1914. Reid family Papers, 35B–1264, letter of April 11, 1914, Irving Blake to Mrs Reid.

medallions against a background of translucent diamond quarries.[45] While Mather's concern about the delicate nature of the silver stain is legitimate, ultimately he chose windows that corresponded to his idea of the medieval as he had seen it on his trips to England and the Continent, namely, colorful, fractured glass with awkwardly drawn figures.

Thomas brought along other stock as well. While the style of the Saint Nicholas panels never appealed to Mather, other windows of the Neave purchase with their more vigorous color and drawing style did. The architect C. A. Platt, who was designing a home for Mather, selected some panels in New York and Soldwedel took twelve of them to Cleveland for Mather's inspection. Of these, Mather chose three panels for his office and two panels for the reception room. At the same time his brother Samuel was intrigued by the glass and bought two related panels.[46] Soldwedel installed the stained glass in both houses in December 1916.

It is not a coincidence that Thomas sought space in Frederick Soldwedel's studio. Soldwedel was working on several projects at Ophir Hall including the glazing of windows. It may have been a mention by Soldwedel or an advance letter from Thomas himself that alerted Mrs Reid's architects to a new shipment of stained glass arriving in America. A letter from Irving Blake of September 12, 1916, reports to Mrs Reid that her request to shift the glass in the south window and to make borders for some other panels might take as long as three months.[47] These orders and the payment to Thomas early in January 1917 indicate that the installation of stained glass at Ophir Hall was ongoing, in all probability using another consignment from Thomas. Such additions would account for those panels not identified in the Charles Gallery catalogue. The final installation placed stained glass in nearly every room of Ophir Hall, proving that Mrs Reid went well beyond her original plans.

The value of one other appointment, that with Henry C. Lawrence and his friend Raymond Pitcairn, justified the hazard of crossing the Atlantic in wartime. Lawrence bought four Flemish panels, two belonging to a series celebrating the Foundation of a Monastery and a pair of Old Testament scenes Thomas had just acquired in the Neave purchase.[48] Pitcairn bought two panels

45 Raguin and Zakin (2001), vol. 2, p. 208, ill. TC 3–12; For Thomas sales affecting other mid-west collections, see, Raguin and Zakin (2001), vol. 1, 47–49n159, by Beaven.

46 William Mather's panels are now at the Cleveland Museum of Art. *Tamar Weeping*, *Jacob Returning to Canaan*, *Elias and the Widow of Sarepta*, and *Heraldic Shield, France ancient*, Raguin and Zakin (2001), II, 138–19, 157–63, and 180–84. WRHS, Mather Archive, Box 6, Letter of December 9, 1916. Samuel Mather's windows are *The Garden of Gethsemane*, *Kiss of Judas*, Raguin and Zakin (2001), II, 170–78, shown at the Charles Gallery exhibition but not bought until 1916.

47 Reid Family papers, B 35–1266 Letter of September 11, 1916 Irving Blake to Miss Scarth (Mrs Reid's secretary). On Mrs Reid's renovations at Ophir Hall, also see the discussion compiled by Robert Vosburgh inHayward 2003, 1: 129n1.

48 'Gothic and other Ancient Art collected by Mr. Henry C. Lawrence of New York,' American Art Association, [sale cat. January 27–29] (New York, 1921). Hereafter Lawrence sale. There is a Lawrence sale catalogue in the Pitcairn files annotated with the buyers' names. In addition, an attached sheet identifies the dealer from whom Lawrence purchased the panels; it lists Thomas for these four windows. Lot no. 352, the two panels depicting the Foundation

from Salisbury Cathedral, a medallion and a lancet.[49] These he intended to use in building the church for the Swedenborgen national center adjacent to his home in Bryn Athyn, Pennsylvania. Pitcairn had recently turned his attention to the needs of his glaziers. His philosophy was to use the medieval panels as models to inspire the painting of new stained glass rather than installing them in the church.[50] From the archive notes at Glencairn we know that the stained glass was not bought when they were first shown in 1913, but carried forward in stock until Thomas offered them in a meeting on 16 April 1916. They became the first stained glass panels that Pitcairn acquired.[51]

Of the eighteen or twenty Flemish panels that Grosvenor Thomas acquired from Sir Thomas Neave, a few more are traceable to American collections.[52] In 1917, Isaac Fletcher gave the Metropolitan Museum of Art just such a group of Flemish panels as Drake described. We can place Fletcher's purchases probably in the fall of 1916 because he was the one who bought the Saint Nicholas panel after Mather rejected it at the end of August. Two other panels can be positively identified out of the Drake list, *Joseph Being Stripped of his Cloak by his Brothers*, and *Antiochus Punishing the Maccabees*. Fletcher gave nine panels to the Metropolitan and since we can identify four of them from this list it seems reasonable to propose that he bought all his others at the same time.

Grosvenor Thomas returned to England in early July 1916. He left Soldwedel the technical jobs of installing the windows at Trinity Cathedral and at the Reid and Mather homes. His confidence extended further in that Soldwedel was given authority to sell as many of the remaining panels as he could to William Mather. Surely, there was a partnership forming between the two men.

Concluding this set of transactions with William Mather in September of 1917, Grosvenor Thomas writes from London, 'I have recently acquired a large 15th Century, 6 light window of English workmanship … which I intend to take to America as soon as conditions are more favorable,' as indeed he would.[53] Not more than a year later Mather would purchase two additional windows for Trinity Cathedral from the Costessey Collection newly acquired by Thomas. In every way, the venture to Charles Gallery in the Spring of 1913 laid the groundwork for Grosvenor Thomas to enter the American market and to build a solid following among architects, curators and private collectors.

of a Monastery were bought by the Kleinberger Galleries and their present whereabouts is unknown. Lot no. 355, *Elijah Bringing the Widow's Son to Life* and lot no. 356, *Bathsheba Obtains the Kingdom from David for Solomon* were bought by the Metropolitan Museum and are numbers 21.27.1 and 21.27.2 respectively. All of these panels postdate the Charles Gallery sale. I would like to thank Michael C. Cothren for sharing the Pitcairn notes on the Lawrence sale.

49 Charles Gallery Part 2, p. 3, lot 1 and 2 where the provenance is given as Snodland Church, Kent; now Glencairn Museum 03.SG.31 (Lancet) and 03.SG.218 (Medallion).

50 For an overview of Pitcairn see Jane Hayward and Walter Cahn, *Radiance and Reflection, Medieval Art from the Raymond Pitcairn Collection* (New York, 1982), 33–45.

51 Since his death, the Pitcairn collection has become the Glencairn Museum of the Academy of the New Church, Bryn Athyn, Penn.

52 MMA 17.120.16 (*Joseph*) and 17.120.12 (*Antiochus*). Drake 1915, n. 39 above lists panels.

53 WRHS Mather Archive, Box 9, Letter September 11, 1917.

Conclusions

The early clients of Grosvenor Thomas had a variety of motives behind the choice of old stained glass for their collections. They all had enough funds to purchase the best contemporary stained glass (opalescent, for example) if they wished, but they chose medieval and Renaissance. In hiring McKim, Mead, and White, the Reids were participating in a wave of building fueled by the rising American affluence.[54] They did not select, however, a mansion of the type being built in Newport. Rather they took great pleasure in having the gray stone quarried on their own property and commissioned a dark, rough Richardsonian-like building. The Reids consciously borrowed from English stately homes because they felt a sympathetic connection with England.[55] Mrs Reid placed her most important pieces, the panels of English heraldry, in her library. She used the remainder of her stained glass throughout the rest of the house in a purely decorative way. The glass functioned in her domestic setting as it would have in the home of an English collector.

Pratt, on the other hand, was concerned with more than the decorative aspect of his glass. It was a part of his increasing efforts to encourage the appreciation of medieval art at the Metropolitan. Because of his friendship with the Arms and Armor curator, Bashford Dean, collecting and the study of early stained glass went hand in hand. Furthermore, the life of his collection extended beyond his own display at Killenworth. There was an understanding that it would eventually go to the Metropolitan Museum of Art.

Henry C. Lawrence was probably the true antiquarian in the group of people who profited from the arrival of Grosvenor Thomas. He was known for his study of medieval glass and he specifically sought to buy early gothic panels. Lawrence's reputation as a knowledgeable connoisseur encouraged other buyers like Pitcairn to emulate his taste. However, his influence and the life of his collection ended with his death. It was sold at auction in 1921 and dispersed.[56]

Raymond Pitcairn and William Mather are examples of Americans collecting old stained glass because of its original religious content. Mather was looking for old glass to reinstall in a Cathedral to lend the building an aura of authenticity and continuity. His stained glass came out of a collection and was returned to a religious setting. Pitcairn, too, was concerned with glass for religious reasons but in a different way. He did not install his old stained glass

54 Elizabeth Reid was heir to the fortune of Darius O. Mills, an entrepreneur who made his first fortune during the California gold rush. Ophir Hall, Elizabeth Reid's home in 1931 is pictured in 'A House of Many Treasures,' *Arts and Decoration* (June, 1931): 19–21, 76, and 81.

55 This was only enhanced by the trials of WWI. During most of the war Mrs Reid was in London leading a Red Cross contingent dedicated to helping American soldiers.

56 Lawrence sale. According to Pitcairn's annotations, lots, 351, 352, 346, and 383 came from Thomas. Lots 346 and 383 can be identified in the Charles Gallery catalogue, Part 2 as 251 and 2a respectively. Lot 346 (251) was bought by N. W. Seaman, acting as agent for an unknown client. The panel's present whereabouts is unknown. Lot 383 (2a) was bought by Seligman, Rey & Co. for the Cleveland Museum of Art, Cleveland, Ohio, inv. no. 21.106, see Raguin and Zakin, (2001), 142–46.

in the Bryn Athyn Cathedral but used it as a prototype for the neo-gothic panels which were made on the site. The original panels were mounted in his Romanesque-style house, built specifically to keep the stained glass together as a collection. Pitcairn's Gothic glass was installed, along with his other medieval purchases, in a recreated setting which became The Glencairn Museum.

After Grosvenor Thomas held his exhibition of 'ancient' stained glass in New York, the American market changed significantly. Buyers became aware that original old glass was available and that it was an asset in their living spaces. Americans with construction plans instructed their architects to include 'ancient' glass in their designs. The reverse was also true. Architects became aware of the availability of Thomas's old glass and they suggested it to their clients. Such was his success, that by the time of his death in 1923, Thomas had sold as many as a thousand panels of 'ancient' stained glass. When his son Roy and partner Wilfred Drake took over the business in 1922, they could enjoy a continuing clientele simply from the news of the previous sales. Dealers, museum curators, architectural firms, and individuals acting on their own sought them out for expertise and the opportunity to buy.

Appendix

IDENTIFIABLE BUYERS IN THE CHARLES GALLERY CATALOGUE
SPRING AND FALL EXHIBITION 1913

Buyer	Total Panels Bought	Catalogue lot numbers
Elizabeth Mills Reid, Ophir Hall, Purchase, N.Y.	62	*Part 1*: 1c, 1d, 10 (4)[57], 21, 57, 69, 73, 79, 95, 96, 103, 104, 111, 112, 128, 150a, 152–155, 172, 182, 186, 187, 218, 219, 238, 240, 245a (9), 255–261. *Part 2*: 1a (4), 10 (2), 10a (5), 52a (5), 185 (2), 199.
George B. Pratt, Killenworth, Long Island, N.Y.	27	*Part 1*: 1b, 86, 94, 167, 179, 188, 238, 250–253. *Part 2*: 3 a, b, c, 6, 7a (4), 19, 223, 227–232.
Frank L. Babbott, Long Island, N.Y.	12	*Part 1*: 3, 26, 75, 166, 171, 190, 192, 193, 246–249.
Metropolitan Museum of Art, New York, N.Y.	5	*Part 1*: 156, 224–227.

57 Bracketed numbers indicate a multiple number of panels in the lot.

Buyer	Total Panels Bought	Catalogue lot numbers
Mr & Mrs Martin A. Ryerson,[1] Chicago, Ill.	3	*Part 2*: 50, 51, 59.
The Brooklyn Museum, Brooklyn, N.Y.	2	*Part 2*: 151, and a canopy acquired at the same time as 151 but not identifiable in the catalogue. Brooklyn Museum files record the purchase from Grosvenor Thomas.
Henry C. Lawrence, New York, N.Y.	2	*Part 2*: 2a, 251

Medieval Stained Glass and Alexandre Lenoir

Mary B. Shepard

Alexandre-Marie Lenoir (1761–1839), the founder and director of the short-lived Musée des monuments français (1790–1816), filled the windows of his museum with stained glass reported to have been 'transported from the glowing windows of a thousand churches, which the bigoted intolerance of modern philosophy had doomed to devastation and pillage.'[1] Lenoir's museum was originally set up as a provisional depot in the suppressed Parisian convent of the Petits-Augustins to store works of art seized from ecclesiastical holdings during the French Revolution and was among the earliest to feature chronological installations extending from what Lenoir saw as the beginnings of French art until his own time, or as one contemporary touted, from 'its origin up to its perfection.'[2] Medieval stained glass functioned as an essential crux in Lenoir's strategic portrayal of the advancement of French art, largely inspired by Johann Joachim Winckelmann's theories of artistic progress and decline.[3] Never objective, Lenoir's interest came to be also intensely nationalistic.

It is not fully accurate to say, like Francis Haskell, that 'Lenoir had no feeling for medieval art.'[4] Nor should we altogether follow Louis Grodecki's dismissal of Lenoir as an opportunist motivated to collect stained glass simply to fill the empty windows of his museum.[5] Rather, as Lenoir's awareness of glass painting developed and its role in the Musée des monuments français expanded, medieval stained glass increasingly gained stature and importance as it buttressed Lenoir's argument for the French creation of the art form. Thus,

[1] I am indebted to the American Council of Learned Societies for their generous support of my research on Alexandre Lenoir and his interpretation of medieval art. Unless otherwise noted, translations from the French are my own. Rev. William Shepherd, *Paris in Eighteen Hundred and Two and Eighteen Hundred and Fourteen* (London, 1814), 85.

[2] J. E. Biet and J. P. Brès, *Souvenirs du Musée des Monuments français* (Paris, 1821), n.p.

[3] Alexandre Lenoir, *Description historique et chronologique des monumens de sculpture, réunis au Musée des monumens français*, 5th ed. (Paris, year VIII [1799]), 351, referring to Winckelmann's *Geschichte der Kunst des Alterhums* (Dresden, 1764; translated into French, 1766).

[4] Francis Haskell, *History and its Images: Art and the Interpretation of the Past* (New Haven, 1993), 238.

[5] Louis Grodecki, *Les vitraux de Saint-Denis*, Corpus Vitrearum, France, Études 1 (Paris, 1976), 43.

by 1811, Lenoir could even envision a museum gallery devoted solely to the art of stained glass (a branch of painting for which he faced no competition from the Louvre).[6] Although this gallery was never realized, by the Museum's closing five years later Lenoir could boast that stained glass was installed in all his museum galleries, representing all phases of its development.

Nonetheless, scholars have given little attention to the critical role stained glass played in Lenoir's museum installations; indeed, many of his own writings on the subject have been largely unexplored.[7] This brief paper seeks not to explicate the vast subject that was Lenoir's museum—an institution both admired and reviled in his own day, but rather to specifically focus attention on Lenoir's attitudes towards medieval stained glass and how this outlook developed over Lenoir's career.

From a modern perspective, Lenoir's legacy in the history of stained glass is far from pristine. Under his tenure at the Musée des monuments français, demounted medieval glass languished in storerooms; selected works surreptitiously found their way to the British art market through the auspices of Lenoir's glazier, Jean-François Tailleur; other panels catalogued as part of the museum disappeared into obscurity. With the museum's closing, works were returned to their original sites or transported to the former abbey church of Saint-Denis; others were left in ruin.[8]

6 Paris, Archives du Louvre, Z 62–3, cited by Dominique Poulot, 'Le musée des Monuments français d'Alexandre Lenoir,' in *Patrimoine, Temps, Espace: Patrimoine en place, patrimoine déplacé*, ed. François Furet (Paris, 1997), 108. For conflicts between Lenoir and the Louvre, see Andrew McClellan, *Inventing the Louvre: Art Politics, and the Origins of the Modern Museum in Eighteenth-Century Paris* (Berkeley, 1999), esp. 160–61.

7 Scholars have generally skimmed over the role of glass painting in Lenoir's efforts, citing only the provenance or artist of the glass located in various galleries. See, for example, McClellan, *Inventing the Louvre*, 180; Alain Erlande-Brandenburg, 'Alexandre Lenoir et le Musée des monuments français,' in *Le 'Gothique' Retrouvé avant Viollet-le-Duc*, exhb. cat. Paris: Hôtel de Sully 1979–80 (Paris, 1979), 82–83, and Georges Huard, 'La Salle du XIIIe siècle du Musée des monuments français à l'École des Beaux-Arts,' *La Revue de l'art ancien et moderne* 47 (1925), 113–26. Haskell was unusual in his recognition of the relationship Lenoir posed between stained glass and mood he wished to create. *History and its Images*, 243. Dominique Poulot, in his landmark essay 'Alexandre Lenoir et les Musées des monuments français,' in *Les lieux de Mémoire*, ed. Pierre Nora, 3 vols (Paris, 1984–86) 2: 497–531, overlooked Lenoir's use of stained glass altogether. Two doctoral dissertations have looked at stained glass in Gallery of the Thirteenth Century within the context of larger studies: Anne F. Harris, 'The Spectacle of Stained Glass in Modern France and Medieval Chartres: A History of Practices and Perceptions,' (unpublished diss., The University of Chicago, 1999), 56–67, and Mary B. Shepard, 'The Thirteenth-Century Stained Glass from the Parisian Abbey of Saint-Germain-des-Prés,' (unpublished diss., Columbia University, 1990), 23–38. Less attention has been given to Lenoir's writings on stained glass. Madeline H. Caviness, with the assistance of Evelyn Ruth Staudinger (Lane), *Stained Glass before 1540: An Annotated Bibliography* (Reference Publication in Art History), (Boston, 1983), included three examples in their work: 1, 47, and 129, but there has heretofore been little follow-up. Dominique Poulot, for example, mentions only that Lenoir's museum guides contained discussions of the development of stained-glass technique. *Musée, nation, patrimoine 1789–1815* (Paris, 1997), 316.

8 See, with further bibliography, Grodecki, *Les Vitraux de Saint-Denis*, 45–46; Shepard, 'Stained Glass from Saint-Germain-des-Prés,' 34–53; Christiane Naud, et al., *Sainte Vaubourg au Val de la Haye: Mille ans d'histoire* (Veneux-les Sablons, 1999), 64–65. For Tailleur, see Jean

Contradicting this seeming disregard for the care and preservation of stained glass, Lenoir could also be a tenacious advocate for the medium. In this case, one must view Lenoir's actions against the widespread destruction of medieval monuments and images sanctioned in 1792 by legislation authorizing the eradication of buildings and symbols of the *ancien régime* erected in 'pride, prejudice, and tyranny.'[9] Included among the resulting 'slaughter' of monuments in 1793 (the same year in which Lenoir first published a listing of the depot's holdings), were fifty-one royal tombs at the abbey church of Saint-Denis and the west portal of the Benedictine abbey of Saint-Germain-des-Prés; the cathedral of Paris was put up for sale, while ninety of its jamb sculptures were systematically decapitated and smashed.[10] Whereas Lenoir's duty had been to supervise the storage of art already stripped from suppressed churches, he now turned to saving and salvaging threatened works of art. Stained glass was not exempt. By the year VI (1797–98) with his position at the depot fairly secure, Lenoir facilitated a significant influx of stained glass into the museum, having not only justified its transfer from redundant churches to save panels from damage, but in order to preserve the compositions 'as works useful to the history of art.'[11]

First and foremost, Lenoir was trained as a history painter and thus, it is not surprising that the primary ambition of his gallery installations was to suggest a kind of physical ambiance of the past.[12] His approach was fundamentally more creative and artistic than that of an *archéologue* or *antiquaire* infused with a passion for the picturesque.[13] Rather, we need to consider Lenoir's desire to represent—and I think we need to see it as depicting (in the sense an artist depicts)—what he called 'the character, the exact physiognomy of the century' in question.[14] And in so doing, Lenoir set out to reclaim the past, not with paint or with stone, but with the actual artifacts of the age.

This is not to say he was any kind of an objective historian or even a conscientious recorder of French history.[15] As Dominique Poulot has observed,

Lafond, 'The Traffic in Old Stained Glass from Abroad during the 18th and 19th Centuries in England,' *Journal of the British Society of Master Glass-Painters* 14 (1964): 61.

[9] Louis Réau, *Histoire du vandalisme: Les Monuments détruits de l'art français*, augmented by Michel Fleury and Guy-Michel Leproux (Paris, 1994), 297.

[10] Lenoir, *Notice succinte des objets de sculpture et architecture réunis au Dépôt provisoire national, rue des Petits-Augustins* (Paris, 1793). Réau, *Histoire du vandalisme*, 288, 387, and 381; Carmen Gómez-Moreno, *Sculpture from Notre-Dame, Paris: A Dramatic Discovery*, exhb. cat.: New York and Cleveland, 1979–80 (New York, 1979), 8; and the summary in Haskall, *History and its Images*, 236–41.

[11] Paris, Archives nationales, F21 568, Report from Lenoir to the Minister of the Interior, 2 floréal, year VI. Similarly, see reports dated 3 frimaire, and 4 thermidor, year VI.

[12] See Louis Courajod, *Alexandre Lenoir: Son journal et le Musée des monuments français*, 3 vols (Paris, 1878) 2: 234.

[13] As suggested by Haskell, *History and its Images*, 242.

[14] Lenoir, *Description historique et chronologique des monumens des sculpture réunis au Musée des monumens français*, 6th ed. (Paris, year X [1801]), 5.

[15] Detractors of Lenoir, the most rancorous of whom must be Louis Dimier, *Les impostures de Lenoir* (Paris, 1903), have long taken delight in pointing out his many errors. Dominique Poulot provided a more even-handed historiographic context for Lenoir's approach (and

the vacuum of the Revolution afforded Lenoir the opportunity to both forge and impose his own vision of artistic development in France.[16] Within this matrix, medieval art—including stained glass—could be altered, reconfigured, or 'cut to fit' in order to better convey Lenoir's overarching design. Whereas Stephen Bann argued that Lenoir's proclivity to reuse and adapt original objects 'strongly suggests that he had no overriding notion of historical authenticity,' it is more exact to say that, for Lenoir, historical authenticity was not an end in itself.[17] Rather, he sought to capture the elusive spirit of a particular age—its '*genie*,' and in so doing, the original meaning and function of the art installed in a particular gallery could be subordinated to this all-embracing signification. Accordingly, works functioned less as metonymic devices standing in for their various provenances (as per Bann), than as individual objects that when assembled into a new ensemble (or whole) reflected Lenoir's interpretation of a particular century's artistic essence.[18] In contrast to Andrew McClellan's likening of Lenoir's galleries to 'period rooms,' Lenoir's creations more closely dovetail the work of a twentieth-century installation artist than a museum curator whose goal in constructing a period room is to reflect an accurate disposition of objects related by time and place.[19] It was this approach that, once the need for 'rescuing' art was past, led to Lenoir's relentless desire to acquire in order to further build and enrich the museum's collection.

Lenoir's fascination with stained glass was established early on. In 1795, with the new-found stability of the Directory and growing governmental appreciation for his efforts at the Petits-Augustins (it was to be rechristened as the Musée des monuments français in that year), Lenoir expanded his earlier gallery list into a lengthy guide to the collection, including an appended 'treatise' on stained glass.[20] This *traité* mapped out a format he would use throughout his tenure in which specific examples of stained glass were described in chronological order—from Saint-Denis to Versailles, with the aim of establishing an historical sequence for the art form. Not every case in point was on view at the Petits-Augustins. Rather, each reference represented a particular phase of development, with Abbot Suger's windows at the abbey church of Saint-Denis serving as the baseline. Eschewing any analysis other than classifying the glass

failings) as well as the scholarly reception. 'Alexandre Lenoir et les Musées des monuments français.'

[16] Poulot, *Musée, nation, patrimoine*, 336.

[17] Stephen Bann, *The Clothing of Clio: A study of the representation of history in nineteenth-century Britain and France* (Cambridge, 1984), 84.

[18] Bann, *The Clothing of Clio*, 83–84. Similarly, Harris takes issue with Bann's approach, suggesting that Lenoir was motivated more to portray 'a history understood by its ages and categories.' 'Spectacle of Stained Glass,' 59n10. For a discrete example of an artistic work by Lenoir using original medieval elements, see Mary B. Shepard, 'A Tomb for Abelard and Heloise,' *Romance Studies* 25 (2007), 29–42.

[19] See McClellan, *Inventing the Louvre*, 178 and 182. For the history of period rooms, see Dianne H. Pilgrim, 'Inherited from the Past: The American Period Room,' *The American Art Journal* 10 (1978): 4–23.

[20] Paris, Bibliothèque nationale de France, Estampes, Collection Deloynes, vol. 52, no. 1814, 'Notice historique des monumens des arts … suivis d'une traité de la peinture sur verre' (Paris, year IV [1795]), 80–112.

as uniformly 'Gothic,' Suger's windows were highlighted by Lenoir as providing 'an idea of the state of drawing, painting, and the arts' at the middle of the twelfth century.[21] Such a sweeping appraisal is typical of Lenoir at this moment in time; he paid little attention to subject matter or aesthetic qualities. Stained glass was referred to as an historic object by virtue of its connection to a monument, artist, or patron. Following this schema, strides in its development made by masters like Jean Cousin (the Sainte-Chapelle at Vincennes) or Raphael (whose designs were adapted for a series depicting the story of Psyche at the chateau at Ecouen), were evident in comparison with the Saint-Denis windows, the identity of whose artists were unknown.[22] Supported by this progressive historical framework (as well as the clear absence at this time of any medieval glass in his holdings), Lenoir declared his intention to build an encyclopedic collection—already positioning himself as the champion to rescue 'precious stained glass' like Abbot Suger's windows, which, he warned, were in peril of being vandalized.[23]

Yet, Lenoir's first acquisition of medieval stained glass came not from Saint-Denis, but from the imposing Grande Chapelle de la Vierge, a free-standing chapel built by Pierre de Montreuil between 1244 and 1255 at the Abbey of Saint-Germain-des-Prés. In 1796, Lenoir traded a baptismal font and various other liturgical objects for panels from Saint-Germain-des-Prés, no doubt with the intention of installing them in the first of his chronological rooms, the Gallery of the Thirteenth Century (fig. 27.1).[24] Lenoir had the vaults of this intimate space near the Museum's entrance painted deep blue with golden stars; 'sepulchral lamps' hung at the ceiling's center. The inscription, 'The State of Art in the 13th-Century,' framed the moldings of the gallery's entrance.[25] Into this setting were placed more than thirty-five sculptures, including the trumeau figure of Childebert from the refectory of Saint-Germain-des-Prés and *gisants* from the abbey churches of Saint-Denis and Royaumont. Nottingham alabasters, various altar frontals, and the sumptuous processional cross from the Grands Carmes in Paris punctuated the walls.

The mood Lenoir initially wished to set was one of both mystery and mysticism. Even before the opening of the gallery, he had emphasized in his 1795 essay how medieval stained glass harnessed sunlight, allowing an 'air of mysticism' to permeate a space.[26] He intuitively understood the affecting qualities produced by stained glass which could, in the sense of Edmund Burke's *Philosophical Enquiry into the Origin of our Ideas of the Sublime and Beautiful* (1757, translated into French in 1765), turn viewers away from their rational selves. 'The somber light which illuminates this place,' Lenoir mused

[21] 'Notice historique,' 97.

[22] 'Notice historique'.

[23] 'Notice historique,' 88 and 97.

[24] Jules Guiffrey, *Inventaire général des richesses d'art de la France: Archives du Musée des monuments français*, 3 vols (Paris, 1886), 2: 321–22 and 399.

[25] Lenoir, *Description historique*, 6th ed., 123.

[26] BnF Est., Deloynes, vol. 52, no. 1814, pp. 95–96. See also Lenoir, *Description historique*, 5th ed., 377.

27.1 The Gallery of the Thirteenth Century in Lenoir's Musée des monuments français (detail).

(in contemporary translation), 'is also (in) imitation of the times,' creating a '… magic by which they kept those in a continual state of feebleness whom superstition had struck with terrors.'[27] This atmospheric effect was, for Lenoir, fundamental to capturing the imprint of the Middle Ages: 'I have observed that the more we go back towards those ages which resemble our own, the more the light is spread over public monuments, as if the sight of the sun suited only enlightened men.'[28]

Following this construct, the reverse of 'enlightened' was 'emotional' and 'irrational.' Lenoir employed medieval stained glass in his Gallery of the Thirteenth Century to convey this emotive spirit (particularly in comparison with the stained glass in later galleries which he characterized as the result of *travail raisonné.*'[29]) A somber interior created through the use of stained-glass windows was already a longstanding (and pejorative) signal for the Middle Ages. In 1718, for example, the darkened sanctuaries of the cathedrals of

[27] Lenoir, *Description historique*, 6th ed., 123. For the contemporary translation into English, see Henry Redhead Yorke, *Letters from France*, 2 vols (London, 1804), 2:121.

[28] Lenoir, *Description historique*, 6th ed., 123; Yorke, *Letters*, 121.

[29] Lenoir, *Traité historique et description de vitraux anciens et moderns pour servir à l'Histoire de l'Art en France* (Paris, 1856), 67.

Chartres and Bourges were criticized not only for being out of style, but for hindering the recitation of liturgical offices—even when the sun was at its height.[30] Lenoir not only played upon this association to visually signify the time period embraced by the Gallery of the Thirteenth Century, but also to affect the senses of visitors (just as it had their medieval counterparts) and arouse in them a kind of marvelous awe and dread. Thus inspired, an American traveler could write home to his brother that 'I have been so particular that you might ... *feel* as I have *felt*'[31] (emphases mine). This kind of emotional response stimulated by the gallery's atmospheric qualities allowed Lenoir to bind the disparate artworks on exhibition (not all of which dated to the 1200s) into a cohesive ensemble.[32] William Shepherd, an English tourist who visited the museum on several different occasions, recognized and lauded this effect. Invoking Milton, he described the gallery as pervaded by 'the dim religious gloom ... destined for the reception of the recumbent figures of saints and warriors of the middle ages, (lending) the rude efforts of art an interest which they do not in themselves possess.'[33]

To this end, the glass Lenoir employed was carefully selected; he was not insensitive to how the 'gothic legends' depicted on stained-glass windows functioned as an indication of their antiquity.[34] Of the many panels Lenoir had acquired from Saint-Germain-des-Prés, he chose to install scenes from a series of windows recounting the life and relic history of St Germain of Paris, a sixth-century bishop and titular saint of the abbey (fig. 27.2).[35] Compositions depicting the passion and relic history of St Vincent, the Life of the Virgin, and other corollary Marian windows remained in storage. Early on, Lenoir blandly described the St Germain series as showing 'moral subjects taken from domestic life,' and it would appear that he consciously selected panels that were not overtly hagiographic in appearance.[36] Only two included St Germain dressed in his episcopal regalia; the majority illustrated characters from the saint's childhood or the beneficiaries of his miracles. This kind of excerption dovetailed well with the renewed repression of the Catholic Church during

30 Jean-Baptiste Le Brun des Marettes, *Voyages liturgiques de France* (Paris, 1718), 140, 142, and 227.

31 Robert Gilmore, Baltimore, Maryland Historical Society, Manuscript Division, Gilmore Letterbooks, ms. 387, Vol. 1, Letter 6.

32 In this way, Lenoir did attempt some semblance of historical illusion and integration (as opposed to Bann's argument that the objects exhibited at the museum lacked an 'associative link except what arose from the simple fact of contiguity or juxtaposition.') Bann, *Clothing of Clio*, 83–84.

33 Shepherd, *Paris*, 84. For Milton's reference, see Richard Marks, 'The Reception and Display of Northern European Roundels in England,' *Gesta* 37 (1998): 220 and 224n20.

34 BnF Est., Deloynes, vol. 52, no. 1814, 95.

35 For the stained glass from Saint-Germain-des-Prés, see Shepard, 'Stained Glass from Saint-Germain-des-Prés,' and Jane Hayward, *English and French Medieval Stained Glass in the Collection of The Metropolitan Museum of Art*, ed. Mary B. Shepard and Cynthia Clark, Corpus Vitrearum, USA I, 2 vols (New York, 2003), 1:163–85. There is no evidence that the St Vincent glass was installed in the Gallery of the Thirteenth Century, as claimed in Harris, 'Spectacle of Stained Glass,' 66.

36 Lenoir, *Description historique*, 5th ed., 368.

27.2 Julien Léopold Bouilly, The Gallery of the Thirteenth Century.

the Directory, recalled by the sculptor Louis-Pierre Deseine as a time when the word 'religion' was regarded as 'an enemy of liberty.'[37] This is not to say that Lenoir recognized the true subject matter of the series (indeed it has been explained only recently) and chose to obscure it.[38] Rather, he responded to the anti-clerical climate of the day by consciously selecting those works which were the least inflammatory. As a result, the museum visitor was not distracted by iconography, but could instead focus on the 'crepuscular' imprint created by the medieval windows, especially in contrast to the ever-increasing light and openness of the sequential galleries devoted to the fifteenth and sixteenth centuries, glazed with less-saturated glass from the chapels at Vincennes, Anet, and Ecouen.[39]

For a considerable period of time, this was the rubric under which the development of glass painting in France was presented at the Musée des monuments français. It was not until the height of the Napoleonic wars that the explanation of the windows in the Gallery of the Thirteenth Century changed. In 1806, with Napoleon I ensconced as Emperor, Lenoir reinterpreted the windows as portraying episodes from the life of Blanche of Castile and her son, Louis IX (1214–70), recalling a medieval model of good government and beneficial rule—with obvious analogies to Bonaparte.[40] In this context, Lenoir's earlier mistaken assertion that the panels had come from the refectory of Saint-Germain-des-Prés (destroyed in 1794) took on a new prominence.[41] Perhaps interpolating from an early eighteenth-century reference that the refectory's windows bore the arms of Castile in honor of Queen Blanche of Castile, Lenoir declared the refectory windows to have been made by order of her son, Louis IX. This association, in turn, was made all the more explicit by the extraneous fleurs-de-lis borders Lenoir had added to the Saint-Germain-des-Prés scenes in order to make the panels fit into the pre-existing window openings.[42]

37 BnF Est., Deloynes, vol. 54, no. 1634, pp. 14–16.

38 For the St Germain cycle, see Mary B. Shepard, 'The St. Germain Windows from the Thirteenth-Century Lady Chapel at Saint-Germain-des-Prés,' in *The Cloisters: Studies in Honor of the Fiftieth Anniversary*, ed. Elizabeth C. Parker and Mary B. Shepard, (New York, 1992): 282–301, and Mary B. Shepard, 'The Relics Window of St. Vincent of Saragossa at Saint-Germain des Prés,' *Gesta* 37 (1998), 261–63 and 264n22.

39 McClellan has pointed out Lenoir's use of graduated lighting. *Inventing the Louvre*, 182, 263n82. For Renaissance art as the apogee of French style, see Lenoir, *Traité historique*, 67–88, and also Poulot's discussion in *Musée, nation, patrimoine*, 316–17.

40 Nor was this the only instance of Lenoir's implied coupling of Louis IX and Napoleon I; a topic I am exploring in a book on Lenoir's interpretation of medieval art at the Musée des monuments français. For his later interpretation, see Lenoir, *Description historique et chronologique des monumens de sculpture, réunis au Musée des monumens français*, 8th ed. (Paris, 1806), 46.

41 Lenoir, *Description historique*, 5th ed., 368. Regrettably, this misattribution has been perpetuated by modern scholars, see for example, Huard, 'Salle du XIIIe Siècle,' 118, and Philippe Verdier, 'The Window of St. Vincent from the Refectory of the Abbey of Saint-Germain-des-Prés (1239–44),' *The Journal of the Walters Art Gallery* 25–26 (1962–63), 38–99.

42 Lenoir, *Traité historique*, 61–62. For the Saint-Germain-des-Prés refectory windows, see Dom Jacques Bouillart, *Histoire de l'Abbaye Royale de Saint-Germain-des-Prés* (Paris, 1724), 123. For the fleur-des-lis borders (acquired by Lenoir in 1793), see Shepard, 'Stained Glass from Saint-Germain-des-Prés,' 33–34.

From the time of Bonaparte's ascendancy, Louis IX increasingly became a pivotal figure in Lenoir's interpretation of medieval art. He fervently (and tenaciously throughout his life) believed that the pointed arch—widely recognized at the time as the defining element of Gothic architecture—had been brought to France by Louis's crusaders returning from the Holy Land.[43] For Lenoir, the king's private chapel—the Sainte-Chapelle—was a paradigm of Eastern influence, representing 'a perfect imitation of Arab monuments' which the architect had clearly studied while on crusade. The impact of so-called Arab models upon French artists included not only the borrowing of the pointed arch, but the signature effect of stained-glass windows. 'One admires the magical effect of stained glass,' Lenoir observed, 'which when it hits the sunlight reflects its vibrant and varied colors upon the paintings and the gilding ornamenting the columns and vaults (of the building).' It was this impression of the 'mystical colors' produced by stained glass that Lenoir saw as something completely new in French art—a 'foreign physiognomy' that distinguished buildings created following Louis's return from the Levant.[44]

Lenoir sought to specifically elucidate this viewpoint in the Gallery of the Fourteenth Century, one of the last of his museum galleries to be opened to the public and finished only in 1809—the same year in which he published a new, more comprehensive essay on the history of stained glass.[45] The installation of the tribune arcade from the Sainte-Chapelle, under whose arches Lenoir set up six of the chapel's twelve sculptures of the apostles (fig. 27.3) together with twenty *gisants* (predominately from Saint-Denis) vertically aligned around three of the gallery's walls and under an ogive dado arcade also removed from the abbey church conspicuously emphasized the pointed arch.[46] Positing (incorrectly) that the Sainte-Chapelle was erected at the end of the thirteenth century after Louis's return from crusade, Lenoir's intent was to make manifest his belief in the arrival in France of 'a new style of decoration … in the Arab taste.'[47] In his mind, artists in the king's retinue, having been inspired by Arab models, created majestic structures like the Sainte-Chapelle with interiors 'laden with gilding, glasswork and brilliant color, [exhibiting] the most imposing extravagance.'[48]

43 See, for example, Alexandre Lenoir, 'Sur l'origine de l'architecture appelée improprement gothique,' *Mémoires de l'académie celtique* 3 (1809), 349–51. The relationship between the pointed arch and Lenoir's understanding of medieval art is the subject of a separate study; see my forthcoming article 'L'Oeuf Sacré: Alexandre Lenoir's *Cour Arabe* and the Pointed Arch,' in *Medieval Art and Architecture after the Middle Ages*, ed. Alyce Jordan and Janet Marquardt (Cambridge Scholars Press).

44 Lenoir, 'De l'architecture Syrienne,' in BnF Est., Ya2 151–8, 4:116; and Lenoir, *Musée des monumens français*, 8 vols (Paris, year X [1802?]), 3:8.

45 For the Gallery of the Fourteenth Century, see A.N., F21 567, Report by Lenoir outlining work completed in 1809. Lenoir, 'Sur l'ancienne Peinture sur verre … depuis l'époque de son invention jusqu'à nos jours,' *Mémoires de l'académie celtique* 3 (1809): 238–66.

46 For Lenoir's removal of the dado arcade at Saint-Denis, see Caroline Astrid Bruzelius, *The 13th-Century Church at St-Denis* (New Haven, 1985), 184n40.

47 Lenoir, *Description historique*, 6th ed., 146.

48 Lenoir, *Description historique*, 6th ed., 146.

MUSÉE DES MONUMENS FRANÇAIS.

1ᴿᴱ VUE DE LA SALLE DU XIVᵉ SIÈCLE.

27.3 The Gallery of the Fourteenth Century.

MUSÉE DES MONUMENS FRANÇAIS

27.4 The Saint-Denis Griffin Windows as installed in the Gallery of the
Fourteenth Century (detail).

Lenoir sought to invoke this splendor by installing stained-glass panels
excerpted from Abbot Suger's Tree of Jesse and the ornamental Griffin
windows (figs. 27.4 and 27.5), which he had finally demounted in 1799.[49] This
seemingly incongruous choice demonstrates the relative meaning of chronology
for Lenoir. It reveals not so much an act of ignorance as the overriding
ambition in his installations to capture a decisive aesthetic moment. The
vibrant coloring and patterning of the glass won out over the incongruity of
its twelfth-century date, of which he was fully aware.[50] Calling the panels

[49] Saint-Denis panels were not installed in the Gallery of the Thirteenth Century as per
Harris, 'Spectacle of Stained Glass,' 57. For work on the glass prior to exhibition, see A.N., F
21 568, memoranda of 13 messidor year X, and n.d. germinal an X. In his memoirs, the abbey's
organist, Ferdinand Gautier, confirmed that Lenoir removed stained glass from the 'temps de
Suger' in September of 1799. BnF ms. fr. 11681, fol. 129. While Grodecki believed that Lenoir's
mention of the Sugerian glass in his 1795 essay indicated that he had already removed the
glass to his museum (*Vitraux de Saint-Denis*, 43), Lenoir clearly differentiated between the
glass then on view and early exempla of the medium. By the year X (1801–1802), he indicated
that Saint-Denis glass, albeit from the nave, was at the museum (Lenoir, *Description historique*,
6th ed., 365). This may be a reference to the grisaille panels with fleurs-de-lis (1320–24) Jane
Hayward suggested originated in the nave chapel of St Louis, also removed by Lenoir (*English
and French Medieval Stained Glass*, 1:244–46).

[50] While he had acknowledged the provenance and mid-twelfth-century date for the
Sugerian glass in 1795, (BnF Est., Deloynes, vol. 52, no. 1814, p. 97), its provenance was not

27.5 The Saint-Denis Tree of Jesse Window as installed in the Gallery of the
Fourteenth Century (detail).

'arabesques,' Lenoir emphasized the repetition of their design as well as the
striking interplay of geometric shapes in their compositions—no doubt a
pointed reference to the Griffin windows.[51] Once again, Lenoir's deliberate
choice of stained glass demonstrated that historical accuracy was less
important than capturing the '*genie*' of the century; that the original meaning
and provenance of stained glass could be subsumed into the overall import
of a gallery's theme.[52]

At the same time, this connection with the East was bolstered by Lenoir's
inquiry into the technical development of stained-glass manufacture. He
believed the assemblage of varied and vivid colors in windows—appearing
like 'a *parterre* enameled with flowers'—suggested its derivation from
decorative work such as mosaic: 'I also think that the fortunate use of mosaic
in interior decoration instigated the invention of painting on glass.'[53] Besides

mentioned in subsequent catalogues. Instead, the rich patterning of the panels was
emphasized. Lenoir, *Musée Impérial des monumens français* (Paris, 1810), 297.

[51] Lenoir, *Traité historique*, 62–64.

[52] This is admittedly a more positivist assessment than McClellan's, who saw in Lenoir's
assemblages 'an exotic concoction intended to be more impressive than the sum of its parts.'
Inventing the Louvre, 183.

[53] Lenoir, 'Sur l'ancienne Peinture sur verre,' 239.

their analogous palettes, stained glass and mosaics were, in his estimation, distinguished by a similar technique of joining colored glass together by means of metal cells.[54] Lenoir later claimed: 'It is justified that I have given the name of *transparent mosaics* to these paintings.'[55] To further prove the point, he placed what he called 'an Arab paving from Saint-Denis' in the Gallery of the Fourteenth Century in clear association with the Sugerian glass.[56]

In shaping an understanding of the art of stained glass, Lenoir came to approach the problem taxonomically, citing specific examples from the museum to convey the idea of an encyclopedic collection.[57] Medieval glass, he contended, represented the 'simple' stage in the development of the art form in which the glass was literally 'stained' with color. This practice separated medieval productions from later stained glass which was characterized by the firing of enamel or color onto 'a single piece of glass.'[58] 'Our bygone masters of the art,' Lenoir proclaimed, had to join pieces of glass together with lead for two reasons: They were unaware of how to color large plates of glass as well as how to stain a single piece of glass with two colors. In Lenoir's mind, it was the very difficulty of creating stained glass 'in the old manner' that merited its admiration.[59] He outlined the stages in its manufacture from the creation of a cartoon, to choosing the pieces of glass in order to meet the patron's specifications, to painting on each piece of glass—matching the parts of figures or drapery folds or delicately scratching lines in the paint to highlight strands of hair or folds in clothing, to the final assembly into a recognizable image with leads joining the pieces together.[60] The result of this analysis was a developing (often grudging) appreciation for medieval stained glass as a veritable branch of painting.[61] While Lenoir confessed 'I am far from praising the design' of twelfth-century stained glass, he asserted its embodiment of lofty character, with colors that were 'as beautiful as those in the stained glass of Jean Cousin.'[62] Accordingly, he singled out Suger's panels from Saint-Denis as possessing the power to both affect and uplift one's sensibilities.[63]

Yet, one must balance this emerging regard with the fact that Lenoir never wavered from a belief in the superiority of later glass and its rendering of

[54] Lenoir, 'Sur l'ancienne Peinture sur verre,' 239 and Lenoir, *Traité historique*, 64.

[55] Lenoir, 'Observations sur une nouvelle exposition de peintures sur verre,' *Journal des artistes* 1 (1827),. 252.

[56] A.N., F21 568, Proposed work for the year X, p. 2. See also Lenoir, *Description historique*, 6th ed., 142–43.

[57] As early as 1801, Lenoir proposed assembling a comprehensive collection by removing glass from churches and replacing it with white glass. A.N., F21 568, Memorandum from Lenoir, 28 nivoise year IX. See Shepherd, *Paris*, 226, for praise of Lenoir's endeavors.

[58] Lenoir, 'Sur l'ancienne Peinture sur verre,' 240, and 241. He consistently differentiated between the techniques of fusing color into glass and painting enamel onto the surface. See Lenoir, 'Observations,' 185, 188, and 252, including experiments by painters Jean-Charles Develly and Charles Mortelet.

[59] Lenoir, 'Sur l'ancienne Peinture sur verre,' 244.

[60] Lenoir, 'Sur l'ancienne Peinture sur verre,' 244–5.

[61] Lenoir, 'Sur l'ancienne Peinture sur verre,' 258.

[62] Lenoir, 'Sur l'ancienne Peinture sur verre,' 241.

[63] Lenoir, 'Sur l'ancienne Peinture sur verre,' 242. See also Lenoir, 'Observations,' 252.

painterly effects. The work of Jean Cousin was lauded as a great leap in advance of medieval techniques: 'The drawing is more correct, the expressions truer and better expressed.' [64] He described sixteenth- and seventeenth-century painting on glass as exhibiting 'grace' and 'finesse,' with charming facial expressions and draperies rendered in an 'exquisite style.'[65] This bias was similarly reflected in Lenoir's private collection. While he personally owned medieval objects of the highest quality, such as the ivory Virgin and Child (around 1250–60) from the Sainte-Chapelle, the twelve panels of stained glass included in the 1836 sale of his private collection overwhelmingly dated to the sixteenth century, including one of his favorites, an oval panel painted in enamel with 'Charles IX and the Queen mounted upon the same horse and hunting.'[66]

What is evident in this kind of hierarchy is Lenoir's positioning of medieval stained glass to provide the incipient foundation for the French claim to its invention. Later in life with the Musée des monuments français behind him, Lenoir felt compelled to respond to an 1826 exhibition in Paris of British paintings on glass to counter any misconceived claim regarding the discovery of stained glass. 'The English did not invent the art of painting on glass!' he declared emphatically.[67] His outrage—particularly at how English examples were offered as models for 'our French artists … to consult' —was based upon his longstanding belief, first articulated in 1809, in the French creation and mastery of the art.[68] By outlining the long continuity of making stained glass in France, beginning with Suger's descriptions of the glass made under his direction at Saint-Denis and extending to contemporary works decorating the 'boudoir of a pretty woman,' Lenoir asserted that stained glass was an art form that had never died out in France.[69] Rather, he affirmed, it was an art that 'we invented, and that we have not ceased to practice for more than eight centuries.'[70] The encyclopedic collection at the Musée des monuments français served as physical proof, destroying 'the hope of foreigners who would have the pretension to compete with [French painters].'[71]

Lenoir came to see himself as building upon these historical achievements to facilitate the vibrancy of an indigenously French art form. Incredulously, he pointed out that the Germans (and later the English)—'foreign charlatans'—had been credited in with the revival of stained glass.[72] It was the very antiquity of stained glass in France, he argued—once demonstrable in the halls of the Musée

[64] Lenoir, *Musée Impérial*, 298.

[65] Lenoir, *Musée Impérial*, 300–301.

[66] *Catalogue des antiquités et objets d'art qui composent le cabinet de M. Le Chevalier Alexandre Lenoir*, 11 décembre 1837 (Paris, 1837), 27n230.

[67] Lenoir, 'Observations,' 185. For the exhibition, see Hervé Cabezas, 'Recherches sur la renaissance du vitrail peint à Paris entre 1800 et 1830,' in *Les Arts du verre: Histoire, technique, et conservation* (Toulouse, 1991), 49.

[68] Lenoir, 'Oberservations,' 183; see also 185 and 268–69.

[69] Lenoir, 'Sur l'ancienne Peinture sur verre,' 255.

[70] Lenoir, 'Sur l'ancienne Peinture sur verre,' 266, and Lenoir, 'Observations,' 185.

[71] Lenoir, 'De la Peinture sur Glace,' *Journal des Artistes* 1 (1827): 316.

[72] Lenoir, 'Sur l'ancienne Peinture sur verre,' 265–66; Lenoir 'Observations,' 188.

des monuments français—that proved such assertions false. Not only had the windows installed in the museum served to teach young artists, their exhibition had kept the art form alive and inspired new creations celebrating the glory of France.[73]

Lenoir's efforts indeed did bring a new attention to medieval stained glass. Even in his own lifetime, Lenoir was recognized by Eustache-Hyacinthe Langlois, the President of the Academy of Rouen and the author of the important *Essai historique et descriptif sur la Peinture sur Verre* (1832), as having had as significant an influence as the pioneering theorists Pierre Le Vieil, author of one of the first systematic histories of the medium, and Winckelmann.[74] After Lenoir, stained glass was no longer relegated to vague descriptions of its effulgent effects, but came to be increasingly appreciated for both its historical significance and technical achievements. While he judged the medieval rendering of figures to be 'simple' and the style of its painting 'severe,' Lenoir also came to appreciate the power of medieval compositions, likening them to the grandeur of late Roman art.[75] In this way, he forcefully argued for the recognition of medieval stained glass within the history of French art. Its validity was proven by the very continuity of the art form. Writing a decade after his museum was closed, Lenoir asserted the legacy of his endeavors: 'The rich collection of paintings on colored glass on view at the Museum [of French monuments] … inspired in French and foreign artists the idea of restoring an art form which people of the world had considered lost.'[76]

73 Lenoir, 'Sur l'ancienne Peinture sur verre,' 258–59.

74 E.-H. Langlois, *Essai historique et descriptif sur la Peinture sur Verre* (Rouen, 1832), 3. Pierre Le Vieil, *L'Art de la peinture sur verre et de la vitrerie* (Paris, 1774).

75 Lenoir, 'Observations,' 252.

76 Lenoir, 'Observations,' 187.

PART NINE

Politics and Ideology

Pathos and Politics: Nicholas Love's *Mirror* and Mel Gibson's *The Passion of the Christ*

Sarah Stanbury

As critics remarked in a virtual flood of pre- as well as post-release critical commentary, Mel Gibson's film, *The Passion of the Christ*, gives an excruciating amount of airtime to Christ's scourging. For the viewer, one even prepared by the media buzz for a harrowing spectacle of violence, the discomfort of watching the scourging is compounded by a few surprise elements, as if the sheer amount of time that we are forced to sit in our seats watching were not enough. One of these surprises comes when whips are replaced by flails. Pilate has sentenced Jesus to punishment—and it seems, after a few long minutes, that the punishment is over. But when Jesus staggers to his feet, a fore-shadowing, no doubt, of his body's superior power, Pilate orders that the scourges begin anew. This time they choose not whips but nail-studded flails that literally shred Christ's skin. But at least as painful is the camera's attention to Jesus's mother's reactions to her son's torture. For most of the scene the camera concentrates on the gleeful faces of the torturers and on Jesus's progressively mutilated body as it receives each blow, but it also cuts briefly to show the crowd, in particular Mary, who is performed powerfully by Maia Morgenstern, and Mary Magdalene as a kind of younger version of herself. As the scourges test out their flails, Jesus and his mother exchange looks across the crowd. Later, as the blows continue, she wanders through an arcade. As we listen to the sounds of torture—the swish of the flails through the air, the socking sounds as the flails make contact with skin, Jesus's groans, the hooting of the crowd, and especially the tallying of blows ('viginti otto' …)—the camera cuts to Mary's face.

How can she bear to listen and watch? If we are uncomfortable, we ask ourselves—as the camera shifts to her face—how can a mother bear it? Aren't there some things, such as your child's execution, you should never have to see? Mary's presence, however, is a continuous one, and as the film progresses we understand she has no choice. Her love for her son requires her presence, even at his death. She is there among the crowd as people call 'Crucify him.' She is one of the crowd of onlookers as he carries his cross to Calvary, even taking a shortcut to bypass the crush. At the Crucifixion the camera cuts several times to her face as she watches with Mary Magdalene. At the end of the film,

after Christ has been taken from the cross, she holds his body and looks out to meet the viewer's gaze, a shot that is carefully composed to echo centuries of devotional art. She becomes the mother in the pietà.

The pietà is so deeply iconic that it does not require a degree in art to recognize this moment in the film through its visual history. How our familiarity with a film's story affects our reception is a complex topic—and a question that is especially pertinent to Gibson's film, where virtually all viewers will know at least part of its narrative; if little else, most will know how the story ends. For viewers who are also acquainted with medieval art and literature, not only Gibson's pietà but also his entire film comes as a déjà vu. If there is a single story retold again and again in sermons, drama, lyric, and didactic literature, pictured in wall paintings and in stained-glass windows, and carved in stone, it would be story of Christ's Passion—his death and resurrection. In late medieval Europe, many of the episodes that Gibson has used for his film—the Betrayal, the Flagellation, the Carrying of the Cross, the Crucifixion and the Deposition—were pictured virtually everywhere one would find images.[1] Mary's presence forms an important node in these narrative traditions. Although Mary is rarely present at the flagellation in medieval art, she is invariably to be found at the foot of the cross in representations of the Crucifixion, sometimes even pointing to Christ's wounds.[2] Her presence here forms a sub-genre of late medieval Passion representation in both literature and the visual arts. In some traditions she swoons;[3] in some she turns away and averts her gaze.[4] In images of the Man of Sorrows, she studies and displays her son's wounded body, sometimes even appearing to engage in dialogue with him.[5] Playing 'Passion' as compassion, Mary's dialogue with Jesus on the

[1] There is an immense literature on the representation of the Passion in the Middle Ages including Ellen M. Ross, *The Grief of God: Images of the Suffering Jesus in Late Medieval England* (New York, 1997); Vincent Gillespie, 'Strange Images of Death: The Passion in Later Medieval English Devotional and Mystical Writings,' in *Zeit, Tod, und Ewigkeit in der Renaissance Literatur*, ed. James Hogg, Analecta Cartusiana 16 (Salzburg, 1987), 111–56; Sarah Beckwith, *Christ's Body: Identity, Culture and Society in Late Medieval Writings* (New York, 1993); and for a discussion of images in religious contemplation, Jeffrey Hamburger, 'The Visual and the Visionary: The Image in late Medieval Monastic Devotions,' *Viator* 20 (1989), 161–204.

[2] Ross, *Grief of God*, 52.

[3] For the swooning Virgin, see Gertrud Schiller, *Iconography of Christian Art*, 2 vols (Greenwich, Conn., 1968), 2:153–7 and Figs. 509, 511, 512, and 517. The swooning Virgin is frequently represented in fifteenth-century English alabasters; see Francis Cheetham, *Alabaster Images of Medieval England* (Woodbridge, Suffolk 2003), Figs. 50, 54–63.

[4] See in Schiller, *Iconography of Christian Art*, 2, a Crucifixion in a late thirteenth-century Psalter, Fig. 453; and a thirteenth-century rood screen in Naumburg Cathedral, Figs. 481–2; and see examples in Margaret Rickert, *Painting in Britain in the Middle Ages* (London, 1954): a Crucifixion in the Lytlington Missal (1383–84), 154; and a Crucifixion in an early fifteenth-century Missal by Herman Scheere, 167. It is not always clear whether Mary is turning away or swooning.

[5] For images of the Virgin with Man of Sorrows see Schiller, *Iconography of Christian Art*, 2, Figs. 730–47; and for apparent dialogue between the Virgin and Man of Sorrows see esp. Fig. 736, a Man of Sorrows by Lorenzo Monaco, 1404; and Fig. 745, a 1524 painting by Lucas Cranach from Freiburg im Breisgau; and also the exhibition catalogue by Francis Cheetham, *Alabaster Men: Sacred Images of Medieval England* (London, 2001), Fig. 12.

cross has a vital life in medieval lyrics in the *planctus* tradition, many of which brilliantly exploit dramatic possibilities: the mother, fainting with grief, tells her son she can't bear to see him suffer; and the son, dying, responds that he can't bear to watch her suffering for his sake.[6] The Virgin's presence is so central to medieval representations of the Passion—and so crucial to acts of witnessing in Gibson's film—that we might ask how the spectacle of her gaze, the spectacle of her participatory spectatorship, shapes the viewer's responses. Why, in the history of Passion pictures, has it been so important to experience Christ's death through the gaze of his mother?

In the forward from a volume of photographs from the film, Gibson comments that 'Holy Scripture and accepted visions of The Passion were the only possible texts I could draw from to fashion a dramatic film.'[7] 'Accepted visions' include those of German nun Anne Catherine Emmerich (1774–1824), whose meditations, *The Dolorous Passion of our Lord Jesus Christ*, were transcribed in the 1820s. The details of this lengthy meditation on the Passion are so close to Gibson's film, in fact, as to suggest that Gibson owes not only credit to Emmerich's estate but also royalties. Emmerich imagines herself present at the Passion. She speaks as a witness:

When the executioners took Jesus into the guardhouse, to crown him with thorns, I longed to follow that I might again contemplate him in his sufferings. Then it was that the Mother of Jesus, accompanied by the holy women, approached the pillar and wiped up the blood with which it and the ground around were saturated. The door of the guard-house was open, and I heard the brutal laughter of the heartless men who were busily employed in finishing off the crown of thorns which they had prepared for our Lord. I was too much affected to weep, but I endeavoured to drag myself near to the place where our Lord was to be crowned with thorns.[8]

In this scene, which Gibson has followed closely, Emmerich adopts the persona of a member of the crowd. She watches Mary and the holy women as she takes on the job of recording events and feeling pain.

Yet many of Gibson's less-acknowledged debts can be located between the writing of the Gospels and Emmerich's visions. Emmerich's *Dolorous Passion* derives from apocryphal sources, the most important of which is the *Meditationes Vitae Christi*, or *Meditations on the Life of Christ*. This prose work, of which Gibson appears to have been unaware, is believed to have been written by the Franciscan Johannes de Caulibus in San Gimignano in the fourteenth century, was one of the most widely read and translated texts of the late Middle Ages, and had an influence on later art, drama, and devotional literature that

[6] Sandro Sticca, *The Planctus Mariae in the Dramatic Tradition of the Middle Ages*, tr. Joseph R. Berrigan (Athens, 1988), 71–101; for dialogue in Middle English laments see Sarah Stanbury, 'The Virgin's Gaze: Spectacle and Transgression in Middle English Lyrics of the Passion,' *PMLA* 106 (1991), 1083–94; Rosemary Woolf, *The English Religious Lyric in the Middle Ages* (Oxford, 1968), 239–73.

[7] Ken Duncan, *Passion: Photography from the Movie 'The Passion of the Christ*,' http://www.leftbehind.com/channelbooks.asp?pageid=916&channelID=198.

[8] Anne Catherine Emmerich, *The Dolorous Passion of Our Lord Jesus Christ*, ed. and trans. George D. Smith (Westminster, 1928), ch. 25, sect. 218; http://www.emmerich1.com/DOLOROUS_PASSION_OF_OUR_LORD_JESUS_CHRIST.htm.

critics have labeled 'incalculable.'[9] Some viewers of Gibson's films have remarked that the film owes a debt to medieval Passion plays; that is certainly true, but much of the iconography in medieval drama was based itself on the *Meditations*. The work can be thought of as the *urtext* for representations of Christ's life and death as those scenes have appeared in stained glass, panel painting, and manuscript illumination since the time of its writing. The *Meditations* also provided specific scenes and narrative form for countless reprisals of Christ's life story in drama and devotional literature from the late Middle Ages even to the present day. St Ignatius Loyola's *Spiritual Exercises* (1520s through 1540s) are based in large measure on the Meditations;[10] modern Christmas pageants as performed by millions of children throughout the world today are also a direct legacy.

This long work of instruction is a guided meditation, laced with homiletic interludes, on the events of Christ's life and death. A narrator explains in the Prohemium to the Meditations that to understand Christ it is important to imagine his life, even if we go beyond the exact text of the Gospels.[11] When the narrator interrupts the homily to describe the sequential events of the life of Christ, he does so through instructions on how to watch: the voice is direct and personal as it tells us how to imaginatively 'behold' the Angel receiving his instructions from God, or how to imagine the scene when Gabriel comes to Mary: 'Let us pause here and remember what I told you in the beginning, that you must learn all the things said and done as though you were present. Thus here you may imagine God and regard Him as best you can. …'[12] Like the Virgin in Gibson's film—and also like the narrator in Emmerich's Dolorous Passion—we take on the role of witness, both feminine and feminized, emotionally present at the Annunciation, the Nativity, the Raising of Lazarus, and especially the Crucifixion, as I discuss below. Where the medieval Meditations differs from Emmerich's Dolorous Passion is in the use of person; Emmerich uses a first-person 'I' to tell us precisely how she sees the Passion unfold, while the narrator in the earlier Meditations adopts the voice of a priest directing us in second person ('you') exactly where to stand and how to watch:

With your whole mind you must imagine yourself present and consider diligently everything done against your Lord and all that is said and done by Him and regarding Him. With your mind's eye, see some thrusting the cross into the earth, others equipped with nails and hammers, others with the ladder and other

9 The text has recently been edited by M. Stallings-Taney: *Johannis de Caulibus, Meditaciones Vite Christi (olim S. Bonaventuro attributae)* (Turnhout, 1997). A possible date of 1376 is given by Michael Sargent, ed., *Nicholas Love's Mirror of the Blessed Life of Jesus Christ: A Critical Edition* (New York, 1992), xix. On the importance of the *Meditations* see John Fleming, *An Introduction to the Franciscan Literature of the Middle Ages* (Chicago, 1977), ch. 6, pp. xix–xx; and Elizabeth Salter, *Nicholas Love's 'Myrrour of the Blessyd Lyf of Jesu Christ,' Analecta Cartusiana*, vol. 10 (Salzburg, 1974), 103.

10 John W. O'Malley, *The First Jesuits* (Cambridge, Mass., 1993), 25 and 46.

11 For an accessible translation, see *Meditations on the Life of Christ: An Illustrated Manuscript of the Fourteenth Century*, trans. Isa Ragusa and Rosalie B. Green (Princeton, 1961), 5.

12 Ragusa and Green trans., *Meditations on the Life of Christ*, 15–16.

instruments, others giving orders about what should be done, and others stripping Him.[13]

Emmerich, who pictures these scenes in first person, thus performs the mandate of the Meditations; told to imagine Christ's life, she presents her vision as a direct experience. In both of these sources—and in Gibson's adaptation as well—seeing also becomes the reader's ethical and devotional mandate.[14]

My interests in these Passion remakes center on the social and even political uses of empathy and horror as those emotions are transferred from internal viewers to the audience. How do writers or film directors use visual theater to move the emotions and desires of their audiences? By quickening our emotional responses, how do texts and visual media make us want what we want? This essay first explores the uses of witnessing in the Meditations, taking a particular look at an early fifteenth-century English translation and adaptation, the *Mirror of the Life of Christ*, by Nicholas Love, a Carthusian prior, and then using it as a lens through which we can then examine Gibson's feminization of pathos.[15] How does the narrator organize and socialize his reader by telling that reader where to be, what to look at, and how to feel about it? I have chosen Love's translation of the Meditations from a large set of vernacular versions, because it offers a particularly striking example of the way a text can be reprised to address issues of its own time. Gibson and Nicholas Love both use the Passion to stir their audiences toward faith communities; both also guide the audience's emotions and sense of the sacred in the service of conservative social and political agendas. They differ strikingly, however, in their uses of the Virgin and of the Virgin's participatory gaze as a filter for our emotions. For Love, the Virgin's presence works to redefine the community of the faithful as a new form of family unified against enemies of the Church and even the state. For Gibson, the Virgin's gaze and presence at scenes from the Passion serve to sacralize a particularly masculine, and particularly twenty-first century, idea of martyrdom.

Extant in over fifty manuscripts, the *Mirror*, the first complete translation of the Latin Meditations,[16] was extremely popular in fifteenth- and sixteenth-century England, serving as an important iconographic mine for pre-Reformation English drama and devotional art.[17] Love's version of the Meditations is fascinating as a popular, vernacular text that was written to further specific religious interests—and perhaps political ones as well. This work was probably published in 1410, just one year after Archbishop Arundel had circulated a set of Constitutions condemning as heretical the ownership of all books associated

[13] Ragusa and Green trans., *Meditations on the Life of Christ*, 333.

[14] Margery Kempe, in her spiritual autobiography from the early fifteenth century, makes a similar use of the *Meditations*: *The Book of Margery Kempe*, ed. Barry Windeatt (Harlow, England, 2000), ch. 79–81.

[15] The *Mirror* has been edited by Michael G. Sargent in two versions: *The Mirror of the Blessed Life of Jesus Christ: A Reading Text*, (Exeter, 2004); and a *Critical Edition*. Citations are taken from the *Critical Edition*.

[16] Salter, *Nicholas Love's 'Myrrour,'* 45.

[17] Sargent, *Mirror*, xlv; Kantik Ghosh, *The Wycliffite Heresy: Authority and the Interpretation of Texts* (Cambridge, 2002), 147–48.

with the important Oxford theologian John Wyclif. Particularly targeted in this censorship campaign were English translations of the Gospels by Wyclif and his followers. The Lambeth Constitutions imposed, it has been argued, some of the most draconian acts of censorship in English history.[18] Just a few years before the Mirror was published, heresy had become a capital offense, with burning the punishment of choice. Lollardy, as this reformist movement was called, had apparently become a significant enough threat to the established church as to merit classification as an official heresy, punishable by death.

Nicholas Love's narrative circulated in the fifteenth century, not only as a work of religious meditation and instruction, but also as a social and even political text. As Paul Strohm has argued, Lollardy may have offered usurper Henry IV a convenient enemy as he worked to solidify the legitimacy of his dynastic claims.[19] The same Archbishop who outlawed Lollard texts in 1409 gave, in 1410, his stamp of approval to Nicholas Love's Mirror, a gesture suggesting that Love's version of the Meditations might even have been written in part to order, commissioned as an English gospel narrative to counter to the newly outlawed vernacular Bible.[20] The margins of many manuscripts contain the annotation, presumably by Love, 'contra lollardos'—to indicate where Love has added text defending certain church rituals or beliefs that the Lollards opposed. You are a good Christian or else you are a heretic—that is, you are a Lollard. And in the Passion sequence, this division separating Us from Them is dramatized through the narration of the death of Christ. We live our orthodoxy not only through the articles of the faith but also by active participation in its story—through our mirroring, in our acts, of its 'life.' We are with the faithful (which means positioned with Mary, Mary Magdalene, and John) or else we are an enemy, maybe one of the torturers. In early fifteenth-century Lancastrian England, Church and royal power were closely allied; and it is in this sense I suggest that Love's Mirror uses pathos for politics. This work, in compelling ways, uses a holy family romance to make us want to be part of that family—the community of the faithful—and perhaps even good subjects of the nation, a metaphorical family, as well.

The section on the Passion gives a vivid demonstration of orchestrated devotional witnessing. In medieval Passion plays and visual arts this scene is often vividly dramatized, with the workers who are doing the nailing pictured as both vulgar and efficient.[21] Gibson's scene of the Crucifixion follows directly

[18] See especially Nicholas Watson, 'Censorship and Cultural Change in Late-Medieval England: Vernacular Theology, the Oxford Translation Debate, and Arundel's Constitutions of 1409,' *Speculum* 70 (1995): esp. 825–30; Ghosh, 212–13; James Simpson, *Reform and Cultural Revolution*, The Oxford English Literary History, vol. 2, 1350–1547 (Oxford, 2002), 378.

[19] Paul Strohm, *England's Empty Throne: Usurpation and the Language of Legitimization 1399–1422* (New Haven, 1996), 32–62; Simpson, *Reform and Cultural Revolution*, 395; Sargent, *The Mirror: A Reading Text*, xvii.

[20] Jonathan Hughes, *Pastors and Visionaries: Religion and Secular Life in Late Medieval Yorkshire* (Woodbridge, Suffolk, 1988), 230–35; Watson, 'Censorship and Cultural Change,' 852–53.

[21] Jesus's stretched arm nailed by crude-faced workers appears in stained glass at the Church of St Peter, Stockerston, Leicestershire; see Sarah Crewe, *Stained Glass in England 1189–1540* (London, 1987), Fig. 30.

in this tradition. In the Mirror, the description of how Jesus was nailed to the cross takes up fifty-five lines. As a preamble to them, the narrator states that we are meant to visualize this process in detail:

Take heed now with all your heart, all the things that are come to pass, and make yourself present there in your mind, beholding all that shall be done against your lord Jesus and that has been spoken or done against him. And so with the inner eye of your soul behold some people setting and fixing the cross firmly in the earth. Some preparing the nails and the hammers to drive them with. Others preparing and setting up ladders, and choosing other instruments that they think necessary, and others hurrying about to strip him and take off his clothes. And so is he now for the third time stripped and stands naked in sight of all those people, and so now for the third time the bruises of his wounds from his scourging are renewed by the tearing of his clothes from his flesh.[22]

Right after this we are told that his mother is there at the cross as well, watching and responding with shame and horror: 'Now first his mother also sees how he is taken this way and ordained to death. Wherefore she is immeasurably sad and full of shame to see him standing all naked.'[23] Since our presence and postures as witnesses mimic hers, we, by extension, should also feel her horror. We are even led to try to imagine her agony: 'Aa lorde in what sorowe is hir soule nowe? Sothely I trowe that she miht not speke one worde to him for sorowe' (lines 26–27). The directives to be 'present there in your mind' beholding 'all that shall be done against your lord' thus use Mary as a lens for our own imaginative visualizing.

It may seem from this Passion sequence that Nicholas Love's text is a direct source for Gibson's film. While it is a source through Emmerich, and next to the Gospels, perhaps even the chief source, there are crucial differences in ways these two works orchestrate our emotions and identification. One hundred and fifty pages of the Mirror (Sargent's edition) deal with Jesus's life preceding his death, and only thirty-nine pages concern the Passion. In the film, however, we see very little of that previous history. The Mirror gives us that background so that by the time we get to the chapter on the Passion, we have heard about Jesus's entire life.

The Mirror also invites its readers to be part of imagined communities by using Christ's life to simulate ritual actions of the established Church in ways that differ from *The Passion of the Christ*. The analogy between the life of Christ

[22] 'Take hede now diligently with alle thi mynde, beholdyng alle that shale be done ageynus thii lorde Jesu & that bene spoken or done of him. And so with the innere eye of thi soule beholde sume, settyng & ficchyng the crosse fast into the erthe. Sume makyng redye the nailes & the hameres to dryue hem with. Othere makyng redy & settyng vp laddres, & ordeinyng other instrumentis that hem thouht nedeful, & other faste aboute to spoile him, & drawe of hees clothes. And so is he now the thridde tyme spoilede & standeth nakede in siht of alle that peple, & so bene nowe the thridde tyme renvede the brisours of the wondes in his scourgyng by the cleuyng of the clothes to his flesh.' Love, *Mirror*, 176, lines 7–19. I have normalized the spelling in all quotations from Love, writing thorns as 'th' and yoghs as 'g.'

[23] 'Now also first his modere seeth how he so takene & ordeyned to the deth. Wherefore she sorouful out of mesure, & hauyng shame to se him standyng alle nakede.' Love, *Mirror*, 176, lines 20–22.

and liturgical ritual made by Love is perhaps nowhere more carefully orchestrated than in the scene of the deposition, where Nicodemus, Joseph of Arimathea, The Virgin, John, and Mary Magdalene all help take Jesus from the cross:

And then Nicodemus comes down to draw out the third nail from the feet, and in the mean time Joseph supports the body. Truly blessed is he that may sustain and hold that holiest body of our lord Jesus. Then our lady reverently takes in her hands our lord's right hand, and looks at it and lays it to her eyes and devoutly kisses it, sadly weeping and sighing. And when the nail was drawn out from his feet, Joseph came down quietly and all laid to hand, and took our lord's body and laid it down on the earth, and our lady took the head and shoulders and laid it on her lap. …[24]

This passage is remarkable for its representation of shared, communal handling of Christ's body. Consonant with the ocular directives of the text as a whole, the passage describes watching as a fully embodied and physical act, a kind of visual touch—or what one scholar might call 'ocular communion.'[25] And indeed, gazing in this passage suggests communion of a literal kind: the shared touching of Christ's body in the deposition evokes the Eucharist, the 'sharing' of Christ's body. One of Love's most ardent defenses 'contra lollardos' concerns the literal, physical presence of Christ in the eucharistic wafer—the 'real presence.' Lollards, often described by scholars as having been proto-Protestant in their attitude toward the Eucharist, challenged the doctrine of transubstantiation, or the belief in the literal transformation of the eucharistic wafer into God's body.[26] Throughout the Mirror, Love, in a counter move, insists on the physical presence of bodies, using a guided meditation to give emotional force to a doctrinal argument. Paul Strohm speculates that Archbishop Arundel and Henry IV may have even exploited the Eucharist as a foil for another kind of debate about authenticity. The insistence on the real presence of the Eucharist as it developed in the reign of usurper Henry IV may have symbolized the legitimacy of another transformation: the man into a king through the ritual of coronation.[27] Love describes the deposition as a eucharistic ritual, a community formed through sharing of a sacramental body. Nicodemus draws out the nail, Joseph supports the body, Mary holds his hand. Touched and held, Christ's body is literally shared among his community of believers. Each of the faithful gets a piece of his flesh.

[24] 'And than Nichodeme cometh done fort drawe out the thridde naile of the feete, & in the mene tyme, Joseph susteneth the bodye. Sothely wele is him that may susteyn & clippe that holiest body of oure lorde Jesu. Therwith oure lady taketh in hir handes reuerently oure lordes riht hande, & beholdeth it & leith it to hir eyene & deuoutly kisseth it. Sore wepyng & sihhyng. And when the naile of the feete was drawe out. Joseph came done softly & alle leiden to hande, & token oure lordes bodie, & leide it done on the erthe, & oure lady toke the hede & the sholderes & leide it in hir barme.' Love, Mirror, 185, lines 18–27.

[25] Susanna Biernoff, Sight and Embodiment in the Middle Ages (Houndmills, England, 2002), 133–64.

[26] For a succinct discussion of Wyclif's views on the Eucharist see Richard Rex, The Lollards (Hampshire, 2002), 42–45.

[27] Strohm, England's Empty Throne, 62.

In his conflation of vision and touch in this passage Love understands sensory processes, especially sight, to operate in ways that differ substantially from the way we understand them today. In the late Middle Ages, vision was believed to be an active process that connected us physically with other objects and people through the workings of visual 'species,' or visual rays projected both from the eye as well as from objects. [28] Lyrics and romances frequently picture these 'species' through dramatic metaphors as rays or even daggers sent from one eye to another to wound the heart. In treatises on perspective as well as in poetry, sight is repeatedly represented as an active principle engaging the material world in a tissue of animate relationships.[29] Seeing is a form of touch. As agents of touch that link us with others, visual rays offer a compelling physical logic for medieval devotional practices. When we witness Christ's suffering we literally touch him; our spiritual experience is also a somatic one, and one that can be explained by natural science.

Love's Mirror, with its injunctions to look and touch, is thus fully grounded in the metaphysics of sight, which it invokes through its strategic directives to imagine ourselves participating in a devotional community.[30] The text's visual orchestration even mimics elements of the mass, whose epiphanic moment in the late Middle Ages was a visual one: the elevation of the consecrated host.[31] The directives to picture the life of Jesus, voiced by a priest, are also directives to participate in the Eucharist, the condensed sign of Christ. The scene of the Deposition thus crystallizes the visual practices that conscript us, as readers, into a Christian community, imagined through the domestic trope of the family and, with particularly emotional clarity, the mother. Just as Christ's followers touch and share his body, the worshipper sees, and hence shares, that body as well.[32]

[28] The authoritative survey of medieval optics remains David C. Lindberg, *Theories of Vision from Al-Kindi to Kepler* (Chicago, 1976). On Bacon's theory of species, see David C. Lindberg, *Roger Bacon's Philosophy of Nature: a Critical Edition with English Translation, Introduction, and Notes, of De multiplicatione specierum and De speculis comburentibus* (Oxford, 1983), lv.

[29] See Michael Camille, 'Before the Gaze: The Internal Senses and Late Medieval Practices of Seeing,' in *Visuality Before and Beyond the Renaissance: Seeing as Others Saw*, ed. Robert S. Nelson (Cambridge, 2000), 207; Sarah Stanbury, 'Regimes of the Visual in Premodern England: Gaze, Body, and Chaucer's Clerk's Tale,' *New Literary History* 28 (1997), 261–89; Carolyn Collette, *Species, Phantasms, and Images: Vision and Medieval Psychology in The Canterbury Tales* (Ann Arbor, Mich., 2002), 13–20. See also the recent discussion in Biernoff, *Sight and Embodiment*, 73–81, 86–91, and 102, 'whether carnal or scientific, vision was a dynamic extension of the subject into the world and at the same time a penetration and alteration of the viewer's body by the object.'

[30] On devotional gazing and medieval optics see Cynthia Hahn, '"Visio Dei": Changes in Medieval Visuality,' in *Visuality Before and Beyond the Renaissance: Seeing as Others Saw*, ed. Robert S. Nelson (Cambridge, 2000), 169–96; and on the use of mental pictures in Love see Kathleen Kamerick, *Popular Piety and Art in the Late Middle Ages: Image Worship and Idolatry in England 1350–1500* (New York, 2002), 140 and 168.

[31] Miri Rubin, *Corpus Christi: The Eucharist in Late Medieval Culture* (Cambridge, 1991), 54–63.

[32] On Christ's body as a demonstration of the Eucharist, see Hans Belting, *The Image and its Public in the Middle Ages: Form and Function of Early Paintings of the Passion* (New Rochelle, N.Y., 1990), 68–89; see also Miri Rubin, 'The Eucharist and the Construction of Medieval

In Gibson's *The Passion of the Christ*, witnessing is far less communal—though one story, perhaps an urban legend, has it that after watching the film a murderer came forward to confess his crime; 'community' in a celluloid and cyber-world has dramatically broader dimensions. In the film, the group of supporters is very small and scattered, and the host of enemies impressively large. This Passion remake, which comes at us with little or no historical framing, situates the good and the true as scattered and disparate people surrounded by a world of enemies. Whereas Nicholas Love organizes his readers into witnesses in order to idealize Christian communities as forms of family, the film exploits techniques of distance: in real (or reel) time we can watch, but we can't help at all. The very organization of lines of sight through the camera lens works to reinforce the viewer's helplessness. As the camera cuts to the anguished faces of the small group of supporters, it forces us to acknowledge just how small that grouping is. There is also a vast difference between watching a film and listening to directives on how to imagine. The camera lens, selecting what and how we see, gives a film director far greater control over visual sequencing than even the most explicit narrator of a written text. No matter how coercive the book's narrator's voice might be in its directives to picture Jesus's life, it at least allows us to put the book down, whereas the film traps us in our seats. Our only escape from the picture is literally to close our eyes and ears.

The past three decades have seen a rich proliferation of studies on vision, or more exactly 'visuality,' that have helped us understand how vision is an act closely tied to cultural or psycho/social norms. Postmodern studies of vision, which have revolutionized our understanding of vision as a cultural practice, have also contributed in far-reaching ways to discourses on race, gender, and intersubjectivity: how we know, claim, and use the other is a reflex, in part, to our gaze on that other. Work on vision has spanned many fields, but a central shared insight is that gazing is linked to the psychodynamics of power and domination. Feminist film theory, in particular, has exposed the sexual politics of looking by showing how Hollywood cinema reinforces dynamics of sexual power through its very structure. In Hollywood film the filmic apparatus, it has been suggested, is a technology that both produces and reproduces gender relations: a 'male' viewer takes a distanced, controlling, often voyeuristic position of mastery; the female body—fetishized, objectified, sexualized—is the object of that look. To see is primarily to take the position of male characters in the film or of the male-identified audience. To-be-seen is to take the position of a woman.[33]

Identities,' in *Culture and History 1350–1600: Essays on English Communities, Identities and Writing*, ed. David Aers (Detroit, 1992), 50.

[33] The psychoanalytic interrogation of gender and film has developed from a few key studies, most notably Laura Mulvey, 'Visual Pleasure and Narrative Cinema,' *Screen* 16 (1975); Tania Modleski, 'Hitchcock, Feminism, and the Patriarchal Unconscious,' in *The Women Who Knew Too Much: Hitchcock and Feminist Theory* (New York, 1988); Pam Cook and Claire Johnston, 'The Place of Woman in the Cinema of Raoul Walsh,' in *Raoul Walsh*, ed. Philip Hardy (Colchester, England, 1974). These classic essays and others are reprinted in *Issues in*

In Gibson's *The Passion of the Christ*, the spectacle of desire and violence gets extraordinarily queer play. I have argued that Nicholas Love draws on theories about the workings of sight that circulated in his own time to structure the Mirror; and a similar argument can be made, I believe, for Gibson's film, though much of the film's impact relies on reversals of Hollywood norms. The body on display is that of a man, looked at by, among others, a woman. As we have seen, the Virgin plays a strategic role in this drama of heroic and cultic masculinity in part because her presence ratchets up the violation: I can take it, we might think, but can or should a mother? She re-routs our empathy. When the camera cuts to her face, we watch almost furtively to see how she is taking it. But her gesture, a woman looking at a scene of torture, also bespeaks more than maternal pain, I think. Ignoring laws of decorum and passivity that might relegate the female to the position of the observed, not the observer, she chooses to watch. Feminist film theory might even suggest that she is being punished for looking. As Linda Williams has provocatively argued for horror and slasher films, the visually assertive woman—usually coded as inquisitive or vampish— finally does *see*, but what she sees will often be horrifying or even fatal to her.[34]

Does Mary's look cross the bounds of decorum and go too far? Maternal right, of course, legitimizes her gaze; 'looking after' the children was never just a metaphor. Real mothers spend hours each day literally *looking* at their children. Nevertheless, reversals in action and passivity set Jesus and Mary apart from the crowd in the film as well as from the audience in the theater. She watches him; he rarely looks back. The woman becomes the subject of the gaze and the man its object. Furthermore, Christ, played by James Caviezel, dazzles as a beautiful man and Mary, acted by Maia Morgenstern, seems simply too young to be his mother. They seem more like lovers than mother and son. Camera work also makes Caviezel seem uncannily large, and always manly. Often Caviezel is shot from below, a technique that gives the illusion that he is even something of a giant. His body, in scenes of the scourging or the carrying of the cross, is always that of a large man.

In contrast, humanity, and even a feminized or passive humanity, is central to the representations of Christ in the medieval tradition.[35] As Caroline Walker Bynum has shown, the idea of Christ as a nurturing mother was a commonplace, at times he was even described as feeding the faithful with milk from his

Feminist Film Criticism, ed. Patricia Erens (Bloomington, Ind., 1990). For a recent volume containing 'classic' essays as well as recent articles problematizing the heterosexist and classist assumptions of earlier work see *Feminism and Film*, ed. E. Ann Kaplan (Oxford, 2000).

34 Linda Williams, 'When the Woman Looks,' in *Re-Vision: Essays in Feminist Film Theory*, ed. M. A. Doane, P. Mellencamp, and L. Williams (Frederick, MD, 1984), 83–99; as Madeline Caviness has skillfully argued, gendered taboos on gazing are by no means restricted to the modern West, but also underwrite numerous pictorial representations in medieval art: *Visualizing Women in the Middle Ages: Sight, Spectacle, and Scopic Economy* (Philadelphia, 2001), 45–81.

35 David Aers and Lynn Staley, *The Powers of the Holy: Religion, Politics and Gender in Late Medieval English Culture* (University Park, Penn., 1996), esp. part 1, 15–104.

breasts.[36] Julian of Norwich, writing in the late fourteenth century, speaks of 'Mother Jesus,' sweet, kind, and nourishing: 'The moder may leyn the child tenderly to her brest, but our tender Moder Jesus, He may homely leden us into His blissid brest be His swete open side. …'[37] Gibson's Christ, however, is tall and well-muscled—even a working icon of the body-building Jesus now popular among evangelical Christians.[38] In what may be the only comic moment in the film, a flashback shows Jesus as a young carpenter building a table and proudly showing it to his mother—but the scene reads more like one of young husband and wife than mother and son.

The slippage in family roles thickens the family plot to allow the maternal drama a share of heterosexual romance: several kinds of love are at play through Mary's determined and persistent watching. If there is transgression, it comes partly through the apparent shifting of roles. While the love relationship between Mary and Jesus was a commonplace in medieval poetry and liturgy, it is much less familiar today and hence carries the shock of surprise for a twenty-first-century viewer. Mary's pain here is a lover's as well as a mother's; and looking at a body in pain, she is literally punished herself.

That's the punishment for love. But we can take this further, I think. If Nicholas Love's Passion narrative builds a synergy between family values and Christian communities, using a feminized gaze of helpless veneration as a model for the gazes and postures of good Christian subjects, do the gazes of women in Gibson's film serve a similar agenda? There are some significant differences, especially if we consider the assertively heterosexist slant of Gibson's family values. By organizing a gaze through female spectators, the film tells us that compassion and love belong to male/female relationships, and only there. We are first shown this in a literal jolt. The film opens with Jesus in the Garden of Gesthemane. He is with his disciples, but is agonized by grief and isolation from them. Shots cut back and forth between the garden and the temple of Caiaphas, as we watch Judas take his bribe and lead Caiaphas's henchmen to the spot. Just at the moment that Jesus is taken, the film cuts, for the first time, to Mary. When he is taken, she jerks awake in her own bed at home; Mary Magdalene asks her what is wrong. What this scene communicates, in the first of many like it, is that Jesus is umbilically connected to his mother and secondarily to Magdalene. He belongs to women as defined by two principle roles, the mother and the lover.

This emotional linkage is framed by queer alternatives. Contrasting with the love of women is the perverse desire of queered others, who also have their uses for Jesus's body. One of these is the freaky Satan, played by Rosalinda Celentano, who lurks in the garden and slips through the crowd during the rest

[36] Caroline Walker Bynum, *Jesus as Mother: Studies in the Spirituality of the High Middle Ages* (Berkeley, 1982), 110–69.

[37] *The Shewings of Julian of Norwich*, ed. Georgia Roman Crampton, TEAMS (Kalamazoo, Mich., 1993), ch. 60, 124.

[38] See, for instance, 'Adam's Natural Bodybuilding Site,' http://www.geocities.com/Colosseum/Dugout/4143/; 'Caveman Classic,' where Jesus is described as a 'Spotter' for bodybuilders: http://www.thecaveman.com/aword.htm.

of the movie. Evil, the film seems to say, is unnatural and sexually ambiguous, as is this Satan who has the face of a woman but the voice of a man. It may be argued that Gibson punishes Mary for watching by aligning her subtly with Satan; the two actresses resemble each other. Satan also announces his/her evil intent or status as evil thing through a determined and directed stare—a stare all the more venomous as the stare of a woman's eyes. It's an old story, of course, Eve and Mary, or as medieval writers sometimes punned, *Eva* and *Ave*: Eve, the sinner who caused the fall and Ave Maria, the Virgin who redeemed it.[39] There are two women who stare in this film, one wholly evil and the other wholly good, as if they were shadow images of the same person. Satan is an Eve figure, even with a snake in the garden, the opposite face of the Virgin sleeping in her bed. This pairing of the cross-dressed Satan with Mary might make us uneasy, I think, about Gibson's insistence on Mary's tortured participation in the Passion, for it implies not only that women have a social role as the ones who suffer but also, and more problematically, that women need to suffer in order for men to be fully male. If we think of Mel Gibson's roles in *Lethal Weapon* and *Braveheart*, which he also directed, we can see that the death or suffering of a woman often seems the tonic required to ignite masculine heroic martyrdom. At the beginning of *Lethal Weapon 1* Riggs's (Gibson's) wife has been killed, a trauma that has transformed him into a suicidal lethal weapon; and in *Braveheart* it is the execution of William Wallace's young wife that spurs Wallace (Gibson) on to a life of nationalistic vengeance.

Herod is also queer, even overtly feminized in a parody of homosexual perversion, as if to say that homosexuality were synonymous with the libertine. In medieval mystery plays Herod is usually as foppish and feminine, and in this sense Gibson's representation is traditional. Yet in the context of the film's family romance, Herod's homosexuality works to further the film's celebration of heterosexual, masculine heroism. The torturers may also be queer. Uniformly they are drunken and diabolical. They love to torment Jesus. Why? The film never explains their pleasure, but the pleasure never relents. Their sadism is so extreme and so sensualized as to suggest we are to see their rage as homoerotic in its drive. The torturers take pleasure in punishing that which they want but can't have. Jesus belongs to women. In fact, at the very moment that Jesus gazes at his mother during the scourging, the torturers are trying out their flails. It may be that the film's extremes of violence are required to neutralize its homoerotic pleasures, disciplining the audience's own queer desires as well. The film puts on display a male body, whose beauty we see briefly in flashbacks, but then punishes what it loves. Commenting on *Lethal Weapon*, critic Tania Modleski writes that the film 'takes male homoerotic impulses, embedded in homosexual panic, to their most murderous extreme.'[40] In *The Passion of the Christ* Gibson appears to have raised the bar on what constitutes the 'most murderous extreme.' There are essentially two positions

39 Ernst Guldan, *Eva und Maria: Eine Antithese als Bildmotiv* (Cologne, 1966).

40 Tania Modleski, *Feminism Without Women: Culture and Criticism in a Postfeminist Age* (New York, 1991), 137.

one can take: one is heterosexual, family-based. The other is queer—Herod, the happy flagellators, the ambiguous Satan. This other encompasses everyone else. Mary's gaze works to demonize much of the world as a coalition of enemies.

Gibson's film also shows that however much Mary may be tied to her son, she can't have him. This message may be summed up when in one of the flashbacks we hear Jesus telling his all-male followers, 'The greatest sacrifice a man may make is to die for his friends.' Friends are the boys. In present time, though, the ones who suffer most visibly and deeply are women, who can only watch. In fact the film uses Mary as spectator to suggest that heroic masculinity exists only *apart* from women—and even in punishing women who would try to hang on to their boys. The most graphic example of this overprotective mother comes when Mary runs to Jesus when he falls beneath his cross. Here the film flashes back to a scene from his childhood (the film's only one), when Jesus is a toddler at home with his mother. Wandering away from her, he falls; she runs to him, her face a mask of terror. Mary's foreboding about her son's future is common in Christian iconography, and on a symbolic level, this brief flashback evokes that tradition. Yet modern viewers may see only an overreaction to a toddler's ordinary tumble.

If Mary is first positioned as the overprotective Madonna, at the end of the film she turns into the vampire and perhaps even the vindictive Madonna. In one of the film's most unsettling shots, during the Crucifixion, after Jesus has died, Mary approaches the cross and kisses his feet—merging symbolically with Mary Magdalene, who traditionally has special rights over Jesus's feet. His feet are dripping with his blood, and after she kisses his toes the camera cuts to her face to show her lips stained with blood. While the shot communicates the extent of her love, the picture of blood-stained lips is most cinematically familiar from vampire movies. What are we to make of this brief filmic echo? All along it has been excruciating to watch her watching. By the end of the film it is more painful to watch her watching than to look at Jesus's body, reduced as it is to unrecognizability—and even to the likeness of a painting, brush strokes and all. She's been punished for loving too much, and the film's final shots show us these excesses. In one of the film's last scenes, following the deposition from the cross, the mourners are composed into the configuration of the lamentation, a close relative of the pietà. Mary holds Jesus's head and Mary Magdalene bends over his feet. Some viewers may even see Mary as the vindictive or judgmental Madonna, staring directly at the camera lens as if to implicate the viewer in the blame. Everything else in this composed scene is familiar except for her directed stare right at the camera lens.

What we are accused of in that stare is summed up in the film's final shot, which shifts to the cave. The stone rolls away, and light fills the space. We see the empty shroud, billowing in a breeze. Then we see, just in profile, Jesus, his body restored. It is immensely reassuring to see this body, which had been shredded and lacerated, again intact in all its beauty. In the Gospels, when Jesus's followers return to the cave, they find it empty. They see him only later—on the road to Emmaus and in the garden. In John 20, the first of his

followers to see Jesus is Mary Magdalene, who is warned away by Jesus's command not to touch him, 'noli me tangere.'[41] In a peculiar intervention, Gibson gives the act of witnessing over to the moviegoer and has the Resurrection happen within the cave itself. No witnesses are present at all. This is the final triumph of heroic masculinity: it is alone. Jesus doesn't even look at us. In her final image in the film, Mary accosts us with her angry stare; all she gets is the broken body. But when that body is restored to itself, it is alone.

So what are the ends of community in this film and in its medieval precursor? Nicholas Love's fifteenth-century and Mel Gibson's twenty-first century Passions both conscript identification through feminized spectators, though in rather different ways; both also build communities, and do so for distinctly conservative social and political ends. Both use pathos for politics. For Love, enemies are those who would challenge orthodox practices of faith; friends, in his domestic narrative, are part of a Christian family. In Gibson's heteronormic, homosocial, and zenophobic film, enemies, it seems, are everywhere and can be almost anyone. Released when the United States was at war with Iraq, the film also seemed particularly well-timed to idealize a Christian West, figured through American James Caviezel as its icon of sacrificial American manhood, attacked by a hoard of Middle Eastern men in skirts.[42] Apart from the Romans, all of the enemies are Jews, of course; but to an American audience at the time of the film's release, conditioned to nightly news images of Afghani and Iraqi men wearing robes, distinctions among ethnicities may not have been clear in the context of this vivid picture of sacrifice in the desert.

Discussing the structure of torture in her study of suffering, *The Body in Pain*, Elaine Scarry comments that pain is 'world-destroying' and that practices of torture convert 'absolute pain into the fiction of absolute power.'[43] With whom does that fiction of power rest? In both of these narratives it rests in large measure in the hands of the director. In Nicholas Love's fifteenth-century text, power lies with a voice that not only tells us how to feel but also what to see. Through his spectral priest, the narrator speaks for the Church, instructing members of the congregation (us) in postures of piety. In Gibson's film, absolute power lies *not* with the scourges, even though they are the vehicles or messengers of pain. Perhaps it rests with the camera. Few viewers of the film will be unaware that camera is in the hands of Mel Gibson, an Oscar-winning international star with a legacy of hypermasculine Hollywood credits. The greatest love we can have, the movie seems to say, is for a beautiful male. The most precious body belongs to Western or Caucasian man, starkly at risk out there in the world.

[41] For medieval traditions of the 'Noli me Tangere,' see Theresa Coletti, *Mary Magdalene and the Drama of the Saints: Theater, Gender, and Religion in Late Medieval England* (Philadelphia, 2004), 83–84.

[42] Ironically, the film has been a hit in the Middle East, principally for its portrayal of Jewish guilt. 'The Passion of the Arab World,' *The Atlantic*, July/August (2004), 62.

[43] Elaine Scarry, *The Body in Pain: The Making and Unmaking of the World* (New York, 1985), 29 and 27.

Realpolitik and Artistic Patronage in Twelfth- and Thirteenth-Century Troyes[1]

Elizabeth Carson Pastan

The medieval comital territory of Champagne figures prominently in most accounts of the central Middle Ages as the region whose size and prosperity best positioned it to challenge the remarkable rise of the Capetians.[2] Champagne serves as one of the principle examples of a potentially dangerous competitor transformed through the patient insinuation of royal authority into yet another conquest that contributed to the territorial cohesion of modern France in Robert Fawtier's study of the Capetian kings of France.[3] In Capetian-centered accounts such as Fawtier's, Champagne is of interest in the twelfth century when it became a desirable conquest, and in the later thirteenth century when its *de facto* annexation to the crown took place.[4] In this study, however, the period in between these two poles will be investigated, in order to focus on the internal dynamic within Champagne.

The twelfth century marks the highpoint of Champenois history in any narrative, for it was in this period that the counts recast the frontier zone between the French kingdom and the German Empire into one of the wealthiest principalities in the realm. The territories comprising Champagne, newly consolidated in the reign of Count Henry I (1152–81),[5] virtually eclipsed in size

[1] I am indebted to Madeline Caviness for pointing me towards the study of stained glass in Troyes. I acknowledge not only Madeline's 'seminal' art historical influence, but also her own inspiring Realpolitik. In addition, I am grateful to Theodore Evergates, Ellen Shortell, and Barbara Abou-El-Haj for close and thoughtful readings.

[2] Michel Bur, 'Rôle et place de la Champagne dans le royaume de France au temps de Philippe Auguste,' *La France de Philippe Auguste: Le temps de mutations*, ed. Robert-Henri Bautier (Paris, 1982), 236–54.

[3] Robert Fawtier, *The Capetian Kings of France, Monarchy & Nation (987–1328)*, trans. Lionel Butler and R. J. Adam (1942; repr. London, 1960).

[4] Although Champagne was not annexed to the royal domain until 1361, John Benton, 'Philip the Fair and the Jours of Troyes,' *Studies in Medieval and Renaissance History* 6 (1969): 281–338, demonstrates that the crown assumed control from 1285.

[5] On the large number of fiefs held from the king of France, the Holy Roman emperor, the duke of Burgundy, the archbishop of Reims, and others from which the counts of Champagne created their principality, see the excellent overviews in Jean Longnon, 'La Champagne,' in *Histoire des institutions françaises au Moyen Age*, ed. Ferdinand Lot and Robert Fawtier, vol. 1: *Institutions seigneuriales* (Paris, 1957), 123–36; Michel Bur, *La formation du comté de Champagne,*

those of the royal domain.[6] Its trade markets, the famed Fairs of Champagne, served as centers of international exchange for merchants from the North Sea and the Mediterranean, from Paris and the Empire, and pioneered techniques in the management of credit such as promissory notes and bills of exchange.[7] These Fairs, on which the counts' wealth depended, were scheduled every two months throughout the year and held in southern Champagne where the counts were the dominant power,[8] thereby effectively choking off the episcopal city of Reims in the north.[9] But the hegemony that the counts' territories and wealth earned them in the twelfth century waned in the early thirteenth century, when they struggled to maintain authority.[10]

What factors contributed to these changes in Champagne? Since the counts of Champagne were known for their generous patronage,[11] this study will use works of art commissioned in late twelfth- and early thirteenth-century Troyes as a focus for understanding the new social and political dynamics in Champagne. Art associated with the comital seat of Troyes, such as the exquisite stained-glass panel dating to the third quarter of the twelfth century in the Victoria & Albert Museum in London (fig. 29.1), has justly been recognized for its superb craftsmanship.[12] And the counts' patronage extended into many areas: Count Henry alone is estimated to have created over 196 clerical livings, earning him the epithet Henry the Liberal.[13] His giving was said to have provoked King Louis VII, who was both the count's father-in-law and his

v. 950–v. 1150 (Nancy, 1974), 403–15; and Theodore Evergates, 'Champagne, County,' in *Dictionary of the Middle Ages*, 13 vols, ed. Joseph R. Strayer (New York, 1982–9), 3: 243–50, esp. the helpful maps on pp. 244 and 247.

[6] See Michel Bur, 'Les Comtes de Champagne et la "Normanitas:" Sémiologie d'un tombeau,' *Procedings of the Battle Conference on Anglo-Norman Studies* 3 (1980), 30, map 1.

[7] On the economic importance of the Fairs, see Félix Bourquelot, 'Etudes sur les foires de Champagne, sur la nature, l'étendue et les règles du commerce qui s'y faisait aux XIIe, XIIIe et XIVe siècles,' *Mémoires présentés par divers savants à l'Academie des inscriptions et belles-lettres* 5, 2 vols (Paris, 1865); Robert-Henri Bautier, 'Les foires de Champagne: Recherches sur une évolution historique,' *Recueils de la société Jean Bodin pour l'histoire comparative des institutions* 5 (1953): 97–147; and R. D. Face, 'Techniques of Business in the Trade between the Fairs of Champagne and the south of Europe in the Twelfth and Thirteenth Centuries,' *Economic History Review* 10 (1957–58): 427–38.

[8] Bur, *La Formation*, 188–91, points out that Troyes was the only episcopal town in Champagne where they exercised control.

[9] Elizabeth Chapin, *Les villes de foires de Champagne, des origines au début du XIVe siècle*, Bibliothèque de l'Ecole des Hautes Etudes, 268 (Paris, 1937), 15–20; Bur, *La Formation*, 292–305.

[10] Underlying these analyses is Elizabeth C. Pastan and Sylvie Balcon, *Les vitraux du chœur de la cathédrale de Troyes (XIIIe siècle)*, Corpus Vitrearum France, vol. II (Paris: Comité des travaux historiques et scientifiques, 2006), esp. 19–29.

[11] John F. Benton, 'The Court of Champagne as Literary Center,' *Speculum* 36 (1961): 551–91; Patrick Corbet, 'Les collégiales comtales de Champagne (v. 1150–1230),' *Annales de l'Est* 29 (1977): 199–204.

[12] Louis Grodecki, 'Problèmes de la peinture en Champagne pendant la seconde moitié du douzième siècle,' *Romanesque and Gothic Art: Studies in Western Art*, Acts of the Twentieth International Congress of the History of Art (Princeton, 1963): 1:129–41; and Léon Pressouyre, 'Réflexions sur la sculpture de XIIème siècle en Champagne,' *Gesta* 9 (1970): 16–31.

[13] Henri d'Arbois de Jubainville, *Histoire de ducs et des comtes de Champagne*, 6 vols (Troyes, 1859–66), 3: 178–9; Corbet, 'Collégiales comtales,' 196–207.

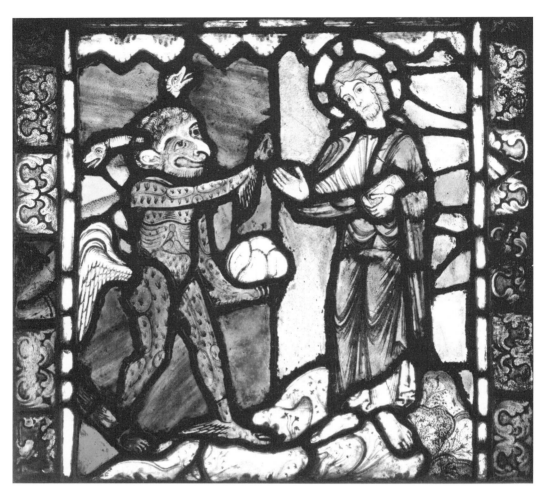

29.1 Stained-glass panel of the First Temptation of Christ, The Victoria & Albert Museum, London, from Troyes, possibly the collegiate church of Saint-Etienne, ca. 1170–80.

brother-in-law, into remonstrating with Henry for dissipating his children's inheritance in gifts to the clergy.[14] But the works of art the counts inspired,[15] like the clerical livings and masses they endowed, were also an important aspect of their Realpolitik. By pointing out all the advantages that accrued to

[14] Arbois de Jubainville, *Histoire* 3:180 with French translation from the Chronicle of Laon (ca. 1165). For the latter, see 'Ex Chronico Anonymi,' in *Recueil des historiens des Gaules et de la France* 13 (1869), 679E–680A.

[15] Norbert Bongartz, *Die frühen Bauteile der Kathedrale in Troyes, Architekturgeschicht-liche Monographie* (Stuttgart, 1979), 251–52 addresses the question of the agency of the counts, pointing out that, regardless of their level of personal involvement, the counts' financial support of churches in the region broadened the range of artistic possibilities in Champagne.

the count from his strategic giving, Patrick Corbet has demonstrated that Henry was actually shrewdly liberal.[16]

The two key monuments of art that will be the focus here, the collegiate church of Saint-Etienne of Troyes, founded in 1157 when the counts were at the apex of their power, and the statues of bishops in the choir of the cathedral of around 1210–20 from the period of the growing independence of the bishop of Troyes, will allow us to assess how artistic patronage figures in Troyes during the changing circumstances of the thirteenth century. These two monuments have an undeniable poignancy because both were destroyed during the French Revolution, but fortunately, sufficient archeological and documentary evidence remains to allow us to portray a reasonably detailed picture of these works and their political context.

Henry the Liberal and Saint-Etienne of Troyes

In order to position themselves as the rulers of a principality that could rival the kings of France, the counts of Champagne needed to 'uncover symbols and legends from their past which would ensure their future.'[17] When in 1157 Count Henry I replaced a small oratory served by two chaplains,[18] with the large and richly endowed collegiate church of Saint-Etienne adjacent to his palace in Troyes, he was arguably creating a structure that could serve just such a purpose.[19] It was likely intended to serve as a dynastic sanctuary, as it was here that the bronze, enameled tombs of Count Henry and his son were installed in the choir.[20] Henry's ambitions are also evident in the name of the collegial; he called it Saint Etienne or Saint Stephen, the name of the archbishopric of the diocese, Saint-Etienne of Sens, which served as its primary artistic model,[21] and also the name of Henry's uncle Stephen of Blois, king of England from 1135–54, and the only crowned head of state from the house of Champagne.[22] Thus on the claims staked by the title alone, the palace church of Saint-Etienne was intended to be a major undertaking.

[16] Corbet, 'Collégiales comtales,' 225–31.

[17] Bur, *La Formation*, 462 from his chapter entitled, 'Champagne, une Principauté?'

[18] Anne-François Arnaud, *Voyage archéologique et pittoresque dans le département de l'Aube and dans l'ancien diocèse de Troyes* (Troyes, 1837), 27. On the trend towards creating a separate (if adjoining) structure as a visible sign of comital power, see Jean Mesqui, *Châteaux et enceintes de la France médiévale: De la defense à la residence*, 2 vols (Paris, 1993), 2: 20, 26, and 112–16. Also see the two successive chapels of increasing prominence the counts built at their palace in Provins in Mesqui, *Châteaux et enceintes* 2: 128–29 and Fig. 146.

[19] Bur, *La Formation*, 478–79. For the text of the foundation charter of 1157, see Chapin, *Villes de foire*, pièce justificatif no. 1, 279–82, and discussion pp. 78–80.

[20] Bur, *La Formation*, 477–78. Now see Xavier Dectot, 'Les tombeaux des comtes de Champagne (1151–1284): Un manifeste politique,' *Bulletin monumental* 162 (2004), 3–64.

[21] Most recently, Anne Prache, 'La collégiale Saint–Etienne,' in *Splendeurs de la Cour de Champagne au temps de Chrétien de Troyes*, exhb. cat., 18 June–11 September, Troyes, Bibliothèque municipale (Troyes, 1999), 19–21 with further bibliography.

[22] Bur *La Formation*, 288–89; idem, 'Les Comtes de Champagne et la "Normanitas,"' 28–29.

However, this brilliant new architectural centerpiece also represented a political miscalculation on Henry's part. A dispute that arose over the jurisdiction of Saint-Etienne became a rallying point for those who wanted to keep the count in check.[23] In 1171–72, a coalition that included Louis VII, Bishop Matthew of Troyes, and the count's brother William of the White Hands, who was then the archbishop of Sens, arose against a special exemption that Henry had claimed for Saint-Etienne.[24] The papal bulls that describe the incident report that the count wanted his canons to be free from the jurisdiction of the bishop of Troyes, with Henry arguing that such exemptions were customary for the clerics who served the chapels of kings and princes.[25] The affair concluded in 1173 with the canons of Saint-Etienne returning to episcopal jurisdiction and Count Henry renewing and expanding his endowments to the collegiate.[26] Although it might seem a tempest in a teapot, Michel Bur has identified this event as the first occasion when the king intervened in the hitherto unchallenged rule of the counts of Champagne.[27]

The focus of the controversy, the church of Saint-Etienne, is worth examining in some detail. It was a large structure that towered over the palace of the counts it adjoined. In the nineteenth-century view of the collegial from the north (fig. 29.3), the structure of Saint-Etienne at the left eclipses the palace of the counts that is perpendicular to it at right. Although the nearby Gothic cathedral is now considerably larger,[28] in the mid twelfth century when Saint-Etienne was built, the cathedral was probably still a tenth-century structure about 73 meters in length by 20 meters in width (240 × 65.5 ft.).[29] Henry's palace chapel at the very least approached and likely surpassed the dimensions of the cathedral at the

[23] Arbois de Jubainville, *Histoire*, 3: 72–81 on others who had quarrels with the count. On p. 81 he concludes with the bitter judgment of the count by Alberic of Trois-Fontaines (ca. 1220–41), who specifically refers to the fact that Bishop Matthew of Troyes complained about the count's behavior to the pope. While Arbois de Jubainville claims not to know which incident Alberic was referring to, the proximity of the date of Alberic's entry of 1163 to the foundation of Saint-Etienne in 1157, argues that Alberic was referring to the incident described here. Also see n. 71 below.

[24] The two papal bulls describing the incident are preserved in Troyes, Archives départementales de l'Aube, G 20, and published in Julius von Pflugk-Harttung ed., *Acta pontificum Romanorum inedita*, vol. 1: *Urkunden der Päpste vom jahre 748 bis zum Jahre 1198* (Tübingen, 1881), doc. nos. 271 and 272, pp. 250–51. Discussed in Corbet, 'Collégiales comtales,' 198–202.

[25] One aspect of Count Henry's insistence on freedom from episcopal jurisdiction for his canons, may well be the fact that the canons of the cathedral of Saint-Pierre were not under the bishop's jurisdiction. As Charles Lalore, *Collection des principaux cartulaires du diocèse de Troyes*, vol. 5: *Cartulaire de Saint-Pierre de Troyes*, *Chartes de la collègiale de Saint-Urbain* (Paris, 1880), XLVII [hereafter, Lalore, *Cartuliare de Saint-Pierre de Troyes*], explains, from the twelfth century on, it was the cathedral chapter that judged cases and turned to the archbishopric of Sens when needed.

[26] For the text of the renewal of the foundation charter and further expansion of its endowments in 1173, see Courbet, 'Collégiales comtales,' no. 10, pp. 234–37.

[27] Bur, *La Formation*, 189n128.

[28] Mgr. André Marsat, *La cathédrale de Troyes* (Paris, 1987), 33 gives the dimensions of the current Gothic cathedral as 114 meters long, 50 meters wide at the transepts (374 × 164 ft.).

[29] Calculations based on the plan of Milon's cathedral projected against the current structure in Roserot de Melin, *Bibliographie*, 1: pl. 2 facing p. 12.

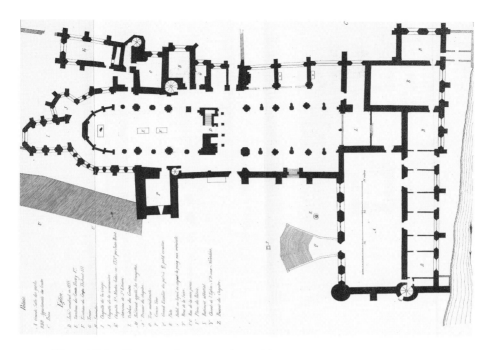

29.2 Plan of Saint-Etienne of Troyes, adapted from plan of the engineer Bocher de Coluel (1753–69).

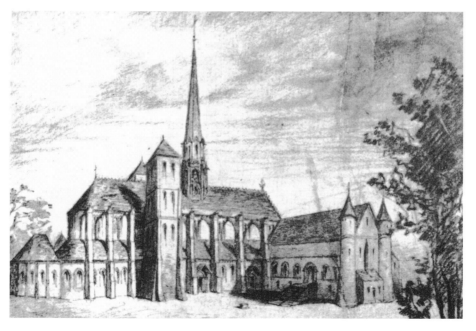

29.3 Anonymous sketch of Saint-Etienne and the palace of the counts of Champagne, Troyes Musée historique de Troyes et de la Champagne, probably nineteenth century.

time. The antiquarian Anne-François Arnaud, writing in 1837 of the building 'which was just before our eyes,'[30] provided the oriented plan of Saint-Etienne reproduced here (fig. 29.2) with an inset metric key that would yield a preposterously large structure of approximately 118 meters in length and nearly 36 meters in width (387 × 118 ft.).[31] Others have given smaller dimensions for Saint-Etienne that would place it nearer to 68 meters (223 ft.) in length,[32] but even these would underscore that it was a very large structure, conceived more on the scale of a cathedral than a 'chapel.'

The size of the building of Saint-Etienne corresponds to the large number of officiants Count Henry established there; he endowed his collegial with at least sixty canons.[33] Through these prebends, Henry secured the loyalty of the Champenois nobility who were awarded the majority of these appointments, thereby enforcing close ties with the clergy capable of succeeding to high office, and he could contribute to the urban development of southern Champagne by providing his court with an administrative infrastructure, including notaries, inspectors, and clerical staff.[34] Duke Hugues III of Burgundy, for example, established the canons in his palace chapel in Dijon in 1172, 'as much for administrative tasks as for spiritual ones,' although he only required twenty canons.[35] The number of celebrants in Henry's chapel exceeded those of the archbishopric of the diocese at Sens with thirty-one and the cathedral of Troyes with forty, and may even have matched the seventy-two canons at Reims Cathedral, the archbishopric of northern Champagne.[36]

30 Arnaud, *Voyage archéologique*, 27.

31 Arnaud, *Voyage archéologique*, 27, gives the dimensions of Saint-Etienne as twenty-nine 'pieds' in width, a unit of measurement which he stated was repeated 'exactly three times' between the entry to the nave and the back of the apse (which would yield a structure eighty-seven 'pieds' long). However, Arnaud's plan does not conform to these specifications, nor does the plan of the engineer Bocher de Coluel of 1769 on which it is based; both are longer. According to Ronald Edward Zupko, *French Weights and Measures before the Revolution*, A *Dictionary of Provincial and Local Units* (Bloomington, 1978),134–35, a 'pied' should equal 3.24 meters in this period, but Arnaud's measurements are more consistent with other indications of the scale of the building, as well as his own plan, if they are read as meters.

32 Alphonse Roserot, *Dictionnaire historique de la Champagne Méridionale*, 3 vols (1948; repr. Marseille, 1984), 3:1600 gives the length as 68 meters (223 ft); see the plans and images he reproduces, 1598, 1600 (plan Coluel), 1655, and 1657; these are discussed more fully (although dimensions are not provided) in Joseph Roserot de Melin, 'Documents iconographiques inédits du palais des comtes de Champagne et de la collégiale Saint-Etienne,' *Mémoires de la Société academique de l'Aube* 105 (1967–70), 5–11.

33 Traditionally, the number of canons at Saint-Etienne is referred to as 72. Corbet, 'Collégiales comtales,' 199n2, notes that the earliest source is the Pouillé of 1350, published by Auguste Longnon, *Pouillés de la province de Sens* (Paris, 1904), 275–77, where I count sixty prebends. This latter figure is also cited in Bur, *La Formation*, 478 and in Roserot, *Dictionnaire historique de la Champagne*, 3: 1597. Also see Jean Hubert, 'La vie commune des clercs et l'archéologie,' in *La vita commune del clero nei secoli XI et XI*, Miscellanea del Centro di Studi Medioevali 3 (Milan,1959),102–3 and Figs. 9 and 10 where Hubert considers the later evidence offered by the large numbers of canons' houses.

34 Corbet,'Collégiales comtales,' 225–31.

35 Jean Richard, *Les ducs de Bourgogne et la formation du duché* (Paris, 1954), 427 and see also 398–40 and 428–30.

36 These figures, culled from various liturgical sources, which changed over time as new endowments were made, can be disputed but establish that generally-speaking, about forty

The disparity between the cathedral and Saint-Etienne is conveyed quali-
tatively by the chronicler Robert of Auxerre, in his description of a fire that
engulfed the town in 1188:

The cathedral, covered with fine leaden roof tiles, was destroyed by the fire. And
the church of Saint-Etienne, which Count Henry had founded, endowed with rents,
and equipped with gold and silver ornaments and furnishings, also perished with
its entire accumulation of remarkable objects.[37]

Robert clearly contributed some narrative embellishment, since neither the
cathedral nor Saint-Etienne actually 'perished' during the fire.[38] However, his
testimony about the splendor with which Saint-Etienne was adorned is
confirmed by another source, the papal bull of 1171–72 written during the
dispute over the jurisdiction of Saint-Etienne. At one point in the Saint-Etienne
affair, Henry had threatened to tear down the building if the pope did not grant
him the exemption he sought, and the papal bull lingered over the beauty of
the threatened structure, stating incredulously:

… [Count Henry I] would entirely destroy that very chapel, which he had endowed
with possessions and ornaments in such a beautiful arrangement in the treasury,
and build it elsewhere.[39]

Such contemporaneous descriptions, combined with suggestive archeological
findings and documents from the French Revolution deeding stained glass
windows from Saint-Etienne to the cathedral of Troyes, have led me to argue
elsewhere that the seventeen magnificent twelfth-century stained glass panels
now dispersed in museum collections, such as the panel of the First Temptation
of Christ (fig. 29.1) may have originated in Saint-Etienne.[40]

canons was the norm. See Wolfgang Schöller, *Die rechtliche Organisation des Kirchenbaues im
Mittelalter vornehmlich des Kathedralbaues: Baulast, Bauherrenschaft, Baufinanzierung* (Cologne,
1989), 72–73n76, who counts eighty-nine canons and six half-livings at Chartres, fifty-two at
Paris, forty-nine at Bayeux, forty-two canons and six half-livings at Beauvais, and forty each
at Bourges, Clermont-Ferrand, and Troyes. For this reference, I am indebted to Dany
Sandron.

37 '*Episcopalis ecclesia, tegulis plumbeis decenter ornate, illo tunc incendio conflagravit, necnon et
Sancti-Stephani basilica, quam Henricus Come fundarat et dotarat reditibus, aurique et argenti et
ornamentorum varia suppellectile adornarat, periit, et cum ea tota illa ornamentorum insignium
congesta varietas.*' See Robert of Saint-Marien in Auxerre, *Chronicon*, in *Recueil des histroiens des
Gaules et de la France* 18 (1879), 258–59; now translated into English in Theodore Evergates,
Feudal Society in Medieval France, Documents from the County of Champagne (Philadelphia, 1993),
no. 99, 130.

38 Mgr. Joseph Roserot de Melin, *Bibliographie commentée des sources d'une histoire de la
cathédrale de Troyes*, 2 vols (Troyes, 1966–70), 1:9–11.

39 '*et eandem capellam, quam speciosa compositione thesauro, possessionibus et ornamentis
magnifice ditaverat, funditus dirueret et alibi edificaret.*' Troyes, Achives départementales de
l'Aube, G 20. Published in J. von Pflugk-Harttung ed., *Acta pontificum Romanorum ine*dita, vol.
I: *Urkunden der Päpste vom jahre 748 bis zum Jahre 1198* (Tübingen, 1881), doc. no. 271, p. 251,
doc. no. 272 quoted on the same page includes very similar wording.

40 Elizabeth Carson Pastan, 'Fit for a Count: The Twelfth-Century Stained Glass Panels
from Troyes,' *Speculum* 64 (1989): 338–72, with further bibliography and a catalogue of the
dispersed panels, 340–43; note that no. 16, p. 343 now belongs to the collection of the Musée
national du Moyen Age in Paris (Cl. 23530). While Saint-Etienne is a plausible site for the

A large extant Corinthian capital from Saint-Etienne (fig. 29.4), now housed in the Musée Saint Loup in Troyes,[41] also bears witness to the rich furnishings of which Robert of Auxerre and the papal bulls speak so admiringly. The capital sports four tiers of curling acanthus leaves carved with finely scalloped edges and, even in its mutilated state, remains fairly three-dimensional. The abacus, or rectilinear 'cushion' at the top of the capital, on the best-preserved side is designed with a band of lozenges presented in depth, like a row of canted boxes.[42] This motif recalls some of the plastically realized borders in the twelfth-century glass panels (figs. 29.1 and 29.4); in each medium the building up of layers of paint or carving away is painstaking. On the basis of such meager but evocative remains, one gleans a sense of the beauty of the adornments of Saint-Etienne.

As the visible embodiment of the counts' emerging status, the dedication, scale, number of celebrants, and embellishments of Saint-Etienne, as well as the exemptions claimed for it, were so irritatingly extravagant that they provoked the clergy of Troyes, whom the counts of Champagne had always dominated.[43] Ever the useful ally when provided with this kind of leverage, the king of France then intervened. Henry's patronage of Saint-Etienne thus provided an opening that the Capetians were able to exploit: even Fawtier admitted that one of the chief political virtues of the Capetian dynasty consisted of making good use of opportunities.[44]

The Thirteenth-Century Regency of Blanche of Navarre

New challenges presented themselves in the thirteenth century, when the principality of Champagne was in a considerably weakened position.[45] Countess Blanche of Navarre (r. 1201–22) served as regent for her infant son Thibaut IV

origin of the glass, it remains a suggestive case, but has been widely adopted: *Les vitraux de Champagne-Ardenne*, Corpus Vitrearum France, Recensement 4, (Paris, 1992), 239; Jane Hayward, *English and French Medieval Stained Glass in the Collection of the Metropolitan Museum of Art*, 2 vols, ed. Mary B. Shepard and Cynthia Clark, Corpus Vitrearum USA (London, 2003), 1:cat. nos. 4, pp. 60–67; and Paul Williamson, *Medieval and Renaissance Stained Glass in the Victoria and Albert Museum* (London, 2003), nos. 6–8, pp. 132–33, and pls. 6–8; No. 6, Inv. No. c-107–1919 corresponds to Fig. 1, reproduced here.

[41] Troyes, don Arnaud, 1835; Inv. 835.32. Its dimensions are 78 × 65–75 cm (just over 2.5 ft. in height and the width ranges from a little over 2 ft. to nearly 2.5 ft.). See Robert Branner, *Burgundian Gothic Architecture* (London, 1960; repr. 1985), 186–88 and pl. 39c; and Mgr. André Marsat in *Champagne romane*, La Nuit de Temps 55 (La-Pierre-qui-Vire, 1981), 108 and plate 51. I gratefully acknowledge the kindness of Mme. Chantal Rouquet, Conservateur en Chef of the Musées d'Art et d'Histoire in Troyes.

[42] Its state of preservation does not allow us to locate it within the building; Arnaud, *Voyage archéologique*, 46 argued that the capital was part of an applied column, while Neil Stratford, 'Sur quelques chapiteaux romans du Musée des Beaux-Arts de Troyes,' *Mélanges d'archéologie et d'histoire médiévales dans l'Aube*, Société archéologique de l'Aube (Troyes, 1985), 120, pl. 11 suggested it was one of the paired columns in the hemicycle.

[43] Corbet, 'Collégiales comtales,' 202.

[44] Fawtier, *Capetian Kings*, 229.

[45] Bur, 'Rôle et Place,' 248–53.

29.4 Capital from Saint-Etienne, Musée Saint Loup, Troyes, mid twelfth-century.

(r. 1222–53), and had to confront rival claimants to the comital seat without the kinds of familial or noble support the counts of Champagne had traditionally enjoyed; her husband, Count Thibaut III (r. 1197–1201), had died suddenly in the course of preparations for the Third Crusade and most of the nobility capable of helping her defend the seat were in the Holy Land. The countess was forced to place herself under King Philip Augustus's protection, performing homage

in the days between the death of her husband, and the birth of their son Thibaut IV.[46] The terms of the agreement of 1201 between the king and the countess were onerous: Blanche agreed neither to remarry nor allow her infant daughter to marry without the king's consent, and she ceded the guardianship of two important castles along with five hundred *libras provins* for their upkeep to the king. This initial agreement had to be followed with additional concessions to insure the king's loyalty in 1209 and 1213 with payments on each occasion totaling fifteen thousand *libras parisis*.[47] The magnitude of this payment may be suggested by recalling that a typical clerical prebend, such as those that Count Henry had endowed at Saint-Etienne, averaged ten *libras provins* a year.[48]

The process of appointing a new bishop also reflects the diminished powers of the principality under Blanche's regency. When the see fell vacant in 1205, King Philip Augustus quickly weighed in, assuming the possessions of the bishop of Troyes during the vacancy of the post and even a few months beyond.[49] When the election among the canons ended in a draw, the process that had traditionally been overseen by the counts,[50] was instead referred to Pope Innocent III, who preferred Herveus, a Parisian-trained 'doctor of divinity' from a modest family.[51] Herveus (1207–23) was thus the first bishop of Troyes who could claim to be truly independent of the counts, since he owed neither his family's status nor his episcopal appointment to them.[52] In fact, a particular animus developed between Bishop Herveus and the countess. In 1217 at the Council of Reims, Bishop Herveus of Troyes failed to endorse Blanche in a crucial vote against rival claimants for the comital seat.[53] Given the regent's precarious position, Herveus's lack of support must have been especially hard to take. According to a document

[46] Arbois de Jubainville, *Histoire*, 4:101–4.

[47] See the useful analysis with further documentation in John W. Baldwin, *The Goverment of Philip Augustus, Foundations of French Royal Power in the Middle Ages* (Berkeley, 1986), 196–97 and 278–79; on p. 279, he notes that 500 *libras provins* from the initial agreement would be the equivalent of 375 *libras parisis*.

[48] Evergates, *Feudal Society*, 3.

[49] M. J. Monicat and M. J. Boussard, *Recueil des Actes de Philippe Auguste, Roi de France* (Paris, 1966), 3: no. 982, 32–35 where the delay between Herveus's confirmation in office by Innocent III on 20 February 1207 and the king's release of his possessions indicated in a document issued between April 22 and October 31, 1207 is evident. On Philip Augustus' general policy of exercising his regalian rights, see Baldwin, *Government of Philip Augustus*, 161–62.

[50] As noted in Lalore, *Cartulaire de Saint-Pierre de Troyes*, p. LIV–LV, the chapter of Troyes Cathedral had the right to elect the bishop from among its members. However, as clearly demonstrated in Joseph Roserot de Melin, *Le diocèse de Troyes des origines à nos jours (XXXe s.–1955)* (Troyes, 1955), 78–81, the counts controlled the process.

[51] Both of these details are provided by the epitaph on his tomb of 1223, which is quoted in full in Arnaud, *Voyage archéologique*, 180.

[52] Bur, *La Formation*, 189 and 496n92. Bur suggests that the bishop of Troyes's true independence rested on the king's confirmation of the possessions of the bishop of Troyes in 1177, at the conclusion of the Saint-Etienne affair. On this confirmation (Troyes, Archives départementales, G 2551), see Achille Luchaire, *Etudes sur les actes de Louis VII* (Paris, 1885; Brussels, 1964), no. 736, p. 329.

[53] The Council of Reims nonetheless voted that the excommunication of the rival claimants to the seat of Champagne should be publicly decreed in all the dioceses. Arbois de Jubainville, *Histoire*, 4:145–6; 5: no. 1062, p. 114.

of 12 November 1219 in which Herveus reiterated his objections, the bishop of Troyes claimed that, as a usurer, Blanche had no right to petition him.[54]

Countess Blanche did succeed in finding external allies to help her. Besides her purchase of the king's support, Blanche also received the backing of Innocent III.[55] The papal legate Robert de Courson stated that as a widow, the countess deserved the special protection of the church, and he oversaw church councils that excommunicated her rivals for the comital seat.[56]

A perpetual daily Mass that Countess Blanche founded at Saint-Etienne of Troyes in 1209 serves to further highlight political tensions within Troyes.[57] In making this endowment of ten *libras provins* per year, Blanche stated that her gift honored the 'familiarity and love' that Queen Adela of France, the mother of Philip Augustus, held for her while alive. Blanche does not describe her own affection for Adela, but instead, self-reflexively, the queen's regard for her. As Megan McLaughlin notes of this 'unusual transaction,' such a liturgical foundation might 'publicize' a relationship, which however genuine, also carried social benefits to the founder.[58] In the context of the new agreement for protection that Blanche forged with Philip Augustus in the same year, it would have been politically astute for the countess to invoke her friendship with the king's mother. At the time of this bequest, however, the cathedral of Troyes was undergoing a major building campaign; a purchase of land undertaken in 1208 by Bishop Herveus to the east of the older site allowed for the expansion of the cathedral beyond the old town walls.[59] It may thus be surmised that with this gift Blanche pointedly chose not to support the new Bishop Herveus and his

54 Arbois de Jubainville, *Histoire*, 5: no. 1236, p. 148. The diocese under the lead of Archbishop Pierre le Corbeil of Sens took a strong stand against usury: at an ecclesiastical council at which he officiated in Melun in 1216, the archbishop declared that any prior who received money from a Jew should be stripped of his office. See Solomon Grayzel, *The Church and the Jews in the XIIIth Century*, revised ed. (New York, 1966), no. 14, p. 313. Usury is discussed in William Chester Jordan, *The French Monarchy and the Jews, From Philip Augustus to the Last Capetians* (Philadelphia, 1989), 80–82. I have argued elsewhere that the issue of usury bitterly divided the countess and bishop, see Elizabeth Carson Pastan, 'Process and Patronage in the Decorative Arts of the Early Campaigns of Troyes Cathedral, ca. 1200–1220s,' *Journal of the Society of Architectural Historians* 53 (1994): 229–30.

55 Arbois de Jubainville, *Histoire*, 4:147 stated his conviction that Blanche 'spared nothing to stimulate the zeal of the clergy on her behalf,' while admitting that he could only locate fairly meager evidence, and not before 1216.

56 Arbois de Jubainville, *Histoire*, 4:141 giving a French translation of the document excommunicating her rival claimants to the comital seat, and *Histore* 5: *Catalogue des actes des comtes de Champagne*, no. 833, p. 75.

57 Megan McLaughlin, '"Familiarity and Love": Noble Friendship and Liturgical Commemoration in the Twelfth and Thirteenth Centuries,' *Proceedings of the Annual Meeting of the Western Society for French History* 18 (1991): 60–69.

58 McLaughlin, 'Familiarity and Love,' 66.

59 Transcribed in Henri d'Arbois de Jubainville, 'Documents rélafits aux travaux de construction faits à la cathédrale de Troyes pendant les XIIe, XIVe et XVe siècles,' *Bibliothèque de l'Ecole des chartes* 23 (1862): no. 1, pp. 217–18. Text analyzed and illustrated in Roserot de Melin, *Bibliographie*, 1:13–19. Requests for financial donations to the building under way issued by the papal legates in 1213 and in 1215 also testify to the continuing need for funds at this critical juncture in the building's construction. See Arbois de Jubainville, 'Documents rélatifs aux travaux,' nos. 2 and 3, pp. 218–19; Roserot de Melin, *Bibliographie*, 1:20–1.

enlargement of the cathedral, instead bestowing another distinction on the comital chapel.

Troyes Cathedral may well have been rebuilt in the early thirteenth century with the intent of equaling the grandeur of the comital chapel. Besides its increased size, another noteworthy aspect of the new cathedral was the addition of eight statues of bishops poised on the front shafts of the choir hemicycle. As may be seen in the upper left of a lithograph of the cathedral choir made in 1857 (fig. 29.5), these statues rise, over life size, from the height of the altar cross to the base of the triforium.[60] At present, only seven of the architectural canopies are original and the bishops themselves are nineteenth-century replacements. Nonetheless, on the basis of stylistic comparisons between the extant canopies of the bishops and capitals at Laon and Chartres and in the choir ambulatory of Troyes Cathedral, the statue cycle has been persuasively dated to 1210–20.[61] Since the bishops' statues, with their distinctive *prise de possession* of the choir, would seem to make a striking statement of episcopal power, they will be considered in some detail.

Although the individual statues are restorations, we can confirm the number and subject of the originals. Following the destruction of the medieval statues during the French Revolution, Anne-François Arnaud, a local artist turned *Monuments historiques* inspector, recommended using copies from the south transept of Chartres because of their similarity of subject and date.[62] Arnaud's advice was not easily ignored; he devoted himself to documenting the works of art destroyed during the French Revolution. As the first to make a detailed inventory of the cathedral after the vandalism that had occurred, he vividly conveyed the chisel marks still silhouetted on the columns from which the statues were wrenched off.[63] The statues portrayed the first sainted bishops of the diocese: saints Amator, Melain, Urse, Loup, Camelien, Vincent, Leuçon, and Prudence, although at some point Louis and Jacques Raguier, the fifteenth- and sixteenth-century bishops credited with overseeing the northern and western facades, respectively, were either added or substituted.

Even regional programs with interior choir sculpture such as Châlons-en-Champagne, Margerie, Montier-en-Der, and Saint-Remi of Reims offer no precise parallels.[64] Perhaps the closest analogies for the content of the Troyes sculpture may be found in the choir glazing of Saint-Remi of Reims. As Madeline Caviness has shown, the clerestory windows undertaken in the campaign of around 1200 depicted a total of sixty-six figures with apostles

[60] In this lithograph, two of the statues are shown in the upper left; the one in the foreground is viewed as a dark silhouette. For a frontal view of all eight statues, see Marsat, *Cathédrale de Troyes*, 32.

[61] Bongartz, *Die frühen Bauteile der Kathedrale in Troyes*, 209–11.

[62] On the politics of the restorations at Troyes, see Elizabeth Carson Pastan, 'Restoring the Stained Glass of Troyes Cathedral: The Ambiguous Legacy of Viollet-le-Duc,' *Gesta* 29 (1990): 155–66.

[63] Arnaud, *Voyage archéologique*, 165.

[64] Pastan, 'Process and Patronage,' 227–30.

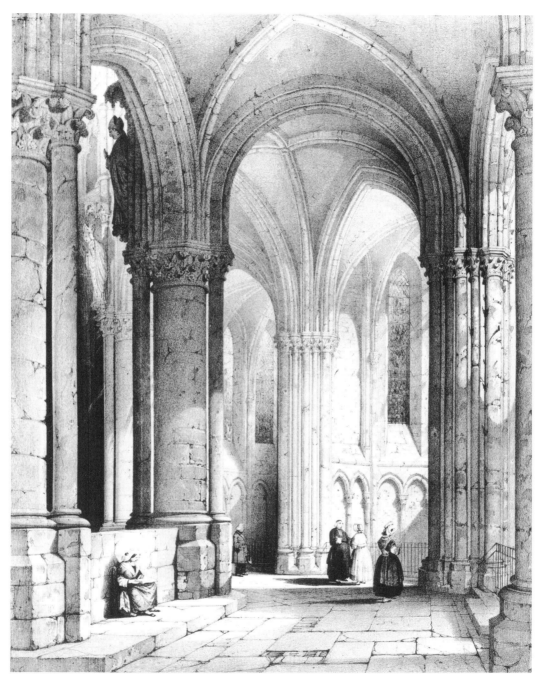

29.5 Lithograph of the interior of Troyes Cathedral with two of the choir statues of bishops visible in the upper left.

and prophets above and thirty-three archbishops in the lower tier.[65] These Remois archbishops recall the Troyes statues, suggesting a similar impulse to enshrine the choir with sainted ecclesiasts. However, the numerous archbishops in Saint-Remi are seated far aloft and in the more ethereal medium of glass, while the eight large and upright statues at Troyes have a kind of participatory immediacy.

The choir statues also relate to contemporary events in Bishop Herveus's tenure. By evoking his predecessors, Herveus underscored his own authority and emphasized the antiquity of saintly bishops from Troyes. The choir statuary in the region and the archbishops in the choir glazing of Saint-Remi of Reims demonstrate that the imagery would have been meaningful in general symbolic terms as distinguished forbearers and Christian moral exemplars. Nonetheless, given the controversies between Countess Blanche and the bishop, the choir statues of bishops in Troyes Cathedral surely also underscore the newly independent authority of Herveus.

While it is tempting to interpret these bishops as a blunt statement of episcopal hegemony, the bishop's authority in thirteenth-century Troyes, like the counts', was contested. A papal bull of 15 January 1219 lays out the ongoing strains between the cathedral and Saint-Etienne and suggests the vehemence of the competition between the two establishments.[66] At issue were various questions of jurisdiction: Was the cathedral or the collegial to ring its bells first at Easter? When were the canons from the palace chapel required to process to the cathedral? Under what circumstances would the bishop, who was to be given a living at Saint-Etienne, pronounce mass there? And, returning again to the issue of episcopal authority, to whom were the canons of Saint-Etienne answerable?

Saint-Etienne ceded all points of dispute to the cathedral, with the exception of the issue of episcopal jurisdiction, which, as we have seen, was a subject of dispute going back to 1171–72. By insisting on independence from the bishop in this thirteenth-century adjudication, the chapter finally returned to the terms of Count Henry's original foundation charter.[67] However satisfying this may have been for the doyen and chapter of Saint-Etienne, it would have nonetheless been a rather hollow victory, since their status depended on the counts, whose influence was on the wane. Indeed, in 1223 the chapter would undergo the indignity of seeing its altar furnishings pawned to support Count Thibaut's need for ready cash.[68]

In early thirteenth-century Troyes we thus find the various principles (countess, bishop, pope, and king) attempting to assert authority in the

[65] Madeline Harrison Caviness, *Sumptuous Art at the Royal Abbeys in Reims and Braine: 'Ornatus elegantiae varietate stupendes'* (Princeton, 1990), 58–61.

[66] Troyes, Archives départementales, G 3349; see Henri d'Arbois de Jubainville and Francisque André, *Inventaire sommaire des Archives Départementales anterieures à 1790: Archives ecclésiastiques, série G*, 3 vols (Paris, 1873–1930), 2:116–17 and Théophile Boutiot, *Histoire de la ville de Troyes et de la Champagne méridionale*, 2 vols (Troyes, 1870), 1:303–4.

[67] Boutiot, *Histoire de la ville de Troyes*, 304.

[68] Arnaud, *Voyage archéologique*, 34.

circumstances that included dynastic insecurity, a bishopric no longer under the counts' control, the ever-present need for ready cash to purchase royal support, and a newly activist papacy.[69] These power struggles suggest that while the Realpolitik of the thirteenth century continued to include traditional forms of patronage, these were tempered by new realities. The counts still made endowments to the church, as we have seen in the case of the Mass Blanche endowed at Saint-Etienne, but not on the scale that they had previously undertaken; their own need for disposable income was too great. In contrast, with the appointment of Bishop Herveus and the rebuilding he oversaw, the cathedral's artistic patronage expanded considerably, although it was in essence catching up to Saint-Etienne. But it is the appearance of two new outside influences, who had not figured so prominently in the twelfth-century political landscape of Troyes before the Saint-Etienne affair, that was the most conspicuous development of this new era. It was the combined support of the papacy (but not Bishop Herveus) and of Philip Augustus (however costly) that enabled Countess Blanche to retain the territories of Champagne until her son Thibaut IV reached majority. And it was these same external forces that enabled Bishop Herveus to exercise authority in the Champenois context previously dominated by the counts.[70]

Indeed Realpolitik in thirteenth-century Troyes consisted chiefly of checks and balances, partly because of the external controls provided by the pope and king, and partly because of the competition between the counts and bishops. In contrast in the twelfth century when Count Henry named his chapel after the crowned member of his dynasty and endowed clerics on the same scale as the archbishoprics, he envisioned his principality of Champagne on a larger stage and behaved as though he were answerable to no one.[71] Arguably, what made Saint-Etienne so incendiary a symbol was the very real power plays by Count Henry that lay behind it. But thirteenth-century patronage was a limited and retaliatory affair, epitomized by the bishops' statues of Troyes Cathedral, which may have proclaimed the bishop's new prominence, but ultimately made an ambiguous political statement since they were erected during the period when the bishop failed to maintain his authority over the many nearby canons of Saint-Etienne.

[69] Colin Morris, *The Papal Monarchy: the western church from 1050–1250* (Oxford, 1989), 413–51, esp. 426–33; André Vauchez, 'Eglise, Pouvoirs, Société,' in *Apogée de la papauté et expansion de la chrétienté*, from the series *Histoire du christianisme des origines à nos jours*, ed. Jean-Marie Mayer et al., vol. 5 (Paris, 1993), 617–38.

[70] See n. 52 *supra*.

[71] Henry's brash actions and motivations are the subject of very pithy statements by Alberic of Trois-Fontaines (ca. 1220–41), who was writing about him in this very era. See Alberic of Trois-Fontaines, 'Chronica Albrici monachi Trium-Fontium a monacho Novi-Monasterii Hoiensis interpolata', ed. Paul Scheffer-Boichorst, *Monumenta Germaniae historica, Scriptores* 23 (Hanover, 1874): s.v., Anno 1163, 847. Partial French translation in Arbois de Jubainville, *Histoire* 3:81. On the value of Alberic (or Aubri) as an historical source, see Theodore Evergates, *Feudal Society in the Bailliage of Troyes under the Counts of Champagne, 1152–1284* (Baltimore, 1975), 54–55.

Returning to the analyses of Robert Fawtier, with whom this study began, it is fair to conclude that Fawtier gave the Capetians too much credit. The creation of monumental art such as the so-called palace chapel of the counts and the new Gothic choir of the cathedral of Troyes involves the appropriation of physical space, financial resources, and spiritual symbolism, and for these reasons, can naturally become a focus for other kinds of issues, which is why it has served us well in highlighting power struggles between the counts and the clergy.[72] By analyzing Realpolitik in the comital seat of Troyes in the later twelfth and early thirteenth century, a period Fawtier largely jumps over, we can see that internal dissent in Champagne laid the groundwork for new external influences. I have sought to demonstrate how patronage in Troyes reflects a pattern of staking claims and counterclaims in the decor and ambition of the palace chapel of Saint-Etienne, in the Masses the countess established there, in the rebuilding of the cathedral to equal the grandeur of the comital chapel, in disputes over the cathedral's privileges, and in the larger-than-life-sized bishops' statues adorning the cathedral choir. It is ironic that both the church of Saint-Etienne and the cathedral's statue cycles were destroyed during the French Revolution, thus effectively treating these distinct and competing entities in the same manner, and making them even more difficult to [re]situate within the Realpolitik of the earlier era.

72 For a general discussion of these issues with further bibliography, see Barbara Abou-El-Haj, 'Artistic Integration Inside the Cathedral Precinct: Social Consensus Outside?' in *Artistic Integration in Gothic Buildings*, ed. Virginia Chieffo Raguin, Kathryn Brush, and Peter Draper (Toronto, 1995), 214–35.

Rhetoric and Reform: The St Thomas Becket Window of Sens Cathedral

Alyce A. Jordan

Introduction

In life, and particularly in death, Thomas Becket was nothing short of a medieval celebrity. During his seven years as chancellor of England, Becket became the close companion and confidant of the English king, Henry II. When, in 1162, the king selected Becket to become the next archbishop of Canterbury, popular consensus held that it was Becket's track record as a skilled executor of royal policy, rather than any demonstrated aptitude for the ecclesiastical profession, that had recommended his appointment. Following his consecration, however, Becket proved himself an ardent, if unanticipated, defender of the Church. Thomas Becket and Henry II, former friends and hunting companions, entered into a series of combative engagements focused on the issue of clerical immunity. The dispute culminated in Becket's refusal to endorse the Constitutions of Clarendon. In 1164, fearing for his safety, Becket fled Canterbury. He spent the next six years living in exile in France. A series of protracted negotiations returned the prelate to England near the end of 1170, where, on December 29, he was slain in Canterbury cathedral by four of Henry II's knights. Public outrage accompanied miraculous occurrences at the archbishop's tomb. In 1173, less than three years after his murder, Thomas Becket was canonized. His relics were translated in 1220 in a splendid ceremony presided over by Archbishop Stephen Langton. Becket's shrine remained for centuries the most frequented pilgrimage site in England.

Even before his murder, Becket's life comprised the stuff of story. His humble origins, meteoric rise and fall from royal favor, arduous exile, and dramatic demise offered all the elements of a gripping narrative. That Becket's professional circle was composed largely of men whose careers focused on the written word assured the rapid broadcasting of the events of his life, and circumstances of his death, in the medium of text.[1] The visual corpus that

[1] The primary textual sources are collected in J. C. Robertson and J. B. Sheppard, eds, *Materials for the History of Thomas Becket, archbishop of Canterbury*, Rolls Series, 7 vols (London, 1875–85). The major biographies of Becket are Frank Barlow, *Thomas Becket* (1986; repr. London,

Thomas Becket's life and death inspired, though less well preserved,[2] is comparably impressive. Images of Becket appeared almost immediately following his murder.[3] Early works took the form of figurative ampullae designed to hold water mixed with a drop of the martyr's blood.[4] Narrative accounts of Becket's murder appeared quickly in manuscripts and were widely disseminated on enameled reliquaries produced in Limoges.[5] While this first generation of Becket imagery focused on single images of the saint, or curtailed accounts of his murder, a shift to monumental and expanded renderings of Becket's life occurred at Canterbury Cathedral, where the choir was redesigned and decorated to house the lavish new shrine to which the saint's relics were translated in 1220. Twelve windows encircled the shrine at aisle level. Ten of these depict the many healing miracles which Becket's relics had already effected in the fifty years following his death.[6] Two additional windows, of which only one scene survives, are believed to have contained a narrative account of Becket's life.[7]

That Thomas Becket's story should find its earliest elaboration in the medium of glass is not surprising, reinforcing as it does the observations of Madeline Caviness, Wolfgang Kemp, and others that stained-glass windows constituted a primary locus for the elaboration of story in medieval visual narrative.[8] Inspired perhaps by the Canterbury ensemble and the translation of Becket's relics, four windows devoted to the archbishop's life appeared in the French cathedrals of Sens, Chartres, Coutances, and Angers during the first half of the thirteenth century.[9] They are among the earliest works of monumental narrative art devoted to Becket outside Canterbury. All four expand the visual repertoire devoted to Becket in their depiction of events not immediately tied to his murder and vary dramatically in form and content from one to the other. This essay focuses on the window of Sens Cathedral, which exhibits both a notable

1997); David Knowles, *Thomas Becket* (1970; repr. London, 1971); and, most recently, Anne Duggan, *Thomas Becket* (London, 2004).

 [2] See Tancred Borenius, *St. Thomas Becket in Art* (1932; repr. Port Washington, N.Y., 1970), 109–10.

 [3] Borenius, *St. Thomas Becket in Art*; Raymonde Foreville, ed., *Thomas Becket: Actes du Colloque international de Sédières 19–24 août 1973* (Paris, 1975).

 [4] Brian Spencer, *Pilgrim Souvenirs and Secular Badges* (London, 1998), 37–72.

 [5] The Metropolitan Museum of Art, *Enamels of Limoges 1100–1350* (New York, 1996), 14, 162–64. Fifty-two reliquaries, produced between 1180 and 1220, are known to exist.

 [6] See Madeline Harrison Caviness, *The Early Stained Glass of Canterbury Cathedral 1175–1220* (Princeton, 1977), 83–97 and 146–50; and Madeline Harrison Caviness, *The Windows of Christ Church Cathedral Canterbury*, Corpus Vitrearum Medii Aevi, Great Britain 2 (London, 1981), 157–214.

 [7] Madeline H. Caviness, ed. *Medieval and Renaissance Stained Glass from New England Collections* (Medford, Mass., 1978), 12–13.

 [8] Madeline H. Caviness, 'Biblical Stories in Windows: Were They Bibles for the Poor?' in *The Bible in the Middle Ages: Its Influence on Literature and Art*, ed. Bernard S. Levy, Medieval and Renaissance Texts and Studies 89 (Binghamton, N.Y., 1992), 106; Wolfgang Kemp, *The Narratives of Gothic Stained Glass*, trans. Caroline Dobson Saltzwedel (Cambridge, 1997), 1.

 [9] Catherine Brisac, 'Thomas Becket dans le vitrail français au debut du XIIIᵉ siècle,' in *Thomas Becket: Actes du Colloque international de Sedières 19–24 août 1973*, ed. Raymond Foreville (Paris, 1975), 221–31.

enlargement and a specific diversification of the visual repertoire devoted to Becket. Produced in a relatively short period of time surrounding the translation of the saint's relics in 1220, the window constitutes an intriguing case study of the ways in which the story of Thomas Becket was re-presented and retold at a seminal moment in the expansion of his cult.

Thomas Becket at Sens

Outside of Canterbury, Sens is one of the most likely places to find visual evidence for the veneration of Thomas Becket. The archbishop spent all of his six years of exile in the vicinity of Sens, taking refuge first in the Cistercian abbey of Pontigny and then in the Benedictine monastery of Sainte-Colombe.[10] Madeline Caviness has proposed that the Becket window, which exhibits close formal connections to the windows at Canterbury, was executed using patterns brought to Sens by the Canterbury monastic community as part of another archiepiscopal entourage-in-exile, that of Stephen Langton. Langton's election as archbishop of Canterbury had been opposed by King John of England, and Langton spent six years between 1207 and 1213 living in exile, as Becket had done, at the abbey of Pontigny.[11]

The Sens window recounts a story appropriate to the mythology to which the martyr's life had so quickly given rise.[12] Thirteen scenes read from bottom to top and commence with the reconciliation of Thomas Becket and Henry II. Becket's return to Canterbury transpires across three successive scenes which detail Becket's crossing of the English Channel, his journey on horseback to Canterbury, and his reception by the monks at the doors of Canterbury Cathedral (fig.30.1). These are followed by five panels depicting the archbishop engaged in a series of quintessentially episcopal acts. Becket appears preaching a sermon, celebrating Mass, receiving correspondence, confirming children, and consecrating a church outfitted with state-of-the-art flying buttresses (figs. 30.1 and 30.2). Situated ominously at the center of this industrious visual resume of pastoral activity is a scene of Becket receiving Henry II's envoys (fig. 30.2). The upper portion of the window recounts, in successive panels, the archbishop's murder and entombment and culminates in a scene of Christ enthroned and flanked by angels (fig. 30.3). That the narrative commences with the reconciliation of Henry II and Becket, and the latter's departure for England, suggests, as Borenius and others have observed, that a companion window detailing the

[10] Barlow, *Thomas Becket*, 117–97; Knowles, *Thomas Becket*, 101–34; Michael Staunton, *The Lives of Thomas Becket* (Manchester, 2001), 116–81.

[11] Caviness, *Early Stained Glass*, 10–11, 25, 84–95, and esp. 92–93; Caviness, *Windows of Christ Church*, 159, 161–62, 164, 187, and 193; Abbe Brulée, 'Descriptions des verrières de la cathédrale de Sens,' *Société archéologique de Sens* 7 (1861): 161–216; Eugène Chartraire, *La Cathédrale de Sens* (Paris, 1921), 85–93; Lucien Bégule, *La Cathédrale de Sens* (Lyon, 1929), 43–75; and Jean Taralon et al., *Les Vitraux de Bourgogne, Franche-Comte, et Rhone-Alpes*, Corpus Vitrearum, France, Recensement des vitraux anciens de la France 3 (Paris, 1986), 178–80.

[12] Brisac, 'Becket dans le vitrail,' 224–26.

30.1 Sens, Cathedral of Saint-Étienne, north ambulatory, St Thomas Becket Window (lower portion), ca. 1207–13.

earlier part of Becket's life may originally have existed.[13] Even the single lancet, however, comprises a significant expansion of earlier narratives. This version of Becket's story offers a counterpoint to textual accounts in its rendering of the archbishop's return to Canterbury, replete with exacting details, such as the crowds, both ecstatic and hostile, that attended his arrival on English soil (fig. 30.1).[14] The illustration of pastoral activities provides an accurate synopsis of the acts in which Becket engaged during his final weeks.[15]

[13] Borenius, *St. Thomas Becket in Art*, 45; Brulée, 'Description des verrières,' 165; Caviness, *Medieval and Renaissance Stained Glass*, 13.

[14] Barlow, *Thomas Becket*, 224; Knowles, *Thomas* Becket, 134; Staunton, *Lives of Becket*, 182–83.

[15] Barlow, *Thomas Becket*, 225–50; Knowles, *Thomas Becket*, 135–49; Staunton, *Lives of Becket*, 182–203.

30.2 Sens, Cathedral of Saint-Étienne, north ambulatory, St Thomas Becket Window (center portion), ca. 1207–13.

In addition to documenting Becket's return to Canterbury, and his untimely demise, the window, particularly in its focus on the archbishop's pastoral and administrative activities, also recalls key events in the Becket conflict. It was while preaching at Vézelay that the saint pronounced sentences of excommunication and anathema on members of the English clergy and aristocracy. While preaching at Canterbury on Christmas day 1170, Becket declared himself ready to liberate his church and congregation from royal oppression or to die 'among them and for them' (figs. 30.1 and 30.4).[16] The transmission of correspondence between Thomas, Henry II, Pope Alexander III, and the English clergy, and the increasingly draconian measures Henry II took to thwart its delivery, constituted a dramatic through-line in the six-year dispute (fig. 30.2).[17] The

[16] Barlow, *Thomas Becket*, 146–48; Beryl Smalley, *The Becket Conflict and the Schools* (Totowa, N.J., 1973), 194.
[17] Barlow, *Thomas Becket*, 191–92 and 203–5.

30.3 Sens, Cathedral of Saint-Étienne, north ambulatory, St Thomas Becket Window (upper portion), ca. 1207–13.

pastoral activities of churchmen who continued to exercise their ecclesiastical duties despite censures and even excommunications at Becket's hands comprised another central element of the conflict.[18] The full spectrum of these details of the Becket affair would have resonated with the contemporary viewers of the Sens window.

Another historical frame relevant to the Becket window concerns the archbishop of Sens and his role in the Becket conflict. William of the White Hands, bishop of Chartres and, after 1168, archbishop of Sens, proved an ardent defender of the exiled prelate and among the most visible advocates of Becket's cause in the later years of his exile. William played a key role in the final stage

[18] Barlow, *Thomas Becket*, 145, 184–85, 191–92, and 195.

30.4 Sens, Cathedral of Saint-Étienne, north ambulatory, St Thomas Becket Preaching, St Thomas Becket Window (lower portion), ca. 1207–13.

of negotiations between Becket and Henry.[19] After Becket's death, the archbishop of Sens led the French Church in its call for the punishment of those responsible for the archbishop's murder. It was William who, in January 1171, pronounced an interdict on Henry's continental lands.[20] In its depiction of the life of the archbishop of Canterbury, the window also honors the archbishop of Sens, who, in his advocacy of Church rights and his protection of virtuous churchmen forced into exile by tyrannical monarchs, exemplified the very ideals for which the saintly archbishop Thomas had quickly become the

19 Barlow, *Thomas Becket*, 205–10.
20 Barlow, *Thomas Becket*, 252–55.

standard bearer. Finally, Becket's episcopal vestments, long kept in the cathedral treasury and venerated as relics, offer perhaps the most salient element in the cult surrounding his exile at Sens and the particular visualization of his life articulated in the cathedral's glass.[21]

Thomas Becket as Episcopal Exemplum

As is often the case in visual narrative, the Sens Becket window includes details recorded in textual sources, but does not illustrate any particular one of these. Rather, the window constitutes a singular manifestation of Becket's story.[22] Though distinct relative to the copious literary accounts of the archbishop's life, the Sens Becket window appears less unusual when compared with windows devoted to other episcopal saints. While Becket did indeed spend his final weeks engaged in the various ecclesiastical activities the window depicts, this visual resume also comprises a recurrent theme in depictions of bishop saints memorialized in medieval glass (figs. 30.2, 30.4, and 30.5). Madeline Caviness has observed that, in the first half of the thirteenth century, lives of ecclesiastical, particularly episcopal, saints are frequently reduced to a seemingly mundane repetition of liturgical acts.[23] The Life of St Remy window at Chartres, for example, depicts the saint baptizing and preaching, activities comparable to those performed by Thomas Becket at Sens. St Remy even appears extinguishing a church fire in a scene which, as Caviness notes, 'looks more as if he is performing a consecration,' and, as such, closely resembles the Sens Becket panel in which the saint does indeed consecrate an ecclesiastical building (fig. 30.2).[24] Such compositional and occupational parallels tie the Sens Becket window not only to the Chartres Life of St Remy, but to other chartrain windows devoted to episcopal saints, including those of St Silvester, St Martin of Tours, and St Germain d'Auxerre.[25]

Comparably generic accounts of bishop saints appear in other thirteenth-century venues. Michael Cothren has argued that a bishop saint window from the axial chapel of Beauvais Cathedral, the subject of which has long defied identification, portrays its enigmatic protagonist in a protracted series of scenes that focuses not on specific biographical details but on the bishop's 'scrupulous performance of the routine responsibilities of his elevated

[21] Bégule, *Cathédral de Sens*, 81–83; Brulée, 'Description des verrières,' 168.

[22] Caviness, 'Biblical Stories in Windows,' 128–47, uses the story of Joseph in Egypt to demonstrate the complementarity, rather than the dependence, of visual narratives relative to textual 'sources.'

[23] Madeline H. Caviness, 'Episcopal Cults and Relics: The Lives of Good Churchmen and Two Fragments of Stained Glass in Wilton,' in *Pierre, lumière, couleurs: études d'histoire de l'art du Moyen Âge*, *Hommage à Anne Prache*, ed. Fabienne Joubert et Dany Sandron, Cultures et Civilisations Médiévales 20 (Paris, 1999), 79–80.

[24] Caviness, 'Episcopal Cults,' 80.

[25] Caviness, 'Episcopal Cults,' 79–84; Colette Deremble and Jean-Paul Deremble, *Vitraux de Chartres* (Paris, 2003), 128–33.

30.5 Sens, Cathedral of Saint-Étienne, north ambulatory, St Thomas Becket Celebrating Mass, St Thomas Becket Window (center portion), ca. 1207–13.

rank.'[26] Cothren proposes that the incumbent bishop of Beauvais, Robert de Cressonsacq, who oversaw the glazing campaign, may have sought to cast his own episcopacy in a favorable light through the inclusion of a narrative window dedicated to the impeccable episcopal resume of some sainted predecessor. The import of this window for a medieval audience, Cothren argues, may thus have resided less in the identity of the bishop saint it portrayed than in the episcopal image it projected.[27]

[26] Michael W. Cothren, 'Who is the Bishop in the Virgin Chapel of Beauvais Cathedral?' *Gazette des beaux-arts*, 6th ser., 125 (1995), 7.

[27] Cothren, 'Who is the Bishop,' 7–12.

The focus on standardized pastoral activities at the expense of a more individualized depiction, while perhaps surprising in the case of a recently deceased figure such as Thomas Becket, can be related to contemporary rhetorical trends and theological preoccupations. I have argued elsewhere that techniques of repetition in medieval visual narrative function as argumentative strategies in ways that strongly parallel devices outlined in medieval rhetorical treatises on storytelling.[28] The Becket window at Sens, like episcopal windows elsewhere which suppress specific biographical details in favor of a repetitive compendium of exemplary pastoral activities, locates the archbishop of Canterbury in a paradigm of ecclesiastical power and pastoral reform of central concern to the late twelfth- and early thirteenth-century Church. Colette Manhes-Deremble has linked depictions of quotidian liturgical acts, such as preaching and the celebration of Mass, to reforms instituted at the Third Lateran Council of 1179, while Caviness sees them more specifically in relation to the forceful reaffirmation of 'the sacred rituals of the priesthood that had been challenged by the Cathar heresy throughout Europe around 1200, and that were firmly restated as ecclesiastical prerogatives by the Lateran Council of 1215.'[29] The assertion of ecclesiastical authority and renewal propounded in Lateran Three and Four finds a visual counterpart in these recurrent depictions of industrious clerical activity. As Caviness eloquently states, these churchmen, immersed in the execution of their office, '... do the ideological work of maintaining the power of the very institutions whose walls they decorate.'[30]

Thomas Becket thus joins a panoply of saintly prelates performing their pastoral duties across the windows of medieval France. That he does so in the cathedral of Sens imparts another interpretive layer to the narrative. For the ecclesiastical reformers of the thirteenth century and beyond, the martyred archbishop who died in defense of church liberties offered not just an example of a model prelate, but the foremost exemplum of the reform ideal. Indeed, Becket became what Anne Duggan has called 'a figure of epic quality, the hero of the reformers. ...'[31] More striking still, Becket's life and legend served as the primary vehicle upon which Stephen Langton constructed his program for the reform of the English Church, a program developed over the course of the thirty years he spent in Paris during the early part of his career and further elaborated during his years of exile in Sens. The Sens Becket window may, then, simultaneously articulate a litany of ideal pastoral activities that mirrored hagiographic windows elsewhere, and one reformer's specific vision of pastoral renewal.

[28] Alyce A. Jordan, *Visualizing Kingship in the Windows of the Sainte-Chapelle*, Publications of the International Center of Medieval Art 5 (Turnhout, 2002), 9–14.

[29] Colette Manhes-Deremble, *Les Vitraux narratifs de la cathédrale de Chartres: étude iconographique*, Corpus Vitrearum, France, Études 2 (Paris, 1993), 30–32; Caviness, 'Episcopal Cults,' 84.

[30] Caviness, 'Episcopal Cults,' 84.

[31] Anne Duggan, 'The Cult of St Thomas Becket in the Thirteenth Century,' in Meryl Jancey, ed., *St Thomas Cantilupe Bishop of Hereford: Essays in His Honour*, (Hereford, 1982), 22.

Thomas Becket, Stephen Langton, and the Reform Ideal

The reform of the Church initiated by Pope Gregory VII in the late eleventh century was closely linked with the investiture controversy, whereby secular leaders claimed the right to appoint and depose high ranking clergy. Gregory, by contrast, called for an autonomous Church free of secular interference, rededicated to its early apostolic mission of pastoral care. This agenda, addressed in the Lateran Council of 1179, was further elaborated and codified during the Fourth Lateran Council in 1215. Both Councils called for the elimination of internal abuses and laxities, the education of the clergy, and a renewed dedication to pastoral duties, with particular emphasis placed on preaching. [32]

Becket's supporters, having declared him the moral conscience of the Church during his exile, proclaimed his martyrdom and canonization—his triumph in death—as divine proof of the rightness of his cause.[33] In sermons, and in the liturgical offices composed following his canonization in 1173, Becket is repeatedly invoked as an exemplum of model clerical behavior. Two especially powerful images that emerge from these texts are Becket as defender of the Church and Becket as the *bonus pastor*.[34] The archbishop's courageous, steadfast, and selfless defense of Church rights and liberties against the tyrannical encroachments of Henry II permeated the collective consciousness of the medieval west and transformed Becket into an icon of Church liberty from Iceland to Poland.[35] The second mantle claimed for the martyred archbishop, the *bonus pastor*, or good shepherd who tended to the needs of his flock even at the cost of his own life, offered a model for the industrious, devoted cleric focused upon the exemplary execution of his pastoral duties. These two *topoi*, which effectively encompassed the reform ideal of a Church free of secular interference and committed to its early apostolic mission, were among the most frequently invoked themes of the Becket sermon corpus.[36] By crafting Becket's life as a resume of his episcopal office in juxtaposition with his martyrdom, the Sens window foregrounds both of these saintly legacies. This particular realization may relate not only to Becket's import for the reform movement

[32] Karl F. Morrison, *Tradition and Authority in the Western Church 300–1140* (Princeton, 1969); I. S. Robinson, *Authority and Resistance in the Investiture Contest* (Manchester, 1978); and the collection of primary documents assembled by Brian Tierney, ed., *The Crisis of Church and State 1050–1300* (Englewood Cliffs, N.J., 1964); Marshall W. Baldwin, *Alexander III and the Twelfth Century* (New York, 1968), 192–93 and 199; Marion Gibbs and Jane Lang, *Bishops and Reform 1215–1272 with Special Reference to the Lateran Council of 1215* (London, 1934), 94–101; Smalley, *The Becket Conflict*, 18–38.

[33] Barlow, *Thomas Becket*, 198–99 and 264–75.

[34] Phyllis B. Roberts, *Thomas Becket in the Medieval Latin Preaching Tradition* (Steenbrugis, 1992), 19–20; Duggan, 'The Cult of St Thomas Becket,' 33–35; and Kay Brainerd Slocum, *Liturgies in Honour of Thomas Becket* (Toronto, 2004).

[35] Slocum, *Liturgies in Honour*, 123–26.

[36] Roberts, *Becket in the Medieval Latin Preaching Tradition*, 32–42; Phyllis B. Roberts, 'University Masters and Thomas Becket: Sermons Preached on St. Thomas of Canterbury at Paris and Oxford in the Thirteenth and Fourteenth Centuries,' *History of Universities* 6 (Oxford, 1986): 66–68; Slocum, *Liturgies in Honour*, 4.

generally but also to the presence of the reformer Stephan Langton in the environs of Sens during the years 1207–13.

The Paris academic community, in which Langton studied and taught from 1170 until 1206, evinced a strong pro-Becket sentiment even before the archbishop's murder.[37] Phyllis Roberts discovered that a significant quantity of Becket sermons originated in this Parisian milieu, and that many of the prominent figures associated with the university in the late twelfth and early thirteenth centuries strongly promoted Becket's cult both during and after their university tenures.[38] Among Langton's teachers, these Becket supporters included such luminaries as Peter the Chanter and one of Langton's fellow students, the future Innocent III.[39] Indeed, Langton's election to the archbishopric of Canterbury resulted directly from Innocent's advocacy.

Already apparent in sermons he preached during his time in Paris, Langton's devotion to Becket deepened during the events that followed his consecration as archbishop. King John opposed Langton's election in no small measure because he feared the installation of a primate who had developed such strong ties to France and who he believed shared the pro-Becket sympathies with which the university was identified.[40] As Roberts has said, 'by the time of his return to England in 1213, Langton may well have been convinced that he was himself a successor to Becket in spirit as well as title.'[41] Following his installation at Canterbury, Langton resumed preparations for Becket's translation, which included the completion and decoration of Trinity Chapel. Langton, in addition to presiding over the Translation ceremony, preached at least two sermons on Becket, one at the Translation itself, which took place on July 7, 1220, and later the same year in Rome, at the request of Pope Honorius III, on December 29, the jubilee of the saint's martyrdom. Both sermons pressed the identification of Thomas Becket with the reform ideals that Langton had also embraced during his tenure in Paris.[42] Langton's orchestration of the sumptuous translation ceremony, and the attendant expansion of the saint's already far-flung cult, became the centerpiece of his own program of pastoral renewal. Numerous Becket scholars have noted that the persona of the saint, one which endured for centuries, was largely a product of Langton's crafting.[43]

[37] Phyllis Barzillay Roberts, *Stephanus de Lingua-Tonante: Studies in the Sermons of Stephen Langton* (Toronto, 1968), 1–5; and F. M. Powicke, *Stephen Langton: being the Ford Lectures delivered in the University of Oxford in Hilary Term 1927* (Oxford, 1928).

[38] Roberts, 'University Masters and Thomas Becket,' 68 and 75.

[39] Powicke, *Stephen Langton*, 29–48; Phyllis B. Roberts, 'Stephen Langton and his Preaching on Thomas Becket in 1220,' in *De Ore Domini: Preacher and Word in the Middle Ages*, ed. Thomas L. Amos, Eugene A. Green, Beverly Mayne Kienzle, Studies in Medieval Culture 27 (Kalamazoo, Mich., 1989), 78; John W. Baldwin, *Masters, Princes, and Merchants: The Social Views of Peter the Chanter and His Circle*, 2 vols (Princeton, 1970), 1:32–46, 296–311, and 312–43; and Smalley, *The Becket Conflict*.

[40] Powicke, *Stephen Langton*, 96; Smalley, *The Becket Conflict*, 204–5; Roberts, *Stephanus de Lingua-Tonante*, 7–8.

[41] Roberts, 'University Masters and Thomas Becket,' 68.

[42] Roberts, 'Stephen Langton and his Preaching on Thomas Becket,' 77–82.

[43] Duggan, 'The Cult of St Thomas Becket,' 37; Slocum, *Liturgies in Honour*, 242–47; Raymonde Foreville, *Le Jubilé de Saint Thomas Becket du XIIIe au XVe siècle (1220–1470)*, (Paris, 1958).

In her analysis of the Sens and Canterbury windows, Madeline Caviness demonstrated the tangible exchange of designs between the two sites. These shared stylistic elements, however, provide no evidence that the Sens window offers a record of the lost Canterbury Life of Becket narratives.[44] What can, I think, be claimed for the window is that it participates in a larger visual conversation transpiring in thirteenth-century glass that can be linked with a particular image of Becket propounded by Langton both before and after his exile in Sens.

The Becket Window as Visual Discourse

The Sens window can thus be situated within the historical context of Becket's own exile, the subsequent exile of Stephen Langton and the Canterbury community, and the broader discourse of the reform movement and its identification of St Thomas with that cause.[45] Becket's efforts to defend the liberties of the Church against secular, specifically royal, encroachment, combined with his exemplary execution of his episcopal office, were already the stuff of legend during his lifetime, and were rapidly disseminated in the biographies, liturgies, and sermons following his death and canonization.[46] In addition to these historical and rhetorical connections, the visual construction of Becket's life at Sens offers additional discursive links to Canterbury and to France.

The opening scene of the Sens Becket narrative locates at center stage not the window's main protagonist, but rather, the French king, Louis VII, who reconciles the English monarch Henry II with his archbishop in a composition reminiscent of medieval scenes of matrimony. Louis VII here occupies the position of priest, flanked by the couple he has brought together (fig. 30.1). While in England, Church and State remained distinct—often antagonistic—entities, in France the ecclesiastical and monarchic realms appear harmoniously united in the figure of Louis VII. The cult of French sacral kingship, so meticulously crafted over the course of the thirteenth century, was rooted in a perception and promotion of the French kings as exceptionally pious defenders of the Church, a notion fostered by the safe haven which Sens, situated in the heart of the French realm, had provided to high-profile ecclesiastics in exile.[47] These included not only Becket and Langton, but also Pope Alexander III, who had lived in exile in Sens from 1163 to 1165.[48]

While the cult of French sacral kingship was only fully realized in the canonization of Louis IX in 1297, the identification of the kings of France as

44 Caviness, *Early Stained Glass*, 84–86 and 154.

45 Duggan, 'The Cult of St Thomas Becket,' pp. 36–42; Roberts, 'University Masters and Thomas Becket,' 68–69.

46 Staunton, *Lives of Becket*, 67–69 and 192–93.

47 Louis VII's piety and devotion to the Church were contrasted to the tyranny of Henry II, whom various biographers liken to the biblical Herod. See Staunton, *Lives of Becket*, 75–76, 82, 87, 120, and 148–89.

48 Barlow, *Thomas Becket*, 134–35 and 167–69; Smalley, *The Becket Conflict*, 138–59.

good monarchs who upheld the rights of the Church emerges as a recurrent theme in the works of twelfth- and early thirteenth-century scholars, particularly those associated with the University of Paris. In addition to the ardently pro-Becket stance evinced by Peter the Chanter and others, writers such as Gerald of Wales articulated the historical and moral, hence monarchical, superiority of the French kings Louis VII and Philip Augustus, which he contrasted with the tyrannical reigns of such Norman and Angevin kings as William Rufus, Henry II, and John.[49] This French royal bias also appears frequently in the early sermons of Stephen Langton, where monarchs engaged in the exemplary execution of their offices are inevitably identified as French.[50] By foregrounding the role of Louis VII as the architect of the reconciliation of Thomas Becket and Henry II, the Sens window recalls Louis VII's hospitality to and support of the archiepiscopal exile, thus offering a visual counterpart to the positive image of French monarchs prevalent in the Parisian university circles of Langton's youth.

If the Sens narrative begins by paying homage to the protection which the Church enjoyed under the king of France, the central portion of the window comprises a celebration, played out on multiple interpretive levels, of the reform Church itself. The most obvious of these involves the choice of narrative action. From the moment he returns to Canterbury, Archbishop Thomas immerses himself in his pastoral duties. Becket's biographers, as well as the authors of the liturgical texts composed soon after his canonization in 1173, reference Becket's attentiveness to the administrative and sacramental dimensions of his office. Becket conducted the holy sacraments 'most reverently so that his handling might shape the faith and habits of the onlookers.'[51] In like manner, the archbishop zealously undertook his role as judge in ecclesiastical cases. Both John of Salisbury and Herbert of Bosham point out that Becket executed his judicial tasks with great integrity and strove 'to eradicate all improper fees and bribes.'[52] Such high-minded behavior was also extolled in the Paris schools, where Peter the Chanter praised Becket for refusing to allow the imposition of fees for the affixing of the archiepiscopal seal to documents emanating from his chancery.[53] The second lesson in *Studens livor*, the most widely circulated of the liturgical offices composed for Becket's feast day, states that Becket brought the same 'incomparable energy' to his pastoral duties that he had earlier displayed in his administration of the chancellorship of England.[54] The Sens window depicts the archbishop engaged in a comparable whirlwind of ecclesiastical activity. Each panel of the window's central portion

[49] Giraldus Cambrensis (Gerald of Wales), *De Principis Instructione Liber*, ed. George F. Warner (London, 1891), 132–38, 289–91, 301–3, 310, 322, and 326; Giraldus Cambrensis, *Opera*, ed. J. S. Brewer, J. F. Dimock and G. F. Warner, 8 vols, Rolls Series (London, 1861–91); Robert Bartlett, *Gerald of Wales 1146–1223* (Oxford, 1982), 58–100.

[50] Roberts, *Stephanus de Lingua-Tonante*, 71–73 and 134–35.

[51] Slocum, *Liturgies in Honour*, 32, quoting the final lesson of the Office for the Feast of St Thomas Becket found in the Hyde Abbey Breviary.

[52] Slocum, *Liturgies in Honour*, 32.

[53] Smalley, *The Becket Conflict*, 203.

[54] Slocum, *Liturgies in Honour*, 176.

locates the bishop on the left with his arm raised in mid-action as he makes the sign of the cross on the forehead of a child, consecrates a new church, and takes a package of documents from a kneeling messenger (fig. 30.2). Such images stress agency of the sort claimed for the archbishop in the myriad texts that valorized him as the model of 'change and renewal' within the reform Church.[55]

One panel that breaks with the compositional conventions of narrative time, implicit in the left to right orientation of these activities, depicts Becket preaching before a symmetrically and hierarchically arranged group of clerics and laity (figs. 30.1 and 30.4). Becket's static, frontal pose, reinforced by the axially disposed audience and additionally highlighted by the focused gazes of the laity, who crane their necks as they look and listen with rapt attentiveness to the archbishop's sermon, imparts a solemnity to this composition worthy of the centrality that preaching assumed in the Church's agenda of reform.[56] Indeed, it was primarily through preaching that the Gregorian reformers believed they would most fully effect the moral regeneration of the Church as well as the laity—a dual agenda articulated in the two-tiered audience of the Sens panel. Innocent III and Stephen Langton embodied this ideal in their own extensive preaching activities, which they continued even following their respective elections as pope and archbishop.[57]

The Becket window thus articulates key elements of the Gregorian reform in the purposeful selection of the events by which it records the archbishop's final days. This thematic emphasis, I would argue, is further actualized not only by the visual litany of ecclesiastical duties in which Becket engages, but by the architectural apparatus against which the narrative unfolds. Architectural settings dominate virtually every scene (figs. 30.1–30.5). These structural elaborations identify the institution of the Church as a tangible entity, a major character in the story. As such, the architectural settings, like the archbishop's execution of his pastoral duties, become a metaphor for Becket's office and the ideals for which Becket died. Architecture of comparable design fills the windows devoted to Thomas Becket's miracles at Canterbury. As at Sens, the Trinity Chapel windows employ circular or elliptical compartments in which figures stand upon horizontal ground-lines. The narrative scenes are played out on a shallow stage against extravagant architectural sets. The depiction of Becket's tomb in the Sens window, with its niches that gave pilgrims tactile access to the sarcophagus, mirrors the myriad invocations of the martyr's early shrine at Canterbury (fig. 30.3).[58] Such compositional parallels offer further evidence of the close formal relationship between the Sens and Canterbury Becket windows.

55 Slocum, *Liturgies in Honour*, 38.

56 Smalley, *The Becket Conflict*, 21.

57 Phyllis B. Roberts, ed. *Selected Sermons of Stephen Langton* (Toronto, 1980), 4–5; Powicke, *Stephen Langton*, 41–45. While few specific references appear relative to Becket's particular skills as a preacher, the fourth lesson in the office, *Studens livor*, states that the archbishop 'zealously carried out the ministry entrusted to him.' See Slocum, *Liturgies in Honour*, 180.

58 Caviness, *Early Stained Glass*, Figs. 115, 159–60, 162, 167, and 185; Barlow, *Thomas Becket*, 266–67.

In her study of the Canterbury glass, Caviness interpreted the compositional interplay between the cathedral's biblical and Becket windows as signaling the 'authority of scriptural illustration' and as a utilitarian adaptation of established compositional models in the creation of new imagery. At the same time, Caviness observed that 'such borrowings from scriptural scenes become metaphorical' and could thus function effectively as a kind of visual typology to promote identification of Becket's life with that of Christ.[59] A comparable argument can, I propose, be made for the compositional reliance of the Sens Becket window on those of Canterbury. On one level they underscore the close relationship between the two ensembles and the likelihood that the Canterbury entourage played some part in the window's design. Like Caviness, I believe that such borrowings can also be interpreted metaphorically. In its formal dependence, the Sens window promoted the artistic authority of Canterbury. Similarly, in its depiction of Becket as the ideal prelate, the *bonus pastor* who died in defense of Church liberty, the Sens window promoted a particular crafting of Becket's cult.

This analysis of the interrelationship of form and content, or, more precisely, the interrelationship of form *as* content, is relevant to other aspects of the Sens window. The Becket narrative honors the Church in its foregrounding of pastoral activity and visual showcasing of institutional signifiers. These include not only its architectural backdrops, but also its textual foundation. Inscriptions, disposed across the ground-line of each panel, provide a literal and metaphoric foundation to the story and accentuate the institutional valence I have ascribed to the narrative through its elaboration, in verbal signs, of Becket's ecclesiastical acts. The inscription that accompanies the scene of Becket preaching thus reads 'Predicatio Sancti Tomas ad populum (fig. 30.4).' Becket's own utterance, 'Orate pro me, fratres, et ego pro vobis,' animates the depiction of the archbishop celebrating Mass (fig. 30.5), while the inscriptions, 'Beatus Thomas dedicat [ecclesiam]' and 'Hic confirmat S(anctus) Tomas pueros,' function as verbal intensifiers to the visual record of Becket's activity (fig. 30.2).

In the early thirteenth century, language and literacy remained largely the official purview of the Church. While these inscriptions serve to clarify the imagery, they function also—and perhaps more importantly—as a sign of Church authority and, arguably, as another sign of the specific authority of Canterbury relative to the artistic dissemination of Becket's cult.[60] Caviness has observed that inscriptions in stained glass windows appear more often in ensembles destined for a clerical audience, who would have been more capable of reading them.[61] Indeed, textual inscriptions fill the Canterbury Becket

[59] Caviness, *Early Stained Glass*, 150.

[60] The identification of texts in images as institutional signifiers and the degree to which the written word—specifically Latin—embodied expansive and powerful notions of ecclesiastical hegemony have been insightfully explored by Michael Camille, 'Seeing and Reading: Some Visual Implications of Medieval Literacy and Illiteracy,' *Art History* 8 (1985), 26–49; and Michael Camille, 'Visual Signs of the Sacred Page: Books in the *Bible moralisée*,' *Word and Image* 5 (1989): 111–30.

[61] Caviness, *Early Stained Glass*, 102–3; Caviness, 'Biblical Stories in Windows,' 108–9.

windows and, as at Sens, are frequently incorporated into the ground-lines of the compositions.[62] Located in windows close to eye-level, the Canterbury *tituli* operated simultaneously on multiple discursive planes, as clarifying text to the literate viewer, as prompts for the monks whose task it was to explain the images to the throngs of illiterate pilgrims who visited the shrine, and as symbol of Church authority more generally.[63] The viewers of the Becket window at Sens, situated in the north choir aisle, would have comprised a comparably broad demographic. The import and impact of the inscriptions would thus have been similarly varied. As such, the inscriptions, like the architectural framework and selective repertoire of activities, contributed to a narrative, the design of which collectively proffered a story of Becket's life as a visual celebration of the ecclesiastical realm. [64]

Conclusion

Becket's final days at Canterbury have been described as constructing 'a bridge between his life and his Passion.'[65] The Sens Becket window parallels that bridge and extends its trajectory. Executed most likely prior to the elaborate translation ceremony orchestrated by Archbishop Stephen Langton, the narrative concludes with Becket's entombment in the Christ Church crypt. By the time of the window's probable completion by or before 1213, however, Becket's rapid metamorphosis from exile, to martyr, to miracle-working saint, to standard bearer of Church liberty and reform was well established. The reification of his sanctity, effected in the hundreds of miracles attributed to him across Europe, already reverberated in the Sens glass. St Thomas's salvific acts of healing and even resurrection amplified the salvific power of the liturgical acts Archbishop Thomas performs. The iconic status Becket assumed in the years following the translation of his relics in 1220 could only have enhanced the counterpoint between history and ideology, between Becket as a figure of contemporary story and Becket as a paradigm of ecclesiastical sanctity and supremacy that the Sens window constructs.

[62] Caviness, *Early Stained Glass*, Figs. 162, 167, and 197.

[63] This imbrication of image and text was additionally disseminated through the inclusion of shared phrases in the Becket liturgies and the Trinity Chapel windows and on pilgrims' ampullae decorated with scenes of miracles. Caviness noted that, in the case of the latter, 'the verse could be recited like a spell over the sick person who was to receive the blood of Thomas; even if he/she could not understand the Latin, the inscribed letters carried the mystique of literacy that was associated with the church.' Madeline Caviness, 'Beyond the Corpus Vitrearum: Stained Glass at the Crossroads,' *Compte Rendu: Union académique internationale*, 72ème session (Brussels, 1998), 20–21; Sarah Blick, 'Comparing Pilgrim Souvenirs and Trinity Chapel Windows at Canterbury Cathedral,' *Mirator* (September 2001): 1–27.

[64] While the inclusion of *tituli* is hardly unique to these windows, they take on an added valence in that the fundamental conflict between the archbishop and Henry II turned on the issue of writing. As Becket's biographers emphasize, what made the Constitutions of Clarendon so singular a threat to Church rights was specifically the fact that they had been written down. Staunton, *Lives of Becket*, 90–91, 143–44; Camille, 'Seeing and Reading,' 32–40.

[65] Smalley, *The Becket Conflict*, 194.

As the earliest surviving window devoted to Thomas Becket outside of Canterbury, the Sens narrative might be expected to have exerted some influence on the design of the other French Becket windows. This, however, is not the case. The Becket windows at Chartres, Angers, and Coutances craft versions of Becket's life distinct from the window at Sens and from one another. While Chartres cathedral boasts numerous windows in which model prelates engage in ecclesiastical activities of the sort depicted at Sens, the Chartres Becket window devotes most of its scenes to diplomatic encounters between the archbishop, the pope, the kings of France and England, and the other bishops who participated in the protracted negotiations that transpired throughout the saint's exile. The Angers and Coutances windows, in contrast, proffer narratives in which Becket's suffering at the hands of Henry II appears anachronistically minimized.[66] Viewed as a group, the windows suggest the richness, complexity, and discursive subtlety inherent in many medieval stained glass narratives. They may also suggest a fundamental reason for the fascination with Thomas Becket.[67] Beryl Smalley has proposed that Becket's popularity was due in part to the fact that his cult 'held something for everyone.'[68] The worldly chancellor turned pious archbishop, exile, and martyr, claimed as a national saint by England as well as France, Becket's appeal was broadly based and multifaceted. This diverse legacy may find greater realization in the diversity of the visual narratives devoted to the saint than in the textual sources, all of which, tend, to greater or lesser extents, to shape Becket's life according to established hagiographic and Christological models. The Becket window at Sens, in its recursive movement between historical details and universal claims, offers an apt mirror to the archbishop's compelling and capacious place in the theological, political, and popular discourse of the Middle Ages.

[66] These windows comprise part of a larger study I am preparing on Becket imagery in France.

[67] Caviness, 'Biblical Stories in Windows,' 135–47, demonstrates a comparable diversity in the myriad thirteenth-century renderings of the biblical story of Joseph.

[68] Smalley, The Becket Conflict, 191.

Madeline Harrison Caviness: Selected Bibliography

Published Writings of Madeline Harrison Caviness

Items are listed in chronological order of publication.

Books

The Early Stained Glass of Canterbury Cathedral, circa. 1175–1220. Princeton, 1977. (Awarded the Brown Prize.)

With Suzanne M. Newman, *Medieval and Renaissance Glass from New England Collections*, edited by Madeline H. Caviness, exhb. cat., Busch-Reisinger Museum of Harvard University. Medford, Mass., 1978. Editor, Introduction and 1–6.

The Windows of Christ Church Cathedral, Canterbury, Corpus Vitrearum Medii Aevi Great Britain 2. London, 1981. (Presented by the British Academy to Prince Charles and Lady Diana on their wedding.)

With the assistance of Evelyn Ruth Staudinger (Lane), *Stained Glass before 1540: An Annotated Bibliography* (Reference Publications in Art History). Boston, 1983.

Stained Glass before 1700 in American Collections. Corpus Vitrearum (Checklists I–IV) National Gallery of Art, *Studies in the History of Art*, volumes 15, 23, 28, and 39. Washington, D.C., 1985–91. Editor and joint author.

Sumptuous Arts at the Royal Abbeys in Reims and Braine, Ornatus Elegantiae, Varietate Stupendes. Princeton, 1990. (Awarded the Haskins Medal.)

Stained Glass Windows (Typologie des Sources du Moyen Age Occidental 76). Tournhout, 1996.

Paintings on Glass: Studies in Romanesque and Gothic Monumental Art. Aldershot, England, 1997.

Visualizing Women in the Middle Ages: Sight, Spectacle and Scopic Economy. Philadelphia, 2001.

Art in the Medieval West and its Audience. Aldershot, England, 2001.

Reframing Medieval Art: Difference, Margins, Boundaries (Tufts University electronic book). Medford, Massachusetts, 2001. http://nils.lib.tufts.edu/Caviness

Visualizing Women in the Middle Ages: Sight, Spectacle and Scopic Economy. Japanese translation by Kumiko Tanaka. Tokyo, 2005.

Articles

'A panel of thirteenth-century stained glass from Canterbury in America.' *Antiquaries Journal* 45 (1965): 192–99.

'Three medallions of stained glass from the Sainte Chapelle of Paris.' *Philadelphia Museum of Art Bulletin* 62 (1967): 245–59.

With Louis Grodecki. 'Les vitraux de la Sainte Chapelle.' *Revue de L'Art* 1 (1968): 8–16.

'The fifteenth-century stained glass from Hampton Court, Herefordshire in the Boston Museum and elsewhere.' *Walpole Society Publications* (1970): 35–60.

'French thirteenth-century stained glass at Canterbury: A fragment from the Sainte Chapelle.' *Canterbury Cathedral Chronicle* 66 (1971): 35–41.

'Saving Canterbury's Medieval Glass.' *Country Life* (September 28, 1972): 739–40.

'Canterbury Stained Glass in Richmond.' *Arts in Virginia* 13 (1973): 4–15.

'*De convenientia et cohaerentia antiqui et novi operis*: Medieval conservation, restoration, pastiche and forgery.' In *Intuition und Kunstwissenschaft: Festschrift für Hanns Swarzenski*, edited by Tilmann Buddensieg, Berlin, 1973, 205–21.

'A Lost Cycle of Canterbury Paintings of 1220.' *The Antiquaries Journal* 54 (1974): 60–74.

'The Canterbury Jesse Window.' In *The Year 1200, 3, A Symposium*. New York, 1975, 373–98.

'Conflicts Between *Regnum* and *Sacerdotium* as Reflected in a Canterbury Psalter of ca. 1215.' *Art Bulletin* 61 (1979): 38–58.

'Problems of Conservation and Restoration at Canterbury: A Review of Former and Current Practices,' *Corpus Vitrearum News Letter* 29 (April 1979): 27–32.

With Virginia C. Raguin. 'Another Dispersed Window from Soissons Cathedral.' *Gesta* 20 (1981): 191–98. (Festschrift for Harry Bober.)

'Some aspects of Nineteenth Century Stained Glass Restoration: *Membra Disjecta et Collectanea*.' In *Crown in Glory: A Celebration of Craftsmanship—Studies in Stained Glass*, edited by Peter Moore. Norwich, Eng., 1982, 69–72. (Festschrift for Dennis King.)

'Canterbury Cathedral Clerestory: the Glazing Programme in Relation to the Campaigns of Construction.' *Medieval Art and Architecture at Canterbury*. (London, 1982): 46–55.

'Images of Divine Order and the Third Mode of Seeing.' *Gesta* 22 (1983): 99–120.

With Elizabeth Pastan and Marilyn Beaven. 'The Gothic Window from Soissons: A Reconsideration.' *Fenway Court* (1983): 6–25.

'Stained Glass.' In *English Romanesque Art, 1066–1200*, exhibition catalogue, edited by George. Zarnecki. London, April–July, 1984. 135–45. (Introduction and catalogue entries.)

'Saint-Yved of Braine: The Primary Sources for dating the Gothic Church.' *Speculum* 59 (1984): 524–58.

'Rediscovered Glass of about 1200 from the Abbey of St.-Yved at Braine,' *Studies on Medieval Glass: Selected Papers from the XIth International Colloquium of the Corpus Vitrearum*, New York, June 1–6, 1982, edited by M. H. Caviness and T. Husband, (New York, 1985): 34–47.

'Checklist of stained glass before 1700: New England and New York,' (Corpus Vitrearum, Checklist 1) *Studies in the History of Art* 15 (1985). (Introduction and catalogue entries.)

'Glass, Stained.' *Dictionary of the Middle Ages*, edited by Joseph R. Strayer, American Council of Learned Societies, 5. New York, 1985, 548–54.

'Hemmel, Peter.' *Dictionary of the Middle Ages*, edited by Joseph R. Strayer, American Council of Learned Societies, 6. New York, 1985, 153.

'A Man with a Dragon from one of the Tribune Oculi of Mantes.' *Gesta* 25 (1986): 127–34.

'Stained Glass: The State of Research.' In *Abbot Suger and Saint-Denis: A Symposium*, edited by Paula Gerson. New York, 1986, 257–72.

'Checklist of stained glass before 1700: Mid-Atlantic and Southeastern Seaboard States,' (Corpus Vitrearum, Checklist 2). *Studies in the History of Art* 23 (1986). (Introduction and entries.)

'Erweiterung des 'Kunst'-Begriffs: Die Rezeption mittelalterlicher Werke im Kontext nachimpressionisticher Bewegungen.' *Oesterreichische Zeitschrift für Kunst und Denkmalpflege* 40 (1986): 204–15.

'Romanesque "belles verrières" in Canterbury?' In *Romanesque & Gothic: Essays for George Zarnecki*, edited by Neil Stratford. Woodbridge, 1987, 35–38.

'Broadening the Definitions of "Art": The Reception of Medieval Works in the Context of Post-impressionist Movements.' In *Hermeneutics and Medieval Culture*, edited by P. J. Gallacher and H. Damico. Albany, 1989, 259–82.

'Ein Spiel des Zusammensetzens: Rekonstruktion der Hochchorglasfenster in der Kathedrale von Soissons.' In *Bau und Bildkunst im Spiegel Internationaler Forschung (Festschrift für Edgar Lehmann)*, edited by Maria Flügge, et al. Berlin, 1989, 41–51.

With Jane Hayward. 'Checklist of stained glass before 1700: Midwestern and Western States,' Corpus Vitrearum, Checklist 3. *Studies in the History of Art* 28 (1989). (Introduction and entries.)

'Modular Assemblages: Reconstructing the Choir Clerestory Glazing of Soissons Cathedral.' *Journal of the Walters Art Gallery* 48 (1990): 57–68.

'Checklist of stained glass before 1700: Silver Stained Roundels, and Addendum,' Corpus Vitrearum, Checklist 4. *Studies in the History of Art* 39 (1991). (Entries.)

'"The Simple Perception of Matter" and the Representation of Narrative, ca. 1180–1220,' *Gesta* 30/1 (1991): 48–64.

'Corpus Vitrearum Medii Aevi: Rapport' and 'Le Vitrail comme sujet de recherches historiques.' In *Compte Rendu de la 65e session annuelle de l'Union Académique Internationale, Paris, June 1991*. Brussels, 1992, 41–43, 48–50.

'The Twelfth-Century Ornamental Windows of Saint-Remi in Reims.' In *The Cloisters: Studies in Honor of the Fiftieth Anniversary*, edited by E. C. Parker. New York, 1992, 178–93.

'Biblical Stories in Windows: Were They Bibles for the Poor?' In *The Bible in the Middle Ages: its influence on literature and art*, edited by Bernard S. Levy, Medieval & Renaissance, Texts & Studies, Binghamton, N.Y., 1992, 103–47.

'Corpus Vitrearum – Tagung für Glasmalereiforschung 16. internationales Kolloquium.' *Kunstchronik* 45 (1992): 288–96.

'(En)gendering Marginalia in Books made for Men and Women.' *Medieval Europe 1992: Art and Symbolism* (pre-printed papers, 7). (York, 1992): 97–102.

'Patron or Matron? A Capetian Bride and a *Vade Mecum* for her Marriage Bed,' *Speculum* 68, (1993): 333–62; reprinted in *Studying Medieval Women: Sex, Gender, Feminism*, edited by Nancy F. Partner. Cambridge, MA, 1993 31–60, with annotated bibliography, 175–81.

'Introduction: The Corpus Vitrearum Project.' In *Stained Glass: Conservation of Monumental Stained and Painted Glass*, edited by Ernst Bacher (International Scientific Committee 10th General Assembly). Colombo, Sri Lanka, 1993, 7–9.

With Charles G. Nelson. 'Women in Medieval Art and Literature.' *Medieval Feminist Newsletter* 15 (Spring 1993): 17–20.

'The politics of conservation and the role of the Corpus Vitrearum in the preservation of stained glass windows.' *XXVIII Internationaler Kongress für Kunstgeschichte, Berlin, July 1992* (Berlin, 1994): 381–90.

'Learning from Forest Lawn.' *Speculum* 69 (1994): 963–92.

'Artistic Integration in Gothic Buildings: A Post-modern Construct?' In *Artistic Integration in Gothic Buildings*, edited by V. C. Raguin, K. Brush and P. Draper. Toronto, 1995, 249–61.

'A Feminist Reading of the Hours of Jeanne d'Evreux.' In *Japan and Europe in Art History: Papers of the Colloquium of the Comité International d'Histoire de l'Art, Tokyo, 1991*, edited by Shuji Takashina. (Tokyo, 1995): 481–536.

'Editorial.' *Revue de l'Art* 107 (March 1995): 5–7.

'Anchoress, Abbess and Queen: Donors and Patrons or Intercessors and Matrons?' In *The Cultural Patronage of Medieval Women*, edited by June Hall McCash. Athens, GA, 1996, 105–54.

'Gender Symbolism and Text Image Relationships: Hildegard of Bingen's *Scivias*.' In *Translation Theory and Practice in the Middle Ages*, edited by Jeanette Beer. Kalamazoo, MI, 1997, 71–111.

'Hildegard of Bingen: German author, illustrator, and musical composer, 1098–179.' In *Dictionary of Women Artists*, edited by Delia Gaze. London, 1997, 685–87.

'The Feminist Project: Pressuring the Medieval Object.' *Frauen Kunst Wissenschaft* 24. Marburg, December 1997, 13–21.

'Obscenity and Alterity: Images that Shock and Offend Us/Them, Now/Then?' *Obscenity: Social Control and Artistic Creation in the European Middle Ages*, edited by Jan M. Ziolkowski, (Cultures, Beliefs and Traditions 4). Leiden, 1998, 155–75.

'Hildegard as Designer of the Illustrations to her Works.' In *Hildegard of Bingen: The Context of her Thought and Art*, edited by Charles Burnett and Peter Dronke. London, 1998, 29–63.

'Artist: To see, Hear, and Know, All at Once.' In *Voice of the Living Light: Hildegard of Bingen and her World*, edited by Barbara Newman. Berkeley, 1998, 110–24.

'The rationalization of sight and the authority of visions? A feminist (re)vision.' In *Miscel·lània en Homenatge a Joan Ainaud de Lasarte*, 1. Barcelona, 1998, 181–87.

'A Comtemplative Life in Washington.' In *Essays on Stained Glass in Honor of Jane Hayward (1918–1994)*, edited by Michael W. Cothren and Mary B. Shepard, *Gesta* 37 (1998): 150–57.

'Beyond the Corpus Vitrearum: Stained Glass at the Crossroads.' In *Soixante-douzième session annuelle du Comité, Bruxelles, du 21 au 27 juin 1998: Compte Rendu*. Brussels, n.d., 15–39.

'Episcopal Cults and Relics: The Lives of Good Churchmen and Two Fragments of Stained Glass in Wilton.' In *Pierre, lumière, couleur: Etudes d'histoire de l'art du Moyen Âge en l'honneur d'Anne Prache*, edited by Fabienne Joubert and Dany Sandron. Paris, 1999, 61–71.

'Stasis and Movement: Hagiographical Windows and the Liturgy.' *Corpus Vitrearum Medii Aevi, XIXth. International Colloquium, Kraków, 1998, 14–16 May*, edited by Lech Kalinowski, Helena Malkiewicz, and Pawel Karaskiewicz. Cracow, 1999, 67–79.

'Louis Grodecki (1910–1982).' In *Medieval Scholarship: Biographical Studies on the Formation of a Discipline 3: Philosophy and the Arts*, edited by Helen Damico. New York, 2000, 307–21.

'Putting the Judge in his P(a)lace: Pictorial Authority in the Sachsenspiegel.' *Österreichische Zeitschrift für Kunst und Denkmalpflege (Festschrift für Ernst Bacher)* 54 (2000): 308–20.

'Tacking and veering through three careers.' *Medieval Feminist Forum* 30 (Fall 2000): 23–27.

'Stained Glass Windows in Gothic Chapels and the Feasts of the Saints.' In *Römisches Jahrbuch der Bibliotheca Hertziana: Kunst und Liturgie im Mittelalter*, edited by Nicolas Bock, Sible de Blaauw, Christoph Luitpold Frommel, and Herbert Kessler, *Kunst und Liturgie im Mittelalter : Akten des internationalen Kongresses der Bibliotheca Hertziana und des Nederlands Instituut te Rome, Rom, 28–30 September 1997*. Munich, 2000, 135–48.

'Review Article: Hildegard of Bingen: Some Recent Books.' *Speculum* 77 (2002): 113–20.

'No laughing matter: Imag(in)ing Chimeras and Freaks around 1300.' *Magistro et Amico amici discipulique: Lechowi Kalinowskiemu w osiemdziesiolecie urodzin* (Festschrift for Lech Kalinowski), (Crakow, 2002): 87–100.

'Iconclasme et iconophobie: quatre études de cas historiques.' *Diogène* 199 (Juillet-Septembre, 2002): 119–34; published in English as: 'Iconoclasm and Iconophobia: Four Historical Case Studies.' *Diogenes* 199 (2003): 99–114.

With Charles G. Nelson. 'Silent Witnesses, Absent Women, and the Law Courts in Medieval Germany.' In *Fama: The Politics of Talk and Reputation in Medieval Europe*, edited by Thelma Fenster and Daniel L. Smail. Ithaca, N.Y., 2003, 47–72.

'Las Vidrearas Inglesas.' In *Vidreiras Medievales en Europa*, edited by Xavier Barral I Altet. Barcelona, 2003, 65–91.

'The law (en)acted: Performative Space in the Town Hall of Lüneburg.' In *Glas. Malerei. Forschung. Internationale Studien zu Ehren von Rüdiger Becksmann*, edited by H. Scholz, I. Rauch, and D. Hess. Berlin, 2004, 181–90.

'Tucks and Darts: Adjusting patterns to fit figures in stained glass windows around 1200.' In *Medieval Fabrications: dress, textiles, clothwork, and other cultural imaginings*, edited by E. Jane Burns. London, 2004, 105–19; web supplement: http://www.tufts.edu/~mcavines/glassdesign.html

'Reception of Images by Medieval Viewers.' In *A Companion to Medieval Art: Romanesque and Gothic in Northern Europe*, edited by Conrad Rudolph. Malden, MA, 2006, 65–85.

Reviews

'James Rosser Johnson: *The Radiance of Chartres*.' *Speculum* 41 (1966): 338–41.

'Rüdiger Becksmann, Die Architektonische Rahmung des Hochgotischen Bildfensters.' *Art Bulletin* 52 (1970): 432–34.

'Eva Frodl-Kraft, Die Mittelalterlichen Glasgemalde in Niederosterreich, 1,' *Speculum* 50 (1975): 13–16.

'Guiseppe Marchini, *Le Vetrate dell Umbria* (Corpus Vitrearum Medii Aevi, Italia, 1).' *Art Bulletin* 57 (1976): 124–26.

'Clifford Davison and David E. O'Connor, *York Art: A subject list of extant and lost art including items relevant to early drama*.' *Speculum* 56 (1981): 114–16.

'R. Becksmann. *Die mittelalterlichen Glasmalereien in Baden und der Pfalz* CVMA Deutschland 2/1, (Berlin, 1979).' *Speculum* 57 (1982): 857–59.

'Knud Banning ed., *A Catalogue of Wall-Paintings in the Churches of Medieval Denmark, 1100–1600*. Scania, Halland, Blekinge, Copenhagen, 1976–1982.' *Speculum* 58 (1983): 142–45.

'Louis Grodecki et al., CVMA France: *Recensement*, 1 and 2.' *Art Bulletin* 65 (1983): 505–6.

'*The Architectural History of Canterbury Cathedral*, by Francis Woodman.' *Catholic Historical Review* 70 (1984): 149–50.

With Lasse Antonsen. 'Ulla Hasstrup ed., *Kristus Fremstillinger*.' *Speculum* 58 (1983): 1045–47.

'Virginia Raguin, *Stained Glass in Thirteenth Century Burgundy*.' *Speculum* 60 (1985): 454–56.

'Nigel Morgan, *The Medieval Painted Glass of Lincoln Cathedral*.' *Burlington Magazine* 127 (1985): 95–96.

'Peter Fergusson. *Architecture of Solitude: Cistercian Abbeys in Twelfth-Century England*, Princeton University Press, 1984.' *Manuscripta* 29 (1985): 122–23.

'L. Grodecki and C. Brisac, *Gothic Stained Glass, 1200–1300*. Trans. Barbara Drake Boehm. Ithaca: 1985.' *Speculum* 63 (1988): 669–71.

V. Beyer, C. Wild-Block and F. Zschokke. '*Les Vitraux de la Cathédrale Notre-Dame de Strasbourg* (Corpus Vitrearum: France 9–1, Département du Bas-Rhin 1). Paris, 1986 and J. Taralon, A. Prache and N. Blondel. *Inventaire général des monuments et richesses artistiques de la France: Les Vitraux de Bourgogne, Franche Comté et Rhone-Alpes*. (Corpus Vitrearum: France, série complémentaire, Recensement des vitraux anciens de la France, 3). Paris, 1986.' *Burlington Magazine* 131 (1989): 38–39.

'R. Becksmann, with F. Herz, H. Wentzel and F. Werner. *Die Mittelalterlichen Glasmalereien in Schwaben von 1350–1530 ohne Ulm*. (Corpus Vitrearum Medii Aevi, Germany 1, part 2.) Berlin, 1986.' *Speculum* 65 (1990): 118–19.

'W. Kemp, *Sermo Corporeus: Die Erzählung der mittelalterlichen Glasfenster*, Munich, 1987; and J. P. Dremble and C. Manhes, *Les vitraux légendaires de Chartres: Des récits en images*, Paris, 1988.' *Speculum* 65 (1990): 972–75.

'Michael Camille, The *Gothic Idol: Ideology and Image-Making in Medieval Art*.' *Speculum* 68 (1993): 120–22.

'Meredith Parsons Lillich, *Rainbow Like and Emerald: Stained Glass in Lorraine in the Thirteenth and Early Fourteenth Centuries* (Monographs on the Fine Arts 48), University Park and London: Pennsylvania State University Press for the College Art Association, 1991.' *Journal of the Society of Architectural Historians* 52 (1993): 232–33.

'Michael Camille, *Image on the Edge*, Cambridge' Harvard University Press, 1992.' *Studies in Iconography* 15 (1993): 265–70.

'Richard Marks, *Stained Glass in England during the Middle Ages*, Buffalo, NY: University of Toronto Press, 1993.' *Catholic Historical Review* 81 (1995): 259–60.

'Brigitte Buettner, *Boccaccio's "Des cleres et nobles femmes": Systems of Signification in an Illuminated Manuscript* (College Art Association Monograph 53).' *Medieval Feminist Newsletter* 27 (Spring 1999): 37–39.

'Daniel H. Weiss, *Art and Crusade in the Age of Saint Louis* (New York: Cambridge University Press. 1998).' *Catholic Historical Review* 86 (2000): 111–13.

'Jeffrey F. Hamburger, *The Visual and the Visionary: Art and Female Spirituality in Late Medieval Germany*, New York: Zone Books, 1998.' *Aurora* 1 (2000): 138–46.

'Bernard J. Muir ed., *Reading Texts and Images: Essays on Medieval and Renaissance Art and Patronage in honor of Margaret M. Manion*, Exeter: University of Exeter Press, 2002.' *TMR* online review, 2003.

'Anne Rudloff Stanton, *The Queen Mary Psalter: A Study of Affect and Audience* (Transactions of the American Philosophical Society 91) Philadelphia: American Philosophical Society, 2001.' *TMR* online review, 2004.

'*Saint-Jean-des-Vignes in Soissons: Approaches to its Architecture, Archaeology and History*. Edited by Sheila Bonde and Clark Maines. (Bibliotheca Victoriana, Vol. 40), Turnhout: Brepols. 2003.' *Catholic Historical Review* 90 (2005): 754–55.

Appendix

The Curriculum Vitae of Madeline Harrison Caviness

Education

B.A., M.A., Cambridge University
Ph.D., Harvard University
Honorary Doctor of Letters, University of Bristol, England, 2000

Academic Appointments

1981 Professor, Department of Art and the History of Art, Tufts University
1987 Mary Richardson Professor, Tufts University
Professeur Associé, Faculté des Lettres, Université Laval, Québec (honorary)

Positions Held

Robert Sterling Clark Visiting Professor, Williams College/Clark Art Institute, spring 1996
Benjamin Sonnenberg Visiting Professor, Institute of Fine Arts, New York University, fall 1991
Chair, Fine Arts Department, Tufts University, 1975–82, 1988–90
Associate Professor, Fine Arts Department, Tufts University, 1976–81; Assistant Professor, 1972–75
Radcliffe Institute Fellow, Harvard University, 1970–72

Committees, Boards and Consulting (at large)

Groupe d'Etudes et de Recherches sur les Mondialisations (GERM/Group for Study and Research on Globalisations), Scientific Committee, from 2005
International Council for Philosophy and Humanistic Studies (Conseil International de la Philosophie et des Sciences Humaines or CIPSH), an affiliate of UNESCO: Vice-President 1997–98; President 2001–4; Honorary President from 2004; scientific committee for its journal *Diogène* from 2005

Union Académique Internationale in Brussels: Delegate from the American Council of Learned Societies, from 1984; Comité des affaires internes, 1991; Bureau, 1992–95; Vice-President 1995–98; President 1998–2001

International Center of Medieval Art, Board of Directors, 1978–84; Vice President, 1983–84; President, 1984–87; Board, 2002–3; Nominating Committee, 2003

Medieval Academy of America: Council, 1981–84; Vice President, 1991–93; President, 1993–94

Medieval Academy Reprints for Teaching, Editorial Board, 1986–99

Corpus Vitrearum International Board, Vice President, 1983–87; President, 1987–95; Honorary President, from 2000

Corpus Vitrearum Committee for the U.S.A., from 1975; Chair of the Editorial Subcommittee, from 1982 and treasurer from 1986

American Council of Learned Societies, Board, 1986–1993 and fellowship sub-committee

Research Council of Canada and Australian Research Council, reviewer, from 1995

The Canterbury Cathedral Glass Advisory Committee, from 1971

Getty Conservation Institute Advisory Committee on Leon Cathedral glass 1986–87

Millard Meiss Publication Fund Committee of the College Art Association of America, 1987–90

Editorial Boards, *Journal of Glass Studies*, *Art New England*, and *Canadian Art Review*; Advisory Committee *Art Bulletin*

Census of American Stained Glass, Governing Board, 1980–82; Advisor from 1982

New England Medieval Conference: Board of Directors, 1977–80, 1980–84; Vice-President, 1985; President, 1986; Chairman, Steering Committee, Conference on the Civilization of Champagne and Burgundy, Tufts, October 1984

Arts Council of Great Britain, Advisory Committee for Romanesque Art Exhibition, 1981–82

International Congress on the History of Glass, Program Committee, 1982

Rhodes Scholarship Selection Committee for Massachusetts, 1981

Boston Museum of Fine Arts, Ad Hoc Trustee Committee on the School, 1978

Radcliffe Institute Selection Committee, 1977–78

Radcliffe Graduate Society Medal Committee, 1976–78; Chair, 1977–78

Grants Administered

National Endowment for the Humanities, Director of Basic Research Grant (Corpus Vitrearum): 1985–87, 1987–90, 1990–92

Getty Trust Grant Administrator (Corpus Vitrearum), 1987–90

Kress Foundation Grants for the Corpus Vitrearum, 1986–90

National Endowment for the Humanities, Director of Project Grant, 1977–78

Honors

AAUW Founders Distinguished Senior Scholar Award, 2005

Tufts University, Distinguished Scholar Award, 2005

Tufts University, Seymour Simches Award for Distinguished Teaching and Advising, 2005

Named among 100 international scholars honored by the Group for Study and
 Research on Globalisations (GERM) for achievements in 2004
The Haskins Medal of the Medieval Academy, 1993
Fellow of the Medieval Academy of America (elected 1992)
John Nicholas Brown Prize of the Medieval Academy, 1981
Fellow of the Society of Antiquaries of London (elected 1980)
Honorary Phi Beta Kappa of Radcliffe College, 1977

General Index

Note to the reader: illustrations are indicated by numbers in bold at the end of the citation.